GARDNER'S A Planthrough the GEES

BACKPACK EDITION Renaissance and Baroque

Australia • Brazil • Japan • Korea • Mexico • Singapore • Spain • United Kingdom • United States

Gardner's Art through the Ages: A Global History, Fourteenth Edition Renaissance and Baroque Art, Book D Fred S. Kleiner

Publisher: Clark Baxter

Senior Development Editor: Sharon Adams Poore

Assistant Editor: Ashley Bargende

Editorial Assistant: Elizabeth Newell

Associate Media Editor: Kimberly Apfelbaum

Senior Marketing Manager: Jeanne Heston

Marketing Coordinator: Klaira Markenzon

Senior Marketing Communications Manager: Heather Baxley

Senior Content Project Manager: Lianne Ames

Senior Art Director: Cate Rickard Barr

Senior Print Buyer: Mary Beth Hennebury

Rights Acquisition Specialist, Images: Mandy Groszko

Production Service & Layout: Joan Keyes, Dovetail Publishing Services

Text Designer: tani hasegawa

Cover Designer: tani hasegawa

Cover Image: © Giraudon/The Bridgeman Art Library

Compositor: Thompson Type, Inc.

© 2013, 2009, 2005 Wadsworth, Cengage Learning

ALL RIGHTS RESERVED. No part of this work covered by the copyright herein may be reproduced, transmitted, stored, or used in any form or by any means graphic, electronic, or mechanical, including but not limited to photocopying, recording, scanning, digitizing, taping, Web distribution, information networks, or information storage and retrieval systems, except as permitted under Section 107 or 108 of the 1976 United States Copyright Act, without the prior written permission of the publisher.

For product information and technology assistance, contact us at Cengage Learning Customer & Sales Support, 1-800-354-9706

For permission to use material from this text or product, submit all requests online at **www.cengage.com/permissions**. Further permissions questions can be emailed to **permissionrequest@cengage.com**.

Library of Congress Control Number: 2011931846 ISBN-13: 978-0-8400-3057-3 ISBN-10: 0-8400-3057-6

Wadsworth

20 Channel Center Street Boston, MA 02210 USA

Cengage Learning is a leading provider of customized learning solutions with office locations around the globe, including Singapore, the United Kingdom, Australia, Mexico, Brazil and Japan. Locate your local office at **international.cengage.com/region**

Cengage Learning products are represented in Canada by Nelson Education, Ltd.

For your course and learning solutions, visit **www.cengage.com**. Purchase any of our products at your local college store or at our preferred online store **www.cengagebrain.com**.

Instructors: Please visit **login.cengage.com** and log in to access instructor-specific resources.

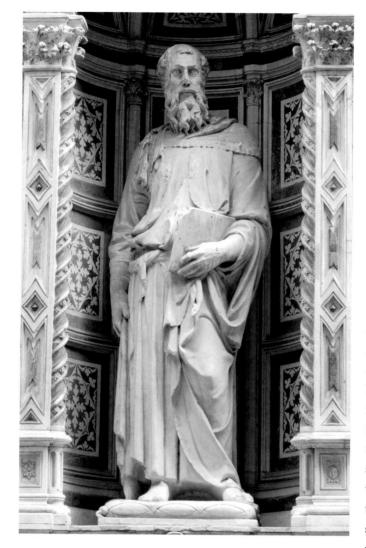

DONATELLO, *Saint Mark*, south facade of Or San Michele, Florence, Italy, ca. 1411–1413. Marble, figure 7' 9" high. Modern copy. Original sculpture in museum on second floor of Or San Michele, Florence.

One of the celebrated masters of the early Renaissance in Italy was DONATELLO (ca. 1386–1466). Saint Mark, executed for the Florentine guild of linen makers and tailors, is one of his most important works. In this sculpture, Donatello took a fundamental step toward depicting motion in the human figure by recognizing the principle of weight shift, or contrapposto. Greek sculptors of the fifth century BCE were the first to grasp that the act of standing requires balancing the position and weight of the differ-

ent parts of the human body. They recognized the body as not a rigid mass but as a flexible structure that moves by continuously shifting its weight from one supporting leg to the other, its constituent parts moving in consonance. Donatello reintroduced this concept into Renaissance statuary. As the saint's body "moves," his garment "moves" with it, hanging and folding naturally from and around different body parts so that the viewer senses the figure as a nude human wearing clothing, not as a stone statue with arbitrarily incised drapery. Donatello's *Saint Mark* is the first Renaissance statue whose voluminous robe (the pride of the Florentine guild that paid for the statue) does not conceal but accentuates the movement of the body.

That we know the name and details of the career of Donatello is not surprising, because it was during the Renaissance that the modern notion of individual artistic genius took root. But in many periods of the history of art, artists toiled in anonymity to fulfill the wishes of their patrons, whether Egyptian pharaohs, Roman emperors, or medieval monks. *Art through the Ages* surveys the art of all periods from prehistory to the present, and worldwide, and examines how artworks of all kinds have always reflected the historical contexts in which they were created.

BRIEF CONTENTS

PREFACE xiii BEFORE 1300 xxi

INTRODUCTION WHAT IS ART HISTORY? 1

CHAPTER 14 LATE MEDIEVAL ITALY 400

CHAPTER 20 LATE MEDIEVAL AND EARLY RENAISSANCE NORTHERN EUROPE 534

CHAPTER 21 THE RENAISSANCE IN QUATTROCENTO ITALY 558

CHAPTER 22 RENAISSANCE AND MANNERISM IN CINQUECENTO ITALY 598 **CHAPTER 23**

HIGH RENAISSANCE AND MANNERISM IN NORTHERN EUROPE AND SPAIN 644

CHAPTER 24 The baroque in italy AND Spain 668

CHAPTER 25

THE BAROQUE IN NORTHERN EUROPE 694

NOTES 726 GLOSSARY 727 BIBLIOGRAPHY 733 CREDITS 737 MUSEUM INDEX 739 SUBJECT INDEX 741

CONTENTS

PREFACE xiii BEFORE 1300 xxi

INTRODUCTION

WHAT IS ART HISTORY? 1

Art History in the 21st Century 2

Different Ways of Seeing 13

CHAPTER 14 LATE MEDIEVAL ITALY 400

FRAMING THE ERA | Late Medieval or Proto-Renaissance? 401

TIMELINE 402

- 13th Century 402
- 14th Century 406
- RELIGION AND MYTHOLOGY: The Great Schism, Mendicant Orders, and Confraternities 404
- ART AND SOCIETY: Italian Artists' Names 405
- MATERIALS AND TECHNIQUES: Fresco Painting 408
- WRITTEN SOURCES: Artists' Guilds, Artistic Commissions, and Artists' Contracts 410

ART AND SOCIETY: Artistic Training in Renaissance Italy 414

MAP 14-1 Italy around 1400 405

THE BIG PICTURE 421

CHAPTER 20

LATE MEDIEVAL AND EARLY RENAISSANCE NORTHERN EUROPE 534

FRAMING THE ERA The Virgin in a Flemish Home 535

TIMELINE 536

Northern Europe in the 15th Century 536

Burgundy and Flanders 536

France 550

Holy Roman Empire 552

- MATERIALS AND TECHNIQUES: Tempera and Oil Painting 539
- MATERIALS AND TECHNIQUES: Framed Paintings 543
- ART AND SOCIETY: The Artist's Profession in Flanders 545
- MATERIALS AND TECHNIQUES: Woodcuts, Engravings, and Etchings 556

MAP 20-1 France, the duchy of Burgundy, and the Holy Roman Empire in 1477 536

THE BIG PICTURE 557

CHAPTER 21 THE RENAISSANCE IN QUATTROCENTO ITALY 558

FRAMING THE ERA | Medici Patronage and Classical Learning 559

TIMELINE 560

Renaissance Humanism 560

Florence 560

The Princely Courts 589

- MATERIALS AND TECHNIQUES: Linear and Atmospheric Perspective 567
- ARTISTS ON ART: Cennino Cennini on Imitation and Emulation in Renaissance Art 573
- ART AND SOCIETY: Italian Renaissance Family Chapel Endowments 584
- ART AND SOCIETY: Italian Princely Courts and Artistic Patronage 591

MAP 21-1 Renaissance Florence 561

THE BIG PICTURE 597

CHAPTER 22 RENAISSANCE AND MANNERISM IN CINQUECENTO ITALY 598

FRAMING THE ERA | Michelangelo in the Service of Julius II 599

TIMELINE 600

High and Late Renaissance 600

Mannerism 632

- MATERIALS AND TECHNIQUES: Renaissance Drawings 604
- ARTISTS ON ART: Leonardo and Michelangelo on Painting versus Sculpture 609
- WRITTEN SOURCES: Religious Art in Counter-Reformation Italy 617
- ART AND SOCIETY: Women in the Renaissance Art World 630
- ARTISTS ON ART: Palma il Giovane on Titian 631

MAP 22-1 Rome with Renaissance and Baroque monuments 600

THE BIG PICTURE 643

CHAPTER 23 HIGH RENAISSANCE AND MANNERISM IN NORTHERN EUROPE AND SPAIN 644

FRAMING THE ERA | Earthly Delights in the Netherlands 645

TIMELINE 646

Northern Europe in the 16th Century 646

Holy Roman Empire 647

France 656

The Netherlands 658

Spain 664

RELIGION AND MYTHOLOGY: Catholic and Protestant Views of Salvation 653

MAP 23-1 Europe in the early 16th century 646

THE BIG PICTURE 667

CHAPTER 24 The baroque In Italy and spain 668

FRAMING THE ERA | Baroque Art and Spectacle 669

TIMELINE 670

"Baroque" Art and Architecture 670

Italy 670

Spain 687

- WRITTEN SOURCES: Giovanni Pietro Bellori on Annibale Carracci and Caravaggio 682
- ARTISTS ON ART: The Letters of Artemisia Gentileschi 684
- ART AND SOCIETY: Velázquez and Philip IV 690

MAP 24-1 Vatican City 673

THE BIG PICTURE 693

CHAPTER 25 THE BAROQUE IN NORTHERN EUROPE 694

FRAMING THE ERA | Still-Life Painting in the Dutch Republic 695

TIMELINE 696

War and Trade in Northern Europe 696

Flanders 697

Dutch Republic 702

France 714

England 723

ARTISTS ON ART: Rubens on Consequences of War 700

■ ART AND SOCIETY: Middle-Class Patronage and the Art Market in the Dutch Republic 703

ARTISTS ON ART: Poussin's Notes for a Treatise on Painting 719

MAP 25-1 Europe in 1648 after the Treaty of Westphalia 696

THE BIG PICTURE 725

NOTES 726 GLOSSARY 727 BIBLIOGRAPHY 733 CREDITS 737 MUSEUM INDEX 739 SUBJECT INDEX 741

PREFACE

THE GARDNER LEGACY IN THE 21ST CENTURY

I take great pleasure in introducing the extensively revised and expanded 14th edition of *Gardner's Art through the Ages: A Global History*, which, like the enhanced 13th edition, is a hybrid art history textbook—the first, and still the only, introductory survey of the history of art of its kind. This innovative new kind of "Gardner" retains all of the best features of traditional books on paper while harnessing 21st-century technology to increase by 25% the number of works examined—without increasing the size or weight of the book itself and at very low additional cost to students compared to a larger book.

When Helen Gardner published the first edition of *Art through the Ages* in 1926, she could not have imagined that more than 85 years later instructors all over the world would still be using her textbook in their classrooms. Indeed, if she were alive today, she would not recognize the book that, even in its traditional form, long ago became—and remains—the most widely read introduction to the history of art and architecture in the English language. During the past half-century, successive authors have constantly reinvented Helen Gardner's groundbreaking global survey, always keeping it fresh and current, and setting an ever-higher standard with each new edition. I am deeply gratified that both professors and students seem to agree that the 13th edition, released in 2008, lived up to that venerable tradition, for they made it the number-one choice for art history survey courses. I hope they will find the 14th edition of this best-selling book exceeds their high expectations.

In addition to the host of new features (enumerated below) in the book proper, the 14th edition follows the enhanced 13th edition in incorporating an innovative new online component. All new copies of the 14th edition are packaged with an access code to a web site with *bonus essays* and *bonus images* (with zoom capability) of more than 300 additional important paintings, sculptures, buildings, and other art forms of all eras, from prehistory to the present and worldwide. The selection includes virtually all of the works professors have told me they wished had been in the 13th edition, but were not included for lack of space. I am extremely grateful to Cengage Learning/Wadsworth for the considerable investment of time and resources that has made this remarkable hybrid textbook possible.

In contrast to the enhanced 13th edition, the online component is now fully integrated into the 14th edition. Every one of the more than 300 bonus images is cited in the text of the traditional book and a thumbnail image of each work, with abbreviated caption, is inset into the text column where the work is mentioned. The integration extends also to the maps, index, glossary, and chapter summaries, which seamlessly merge the printed and online information. The 14th edition is in every way a unified, comprehensive history of art and architecture, even though the text is divided into paper and digital components.

KEY FEATURES OF THE 14TH EDITION

In this new edition, I have added several important features while retaining the basic format and scope of the previous edition. Once again, the hybrid Gardner boasts roughly 1,700 photographs, plans, and drawings, nearly all in color and reproduced according to the highest standards of clarity and color fidelity, including hundreds of new images, among them a new series of superb photos taken by Jonathan Poore exclusively for Art through the Ages during three photographic campaigns in France and Italy in 2009, 2010, and 2011. The online component also includes custom videos made at each site by Sharon Adams Poore. This extraordinary new archive of visual material ranges from ancient Roman ruins in southern France to Romanesque and Gothic churches in France and Tuscany to Le Corbusier's modernist chapel at Ronchamp and the postmodern Pompidou Center and the Louvre Pyramide in Paris. The 14th edition also features the highly acclaimed architectural drawings of John Burge. Together, these exclusive photographs, videos, and drawings provide readers with a visual feast unavailable anywhere else.

The captions accompanying those illustrations contain, as before, a wealth of information, including the name of the artist or architect, if known; the formal title (printed in italics), if assigned, description of the work, or name of the building; the provenance or place of production of the object or location of the building; the date; the material(s) used; the size; and the present location if the work is in a museum or private collection. Scales accompany not only all architectural plans, as is the norm, but also appear next to each photograph of a painting, statue, or other artwork—another unique feature of the Gardner text. The works discussed in the 14th edition of *Art through the Ages* vary enormously in size, from colossal sculptures carved into mountain cliffs and paintings that cover entire walls or ceilings to tiny figurines, coins, and jewelry that one can hold in the hand. Although the captions contain the pertinent dimensions, it is difficult for students who have never seen the paintings or statues in person to translate those dimensions into an appreciation of the real size of the objects. The scales provide an effective and direct way to visualize how big or how small a given artwork is and its relative size compared with other objects in the same chapter and throughout the book.

Also retained in this edition are the Quick-Review Captions introduced in the 13th edition. Students have overwhelmingly reported that they found these brief synopses of the most significant aspects of each artwork or building illustrated invaluable when preparing for examinations. These extended captions accompany not only every image in the printed book but also all the digital images in the online supplement. Another popular tool introduced in the 13th edition to aid students in reviewing and mastering the material reappears in the 14th edition. Each chapter ends with a full-page feature called The Big Picture, which sets forth in bulletpoint format the most important characteristics of each period or artistic movement discussed in the chapter. Small illustrations of characteristic works accompany the summary of major points. The 14th edition, however, introduces two new features in every chapter: a timeline summarizing the major developments during the era treated (again in bullet-point format for easy review) and a chapteropening essay on a characteristic painting, sculpture, or building. Called Framing the Era, these in-depth essays are accompanied by a general view and four enlarged details of the work discussed.

The 14th edition of Art through the Ages is available in several different traditional paper formats-a single hardcover volume; two paperback volumes designed for use in the fall and spring semesters of a yearlong survey course; a six-volume "backpack" set; and an interactive e-book version. Another pedagogical tool not found in any other introductory art history textbook is the Before 1300 section that appears at the beginning of the second volume of the paperbound version of the book and at the beginning of Book D of the backpack edition. Because many students taking the second half of a survey course will not have access to Volume I or to Books A, B, and C, I have provided a special set of concise primers on architectural terminology and construction methods in the ancient and medieval worlds, and on mythology and religion-information that is essential for understanding the history of art after 1300, both in the West and the East. The subjects of these special boxes are Greco-Roman Temple Design and the Classical Orders; Arches and Vaults; Basilican Churches; Central-Plan Churches; The Gods and Goddesses of Mount Olympus; The Life of Jesus in Art; Buddhism and Buddhist Iconography; and Hinduism and Hindu Iconography.

Boxed essays once again appear throughout the book as well. This popular feature first appeared in the 11th edition of *Art through the Ages*, which in 2001 won both the Texty and McGuffey Prizes of the Text and Academic Authors Association for a college textbook in the humanities and social sciences. In this edition the essays are more closely tied to the main text than ever before. Consistent with that greater integration, almost all boxes now incorporate photographs of important artworks discussed in the text proper that also illustrate the theme treated in the boxed essays. These essays fall under six broad categories:

Architectural Basics boxes provide students with a sound foundation for the understanding of architecture. These discussions are concise explanations, with drawings and diagrams, of the major aspects of design and construction. The information included is essential to an understanding of architectural technology and terminology. The boxes address questions of how and why various forms developed, the problems architects confronted, and the solutions they used to resolve them. Topics discussed include how the Egyptians built the pyramids; the orders of classical architecture; Roman concrete construction; and the design and terminology of mosques, stupas, and Gothic cathedrals.

Materials and Techniques essays explain the various media artists employed from prehistoric to modern times. Since materials and techniques often influence the character of artworks, these discussions contain essential information on why many monuments appear as they do. Hollow-casting bronze statues; fresco painting; Chinese silk; Andean weaving; Islamic tilework; embroidery and tapestry; engraving, etching, and lithography; and daguerreotype and calotype photography are among the many subjects treated.

Religion and Mythology boxes introduce students to the principal elements of the world's great religions, past and present, and to the representation of religious and mythological themes in painting and sculpture of all periods and places. These discussions of belief systems and iconography give readers a richer understanding of some of the greatest artworks ever created. The topics include the gods and goddesses of Egypt, Mesopotamia, Greece, and Rome; the life of Jesus in art; Buddha and Buddhism; Muhammad and Islam; and Aztec religion.

Art and Society essays treat the historical, social, political, cultural, and religious context of art and architecture. In some instances, specific monuments are the basis for a discussion of broader themes, as when the Hegeso stele serves as the springboard for an exploration of the role of women in ancient Greek society. Another essay discusses how people's evaluation today of artworks can differ from those of the society that produced them by examining the problems created by the contemporary market for undocumented archaeological finds. Other subjects include Egyptian mummification; Etruscan women; Byzantine icons and iconoclasm; artistic training in Renaissance Italy; 19th-century academic salons and independent art exhibitions; the Mesoamerican ball game; Japanese court culture; and art and leadership in Africa.

Written Sources present and discuss key historical documents illuminating important monuments of art and architecture throughout the world. The passages quoted permit voices from the past to speak directly to the reader, providing vivid and unique insights into the creation of artworks in all media. Examples include Bernard of Clairvaux's treatise on sculpture in medieval churches; Giovanni Pietro Bellori's biographies of Annibale Carracci and Caravaggio; Jean François Marmontel's account of 18th-century salon culture; as well as texts that bring the past to life, such as eyewitness accounts of the volcanic eruption that buried Roman Pompeii and of the fire that destroyed Canterbury Cathedral in medieval England.

Finally, in the *Artists on Art* boxes, artists and architects throughout history discuss both their theories and individual works. Examples include Sinan the Great discussing the mosque he designed for Selim II; Leonardo da Vinci and Michelangelo debating the relative merits of painting and sculpture; Artemisia Gentileschi talking about the special problems she confronted as a woman artist; Jacques-Louis David on Neoclassicism; Gustave Courbet on Realism; Henri Matisse on color; Pablo Picasso on Cubism; Diego Rivera on art for the people; and Judy Chicago on her seminal work *The Dinner Party*.

For every new edition of *Art through the Ages*, I also reevaluate the basic organization of the book. In the 14th edition, the unfolding narrative of the history of art in Europe and America is no longer interrupted with "excursions" to Asia, Africa, and Oceania. Those chapters are now grouped together at the end of Volumes I and II and in backpack Books D and F. And the treatment of the art of the later 20th century and the opening decade of the 21st century has been significantly reconfigured. There are now separate chapters on the art and architecture of the period from 1945 to 1980 and from 1980 to the present. Moreover, the second chapter (Chapter 31, "Contemporary Art Worldwide") is no longer confined to Western art but presents the art and architecture of the past three decades as a multifaceted global phenomenon. Furthermore, some chapters now appear in more than one of the paperbound versions of the book in order to provide enhanced flexibility to instructors who divide the global history of art into two or three semester-long courses. Chapter 14-on Italian art from 1200 to 1400-appears in both Volumes I and II and in backpack Books B and D. The Islamic and contemporary art chapters appear in both the Western and non-Western backpack subdivisions of the full global text.

Rounding out the features in the book itself is a greatly expanded Bibliography of books in English with several hundred new entries, including both general works and a chapter-by-chapter list of more focused studies; a Glossary containing definitions of all italicized terms introduced in both the printed and online texts; and, for the first time, a complete museum index listing all illustrated artworks by their present location.

The 14th edition of *Art through the Ages* also features a host of state-of-the-art online resources (enumerated on page xviii).

WRITING AND TEACHING THE HISTORY OF ART

Nonetheless, some things have not changed in this new edition, including the fundamental belief that guided Helen Gardner so many years ago-that the primary goal of an introductory art history textbook should be to foster an appreciation and understanding of historically significant works of art of all kinds from all periods and from all parts of the globe. Because of the longevity and diversity of the history of art, it is tempting to assign responsibility for telling its story to a large team of specialists. The original publisher of Art through the Ages took this approach for the first edition prepared after Helen Gardner's death, and it has now become the norm for introductory art history surveys. But students overwhelmingly say the very complexity of the global history of art makes it all the more important for the story to be told with a consistent voice if they are to master so much diverse material. I think Helen Gardner would be pleased to know that Art through the Ages once again has a single storyteller-aided in no small part by invaluable advice from well over a hundred reviewers and other consultants whose assistance I gladly acknowledge at the end of this Preface.

I continue to believe that the most effective way to tell the story of art through the ages, especially to anyone studying art history for the first time, is to organize the vast array of artistic monuments according to the civilizations that produced them and to consider each work in roughly chronological order. This approach has not merely stood the test of time. It is the most appropriate way to narrate the *history* of art. The principle underlying my approach to every period of art history is that the enormous variation in the form and meaning of the paintings, sculptures, buildings, and other artworks men and women have produced over the past 30,000 years is largely the result of the constantly changing contexts in which artists and architects worked. A historically based narrative is therefore best suited for a global history of art because it enables the author to situate each work discussed in its historical, social, economic, religious, and cultural context. That is, after all, what distinguishes art history from art appreciation.

In the 1926 edition of Art through the Ages, Helen Gardner discussed Henri Matisse and Pablo Picasso in a chapter entitled "Contemporary Art in Europe and America." Since then many other artists have emerged on the international scene, and the story of art through the ages has grown longer and even more complex. As already noted, that is reflected in the addition of a new chapter at the end of the book on contemporary art in which developments on all continents are treated together for the first time. Perhaps even more important than the new directions artists and architects have taken during the past several decades is that the discipline of art history has also changed markedly-and so too has Helen Gardner's book. The 14th edition fully reflects the latest art historical research emphases while maintaining the traditional strengths that have made previous editions of Art through the Ages so popular. While sustaining attention to style, chronology, iconography, and technique, I also ensure that issues of patronage, function, and context loom large in every chapter. I treat artworks not as isolated objects in sterile 21st-century museum settings but with a view toward their purpose and meaning in the society that produced them at the time they were produced. I examine not only the role of the artist or architect in the creation of a work of art or a building, but also the role of the individuals or groups who paid the artists and influenced the shape the monuments took. Further, in this expanded hybrid edition, I devote more space than ever before to the role of women and women artists in societies worldwide over time. In every chapter, I have tried to choose artworks and buildings that reflect the increasingly wide range of interests of scholars today, while not rejecting the traditional list of "great" works or the very notion of a "canon." Indeed, the expanded hybrid nature of the 14th edition has made it possible to illustrate and discuss scores of works not traditionally treated in art history survey texts without reducing the space devoted to canonical works.

CHAPTER-BY-CHAPTER CHANGES IN THE 14TH EDITION

All chapters feature many new photographs, revised maps, revised Big Picture chapter-ending summaries, and changes to the text reflecting new research and discoveries.

Introduction: What is Art History? New painting by Ogata Korin added.

14: Late Medieval Italy. New Framing the Era essay "Late Medieval or Proto-Renaissance?" and new timeline. New series of photos of architecture and sculpture in Florence, Orvieto, Pisa, and Siena. Andrea Pisano Baptistery doors added.

20: Late Medieval and Early Renaissance Northern Europe. New Framing the Era essay "The Virgin in a Flemish Home" and new timeline. New section of the *Nuremberg Chronicle* illustrated. Diptych of Martin van Nieuwenhove added.

21: The Renaissance in Quattrocento Italy. New Framing the Era essay "Medici Patronage and Classical Learning" and new time-

line. Expanded discussion of Botticelli and Neo-Platonism. Revised boxes on linear and atmospheric perspective and on Cennino Cennini. Tomb of Leonardo Bruni and *Resurrection* by Piero della Francesca added.

22: Renaissance and Mannerism in Cinquecento Italy. New Framing the Era essay "Michelangelo in the Service of Julius II" and new timeline. Michelangelo's late *Pietà* and Parmigianino's self-portrait added. Revised box on "Palma il Giovane and Titian." Series of new photos of Florence, Rome, and Venice.

23: High Renaissance and Mannerism in Northern Europe and Spain. New Framing the Era essay "Earthly Delights in the Netherlands" and new timeline. Dürer's self-portrait and *Melencolia I* and El Greco's *View of Toledo* added.

24: The Baroque in Italy and Spain. New Framing the Era essay "Baroque Art and Spectacle" and new timeline. Bernini's Four Rivers Fountain and Gentileschi's self-portrait added.

25: The Baroque in Northern Europe. New Framing the Era essay "Still-Life Painting in the Dutch Republic" and new timeline. Expanded discussion of Dutch mercantilism. Vermeer's *Woman Holding a Balance* added.

Go to the online instructor companion site or PowerLecture for a more detailed list of chapter-by-chapter changes and the figure number transition guide.

ACKNOWLEDGMENTS

A work as extensive as a global history of art could not be undertaken or completed without the counsel of experts in all areas of world art. As with previous editions, Cengage Learning/Wadsworth has enlisted more than a hundred art historians to review every chapter of Art through the Ages in order to ensure that the text lives up to the Gardner reputation for accuracy as well as readability. I take great pleasure in acknowledging here the important contributions to the 14th edition made by the following : Michael Jay Adamek, Ozarks Technical Community College; Charles M. Adelman, University of Northern Iowa; Christine Zitrides Atiyeh, Kutztown University; Gisele Atterberry, Joliet Junior College; Roann Barris, Radford University; Philip Betancourt, Temple University; Karen Blough, SUNY Plattsburgh; Elena N. Boeck, DePaul University; Betty Ann Brown, California State University Northridge; Alexandra A. Carpino, Northern Arizona University; Anne Walke Cassidy, Carthage College; Harold D. Cole, Baldwin Wallace College; Sarah Cormack, Webster University, Vienna; Jodi Cranston, Boston University; Nancy de Grummond, Florida State University; Kelley Helmstutler Di Dio, University of Vermont; Owen Doonan, California State University Northridge; Marilyn Dunn, Loyola University Chicago; Tom Estlack, Pittsburgh Cultural Trust; Lois Fichner-Rathus, The College of New Jersey; Arne R. Flaten, Coastal Carolina University; Ken Friedman, Swinburne University of Technology; Rosemary Gallick, Northern Virginia Community College; William V. Ganis, Wells College; Marc Gerstein, University of Toledo; Clive F. Getty, Miami University; Michael Grillo, University of Maine; Amanda Hamilton, Northwest Nazarene University; Martina Hesser, Heather Jensen, Brigham Young University; Grossmont College; Mark Johnson, Brigham Young University; Jacqueline E. Jung, Yale University; John F. Kenfield, Rutgers University; Asen Kirin, University of Georgia; Joanne Klein, Boise State

University; Yu Bong Ko, Tappan Zee High School; Rob Leith, Buckingham Browne & Nichols School; Adele H. Lewis, Arizona State University; Kate Alexandra Lingley, University of Hawaii-Manoa; Ellen Longsworth, Merrimack College; Matthew Looper, California State University-Chico; Nuria Lledó Tarradell, Universidad Complutense, Madrid; Anne McClanan, Portland State University; Mark Magleby, Brigham Young University; Gina Miceli-Hoffman, Moraine Valley Community College; William Mierse, University of Vermont; Amy Morris, Southeastern Louisiana University; Charles R. Morscheck, Drexel University; Johanna D. Movassat, San Jose State University; Carola Naumer, Truckee Meadows Community College; Irene Nero, Southeastern Louisiana University; Robin O'Bryan, Harrisburg Area Community College; Laurent Odde, Kutztown University of Pennsylvania; E. Suzanne Owens, Lorain County Community College; Catherine Pagani, The University of Alabama; Martha Peacock, Brigham Young University; Mabi Ponce de Leon, Bexley High School; Curtis Runnels, Boston University; Malia E. F. Serrano, Grossmont College; Molly Skjei, Normandale Community College; James Swensen, Brigham Young University; John Szostak, University of Hawaii-Manoa; Fred T. Smith, Kent State University; Thomas F. Strasser, Providence College; Katherine H. Tachau, University of Iowa; Debra Thompson, Glendale Community College; Alice Y. Tseng, Boston University; Carol Ventura, Tennessee Technological University; Marc Vincent, Baldwin Wallace College; Deborah Waite, University of Hawaii-Manoa; Lawrence Waldron, Saint John's University; Victoria Weaver, Millersville University; and Margaret Ann Zaho, University of Central Florida.

I am especially indebted to the following for creating the instructor and student materials for the 14th edition: William J. Allen, Arkansas State University; Ivy Cooper, Southern Illinois University Edwardsville; Patricia D. Cosper, The University of Alabama at Birmingham; Anne McClanan, Portland State University; and Amy M. Morris, Southeastern Louisiana University. I also thank the members of the Wadsworth Media Advisory Board for their input: Frances Altvater, University of Hartford; Roann Barris, Radford University; Bill Christy, Ohio University-Zanesville; Annette Cohen, Great Bay Community College; Jeff Davis, The Art Institute of Pittsburgh–Online Division; Owen Doonan, California State University-Northridge; Arne R. Flaten, Coastal Carolina University; Carol Heft, Muhlenberg College; William Mierse, University of Vermont; Eleanor F. Moseman, Colorado State University; and Malia E. F. Serrano, Grossmont College.

I am also happy to have this opportunity to express my gratitude to the extraordinary group of people at Cengage Learning/ Wadsworth involved with the editing, production, and distribution of Art through the Ages. Some of them I have now worked with on various projects for nearly two decades and feel privileged to count among my friends. The success of the Gardner series in all of its various permutations depends in no small part on the expertise and unflagging commitment of these dedicated professionals, especially Clark Baxter, publisher; Sharon Adams Poore, senior development editor (as well as videographer extraordinaire); Lianne Ames, senior content project manager; Mandy Groszko, rights acquisitions specialist; Kimberly Apfelbaum, associate media editor; Robert White, product manager; Ashley Bargende, assistant editor; Elizabeth Newell, editorial assistant; Amy Bither and Jessica Jackson, editorial interns; Cate Rickard Barr, senior art director; Jeanne M. Heston, senior marketing manager, Heather Baxley, senior marketing communications manager, and the incomparable group of local sales representatives who have passed on to me the welcome

advice offered by the hundreds of instructors they speak to daily during their visits to college campuses throughout North America.

I am also deeply grateful to the following out-of-house contributors to the 14th edition: the peerless and tireless Joan Keyes, Dovetail Publishing Services; Helen Triller-Yambert, development editor; Ida May Norton, copy editor; Do Mi Stauber and Michael Brackney, indexers; Susan Gall, proofreader; tani hasegawa, designer; Catherine Schnurr, Mary-Lise Nazaire, Lauren McFalls, and Corey Geissler, PreMediaGlobal, photo researchers; Alma Bell, Scott Paul, John Pierce, and Lori Shranko, Thompson Type; Jay and John Crowley, Jay's Publishing Services; Mary Ann Lidrbauch, art manuscript preparer; and, of course, Jonathan Poore and John Burge, for their superb photos and architectural drawings.

Finally, I owe thanks to my former co-author, Christin J. Mamiya of the University of Nebraska–Lincoln, for her friendship and advice, especially with regard to the expanded contemporary art section of the 14th edition, as well as to my colleagues at Boston University and to the thousands of students and the scores of teaching fellows in my art history courses since I began teaching in 1975. From them I have learned much that has helped determine the form and content of *Art through the Ages* and made it a much better book than it otherwise might have been.

Fred S. Kleiner

FRED S. KLEINER (Ph.D., Columbia University) is the author or coauthor of the 10th, 11th, 12th, and 13th editions of *Art through the Ages: A Global History*, as well as the 1st, 2nd, and 3rd editions of *Art through the Ages: A Concise History*, and more than a hundred publications on Greek and Roman art and architecture, including *A History of Roman Art*, also published by Wadsworth, a part of Cengage Learning. He has taught the art history survey course for more than three decades, first at the University of Virginia and, since 1978, at Boston University, where he is currently Professor of Art History and Archaeology and Chair of the Department of History of Art and Architecture. From 1985 to 1998, he was Editor-in-Chief of the *American Journal of Archaeology*. Long acclaimed for his inspiring lectures and dedication to students, Professor Kleiner

won Boston University's Metcalf Award for Excellence in Teaching as well as the College Prize for Undergraduate Advising in the Humanities in 2002, and he is a two-time winner of the Distinguished Teaching Prize in the College of Arts and Sciences Honors Program. In 2007, he was elected a Fellow of the Society of Antiquaries of London, and, in 2009, in recognition of lifetime achievement in publication and teaching, a Fellow of the Text and Academic Authors Association.

Also by Fred Kleiner: *A History of Roman Art, Enhanced Edition* (Wadsworth 2010; ISBN 9780495909873), winner of the 2007 Texty Prize for a new college textbook in the humanities and social sciences. In this authoritative and lavishly illustrated volume, Professor Kleiner traces the development of Roman art and architecture from Romulus's foundation of Rome in the eighth century BCE to the death of Constantine in the fourth century CE, with special chapters devoted to Pompeii and Herculaneum, Ostia, funerary and provincial art and architecture, and the earliest Christian art. The enhanced edition also includes a new introductory chapter on the art and architecture of the Etruscans and of the Greeks of South Italy and Sicily.

RESOURCES

FOR FACULTY

PowerLecture with Digital Image Library

This flashdrive is an all-in-one lecture and class presentation tool that makes it easy to assemble, edit, and present customized lectures for your course using Microsoft* PowerPoint*. The Digital Image Library provides high-resolution images (maps, diagrams, and most of the fine art images from the text, including the over 300 new images) for lecture presentations, either in PowerPoint format, or in individual file formats compatible with other image-viewing software. A zoom feature allows you to magnify selected portions of an image for more detailed display in class, or you can display images side by side for comparison. You can easily add your own images to those from the text. The Google Earth™ application allows you to zoom in on an entire city, as well as key monuments and buildings. There are links to specific figures for every chapter in the book. PowerLecture also includes an Image Transition Guide, an electronic Instructor's Manual and a Test Bank with multiplechoice, matching, short-answer, and essay questions in ExamView® computerized format. The text-specific Microsoft® PowerPoint® slides are created for use with JoinIn[™], software for classroom personal response systems (clickers).

WebTutor[™] with eBook on WebCT[®] and Blackboard[®]

WebTutor[™] enables you to assign preformatted, text-specific content that is available as soon as you log on. You can also customize the WebTutor[™] environment in any way you choose. Content includes the Interactive ebook, Test Bank, Practice Quizzes, Video Study Tools, and CourseMate[™].

To order, contact your Cengage Learning representative.

FOR STUDENTS

CourseMateTM with eBook

Make the most of your study time by accessing everything you need to succeed in one place. Open the interactive eBook, take notes, review image and audio flashcards, watch videos, and take practice quizzes online with CourseMate[™]. You will find hundreds of zoomable, high-resolution bonus images (represented by thumbnail images in the text) along with discussion of the images, videos created specifically to enhanced your reading comprehension, audio chapter summaries, compare-and-contrast activities, Guide to Studying, and more.

Slide Guides

The Slide Guide is a lecture companion that allows you to take notes alongside thumbnails of the same art images that are shown in class. This handy booklet includes reproductions of the images from the book with full captions, page numbers, and space for note taking. It also includes Google Earth[™] exercises for key cities, monuments, and buildings that will take you to these locations to better understand the works you are studying.

To order, go to www.cengagebrain.com

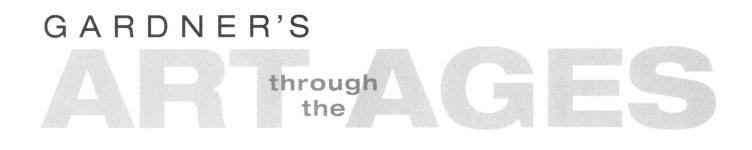

BEFORE 1300

Students enrolled in the second semester of a yearlong introductory survey of the history of art may not have access to paperback Volume I (or backpack Books A, B, and C). Therefore, Volume II and Book D of *Art through the Ages: A Global History* open with a special set of concise primers on Greco-Roman and medieval architectural terminology and construction methods and on Greco-Roman, Buddhist, and Hindu iconography—information that is essential for understanding the history of art and architecture after 1300 both in the West and the East.

CONTENTS

ARCHITECTURAL BASICS

Greco-Roman Temple Design and the Classical Orders xxii

Arches and Vaults xxiv

Basilican Churches xxvi

Central-Plan Churches xxviii

RELIGION AND MYTHOLOGY

The Gods and Goddesses of Mount Olympus xxix The Life of Jesus in Art xxx Buddhism and Buddhist Iconography xxxii Hinduism and Hindu Iconography xxxiii

Greco-Roman Temple Design and the Classical Orders

The gable-roofed columnar stone temples of the Greeks and Romans have had more influence on the later history of architecture in the Western world than any other building type ever devised. Many of the elements of classical temple architecture are present in buildings from the Renaissance to the present day.

The basic design principles of Greek and Roman temples and the most important components of the classical orders can be summarized as follows.

Temple design The core of a Greco-Roman temple was the *cella*, a room with no windows that usually housed the statue of the god or goddess to whom the shrine was dedicated. Generally, only the priests, priestesses, and chosen few would enter the cella. Worshipers gathered in front of the building, where sacrifices occurred at open-air altars. In most Greek temples, for example, the temple erected in honor of Hera or Apollo at Paestum, a *colonnade* was erected all around the cella to form a *peristyle*.

In contrast, Roman temples, for example, the Temple of Portunus in Rome, usually have freestanding columns only in a porch at the front of the building. Sometimes, as in the Portunus temple, *engaged* (attached) half-columns adorn three sides of the cella to give the building the appearance of a *peripteral* temple. Architectural historians call this a *pseudoperipteral* design. The Greeks and Romans also built round temples (called *tholos* temples), a building type that also had a long afterlife in Western architecture. **Classical orders** The Greeks developed two basic architectural orders, or design systems: the *Doric* and the *Ionic*. The forms of the columns and *entablature* (superstructure) generally differentiate the orders. Classical columns have two or three parts, depending on the order: the shaft, which is usually marked with vertical channels (*flutes*); the *capital*; and, in the Ionic order, the *base*. The Doric capital consists of a round *echinus* beneath a square abacus block. Spiral *volutes* constitute the distinctive feature of the Ionic capital. Classical entablatures have three parts: the *architrave*, the *frieze*, and the triangular *pediment* of the gabled roof, framed by the *cornice*. In the Doric order, the frieze is subdivided into *triglyphs* and *metopes*, whereas in the Ionic, the frieze is left open.

The *Corinthian capital*, a later Greek invention very popular in Roman times, is more ornate than either the Doric or Ionic. It consists of a double row of acanthus leaves, from which tendrils and flowers emerge. Although this capital often is cited as the distinguishing element of the Corinthian order, in strict terms no Corinthian order exists. Architects simply substituted the new capital type for the volute capital in the Ionic order, as in the Roman temple probably dedicated to Vesta at Tivoli.

Sculpture played a major role on the exterior of classical temples, partly to embellish the deity's shrine and partly to tell something about the deity to those gathered outside. Sculptural ornament was concentrated on the upper part of the building, in the pediment and frieze.

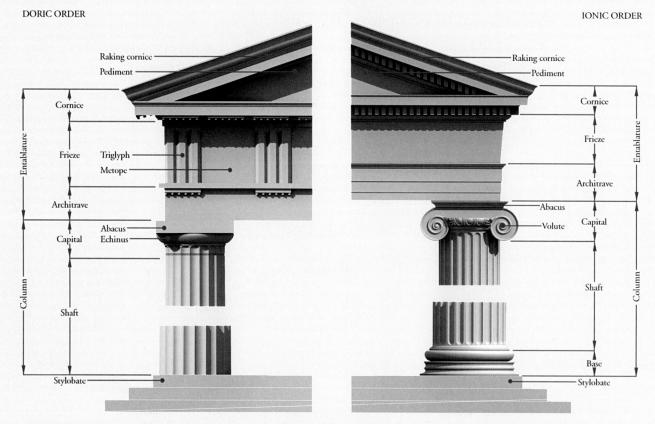

Doric and Ionic orders

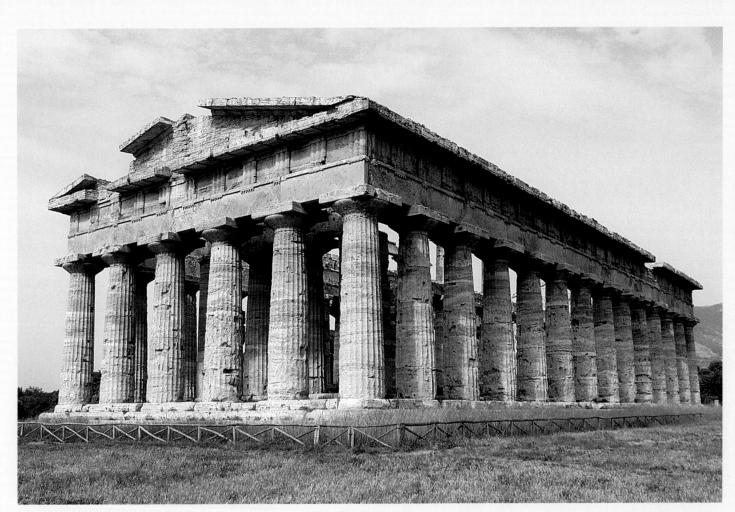

Greek Doric peripteral temple (Temple of Hera or Apollo, Paestum, Italy, ca. 460 BCE)

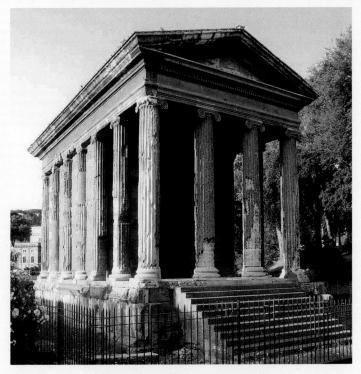

Roman Ionic pseudoperipteral temple (Temple of Portunus, Rome, Italy, ca. 75 BCE)

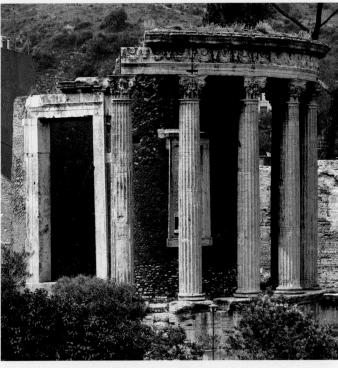

Roman Corinthian tholos temple (Temple of Vesta, Tivoli, Italy, early first century BCE)

ARCHITECTURAL BASICS

Arches and Vaults

A lthough earlier architects used both arches and vaults, the Romans employed them more extensively and effectively than any other ancient civilization. The Roman forms became staples of architectural design from the Middle Ages until today.

- *Arch* The arch is one of several ways of spanning a passageway. The Romans preferred it to the *post-and-lintel* (column-andarchitrave) system used in the Greek orders. Builders construct arches using wedge-shaped stone blocks called *voussoirs*. The central voussoir is the arch's *keystone*.
- **Barrel vault** Also called the *tunnel vault*, the barrel vault is an extension of a simple arch, creating a semicylindrical ceiling over parallel walls.
- **Groin vault** The groin vault, or *cross vault*, is formed by the intersection at right angles of two barrel vaults of equal size. When a series of groin vaults covers an interior hall, the open lateral

arches of the vaults function as windows admitting light to the building.

Dome The hemispherical dome may be described as a round arch rotated around the full circumference of a circle, usually resting on a cylindrical *drum*. The Romans normally constructed domes using *concrete*, a mix of lime mortar, volcanic sand, water, and small stones, instead of with large stone blocks. Concrete dries to form a solid mass of great strength, which enabled the Romans to puncture the apex of a concrete dome with an *oculus* (eye), so that much-needed light could reach the interior of the building.

Barrel vaults, as noted, resemble tunnels, and groin vaults are usually found in a series covering a similar *longitudinally* oriented interior space. Domes, in contrast, crown *centrally* planned buildings, so named because the structure's parts are of equal or almost equal dimensions around the center.

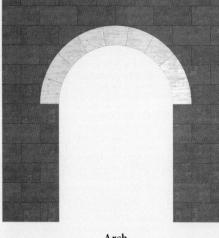

Arch

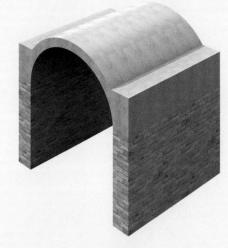

Barrel vault

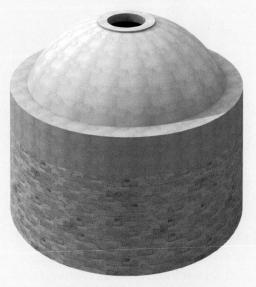

Hemispherical dome with oculus

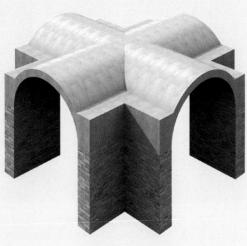

Groin vault

CHITECTURAL BASICS

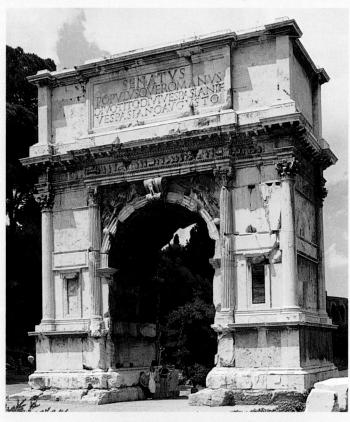

Roman arch (Arch of Titus, Rome, Italy, ca. 81)

Medieval barrel-vaulted church (Saint-Savin, Saint-Savin-sur-Gartempe, France, ca. 1100)

Roman hall with groin vaults (Baths of Diocletian, now Santa Maria degli Angeli, Rome, Italy, ca. 298–306)

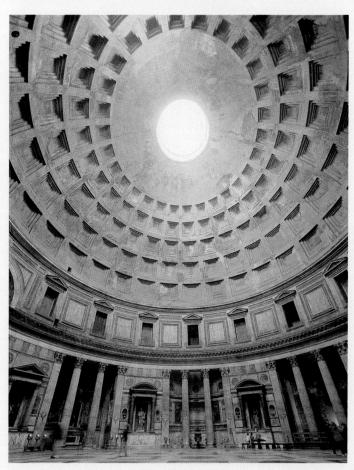

Roman dome with oculus (Pantheon, Rome, Italy, 118-125)

Basilican Churches

C hurch design during the Middle Ages set the stage for ecclesiastical architecture from the Renaissance to the present. Both the longitudinal- and central-plan building types of antiquity had a long postclassical history.

In Western Christendom, the typical medieval church had a *basilican* plan, which evolved from the Roman columnar hall, or basilica. The great European cathedrals of the Gothic age, which were the immediate predecessors of the churches of the Renaissance and Baroque eras, shared many elements with the earliest basilican churches constructed during the fourth century, including a wide central *nave* flanked by *aisles* and ending in an *apse*. Some basilican churches also have a *transept*, an area perpendicular to the nave. The nave and transept intersect at the *crossing*. Gothic churches, however, have many additional features. The key com-

ponents of Gothic design are labeled in the drawing of a typical French Gothic cathedral, which can be compared to the interior view of Amiens Cathedral and the plan of Chartres Cathedral.

Gothic architects frequently extended the aisles around the apse to form an *ambulatory*, onto which opened *radiating chapels* housing sacred relics. Groin vaults formed the ceiling of the nave, aisles, ambulatory, and transept alike, replacing the timber roof of the typical Early Christian basilica. These vaults rested on *diagonal* and *transverse ribs* in the form of pointed arches. On the exterior, *flying buttresses* held the nave vaults in place. These masonry struts transferred the thrust of the nave vaults across the roofs of the aisles to tall piers frequently capped by pointed ornamental *pinnacles*. This structural system made it possible to open up the walls above the *nave arcade* with huge *stained-glass* windows in the nave *clerestory*.

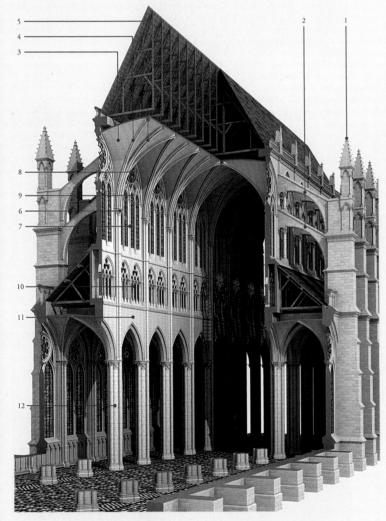

Cutaway view of a typical French Gothic cathedral

(1) pinnacle, (2) flying buttress, (3) vaulting web, (4) diagonal rib,
(5) transverse rib, (6) springing, (7) clerestory, (8) oculus, (9) lancet,
(10) triforium, (11) nave arcade, (12) compound pier with responds

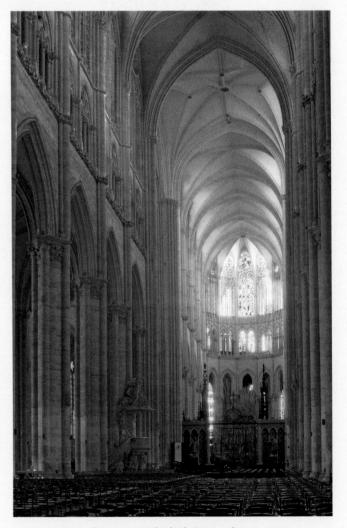

Nave of Amiens Cathedral, France, begun 1220

BEFORE 1300

In the later Middle Ages, especially in the great cathedrals of the Gothic age, church facades featured extensive sculptural ornamentation, primarily in the portals beneath the stained-glass *rose windows*

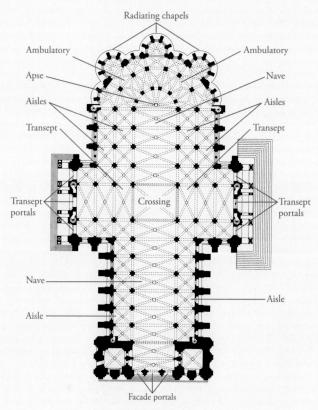

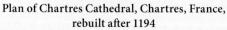

Voussoirs Archivelts Understand Intel Inte

Diagram of medieval portal sculpture

(circular windows with *tracery* resembling floral petals). The major sculpted areas were the *tympanum* above the doorway (akin to a Greco-Roman temple pediment), the *trumeau* (central post), and the *jambs*.

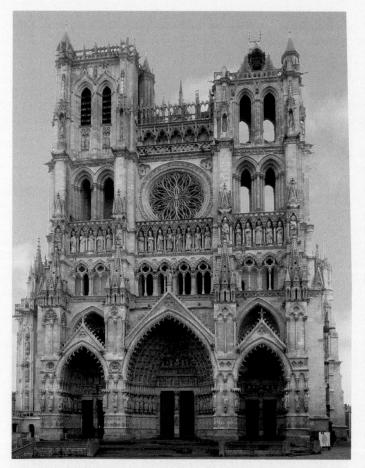

West facade of Amiens Cathedral, Amiens, France, begun 1220

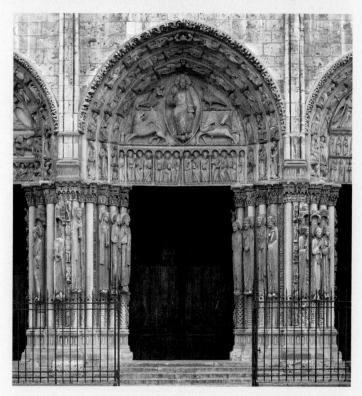

Central portal, west facade, Chartres Cathedral, ca. 1145-1155

Central-Plan Churches

The domed central plan of classical antiquity dominated the architecture of the Byzantine Empire but with important modifications. Because the dome covered the crossing of a Byzantine church, architects had to find a way to erect domes on square bases instead of on the circular bases (cylindrical drums) of Roman buildings. The solution was pendentive construction in which the dome rests on what is in effect a second, larger dome. The top portion and four segments around the rim of the larger dome are omitted, creating four curved triangles, or pendentives. The pendentives

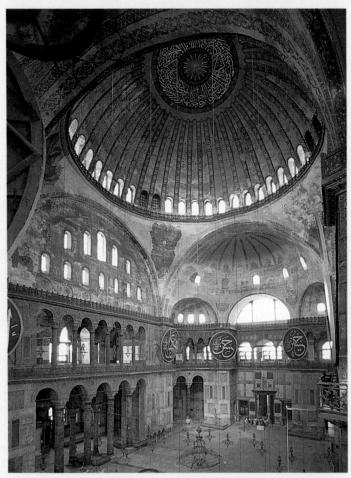

Hagia Sophia, Constantinople (Istanbul), Turkey, 532-537

join to form a ring and four arches whose planes bound a square. The first use of pendentives on a grand scale occurred in the sixthcentury church of Hagia Sophia (Holy Wisdom) in Constantinople.

The interiors of Byzantine churches differed from those of basilican churches in the West not only in plan and the use of domes but also in the manner in which they were adorned. The original mosaic decoration of Hagia Sophia is lost, but at Saint Mark's in Venice, some 40,000 square feet of mosaics cover all the walls, arches, vaults, and domes.

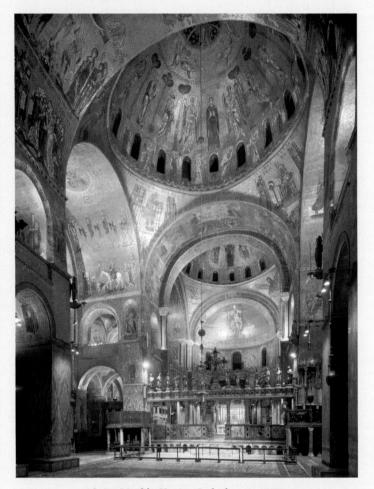

Saint Mark's, Venice, Italy, begun 1063

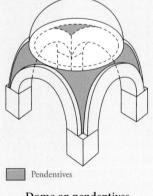

Dome on pendentives

The Gods and Goddesses of Mount Olympus

The chief deities of the Greeks ruled the world from their home on Mount Olympus, Greece's highest peak. They figure prominently not only in Greek, Etruscan, and Roman art but also in art from the Renaissance to the present.

The 12 Olympian gods (and their Roman equivalents) were:

- **Zeus (Jupiter)** King of the gods, Zeus ruled the sky and allotted the sea to his brother Poseidon and the Underworld to his other brother, Hades. His weapon was the thunderbolt. Jupiter was also the chief god of the Romans.
- Hera (Juno) Wife and sister of Zeus, Hera was the goddess of marriage.
- **Poseidon (Neptune)** Poseidon was lord of the sea. He controlled waves, storms, and earthquakes with his three-pronged pitchfork (*trident*).
- **Hestia (Vesta)** Sister of Zeus, Poseidon, and Hera, Hestia was goddess of the hearth.
- **Demeter (Ceres)** Third sister of Zeus, Demeter was the goddess of grain and agriculture.
- **Ares (Mars)** God of war, Ares was the son of Zeus and Hera and the lover of Aphrodite. His Roman counterpart, Mars, was the father of the twin founders of Rome, Romulus and Remus.
- **Athena** (*Minerva*) Goddess of wisdom and warfare, Athena was a virgin born from the head of her father, Zeus.

- **Hephaistos (Vulcan)** God of fire and of metalworking, Hephaistos was the son of Zeus and Hera. Born lame and, uncharacteristically for a god, ugly, he married Aphrodite, who was unfaithful to him.
- **Apollo** (*Apollo*) God of light and music and son of Zeus, the young, beautiful Apollo was an expert archer, sometimes identified with the sun (*Helios/Sol*).
- **Artemis (Diana)** Sister of Apollo, Artemis was goddess of the hunt. She was occasionally equated with the moon (*Selene/Luna*).
- *Aphrodite (Venus)* Daughter of Zeus and a *nymph* (goddess of springs and woods), Aphrodite was the goddess of love and beauty.
- *Hermes (Mercury)* Son of Zeus and another nymph, Hermes was the fleet-footed messenger of the gods and possessed winged sandals. He carried the *caduceus*, a magical herald's rod.

Other important Greek gods and goddesses were:

- Hades (Pluto), lord of the Underworld and god of the dead. Although the brother of Zeus and Poseidon, Hades never resided on Mount Olympus.
- Dionysos (Bacchus), god of wine, another of Zeus's sons.
- **Eros** (*Amor* or *Cupid*), the winged child-god of love, son of Aphrodite and Ares.
- *Asklepios* (*Aesculapius*), god of healing, son of Apollo. His serpent-entwined staff is the emblem of modern medicine.

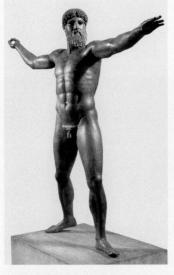

Zeus, from Cape Artemision, ca. 460–450 BCE

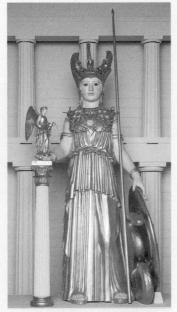

Athena, by Phidias, ca. 438 BCE

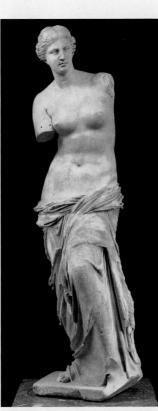

Aphrodite (Venus de Milo), by Alexandros, ca. 150–125 BCE

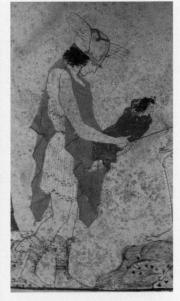

Hermes and infant Dionysos, by the Phiale Painter, ca. 440–435 BCE

BEFORE 1300

The Life of Jesus in Art

C hristians believe Jesus of Nazareth is the son of God, the *Messiah* (Savior, Christ) of the Jews prophesied in Hebrew scripture. His life—his miraculous birth from the womb of a virgin mother, his preaching and miracle working, his execution by the Romans and subsequent ascent to Heaven—has been the subject of countless artworks from Roman times through the present day.

INCARNATION AND CHILDHOOD

The first "cycle" of the life of Jesus consists of the events of his conception (incarnation), birth, infancy, and childhood.

- Annunciation to Mary The archangel Gabriel announces to the Virgin Mary that she will miraculously conceive and give birth to God's son, Jesus.
- **Visitation** The pregnant Mary visits her cousin Elizabeth, who is pregnant with John the Baptist. Elizabeth is the first to recognize that the baby Mary is bearing is the Son of God.
- Nativity, Annunciation to the Shepherds, and Adoration of the Shepherds Jesus is born at night in Bethlehem and placed in a basket. Mary and her husband, Joseph, marvel at the newborn, while an angel announces the birth of the Savior to shepherds in the field, who rush to adore the infant Jesus.

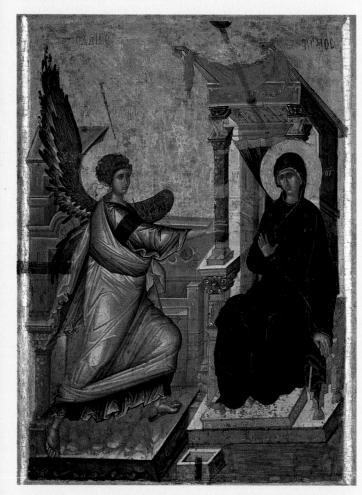

Annunciation, Byzantine icon, Ohrid, Macedonia, early 14th century

- **Adoration of the Magi** A bright star alerts three wise men (*magi*) in the East that the King of the Jews has been born. They travel 12 days to present precious gifts to the infant Jesus.
- Presentation in the Temple In accordance with Jewish tradition, Mary and Joseph bring their firstborn son to the temple in Jerusalem, where the aged Simeon recognizes Jesus as the prophesied savior of humankind.
- **Massacre of the Innocents** and *Flight into Egypt* King Herod, fearful a rival king has been born, orders the massacre of all infants, but the holy family escapes to Egypt.
- **Dispute in the Temple** Joseph and Mary travel to Jerusalem for the feast of Passover. Jesus, only a boy, debates the astonished Jewish scholars in the temple, foretelling his ministry.

PUBLIC MINISTRY

The public-ministry cycle comprises the teachings of Jesus and the miracles he performed.

- **Baptism** Jesus's public ministry begins with his baptism at age 30 by John the Baptist in the Jordan River. God's voice is heard proclaiming Jesus as his son.
- **Calling of Matthew** Jesus summons Matthew, a tax collector, to follow him, and Matthew becomes one of his 12 disciples, or *apostles* (from the Greek for "messenger").
- Miracles Jesus performs many miracles, revealing his divine nature. These include acts of healing and raising the dead, turning water into wine, walking on water and calming storms, and creating wondrous quantities of food.
- **Delivery of the Keys to Peter** Jesus chooses the fisherman Peter (whose name means "rock") as his successor. He declares Peter

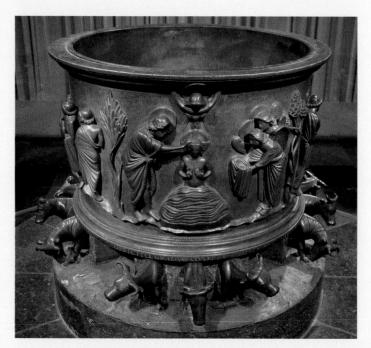

Baptism of Jesus, baptismal font, Liège, Belgium, 1118

3EFORF 1300

is the rock on which his church will be built and symbolically delivers to Peter the keys to the kingdom of Heaven.

- **Transfiguration** Jesus scales a mountain and, in the presence of Peter and two other disciples, is transformed into radiant light. God, speaking from a cloud, discloses Jesus is his son.
- **Cleansing of the Temple** Jesus returns to Jerusalem, where he finds money changers and merchants conducting business in the temple. He rebukes them and drives them out.

PASSION

The passion (Latin *passio*, "suffering") cycle includes the events leading to Jesus's trial, death, resurrection, and ascent to Heaven.

- **Entry into Jerusalem** On the Sunday before his crucifixion (Palm Sunday), Jesus rides into Jerusalem on a donkey.
- **Last Supper** In Jerusalem, Jesus celebrates Passover with his disciples. During this last supper, Jesus foretells his imminent betrayal, arrest, and death and invites the disciples to remember him when they eat bread (symbol of his body) and drink wine (his blood). This ritual became the celebration of *Mass (Eucharist)*.
- **Agony in the Garden** Jesus goes to the Mount of Olives in the Garden of Gethsemane, where he struggles to overcome his human fear of death by praying for divine strength.
- **Betrayal** and **Arrest** The disciple Judas Iscariot betrays Jesus to the Jewish authorities for 30 pieces of silver. Judas identifies Jesus to the soldiers by kissing him, and Jesus is arrested.
- I Trials of Jesus The soldiers bring Jesus before Caiaphas, the Jewish high priest, who interrogates Jesus about his claim to be the Messiah. Jesus is then brought before the Roman governor of Judaea, Pontius Pilate, on the charge of treason because he had proclaimed himself king of the Jews. Pilate asks the crowd to choose between freeing Jesus or Barabbas, a murderer. The people choose Barabbas, and the judge condemns Jesus to death.
- **Flagellation** The Roman soldiers who hold Jesus captive whip (flagellate) him and mock him by dressing him as king of the Jews and placing a crown of thorns on his head.
- **Carrying of the Cross, Raising of the Cross**, and **Crucifixion** The Romans force Jesus to carry the cross on which he will be crucified

Entry into Jerusalem, Sarchophagus of Junius Bassus, Rome, Italy, ca. 359

from Jerusalem to Mount Calvary. Soldiers erect the cross and nail Jesus's hands and feet to it. Jesus's mother, John the Evangelist, and Mary Magdalene mourn at the foot of the cross, while the soldiers torment Jesus. One of them stabs Jesus in the side with a spear. After suffering great pain, Jesus dies on Good Friday.

- **I** Deposition, Lamentation, and Entombment Two disciples, Joseph of Arimathea and Nicodemus, remove Jesus's body from the cross (deposition) and take him to his tomb. Joseph, Nicodemus, the Virgin Mary, John the Evangelist, and Mary Magdalene mourn over the dead Jesus (lamentation). (When in art the isolated figure of the Virgin Mary cradles her dead son in her lap, it is called a *Pietà*—Italian for "pity.") Then his followers lower Jesus into a sarcophagus in the tomb (entombment).
- **Resurrection** and **Three Marys at the Tomb** On the third day (Easter Sunday), Christ rises from the dead and leaves the tomb. The Virgin Mary, Mary Magdalene, and Mary, the mother of James, visit the tomb but find it empty. An angel informs them Christ has been resurrected.
- **I** Noli Me Tangere, Supper at Emmaus, and Doubting of Thomas During the 40 days between Christ's resurrection and his ascent to Heaven, he appears on several occasions to his followers. Christ warns Mary Magdalene, weeping at his tomb, with the words "Don't touch me" (Noli me tangere in Latin). At Emmaus he eats supper with two astonished disciples. Later, Christ invites Thomas, who cannot believe Christ has risen, to touch the wound in his side inflicted at his crucifixion.
- Ascension On the 40th day, on the Mount of Olives, with his mother and apostles as witnesses, Christ gloriously ascends to Heaven in a cloud.

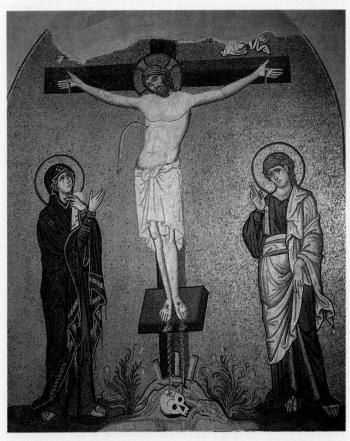

Crucifixion, Church of the Dormition, Daphni, Greece, ca. 1090-1100

Buddhism and Buddhist Iconography

The Buddha (Enlightened One) was born areound 563 BCE as Prince Siddhartha Gautama. When he was 29, he renounced his opulent life and became a wandering ascetic searching for knowledge through meditation. Six years later, he achieved complete enlightenment, or buddhahood, while meditating beneath a pipal tree (the Bodhi tree) at Bodh Gaya (place of enlightenment) in eastern India. The Buddha preached his first sermon in the Deer Park at Sarnath. There he set into motion the Wheel (chakra) of the Law (dharma) and expounded the Four Noble Truths: (1) life is suffering; (2) the cause of suffering is desire; (3) one can overcome and extinguish desire; (4) the way to conquer desire and end suffering is to follow the Buddha's Eightfold Path of right understanding, right thought, right speech, right action, right livelihood, right effort, right mindfulness, and right concentration. The Buddha's path leads to nirvana, the cessation of the endless cycle of painful life, death, and rebirth. The buddha continued to preach until his death at age 80 at Kushinagara.

The earliest form of Buddhism is called Theravada (Path of the Elders) Buddhism. The second major school of Buddhist thought, Mahayana (Great Path) Buddhism, emerged around the beginning of the Christian era. Mahayana Buddhists refer to Theravada Buddhism as Hinayana (Lesser Path) Buddhism and believe in a larger goal than nirvana for an individual—namely, buddhahood for all. Mahayana Buddhists also revere *bodhisattvas* (Buddhas-to-be), exemplars of compassion who restrain themselves at the threshold of nirvana to aid others in earning merit and achieving buddhahood. A third important Buddhist sect, especially popular in East Asia, venerates the Amitabha Buddha (Amida in Japanese), the Buddha

of Infinite Light and Life. The devotees of this Buddha hope to be reborn in the Pure Land Paradise of the West, where the Amitabha resides and can grant them salvation.

The earliest (first century CE) known depictions of the Buddha in human form show him as a robed monk. Artists distinguished the Enlightened One from monks and bodhisattvas by *lakshanas*, body attributes indicating the Buddha's suprahuman nature. These distinguishing marks include an *urna*, or curl of hair between the eyebrows; an *ushnisha*, or cranial bump; and, less frequently, palms of hands and soles of feet imprinted with a wheel. The Buddha is also recognizable by his elongated ears, the result of wearing heavy royal jewelry in his youth.

Representations of the Buddha also feature a repertory of mudras, or hand gestures. These include the *dhyana* (meditation) mudra, with the right hand over the left, palms upward; the *bhumisparsha* (earth-touching) mudra, right hand down reaching to the ground, calling the earth to witness the Buddha's enlightenment; the *dharmachakra* (Wheel of the Law, or teaching) mudra, a two-handed gesture with right thumb and index finger forming a circle; and the *abhaya* (do not fear) mudra, right hand up, palm outward, a gesture of protection or blessing.

Episodes from the Buddha's life are among the most popular subjects in all Buddhist artistic traditions. Four of the most important events are his birth at Lumbini from the side of his mother; his achievement of buddhahood while meditating beneath the Bodhi tree; his first sermon at Sarnath; and his attainment of nirvana when he died (*parinirvana*) at Kushinagara.

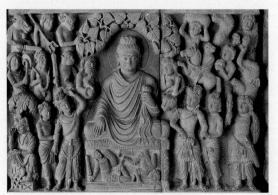

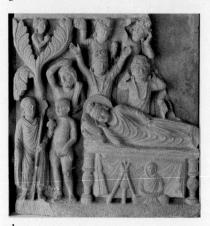

Life and death of the Buddha, from Gandhara, second century. (a) Birth at Lumbini, (b) enlightenment at Bodh Gaya, (c) first sermon at Sarnath, (d) death at Kushinagara (parinirvana)

Hinduism and Hindu Iconography

Unlike Buddhism (and Christianity, Islam, and other religions), Hinduism recognizes no founder or great prophet. Hindism also has no simple definition, but means "the religion of the Indians." The practices and beliefs of Hindus vary tremendously, but ritual sacrifice is central to Hinduism. The goal of sacrifice is to please a deity in order to achieve release (*moksha*, liberation) from the endless cycle of birth, death, and rebirth (*samsara*) and become one with the universal spirit.

Not only is Hinduism a religion of many gods, but the Hindu deities also have various natures and take many forms. This multiplicity suggests the all-pervasive nature of the Hindu gods. The three most important deities are the gods Shiva and Vishnu and the goddess Devi. Each of the three major sects of Hinduism today considers one of these three to be supreme—Shiva in Shaivism, Vishnu in Vaishnavism, and Devi in Shaktism. (*Shakti* is the female creative force.)

Shiva is the Destroyer, but, consistent with the multiplicity of Hindu belief, he is also a regenerative force and, in the latter role, can be represented in the form of a *linga* (a phallus or cosmic pillar). When Shiva appears in human form in Hindu art, he frequently has multiple limbs and heads, signs of his suprahuman

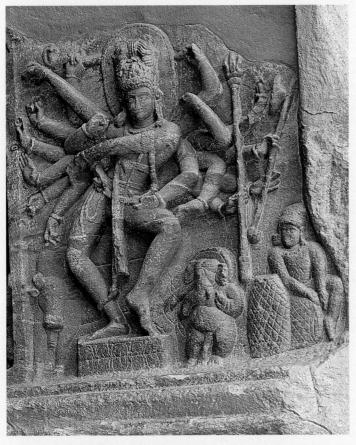

Dancing Shiva, Badami, India, late sixth century

nature, and matted locks piled atop his head, crowned by a crescent moon. Sometimes he wears a serpent scarf and has a third eye on his forehead (the emblem of his all-seeing nature). Shiva rides the bull *Nandi* and often carries a trident.

- **Vishnu** is the Preserver of the Universe. Artists frequently portray him with four arms holding various attributes, including a conchshell trumpet and discus, sometimes sleeping on the serpent Ananta floating on the waters of the cosmic sea as he dreams the universe into reality. When the evil forces in the world become too strong, he descends to earth to restore balance and assumes different forms (*avatars*, or incarnations), including a boar, fish, and tortoise, as well as *Krishna*, the divine lover, and even the Buddha himself.
- Devi is the Great Goddess who takes many forms and has many names. Hindus worship her alone or as a consort of male gods (Parvati or Uma, wife of Shiva; Lakshmi, wife of Vishnu), as well as Radha, lover of Krishna. She has both benign and horrific forms. She creates and destroys. In one manifestation, she is Durga, a multiarmed goddess who often rides a lion. Her son is the elephant-headed Ganesha.

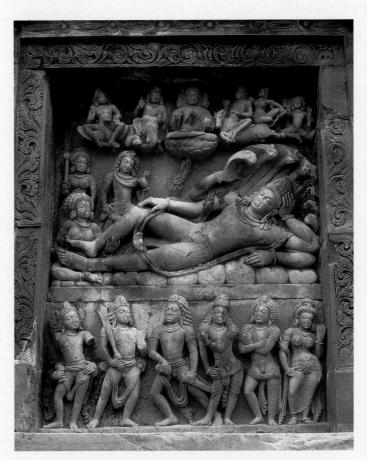

Vishnu Asleep on the Serpent Ananta, Deogarh, India, early sixth century

BEFORE 1300

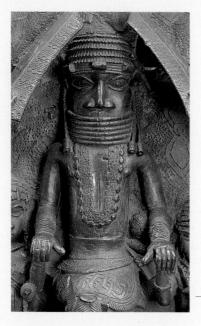

Art historians seek to understand not only why individual artworks appear as they do but also why those works exist at all. Who paid this African artist to make this bronze plaque? Why?

Why did this Benin kingdom sculptor vary the sizes of the figures? Why is the central equestrian figure much larger than his horse? How did the artist inform the viewer the rider is a king?

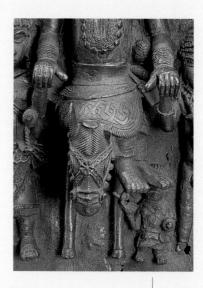

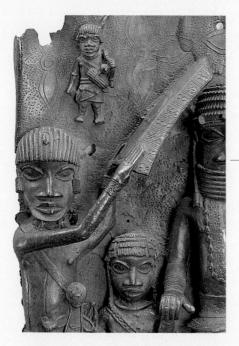

Dating and signing artworks are relatively recent practices. How can art historians determine when an unlabeled work such as this one was made, and by whom? Style, technique, and subject are clues.

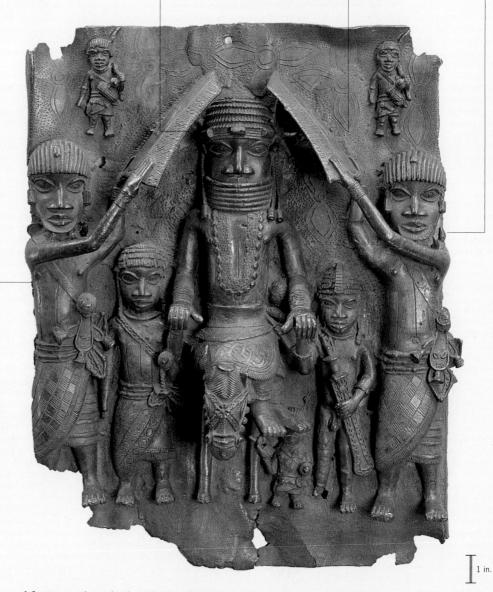

l-1 King on horseback with attendants, from Benin, Nigeria, ca. 1550–1680. Bronze, 1' $7\frac{1''}{2}$ high. Metropolitan Museum of Art, New York (Michael C. Rockefeller Memorial Collection, gift of Nelson A. Rockefeller).

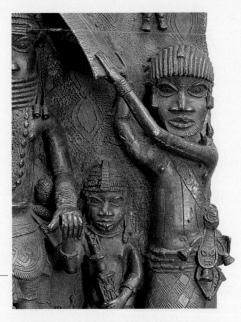

Introduction

WHAT IS Art History?

What tools and techniques did the African sculptor employ to transform molten bronze into this plaque representing a king and his attendants projecting in high relief from the background plane?

What is art history? Except when referring to the modern academic discipline, people do not often juxtapose the words *art* and *history*. They tend to think of history as the record and interpretation of past human actions, particularly social and political actions. In contrast, most think of art, quite correctly, as part of the present—as something people can see and touch. Of course, people cannot see or touch history's vanished human events, but a visible, tangible artwork is a kind of persisting event. One or more artists made it at a certain time and in a specific place, even if no one now knows who, when, where, or why. Although created in the past, an artwork continues to exist in the present, long surviving its times. The first painters and sculptors died 30,000 years ago, but their works remain, some of them exhibited in glass cases in museums built only a few years ago.

Modern museum visitors can admire these objects from the remote past—and countless others humankind has produced over the millennia, whether small bronze sculptures from Africa (FIG. I-1) or large paintings on canvas by American artists (FIG. I-2)—without any knowledge of the circumstances leading to the creation of those works. The beauty or sheer size of an object can impress people, the artist's virtuosity in the handling of ordinary or costly materials can dazzle them, or the subject depicted can move them emotionally. Viewers can react to what they see, interpret the work in the light of their own experience, and judge it a success or a failure. These are all valid responses to a work of art. But the enjoyment and appreciation of artworks in museum settings are relatively recent phenomena, as is the creation of artworks solely for museum-going audiences to view.

Today, it is common for artists to work in private studios and to create paintings, sculptures, and other objects commercial art galleries will offer for sale. This is what American painter CLYFFORD STILL (1904–1980) did when he created large canvases (FIG. 1-2) of pure color titled simply with the year of their creation. Usually, someone the artist has never met will purchase the artwork and display it in a setting the artist has never seen. This practice is not a new phenomenon in the history of art—an ancient potter decorating a vase for sale at a village market stall probably did not know who would buy the pot or where it would be housed—but it is not at all typical. In fact, it is exceptional. Throughout history, most artists created paintings, sculptures, and other objects for specific patrons and settings and to fulfill a specific purpose, even if today no one knows the original contexts of those artworks. Museum visitors can appreciate the visual and tactile qualities of these objects, but they cannot understand why they were made or why they appear as they do without knowing the circumstances of their creation. Art *appreciation* does not require knowledge of the historical context of an artwork (or a building). Art *history* does.

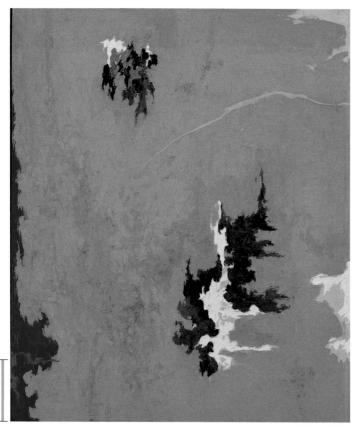

I-2 CLYFFORD STILL, 1948-C, 1948. Oil on canvas, 6' $8\frac{7''}{8} \times 5' 8\frac{3''}{4}$. Hirshhorn Museum and Sculpture Garden, Smithsonian Institution, Washington, D.C. (purchased with funds of Joseph H. Hirshhorn, 1992).

Clyfford Still painted this abstract composition without knowing who would purchase it or where it would be displayed, but throughout history, most artists created works for specific patrons and settings.

Thus, a central aim of art history is to determine the original context of artworks. Art historians seek to achieve a full understanding not only of why these "persisting events" of human history look the way they do but also of why the artistic events happened at all. What unique set of circumstances gave rise to the construction of a particular building or led an individual patron to commission a certain artist to fashion a singular artwork for a specific place? The study of history is therefore vital to art history. And art history is often indispensable for a thorough understanding of history. Art objects and buildings are historical documents that can shed light on the peoples who made them and on the times of their creation in ways other historical documents may not. Furthermore, artists and architects can affect history by reinforcing or challenging cultural values and practices through the objects they create and the structures they build. Thus, the history of art and architecture is inseparable from the study of history, although the two disciplines are not the same.

The following pages introduce some of the distinctive subjects art historians address and the kinds of questions they ask, and explain some of the basic terminology they use when answering these questions. Readers armed with this arsenal of questions and terms will be ready to explore the multifaceted world of art through the ages.

ART HISTORY IN THE 21ST CENTURY

Art historians study the visual and tangible objects humans make and the structures humans build. Scholars traditionally have classified these works as architecture, sculpture, the pictorial arts (painting, drawing, printmaking, and photography), and the craft arts, or arts of design. The craft arts comprise utilitarian objects, such as ceramics, metalwork, textiles, jewelry, and similar accessories of ordinary living. Artists of every age have blurred the boundaries among these categories, but this is especially true today, when multimedia works abound.

Beginning with the earliest Greco-Roman art critics, scholars have studied objects their makers consciously manufactured as "art" and to which the artists assigned formal titles. But today's art historians also study a multitude of objects their creators and owners almost certainly did not consider to be "works of art." Few ancient Romans, for example, would have regarded a coin bearing their emperor's portrait as anything but money. Today, an art museum may exhibit that coin in a locked case in a climate-controlled room, and scholars may subject it to the same kind of art historical analysis as a portrait by an acclaimed Renaissance or modern sculptor or painter.

The range of objects art historians study is constantly expanding and now includes, for example, computer-generated images, whereas in the past almost anything produced using a machine would not have been regarded as art. Most people still consider the performing arts—music, drama, and dance—as outside art history's realm because these arts are fleeting, impermanent media. But during the past few decades, even this distinction between "fine art" and "performance art" has become blurred. Art historians, however, generally ask the same kinds of questions about what they study, whether they employ a restrictive or expansive definition of art.

The Questions Art Historians Ask

HOW OLD IS IT? Before art historians can write a history of art, they must be sure they know the date of each work they study. Thus, an indispensable subject of art historical inquiry is *chronology*, the dating of art objects and buildings. If researchers cannot determine a monument's age, they cannot place the work in its historical context. Art historians have developed many ways to establish, or at least approximate, the date of an artwork.

Physical evidence often reliably indicates an object's age. The material used for a statue or painting—bronze, plastic, or oil-based pigment, to name only a few—may not have been invented before a certain time, indicating the earliest possible date (the *terminus post quem:* Latin "point after which") someone could have fashioned the work. Or artists may have ceased using certain materials—such as specific kinds of inks and papers for drawings—at a known time, providing the latest possible date (the *terminus ante quem:* Latin "point before which") for objects made of those materials. Sometimes the material (or the manufacturing technique) of an object or a building can establish a very precise date of production or construction. The study of tree rings, for instance, usually can determine within a narrow range the date of a wood statue or a timber roof beam.

Documentary evidence can help pinpoint the date of an object or building when a dated written document mentions the work. For example, official records may note when church officials commissioned a new altarpiece—and how much they paid to which artist. *Internal evidence* can play a significant role in dating an artwork. A painter might have depicted an identifiable person or a kind of hairstyle, clothing, or furniture fashionable only at a certain time. If so, the art historian can assign a more accurate date to that painting.

Stylistic evidence is also very important. The analysis of *style* an artist's distinctive manner of producing an object—is the art historian's special sphere. Unfortunately, because it is a subjective assessment, stylistic evidence is by far the most unreliable chronological criterion. Still, art historians find style a very useful tool for establishing chronology.

WHAT IS ITS STYLE? Defining artistic style is one of the key elements of art historical inquiry, although the analysis of artworks solely in terms of style no longer dominates the field the way it once did. Art historians speak of several different kinds of artistic styles.

Period style refers to the characteristic artistic manner of a specific era or span of years, usually within a distinct culture, such as "Archaic Greek" or "High Renaissance." But many periods do not display any stylistic unity at all. How would someone define the artistic style of the second decade of the new millennium in North

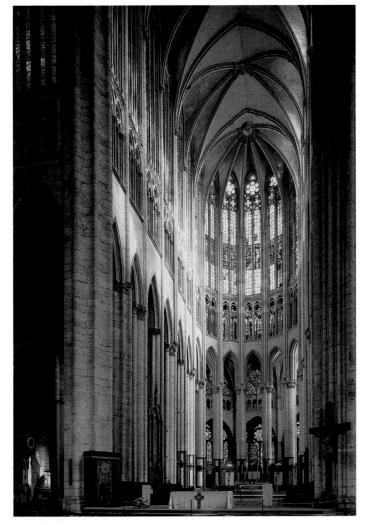

I-3 Choir of Beauvais Cathedral (looking east), Beauvais, France, rebuilt after 1284.

The style of an object or building often varies from region to region. This cathedral has towering stone vaults and large stained-glass windows typical of 13th-century French architecture.

America? Far too many crosscurrents exist in contemporary art for anyone to describe a period style of the early 21st century—even in a single city such as New York.

Regional style is the term art historians use to describe variations in style tied to geography. Like an object's date, its *provenance*, or place of origin, can significantly determine its character. Very often two artworks from the same place made centuries apart are more similar than contemporaneous works from two different regions. To cite one example, usually only an expert can distinguish between an Egyptian statue carved in 2500 BCE and one made in 500 BCE. But no one would mistake an Egyptian statue of 500 BCE for one of the same date made in Greece or Mexico.

Considerable variations in a given area's style are possible, however, even during a single historical period. In late medieval Europe, French architecture differed significantly from Italian architecture. The interiors of Beauvais Cathedral (FIG. **I-3**) and the church of Santa Croce (FIG. **I-4**) in Florence typify the architectural styles of France and Italy, respectively, at the end of the 13th century. The rebuilding of the east end of Beauvais Cathedral began in 1284. Construction commenced on Santa Croce only 10 years later. Both structures employ the *pointed arch* characteristic of this era, yet the two churches differ strikingly. The French church has towering stone ceilings and large expanses of colored windows, whereas the Italian building has a low timber roof and small, widely separated windows. Because the

I-4 Interior of Santa Croce (looking east), Florence, Italy, begun 1294.

In contrast to Beauvais Cathedral (FIG. I-3), this contemporaneous Florentine church conforms to the quite different regional style of Italy. The building has a low timber roof and small windows.

1-5 GEORGIA O'KEEFFE, Jack-in-the-Pulpit No. 4, 1930. Oil on canvas, $3' 4'' \times 2' 6''$. National Gallery of Art, Washington (Alfred Stieglitz Collection, bequest of Georgia O'Keeffe).

1 ft.

O'Keeffe's paintings feature close-up views of petals and leaves in which the organic forms become powerful abstract compositions. This approach to painting typifies the artist's distinctive personal style.

two contemporaneous churches served similar purposes, regional style mainly explains their differing appearance.

Personal style, the distinctive manner of individual artists or architects, often decisively explains stylistic discrepancies among monuments of the same time and place. In 1930 the American painter GEORGIA O'KEEFFE (1887-1986) produced a series of paintings of flowering plants. One of them-Jack-in-the-Pulpit No. 4 (FIG. 1-5)—is a sharply focused close-up view of petals and leaves. O'Keeffe captured the growing plant's slow, controlled motion while converting the plant into a powerful abstract composition of lines, forms, and colors (see the discussion of art historical vocabulary in the next section). Only a year later, another American artist, BEN SHAHN (1898–1969), painted The Passion of Sacco and Vanzetti (FIG. 1-6), a stinging commentary on social injustice inspired by the trial and execution of two Italian anarchists, Nicola Sacco and Bartolomeo Vanzetti. Many people believed Sacco and Vanzetti had been unjustly convicted of killing two men in a robbery in 1920. Shahn's painting compresses time in a symbolic representation of the trial and its aftermath. The two executed men lie in their coffins. Presiding over them are the three members of the commission (headed by a college president wearing academic cap and gown) who declared the original trial fair and cleared the way for the

I-6 BEN SHAHN, The Passion of Sacco and Vanzetti, 1931–1932. Tempera on canvas, 7' $\frac{1''}{2}$ × 4'. Whitney Museum of American Art, New York (gift of Edith and Milton Lowenthal in memory of Juliana

O'Keeffe's contemporary, Shahn developed a style markedly different from hers. His paintings are often social commentaries on recent events and incorporate readily identifiable people.

Force).

executions. Behind, on the wall of a stately government building, hangs the framed portrait of the judge who pronounced the initial sentence. Personal style, not period or regional style, sets Shahn's canvas apart from O'Keeffe's. The contrast is extreme here because of the very different subjects the artists chose. But even when two artists depict the same subject, the results can vary widely. The way O'Keeffe painted flowers and the way Shahn painted faces are distinctive and unlike the styles of their contemporaries. (See the "Who Made It?" discussion on page 6.)

The different kinds of artistic styles are not mutually exclusive. For example, an artist's personal style may change dramatically during a long career. Art historians then must distinguish among

I-7 GISLEBERTUS, The weighing of souls, detail of *Last Judgment* (FIG. 12-1), west tympanum of Saint-Lazare, Autun, France, ca. 1120–1135.

In this high relief portraying the weighing of souls on judgment day, Gislebertus used disproportion and distortion to dehumanize the devilish figure yanking on the scales of justice.

the different period styles of a particular artist, such as the "Rose Period" and the "Cubist Period" of the prolific 20thcentury artist Pablo Picasso.

WHAT IS ITS SUBJECT? Another major concern of art historians is, of course, subject matter, encompassing the story, or narrative; the scene presented; the action's time and place; the persons involved; and the environment and its details. Some artworks, such as modern *abstract* paintings (FIG. I-2), have no subject, not even a setting. The "subject" is the artwork itself—its colors, textures, composition, and size. But when artists represent people, places, or actions, viewers must identify these features to achieve complete understanding of the work. Art historians traditionally separate pictorial subjects into various categories, such as religious, historical, mythological, *genre* (daily life), portraiture, *landscape* (a depiction of a place), *still life* (an arrangement of inanimate objects), and their numerous subdivisions and combinations.

Iconography—literally, the "writing of images"—refers both to the content, or subject, of an artwork, and to the study of content in art. By extension, it also includes the study of *symbols*, images that stand for other images or encapsulate ideas. In Christian art, two intersecting lines of unequal length or a simple geometric cross can serve as an emblem of the religion as a whole, symbolizing the cross of Jesus Christ's crucifixion. A symbol also can be a familiar object the artist imbued with greater meaning. A balance or scale, for example, may symbolize justice or the weighing of souls on judgment day (FIG. 1-7).

Artists may depict figures with unique *attributes* identifying them. In Christian art, for example, each of the authors of the biblical gospel books, the four evangelists (FIG. **I-8**), has a distinctive attribute. People can recognize Saint John by the eagle associated with him, Luke by the ox, Mark by the lion, and Matthew by the winged man.

Throughout the history of art, artists have used *personi-fications*—abstract ideas codified in human form. Worldwide, people visualize Liberty as a robed woman wearing a rayed crown and holding a torch because of the fame of the colossal statue set up in New York City's harbor in 1886.

l-8 The four evangelists, folio 14 verso of the *Aachen* Gospels, ca. 810. Ink and tempera on vellum, $1' \times 9\frac{1''}{2}$. Domschatzkammer, Aachen.

Artists depict figures with attributes in order to identify them for viewers. The authors of the four gospels have distinctive attributes—eagle (John), ox (Luke), lion (Mark), and winged man (Matthew).

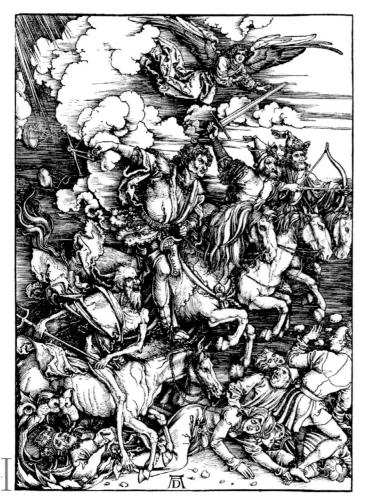

I-9 ALBRECHT DÜRER, *The Four Horsemen of the Apocalypse*, ca. 1498. Woodcut, 1' $3\frac{1}{4}^{"} \times 11^{"}$. Metropolitan Museum of Art, New York (gift of Junius S. Morgan, 1919).

Personifications are abstract ideas codified in human form. Here, Albrecht Dürer represented Death, Famine, War, and Pestilence as four men on charging horses, each one carrying an identifying attribute.

The Four Horsemen of the Apocalypse (FIG. 1-9) is a terrifying late-15th-century depiction of the fateful day at the end of time when, according to the Bible's last book, Death, Famine, War, and Pestilence will annihilate the human race. German artist ALBRECHT DÜRER (1471–1528) personified Death as an emaciated old man with a pitchfork. Dürer's Famine swings the scales for weighing human souls (compare FIG. 1-7), War wields a sword, and Pestilence draws a bow.

Even without considering style and without knowing a work's maker, informed viewers can determine much about the work's period and provenance by iconographical and subject analysis alone. In *The Passion of Sacco and Vanzetti* (FIG. 1-6), for example, the two coffins, the trio headed by an academic, and the robed judge in the background are all pictorial clues revealing the painting's subject. The work's date must be after the trial and execution, probably while the event was still newsworthy. And because the two men's deaths caused the greatest outrage in the United States, the painter–social critic was probably American.

WHO MADE IT? If Ben Shahn had not signed his painting of Sacco and Vanzetti, an art historian could still assign, or *attribute* (make an *attribution* of), the work to him based on knowledge of

the artist's personal style. Although signing (and dating) works is quite common (but by no means universal) today, in the history of art countless works exist whose artists remain unknown. Because personal style can play a major role in determining the character of an artwork, art historians often try to attribute anonymous works to known artists. Sometimes they assemble a group of works all thought to be by the same person, even though none of the objects in the group is the known work of an artist with a recorded name. Art historians thus reconstruct the careers of artists such as "the Achilles Painter," the anonymous ancient Greek artist whose masterwork is a depiction of the hero Achilles. Scholars base their attributions on internal evidence, such as the distinctive way an artist draws or carves drapery folds, earlobes, or flowers. It requires a keen, highly trained eye and long experience to become a connoisseur, an expert in assigning artworks to "the hand" of one artist rather than another. Attribution is subjective, of course, and ever open to doubt. At present, for example, international debate rages over attributions to the famous 17th-century Dutch painter Rembrandt van Rijn.

Sometimes a group of artists works in the same style at the same time and place. Art historians designate such a group as a *school. School* does not mean an educational institution or art academy. The term connotes only shared chronology, style, and geography. Art historians speak, for example, of the Dutch school of the 17th century and, within it, of subschools such as those of the cities of Haarlem, Utrecht, and Leyden.

WHO PAID FOR IT? The interest many art historians show in attribution reflects their conviction that the identity of an artwork's maker is the major reason the object looks the way it does. For them, personal style is of paramount importance. But in many times and places, artists had little to say about what form their work would take. They toiled in obscurity, doing the bidding of their *patrons*, those who paid them to make individual works or employed them on a continuing basis. The role of patrons in dictating the content and shaping the form of artworks is also an important subject of art historical inquiry.

In the art of portraiture, to name only one category of painting and sculpture, the patron has often played a dominant role in deciding how the artist represented the subject, whether that person was the patron or another individual, such as a spouse, son, or mother. Many Egyptian pharaohs and some Roman emperors, for example, insisted artists depict them with unlined faces and perfect youthful bodies no matter how old they were when portrayed. In these cases, the state employed the sculptors and painters, and the artists had no choice but to portray their patrons in the officially approved manner. This is why Augustus, who lived to age 76, looks so young in his portraits (FIG. I-10). Although Roman emperor for more than 40 years, Augustus demanded artists always represent him as a young, godlike head of state.

All modes of artistic production reveal the impact of patronage. Learned monks provided the themes for the sculptural decoration of medieval church portals (FIG. I-7). Renaissance princes and popes dictated the subject, size, and materials of artworks destined for display in buildings also constructed according to their specifications. An art historian could make a very long list of commissioned works, and it would indicate patrons have had diverse tastes and needs throughout the history of art and consequently have demanded different kinds of art. Whenever a patron contracts an artist or architect to paint, sculpt, or build in a prescribed manner, personal style often becomes a very minor factor in the ultimate

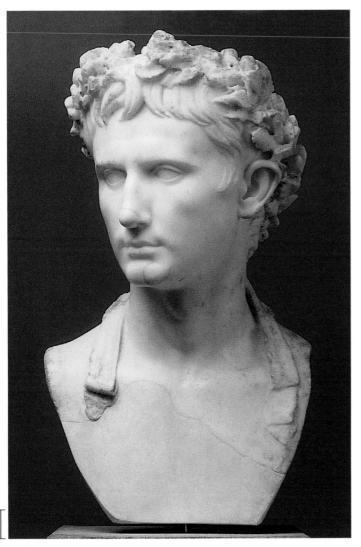

I-10 Bust of Augustus wearing the corona civica, early first century CE. Marble, 1' 5" high. Glyptothek, Munich.

Patrons frequently dictate the form their portraits will take. The Roman emperor Augustus demanded he always be portrayed as a young, godlike head of state even though he lived to age 76.

appearance of the painting, statue, or building. In these cases, the identity of the patron reveals more to art historians than does the identity of the artist or school. The portrait of Augustus illustrated here (FIG. I-10)—showing the emperor wearing a *corona civica*, or civic crown—was the work of a virtuoso sculptor, a master wielder of hammer and chisel. But scores of similar portraits of this Roman emperor also exist today. They differ in quality but not in kind from this one. The patron, not the artist, determined the character of these artworks. Augustus's public image never varied.

The Words Art Historians Use

As in all fields of study, art history has its own specialized vocabulary consisting of hundreds of words, but certain basic terms are indispensable for describing artworks and buildings of any time and place. They make up the essential vocabulary of *formal analysis*, the visual analysis of artistic form. Definitions and discussions of the most important art historical terms follow.

FORM AND COMPOSITION Form refers to an object's shape and structure, either in two dimensions (for example, a figure

painted on a canvas) or in three dimensions (such as a statue carved from a marble block). Two forms may take the same shape but may differ in their color, texture, and other qualities. *Composition* refers to how an artist *composes* (organizes) forms in an artwork, either by placing shapes on a flat surface or by arranging forms in space.

MATERIAL AND TECHNIQUE To create art forms, artists shape materials (pigment, clay, marble, gold, and many more) with tools (pens, brushes, chisels, and so forth). Each of the materials and tools available has its own potentialities and limitations. Part of all artists' creative activity is to select the *medium* and instrument most suitable to the purpose—or to develop new media and tools, such as bronze and concrete in antiquity and cameras and computers in modern times. The processes artists employ, such as applying paint to canvas with a brush, and the distinctive, personal ways they handle materials constitute their *technique*. Form, material, and technique interrelate and are central to analyzing any work of art.

LINE Among the most important elements defining an artwork's shape or form is *line*. A line can be understood as the path of a point moving in space, an invisible line of sight. More commonly, however, artists and architects make a line visible by drawing (or chiseling) it on a *plane*, a flat surface. A line may be very thin, wirelike, and delicate. It may be thick and heavy. Or it may alternate quickly from broad to narrow, the strokes jagged or the outline broken. When a continuous line defines an object's outer shape, art historians call it a *contour line*. All of these line qualities are present in Dürer's *The Four Horsemen of the Apocalypse* (FIG. I-9). Contour lines define the basic shapes of clouds, human and animal limbs, and weapons. Within the forms, series of short broken lines create shadows and textures. An overall pattern of long parallel strokes suggests the dark sky on the frightening day when the world is about to end.

COLOR Light reveals all *colors*. Light in the world of the painter and other artists differs from natural light. Natural light, or sunlight, is whole or *additive light*. As the sum of all the wavelengths composing the visible *spectrum*, it may be disassembled or fragmented into the individual colors of the spectral band. The painter's light in art—the light reflected from pigments and objects—is *subtractive light*. Paint pigments produce their individual colors by reflecting a segment of the spectrum while absorbing all the rest. Green pigment, for example, subtracts or absorbs all the light in the spectrum except that seen as green.

Hue is the property giving a color its name. Although the spectrum colors merge into each other, artists usually conceive of their hues as distinct from one another. Color has two basic variables—the apparent amount of light reflected and the apparent purity. A change in one must produce a change in the other. Some terms for these variables are *value*, or *tonality* (the degree of lightness or darkness), and *intensity*, or *saturation* (the purity of a color, its brightness or dullness).

Artists call the three basic colors—red, yellow, and blue—the *primary colors*. The *secondary colors* result from mixing pairs of primaries: orange (red and yellow), purple (red and blue), and green (yellow and blue). *Complementary colors* represent the pairing of a primary color and the secondary color created from mixing the two other primary colors—red and green, yellow and purple, and blue and orange. They "complement," or complete, each other, one absorbing colors the other reflects.

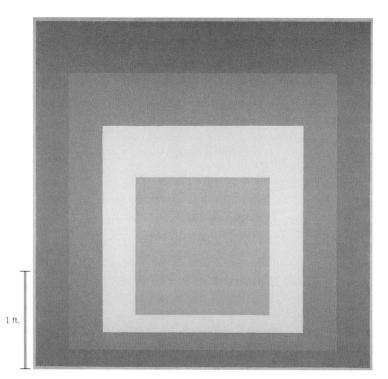

I-11 JOSEF ALBERS, *Homage to the Square: "Ascending,*" 1953. Oil on composition board, $3' 7_2^{1''} \times 3' 7_2^{1''}$. Whitney Museum of American Art, New York.

Albers painted hundreds of canvases using the same composition but employing variations in hue, saturation, and value in order to reveal the relativity and instability of color perception.

Artists can manipulate the appearance of colors, however. One artist who made a systematic investigation of the formal aspects of art, especially color, was JOSEF ALBERS (1888-1976), a German-born artist who emigrated to the United States in 1933. In connection with his studies, Albers created the series Homage to the Square-hundreds of paintings, most of which are color variations on the same composition of concentric squares, as in the illustrated example (FIG. I-11). The series reflected Albers's belief that art originates in "the discrepancy between physical fact and psychic effect."1 Because the composition in most of these paintings remains constant, the works succeed in revealing the relativity and instability of color perception. Albers varied the hue, saturation, and value of each square in the paintings in this series. As a result, the sizes of the squares from painting to painting appear to vary (although they remain the same), and the sensations emanating from the paintings range from clashing dissonance to delicate serenity. Albers explained his motivation for focusing on color juxtapositions:

They [the colors] are juxtaposed for various and changing visual effects.... Such action, reaction, interaction ... is sought in order to make obvious how colors influence and change each other; that the same color, for instance—with different grounds or neighbors—looks different.... Such color deceptions prove that we see colors almost never unrelated to each other.²

TEXTURE The term *texture* refers to the quality of a surface, such as rough or shiny. Art historians distinguish between true texture, that is, the tactile quality of the surface, and represented texture, as when painters depict an object as having a certain tex-

ture even though the pigment is the true texture. Sometimes artists combine different materials of different textures on a single surface, juxtaposing paint with pieces of wood, newspaper, fabric, and so forth. Art historians refer to this mixed-media technique as *collage*. Texture is, of course, a key determinant of any sculpture's character. People's first impulse is usually to handle a work of sculpture even though museum signs often warn "Do not touch!" Sculptors plan for this natural human response, using surfaces varying in texture from rugged coarseness to polished smoothness. Textures are often intrinsic to a material, influencing the type of stone, wood, plastic, clay, or metal sculptors select.

SPACE, MASS, AND VOLUME *Space* is the bounded or boundless "container" of objects. For art historians, space can be the real three-dimensional space occupied by a statue or a vase or contained within a room or courtyard. Or space can be *illusionistic*, as when painters depict an image (or illusion) of the three-dimensional spatial world on a two-dimensional surface.

Mass and *volume* describe three-dimensional objects and space. In both architecture and sculpture, mass is the bulk, density, and weight of matter in space. Yet the mass need not be solid. It can be the exterior form of enclosed space. Mass can apply to a solid Egyptian pyramid or stone statue, to a church, synagogue, or mosque—architectural shells enclosing sometimes vast spaces and to a hollow metal statue or baked clay pot. Volume is the space that mass organizes, divides, or encloses. It may be a building's interior spaces, the intervals between a structure's masses, or the amount of space occupied by three-dimensional objects such as a statue, pot, or chair. Volume and mass describe both the exterior and interior forms of a work of art—the forms of the matter of which it is composed and the spaces immediately around the work and interacting with it.

PERSPECTIVE AND FORESHORTENING Perspective is one of the most important pictorial devices for organizing forms in space. Throughout history, artists have used various types of perspective to create an illusion of depth or space on a two-dimensional surface. The French painter CLAUDE LORRAIN (1600-1682) employed several perspective devices in Embarkation of the Queen of Sheba (FIG. I-12), a painting of a biblical episode set in a 17th-century European harbor with a Roman ruin in the left foreground. For example, the figures and boats on the shoreline are much larger than those in the distance. Decreasing the size of an object makes it appear farther away. Also, the top and bottom of the port building at the painting's right side are not parallel horizontal lines, as they are in a real building. Instead, the lines converge beyond the structure, leading the viewer's eye toward the hazy, indistinct sun on the horizon. These perspective devices-the reduction of figure size, the convergence of diagonal lines, and the blurring of distant forms-have been familiar features of Western art since the ancient Greeks. But it is important to note at the outset that all kinds of perspective are only pictorial conventions, even when one or more types of perspective may be so common in a given culture that people accept them as "natural" or as "true" means of representing the natural world.

In *Waves at Matsushima* (FIG. **I-13**), a Japanese seascape painting on a six-part folding screen, OGATA KORIN (1658–1716) ignored these Western perspective conventions. A Western viewer might interpret the left half of Korin's composition as depicting the distant horizon, as in Claude's painting, but the sky is a flat, unnatural gold, and in five of the six sections of the composition, waves fill the

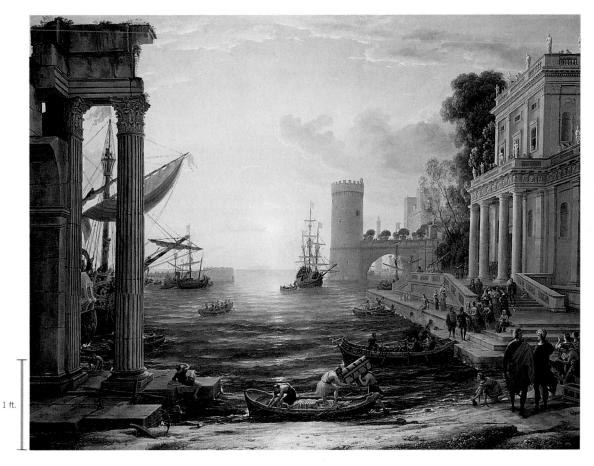

l-12 CLAUDE LORRAIN, Embarkation of the Queen of Sheba, 1648. Oil on canvas, $4' 10'' \times 6' 4''$. National Gallery, London.

To create the illusion of a deep landscape, Claude Lorrain employed perspective, reducing the size of and blurring the most distant forms. Also, all diagonal lines converge on a single point.

full height of the screen. The rocky outcroppings decrease in size with distance, but all are in sharp focus, and there are no shadows. The Japanese artist was less concerned with locating the boulders and waves in space than with composing shapes on a surface, playing the water's swelling curves against the jagged contours of the rocks. Neither the French nor the Japanese painting can be said to project "correctly" what viewers "in fact" see. One painting is not a "better" picture of the world than the other. The European and Asian artists simply approached the problem of picture-making differently.

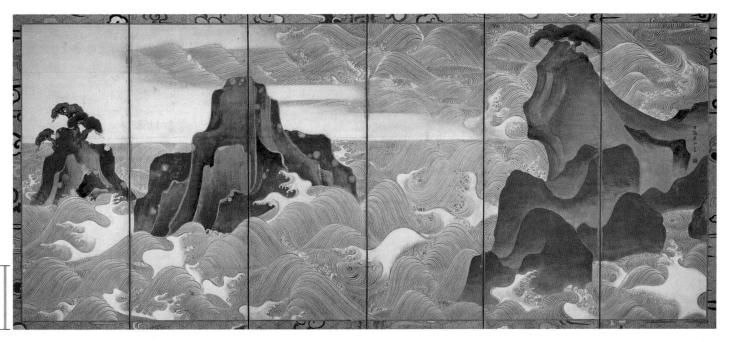

I-13 OGATA KORIN, *Waves at Matsushima*, Edo period, ca. 1700–1716. Six-panel folding screen, ink, color, and gold leaf on paper, 4' $11\frac{1''}{8} \times 12'\frac{7''}{8}$. Museum of Fine Arts, Boston (Fenollosa-Weld Collection).

Korin was more concerned with creating an intriguing composition of shapes on a surface than with locating boulders and waves in space. Asian artists rarely employed Western perspective.

l-14 PETER PAUL RUBENS, *Lion* Hunt, 1617–1618. Oil on canvas, $8' 2'' \times 12' 5''$. Alte Pinakothek, Munich.

Foreshortening—the representation of a figure or object at an angle to the picture plane—is a common device in Western art for creating the illusion of depth. Foreshortening is a type of perspective.

Artists also represent single figures in space in varying ways. When Flemish artist PETER PAUL RUBENS (1577–1640) painted *Lion Hunt* (FIG. I-14), he used *foreshortening* for all the hunters and animals—that is, he represented their bodies at angles to the picture plane. When in life one views a figure at an angle, the body appears to contract as it extends back

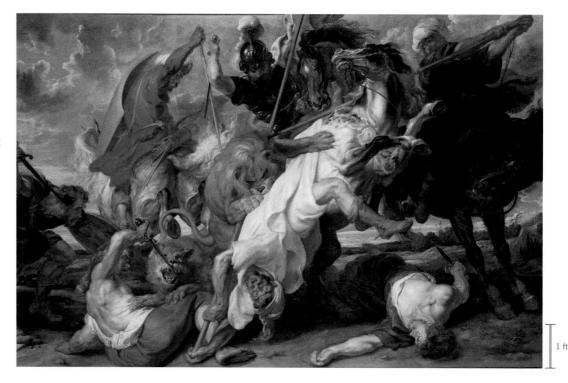

in space. Foreshortening is a kind of perspective. It produces the illusion that one part of the body is farther away than another, even though all the forms are on the same surface. Especially noteworthy in *Lion Hunt* are the gray horse at the left, seen from behind with the bottom of its left rear hoof facing viewers and most of its head hidden

I-15 Hesire, relief from his tomb at Saqqara, Egypt, Dynasty III, ca. 2650 BCE. Wood, 3' 9" high. Egyptian Museum, Cairo.

Egyptian artists combined frontal and profile views to give a precise picture of the parts of the human body, as opposed to depicting how an individual body appears from a specific viewpoint.

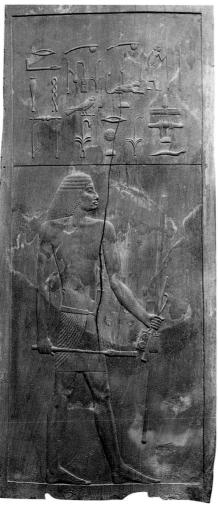

by its rider's shield, and the fallen hunter at the painting's lower right corner, whose barely visible legs and feet recede into the distance.

The artist who carved the portrait of the ancient Egyptian official Hesire (FIG. I-15) did not employ foreshortening. That artist's purpose was to present the various human body parts as clearly as possible, without overlapping. The lower part of Hesire's body is in profile to give the most complete view of the legs, with both the heels and toes of the foot visible. The frontal torso, however, allows viewers to see its full shape, including both shoulders, equal in size, as in nature. (Compare the shoulders of the hunter on the gray horse or those of the fallen hunter in *Lion Hunt*'s left foreground.) The result—an "unnatural" 90-degree twist at the waist—provides a precise picture of human body parts. Rubens and the Egyptian sculptor used very different means of depicting forms in space. Once again, neither is the "correct" manner.

PROPORTION AND SCALE *Proportion* concerns the relationships (in terms of size) of the parts of persons, buildings, or objects. People can judge "correct proportions" intuitively ("that statue's head seems the right size for the body"). Or proportion can be a mathematical relationship between the size of one part of an artwork or building and the other parts within the work. Proportion in art implies using a *module*, or basic unit of measure. When an artist or architect uses a formal system of proportions, all parts of a building, body, or other entity will be fractions or multiples of the module. A module might be a *column*'s diameter, the height of a human head, or any other component whose dimensions can be multiplied or divided to determine the size of the work's other parts.

In certain times and places, artists have devised *canons*, or systems, of "correct" or "ideal" proportions for representing human figures, constituent parts of buildings, and so forth. In ancient Greece, many sculptors formulated canons of proportions so strict and all-encompassing that they calculated the size of every body part in advance, even the fingers and toes, according to mathematical ratios.

Proportional systems can differ sharply from period to period, culture to culture, and artist to artist. Part of the task art history

1 ft.

students face is to perceive and adjust to these differences. In fact, many artists have used disproportion and distortion deliberately for expressive effect. In the medieval French depiction of the weighing of souls on judgment day (FIG. I-7), the devilish figure yanking down on the scale has distorted facial features and stretched, lined limbs with animal-like paws for feet. Disproportion and distortion make him appear "inhuman," precisely as the sculptor intended.

In other cases, artists have used disproportion to focus attention on one body part (often the head) or to single out a group member (usually the leader). These intentional "unnatural" discrepancies in proportion constitute what art historians call hierarchy of scale, the enlarging of elements considered the most important. On the bronze plaque from Benin, Nigeria, illustrated here (FIG. 1-1), the sculptor enlarged all the heads for emphasis and also varied the size of each figure according to the person's social status. Central, largest, and therefore most important is the Benin king, mounted on horseback. The horse has been a symbol of power and wealth in many societies from prehistory to the present. That the Benin king is disproportionately larger than his horse, contrary to nature, further aggrandizes him. Two large attendants fan the king. Other figures of smaller size and status at the Benin court stand on the king's left and right and in the plaque's upper corners. One tiny figure next to the horse is almost hidden from view beneath the king's feet.

One problem students of art history—and professional art historians too—confront when studying illustrations in art history books is that although the relative sizes of figures and objects in a painting or sculpture are easy to discern, it is impossible to determine the absolute size of the work reproduced because they all appear at approximately the same size on the page. Readers of *Art through the Ages* can learn the exact size of all artworks from the dimensions given in the captions and, more intuitively, from the scales positioned at the lower left or right corner of each illustration.

l-16 MICHELANGELO BUONARROTI, unfinished statue, 1527–1528. Marble, 8' 7½" high. Galleria dell'Accademia, Florence.

Carving a freestanding figure from stone or wood is a subtractive process. Michelangelo thought of sculpture as a process of "liberating" the statue within the block of marble.

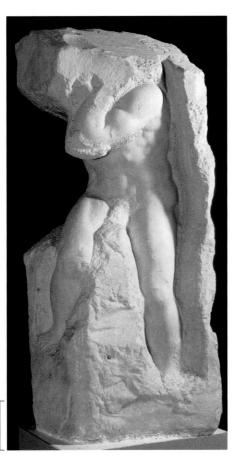

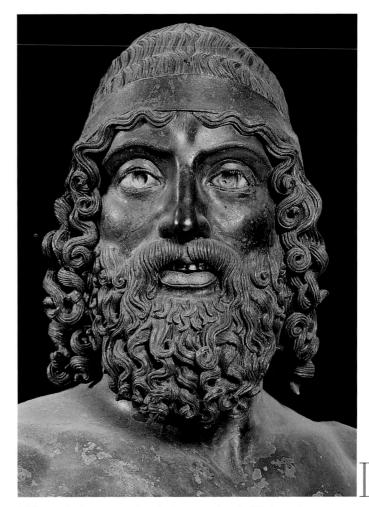

I-17 Head of a warrior, detail of a statue (FIG. 5-35) from the sea off Riace, Italy, ca. 460–450 BCE. Bronze, full statue 6' 6'' high. Museo Nazionale della Magna Grecia, Reggio Calabria.

The sculptor of this life-size statue of a bearded Greek warrior cast the head, limbs, torso, hands, and feet in separate molds, then welded the pieces together and added the eyes in a different material.

CARVING AND CASTING Sculptural technique falls into two basic categories, *subtractive* and *additive. Carving* is a subtractive technique. The final form is a reduction of the original mass of a block of stone, a piece of wood, or another material. Wood statues were once tree trunks, and stone statues began as blocks pried from mountains. The unfinished marble statue illustrated here (FIG. I-16) by renowned Italian artist MICHELANGELO BUONARROTI (1475–1564) clearly reveals the original shape of the stone block. Michelangelo thought of sculpture as a process of "liberating" the statue within the block. All sculptors of stone or wood cut away (subtract) "excess material." When they finish, they "leave behind" the statue—in this example, a twisting nude male form whose head Michelangelo never freed from the stone block.

In additive sculpture, the artist builds up (*models*) the forms, usually in clay around a framework, or *armature*. Or a sculptor may fashion a *mold*, a hollow form for shaping, or *casting*, a fluid substance such as bronze or plaster. The ancient Greek sculptor who made the bronze statue of a warrior found in the sea near Riace, Italy, cast the head (FIG. I-17) as well as the limbs, torso, hands, and feet (FIG. 5-35) in separate molds and then *welded* them together (joined them by heating). Finally, the artist added features, such as the pupils of the eyes (now missing), in other materials. The warrior's teeth are silver, and his lower lip is copper.

RELIEF SCULPTURE *Statues* and *busts* (head, shoulders, and chest) that exist independent of any architectural frame or setting and that viewers can walk around are *freestanding* sculptures, or *sculptures in the round*, whether the artist produced the piece by carving (FIG. I-10) or casting (FIG. I-17). In *relief* sculpture, the subjects project from the background but remain part of it. In *high-relief* sculpture, the images project boldly. In some cases, such as the medieval weighing-of-souls scene (FIG. I-7), the relief is so high the forms not only cast shadows on the background, but some parts are even in the round, which explains why some pieces, for example, the arms of the scales, broke off centuries ago. In *low-relief*, or *bas-relief*, *sculpture*, such as the portrait of Hesire (FIG. I-15), the projection is slight. Artists can produce relief sculptures, as they do sculptures in the round, either by carving or casting. The plaque from Benin (FIG. I-1) is an example of bronze-casting in high relief.

ARCHITECTURAL DRAWINGS Buildings are groupings of enclosed spaces and enclosing masses. People experience architecture both visually and by moving through and around it, so they perceive architectural space and mass together. These spaces and masses can be represented graphically in several ways, including as plans, sections, elevations, and cutaway drawings.

A *plan*, essentially a map of a floor, shows the placement of a structure's masses and, therefore, the spaces they circumscribe and enclose. A *section*, a kind of vertical plan, depicts the placement of the masses as if someone cut through the building along a plane. Drawings showing a theoretical slice across a structure's width are *lateral sections*. Those cutting through a building's length are *longitudinal sections*. Illustrated here are the plan and lateral section of Beauvais Cathedral (FIG. I-18), which readers can compare with the photograph of the church's *choir* (FIG. I-3). The plan shows the choir's shape and the location of the *piers* dividing the *aisles* and supporting the *vaults* above, as well as the pattern of the crisscrossing vault *ribs*. The lateral section shows not only the interior of the choir with its vaults and tall *stained-glass* windows but also the structure of the roof and the form of the exterior *flying buttresses* holding the vaults in place.

Other types of architectural drawings appear throughout this book. An *elevation* drawing is a head-on view of an external or

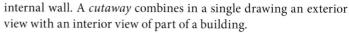

This overview of the art historian's vocabulary is not exhaustive, nor have artists used only painting, drawing, sculpture, and architecture as media over the millennia. Ceramics, jewelry, textiles, photography, and computer graphics are just some of the numerous other arts. All of them involve highly specialized techniques described in distinct vocabularies. As in this introductory chapter, new terms are in *italics* when they first appear. The comprehensive Glossary at the end of the book contains definitions of all italicized terms.

Art History and Other Disciplines

By its very nature, the work of art historians intersects with the work of others in many fields of knowledge, not only in the humanities but also in the social and natural sciences. Today, art historians must go beyond the boundaries of what the public and even professional art historians of previous generations traditionally considered the specialized discipline of art history. In short, art historical research in the 21st century is typically interdisciplinary in nature. To cite one example, in an effort to unlock the secrets of a particular statue, an art historian might conduct archival research hoping to uncover new documents shedding light on who paid for the work and why, who made it and when, where it originally stood, how its contemporaries viewed it, and a host of other questions. Realizing, however, that the authors of the written documents often were not objective recorders of fact but observers with their own biases and agendas, the art historian may also use methodologies developed in fields such as literary criticism, philosophy, sociology, and gender studies to weigh the evidence the documents provide.

At other times, rather than attempting to master many disciplines at once, art historians band together with other specialists in multidisciplinary inquiries. Art historians might call in chemists

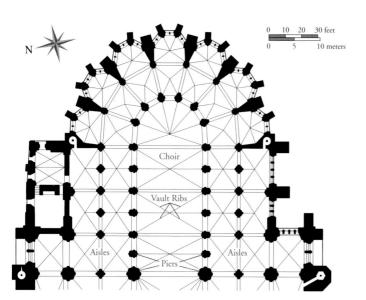

I-18 Plan (left) and lateral section (right) of Beauvais Cathedral, Beauvais, France, rebuilt after 1284.

Architectural drawings are indispensable aids for the analysis of buildings. Plans are maps of floors, recording the structure's masses. Sections are vertical "slices" across either a building's width or length.

to date an artwork based on the composition of the materials used, or might ask geologists to determine which quarry furnished the stone for a particular statue. X-ray technicians might be enlisted in an attempt to establish whether a painting is a forgery. Of course, art historians often reciprocate by contributing their expertise to the solution of problems in other disciplines. A historian, for example, might ask an art historian to determine—based on style, material, iconography, and other criteria—if any of the portraits of a certain king date after his death. Such information would help establish the ruler's continuing prestige during the reigns of his successors. (Some portraits of Augustus [FIG. I-10], the founder of the Roman Empire, postdate his death by decades, even centuries.)

DIFFERENT WAYS OF SEEING

The history of art can be a history of artists and their works, of styles and stylistic change, of materials and techniques, of images and themes and their meanings, and of contexts and cultures and patrons. The best art historians analyze artworks from many viewpoints. But no art historian (or scholar in any other field), no matter how broad-minded in approach and no matter how experienced, can be truly objective. As were the artists who made the works illustrated and discussed in this book, art historians are members of a society, participants in its culture. How can scholars (and museum visitors and travelers to foreign locales) comprehend cultures unlike their own? They can try to reconstruct the original cultural contexts of artworks, but they are limited by their distance from the thought patterns of the cultures they study and by the obstructions to understanding-the assumptions, presuppositions, and prejudices peculiar to their own culture-their own thought patterns raise. Art historians may reconstruct a distorted picture of the past because of culture-bound blindness.

A single instance underscores how differently people of diverse cultures view the world and how various ways of seeing can result in sharp differences in how artists depict the world. Illustrated here are two contemporaneous portraits of a 19th-century Maori chieftain (FIG. **I-19**)—one by an Englishman, JOHN HENRY SYLVESTER (active early 19th century), and the other by the New Zealand chieftain himself, TE PEHI KUPE (d. 1829). Both reproduce the chieftain's facial tattooing. The European artist (FIG. I-19, *left*) included the head and shoulders and downplayed the tattooing. The tattoo pattern is one aspect of the likeness among many, no more or less important than the chieftain's European attire. Sylvester also recorded his subject's momentary glance toward the right and the play of light on his hair, fleeting aspects having nothing to do with the figure's identity.

In contrast, Te Pehi Kupe's self-portrait (FIG. I-19, *right*)—made during a trip to Liverpool, England, to obtain European arms to take back to New Zealand—is not a picture of a man situated in space and bathed in light. Rather, it is the chieftain's statement of the supreme importance of the tattoo design announcing his rank among his people. Remarkably, Te Pehi Kupe created the tattoo patterns from memory, without the aid of a mirror. The splendidly composed insignia, presented as a flat design separated from the body and even from the head, is Te Pehi Kupe's image of himself. Only by understanding the cultural context of each portrait can art historians hope to understand why either representation appears as it does.

As noted at the outset, the study of the context of artworks and buildings is one of the central concerns of art historians. *Art through the Ages* seeks to present a history of art and architecture that will help readers to understand not only the subjects, styles, and techniques of paintings, sculptures, buildings, and other art forms created in all parts of the world during 30 millennia but also their cultural and historical contexts. That story now begins.

I-19 Left: JOHN HENRY SYLVESTER, Portrait of Te Pehi Kupe, 1826. Watercolor, $8\frac{1''}{4} \times 6\frac{1''}{4}$. National Library of Australia, Canberra (Rex Nan Kivell Collection). Right: TE PEHI KUPE, Self-Portrait, 1826. From Leo Frobenius, The Childhood of Man (New York: J. B. Lippincott, 1909).

These strikingly different portraits of the same Maori chief reveal the different ways of seeing by a European artist and an Oceanic one. Understanding the cultural context of artworks is vital to art history.

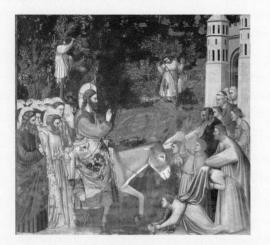

Giotto's cycle of biblical frescoes in the Arena Chapel includes 38 framed panels depicting the lives of the Virgin, her parents, and Jesus. The passion cycle opens with *Entry into Jerusalem*. Giotto's vision of the *Last Judgment* fills the west wall above the entrance to the Arena Chapel. The Paduan banker Enrico Scrovegni built the chapel to expiate the moneylender's sin of usury.

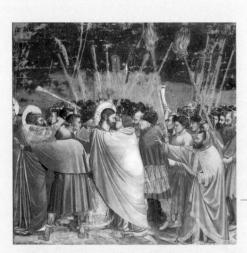

Giotto was a pioneer in pursuing a naturalistic approach to representation based on observation. In *Betrayal of Jesus*, he revived the classical tradition of depicting some figures from the rear.

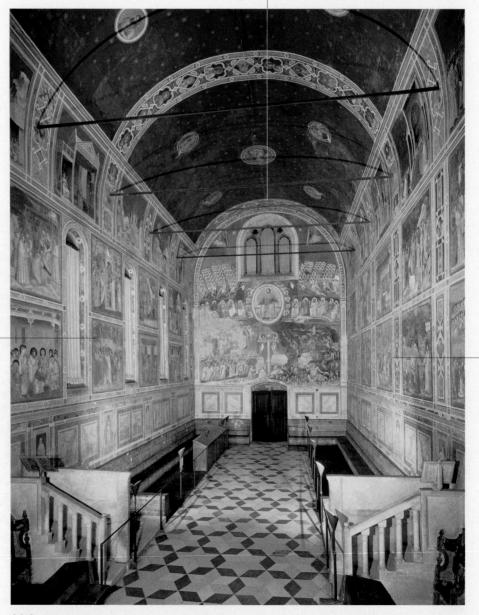

14-1 GIOTTO DI BONDONE, interior of the Arena Chapel (Cappella Scrovegni; looking west), Padua, Italy, 1305–1306.

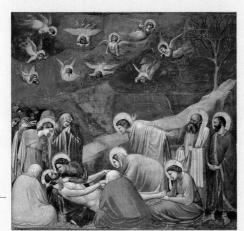

LATE MEDIEVAL ITALY

14

Giotto was also a master of composition. In *Lamentation*, the rocky slope behind the figures leads the viewer's eye toward the heads of Mary and the dead Jesus at the lower left.

LATE MEDIEVAL OR PROTO-RENAISSANCE?

Art historians debate whether the art of Italy between 1200 and 1400 is the last phase of medieval art or the beginning of the rebirth, or *Renaissance*, of Greco-Roman *naturalism*. All agree, however, the pivotal figure of this age was the Florentine painter GIOTTO DI BONDONE (ca. 1266–1337), whose masterwork was the fresco cycle of the Arena Chapel (FIG. 14-1) in Padua. A banker, Enrico Scrovegni, built the chapel on a site adjacent to his palace in the hope it would expiate the moneylender's sin of usury. Consecrated in 1305, the chapel takes its name from an ancient Roman arena (*amphitheater*) nearby.

Some scholars have suggested Giotto himself may have been the chapel's architect, because its design so perfectly suits its interior decoration. The rectangular hall has only six windows, all in the south wall, leaving the other walls as almost unbroken and well-illuminated surfaces for painting. In 38 framed panels, Giotto presented the most poignant incidents from the lives of the Virgin and her parents, Joachim and Anna, in the top level, and, in the middle and lower levels, the life and mission (middle), and the passion and resurrection (bottom) of Jesus. The climactic event of the cycle of human salvation, *Last Judgment*, covers most of the west wall above the chapel's entrance.

The *Entry into Jerusalem*, *Betrayal of Jesus*, and *Lamentation* panels reveal the essentials of Giotto's style. In contrast to the common practice of his day, Giotto based his method of pictorial expression on observation of the natural world—the approach championed by the ancient Greeks and Romans but largely abandoned in the Middle Ages. Subtly scaled to the chapel's space, Giotto's stately and slow-moving half-life-size figures act out the religious dramas convincingly and with great restraint. The biblical actors are sculpturesque, simple, and weighty, often *foreshortened* (seen from an angle) and modeled with light and shading in the classical manner. They convey individual emotions through their postures and gestures. Giotto's naturalism displaced the Byzantine style in Italy (see Chapter 9), inaugurating an age some scholars call "early scientific." By stressing the preeminence of sight for gaining knowledge of the world, Giotto and his successors contributed to the foundation of empirical science. They recognized that the visual world must be observed before it can be analyzed and understood. Praised in his own and later times for his fidelity to nature, Giotto was more than a mere imitator of it. He showed his generation a new way of seeing. With Giotto, Western painters turned away from the spiritual world—the focus of medieval European artists—and once again moved resolutely toward the visible world as the inspiration for their art.

13TH CENTURY

When the Italian humanists of the 16th century condemned the art of the late Middle Ages in northern Europe as "*Gothic*" (see Chapter 13), they did so by comparing it with the contemporaneous art of Italy, which consciously revived *classical** art. Italian artists and scholars regarded medieval artworks as distortions of the noble art of the Greeks and Romans. Interest in the art of classical antiquity was not entirely absent during the medieval period, however, even in France, the center of the Gothic style. For example, on the west front of Reims Cathedral, the 13th-century statues of Christian *saints* and angels (FIG. 13-24) reveal the unmistakable influence of ancient Roman art on French sculptors. However, the classical revival that took root in Italy during the 13th and 14th centuries was much more pervasive and longer-lasting.

Sculpture

Italian admiration for classical art surfaced early on at the court of Frederick II, king of Sicily (r. 1197–1250) and Holy Roman emperor (r. 1220–1250). Frederick's nostalgia for Rome's past grandeur fostered a revival of classical sculpture in Sicily and southern Italy not unlike the classical *renovatio* (renewal) Charlemagne encouraged in Germany and France four centuries earlier (see Chapter 11).

NICOLA PISANO The sculptor Nicola d'Apulia (Nicholas of Apulia), better known as NICOLA PISANO (active ca. 1258-1278) after his adopted city (see "Italian Artists' Names," page 405, and MAP 14-1), received his early training in southern Italy under Frederick's rule. In 1250, Nicola traveled northward and eventually settled in Pisa. Then at the height of its political and economic power, the maritime city was a magnet for artists seeking lucrative commissions. Nicola specialized in carving marble reliefs and ornamentation for large *pulpits* (raised platforms from which priests led church services), completing the first (FIG. 14-2) in 1260 for Pisa's century-old baptistery (FIG. 12-26, left). Some elements of the pulpit's design carried on medieval traditions-for example, the trefoil (triple-curved) arches and the lions supporting some of the columns-but Nicola also incorporated classical elements. The large capitals with two rows of thick overlapping leaves crowning the columns are a Gothic variation of the Corinthian capital (see page 151 and FIG. 5-73, or page xxii-xxiii in Volume II and Book D). The arches are round, as in Roman architecture, rather than pointed (ogival), as in Gothic buildings. Also, each of the large rectangular relief panels resembles the sculptured front of a Roman sarcophagus (coffin; for example, FIG. 7-70).

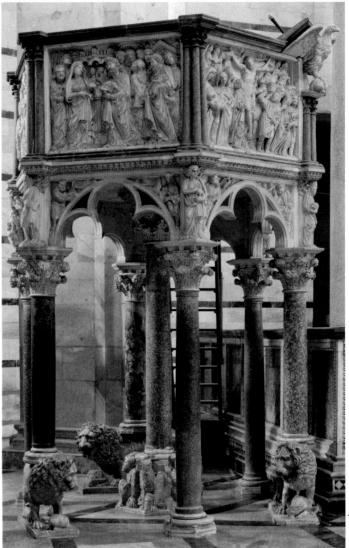

14-2 NICOLA PISANO, pulpit of the baptistery, Pisa, Italy, 1259–1260. Marble, 15' high. ■4

Nicola Pisano's Pisa baptistery pulpit retains many medieval features, for example, the trefoil arches and the lions supporting columns, but the figures derive from ancient Roman sarcophagus reliefs.

*In *Art through the Ages* the adjective "Classical," with uppercase *C*, refers specifically to the Classical period of ancient Greece, 480–323 BCE. Lower-case "classical" refers to Greco-Roman antiquity in general, that is, the period treated in Chapters 5, 6, and 7.

LATE MEDIEVAL ITALY

13th Century

- Bonaventura Berlinghieri and Cimabue are the leading painters working in the Italo-Byzantine style, or maniera greca
- I Nicola and Giovanni Pisano, father and son, represent two contrasting sculptural styles, the classical and the Gothic respectively
- I Fresco cycles in Rome and Assisi foreshadow the revolutionary art of Giotto

14th Century

- In Florence, Giotto, considered the first Renaissance artist, pioneers a naturalistic approach to painting based on observation
- I In Siena, Duccio softens the maniera greca and humanizes religious subject matter
- I Secular themes emerge as important subjects in civic commissions, as in the frescoes of Siena's Palazzo Pubblico
- I Florence, Siena, and Orvieto build new cathedrals that are stylistically closer to Early Christian basilicas than to French Gothic cathedrals

14-3 NICOLA PISANO, Annunciation, Nativity, and Adoration of the Shepherds, relief panel on the baptistery pulpit, Pisa, Italy, 1259–1260. Marble, 2' $10'' \times 3' 9''$.

Classical sculpture inspired the faces, beards, coiffures, and draperies, as well as the bulk and weight of Nicola's figures. The *Nativity* Madonna resembles lid figures on Roman sarcophagi.

1 ft

14-4 GIOVANNI PISANO, Annunciation, Nativity, and Adoration of the Shepherds, relief panel on the pulpit of Sant'Andrea, Pistoia, Italy, 1297–1301. Marble, 2' $10'' \times 3' 4''$.

The French Gothic style had a greater influence on Giovanni Pisano, Nicola's son. Giovanni arranged his figures loosely and dynamically. They display a nervous agitation, as if moved by spiritual passion.

1 ft.

The densely packed large-scale figures of the individual panels also seem to derive from the compositions found on Roman sarcophagi. One of these panels (FIG. **14-3**) depicts scenes from the infancy cycle of Christ (see "The Life of Jesus in Art," Chapter 8, pages 240–241, or pages xxx–xxxi, in Volume II and Book D), including *Annunciation (top left)*, *Nativity (center* and *lower half*), and *Adoration of the Shepherds (top right)*. Mary appears twice, and her size varies. The focus of the composition is the reclining Virgin of *Nativity*, whose posture and drapery are reminiscent of those of the lid figures on Etruscan (FIGS. 6-5 and 6-15) and Roman (FIG. 7-61) sarcophagi. The face types, beards, and coiffures, as well as the bulk and weight of Nicola's figures, also reveal the influence of classical relief sculpture. Art historians have even been able to pinpoint the models of some of the pulpit figures on Roman sarcophagi in Pisa. **GIOVANNI PISANO** Nicola's son, GIOVANNI PISANO (ca. 1250–1320), likewise became a sought-after sculptor of church pulpits. Giovanni's pulpit in Sant'Andrea at Pistoia also has a panel (FIG. 14-4) featuring *Nativity* and related scenes. The son's version of the subject offers a striking contrast to his father's thick carving and placid, almost stolid presentation of the religious narrative. Giovanni arranged the figures loosely and dynamically. They twist and bend in excited animation, and the deep spaces between them suggest their motion. In *Annunciation (top left)*, the Virgin shrinks from the angel's sudden appearance in a posture of alarm touched with humility. The same spasm of apprehension contracts her supple body as she reclines in *Nativity (center)*. The drama's principals share in a peculiar nervous agitation, as if spiritual passion suddenly moves all of them. Only the shepherds and the sheep (*right*)

The Great Schism, Mendicant Orders, and Confraternities

n 1305, the College of Cardinals (the L collective body of all cardinals) elected a French pope, Clement V (r. 1305-1314), who settled in Avignon. Subsequent French popes remained in Avignon, despite their announced intentions to return to Rome. Understandably, the Italians, who saw Rome as the rightful capital of the universal Church, resented the Avignon papacy. The conflict between the French and Italians resulted in the election in 1378 of two popes-Clement VII, who resided in Avignon (and who does not appear in the Catholic Church's official list of popes), and Urban VI (r. 1378-1389), who remained in Rome. Thus began what

14-5 BONAVENTURA BERLINGHIERI, Saint Francis Altarpiece, San Francesco, Pescia, Italy, 1235. Tempera on wood, $5' \times 3' \times 6'$.

Berlinghieri painted this altarpiece in the Italo-Byzantine style, or maniera greca, for the mendicant (begging) order of Franciscans. It is the earliest known representation of Saint Francis of Assisi.

became known as the Great Schism. After 40 years, Holy Roman Emperor Sigismund (r. 1410–1437) convened a council that resolved this crisis by electing a new Roman pope, Martin V (r. 1417–1431), who was acceptable to all.

The pope's absence from Italy during much of the 14th century contributed to an increase in prominence of monastic orders. The Augustinians, Carmelites, and Servites became very active, ensuring a constant religious presence in the daily life of Italians, but the largest and most influential monastic orders were the mendicants (begging friars)-the Franciscans, founded by Francis of Assisi (FIG. 14-5), and the Dominicans, founded by the Spaniard Dominic de Guzman (ca. 1170-1221). These mendicants renounced all worldly goods and committed themselves to spreading God's word, performing good deeds, and ministering to the sick and dying. The Dominicans, in particular, contributed significantly to establishing urban educational institutions. The Franciscans and Dominicans became very popular in Italy because of their devotion to their faith and the more personal relationship with God they encouraged. Although both mendicant orders worked for the glory of God, a degree of rivalry nevertheless existed between the two. For example, in Florence they established their churches on opposite sides of the city—Santa Croce (FIG. 1-4), the Franciscan church, on the eastern side, and the Dominicans' Santa Maria Novella (FIG. 14-6A) on the western (MAP 21-1).

Confraternities, organizations consisting of laypersons who dedicated themselves to strict religious observance, also grew in popularity during the 14th and 15th centuries. The mission of confraternities included tending the sick, burying the dead, singing hymns, and performing other good works. The confraternities as well as the mendicant orders continued to play an important role in Italian religious life through the 16th century. The numerous artworks and monastic churches they commissioned have ensured their enduring legacy.

do not yet share in the miraculous event. The swiftly turning, sinuous draperies, the slender figures they enfold, and the general emotionalism of the scene are features not found in Nicola Pisano's interpretation. The father worked in the classical tradition, the son in a style derived from French Gothic. These styles were two of the three most important ingredients in the formation of the distinctive and original art of 14th-century Italy.

Painting and Architecture

The third major stylistic element in late medieval Italian art was the Byzantine tradition (see Chapter 9). Throughout the Middle Ages, the Byzantine style dominated Italian painting, but its influence was especially strong after the fall of Constantinople in 1204, which precipitated a migration of Byzantine artists to Italy.

BONAVENTURA BERLINGHIERI One of the leading painters working in the Italo-Byzantine style, or *maniera greca* (Greek style), was BONAVENTURA BERLINGHIERI (active ca. 1235–1244) of Lucca. His most famous work is the *Saint Francis Altarpiece* (FIG. 14-5) in the church of San Francesco (Saint Francis) in Pescia. Painted in 1235 using *tempera* on wood panel (see "Tempera and Oil Painting," Chapter 20, page 539), the *altarpiece* honors Saint Francis of Assisi (ca. 1181–1226), whose most important shrine (FIG. 14-5A), at Assisi itself, boasts the most extensive cycle of

Italian Artists' Names

In contemporary societies, people have become accustomed to a standardized method of identifying individuals, in part because of the proliferation of official documents such as driver's licenses, passports, and student identification cards. Modern names consist of given names (names selected by the parents) and family names, although the order of the two (or more) names varies from country to country. In China, for example, the family name precedes the given name (see Chapters 16 and 33).

This kind of regularity in names was not, however, the norm in premodern Italy. Many individuals were known by their place of birth or adopted hometown. Nicola Pisano (FIGS. 14-2 and 14-3) was "Nicholas the Pisan," Giulio Romano was "Julius the Roman," and Domenico Veneziano was "the Venetian." Leonardo da Vinci ("Leonard from Vinci") hailed from the small town of Vinci, near Florence (MAP 14-1). Art historians therefore refer to these artists by their given names, not the names of their towns. (The title of Dan Brown's best-selling novel should have been *The Leonardo Code*, not *The Da Vinci Code*.)

Nicknames were also common. Giorgione was "Big George." People usually referred to Tommaso di Cristoforo Fini as Masolino ("Little Thomas") to distinguish him from his more famous pupil, Masaccio ("Brutish Thomas"). Guido di Pietro was called Fra Angelico (the Angelic Friar). Cenni di Pepo is remembered as Cimabue (FIG. 14-6), which means "bull's head."

Names were also impermanent and could be changed at will. This flexibility has resulted in significant challenges for historians, who often must deal with archival documents and records referring to the same artist by different names.

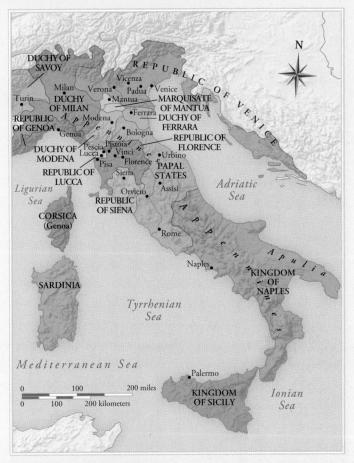

MAP 14-1 Italy around 1400.

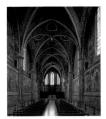

14-5A San Francesco, Assisi, 1228–1253.

14-5B St. FRANCIS MASTER, *Preaching to the Birds*, ca. 1290–1300.

frescoes from 13th-century Italy. Berlinghieri depicted Francis wearing the costume later adopted by all Franciscan monks: a coarse clerical robe tied at the waist with a rope. The saint displays the stigmata-marks resembling Christ's wounds-that miraculously appeared on his hands and feet. Flanking Francis are two angels, whose frontal poses, prominent halos, and lack of modeling reveal the Byzantine roots of Berlinghieri's style. So, too, does the use of gold leaf (gold beaten into tissue-paper-thin sheets, then applied to surfaces), which emphasizes the image's flatness and spiritual nature. The narrative scenes along the sides of the panel provide an active contrast to the stiff formality of the large central image of Francis. At the upper left, taking pride of place at the saint's right, Francis receives the stigmata. Directly below, the saint preaches to the birds, a subject that

also figures prominently in the fresco program (FIG. 14-5B) of San Francesco at Assisi, the work of a painter art historians call the SAINT FRANCIS MASTER. These and the scenes depicting Francis's miracle cures strongly suggest Berlinghieri's source was one or more Byzantine *illuminated manuscripts* (compare FIG. 9-17) with biblical narrative scenes.

Berlinghieri's Saint Francis Altarpiece also highlights the increasingly prominent role of religious orders in late medieval Italy (see "The Great Schism, Mendicant Orders, and Confraternities," page 404). Saint Francis's Franciscan order worked diligently to impress on the public the saint's valuable example and to demonstrate the order's commitment to teaching and to alleviating suffering. Berlinghieri's Pescia altarpiece, painted only nine years after Francis's death, is the earliest known signed and dated representation of the saint. Appropriately, Berlinghieri's panel focuses on the aspects of the saint's life the Franciscans wanted to promote, thereby making visible (and thus more credible) the legendary life of this holy man. Saint Francis believed he could get closer to God by rejecting worldly goods, and to achieve this he stripped himself bare in a public square and committed himself to a strict life of fasting, prayer, and meditation. His followers considered the appearance of stigmata on Francis's hands and feet (clearly visible in the saint's frontal image, which resembles a Byzantine icon) as God's blessing, and viewed Francis as a second Christ. Fittingly, four of the six narrative scenes on the altarpiece depict miraculous healings, connecting Saint Francis even more emphatically to Christ.

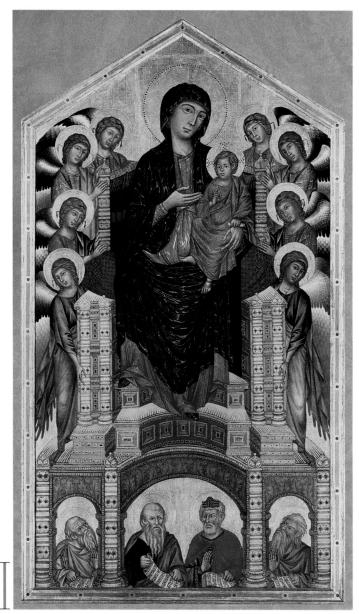

14-6 CIMABUE, Madonna Enthroned with Angels and Prophets, from Santa Trinità, Florence, ca. 1280–1290. Tempera and gold leaf on wood, 12' $7'' \times 7'$ 4". Galleria degli Uffizi, Florence.

Cimabue was one of the first artists to break away from the maniera greca. Although he relied on Byzantine models, Cimabue depicted the Madonna's massive throne as receding into space.

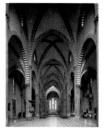

14-6A Santa Maria Novella, Florence, begun ca. 1246. ■4

CIMABUE One of the first artists to break from the Italo-Byzantine style that dominated 13th-century Italian painting was Cenni di Pepo, better known as CIMABUE (ca. 1240– 1302). Cimabue challenged some of the major conventions of late medieval art in pursuit of a new naturalism, the close observation of the natural world—the core of the classical tradition. He painted *Madonna Enthroned with Angels and Prophets* (FIG. **14-6**) for Santa Trinità (Holy Trinity) in Florence, the Benedictine

church near the Arno River built between 1258 and 1280, roughly contemporaneous with the Dominican church of Santa Maria Novella (FIG. **14-6A**). The composition and the gold background reveal the painter's reliance on Byzantine models (compare FIG. 9-18).

Cimabue also used the gold embellishments common to Byzantine art for the folds of the Madonna's robe, but they are no longer merely decorative patterns. In his panel they enhance the threedimensionality of the drapery. Furthermore, Cimabue constructed a deeper space for the Madonna and the surrounding figures to inhabit than was common in Byzantine art. The Virgin's throne, for example, is a massive structure and Cimabue convincingly depicted it as receding into space. The overlapping bodies of the angels on each side of the throne and the half-length prophets who look outward or upward from beneath it reinforce the sense of depth.

14TH CENTURY

In the 14th century, Italy consisted of numerous independent *city-states*, each corresponding to a geographic region centered on a major city (MAP 14-1). Most of the city-states, such as Venice, Florence, Lucca, and Siena, were republics—constitutional oligarchies governed by executive bodies, advisory councils, and special commissions. Other powerful 14th-century states included the Papal States, the Kingdom of Naples, and the Duchies of Milan, Modena, Ferrara, and Savoy. As their names indicate, these states were politically distinct from the republics, but all the states shared in the prosperity of the period. The sources of wealth varied from state to state. Italy's port cities expanded maritime trade, whereas the economies of other cities depended on banking or the manufacture of arms or textiles.

The outbreak of the Black Death (bubonic plague) in the late 1340s threatened this prosperity, however. Originating in China, the Black Death swept across Europe. The most devastating natural disaster in European history, the plague eliminated between 25 and 50 percent of the Continent's population in about five years. The Black Death devastated Italy's inhabitants. In large Italian cities, where people lived in relatively close proximity, the death tolls climbed as high as 50 to 60 percent of the population. The bubonic plague had a significant effect on art. It stimulated religious bequests and encouraged the commissioning of devotional images. The focus on sickness and death also led to a burgeoning in hospital construction.

Another significant development in 14th-century Italy was the blossoming of a vernacular (commonly spoken) literature, which dramatically affected Italy's intellectual and cultural life. Latin remained the official language of Church liturgy and state documents. However, the creation of an Italian vernacular literature (based on the Tuscan dialect common in Florence) expanded the audience for philosophical and intellectual concepts because of its greater accessibility. Dante Alighieri (1265–1321, author of *The Divine Comedy*), the poet and scholar Francesco Petrarch (1304–1374), and Giovanni Boccaccio (1313–1375, author of *Decameron*) were most responsible for establishing this vernacular literature.

RENAISSANCE HUMANISM The development of a vernacular literature was one important sign that the essentially religious view of the world dominating medieval Europe was about to change dramatically in what historians call the *Renaissance*. Although religion continued to occupy a primary position in the lives of Europeans, a growing concern with the natural world, the individual, and humanity's worldly existence characterized the Renaissance period—the 14th through the 16th centuries. The word *renaissance* in French and English (*rinascità* in Italian) refers to a "rebirth" of art and culture. A revived interest in classical cultures—indeed, the veneration of classical antiquity as a model—was central to this rebirth. The notion of the Renaissance representing the restoration of the glorious past of Greece and Rome gave rise to the concept of the "Middle Ages" as the era falling between antiquity and the Renaissance. The transition from the medieval to the Renaissance, though dramatic, did not come about abruptly, however. In fact, much that is medieval persisted in the Renaissance and in later periods.

Fundamental to the development of the Italian Renaissance was humanism, which emerged during the 14th century and became a central component of Italian art and culture in the 15th and 16th centuries. Humanism was more a code of civil conduct, a theory of education, and a scholarly discipline than a philosophical system. As their name suggests, Italian humanists were concerned chiefly with human values and interests as distinct from-but not opposed to-religion's otherworldly values. Humanists pointed to classical cultures as particularly praiseworthy. This enthusiasm for antiquity, represented by the elegant Latin of Cicero (106-43 BCE) and the Augustan age, involved study of Latin literature and a conscious emulation of what proponents believed were the Roman civic virtues. These included self-sacrificing service to the state, participation in government, defense of state institutions (especially the administration of justice), and stoic indifference to personal misfortune in the performance of duty. With the help of a new interest in and knowledge of Greek, the humanists of the late 14th and 15th centuries recovered a large part of Greek as well as Roman literature and philosophy that had been lost, left unnoticed, or cast aside in the Middle Ages. Indeed, classical cultures provided humanists with a model for living in this world, a model primarily of human focus derived not from an authoritative and traditional religious dogma but from reason.

Ideally, humanists sought no material reward for services rendered. The sole reward for heroes of civic virtue was fame, just as the reward for leaders of the holy life was sainthood. For the educated, the lives of heroes and heroines of the past became as edifying as the lives of the saints. Petrarch wrote a book on illustrious men, and his colleague Boccaccio complemented it with 106 biographies of famous women—from Eve to Joanna, queen of Naples (r. 1343–1382). Both Petrarch and Boccaccio were famous in their own day as poets, scholars, and men of letters—their achievements equivalent in honor to those of the heroes of civic virtue. In 1341 in Rome, Petrarch received the laurel wreath crown, the ancient symbol of victory and merit. The humanist cult of fame emphasized the importance of creative individuals and their role in contributing to the renown of the city-state and of all Italy.

Giotto

Critics from Giorgio Vasari[†] to the present day have regarded Giotto di Bondone (FIG. 14-1) as the first Renaissance painter. A pioneer in pursuing a naturalistic approach to representation based on observation, he made a much more radi-

cal break with the past than did Cima-

bue, whom Vasari identified as Giotto's

14-6B CAVALLINI, Last Judgment, ca. 1290–1295

teacher. Scholars still debate the sources of Giotto's style, however. One formative influence must have been Cimabue's work,

[†]Giorgio Vasari (1511–1574) was both a painter and an architect. Today, however, people associate him primarily with his landmark book, *Lives of the Most Eminent Painters, Sculptors, and Architects,* first published in 1550. Despite inaccuracies, Vasari's *Lives* is an invaluable research tool. It is the major contemporaneous source of information about Italian Renaissance art and artists. although Vasari lauded Giotto as having eclipsed his master by abandoning the "crude maniera greca." The 13th-century *murals* of San Francesco at Assisi (FIGS. 14-5A and 14-5B) and those of PIETRO CAVALLINI (ca. 1240–ca. 1340) in Rome (FIG. **14-6B**) may also have influenced the young Giotto. French Gothic sculpture (which Giotto may have seen but which was certainly familiar to him from the work of Giovanni Pisano, who had spent time in Paris) and ancient Roman art probably also contributed to Giotto's artistic education. Yet no mere synthesis of these varied influences could have produced the significant shift in artistic approach that has led some scholars to describe Giotto as the father of Western pictorial art. Renowned in his own day, his reputation has never faltered. Regardless of the other influences on his artistic style, his true teacher was nature—the world of visible things.

MADONNA ENTHRONED On nearly the same great scale as Cimabue's enthroned Madonna (FIG. 14-6) is Giotto's panel (FIG. 14-7) depicting the same subject, painted for the high altar

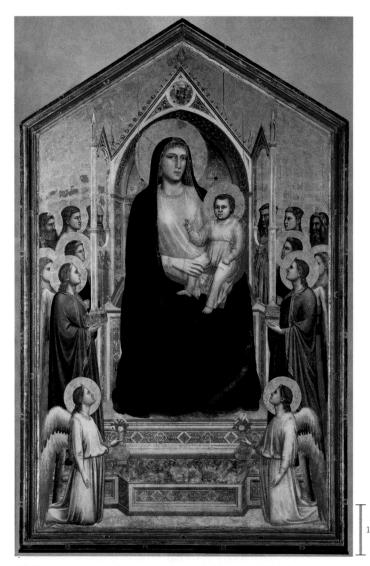

14-7 GIOTTO DI BONDONE, *Madonna Enthroned*, from the Church of Ognissanti, Florence, ca. 1310. Tempera and gold leaf on wood, $10' 8'' \times 6' 8''$. Galleria degli Uffizi, Florence.

Giotto displaced the Byzantine style in Italian painting and revived classical naturalism. His figures have substance, dimensionality, and bulk, and give the illusion they could throw shadows.

resco painting has a long history, particu-H larly in the Mediterranean region, where the Minoans (FIGS. 4-7 to 4-9B) used it as early as the 17th century BCE. Fresco (Italian for "fresh") is a mural-painting technique involving the application of permanent limeproof pigments, diluted in water, on freshly laid lime plaster. Because the surface of the wall absorbs the pigments as the plaster dries, fresco is one of the most durable painting techniques. The stable condition of the ancient Minoan frescoes, as well as those found at Pompeii and other Roman sites (FIGS. 7-17 to 7-26), in San Francesco (FIGS. 14-5A and 14-5B) at Assisi, and in the Arena Chapel (FIGS. 14-1 and 14-8 to 14-8B) at Padua, testify to the longevity of this painting method. The colors have remained vivid (although dirt and soot have necessitated cleaning-most famously in the Vatican's Sistine Chapel; FIG. 22-18B) because of the chemically inert pigments the artists used. In addition to this buon fresco (good, that is, true fresco) technique, artists used fresco secco (dry fresco). Fresco secco involves painting on dried lime plaster, the method the ancient Egyptians favored (FIGS. 3-28 and 3-29). Although the finished product visually approximates buon fresco, the plaster wall does not absorb the pigments, which simply adhere to the surface, so fresco secco is not as permanent as buon fresco.

The buon fresco process is time-consuming and demanding and requires several layers of plaster. Although buon fresco methods vary,

generally the artist prepares the wall with a rough layer of lime plaster called the *arriccio* (brown coat). The artist then transfers the composition to the wall, usually by drawing directly on the arriccio with a burnt-orange pigment called *sinopia* (most popular during the 14th century), or by transferring a *cartoon* (a full-size preparatory drawing). Cartoons increased in usage in the 15th and 16th centuries, largely replacing sinopia underdrawings. Finally, the painter lays the *intonaco* (painting coat) smoothly over the drawing in sections (called *giornate*—Italian for "days") only as large as the artist expects to complete in that session. (In Giotto's *Lamentation*

of Florence's Church of the Ognissanti (All Saints). Although still portrayed against the traditional gold background, Giotto's Madonna rests within her Gothic throne with the unshakable stability of an ancient marble goddess (compare FIG. 7-30). Giotto replaced Cimabue's slender Virgin, fragile beneath the thin ripplings of her drapery, with a weighty, queenly mother. In Giotto's painting, the Madonna's body is not lost—indeed, it is asserted. Giotto even showed Mary's breasts pressing through the thin fabric of her white undergarment. Gold highlights have disappeared from her heavy robe. Giotto aimed instead to construct a figure with substance, dimensionality, and bulk—qualities suppressed in favor of a spiritual immateriality in Byzantine and Italo-Byzantine art. Works painted in the new style portray statuesque figures projecting into the light and giving the illusion they could throw shadows. Giotto's *Madonna Enthroned* marks the end of medieval painting in Italy and the beginning of a new naturalistic approach to art.

Fresco Painting

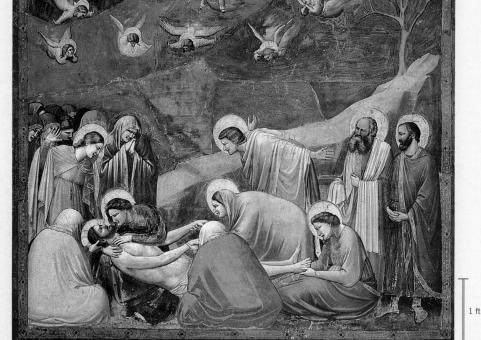

14-8 GIOTTO DI BONDONE, Lamentation, Arena Chapel (Cappella Scrovegni), Padua, Italy, ca. 1305. Fresco, 6' $6\frac{3}{4}'' \times 6' \frac{3}{4}''$.

Giotto painted *Lamentation* in several sections, each corresponding to one painting session. Artists employing the buon fresco technique must complete each section before the plaster dries.

> [FIG. 14-8], the giornate are easy to distinguish.) The buon fresco painter must apply the colors quickly, because once the plaster is dry, it will no longer absorb the pigment. Any unpainted areas of the intonaco after a session must be cut away so that fresh plaster can be applied for the next giornata.

> In areas of high humidity, such as Venice, fresco was less appropriate because moisture is an obstacle to the drying process. Over the centuries, fresco became less popular, although it did experience a revival in the 1930s with the Mexican muralists (FIGS. 29-73 and 29-74).

14-8A GIOTTO, Entry into Jerusalem, ca. 1305.

14-88 GIOTTO, *Betrayal of Jesus*, ca. 1305.

ARENA CHAPEL Projecting on a flat surface the illusion of solid bodies moving through space presents a double challenge. Constructing the illusion of a weighty, three-dimensional body also requires constructing the illusion of a space sufficiently ample to contain that body. In his fresco cycles (see "Fresco Painting," page 408), Giotto constantly strove to reconcile these two aspects of illusionistic painting. His murals in Enrico Scrovegni's Arena Chapel (FIG. 14-1) at Padua show his art at its finest. In 38 framed scenes (FIGS. 14-8, 14-8A, and 14-8B), Giotto presented one of the most impressive and complete Christian pictorial cycles ever rendered. The narrative unfolds on the north and south walls in three zones, reading from top to bottom. Be-

low, imitation marble veneer—reminiscent of ancient Roman decoration (FIG. 7-51), which Giotto may have seen—alternates with personified Virtues and Vices painted in *grisaille* (monochrome grays, often used for modeling in paintings) to resemble sculpture. On the west wall above the chapel's entrance is Giotto's dramatic *Last Judgment*, the culminating scene also of Pietro Cavallini's late-13th-century fresco cycle (FIG. 14-6B) in Santa Cecilia in Trastevere in Rome. The chapel's vaulted ceiling is blue, an azure sky dotted with golden stars symbolic of Heaven. Medallions bearing images of Christ, Mary, and various prophets also appear on the vault. Giotto painted the same blue in the backgrounds of the narrative panels on the walls below. The color thereby functions as a unifying agent for the entire decorative scheme.

The panel in the lowest zone of the north wall, Lamentation (FIG. 14-8), illustrates particularly well the revolutionary nature of Giotto's style. In the presence of boldly foreshortened angels, seen head-on with their bodies receding into the background and darting about in hysterical grief, a congregation mourns over the dead Savior just before his entombment. Mary cradles her son's body, while Mary Magdalene looks solemnly at the wounds in Christ's feet and Saint John the Evangelist throws his arms back dramatically. Giotto arranged a shallow stage for the figures, bounded by a thick diagonal rock incline defining a horizontal ledge in the foreground. Though narrow, the ledge provides firm visual support for the figures. The rocky setting recalls the landscape of a 12thcentury Byzantine mural (FIG. 9-29) at Nerezi in Macedonia. Here, the steep slope leads the viewer's eye toward the picture's dramatic focal point at the lower left. The postures and gestures of Giotto's figures convey a broad spectrum of grief. They range from Mary's almost fierce despair to the passionate outbursts of Mary Magdalene and John to the philosophical resignation of the two disciples at the right and the mute sorrow of the two hooded mourners in the foreground. In Lamentation, a single event provokes a host of individual responses in figures that are convincing presences both physically and psychologically. Painters before Giotto rarely attempted, let alone achieved, this combination of naturalistic representation, compositional complexity, and emotional resonance.

The formal design of the *Lamentation* fresco—the way Giotto grouped the figures within the constructed space—is worth close study. Each group has its own definition, and each contributes to

the rhythmic order of the composition. The strong diagonal of the rocky ledge, with its single dead tree (the tree of knowledge of good and evil, which withered after Adam and Eve's original sin), concentrates the viewer's attention on the heads of Christ and his mother, which Giotto positioned dynamically off center. The massive bulk of the seated mourner in the painting's left corner arrests and contains all movement beyond Mary and her dead son. The seated mourner to the right establishes a relation with the center figures, who, by gazes and gestures, draw the viewer's attention back to Christ's head. Figures seen from the back, which are frequent in Giotto's compositions (compare FIG. 14-8B), represent an innovation in the development away from the formal Italo-Byzantine style. These figures emphasize the foreground, aiding the visual placement of the intermediate figures farther back in space. This device, the very contradiction of Byzantine frontality, in effect puts viewers behind the "observer figures," who, facing the action as spectators, reinforce the sense of stagecraft as a model for painting.

Giotto's new devices for depicting spatial depth and body mass could not, of course, have been possible without his management of light and shade. He shaded his figures to indicate both the direction of the light illuminating their bodies and the shadows (the diminished light), thereby giving the figures volume. In *Lamentation*, light falls upon the upper surfaces of the figures (especially the two central bending figures) and passes down to dark in their garments, separating the volumes one from the other and pushing one to the fore, the other to the rear. The graded continuum of light and shade, directed by an even, neutral light from a single steady source—not shown in the picture—was the first step toward the development of *chiaroscuro* (the use of contrasts of dark and light to produce modeling) in later Renaissance painting (see Chapter 21).

The stagelike settings made possible by Giotto's innovations in perspective (the depiction of three-dimensional objects in space on a two-dimensional surface) and lighting suited perfectly the dramatic narrative the Franciscans emphasized then as a principal method for educating the faithful in their religion. In this new age of humanism, the old stylized presentations of the holy mysteries had evolved into mystery plays. Actors extended the drama of the Mass into one- and two-act tableaus and scenes and then into simple narratives offered at church portals and in city squares. (Eventually, confraternities also presented more elaborate religious dramas called sacre rappresentazioni-holy representations.) The great increase in popular sermons to huge city audiences prompted a public taste for narrative, recited as dramatically as possible. The arts of illusionistic painting, of drama, and of sermon rhetoric with all their theatrical flourishes developed simultaneously and were mutually influential. Giotto's art masterfully synthesized dramatic narrative, holy lesson, and truth to human experience in a visual idiom of his own invention, accessible to all. Not surprisingly, Giotto's frescoes served as textbooks for generations of Renaissance painters.

Siena

Among 14th-century Italian city-states, the Republics of Siena and Florence were the most powerful. Both were urban centers of bankers and merchants with widespread international contacts and large sums available for the commissioning of artworks (see "Artists' Guilds, Artistic Commissions, and Artists' Contracts," page 410).

Artists' Guilds, Artistic Commissions, and Artists' Contracts

The structured organization of economic activity during the 14th century, when Italy had established a thriving international trade and held a commanding position in the Mediterranean world, extended to many trades and professions. *Guilds* (associations of master craftspeople, apprentices, and tradespeople), which had emerged during the 12th century, became prominent. These associations not only protected members' common economic interests against external pressures, such as taxation, but also provided them with the means to regulate their internal operations (for example, work quality and membership training).

Because of today's international open art market, the notion of an "artists' union" may seem strange. The general public tends to think of art as the creative expression of an individual artist. However, artists did not always enjoy this degree of freedom. Historically, they rarely undertook major artworks without receiving a specific commission. The patron contracting for the artist's services could be a civic group, religious entity, private individual, or even the artists' guild itself. Guilds, although primarily business organizations, contributed to their city's religious and artistic life by subsidizing the building and decoration of numerous churches and hospitals. For example, the wool manufacturers' guild oversaw the start of Florence Cathedral (FIGS. 14-18 and 14-18A) in 1296, and the wool merchants' guild supervised the completion of its dome (FIG. 21-30A). The guild of silk manufacturers and goldsmiths provided the funds to build Florence's foundling hospital, the Ospedale degli Innocenti (FIG. 21-31).

Monastic orders, confraternities, and the popes were also major art patrons. In addition, wealthy families and individuals-for example, the Paduan banker Enrico Scrovegni (FIG. 14-1)-commissioned artworks for a wide variety of reasons. Besides the aesthetic pleasure these patrons derived from art, the images often also served as testaments to the patron's piety, wealth, and stature. Because artworks during this period were the product of service contracts, a patron's needs or wishes played a crucial role in the final form of any painting, sculpture, or building. Some early contracts between patrons and artists still exist. Patrons normally asked artists to submit drawings or models for approval, and they expected the artists they hired to adhere closely to the approved designs. The contracts usually stipulated certain conditions, such as the insistence on the artist's own hand in the production of the work, the quality of pigment and amount of gold or other precious items to be used, completion date, payment terms, and penalties for failure to meet the contract's terms.

A few extant 13th- and 14th-century painting contracts are especially illuminating. Although they may specify the subject to be represented, these binding legal documents always focus on the financial aspects of the commission and the responsibilities of the painter to the patron (and vice versa). In a contract dated November 1, 1301, between Cimabue (FIG. 14-6) and another artist and the Hospital of Santa Chiara in Pisa, the artists agree to supply an altarpiece

with colonnettes, tabernacles, and predella, painted with histories of the divine majesty of the Blessed Virgin Mary, of the apostles, of the angels, and with other figures and pictures, as shall be seen fit and shall please the said master of or other legitimate persons for the hospital.*

Other terms of the Santa Chiara contract specify the size of the panel and require the artists to use gold and silver gilding for parts of the altarpiece.

The contract for the construction of an altarpiece was usually a separate document, because it necessitated employing the services of a master carpenter. For example, on April 15, 1285, the leading painter of Siena, Duccio di Buoninsegna (FIGS. 14-9 to 14-11), signed a contract with the rectors of the Confraternity of the Laudesi, the lay group associated with the Dominican church of Santa Maria Novella (FIG. 14-6A) in Florence. The contract specified only that Duccio was to provide the painting, not its frame and it imposed conditions the painter had to meet if he was to be paid.

[The rectors] promise . . . to pay the same Duccio . . . as the payment and price of the painting of the said panel that is to be painted and done by him in the way described below . . . 150 lire of the small florins. . . . [Duccio, in turn, promises] to paint and embellish the panel with the image of the blessed Virgin Mary and of her omnipotent Son and other figures, according to the wishes and pleasure of the lessors, and to gild [the panel] and do everything that will enhance the beauty of the panel, his being all the expenses and the costs. . . . If the said panel is not beautifully painted and it is not embellished according to the wishes and desires of the same lessors, they are in no way bound to pay him the price or any part of it.[†]

Sometimes patrons furnished the materials and paid artists by the day instead of a fixed amount. That was the arrangement Duccio made on October 9, 1308, when he agreed to paint the *Maestà* (FIG. 14-9) for the high altar of Siena Cathedral.

Duccio has promised to paint and make the said panel as well as he can and knows how, and he further agreed not to accept or receive any other work until the said panel is done and completed.... [The church officials promise] to pay the said Duccio sixteen solidi of the Sienese denari as his salary for the said work and labor for each day that the said Duccio works with his own hands on the said panel ... [and] to provide and give everything that will be necessary for working on the said panel so that the said Duccio need contribute nothing to the work save his person and his effort.[‡]

In all cases, the artists worked for their patrons and could count on being compensated for their talents and efforts only if the work they delivered met the standards of those who ordered it.

*Translated by John White, *Duccio: Tuscan Art and the Medieval Workshop* (London: Thames & Hudson, 1979), 34.

^{*}Translated by James H. Stubblebine, *Duccio di Buoninsegna and His School* (Princeton, N.J.: Princeton University Press, 1979), 1: 192. ^{*}Stubblebine, *Duccio*, 1: 201.

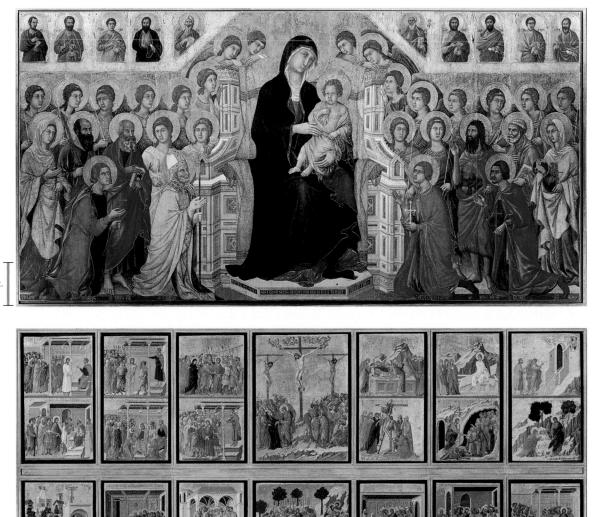

DUCCIO The works of DUCCIO DI BUONINSEGNA (active ca. 1278-1318) represent Sienese art at its most supreme. His most famous painting, the immense altarpiece called Maestà (Virgin Enthroned in Majesty; FIG. 14-9), replaced a much smaller painting of the Virgin Mary on the high altar of Siena Cathedral (FIG. 14-12A). The Sienese believed the Virgin had brought them victory over the Florentines at the battle of Monteperti in 1260, and she was the focus of the religious life of the republic. Duccio and his assistants began work on the prestigious commission in 1308 and completed Maestà in 1311, causing the entire city to celebrate. Shops closed and the bishop led a great procession of priests, civic officials, and the populace at large in carrying the altarpiece from Duccio's studio outside the city gate through the Campo (FIG. 14-15) up to its home on Siena's highest hill. So great was Duccio's stature that church officials permitted him to include his name in the dedicatory inscription on the front of the altarpiece on the Virgin's footstool: "Holy Mother of God, be the cause of peace for Siena and of life for Duccio, because he painted you thus."

As originally executed, Duccio's *Maestà* consisted of the sevenfoot-high central panel (FIG. 14-9) with the dedicatory inscription, **14-9** DUCCIO DI BUONINSEGNA, Virgin and Child Enthroned with Saints, principal panel of the Maestà altarpiece, from Siena Cathedral, Siena, Italy, 1308–1311. Tempera and gold leaf on wood, $7' \times 13'$. Museo dell'Opera del Duomo, Siena.

Duccio derived the formality and symmetry of his composition from Byzantine painting, but relaxed the rigidity and frontality of the figures, softened the drapery, and individualized the faces.

14-10 DUCCIO DI BUONINSEGNA, *Life of Jesus*, 14 panels from the back of the *Maestà* altarpiece, from Siena Cathedral, Siena, Italy, 1308–1311. Tempera and gold leaf on wood, $7' \times 13'$. Museo dell'Opera del Duomo, Siena.

On the back of the *Maestà* altarpiece, Duccio painted Jesus' passion in 24 scenes on 14 panels, beginning with *Entry into Jerusalem* (FIG. 14-10A), at the lower left, through *Noli me tangere*, at top right.

surmounted by seven *pinnacles* above, and a *predella*, or raised shelf, of panels at the base, altogether some 13 feet high. Painted in tempera front and back (FIG. **14-10**), the work unfortunately can no longer be seen in its entirety, because of its dismantling in subsequent centuries. Many of Duccio's panels are on display today as single masterpieces, scattered among the world's museums.

The main panel on the front of the altarpiece represents the Virgin enthroned as queen of Heaven amid choruses of angels and saints. Duccio derived the composition's formality and symmetry, along with the figures and facial types of the principal angels and saints, from Byzantine tradition. But the artist relaxed the strict frontality and rigidity of the figures. They turn to each other in quiet conversation. Further, Duccio individualized the faces of the four saints kneeling in the foreground, who perform their ceremonial gestures without stiffness. Similarly, he softened the usual Byzantine hard body outlines and drapery patterning. The folds of the garments, particularly those of the female saints at both ends of the panel, fall and curve loosely. This is a feature familiar in French Gothic works (FIG. 13-37) and is a mark of the artistic dialogue between Italy and northern Europe in the 14th century.

Despite these changes revealing Duccio's interest in the new naturalism, he respected the age-old requirement that as an altarpiece, *Maestà* would be the focus of worship in Siena's largest and most important church, its *cathedral*, the seat of the bishop of Siena. As such, Duccio knew *Maestà* should be an object holy in itself—a work of splendor to the eyes, precious in its message and its materials. Duccio thus recognized how the function of the altarpiece naturally limited experimentation in depicting narrative action and producing illusionistic effects (such as Giotto's) by modeling forms and adjusting their placement in pictorial space.

Instead, the queen of Heaven panel is a miracle of color composition and texture manipulation, unfortunately not fully revealed in photographs. Close inspection of the original reveals what the Sienese artist learned from other sources. In the 13th and 14th centuries. Italy was the distribution center for the great silk trade from China and the Middle East (see "The Silk Road," Chapter 16, page 458). After processing the silk in city-states such as Lucca and Florence, the Italians exported the precious fabric throughout Europe to satisfy an immense market for sumptuous dress. (Dante, Petrarch, and many other humanists decried the appetite for luxury in costume, which to them represented a decline in civic and moral virtue.) People throughout Europe (Duccio and other artists among them) prized fabrics from China, Persia, Byzantium, and the Islamic world. In Maestà, Duccio created the glistening and shimmering effects of textiles, adapting the motifs and design patterns of exotic materials. Complementing the luxurious fabrics and the (lost) gilded wood frame are the halos of the holy figures, which feature tooled decorative designs in gold leaf (punchwork). But Duccio, like Giotto (FIG. 14-7), eliminated almost all the gold patterning of the figures' garments in favor of creating three-dimensional volume. Traces remain only in the Virgin's red dress.

In contrast to the main panel, the predella and the back (FIG. 14-10) of *Maestà* present an extensive series of narrative panels of different sizes and shapes, beginning with *Annunciation* and culminating with Christ's *Resurrection* and other episodes following his *Crucifixion* (see "The Life of Jesus in Art," Chapter 11, pages

240–241, or pages xxx–xxxi in Volume II and Book D). The section reproduced here, consist-

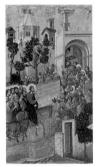

14-10A Duccio, Entry into Jerusalem, 1308–1311.

ing of 24 scenes in 14 panels, relates Christ's passion. Duccio drew the details of his scenes from the accounts in all four Gospels. The viewer reads the pictorial story in zig-zag fashion, beginning with *Entry into Jerusalem* (FIG. **14-10A**) at the lower left. *Crucifixion* is at the top cen-

14-11 DUCCIO DI BUONINSEGNA, Betrayal of Jesus, panel on the back of the Maestà altarpiece, from Siena Cathedral, Siena, Italy, 1309–1311. Tempera and gold leaf on wood, 1' $10\frac{1}{2}'' \times 3' 4''$. Museo dell'Opera del Duomo, Siena.

In this dramatic depiction of Judas's betrayal of Jesus, the actors display a variety of individual emotions. Duccio here took a decisive step toward the humanization of religious subject matter. ter. The narrative ends with Christ's appearance to Mary Magdalene (*Noli me tangere*) at the top right. Duccio consistently dressed Jesus in blue robes in most of the panels, but beginning with *Transfiguration*, he gilded the Savior's garment.

On the front panel, Duccio showed himself as the great master of the formal altarpiece. However, he allowed himself greater latitude for experimentation in the small accompanying panels, front and back. (Worshipers could always view both sides of the altarpiece because the high altar stood at the center of the sanctuary.) Maestà's biblical scenes reveal Duccio's powers as a narrative painter. In Betrayal of Jesus (FIG. 14-11; compare FIG. 14-8B), for example, the artist represented several episodes of the event-the betrayal of Jesus by Judas's false kiss, the disciples fleeing in terror, and Peter cutting off the ear of the high priest's servant. Although the background, with its golden sky and rock formations, remains traditional, the style of the figures before it has changed radically. The bodies are not the flat frontal shapes of Italo-Byzantine art. Duccio imbued them with mass, modeled them with a range of tonalities from light to dark, and arranged their draperies around them convincingly. Even more novel and striking is the way the figures seem to react to the central event. Through posture, gesture, and even facial expression, they display a variety of emotions. Duccio carefully differentiated among the anger of Peter, the malice of Judas (echoed in the faces of the throng about Jesus), and the apprehension and timidity of the fleeing disciples. These figures are actors in a religious drama the artist interpreted in terms of thoroughly human actions and reactions. In this and the other narrative panels, for example, Jesus' Entry into Jerusalem (FIG. 14-10A), a theme treated also by Giotto in the Arena Chapel (FIG. 14-8A), Duccio took a decisive step toward the humanization of religious subject matter.

ORVIETO CATHEDRAL While Duccio was working on *Maestà* for Siena's most important church, a Sienese architect, LORENZO MAITANI, received the commission to design Orvieto's Cathedral (FIG. **14-12**). The Orvieto *facade*, like the earlier facade of Siena Cathedral (FIG. **14-12A**), begun by Giovanni Pisano (FIG. 14-4), demonstrates the appeal of the decorative vocabulary of French Gothic architecture in Italy at the end of the 13th and beginning of the 14th century. Characteristically French are the pointed gables over Orvieto Cathedral's three doorways, the *rose window* and

1 ft.

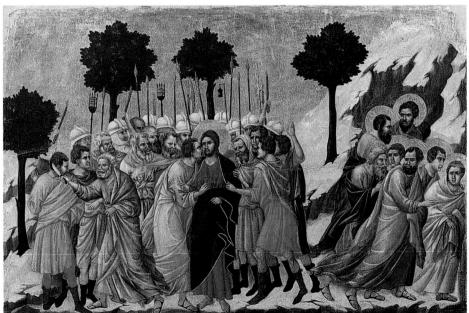

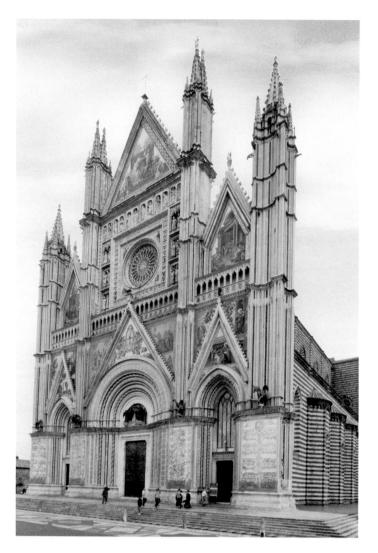

14-12 LORENZO MAITANI, Orvieto Cathedral (looking northeast), Orvieto, Italy, begun 1310. ■4

The pointed gables over the doorways, the rose window, and the large pinnacles derive from French Gothic architecture, but the facade of Orvieto Cathedral masks a traditional timberroofed basilica. statues in niches in the upper zone, and the four large *pinnacles* dividing the facade into three *bays* (see "The Gothic Cathedral," Chapter 13, page 373, or page xxvi in Volume II and Book D). The outer pinnacles serve as miniature substitutes for the tall northern European west-front towers. Maitani's facade, however, is a Gothic overlay masking a marble-revetted *basilican* structure in the Tuscan *Romanesque* tradition, as the three-quarter view of the cathedral in FIG. 14-12 reveals. Few Italian architects fully embraced the Gothic style. The Orvieto facade resembles a great altar screen, its single plane covered with care-

fully placed carved and painted decoration. In principle, Orvieto belongs with Pisa Cathedral (FIG. 12-26) and other earlier Italian

buildings, rather than with the French cathedrals at Amiens (FIG. 13-19) and Reims (FIG. 13-23). Inside, Orvieto Cathedral has a timber-roofed *nave* with a two-story *elevation* (columnar *arcade* and *clerestory*) in the Early Christian manner. Both the *chancel arch* framing the *apse* and the nave arcade's arches are round as opposed to pointed.

14-12A Siena Cathedral, begun ca. 1226. ■◀

SIMONE MARTINI Duccio's successors in the Sienese school also produced innovative works. SIMONE MARTINI (ca. 1285–1344) was a pupil of Duccio's and may have assisted him in painting *Maestà*. Martini was a close friend of Petrarch's, and the poet praised him highly for his portrait of "Laura" (the woman to whom Petrarch dedicated his sonnets). Martini worked for the French kings in Na-

ples and Sicily and, in his last years, produced paintings for the papal court at Avignon, where he came in contact with French painters. By adapting the insubstantial but luxuriant patterns of the Gothic style to Sienese art and, in turn, by acquainting painters north of the Alps with the Sienese style, Martini was instrumental in creating the so-called *International style*. This new style swept Europe during the late 14th and early 15th centuries because it appealed to the aristocratic taste for brilliant colors, lavish costumes, intricate ornamentation, and themes involving splendid processions.

The Annunciation altarpiece (FIG. 14-13) Martini created for Siena Cathedral features elegant shapes and radiant color, fluttering line, and weightless figures in a spaceless setting—all hallmarks of the artist's style.

14-13 SIMONE MARTINI and LIPPO MEMMI, Annunciation altarpiece, from Siena Cathedral, 1333 (frame reconstructed in the 19th century). Tempera and gold leaf on wood, center panel $10' 1'' \times 8' 8^{\frac{3}{4}'}$. Galleria degli Uffizi, Florence.

A pupil of Duccio's, Martini was instrumental in the creation of the International style. Its hallmarks are elegant shapes, radiant color, flowing line, and weightless figures in golden, spaceless settings.

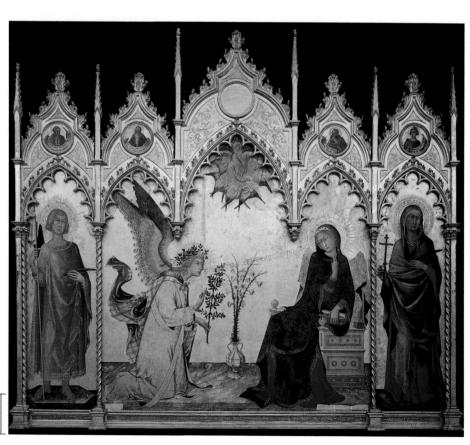

Artistic Training in Renaissance Italy

n Italy during the 14th through 16th centuries, training to be-L come a professional artist capable of earning membership in the appropriate guild (see "Artists' Guilds," page 410) was a laborious and lengthy process. Aspiring artists started their training at an early age, anywhere from age 7 to 15. Their fathers would negotiate an arrangement with a master artist whereby each youth lived with that master for a specified number of years, usually five or six. During that time, the boys served as apprentices to the master of the workshop, learning the trade. (This living arrangement served as a major obstacle for female artists, because it was inappropriate for young girls to live in a male master's household.) The guilds supervised this rigorous training. They wanted not only to ensure their professional reputations by admitting only the most talented members but also to control the number of artists (and thereby limit competition). Toward this end, they frequently tried to regulate the number of apprentices working under a single master.

The skills apprentices learned varied with the type of studio they joined. Those apprenticed to painters learned to grind pigments, draw, prepare wood panels for painting, gild, and lay plaster for fresco. Sculptors in training learned to manipulate different materials—wood, stone, *terracotta* (baked clay), wax, bronze, or stucco although many sculpture workshops specialized in only one or two of these materials. For stone carving, apprentices learned their craft by blocking out the master's designs for statues. As their skills developed, apprentices took on increasingly difficult tasks.

Cennino Cennini (ca. 1370–1440) explained the value of this apprenticeship system, and in particular, the advantages for young artists in studying and copying the works of older masters, in an influential book he published in 1400, *Il Libro dell'Arte (The Handbook of Art)*:

Having first practiced drawing for a while, . . . take pains and pleasure in constantly copying the best things which you can find done by the hand of great masters. And if you are in a place where many good masters have been, so much the better for you. But I give you this advice: take care to select the best one every time, and the one who has the greatest reputation. And, as you go on from day to day, it will be against nature if you do not get some grasp of his style and of his spirit. For if you undertake to copy after one master today and after another one tomorrow, you will not acquire the style of either one or the other, and you will inevitably, through enthusiasm, become capricious, because each style will be distracting your mind. You will try to work in this man's way today, and in the other's tomorrow, and so you will not get either of them right. If you follow the course of one man through constant practice, your intelligence would have to be crude indeed for you not to get some nourishment from it. Then you will find, if nature has granted you any imagination at all, that you will eventually acquire a style individual to yourself, and it cannot help being good; because your hand and your mind, being always accustomed to gather flowers, would ill know how to pluck thorns.*

After completing their apprenticeships, artists entered the appropriate guilds. For example, painters, who ground pigments, joined the guild of apothecaries. Sculptors were members of the guild of stoneworkers, and goldsmiths entered the silk guild, because metalworkers often stretched gold into threads wound around silk for weaving. Guild membership served as certification of the artists' competence, but did not mean they were ready to open their own studios. New guild-certified artists usually served as assistants to master artists, because until they established their reputations, they could not expect to receive many commissions, and the cost of establishing their own workshops was high. In any case, this arrangement was not permanent, and workshops were not necessarily static enterprises. Although well-established and respected studios existed, workshops could be organized around individual masters (with no set studio locations) or organized for a specific project, especially an extensive decoration program.

Generally, assistants to painters were responsible for gilding frames and backgrounds, completing decorative work, and, occasionally, rendering architectural settings. Artists regarded figures, especially those central to the represented subject, as the most important and difficult parts of a painting, and the master reserved these for himself. Sometimes assistants painted secondary or marginal figures but only under the master's close supervision. That was probably the case with Simone Martini's *Annunciation* altarpiece (FIG. 14-13), in which the master painted the Virgin and angel, and the flanking saints are probably the work of his assistant, Lippo Memmi.

*Translated by Daniel V. Thompson Jr., *Cennino Cennini, The Craftsman's Handbook (Il Libro dell'Arte)* (New York: Dover Publications, 1960; reprint of 1933 ed.), 14–15.

The complex etiquette of the European chivalric courts probably dictated the presentation. The angel Gabriel has just alighted, the breeze of his passage lifting his mantle, his iridescent wings still beating. The gold of his sumptuous gown signals he has descended from Heaven to deliver his message. The Virgin, putting down her book of devotions, shrinks demurely from Gabriel's reverent genuflection—an appropriate act in the presence of royalty. Mary draws about her the deep blue, golden-hemmed mantle, colors befitting the queen of Heaven. Between the two figures is a vase of white lilies, symbolic of the Virgin's purity. Despite Mary's modesty and diffidence and the tremendous import of the angel's message, the scene subordinates drama to court ritual, and structural experimentation to surface splendor. The intricate *tracery* of the richly tooled (reconstructed) French Gothic–inspired frame and the elaborate punchwork halos (by then a characteristic feature of Sienese panel painting) enhance the tactile magnificence of *Annunciation*.

Simone Martini and his student and assistant, LIPPO MEMMI (active ca. 1317–1350), signed the altarpiece and dated it (1333). The latter's contribution to *Annunciation* is still a matter of debate, but most art historians believe he painted the two lateral saints. These figures, which are reminiscent of the jamb statues of Gothic church portals, have greater solidity and lack the linear elegance of Martini's central pair. Given the nature of medieval and Renaissance workshop practices, it is often difficult to distinguish the master's hand from those of assistants, especially if the master corrected or redid part of the pupil's work (see "Artistic Training in Renaissance Italy," page 414).

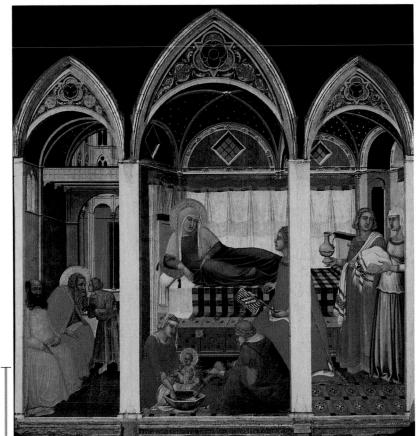

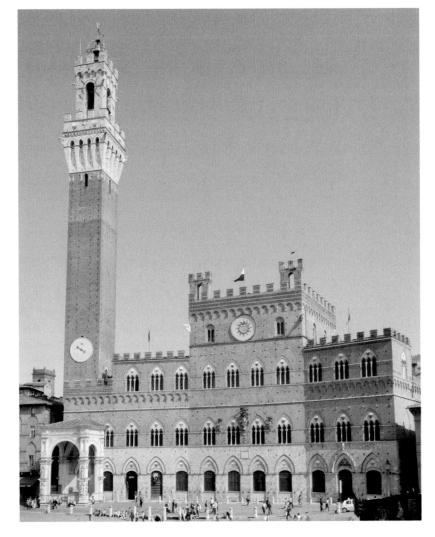

14-14 PIETRO LORENZETTI, Birth of the Virgin, from the altar of Saint Savinus, Siena Cathedral, Siena, Italy, 1342. Tempera on wood, 6' $1'' \times 5' 11''$. Museo dell'Opera del Duomo, Siena.

In this triptych, Pietro Lorenzetti revived the pictorial illusionism of ancient Roman murals and painted the architectural members dividing the panel as if they extended back into the painted space.

PIETRO LORENZETTI Another of Duccio's students, PIETRO LORENZETTI (active 1320-1348), contributed significantly to the general experiments in pictorial realism taking place in 14th-century Italy. Surpassing even his renowned master, Lorenzetti achieved a remarkable degree of spatial illusionism in his Birth of the Virgin (FIG. 14-14), a large *triptych* (three-part panel painting) created for the altar of Saint Savinus in Siena Cathedral. Lorenzetti painted the wooden architectural members dividing the altarpiece into three sections as though they extended back into the painted space. Viewers seem to look through the wooden frame (added later) into a boxlike stage, where the event takes place. That one of the vertical members cuts across a figure, blocking part of it from view, strengthens the illusion. In subsequent centuries, artists exploited this use of architectural elements to enhance the illusion of painted figures acting out a drama a mere few feet away. This kind of pictorial illusionism characterized ancient Roman mural painting (FIGS. 7-18 and 7-19, right) but had not been practiced in Italy for a thousand years.

Lorenzetti's setting for his holy subject also represented a marked step in the advance of worldly realism. Saint Anne—who, like Nicola Pisano's Virgin in *Nativity* (FIG. 14-3), resembles a reclining figure on the lid of a Roman sarcophagus (FIG. 7-61)—props herself up wearily as the midwives wash the child and the women bring gifts. She is the center of an episode occurring in an upper-class Italian house of the period. A number of carefully observed domestic details and the scene at the left, where Joachim eagerly awaits news of the delivery, create the illusion that the viewer has opened the walls of Saint Anne's house and peered inside. Lorenzetti's altarpiece is noteworthy both for the painter's innovations in spatial illusionism and for his careful inspection and recording of details of the everyday world.

PALAZZO PUBBLICO Not all Sienese painting of the early 14th century was religious in character. One of the most important fresco cycles of the period (FIGS. 14-16 and 14-17) was a civic commission for Siena's Palazzo Pubblico ("public palace" or city hall). Siena was a proud commercial and political rival of Florence. The secular center of the community, the civic meeting hall in the main square (the Campo, or Field), was almost as great an object of civic pride as the city's cathedral (FIG. 14-12A). The Palazzo Pubblico (FIG. **14-15**) has a slightly concave

14-15 Palazzo Pubblico (looking east), Siena, Italy, 1288–1309. ■

Siena's Palazzo Pubblico has a concave facade and a gigantic tower visible for miles around. The tower served as both a defensive lookout over the countryside and a symbol of the city-state's power.

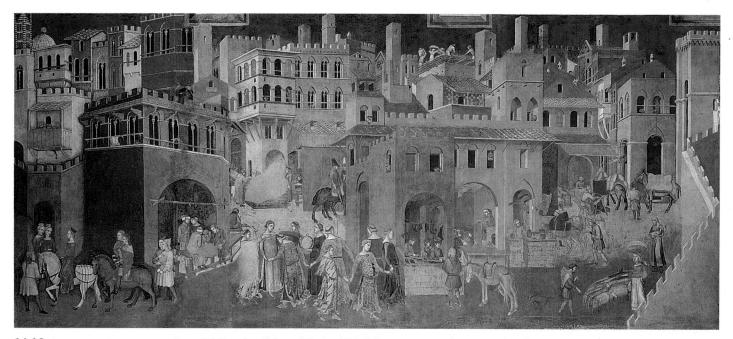

14-16 AMBROGIO LORENZETTI, Peaceful City, detail from Effects of Good Government in the City and in the Country, east wall, Sala della Pace, Palazzo Pubblico, Siena, Italy, 1338–1339. Fresco.

In the Hall of Peace (FIG. 14-16A) of Siena's city hall (FIG. 14-15), Ambrogio Lorenzetti painted an illusionistic panorama of the bustling city. The fresco served as an allegory of good government in the Sienese republic.

facade (to conform to the irregular shape of the Campo) and a gigantic tower visible from miles around (compare FIGS. 13-29 and 14-18B). The imposing building and tower must have earned the admiration of Siena's citizens as well as of visitors to the city, inspiring in them respect for the republic's power and success. The tower served as a lookout over the city and the countryside around it and as a bell tower (campanile) for ringing signals of all kinds to the populace. Siena, as other Italian city-states, had to defend itself against neighboring cities and often against kings and emperors. In addition, it had to secure itself against internal upheavals common in the history of the Italian city-republics. Class struggle, feuds among rich and powerful families, and even uprisings of the whole populace against the city governors were constant threats in medieval Italy. The heavy walls and battlements (fortified parapets) of the Sienese town hall eloquently express how frequently the city governors needed to defend themselves against their own citizens. The Palazzo Pubblico tower, out of reach of most missiles, incorporates machicolated galleries (galleries with holes in their floors to enable defenders to dump stones or hot liquids on attackers below) built out on corbels (projecting supporting architectural members) for defense of the tower's base.

AMBROGIO LORENZETTI The painter entrusted with the major fresco program in the Palazzo Pubblico was Pietro Loren-

1338-1339

zetti's brother AMBROGIO LORENZETTI (active 1319–1348). In the frescoes Ambrogio produced for the Sala della Pace (Hall of Peace; FIG. **14-16A**), he elaborated his brother's advances in illusionistic representation in spectacular fashion while giving visual form to Sienese civic concerns. The subjects of Ambro-

gio's murals are Allegory of Good Government, Bad Government and the Effects of Bad Government in the City, and Effects of Good Government in the City and in the Country. The turbulent politics of the Italian cities—the violent party struggles, the overthrow and reinstatement of governments—called for solemn reminders of fair and just administration, and the city hall was just the place to display these allegorical paintings. Indeed, the leaders of the Sienese government who commissioned this fresco series had undertaken the "ordering and reformation of the whole city and countryside of Siena."

In *Effects of Good Government in the City and in the Country*, Ambrogio depicted the urban and rural effects of good government. *Peaceful City* (FIG. **14-16**) is a panoramic view of Siena, with its clustering palaces, markets, towers, churches, streets, and walls, reminiscent of the townscapes of ancient Roman murals (FIG. 7-19, *left*). The city's traffic moves peacefully, guild members ply their trades and crafts, and radiant maidens, clustered hand in hand, perform a graceful circling dance. Dancers were regular features of festive springtime rituals. Here, their presence also serves as a metaphor for a peaceful commonwealth. The artist fondly observed the life of his city, and its architecture gave him an opportunity to apply Sienese artists' rapidly growing knowledge of perspective.

As the viewer's eye passes through the city gate to the countryside beyond its walls, Ambrogio's *Peaceful Country* (FIG. 14-17) presents a bird's-eye view of the undulating Tuscan terrain with its villas, castles, plowed farmlands, and peasants going about their occupations at different seasons of the year. Although it is an allegory, not a mimetic picture of the Sienese countryside on a specific day, Lorenzetti particularized the view of Tuscany—as well as the city view—by careful observation and endowed the painting with the character of a portrait of a specific place and environment. *Peaceful Country* represents one of the first appearances of *land-scape* in Western art since antiquity (FIG. 7-20).

An allegorical figure of Security hovers above the hills and fields, unfurling a scroll promising safety to all who live under the rule of law. But Siena could not protect its citizens from the plague sweeping through Europe in the mid-14th century. The Black Death (see page 406) killed thousands of Sienese and may have ended the careers of both Lorenzettis. They disappear from historical records in 1348.

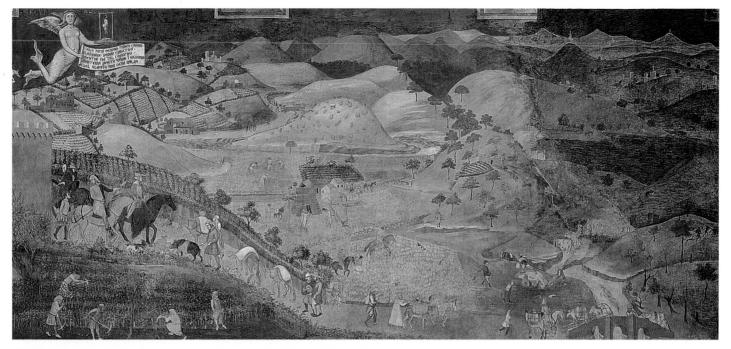

14-17 AMBROGIO LORENZETTI, Peaceful Country, detail from Effects of Good Government in the City and in the Country, east wall, Sala della Pace (FIG. 14-16A), Palazzo Pubblico (FIG. 14-15), Siena, Italy, 1338-1339. Fresco. ■4

This sweeping view of the countryside is one of the first instances of landscape painting in Western art since antiquity. The winged figure of Security promises safety to all who live under Sienese law.

Florence

Like Siena, the Republic of Florence was a dominant city-state during the 14th century. The historian Giovanni Villani (ca. 1270– 1348), for example, described Florence as "the daughter and the creature of Rome," suggesting a preeminence inherited from the Roman Empire. Florentines were fiercely proud of what they perceived as their economic and cultural superiority. Florence controlled the textile industry in Italy, and the republic's gold *florin* was the standard coin of exchange everywhere in Europe.

FLORENCE CATHEDRAL Floren-

tines translated their pride in their predominance into such landmark buildings as Santa Maria del Fiore (FIGS. 14-18 and 14-18A), Florence's cathedral, the center for the most important religious observances in the city. ARNOLFO DI CAMBIO (ca. 1245–1302) began work on the cathedral (*Duomo* in Italian) in 1296, three years before he received

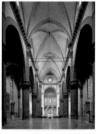

14-18A Nave, Florence Cathedral, begun 1296.

14-18B Palazzo della Signoria, Florence, 1299–1310.

14-18 ARNOLFO DI CAMBIO and others, aerial view of Santa Maria del Fiore (and the Baptistery of San Giovanni; looking northeast), Florence, Italy, begun 1296. Campanile designed by GIOTTO DI BONDONE, 1334. ■4

The Florentine Duomo's marble revetment carries on the Tuscan Romanesque architectural tradition, linking this basilican church more closely to Early Christian Italy than to Gothic France.

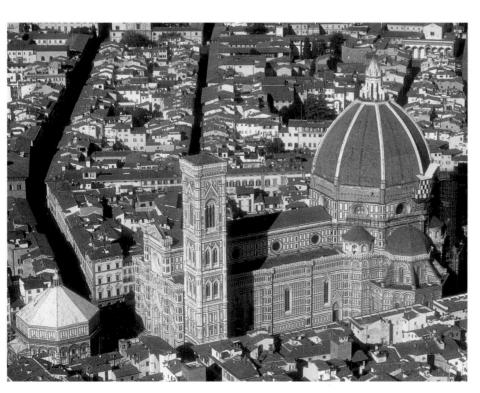

Duomo to hold the city's entire population, and although its capacity is only about 30,000 (Florence's population at the time was slightly less than 100,000), the building seemed so large even the noted architect Leon Battista Alberti (see Chapter 21) commented it seemed to cover "all of Tuscany with its shade." The builders ornamented the cathedral's surfaces, in the old Tuscan fashion, with marble-encrusted geometric designs, matching the revetment (decorative wall paneling) to that of the facing 11th-century Romanesque baptistery of San Giovanni (FIGS. 12-27 and 14-18, left).

The vast gulf separating Santa Maria del Fiore from its northern European counterparts becomes evident in a comparison between the Florentine church and the High Gothic cathedrals of Amiens (FIG. 13-19), Reims (FIG. 13-23), and Cologne (FIG. 13-52). Gothic architects' emphatic stress on the vertical produced an aweinspiring upward rush of unmatched vigor and intensity. The French and German buildings express organic growth shooting heavenward, as the pierced, translucent stone tracery of the spires merges with the atmosphere. Florence Cathedral, in contrast, clings to the ground and has no aspirations to flight. All emphasis is on the horizontal elements of the design, and the building rests firmly and massively on the ground. The clearly defined simple geometric volumes of the cathedral show no tendency to merge either into each other or into the sky.

Giotto di Bondone designed the Duomo's campanile in 1334. In keeping with Italian tradition (FIGS. 12-21 and 12-26), it stands apart from the church. In fact, it is essentially selfsufficient and could stand anywhere else in the city without looking out of place. The same cannot be said of the towers of Amiens, Reims, and Cologne cathedrals. They are essential elements of the structures behind them, and it would be unthinkable to detach one of them and place it somewhere else. No individual element of Gothic churches seems capable of an independent existence. One form merges into the next in a series of rising movements pulling the eye upward and never permitting it to rest until it reaches the sky. The Florentine campanile is entirely different.

Neatly subdivided into cubic sections, Giotto's tower is the sum of its component parts. Not only could this tower be removed from the building without adverse effects, but also each of the parts-cleanly separated from each other by continuous moldings-seems capable of existing independently as an object of considerable aesthetic appeal. This compartmentalization is reminiscent of the Romanesque style, but it also forecasts the ideals of Renaissance architecture. Artists hoped to express structure in the clear, logical relationships of the component parts and to produce self-sufficient works that could exist in complete independence. Compared with northern European towers, Giotto's campanile has a cool and rational quality more appealing to the intellect than to the emotions.

the Baptist.

The facade of Florence Cathedral was not completed until the 19th century, and then in a form much altered from its original design. In fact, until the 17th century, Italian builders exhibited little concern for the facades of their churches, and dozens remain unfinished to this day. One reason for this may be that Italian architects did not conceive the facades as integral parts of the structures but rather, as in the case of Orvieto Cathedral (FIG. 14-12), as screens that could be added to the church exterior at any time.

A generation after work began on Florence's church, the citizens decided also to beautify their 11th-century baptistery (FIGS. 12-27 and 14-18, left) with a set of bronze doors (FIG. 14-19) for the south entrance to the building. The sponsors were the members of

Florence, Italy, 1330–1336. Gilded bronze, doors $16' \times 9' 2''$; individual panels 1' $7\frac{1}{4}$ × 1' 5". (The door frames date to the mid-15th century.)

Andrea Pisano's bronze doors have 28 panels with figural reliefs in French Gothic quatrefoil frames. The lower eight depict Christian virtues. The rest represent the life of Saint John

14-19 ANDREA PISANO, south doors of the Baptistery of San Giovanni (FIG. 12-27),

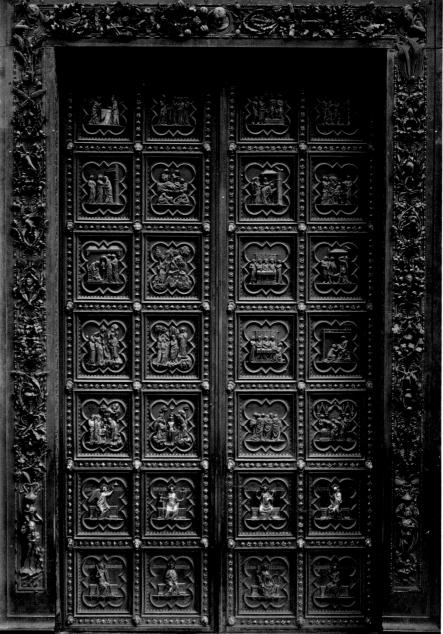

Florence's guild of wool importers, who competed for business and prestige with the wool manufacturers' association, an important sponsor of the cathedral building campaign. The wool-importers' guild hired ANDREA PISANO (ca. 1290-1348), a native of Pontedera in the territory of Pisa-unrelated to Nicola and Giovanni Pisano (see "Italian Artists' Names," page 405)-to create the doors. Andrea designed 28 bronze panels for the doors, each cast separately, of which 20 depict episodes from the life of Saint John the Baptist, to whom the Florentines dedicated their baptistery. Eight panels (at the bottom) represent personified Christian virtues. The quatrefoil (four-lobed, cloverlike) frames are of the type used earlier for reliefs flanking the doorways of Amiens Cathedral (FIG. 13-19), suggesting French Gothic sculpture was one source of Andrea's style. The gilded figures stand on projecting ledges in each quatrefoil. Their proportions and flowing robes also reveal a debt to French sculpture, but the compositions, both in general conception (small groups of figures in stagelike settings) and in some details, owe a great deal to Giotto, for whom Andrea had earlier executed reliefs for the cathedral's campanile, perhaps according to Giotto's designs.

The wool importers' patronage of the baptistery did not end with this project. In the following century, the guild paid for the even more prestigious east doors (FIGS. 21-9 and 21-10), directly across from the cathedral's west facade, and also for a statue of Saint John the Baptist on the facade of Or San Michele, a multipurpose building housing a 14th-century tabernacle (FIG. **14-19A**) by ANDREA ORCAGNA (active ca. 1343–1368) featuring the painting *Madonna and Child Enthroned with Saints* by BERNARDO DADDI (active ca. 1312–1348).

14-19A ORCAGNA, Or San Michele tabernacle, 1355–1359.

Pisa

Siena and Florence were inland centers of commerce. Pisa was one of Italy's port cities, which, with Genoa and Venice (MAP 14-1), controlled the rapidly growing maritime avenues connecting western Europe with the lands of Islam, with Byzantium and Russia, and

with China. As prosperous as Pisa was as a major shipping power, however, it was not immune from the disruption the Black Death wreaked across all of Italy and Europe in the late 1340s. Concern with death, a significant theme in art even before the onset of the plague, became more prominent in the years after midcentury.

CAMPOSANTO Triumph of Death is a tour de force of death imagery (FIG. 14-20). The creator of this large-scale (over 18 by 49 feet) fresco remains disputed. Some art historians attribute the work to FRANCESCO TRAINI (active ca. 1321–1363), while others argue for BUONAMICO BUFFALMACCO (active 1320-1336). Painted on the wall of the Camposanto (Holy Field), the enclosed burial ground adjacent to Pisa's cathedral (FIG. 12-26), the fresco captures the horrors of death and forces viewers to confront their mortality. The painter rendered each scene with naturalism and emotive power. In the left foreground (FIG. 14-20, top), young aristocrats, mounted in a stylish cavalcade, encounter three coffin-encased corpses in differing stages of decomposition. As the horror of the confrontation with death strikes them, the ladies turn away with delicate disgust, while a gentleman holds his nose. (The animals, horses and dogs, sniff excitedly.) At the far left, the hermit Saint Macarius unrolls a scroll bearing an inscription commenting on the folly of pleasure and

14-20 FRANCESCO TRAINI OF BUONAMICO BUFFALMACCO, two details of *Triumph of Death*, 1330s. Full fresco, $18' 6'' \times 49' 2''$. Camposanto, Pisa.

Befitting its location on a wall in Pisa's Camposanto, the enclosed burial ground adjacent to the cathedral, this fresco captures the horrors of death and forces viewers to confront their mortality.

14th Century **419**

14-21 Doge's Palace, Venice, Italy, begun ca. 1340–1345; expanded and remodeled, 1424–1438.

The delicate patterning in cream- and rose-colored marbles, the pointed and ogee arches, and the quatrefoil medallions of the Doge's Palace constitute a Venetian variation of northern Gothic architecture.

the inevitability of death. On the far right, ladies and gentlemen ignore dreadful realities, occupying themselves in an orange grove with music and amusements while above them (FIG. 14-20, *bottom*) angels and demons struggle for the souls of the corpses heaped in the foreground.

In addition to these direct and straightforward scenes, the mural contains details conveying more subtle messages. For example, the painter depicted those who appear unprepared for death— and thus unlikely to achieve salvation—as wealthy and reveling in luxury. Given that the Dominicans—an order committed to a life of poverty (see "Mendicant Orders," page 404)—participated in the design for this fresco program, this imagery surely was a warning against greed and lust.

Venice

One of the wealthiest cities of late medieval Italy—and of Europe was Venice, renowned for its streets of water. Situated on a lagoon on the northeastern coast of Italy, Venice was secure from land attack and could rely on a powerful navy for protection against invasion from the sea. Internally, Venice was a tight corporation of ruling families that, for centuries, provided stable rule and fostered economic growth.

DOGE'S PALACE The Venetian republic's seat of government was the Doge's (Duke's) Palace (FIG. 14-21). Begun around 1340 to 1345 and significantly remodeled after 1424, it was the most ornate public building in medieval Italy. In a stately march, the first level's short and heavy columns support rather severe pointed arches that look strong enough to carry the weight of the upper structure. Their rhythm doubles in the upper arcades, where more slender columns carry ogee arches (made up of double-curving lines), which terminate in flamelike tips between medallions pierced with quatrefoils. Each story is taller than the one beneath it, the topmost as high as the two lower arcades combined. Yet the building does not look top-heavy. This is due in part to the complete absence of articulation in the top story and in part to the walls' delicate patterning, in cream- and rose-colored marbles, which makes them appear paperthin. The Doge's Palace represents a delightful and charming variant of Late Gothic architecture. Colorful, decorative, light and airy in appearance, the Venetian palace is ideally suited to this unique Italian city that floats between water and sky.

THE BIG PICTURE

LATE MEDIEVAL ITALY

13TH CENTURY

- Diversity of style characterizes the art of 13th-century Italy, with some artists working in the maniera greca, or Italo-Byzantine style, some in the mode of Gothic France, and others in the newly revived classical tradition.
- The leading painters working in the Italo-Byzantine style were Bonaventura Berlinghieri and Cimabue. Both drew inspiration from Byzantine icons and illuminated manuscripts. Berlinghieri's Saint Francis Altarpiece is the earliest dated portrayal of Saint Francis of Assisi, who died in 1226.
- Trained in southern Italy in the court style of Frederick II (r. 1197–1250), Nicola Pisano was a master sculptor who settled in Pisa and carved pulpits incorporating marble panels that, both stylistically and in individual motifs, derive from ancient Roman sarcophagi. Nicola's son, Giovanni Pisano, also was a sculptor of church pulpits, but his work more closely reflects the Gothic sculpture of France.
- At the end of the century, in Rome and Assisi, Pietro Cavallini and other fresco painters created mural programs foreshadowing the revolutionary art of Giotto.

Bonaventura Berlinghieri, Saint Francis Altarpiece, 1235

Nicola Pisano, Pisa Baptistery pulpit, 1259–1260

14TH CENTURY

- During the 14th century, Italy suffered the most devastating natural disaster in European history—the Black Death—but it was also the time when Renaissance humanism took root. Although religion continued to occupy a primary position in Italian life, scholars and artists became increasingly concerned with the natural world.
- Art historians regard Giotto di Bondone of Florence as the first Renaissance painter. An architect as well, Giotto designed the bell tower of Florence's Catherdral. His masterpiece is the fresco program of the Arena Chapel in Padua, where he established himself as a pioneer in pursuing a naturalistic approach to representation based on observation, which was at the core of the classical tradition in art. The Renaissance marked the rebirth of classical values in art and society.
- The greatest master of the Sienese school of painting was Duccio di Buoninsegna, whose Maestà still incorporates many elements of the maniera greca. He relaxed the frontality and rigidity of his figures, however, and in the narrative scenes on the back of the gigantic altarpiece in Siena Cathedral took a decisive step toward humanizing religious subject matter by depicting actors displaying individual emotions.
- Secular themes also came to the fore in 14th-century Italy, most notably in Ambrogio Lorenzetti's frescoes for Siena's Palazzo Pubblico. His depictions of the city and its surrounding countryside are among the first landscapes in Western art since antiquity.
- The prosperity of the 14th century led to many major building campaigns, including new cathedrals in Florence, Siena, and Orvieto, and new administrative palaces in Florence, Siena, and Venice. Florence's 11th-century baptistery also received new bronze doors by Andrea Pisano.
- The 14th-century architecture of Italy underscores the regional character of late medieval art. Orvieto Cathedral's facade, for example, incorporates some elements of the French Gothic vocabulary, but it is a screen masking a timber-roofed structure with round arches in the nave arcade in the Early Christian tradition.

Giotto, Arena Chapel Padua, ca. 1305

Duccio, *Maestà*, Siena Cathedral, 1308–1311

Orvieto Cathedral, begun 1310

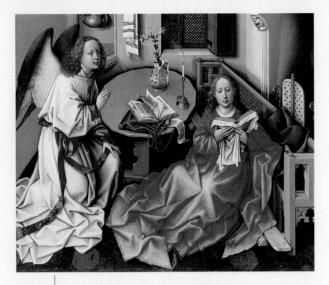

Campin was the leading painter of Tournai. In the *Mérode Altarpiece*, he set *Annunciation* in a Flemish merchant's home in which the objects represented have symbolic significance. The carefully rendered cityscape seen through the window in the right wing of the *Mérode Altarpiece* confirms the identification of the locale of the biblical event as the Inghelbrechts' home.

In the altarpiece's left wing, Campin depicted his patrons, Peter Inghelbrecht and Margarete Scrynmakers, as kneeling witnesses to the announcement of the Virgin's miraculous pregnancy.

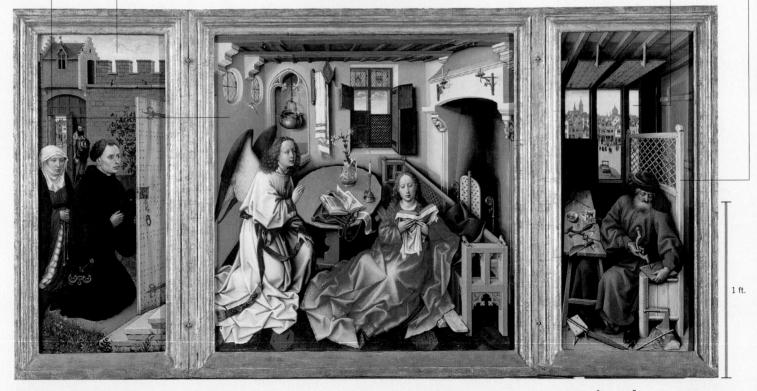

20-1 ROBERT CAMPIN (MASTER OF FLÉMALLE), *Mérode Altarpiece* (open), ca. 1425–1428. Oil on wood, center panel 2' $1\frac{3''}{8} \times 2' \frac{7''}{8}$, each wing 2' $1\frac{3''}{8} \times 10\frac{7''}{8}$. Metropolitan Museum of Art, New York (The Cloisters Collection, 1956).

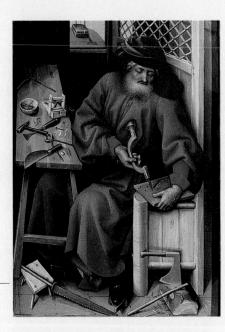

Joseph, in his workshop and unaware of the angel's arrival, has constructed two mousetraps, symbols of the theological concept that Christ is bait set in the trap of the world to catch the Devil.

20

LATE MEDIEVAL AND EARLY RENAISSANCE NORTHERN EUROPE

THE VIRGIN IN A FLEMISH HOME

In 15th-century Flanders—a region corresponding to what is today Belgium, the Netherlands, Luxembourg, and part of northern France—lay patrons far outnumbered the clergy in the commissioning of religious artworks. Especially popular were small altarpieces for household prayer, such as the *Mérode Altarpiece* (FIG. 20-1), the most famous work by the "MASTER OF FLÉMALLE," whom many scholars identify as ROBERT CAMPIN (ca. 1378–1444), the leading painter of Tournai. Perhaps the most striking feature of these private devotional images is the integration of religious and secular concerns. For example, artists often presented biblical scenes as taking place in a Flemish home. Religion was such an integral part of Flemish life that separating the sacred from the secular was almost impossible—and undesirable. Moreover, the presentation in religious art of familiar settings and objects no doubt strengthened the direct bond the patron or viewer felt with biblical figures.

The *Annunciation* theme, as prophesied in Isaiah 7:14, occupies the Mérode triptych's central panel. The archangel Gabriel approaches Mary, who sits reading inside a well-kept home. The view through the window in the right wing and the depicted accessories, furniture, and utensils confirm the locale as Flanders. However, the objects represented are not merely decorative. They also function as symbols. The book, extinguished candle, and lilies on the table, the copper basin in the corner niche, the towels, fire screen, and bench all symbolize the Virgin's purity and her divine mission.

In the right panel, Joseph, apparently unaware of the angel's arrival, has constructed two mousetraps, symbolic of the theological concept that Christ is bait set in the trap of the world to catch the Devil. The ax, saw, and rod Campin painted in the foreground of Joseph's workshop not only are tools of the carpenter's trade but also are mentioned in Isaiah 10:15. In the left panel, the closed garden is symbolic of Mary's purity, and the flowers Campin included relate to Mary's virtues, especially humility.

The altarpiece's donor, Peter Inghelbrecht, a wealthy merchant, and his wife, Margarete Scrynmakers, kneel in the garden and witness the momentous event through an open door. *Donor portraits*—portraits of the individual(s) who commissioned (or "donated") the work—became very popular in the 15th century. In this instance, in addition to asking to be represented in their altarpiece, the Inghelbrechts probably specified the subject. Inghelbrecht means "angel bringer," a reference to the *Annunciation* theme of the central panel. Scrynmakers means "cabinet- or shrine-makers," referring to the workshop scene in the right panel.

NORTHERN EUROPE IN THE 15TH CENTURY

As the 15th century opened, Rome and Avignon were still the official seats of two competing popes (see "The Great Schism," Chapter 14, page 404), and the Hundred Years' War (1337–1453) between France and England still raged. The general European movement toward centralized royal governments, begun in the 12th century, continued apace, but the corresponding waning of *feudalism* brought social turmoil. Nonetheless, despite widespread conflict and unrest, a new economic system emerged—the early stage of European capitalism. In response to the financial requirements of trade, new credit and exchange systems created an economic network of enterprising European cities. Trade in money accompanied trade in commodities, and the former financed industry. Both were in the hands of international trading companies, such as those of Jacques Coeur in Bourges (see Chapter 13) and the Medici in Florence (see Chapter 21). In 1460,

Flemish entrepreneurs established the first international commercial stock exchange in Antwerp. In fact, the French word for stock market (*bourse*) comes from the name of the van der Beurse family of Bruges, the wealthiest city in 15th-century Flanders.

Art also thrived in northern Europe during this time under royal, ducal, church, and private patronage. Two developments in particular were of special significance: the adoption of oil-based pigment as the leading medium for painting, and the blossoming of printmaking as a major art form, which followed the invention of moveable type. These new media had a dramatic influence on artistic production worldwide.

BURGUNDY AND FLANDERS

In the 15th century, Flanders (MAP **20-1**) was not an independent state but a region under the control of the duke of Burgundy, the ruler of the fertile east-central region of France still famous for its

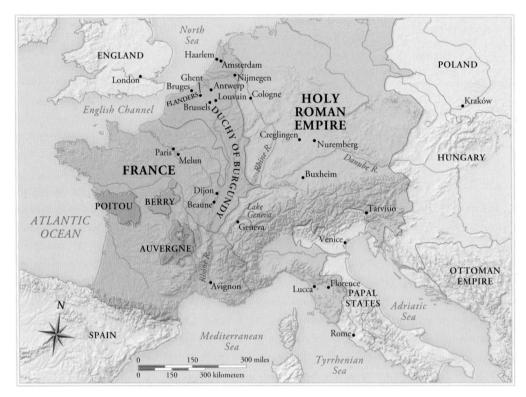

MAP 20-1 France, the duchy of Burgundy, and the Holy Roman Empire in 1477.

LATE MEDIEVAL AND EARLY RENAISSANCE NORTHERN EUROPE

1385	1425 14	450 1	1475 1500
 Claus Sluter carves life-size statues of biblical figures with portraitlike features for Philip the Bold, duke of Burgundy The Limbourg brothers expand the illusionistic capabilities of manuscript illumination for Jean, duke of Berry 	popularize the use of oil paints in Flanders to record the exact surface appearance of objects, fabrics, faces, and landscapes	 The second generation of Flemish master painters— Petrus Christus, Dirk Bouts, and Hugo van der Goes— continue to use oil paints for altarpieces featuring naturalisti representations of religious themes In Germany, Johannes Gutenberg invents moveable type and prints the first Bibles on a letterpress 	altarpieces carved by Veit Stoss and Tilman Riemenschneider Martin Schongauer becomes the first northern European

wines. Duke Philip the Bold (r. 1363-1404) was one of four sons of King John II (r. 1350-1364) of France. In 1369, Philip married Margaret de Mâle, the daughter of the count of Flanders, and acquired territory in the Netherlands. Thereafter, the major source of Burgundian wealth was Bruges, the city that made Burgundy a dangerous rival of France, which then, as in the Gothic age (see Chapter 13), was a smaller kingdom geographically than the modern nationstate. Bruges initially derived its wealth from the wool trade but soon expanded into banking, becoming the financial clearinghouse for all of northern Europe. Indeed, Bruges so dominated Flanders that the duke of Burgundy eventually chose to make the city his capital and moved his court there from Dijon. Due to the expanded territory and the prosperity of the duchy of Burgundy, Philip the Bold and his successors were probably the most powerful northern European rulers during the first three quarters of the 15th century. Although members of the French royal family, they usually supported England (on which they relied for the raw materials used in their wool industry) during the Hundred Years' War and, at times, controlled much of northern France, including Paris, the seat of the French monarchy. At the height of Burgundian power, the reigning duke's lands stretched from the Rhône River to the North Sea.

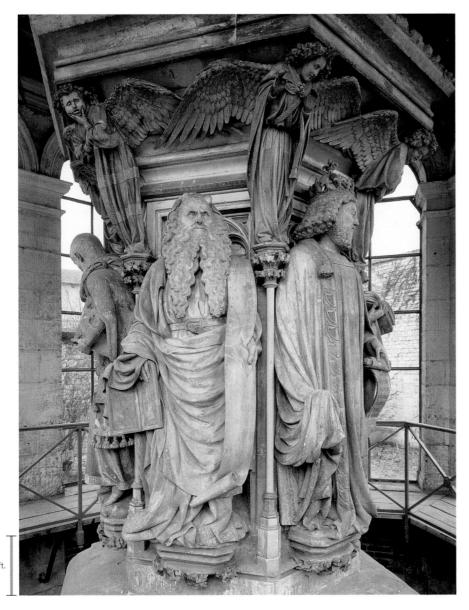

Chartreuse de Champmol

The dukes of Burgundy were great patrons of the arts. They fully appreciated that artworks could support their dynastic and political goals as well as adorn their castles and townhouses. Philip the Bold's grandest artistic enterprise was the building of the Chartreuse de Champmol, near Dijon. A chartreuse ("charter house" in English) is a Carthusian monastery. The Carthusian order, founded by Saint Bruno in the late 11th century at Chartreuse, near Grenoble in southeastern France, consisted of monks who devoted their lives to solitary living and prayer. Unlike monastic orders that earned income from farming and other work, the Carthusians generated no revenues. Philip's generous endowment at Champmol was therefore the sole funding for an ambitious artistic program inspired by Saint-Denis, the royal abbey of France and burial site of the French kings (FIGS. 13-2 to 13-3A). The architect the duke chose was DROUET DE DAMMARTIN, who had worked for Philip's brother, King Charles V (r. 1364–1380), on the Louvre (FIG. 20-16), the French royal palace in Paris. Philip intended the Dijon chartreuse to become a ducal mausoleum and serve both as a means of securing salvation in perpetuity for the Burgundian dukes (the monks prayed continuously for the souls of the ducal family) and as a dynastic symbol of Burgundian power.

CLAUS SLUTER In 1389, Philip the Bold placed the Haarlem (Netherlands) sculptor CLAUS SLUTER (active ca. 1380–1406) in charge of the sculptural program (FIGS. **20-2** and **20-2**A) for the

Chartreuse de Champmol. For the portal (FIG. 20-2A) of the monastery's chapel, Sluter's workshop produced statues of the duke and his wife kneeling before the Virgin and Child. For the cloister, Sluter designed a large sculptural fountain located in a well (FIG. 20-2). The well served as a water source for the monastery, but water

20-2A SLUTER, Chartreuse de Champmol portal, 1385–1393. ■◀

probably did not spout from the fountain because the Carthusian commitment to silence and prayer would have precluded anything that produced sound.

Sluter's *Well of Moses* features statues of Moses and five other prophets (David, Daniel, Isaiah, Jeremiah, and Zachariah) surrounding a base that once supported a 25-foot-tall group of Christ on the cross, the Virgin Mary, John the Evangelist, and Mary Magdalene. The Carthusians called the

20-2 CLAUS SLUTER, *Well of Moses*, Chartreuse de Champmol, Dijon, France, 1395–1406. Limestone, painted and gilded by JEAN MALOUEL, Moses 6' high. ■4

The *Well of Moses*, a symbolic fountain of life made for the duke of Burgundy, originally supported a *Crucifixion* group. Sluter's figures recall French Gothic jamb statues but are far more realistic. Well of Moses a fons vitae, a fountain of everlasting life. The blood of the crucified Christ symbolically flowed down over the grieving angels and Old Testament prophets, spilling into the well below, washing over Christ's prophetic predecessors and redeeming anyone who would drink water from the well. Whereas the models for the Dijon chapel statues were the sculptured portals of French Gothic cathedrals, the inspiration for the *Well of Moses* may have come in part from contemporaneous *mystery plays* in which actors portraying prophets frequently delivered commentaries on events in Christ's life.

The six figures are much more realistically rendered than Gothic jamb statues (FIGS. 13-18 and 13-18A), and the prophets have almost portraitlike features and distinct individual personalities and costumes. David is an elegantly garbed Gothic king, Moses an elderly horned prophet (compare FIG. 12-35) with a waist-length beard. Sluter's intense observation of natural appearance provided him with the information necessary to sculpt the prophets in minute detail. Heavy draperies with voluminous folds swathe the lifesize figures. The artist succeeded in making their difficult, complex surfaces seem remarkably naturalistic. He enhanced this effect by skillfully differentiating textures, from coarse drapery to smooth flesh and silky hair. Originally, paint, much of which has flaked off, further augmented the naturalism of the figures. (The painter was JEAN MALOUEL [ca. 1365-1415], another Netherlandish master.) This fascination with the specific and tangible in the visible world became one of the chief characteristics of 15th-century Flemish art.

MELCHIOR BROEDERLAM Philip the Bold also commissioned a major altarpiece for the main altar in the chapel of the Chartreuse. A collaborative project between two Flemish artists, this altarpiece consisted of a large sculptured shrine by Jacques de Baerze (active ca. 1384–1399) and a pair of painted exterior panels (FIG. **20-3**) by MELCHIOR BROEDERLAM (active ca. 1387–1409).

Altarpieces were a major art form north of the Alps in the late 14th and 15th centuries. From their position behind the altar, they served as backdrops for the Mass. The Mass represents a ritual celebration of the Holy Eucharist. At the Last Supper, Christ commanded his apostles to repeat in memory of him the communion credo that he is tendering them his body to eat and his blood to drink, as reenacted in the Eucharist (see "The Life of Jesus in Art," Chapter 8, pages 240-241, or xxx-xxxi in Volume II and Book D). This act serves as the nucleus of the Mass, which involves this reenactment as well as prayer and contemplation of the Word of God. Because the Mass involves not only a memorial rite but complex Christian doctrinal tenets as well, art has traditionally played an important role in giving visual form to these often complex theological concepts for the Christian faithful. Like sculpted medieval church tympana, these altarpieces had a didactic role, especially for the illiterate. They also reinforced Church doctrines for viewers and stimulated devotion.

Given their function as backdrops to the Mass, it is not surprising many altarpieces depict scenes directly related to Christ's sacrifice. The Champmol altarpiece, or *retable*, for example, features sculpted passion scenes on the interior. These public altarpieces most often took the form of *polyptychs*—hinged multipaneled paintings or multiple carved relief panels. The hinges enabled the clergy to close the polyptych's side wings over the central panel(s). Artists decorated both the exterior and interior of the altarpieces. This multi-image format provided the opportunity to construct narratives through a sequence of images, somewhat as in manuscript illustration. Although concrete information is lacking about when the clergy opened and closed these altarpieces, the wings probably remained closed on regular days and open on Sundays and feast days. On this schedule, viewers could have seen both the interior and exterior—diverse imagery at various times according to the liturgical calendar.

The painted wings (FIG. 20-3) of the Retable de Champmol depict Annunciation and Visitation on the left panel and Presentation into the Temple and Flight into Egypt on the right panel. Dealing with Christ's birth and infancy, Broederlam's painted images on the altarpiece's exterior set the stage for de Baerze's interior sculpted passion scenes (not illustrated). The exterior panels are an unusual amalgam of different styles, locales, and religious symbolism. The two paintings include both landscape and interior scenes. Broederlam depicted the buildings in both Romanesque and Gothic styles (see Chapters 12 and 13). Scholars have suggested the juxtaposition of different architectural styles in the left panel is symbolic. The rotunda (round building, usually with a dome) refers to the Old Testament, whereas the Gothic porch relates to the New Testament. In the right panel, a statue of a Greco-Roman god falls from the top of a column as the holy family approaches. These and other details symbolically announce the coming of the new order under Christ. Stylistically, Broederlam's panels are a mixture of three-dimensional rendition of the landscape and buildings with a solid gold background and flat golden halos for the holy figures, regardless of the positions of their heads. Despite these lingering medieval pictorial conventions, the altarpiece is an early example of many of the artistic developments that preoccupied European artists throughout the 15th century, especially the illusionistic depiction of three-dimensional objects and the naturalistic representation of landscape.

Jan van Eyck

The Retable de Champmol also foreshadowed another significant development in 15th-century art-the widespread adoption of oil paints (see "Tempera and Oil Painting," page 539). Oil paints facilitated the exactitude in rendering details so characteristic of northern European painting. Although the Italian biographer Giorgio Vasari (1511-1574) and other 16th-century commentators credited Jan van Eyck (FIGS. 20-4 to 20-7) with the invention of oil painting, recent evidence has revealed oil paints had been known for some time, well before Melchior Broederlam used oils for Philip the Bold's Dijon altarpiece and Robert Campin painted the Mérode Altarpiece (FIG. 20-1) for Peter Inghelbrecht. Flemish painters built up their pictures by superimposing translucent paint layers on a layer of underpainting, which in turn had been built up from a carefully planned drawing made on a panel prepared with a white ground. With the oil medium, artists could create richer colors than previously possible, giving their paintings an intense tonality, the illusion of glowing light, and enamel-like surfaces. These traits differed significantly from the high-keyed color, sharp light, and rather matte (dull) surface of tempera. The brilliant and versatile oil medium suited perfectly the formal intentions of the generation of Flemish painters after Broederlam, including Campin (FIG. 20-1) and van Eyck, who aimed for sharply focused clarity of detail in their representation of objects ranging in scale from large to almost invisible.

GHENT ALTARPIECE The first Netherlandish painter to achieve international fame was JAN VAN EYCK (ca. 1390–1441), who in 1425 became the court painter of Philip the Good, duke of Burgundy (r. 1419–1467). In 1432, he moved his studio to Bruges, where the duke maintained his official residence. That same

Tempera and Oil Painting

The generic words *paint* and *pigment* encompass a wide range of substances artists have used through the ages. Fresco aside (see "Fresco Painting," Chapter 14, page 408), during the 14th century, egg *tempera* was the material of choice for most painters, both in Italy and northern Europe. Tempera consists of egg combined with a wet paste of ground pigment. In his influential guidebook *Il libro dell'arte* (*The Artist's Handbook*, 1437), Cennino Cennini (ca. 1370-ca. 1440) noted that artists mixed only the egg yolk with the ground pigment, but analyses of paintings from this period have revealed some artists chose to use the entire egg. Images painted with tempera have a velvety sheen. Artists usually applied tempera to the painting surface with a light touch because thick application of the pigment mixture results in premature cracking and flaking.

Some artists used oil paints as far back as the eighth century, but not until the early 1400s did oil painting become widespread. Melchior Broederlam (FIG. 20-3) and other Flemish artists were among the first to employ oils extensively (often mixing them with tempera), and Italian painters quickly followed suit. The discovery of better drying components in the early 15th century enhanced the setting capabilities of oils. Rather than apply these oils in the light, flecked brushstrokes tempera encouraged, artists laid down the oils in transparent layers, or *glazes*, over opaque or semiopaque underlayers. In this manner, painters could build up deep tones through repeated glazing. Unlike works in tempera, whose surface dries quickly due to water evaporation, oils dry more uniformly and slowly, giving the artist time to rework areas. This flexibility must have been particularly appealing to artists who worked very deliberately, such as the Flemish masters discussed in this chapter, as well as the Italian Leonardo da Vinci (see Chapter 22). Leonardo also preferred oil paint because its gradual drying process and consistency enabled him to blend the pigments, thereby creating the impressive *sfumato* (smoky) effect that contributed to his fame.

Both tempera and oils can be applied to various surfaces. Through the early 16th century, wood panels served as the foundation for most paintings. Italians painted on poplar. Northern European artists used oak, lime, beech, chestnut, cherry, pine, and silver fir. Availability of these timbers determined the choice of wood. Linen canvas became increasingly popular in the late 16th century. Although evidence suggests artists did not intend permanency for their early images on canvas, the material proved particularly useful in areas such as Venice where high humidity warped wood panels and made fresco unfeasible. Further, until artists began to use wooden bars to stretch the canvas to form a taut surface, canvas paintings were more portable than wood panels.

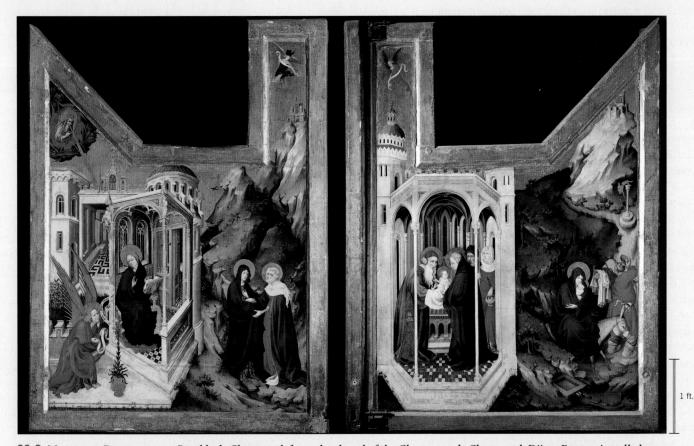

20-3 MELCHIOR BROEDERLAM, Retable de Champmol, from the chapel of the Chartreuse de Champmol, Dijon, France, installed 1399. Oil on wood, each wing 5' $5\frac{3}{4}$ '' × 4' $1\frac{1}{4}$ ''. Musée des Beaux-Arts, Dijon.

This early example of oil painting attempts to represent the three-dimensional world on a two-dimensional surface, but the gold background and flat halos recall medieval pictorial conventions.

year, he completed the Ghent Altarpiece (FIGS. 20-4 and 20-5), which, according to an inscription, his older brother HUBERT VAN EYCK (ca. 1366-1426) had begun. This retable is one of the largest (nearly 12 feet tall) of the 15th century. Jodocus Vyd, diplomat-retainer of Philip the Good, and his wife, Isabel Borluut, commissioned this polyptych as the centerpiece of the chapel Vyd built in the church originally dedicated to Saint John the Baptist (since 1540, Saint Bavo Cathedral). Vyd's largesse and the political and social connections the Ghent Altarpiece revealed to its audience contributed to Vyd's appointment as burgomeister (chief magistrate) of Ghent shortly after the unveiling of the work. Two of the exterior panels (FIG. 20-4) depict the donors. The husband and wife, painted in illusionistically rendered niches, kneel with their hands clasped in prayer. They gaze piously at illusionistic stone sculptures of Ghent's patron saints, Saint John the Baptist and Saint John the Evangelist (who was probably also Vyd's patron saint). The Annunciation appears on the upper register, with a careful representation of a Flemish town outside the painted window of the center panel. In the uppermost arched panels, van Eyck depicted the Old Testament prophets Zachariah and Micah, along with sibyls, Greco-Roman mythological female prophets whose writings the Christian Church interpreted as prophecies of Christ.

> When opened (FIG. 20-5), the altarpiece reveals a sumptuous, superbly colored painting of humanity's redemption through Christ. In the upper register, God the Father-wearing the pope's triple tiara, with a worldly crown at his feet, and resplendent in a deep-scarlet mantlepresides in majesty. To God's right is the Virgin, represented, as in the Gothic age and in an earlier van Eyck diptych (twopaneled painting; FIG. 20-5A), as the queen of Heaven, with a crown of 12 stars upon

> her head. Saint John the Baptist sits to

20-5A VAN EYCK. Madonna in a Church. ca. 1425-1430.

God's left. To either side is a choir of angels, with an angel playing an organ on the right. Adam and Eve appear in the far panels. The inscriptions in the arches above Mary and Saint John extol the Virgin's virtue and purity and Saint John's greatness as the forerunner of Christ. The inscription above the Lord's head translates as "This is God, all-powerful in his divine majesty; of all the best, by the gentleness of his goodness; the most liberal giver, because of his infinite generosity." The step behind the crown at the Lord's feet bears the inscription, "On his head, life without death. On his brow, youth without age. On his right, joy without sadness. On his left, security without fear." The entire altarpiece amplifies the central theme of salvation. Even though humans, symbolized by Adam and Eve, are sinful, they will be saved because God, in his infinite love, will sacrifice his own son for this purpose.

The panels of the lower register extend the symbolism of the upper. In the central panel, the community of saints comes from the four corners of the earth through an opulent, flower-spangled landscape. They proceed toward the altar of the lamb and the octagonal fountain of life (compare FIG. 20-2). The book of Revelation passage recounting the Adoration of the Lamb is the main reading on All Saints' Day (November 1). The lamb symbolizes the sacrificed son of God, whose heart bleeds into a chalice, while into the fountain spills the "pure river of water of life, clear as crystal, pro-

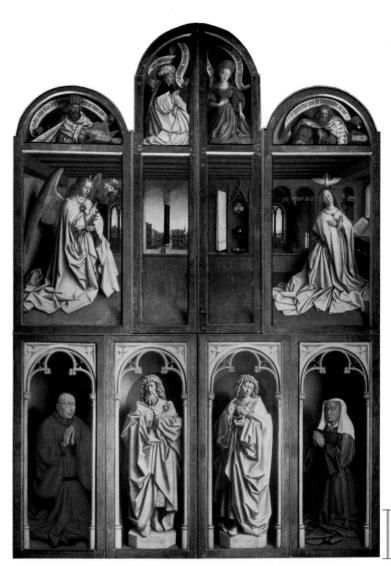

20-4 HUBERT and JAN VAN EYCK, Ghent Altarpiece (closed), Saint Bavo Cathedral, Ghent, Belgium, completed 1432. Oil on wood, 11′ 5″ × 7′ 6″. ■

Monumental painted altarpieces were popular in Flemish churches. Artists decorated both the interiors and exteriors of these polyptychs, which often, as here, included donor portraits.

ceeding out of the throne of God and of the Lamb" (Rev. 22:1). On the right, the 12 apostles and a group of martyrs in red robes advance. On the left appear prophets. In the right background come the virgin martyrs, and in the left background the holy confessors approach. On the lower wings, hermits, pilgrims, knights, and judges approach from left and right. They symbolize the four cardinal virtues: Temperance, Prudence, Fortitude, and Justice, respectively. The altarpiece celebrates the whole Christian cycle from the fall of man to the redemption, presenting the Church triumphant in heavenly Jerusalem.

Van Eyck used oil paints to render the entire altarpiece in a shimmering splendor of color that defies reproduction. No small detail escaped the painter. With pristine specificity, he revealed the beauty of the most insignificant object as if it were a work of piety as much as a work of art. He depicted the soft texture of hair, the glitter of gold in the heavy brocades, the luster of pearls, and the flashing of gems, all with loving fidelity to appearance. This kind of meticulous attention to recording the exact surface appearance of humans, animals, objects, and landscapes, already evident in

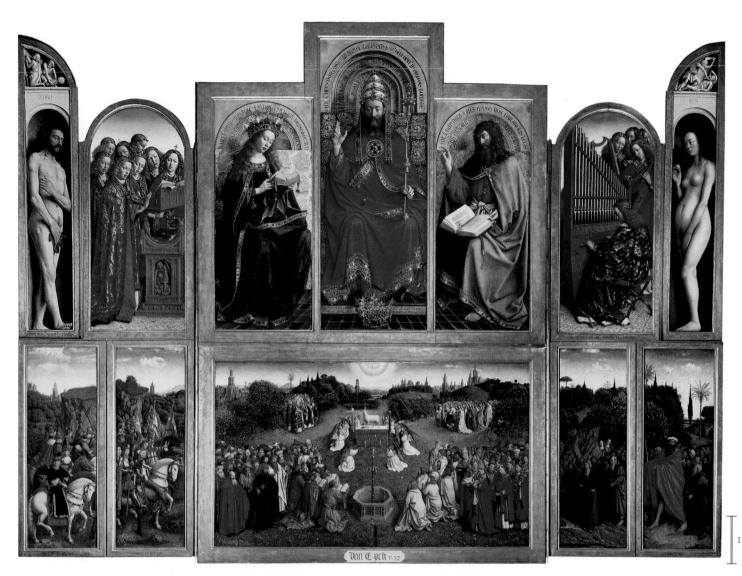

20-5 HUBERT and JAN VAN EYCK, Ghent Altarpiece (open), Saint Bavo Cathedral, Ghent, Belgium, completed 1432. Oil on wood, 11' 5" × 15' 1".

In this sumptuous painting of salvation from the original sin of Adam and Eve, God the Father presides in majesty. Van Eyck used oil paints to render every detail with loving fidelity to appearance.

the *Mérode Altarpiece* (FIG. 20-1), became the hallmark of Flemish panel painting in the 15th century.

GIOVANNI ARNOLFINI Emerging capitalism led to an urban prosperity that fueled the growing bourgeois market for art objects, particularly in Bruges, Antwerp, and, later, Amsterdam. This prosperity contributed to a growing interest in secular art in addition to religious artworks. Both the *Mérode Altarpiece* and the *Ghent Altarpiece* include painted portraits of their donors. These paintings marked a significant revival of portraiture, a genre that had languished since antiquity.

A purely secular portrait, but one with religious overtones, is Jan van Eyck's oil painting of *Giovanni Arnolfini and His Wife* (FIG. **20-6**). Van Eyck depicted the Lucca financier (who had established himself in Bruges as an agent of the Medici family) in his home, a setting that is simultaneously mundane yet charged with the spiritual. Arnolfini holds the hand of his second wife, whose name is not known. According to the traditional interpretation of the painting, van Eyck recorded the couple taking their marriage vows. As in the Mérode Altarpiece (FIG. 20-1), almost every object portrayed carries meaning. The cast-aside clogs indicate this event is taking place on holy ground. The little dog symbolizes fidelity (the common canine name Fido originated from the Latin fido, "to trust"). Behind the pair, the curtains of the marriage bed have been opened. The bedpost's finial (crowning ornament) is a tiny statue of Saint Margaret, patron saint of childbirth. (The bride is not yet pregnant, although the fashionable costume she wears makes her appear so.) From the finial hangs a whisk broom, symbolic of domestic care. The oranges on the chest below the window may refer to fertility. The single candle burning in the left rear holder of the ornate chandelier and the mirror, in which the viewer sees the entire room reflected, symbolize the all-seeing eye of God. The small medallions set into the mirror frame show tiny scenes from the passion of Christ and represent God's promise of salvation for the figures reflected on the mirror's convex surface. Viewers of the period would have been familiar with many of the objects included in the painting because of traditional Flemish customs. Husbands customarily presented brides with clogs, and the solitary lit candle

20-6 JAN VAN EYCK, *Giovanni Arnolfini and His Wife*, 1434. Oil on wood, $2' 9'' \times 1' 10^{\frac{1}{2}''}$. National Gallery, London.

Van Eyck played a major role in establishing portraiture as an important Flemish art form. In this portrait of an Italian financier and his wife, he also portrayed himself in the mirror.

in the chandelier was part of Flemish marriage practices. Van Eyck's placement of the two figures suggests conventional gender roles—the woman stands near the bed and well into the room, whereas the man stands near the open window, symbolic of the outside world.

Van Eyck enhanced the documentary nature of this scene by exquisitely painting each object. He carefully distinguished textures and depicted the light from the window on the left reflecting off various surfaces. He also augmented the scene's credibility by including the convex mirror (complete with its spatial distortion, brilliantly recorded), because viewers can see not only the principals, Arnolfini and his wife, but also two persons who look into the room through the door. (Arnolfini's raised right hand may be a gesture of greeting to the two men.) One of these must be the artist himself, as the florid

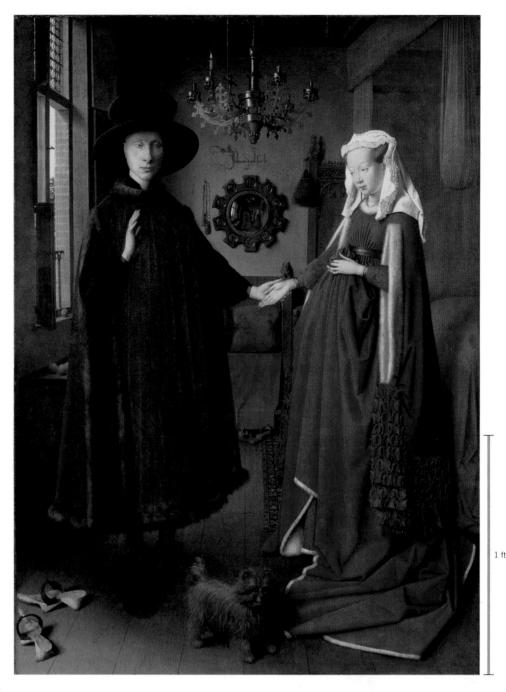

inscription above the mirror, *Johannes de Eyck fuit hic* ("Jan van Eyck was here"), announces he was present. The picture's purpose, then, would have been to record and sanctify this marriage.

Most scholars now reject this traditional reading of the painting, however. The room is a public reception area, not a bedchamber, and it has been suggested that Arnolfini is conferring legal privileges on his wife to conduct business in his absence. In either case, the artist functions as a witness. The self-portrait of van Eyck in the mirror also underscores the painter's self-consciousness as a professional artist whose role deserves to be recorded and remembered. (Compare the 12th-century monk Eadwine's self-portrait as "prince of scribes" [FIG. 12-36], a very early instance of an artist engaging in "self-promotion.")

MAN IN A RED TURBAN In 15th-century Flanders, artists also painted secular portraits without the layer of religious inter-

pretation present in the Arnolfini double portrait. These private commissions began to multiply as both artists and patrons became interested in the reality (both physical and psychological) portraits could reveal. For various reasons, great patrons embraced the opportunity to have their likenesses painted. They wanted to memorialize themselves in their dynastic lines and to establish their identities, ranks, and stations with images far more concrete than heraldic coats of arms. Portraits also served to represent state officials at events they could not attend. Sometimes, royalty, nobility, and the very rich would send artists to paint the likeness of a prospective bride or groom. For example, when young King Charles VI of France sought a bride, he dispatched a painter to three different royal courts to make portraits of the candidates.

In *Man in a Red Turban* (FIG. **20-7**), the man van Eyck portrayed looks directly at the viewer. This is the first known Western painted portrait in a thousand years where the sitter does so. The

Framed Paintings

T ntil the 20th century, when painters began simply to affix canvas to wooden stretcher bars to provide a taut painting surface devoid of ornamentation, artists considered the frame an integral part of the painting. Frames served a number of functions, some visual, others conceptual. For paintings such as large-scale altarpieces that were part of a larger environment, frames often served to integrate the painting with its surroundings. Frames could also be used to reinforce the illusionistic nature of the painted image. For example, the Italian painter Giovanni Bellini, in his San Zaccaria Altarpiece (FIG. 22-32), duplicated the carved pilasters of the architectural frame in the painting itself, thereby enhancing the illusion of space and giving the painted figures an enhanced physical presence. In the Ghent Altarpiece, the frame seems to cast shadows on the floor between the angel and Mary in the Annunciation (FIG. 20-4, top.) More commonly, artists used frames specifically to distance the viewer from the (often otherworldly) scene by calling attention to the separation of the image from the viewer's space.

Most 15th- and 16th-century paintings included elaborate frames the artists themselves helped design and construct. Extant contracts reveal the frame could account for as much as half of the cost of an altarpiece. Frequently, the commissions called for painted or gilded frames, adding to the expense. For small works, artists sometimes affixed the frames to the panels before painting, creating an insistent visual presence as they worked. Occasionally, a single piece of wood served as both panel and frame, and the artist carved the painting surface from the wood, leaving the edges as a frame. Larger images with elaborate frames, such as altarpieces, required the services of a woodcarver or stonemason. The painter worked closely with the individual constructing the frame to ensure its appropriateness for the image(s) produced.

Unfortunately, over time, many frames have been removed from their paintings. For instance, in 1566 church officials dismantled the *Ghent Altarpiece* and detached its elaborately carved frame in order to protect the sacred work from Protestant *iconoclasts* (see Chapter 23). As ill luck would have it, when the panels were reinstalled in 1587, no one could find the frame. Sadly, the absence of many of the original frames of old paintings deprives viewers today of the painter's complete artistic vision. Conversely, when the original frames exist, they sometimes provide essential information, such as the subject, name of the painter, and date. For

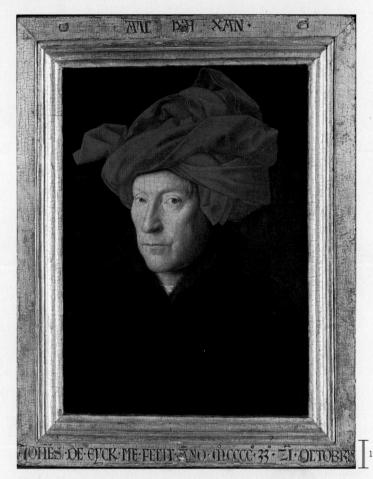

20-7 JAN VAN EYCK, *Man in a Red Turban*, 1433. Oil on wood, 1' $1\frac{1}{8}'' \times 10\frac{1}{4}''$. National Gallery, London.

Man in a Red Turban is the first known Western painted portrait in a thousand years in which the sitter looks directly at the viewer. The inscribed frame suggests it is a self-portrait.

example, the inscriptions on the frame of Jan van Eyck's *Man in a Red Turban* (FIG. 20-7) state he painted it on October 21, 1433, and the inclusion of "As I can" and omission of the sitter's name suggest the painting is a self-portrait.

level, composed gaze, directed from a true three-quarter head pose, must have impressed observers deeply. The painter created the illusion that from whatever angle a viewer observes the face, the eyes return that gaze. Van Eyck, with his considerable observational skill and controlled painting style, injected a heightened sense of specificity into this portrait by including beard stubble, veins in the bloodshot left eye, and weathered, aged skin. Although a definitive identification of the sitter has yet to be made, most scholars consider *Man in a Red Turban* a self-portrait, which van Eyck painted by looking at his image in a mirror (as he depicted himself in the mirror in the Arnolfinis' home). The inscriptions on the frame (see "Framed Paintings," above) reinforce this identification. Across the top, van Eyck wrote "As I can" in Flemish using Greek letters. (One suggestion is this portrait was a demonstration piece intended for prospective clients, who could compare the painting with the painter and judge what he "could do" in terms of recording a faithful likeness. Across the bottom appears the statement (in Latin) "Jan van Eyck made me" and the date. The use of both Greek and Latin suggests the artist's view of himself as a successor to the fabled painters of antiquity.

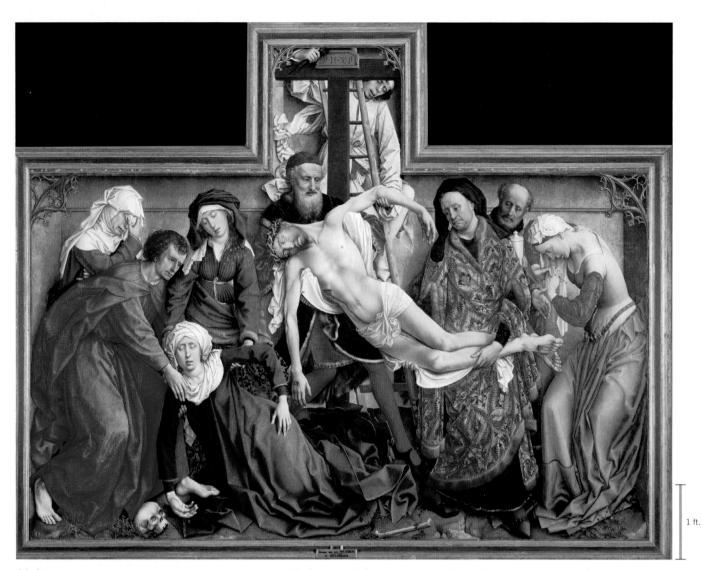

20-8 ROGIER VAN DER WEYDEN, *Deposition*, center panel of a triptych from Notre-Dame hors-les-murs, Louvain, Belgium, ca. 1435. Oil on wood, 7' $2\frac{5}{8}'' \times 8'$ $7\frac{1}{8}''$. Museo del Prado, Madrid.

Deposition resembles a relief carving in which the biblical figures act out a drama of passionate sorrow as if on a shallow theatrical stage. The painting makes an unforgettable emotional impression.

Rogier van der Weyden

When Jan van Eyck received the commission for the *Ghent Altarpiece*, ROGIER VAN DER WEYDEN (ca. 1400–1464) was an assistant in the workshop of Robert Campin (FIG. 20-1), but the younger painter's fame eventually rivaled van Eyck's. Rogier quickly became renowned for his dynamic compositions stressing human action and drama. He concentrated on Christian themes such as *Deposition* (FIG. **20-8**) and other episodes in the life of Jesus that elicited powerful emotions, for example, *Crucifixion* and *Pietà* (the Virgin

20-8A VAN DER WEYDEN, Last Judgment Altarpiece, ca. 1444–1448. ■4

Mary cradling the dead body of her son), moving observers deeply by vividly portraying the sufferings of Christ. He also painted a dramatic vision of *Last Judgment* (FIG. **20-8A**).

DEPOSITION One of Rogier's early masterworks is his 1435 Deposition (FIG. 20-8), the center panel of a triptych commissioned by the archers' guild of Louvain for the church of Notre-Dame hors-les-murs (Notre-Dame "outside the [town] walls"). Rogier acknowledged the patrons of this large painting by incorporating the crossbow (the guild's symbol) into the decorative tracery in the corners. Instead of creating a deep landscape setting, as van Eyck might have, Rogier compressed the figures and action onto a shallow stage with a golden back wall, imitating the large sculptured shrines so popular in the 15th century, especially in the Holy Roman Empire (FIGS. 20-19 and 20-20). The device admirably served his purpose of expressing maximum action within a limited space. The painting, with the artist's crisp drawing and precise modeling of forms, resembles a stratified relief carving. A series of lateral undulating movements gives the group a compositional unity, a formal cohesion Rogier strengthened by depicting the desolating anguish many of the figures share. Present are the Virgin and several of her half-sisters, Joseph of Arimathea, Nicodemus, Saint John the Evangelist, and Mary Magdalene. The similar poses of Christ and his mother further unify the composition and reflect the belief that Mary suffered the same pain at the crucifixion as her son. Their echoing postures also resemble the shape of a crossbow.

Few painters have equaled Rogier van der Weyden in rendering passionate sorrow as it vibrates through a figure or distorts a tearstained face. His depiction of the agony of loss in *Deposition* is

The Artist's Profession in Flanders

s in Italy (see "Artistic Training," Chapter 14, **A** page 414), guilds controlled artistic production in Flanders. To pursue a craft, individuals had to belong to the guild controlling that craft. Painters, for example, sought admission to the Guild of Saint Luke, the patron saint of painters because Luke made a portrait of the Virgin Mary (FIG. 20-9). The path to eventual membership in the guild began, for men, at an early age, when the father apprenticed his son in boyhood to a master, with whom the young aspiring painter lived. The master taught the fundamentals of his craft-how to make implements, prepare panels with gesso (plaster mixed with a binding material), and mix colors, oils, and varnishes. Once the youth mastered these procedures and learned to work in the master's traditional manner, he usually spent several years working as a journeyman in various cities, observing and absorbing ideas from other masters. He then was eligible to become a master and could apply for admission to the guild. Fees could be very high, especially if an artist was not a citizen of the same city. Sometimes, an artist seeking admission to a guild would marry the widow of a member. A woman could inherit her husband's workshop but not run it. Guild membership was essential for establishing an artist's reputation and for obtaining commissions. The guild inspected paintings to evaluate workmanship and ensure its members used quality materials. It also secured adequate payment for its artists' labor.

Women had many fewer opportunities than men to train as artists, in large part because of social and moral constraints that forbade women to reside as apprentices in the homes of male masters. Moreover, from the 16th century, when academic training courses supplemented and then replaced guild training, until the 20th century, women would not as a rule expect or be permitted instruction in figure painting, because it involved dissection of cadavers and study of the nude male model. Flemish women interested in pursuing art as a career, for example, Caterina van Hemessen (FIG. 23-18), most often re-

ceived tutoring from fathers and husbands who were professionals and whom the women assisted in all the technical procedures of the craft. Despite these obstacles, membership records of the art guilds of Bruges and other cities reveal a substantial number of Flemish

20-9 ROGIER VAN DER WEYDEN, Saint Luke Drawing the Virgin, ca. 1435–1440. Oil and tempera on wood, $4' 6\frac{1}{8''} \times 3' 7\frac{5''}{8}$. Museum of Fine Arts, Boston (gift of Mr. and Mrs. Henry Lee Higginson).

Probably commissioned by the painters' guild in Brussels, this painting honors the first Christian artist and the profession of painting. Saint Luke may be a self-portrait of Rogier van der Weyden.

women were able to establish themselves as artists during the 15th century. That they succeeded in negotiating the difficult path to acceptance as professionals is a testament to both their tenacity and their artistic skill.

among the most authentic in religious art and creates an immediate and unforgettable emotional effect on the viewer. It was probably Rogier whom Michelangelo had in mind when, according to the Portuguese painter Francisco de Hollanda (1517–1584), the Italian master observed, "Flemish painting [will] please the devout better than any painting of Italy, which will never cause him to shed a tear, whereas that of Flanders will cause him to shed many."¹ **SAINT LUKE** Slightly later in date is Rogier's *Saint Luke Drawing the Virgin* (FIG. **20-9**), probably painted for the Guild of Saint Luke, the artists' guild in Brussels. The panel depicts the patron saint of painters drawing the Virgin Mary using a *silverpoint* (a sharp *stylus* that creates a fine line). The theme paid tribute to the profession of painting in Flanders (see "The Artist's Profession in Flanders," above) by drawing attention to the venerable history

1 ft

20-9A VAN DER WEYDEN. Portrait of a Lady, ca. 1460.

of the painter's craft and documenting the preparatory work required before the artist could begin painting the figures and setting. Portrait painting was a major source of income for Flemish artists, and Rogier was one of the best (FIG. 20-9A). In fact, many scholars believe Rogier's Saint Luke is a selfportrait, identifying the Flemish painter with the first Christian artist and underscoring the holy nature of painting. Rogier shared with Campin and van Eyck the aim of recording every detail of a scene with loving fidelity to

optical appearance, seen here in the rich fabrics, the floor pattern, and the landscape visible through the window. Also, as his older colleagues did, Rogier imbued much of the representation with symbolic significance. At the right, the ox identifies the figure recording the Virgin's features as Saint Luke (see "The Four Evangelists," Chapter 11, page 314). The carved armrest of the Virgin's bench depicts Adam, Eve, and the serpent, reminding the viewer that Mary is the new Eve and Christ the new Adam who will redeem humanity from original sin.

Later Flemish Painters

Robert Campin, Jan van Eyck, and Rogier van der Weyden were the leading figures of the first generation of "Northern Renaissance" painters. (Art historians usually transfer to northern Europe, with less validity than in its original usage, the term Renaissance, coined to describe the conscious revival of classical art in Italy. They also use the uppercase designation Northern European as a stylistic term parallel to Italian, as opposed to the geographic designation northern European.) The second generation of Flemish masters, active during the latter half of the 15th century, had much in common with their illustrious predecessors, especially a preference for using oil paints to create naturalistic representations, often, although not always, of traditional Christian subjects for installation in churches.

PETRUS CHRISTUS One work of uncertain Christian content is A Goldsmith in His Shop (FIG. 20-10) by PETRUS CHRISTUS (ca. 1410-1472), who settled in Bruges in 1444. According to the traditional interpretation, A Goldsmith in His Shop portrays Saint Eligius (who was initially a master goldsmith before committing his life to God) sitting in his stall, showing an elegantly attired couple a selection of rings. The bride's betrothal girdle lies on the table as a symbol of chastity, and the woman reaches for the ring the goldsmith weighs. The artist's inclusion of a crystal container for Eucharistic wafers (on the lower shelf to the right of Saint Eligius) and the scales (a reference to the last judgment) supports a religious interpretation of this painting and continues the Flemish tradition of imbuing everyday objects with symbolic significance. A halo once encircled the goldsmith's head, seemingly confirming the religious nature of this scene. Scientists have determined, however, that the halo was a later addition by another artist, and restorers have removed it.

Most scholars now think the painting, although not devoid of religious content, should be seen as a vocational painting of the type often produced for installation in Flemish guild chapels. Although the couple's presence suggests a marriage portrait, the patrons were probably not the couple portrayed but rather the goldsmiths' guild in Bruges. Saint Eligius was the patron saint of gold- and silversmiths, blacksmiths, and metalworkers, all of whom shared a chapel

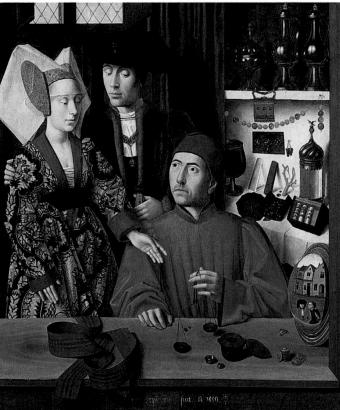

1 ft

20-10 PETRUS CHRISTUS, A Goldsmith in His Shop, 1449. Oil on wood, 3' $3'' \times 2'$ 10". Metropolitan Museum of Art, New York (Robert Lehman Collection, 1975).

Once thought to depict Eligius, the patron saint of goldsmiths, Christus's painting, made for the Bruges goldsmiths guild, is more likely a generic scene of a couple shopping for a wedding ring.

in a building adjacent to their meetinghouse. The reconsecration of this chapel took place in 1449, the same date as the Christus painting. Therefore, it seems probable the artist painted A Goldsmith in His Shop, which illustrates an economic transaction and focuses on the goldsmith's profession, specifically for the guild chapel.

Christus went to great lengths to produce a historically credible image. For example, the variety of objects depicted in the painting serves as advertisement for the goldsmiths' guild. Included are the goldsmiths' raw materials (precious stones, beads, crystal, coral, and seed pearls) scattered among finished products (rings, buckles, and brooches). The pewter vessels on the upper shelves are donation pitchers, which town leaders gave to distinguished guests. All these meticulously painted objects not only attest to the centrality and importance of goldsmiths to both the secular and sacred communities but also enhance the naturalism of the painting.

The convex mirror in the foreground showing another couple and a street with houses serves to extend the painting's space into the viewer's space, further creating the illusion of reality, as in van Eyck's Arnolfini portrait (FIG. 20-6).

DIRK BOUTS In Last Supper (FIG. 20-11), DIRK BOUTS (ca. 1415-1475) of Haarlem chose a different means of suggesting spatial recession. The painting is the central panel of the Altarpiece of the Holy Sacrament, which the Confraternity of the Holy Sacrament in Louvain commissioned

20-11A BOUTS Justice of Otto III, ca. 1470-1475.

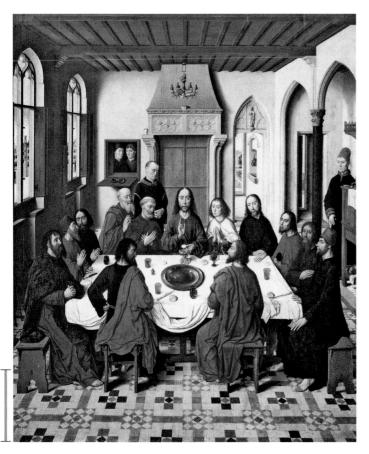

in 1464, four years before Bouts became the city's official painter and produced a series of panels—*Justice of Otto III* (FIG. **20-11A**) —for Louvain's town hall. Bouts's *Last Supper* is one of the earliest Northern Renaissance paintings to demonstrate the use of a *vanishing point* (see "Linear and Atmospheric Perspective," Chapter 21, page 567) for creating *perspective*. All of the central room's *orthogonals* (converging diagonal lines imagined to be behind and **20-11** DIRK BOUTS, Last Supper, center panel of the Altarpiece of the Holy Sacrament, Saint Peter's, Louvain, Belgium, 1464–1468. Oil on wood, $6' \times 5'$.

One of the earliest Northern European paintings to employ Renaissance linear perspective, this *Last Supper* includes four servants in Flemish attire—portraits of the altarpiece's patrons. perpendicular to the picture plane) lead to the vanishing point in the center of the mantelpiece above Christ's head. The small side room, however, has its own vanishing point, and neither it nor the vanishing point of the main room falls on the horizon of the landscape seen through the windows, as in Italian Renaissance paintings.

In *Last Supper*, Bouts did not focus on the biblical narrative itself but instead presented Christ in the role of a priest performing a ritual from the liturgy of the Christian Church—the consecration of the Eucharistic wafer. This contrasts strongly with other depictions of the

same subject, which often focused on Judas's betrayal or on Christ's comforting of John. The Confraternity of the Holy Sacrament dedicated itself to the worship of the Eucharist, and the smaller panels on the altarpiece's wings depict Old Testament *prefigurations* of the Eucharist. Bouts also added four servants (two in the window and two standing) not mentioned in the biblical account, all dressed in Flemish attire. These are portraits of the four members of the confraternity who contracted Bouts to paint the altarpiece, continuing the Flemish tradition of inserting into representations of biblical events portraits of the painting's patrons, first noted in the *Mérode Altarpiece* (FIG. 20-1).

HUGO VAN DER GOES By the mid-15th century, Flemish art had achieved renown throughout Europe. The *Portinari Altarpiece* (FIG. **20-12**), for example, is a large-scale Flemish work in a family chapel in Florence, Italy. The artist who received the commission was HUGO VAN DER GOES (ca. 1440–1482), the dean of the painters' guild of Ghent from 1468 to 1475. Hugo painted the triptych for Tommaso Portinari, an Italian shipowner and agent for the powerful Medici family of Florence. Portinari appears on the wings

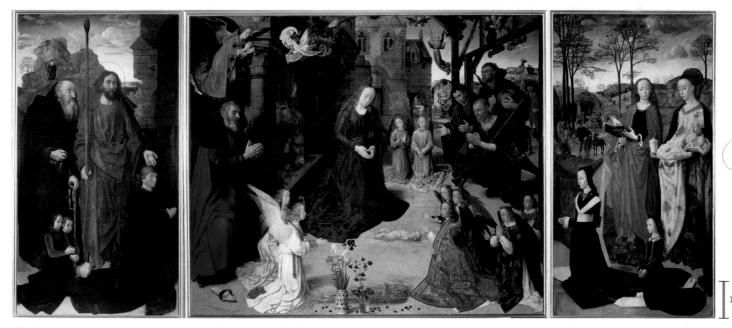

20-12 HUGO VAN DER GOES, *Portinari Altarpiece* (open), from Sant'Egidio, Florence, Italy, ca. 1476. Tempera and oil on wood, center panel 8' $3\frac{1}{2}'' \times 10'$, each wing 8' $3\frac{1}{2}'' \times 4' 7\frac{1}{2}''$. Galleria degli Uffizi, Florence.

This altarpiece is a rare instance of the awarding of a major commission in Italy to a Flemish painter. The Florentines admired Hugo's realistic details and brilliant portrayal of human character.

of the altarpiece with his family and their patron saints. The subject of the central panel is *Adoration of the Shepherds*. On this large surface, Hugo displayed a scene of solemn grandeur, muting the high drama of the joyous occasion. The Virgin, Joseph, and the angels seem to brood on the suffering to come rather than to meditate on the miracle of Jesus' birth. Mary kneels, somber and monumental, on a tilted ground, a device the painter used to situate the main actors at the center of the panel. (The compositional device may derive from the tilted stage floors of 15th-century mystery plays.) Three shepherds enter from the right rear. Hugo represented them in attitudes of wonder, piety, and gaping curiosity. Their lined faces, work-worn hands, and uncouth dress and manner seem immediately familiar.

The architecture and a continuous wintry northern European landscape unify the three panels. Symbols surface throughout the altarpiece. Iris and columbine flowers are emblems of the sorrows of the Virgin. The angels represent the 15 joys of Mary. A sheaf of wheat stands for Bethlehem (the "house of bread" in Hebrew), a reference to the Eucharist. The harp of David, emblazoned over the building's portal in the middle distance (just to the right of the Virgin's head), signifies the ancestry of Christ. To stress the meaning and significance of the illustrated event, Hugo revived medieval pictorial devices. Small scenes shown in the background of the altarpiece represent (from left to right) the flight into Egypt, the annunciation to the shepherds, and the arrival of the magi. Hugo's variation in the scale of his figures to differentiate them by their importance to the central event also reflects older traditions. Still, he put a vigorous, penetrating realism to work in a new direction, characterizing human beings according to their social level while showing their common humanity.

After Portinari placed the altarpiece in his family's chapel in the Florentine church of Sant'Egidio, it created a considerable stir among Italian artists. Although the painting may have seemed unstructured to them, Hugo's masterful technique and what the Florentines deemed incredible realism in representing drapery, flowers, animals, and, above all, human character and emotion made a deep impression on them. At least one Florentine artist, Domenico Ghirlandaio (FIGS. 21-26 and 21-27), paid tribute to the Flemish master by using Hugo's most striking motif, the adoring shepherds, in one of his own *Nativity* paintings.

HANS MEMLING Hugo's contemporary, HANS MEMLING (ca. 1430–1494), became a citizen of Bruges in 1465 and received numerous commissions from the city's wealthy merchants, Flemish and foreign alike. He specialized in portraits of his patrons (one of whom was Tommaso Portinari) and images of the Madonna. Memling's many paintings of the Virgin portray young, slight, pretty princesses, each holding a doll-like infant Christ. The center panel of the *Saint John Altarpiece* depicts the *Virgin with Saints and Angels* (FIG. **20-13**). The patrons of this altarpiece—two brothers and two sisters of the order of the Hospital of Saint John in Bruges—appear on the exterior side panels (not illustrated). In the central panel, two angels, one playing a musical instrument and the other holding a book, flank the Virgin. To the sides of Mary's throne

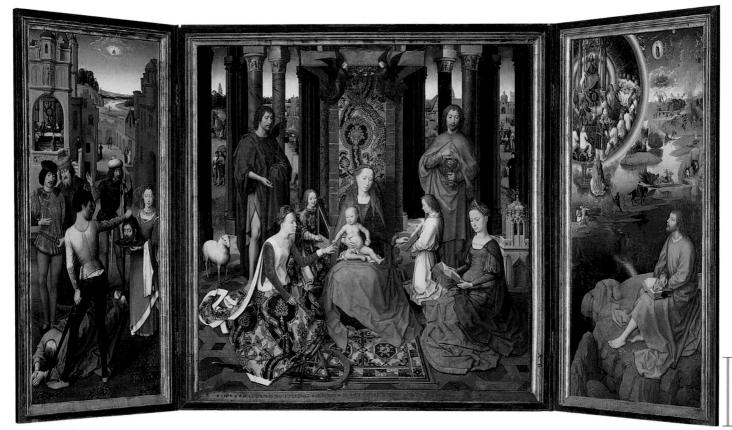

20-13 HANS MEMLING, Virgin with Saints and Angels, center panel of the Saint John Altarpiece, Hospitaal Sint Jan, Bruges, Belgium, 1479. Oil on wood, center panel 5' $7\frac{3}{4}'' \times 5' 7\frac{3}{4}''$, each wing 5' $7\frac{3}{4}'' \times 2' 7\frac{3}{8}''$.

Memling specialized in images of the Madonna. His Saint John Altarpiece exudes an opulence that results from the sparkling and luminous colors and the realistic depiction of rich tapestries and brocades.

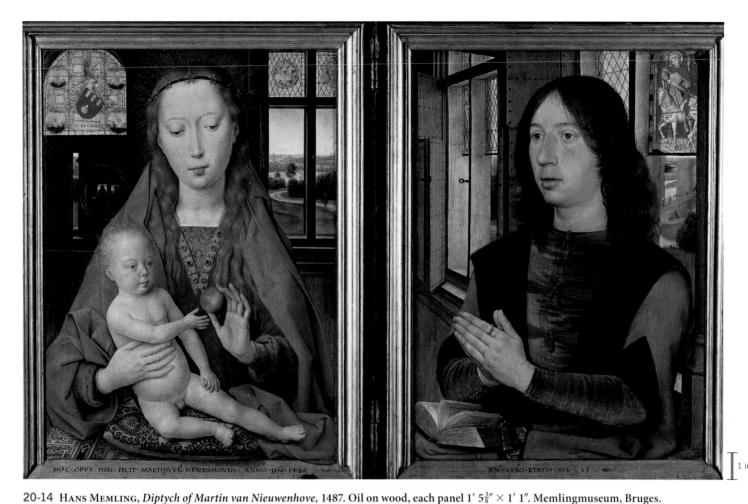

In this diptych the Virgin and Child pay a visit to the home of 23-year-old Martin van Nieuwenhove. A round convex mirror reflects the three figures and unites the two halves of the diptych spatially.

stand Saint John the Baptist on the left and Saint John the Evangelist on the right, and seated in the foreground are Saints Catherine and Barbara. This gathering celebrates the *mystic marriage* of Saint Catherine of Alexandria, one of many virgin saints believed to have entered into a spiritual marriage with Christ. As one of the most revered virgins of Christ, Saint Catherine provided a model of devotion that resonated with women viewers (especially nuns). The altarpiece exudes an opulence that results from the rich colors, meticulously depicted tapestries and brocades, and the serenity of the figures. The composition is balanced and serene, the color sparkling and luminous, and the execution of the highest technical quality.

Memling combined portraiture and Madonna imagery again in a much less ambitious—and more typical—work (FIG. **20-14**) commissioned by Martin van Nieuwenhove, the scion of an important Bruges family that held various posts in the civic government. Martin himself served as burgomeister (mayor) of Bruges in 1497. The painting takes the form of a diptych, with the patron portrayed on the right wing and praying to the Madonna and Child on the left wing. According to inscriptions on the frames, van Nieuwenhove commissioned the work in 1487 when he was 23 years old (he died in 1500).

The format of the van Nieuwenhove diptych follows the pattern Memling used earlier for his wedding triptych of *Tommaso Portinari and Maria Baroncelli* (FIG. 20-14A) but with only a single (male) portrait. The left panel representing the Madonna and Child is probably similar to the lost central section of the Portinari triptych. Memling's portrayals of the Virgin and Child differ little in his smaller, private devotional works and his larger altarpieces (FIG. 20-13) and consistently feature a tender characterization of the young Virgin and her nude in-

20-14A MEMLING, *Tommaso Portinari* and Maria Baroncelli, ca. 1470.

fant son. Here, however, Memling set both the Madonna and her patron in the interior of a well-appointed Flemish home featuring stained-glass windows. The window to the left of the Virgin's head bears van Nieuwenhove's coat of arms. The window behind the donor depicts his patron saint, Martin of Tours. These precisely recorded details identify the home as van Nieuwenhove's (the Minnewater Bridge in Bruges is visible through the open window), and the Madonna and Child have honored him by coming to his private residence. The conceit is a familiar one in Flemish painting. An early example is the Annunciation taking place in the home of Peter Inghelbrecht in Robert Campin's Mérode Altarpiece (FIG. 20-1). In the Memling portrait diptych, the Christ Child sits on the same ledge as the donor's open prayer book. Also uniting the two wings of the diptych is the round convex mirror behind the Virgin's right shoulder in which the viewer sees the reflection of the Virgin and van Nieuwenhove as well as the rest of the room (compare FIGS. 20-6 and 20-10).

20-15 LIMBOURG BROTHERS (POL, HERMAN, JEAN), *January*, from *Les Très Riches Heures du Duc de Berry*, 1413–1416. Colors and ink on vellum, $8\frac{7}{8}'' \times 5\frac{3}{8}''$. Musée Condé, Chantilly.

The sumptuous pictures in *Les Très Riches Heures* depict characteristic activities of each month. The prominence of genre subjects reflects the increasing integration of religious and secular art.

FRANCE

In contrast to the prosperity and peace Flanders enjoyed during the 15th century, in France the Hundred Years' War crippled economic enterprise and prevented political stability. The anarchy of war and the weakness of the kings gave rise to a group of duchies, each with significant power and the resources to commission major artworks. The strongest and wealthiest of these has already been examined—the duchy of Burgundy, which controlled Flanders. But the dukes of Berry, Bourbon, and Nemours as well as members of the French royal court were also important art patrons.

Manuscript Painting

During the 15th century, French artists built on the achievements of Gothic painters (see Chapter 13) and produced exquisitely refined illuminated manuscripts. Among the most significant developments in French manuscript painting was a new conception and presentation of space. Paintings in manuscripts took on more pronounced characteristics as illusionistic scenes. Increased contact with Italy, where Renaissance artists had revived the pictorial principles of classical antiquity, may have influenced French painters' interest in illusionism.

LIMBOURG BROTHERS The most innovative early-15th-century manuscript illuminators were the three LIMBOURG BROTHERS— POL, HERMAN, and JEAN—from Nijmegen in the Netherlands. They were nephews of Jean Malouel, the court artist of Philip the Bold. Following in the footsteps of earlier illustra-

tors such as Jean Pucelle (FIGS. 13-36 and 13-36A), the Limbourg brothers expanded the illusionistic capabilities of illumination. Trained in the Netherlands, the brothers moved to Paris no later than 1402, and between 1405 and their death in 1416, probably from the plague, they worked in Paris and Bourges for Jean, duke of Berry (r. 1360–1416) and brother of King Charles V (r. 1364–1380) of France and of Philip the Bold of Burgundy.

The duke ruled the western French regions of Berry, Poitou, and Auvergne (MAP 20-1). He was an avid art patron and focused on collecting manuscripts, jewels, and rare artifacts. Among the more than 300 manuscripts the duke owned were Pucelle's *Belleville Breviary* (FIG. 13-36) and the *Hours of Jeanne d'Évreux* (FIG. 13-36A) as well as *Les Très Riches Heures du Duc de Berry* (*The Very Sumptuous Hours of*

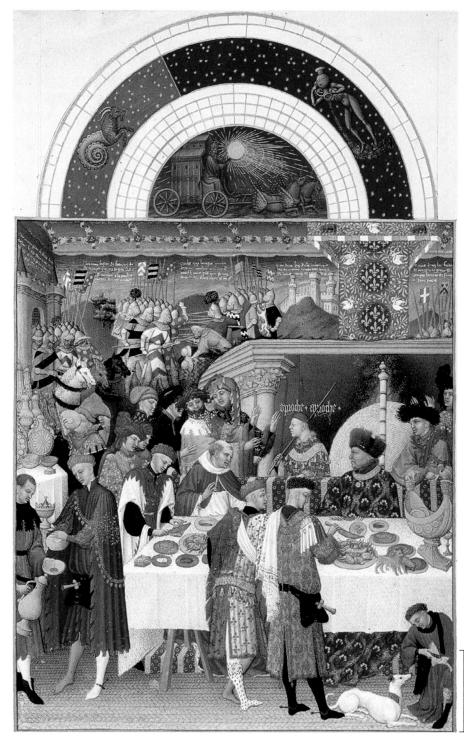

1 in.

the Duke of Berry; FIGS. **20-15** and **20-16**), which he commissioned the Limbourg brothers to produce. A Book of Hours, like a *breviary*, was a book used for reciting prayers (see "Medieval Books," Chapter 11, page 312). As prayer books, they replaced the traditional *psalters* (books of psalms), which were the only liturgical books in private hands until the mid-13th century. The centerpiece of a Book of Hours was the "Office [prayer] of the Blessed Virgin," which contained liturgical passages to be read privately at set times during the day, from *matins* (dawn prayers) to *compline* (the last of the prayers recited daily). An illustrated calendar containing local religious feast days usually preceded the Office of the Blessed Virgin. Penitential psalms, devotional prayers, litanies to the saints, and other prayers, including those of the dead and of the Holy Cross, followed the center-

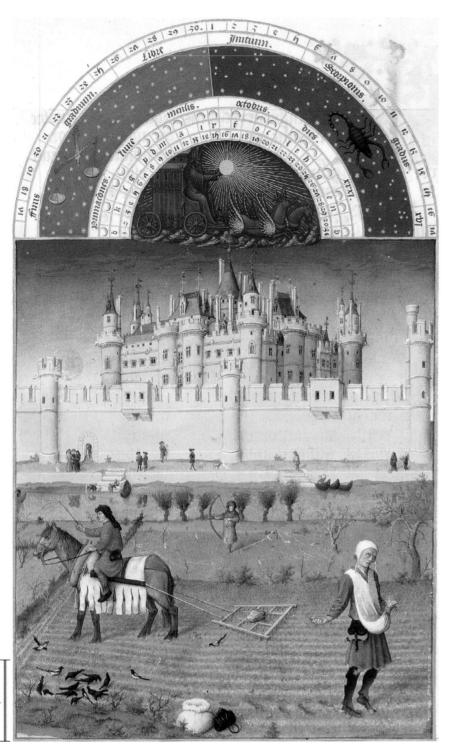

piece. Books of Hours became favorite possessions of the northern European aristocracy during the 14th and 15th centuries. (Mary, the last duchess of Burgundy, commissioned a Book of Hours in which she was portrayed praying; FIG. **20-16A**. It is the masterpiece of the illuminator known as the MASTER OF MARY OF BURGUNDY, possi-

20-16A Hours of Mary of Burgundy, ca. 1480.

bly ALEXANDER BENING [ca. 1444– 1519].) These sumptuous books eventually became available to affluent burghers and contributed to the decentralization of religious practice that was one factor in the Protestant Reformation in the early 16th century (see Chapter 23). **20-16** LIMBOURG BROTHERS (POL, HERMAN, JEAN), October, from Les Très Riches Heures du Duc de Berry, 1413–1416. Colors and ink on vellum, $8\frac{7}{8}'' \times 5\frac{3}{8}''$. Musée Condé, Chantilly.

The Limbourg brothers expanded the illusionistic capabilities of manuscript painting with their care in rendering architectural details and convincing depiction of cast shadows.

The full-page calendar pictures of Les Très Riches Heures are the most famous in the history of manuscript illumination. They represent the 12 months in terms of the associated seasonal tasks, alternating scenes of nobility and peasantry. Above each picture is a lunette in which the Limbourgs depicted the zodiac signs and the chariot of the sun as it makes its yearly cycle through the heavens. Beyond its function as a religious book, Les Très Riches Heures also visually captures the power of the duke and his relationship to the peasants. For example, the colorful calendar picture for January (FIG. 20-15) portrays a New Year's reception at court. The duke appears as magnanimous host, his head circled by the fire screen, almost halolike, behind him. His chamberlain stands next to him, urging the guests forward with the words "aproche, aproche." The lavish spread of food on the table and the large tapestry on the back wall augment the richness and extravagance of the setting and the occasion.

In contrast, the illustration for October (FIG. 20-16) focuses on the peasantry. Here, the Limbourg brothers depicted a sower, a harrower on horseback, and washerwomen, along with city dwellers, who promenade in front of the Louvre (the French king's residence at the time, now one of the world's great art museums). The peasants do not appear discontented as they go about their assigned tasks. Surely this imagery flattered the duke's sense of himself as a compassionate master. The growing artistic interest in naturalism is evident here in the careful way the painter recorded the architectural details of the Louvre and in the convincing shadows of the people and objects (such as the archer scarecrow and the

horse) in the scene.

As a whole, *Les Très Riches Heures* reinforced the image of the duke of Berry as a devout man, cultured bibliophile, sophisticated art patron, and powerful and magnanimous leader. Further, the expanded range of subject matter, especially the prominence of *genre* subjects in a religious book, reflected the increasing integration of religious and secular concerns in both art and life at the time. Although all three Limbourg brothers worked on *Les Très Riches Heures*, art historians have never been able to ascertain definitively which brother painted which images. Given the common practice of collaboration on artistic projects at this time, however, the determination of specific authorship is not very important.

Panel Painting

Images for private devotional use were popular in France, as in Flanders, and the preferred medium was oil paint on wood panels.

JEAN FOUQUET Among the French artists whose paintings were in demand was JEAN FOUQUET (ca. 1420-1481), who worked for King Charles VII (r. 1422-1461, the patron and client of Jacques Coeur; FIG. 13-30) and for the duke of Nemours. Fouquet painted a diptych (FIG. 20-17) for Étienne Chevalier, who, despite his lowly origins, became Charles VII's treasurer in 1452. In the left panel of the Melun Diptych (named for its original location in Melun Cathedral), Chevalier appears with his patron saint, Saint Stephen (Étienne in French). Appropriately, Fouquet's donor portrait of Chevalier depicts his prominent patron as devout-kneeling, with hands clasped in prayer. The representation of the pious donor with his standing saint recalls Flemish art, as do the three-quarter stances and the realism of Chevalier's portrait. The artist portrayed Saint Stephen, whose head also has a portraitlike quality, holding the stone of his martyrdom (death by stoning) atop a volume of the holy scriptures, thereby ensuring that viewers properly identify the saint. Fouquet rendered the entire image in meticulous detail and included a highly ornamented architectural setting.

In its original diptych form (the two panels are now in different museums), the viewer would follow the gaze of Chevalier and Saint Stephen over to the right panel, which depicts the Virgin Mary and Christ Child in a most unusual way—with marblelike flesh, surrounded by red and blue *cherubs* (chubby winged child angels). The juxtaposition of these two images enabled the patron to bear witness to the sacred. The integration of sacred and secular (especially the political or personal), prevalent in other northern European artworks, also emerges here, which complicates the reading of this diptych. Agnès Sorel (1421–1450), the mistress of King Charles VII, was Fouquet's model for the Virgin Mary, whose left breast is exposed and who does not look at the viewer. Chevalier commissioned this painting after Sorel's death, probably by poisoning while pregnant with the king's child. Thus, in addition to the religious interpretation of this diptych, there is surely a personal and political narrative here as well.

HOLY ROMAN EMPIRE

Because the Holy Roman Empire (whose core was Germany) did not participate in the drawn-out saga of the Hundred Years' War, its economy remained stable and prosperous. Without a dominant court to commission artworks, wealthy merchants and clergy became the primary German patrons during the 15th century.

Panel Painting

The art of the early Northern Renaissance in the Holy Roman Empire displays a pronounced stylistic diversity. Some artists followed developments in Flemish painting, and large-scale altarpieces featuring naturalistically painted biblical themes were familiar sights in the Holy Roman Empire.

KONRAD WITZ Among the most notable 15th-century German altarpieces is the *Altarpiece of Saint Peter*, painted in 1444 for the chapel of Notre-Dame des Maccabées in the Cathedral of Saint Peter in Geneva, Switzerland. KONRAD WITZ (ca. 1400–1446), whose studio was in Basel, painted one exterior wing of this triptych with a

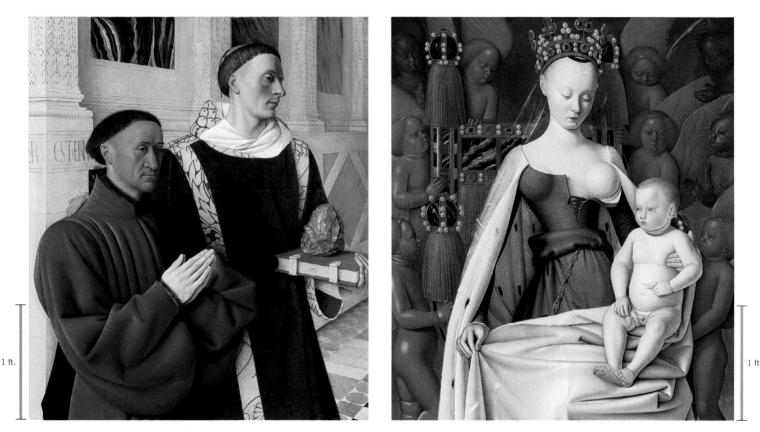

20-17 JEAN FOUQUET, Melun Diptych. Left wing: Étienne Chevalier and Saint Stephen, ca. 1450. Oil on wood, $3' \frac{1}{2}'' \times 2' 9\frac{1}{2}''$. Gemäldegalerie, Staatliche Museen zu Berlin, Berlin. Right wing: Virgin and Child, ca. 1451. Oil on wood, $3' 1\frac{1}{4}'' \times 2' 9\frac{1}{2}''$. Koninklijk Museum voor Schone Kunsten, Antwerp.

Fouquet's meticulous representation of a pious kneeling donor with a standing patron saint recalls Flemish painting, as do the three-quarter stances and the realism of the portraits.

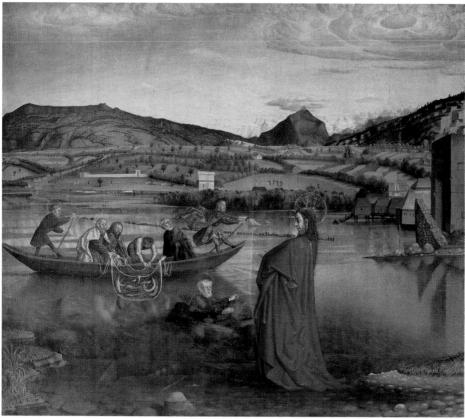

1 ft

representation of *Miraculous Draught of Fish* (FIG. **20-18**). The other exterior wing (not illustrated) depicts the release of Saint Peter from prison. The central panel is lost. On the interior wings, Witz painted scenes of *Adoration of the Magi* and of Saint Peter's presentation of the donor (Bishop François de Mies) to the Virgin and Child. *Miraculous Draught of Fish* shows Peter, the first pope, unsuccessfully trying to emulate Christ walking on water. Some scholars think the choice of subject is a commentary on the part of Witz's patron, the Swiss cardinal, on the limited power of the pope in Rome.

The painting is particularly significant because of the landscape's prominence. Witz showed precocious skill in the study of water ef-

20-18 KONRAD WITZ, *Miraculous Draught* of Fish, exterior wing of Altarpiece of Saint Peter, from the Chapel of Notre-Dame des Maccabées, Cathedral of Saint Peter, Geneva, Switzerland, 1444. Oil on wood, 4' $3'' \times 5' 1''$. Musée d'Art et d'Histoire, Geneva.

Konrad Witz set this biblical story on Lake Geneva. The painting is one of the first 15th-century works depicting a specific locale and is noteworthy for the painter's skill in rendering water effects.

fects—the sky glaze on the slowly moving lake surface, the mirrored reflections of the figures in the boat, and the transparency of the shallow water in the foreground. He observed and represented the landscape so carefully that art historians have been able to determine the exact location shown. Witz presented a view of the shores of Lake Geneva, with the town of Geneva on the right and Le Môle Mountain in the distance behind Christ's head. This painting is one of the first 15th-century works de-

picting a specific, identifiable site.

The work of other leading German painters

of the mid-15th century, for example, STEFAN LOCHNER (ca. 1400–1451), retained medieval features to a much greater degree, as is immediately evident in a comparison between Witz's landscape and Lochner's *Madonna in the Rose Garden* (FIG. **20-18A**).

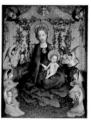

20-18A LOCHNER, Madonna in the Rose Garden, ca. 1440.

Sculpture

In contrast to Flanders, where painted altarpieces were the norm, in the Holy Roman Empire many of the leading 15th-century artists specialized in carving large wooden retables. These grandiose sculpted

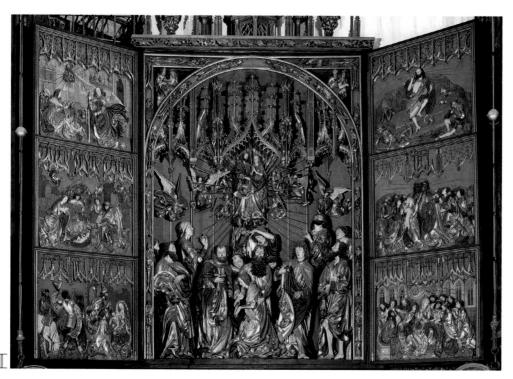

altarpieces reveal the power of the lingering Late Gothic style.

VEIT STOSS The sculptor VEIT STOSS (1447–1533) trained in the Upper Rhine region but settled in Kraków (in present-day Poland) in 1477. In that year, he began work on a monumental altarpiece (FIG. **20-19**) for the church of Saint Mary in Kraków. In the central boxlike shrine, huge carved and painted figures, some nine feet high,

20-19 VEIT STOSS, *Death and Assumption of the Virgin* (wings open), altar of the Virgin Mary, church of Saint Mary, Kraków, Poland, 1477–1489. Painted and gilded wood, center panel 23' 9" high.

In this huge sculptured and painted altarpiece, Stoss used every figural and ornamental element from the vocabulary of Gothic art to heighten the emotion and to glorify the sacred event. represent Death and Assumption of the Virgin. On the wings, Stoss portrayed scenes from the lives of Christ and Mary. The altar forcefully expresses the intense piety of Gothic culture in its late phase, when artists used every figural and ornamental motif in the repertoire of Gothic art to heighten the emotion and to glorify sacred events. In the Kraków altarpiece, Christ's disciples congregate around the Virgin, who collapses, dying. One of them supports her, while another wrings his hands in grief. Stoss posed others in attitudes of woe and psychic shock, striving for realism in every minute detail. He engulfed the figures in restless, twisting, and curving swaths of drapery whose broken and writhing lines unite the whole tableau in a vision of agitated emotion. The artist's massing of sharp, broken, and pierced forms that dart flamelike through the compositionat once unifying and animating it-recalls the design principles of Late Gothic architecture (FIG. 13-27). Indeed, in the Kraków altarpiece, Stoss merged sculpture and architecture, enhancing their union with paint and gilding.

TILMAN RIEMENSCHNEIDER Assumption of the Virgin is also the subject of the center panel (FIG. 20-20) of the Creglingen Altarpiece, created by TILMAN RIEMENSCHNEIDER (ca. 1460-1531) of Würzburg for a parish church in Creglingen, Germany. He incorporated intricate Gothic forms, especially in the altarpiece's elaborate canopy, but unlike Stoss, he did not paint the figures or the background. By employing an endless and restless line running through the garments of the figures, Riemenschneider succeeded in setting the whole design into fluid motion, and no individual element functions without the rest. The draperies float and flow around bodies lost within them, serving not as descriptions but as design elements that tie the figures to one another and to the framework. A look of psychic strain, a facial expression common in Riemenschneider's work, heightens the spirituality of the figures, immaterial and weightless as they appear.

Graphic Arts

A new age blossomed in the 15th century with a sudden technological advance that had widespread effects—the invention by Johannes Gutenberg (ca. 1400–1468) of moveable type around 1450 and the development of the printing press. Printing had been known in China centuries before but had never fos-

20-20A Buxheim Saint Christopher, 1423.

tered, as it did in 15th-century Europe, a revolution in written communication and in the generation and management of information. Printing provided new and challenging media for artists, and the earliest form was the *woodcut* (see "Woodcuts, Engravings, and Etchings," page 556). Artists produced inexpensive woodcuts such as the *Buxheim Saint Christopher* (FIG. 20-20A) before the development of moveable-type printing. But when a rise in literacy and the im-

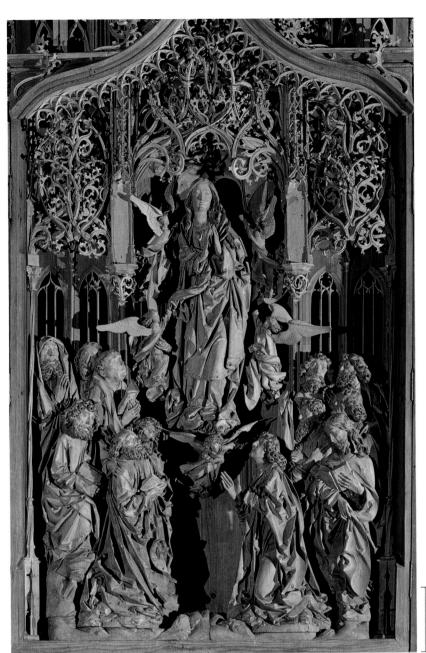

20-20 TILMAN RIEMENSCHNEIDER, Assumption of the Virgin, center panel of Creglingen Altarpiece, parish church, Creglingen, Germany, ca. 1495–1499. Lindenwood, 6' 1" wide.

Riemenschneider specialized in carving large wood retables. His works feature intricate Gothic tracery and religious figures whose bodies are almost lost within their swirling garments.

proved economy necessitated production of illustrated books on a grand scale, artists met the challenge of bringing the woodcut picture onto the same page as the letterpress.

MICHAELWOLGEMUT Theso-called*NurembergChronicle*, a history of the world produced in Nuremberg by ANTON KOBERGER (ca. 1445–1513) with more than 650 illustrations by the workshop of MICHAEL WOLGEMUT (1434–1519), documents this achievement. The hand-colored illustration (FIG. **20-21**) spread across two facing pages represents *Radeburga* (modern Radeberg, near Dresden). The blunt, simple lines of the woodcut technique give a detailed perspective of the city, its harbor and

Berta etas mudi

CLXXX

Refienfis in bonote fancti pauli. Octana bild caput fuit. Zer fuit. Becima fedes im in partbenopol uper comuni-softea ad vrefe. Zand e.pc opus prefuit fanctus Adelb nicij er quadrato tapita 8. Eredunt quog vnat fir 21 rpoffed m Gine narum vícine gentes recurrút, magna z ven perpulera Rolandi, quí carolí ex fozoze nep ecem in pzelio cú te bifpania vícta exercitio Roland ta exercitum in mpeftate fua co ti fama eft) tempe ceft 1R a fortia facta ne

Madeburga

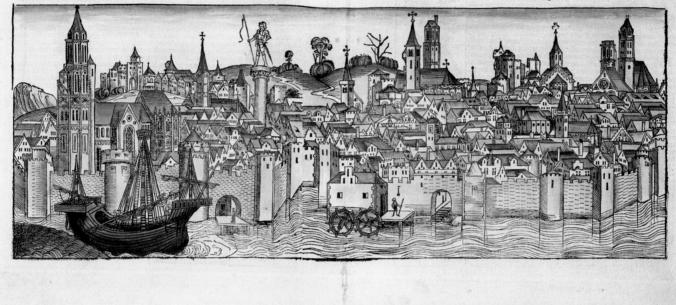

20-21 MICHAEL WOLGEMUT and shop, Radeburga page from the Nuremberg Chronicle, 1493. Woodcut. Printed by ANTON KOBERGER.

The Nuremberg Chronicle is an early example of woodcut illustrations in printed books. The more than 650 pictures include detailed views of towns, but they are generic rather than specific portrayals.

shipping, its walls and towers, its churches and municipal buildings, and the baronial castle on the hill. Despite the numerous architectural structures, historians cannot determine whether this illustration represents the artist's accurate depiction of the city or is the product of a fanciful imagination. Artists often reprinted the same image as illustrations of different cities, and this depiction of Radeburga is very likely a generic view. Regardless, the work is a monument to a new craft, which expanded in concert with the art of the printed book.

MARTIN SCHONGAUER The woodcut medium hardly had matured when the technique of engraving (see "Woodcuts, Engravings, and Etchings," page 556), begun in the 1430s and well developed by 1450, proved much more flexible. Predictably, in the second half of the century, engraving began to replace the woodcut process, for making both book illustrations and widely popular single prints.

MARTIN SCHONGAUER (ca. 1430-1491) was the most skilled and subtle 15th-century Northern Renaissance master of metal engraving. His Saint Anthony Tormented by Demons (FIG. 20-22) shows both the versatility of the medium and the artist's mastery

of it. The stoic saint is caught in a revolving thornbush of spiky demons, who claw and tear at him furiously. With unsurpassed skill and subtlety, Schongauer incised lines of varying thickness and density into a metal plate and created marvelous distinctions of tonal values and textures-from smooth skin to rough cloth, from the furry and feathery to the hairy and scaly. The use of cross-hatching (sets of engraved lines at right angles) to describe forms, which Schongauer probably developed, became standard among German graphic artists. The Italians preferred parallel hatching (FIG. 21-30) and rarely adopted cross-hatching, which, in keeping with the general Northern European approach to art, tends to describe the surfaces of things rather than their underlying structures.

Schongauer probably engraved Saint Anthony between 1480 and 1490. By then, the political geography of Europe had changed dramatically. Charles the Bold, who had assumed the title of duke of Burgundy in 1467, died in 1477, bringing to an end the Burgundian dream of forming a strong middle kingdom between France and the Holy Roman Empire. After Charles's death at the battle of Nancy, the French monarchy reabsorbed the southern Burgundian lands, and the Netherlands passed to the Holy Roman Empire

Woodcuts, Engravings, and Etchings

W ith the invention of moveable type in the 15th century and the new widespread availability of paper from commercial mills, the art of printmaking developed rapidly in Europe. A *print* is an artwork on paper, usually produced in multiple impressions. The set of prints an artist creates from a single print surface is called an *edition*. As with books manufactured on a press, the printmaking process involves the transfer of ink from a printing surface to paper. This can be accomplished in several ways. During the 15th and 16th centuries, artists most commonly used the *relief* and *intaglio* methods of printmaking.

Artists produce relief prints, the oldest and simplest of the printing methods, by carving into a surface, usually wood. Relief printing requires artists to conceptualize their images negatively— that is, they remove the surface areas around the images using a gouging instrument. Thus, when the printmaker inks the ridges that carry the design, the hollow areas remain dry, and a positive image results when the artist presses the printing block against paper. Because artists produce *woodcuts* through a subtractive process (removing parts of the material), it is difficult to create very thin, fluid, and closely spaced lines. As a result, woodcut prints (for example, FIGS. 20-21 and 20-21A) tend to exhibit stark contrasts and sharp edges.

In contrast to the production of relief prints, the intaglio method involves a positive process. The artist incises (cuts) an image on a metal plate, often copper. The image can be created on the plate manually (engraving or drypoint; for example, FIG. 20-22) using a tool (a burin or stylus) or chemically (etching; for example, FIG. 25-16). In the etching process, an acid bath eats into the exposed parts of the plate where the artist has drawn through an acid-resistant coating. When the artist inks the surface of the intaglio plate and wipes it clean, the ink is forced into the incisions. Then the artist runs the plate and paper through a roller press, and the paper absorbs the remaining ink, creating the print. Because the artist "draws" the image onto the plate, intaglio prints differ in character from relief prints. Engravings, drypoints, and etchings generally present a wider variety of linear effects, as is immediately evident in a comparison of the roughly contemporaneous woodcut of Tarvisium (FIG. 20-21) by Michael Wolgemut and Martin Schongauer's engraving of Saint Anthony Tormented by Demons (FIG. 20-22). Intaglio prints also often reveal to a greater extent evidence of the artist's touch, the result of the hand's changing pressure and shifting directions.

The paper and inks artists use also affect the finished look of the printed image. During the 15th and 16th centuries, European printmakers used papers produced from cotton and linen rags that papermakers mashed with water into a pulp. The papermakers then applied a thin layer of this pulp to a wire screen and allowed it to dry to create the paper. As contact with Asia increased, printmakers made greater use of what was called Japan paper (of mulberry fibers) and China paper. Artists, then as now, could select from a

20-22 MARTIN SCHONGAUER, Saint Anthony Tormented by Demons, ca. 1480–1490. Engraving, $1' \frac{1}{4}'' \times 9''$. Fondazione Magnani Rocca, Corte di Mamiano.

Schongauer was the most skilled of the early masters of metal engraving. By using a burin to incise lines in a copper plate, he was able to create a marvelous variety of tonal values and textures.

wide variety of inks. The type and proportion of the ink ingredients affect the consistency, color, and oiliness of inks, which various papers absorb differently.

Paper is lightweight, and the portability of prints has appealed to artists over the years. The opportunity to produce numerous impressions from the same print surface also made printmaking attractive to 15th- and 16th-century artists. In addition, prints can be sold at lower prices than paintings or sculptures. Consequently, prints reached a much wider audience than did one-of-a-kind artworks. The number and quality of existing 15th- and 16th-century European prints attest to the importance of the new print medium.

by virtue of the dynastic marriage of Charles's daughter, Mary of Burgundy (FIG. 20-16A), to Maximilian of Habsburg, inaugurating a new political and artistic era in northern Europe (see Chapter 23). The next two chapters, however, explore Italian developments in painting, sculpture, and architecture during the 15th and 16th centuries.

LATE MEDIEVAL AND EARLY RENAISSANCE NORTHERN EUROPE

BURGUNDY AND FLANDERS

- The most powerful rulers north of the Alps during the first three-quarters of the 15th century were the dukes of Burgundy. They controlled Flanders, which derived its wealth from wool and banking, and were great art patrons.
- Duke Philip the Bold (r. 1363–1404) endowed the Carthusian monastery at Champmol, near Dijon, which became a ducal mausoleum. He employed Claus Sluter, whose Well of Moses features innovative statues of prophets with portraitlike features and realistic costumes.
- Flemish painters popularized the use of oil paints on wood panels. By superimposing translucent glazes, they created richer colors than possible using tempera or fresco. One of the earliest examples of oil painting is Melchior Broederlam's *Retable de Champmol* (1339).
- A major art form in churches and private homes alike was the altarpiece with folding wings. In Robert Campin's *Mérode Altarpiece*, the *Annunciation* takes place in a Flemish home. The work's donors, depicted on the left wing, are anachronistically present as witnesses to the sacred event. Typical of "Northern Renaissance" painting, the everyday objects depicted often have symbolic significance.
- Jan van Eyck, Rogier van der Weyden, and others established portraiture as an important art form in 15th-century Flanders. Their subjects were successful businessmen, both Flemish and foreign, for example, the Italian financier Giovanni Arnolfini. Rogier's *Saint Luke Drawing the Virgin*, a celebration of the painter's craft, is probably a self-portrait.
- Among the other major Flemish painters were Petrus Christus and Hans Memling of Bruges, Dirk Bouts of Louvain, and Hugo van der Goes of Ghent, all of whom produced both altarpieces for churches and portraits for the homes of wealthy merchants. Hugo achieved such renown that he won a commission to paint an altarpiece for a church in Florence. The Italians marveled at the Flemish painter's masterful technique and extraordinary realism.

FRANCE

- During the 15th century, the Hundred Years' War crippled the French economy, but dukes and members of the royal court still commissioned some notable artworks.
- The Limbourg brothers expanded the illusionistic capabilities of manuscript illumination in the Book of Hours they produced for Jean, duke of Berry (r. 1360–1416) and brother of King Charles V (r. 1364–1380). Their full-page calendar pictures alternately represent the nobility and the peasantry, always in seasonal, naturalistic settings with realistically painted figures.
- French court art—for example, Jean Fouquet's *Melun Diptych*—owes a large debt to Flemish painting in style and technique as well as in the integration of sacred and secular themes.

HOLY ROMAN EMPIRE

- The Late Gothic style remained popular in 15th-century Germany for large carved wooden retables featuring highly emotive figures amid Gothic tracery.
- The major German innovation of the 15th century was the development of the printing press, which publishers soon used to produce books with woodcut illustrations. Woodcuts are relief prints in which the artist carves out the areas around the lines to be printed.
- German artists were also the earliest masters of engraving. The intaglio technique allows for a wider variety of linear effects because the artist incises the image directly onto a metal plate.

Sluter, Well of Moses 1395-1406

Campin, Mérode Altarpiece, ca. 1425–1428

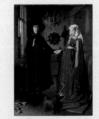

Van Eyck, Giovanni Arnolfini and His Wife, 1434

Limbourg brothers, *Les Très Riches Heures du Duc de Berry*, 1413–1416

Wolgemut, Nuremberg Chronicle, 1493

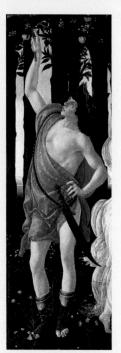

Mercury is the most enigmatic figure in Botticelli's lyrical painting celebrating love in springtime, probably a commemoration of the May 1482 wedding of Lorenzo di Pierfrancesco de' Medici.

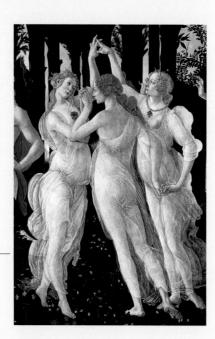

The dancing Three Graces closely resemble ancient prototypes Botticelli must have studied, but in 15th-century Florence, the Graces are clothed, albeit in thin, transparent garments.

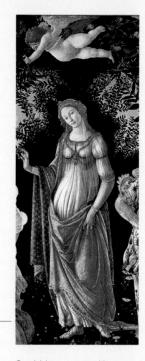

Cupid hovers over Venus, the central figure in this mythological allegory. The sky seen through the opening in the landscape behind Venus forms a kind of halo around the goddess of love's head.

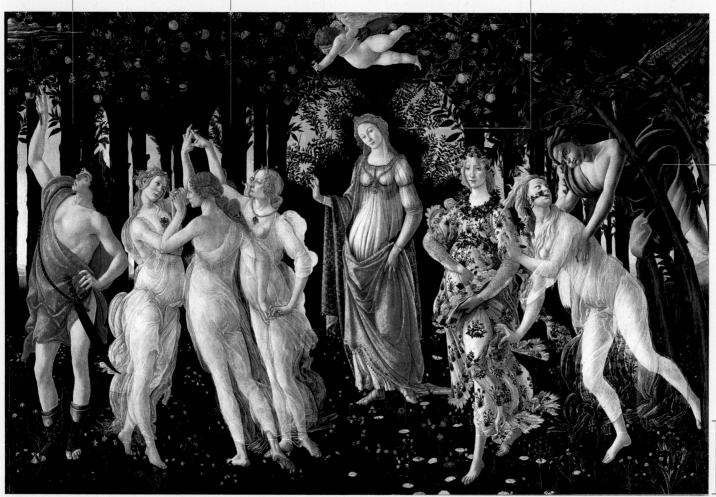

21-1 SANDRO BOTTICELLI, Primavera, ca. 1482. Tempera on wood, 6' 8" × 10' 4". Galleria degli Uffizi, Florence. ■4

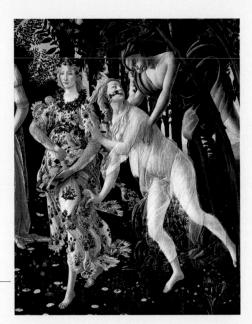

The blue ice-cold Zephyrus, the west wind, carries off and marries the nymph Chloris, whom he transforms into Flora, goddess of spring, appropriately shown wearing a rich floral gown.

21

THE RENAISSANCE IN QUATTROCENTO ITALY

MEDICI PATRONAGE AND CLASSICAL LEARNING

The Medici family of Florence has become synonymous with the extraordinary cultural phenomenon called the Italian Renaissance. By early in the 15th century (the '400s, or *Quattrocento* in Italian), the banker Giovanni di Bicci de' Medici (ca. 1360–1429) had established the family fortune. His son Cosimo (1389–1464) became a great patron of art and of learning in the broadest sense. For example, Cosimo provided the equivalent of \$20 million to establish the first public library since the ancient world. Cosimo's grandson Lorenzo (1449–1492), called "the Magnificent," was a member of the Platonic Academy of Philosophy and gathered about him a galaxy of artists and gifted men in all fields. He spent lavishly on buildings, paintings, and sculptures. Indeed, scarcely a single great Quattrocento architect, painter, sculptor, philosopher, or humanist scholar failed to enjoy Medici patronage.

Of all the Florentine masters the Medici employed, perhaps the most famous today is SANDRO BOTTICELLI (1444–1510). His work is a testament to the intense interest that the Medici and Quattrocento humanist scholars and artists had in the art, literature, and mythology of the Greco-Roman world—often interpreted by writers, painters, and sculptors alike in terms of Christianity according to the philosophical tenets of Neo-Platonism.

Botticelli painted *Primavera* (*Spring*; FIG. **21-1**) for Lorenzo di Pierfrancesco de' Medici (1463–1503), one of Lorenzo the Magnificent's cousins. Venus stands just to the right of center with her son Cupid hovering above her head. Botticelli drew attention to Venus by opening the landscape behind her to reveal a portion of sky that forms a kind of halo around the goddess of love's head. To her right, seemingly the target of Cupid's arrow, are the dancing Three Graces, based closely on ancient prototypes but clothed, albeit in thin, transparent garments. At the right, the blue ice-cold Zephyrus, the west wind, is about to carry off and marry the nymph Chloris, whom he transforms into Flora, goddess of spring, appropriately shown wearing a rich floral gown. At the far left, the enigmatic figure of Mercury turns away from all the others and reaches up with his distinctive staff, the *caduceus*, perhaps to dispel storm clouds. The sensuality of the representation, the appearance of Venus in springtime, and the abduction and marriage of Chloris all suggest the occasion for the painting was young Lorenzo's wedding in May 1482. But the painting also sums up the Neo-Platonists' view that earthly love is compatible with Christian theology. In their reinterpretation of classical mythology, Venus as the source of love provokes desire through Cupid. Desire can lead either to lust and violence (Zephyr) or, through reason and faith (Mercury), to the love of God. *Primavera*, read from right to left, served to urge the newlyweds to seek God through love.

RENAISSANCE HUMANISM

The humanism Petrarch and Boccaccio promoted during the 14th century (see Chapter 14) fully blossomed in the 15th century. Increasingly, Italians in elite circles embraced the tenets underlying humanism—an emphasis on education and on expanding knowledge (especially of classical antiquity), the exploration of individual potential and a desire to excel, and a commitment to civic responsibility and moral duty. Quattrocento Italy also enjoyed an abundance of artistic talent. The fortunate congruence of artistic genius, the spread of humanism, and economic prosperity nourished the Renaissance, forever changing the direction and perception of art in the Western world.

For the Italian humanists, the quest for knowledge began with the legacy of the Greeks and Romans—the writings of Socrates, Plato, Aristotle, Ovid, and others. The development of a literature based on the commonly spoken Tuscan dialect expanded the audience for humanist writings. Further, the invention of moveable metal type in Germany around 1445 (see Chapter 20) facilitated the printing and wide distribution of books. Italians enthusiastically embraced this new printing process. By 1464, Subiaco (near Rome) boasted a press, and by 1469, Venice had established one as well. Among the first books printed in Italy using these new presses was Dante's *Divine Comedy*, his vernacular epic about Heaven, Purgatory, and Hell. The production of editions in Foligno (1472), Mantua (1472), Venice (1472), Naples (1477 and 1478–1479), and Milan (1478) testifies to the widespread popularity of Dante's work.

The humanists also avidly acquired information in a wide range of fields, including botany, geology, geography, optics, medicine, and engineering. Leonardo da Vinci's phenomenal expertise in many fields—from art and architecture to geology, aerodynamics, hydraulics, botany, and military science, among many others still defines the modern notion of the "Renaissance man." Humanism also fostered a belief in individual potential and encouraged individual achievement, as well as civic responsibility. Whereas people in medieval society accorded great power to divine will in determining the events that affected lives, those in Renaissance Italy adopted a more secular stance. Humanists not only encouraged individual improvement but also rewarded excellence with fame and honor. Achieving and excelling through hard work became moral imperatives.

first Renaissance building

Quattrocento Italy witnessed constant fluctuations in its political and economic spheres, including shifting power relations among the numerous city-states and the rise of princely courts (see "Italian Princely Courts," page 591). Condottieri (military leaders) with large numbers of mercenary troops at their disposal played a major role in the ongoing struggle for power. Princely courts, such as those in Urbino and Mantua, emerged as cultural and artistic centers alongside the great art centers of the 14th century, especially the Republic of Florence. The association of humanism with education and culture appealed to accomplished individuals of high status, and humanism had its greatest impact among the elite and powerful, whether in the republics or the princely courts. These individuals were in the best position to commission art. As a result, humanist ideas came to permeate Italian Renaissance art. The intersection of art with humanist doctrines during the Renaissance is evident in the popularity of subjects selected from classical history or mythology (for example, FIG. 21-1); in the increased concern with developing perspective systems and depicting anatomy accurately; in the revival of portraiture and other self-aggrandizing forms of patronage; and in citizens' extensive participation in civic and religious art commissions.

FLORENCE

Because high-level patronage required significant accumulated wealth, those individuals, whether princes or merchants, who had managed to prosper came to the fore in artistic circles. The best-known Italian Renaissance art patrons were the Medici of the Republic of Florence (see "Medici Patronage and Classical Learning," page 559), yet the earliest important artistic commission in 15th-century Florence (MAP **21-1**) was not a Medici project but rather a competition held by the Cathedral of Santa Maria del Fiore and sponsored by the city's guild of wool merchants.

Sculpture

In 1401, the cathedral's art directors held a competition to make bronze doors for the east portal of the Baptistery of San Giovanni (FIG. 12-27). Artists and public alike considered this commission particularly prestigious because the east entrance to the baptistery faced the cathedral (FIG. 14-18). The competition is historically

THE RENAISSANCE IN QUATTROCENTO ITALY

1400	142!	5 1	450 1	1475	1500
Ghiberti wins to design new Florence's ba		Ghiberti installs the <i>Gates</i> of <i>Paradise</i> facing Florence Cathedral	Federico da Montefeltro brings Piero della Francesca to the Urbino court	Botticelli paints Neo-Platonic mythological allegories for the Medici	
 Nanni di Ban and others cr Or San Miche Masaccio car naturalism fu 	eate statues for ele ries Giotto's	 Donatello revives freestanding nude male statuary Michelozzo builds the new Medici palace in Florence Alberti publishes his treatise 	 Alberti designs palaces and churches in Florence and Mantua Mantegna creates illusionistic paintings for the Camera Picta 	 Alberti publishes his treatise on architecture Pope Sixtus IV employs leading painters to decorate the Sistine Chapel 	
perspective a	apel develops linear nd designs the li Innocenti, the	on painting	in Mantua	I Savonarola condemns humanism and the Medici flee Florence	

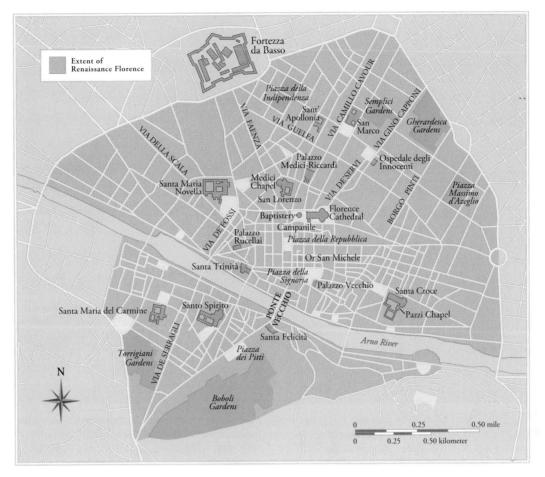

MAP 21-1 Renaissance Florence.

important not only for the quality of the work submitted by those seeking the commission but also because it already showcased several key elements associated with mature Renaissance art: personal or, in this case, guild patronage as both a civic imperative and a form of self-promotion; the esteem accorded to individual artists; and the development of a new pictorial illusionism.

SACRIFICE OF ISAAC Between 1330 and 1335, Andrea Pisano had designed the south doors (FIG. 14-19) of the baptistery. The jurors of the 1401 competition for the second set of doors required each entrant to submit a relief panel depicting the sacrifice of Isaac in a similar French Gothic quatrefoil frame. This episode from the book of Genesis centers on God's order to Abraham to sacrifice his son Isaac as a demonstration of Abraham's devotion (see "Jewish Subjects in Christian Art," Chapter 8, page 238). As Abraham was about to comply, an angel intervened and stopped him from plunging the knife into his son's throat. Because of the parallel between Abraham's willingness to sacrifice Isaac and God's sacrifice of his son Jesus to redeem humankind, Christians viewed the sacrifice of Isaac as a prefiguration (prophetic forerunner) of Jesus' crucifixion. Both refer to covenants (binding agreements between God and humans), and given that the sacrament of baptism initiates the newborn or the convert into these covenants, Isaac's sacrifice was an appropriate choice for baptistery doors.

Contemporary developments, however, may also have been an important factor in the selection of this theme. In the late 1390s, Giangaleazzo Visconti, the first duke of Milan (r. 1378–1395), began a military campaign to take over the Italian peninsula. By 1401, when the cathedral's art directors initiated the baptistery doors competition, Visconti's troops had surrounded Florence, and its independence was in serious jeopardy. Despite dwindling water and food supplies, Florentine officials exhorted the public to defend the city's freedom. For example, the humanist chancellor Coluccio Salutati (1331–1406) urged his fellow citizens to adopt the republican ideal of civil and political liberty associated with ancient Rome and to identify themselves with its spirit. To be a citizen of the Florentine Republic was to be Roman. Freedom was the distinguishing virtue of both societies. The story of Abraham and Isaac, with its theme of sacrifice, paralleled the message Florentine officials had conveyed to rally the public's support. The wool merchants, asserting both their preeminence among Florentine guilds and their civic duty, may have selected the biblical subject with this in mind. The Florentines' reward for their faith and sacrifice came in 1402, when Visconti died suddenly, ending the invasion threat.

BRUNELLESCHI AND GHIBERTI The jury selected seven semifinalists from among the many artists who entered the widely advertised competition. Only the panels of the two finalists, FILIPPO BRUNELLESCHI (1377–1446) and LORENZO GHIBERTI (1378–1455), have survived. As instructed, both artists used the same Frenchstyle frames Andrea Pisano had used for the south doors (FIG. 14-19) and depicted the same moment of the narrative—the angel's interruption of the action. Brunelleschi's entry (FIG. **21-2**) is a vigorous interpretation of the theme and recalls the emotional agitation of Giovanni Pisano's relief sculptures (FIG. 14-4). Abraham seems suddenly to have summoned the dreadful courage needed to murder his son at God's command. He lunges forward, robes flying, and exposes Isaac's throat to the knife. Matching Abraham's energy, the saving angel flies in from the left, grabbing Abraham's arm to stop the killing. Brunelleschi's figures demonstrate his

21-2 FILIPPO BRUNELLESCHI, Sacrifice of Isaac, competition panel for east doors of the Baptistery of San Giovanni, Florence, Italy, 1401–1402. Gilded bronze, 1' 9" × 1' $5\frac{1}{2}$ ". Museo Nazionale del Bargello, Florence.

Brunelleschi's entry in the competition to create new bronze doors for the Florentine baptistery shows a frantic angel about to halt an emotional, lunging Abraham clothed in swirling Gothic robes.

21-3 LORENZO GHIBERTI, Sacrifice of Isaac, competition panel for east doors of the Baptistery of San Giovanni, Florence, Italy, 1401–1402. Gilded bronze, $1' 9'' \times 1' 5\frac{1}{2}''$. Museo Nazionale del Bargello, Florence.

In contrast to Brunelleschi's panel (FIG. 21-2), Ghiberti's entry in the baptistery competition features gracefully posed figures that recall classical statuary. Isaac's altar has a Roman acanthus frieze.

ability to represent faithfully and dramatically all the elements in the biblical narrative.

Whereas Brunelleschi imbued his image with violent movement and high emotion, Ghiberti, the youngest artist in the competition, emphasized grace and smoothness. In Ghiberti's panel (FIG. 21-3), Abraham appears in a typically Gothic pose with outthrust hip (compare FIG. 13-26) and seems to contemplate the act he is about to perform, even as he draws back his arm to strike. The figure of Isaac, beautifully posed and rendered, recalls Greco-Roman statuary and could be regarded as the first classical nude since antiquity. (Compare, for example, the torsion of Isaac's body and the dramatic turn of his head with the posture of the Hellenistic statue of a Gaul plunging a sword into his own chest, FIG. 5-80). Unlike his medieval predecessors, Ghiberti revealed a genuine appreciation of the nude male form and a deep interest in how the muscular system and skeletal structure move the human body. Even the altar on which Isaac kneels displays Ghiberti's emulation of antique models. Decorating it are acanthus scrolls of a type that commonly adorned Roman temple friezes in Italy and throughout the former Roman Empire (for example, FIG. 7-32). These classical references reflect the influence of humanism in Quattrocento Italy. Ghiberti's entry in the baptistery competition is also noteworthy for the artist's interest in spatial illusion. The rocky landscape seems to emerge from the blank panel toward the viewer, as does the strongly foreshortened angel. Brunelleschi's image, in contrast, emphasizes the planar orientation of the surface.

Ghiberti's training included both painting and metalwork. His careful treatment of the gilded bronze surfaces, with their sharply and accurately incised detail, proves his skill as a goldsmith. That Ghiberti cast his panel in only two pieces (thereby reducing the amount of bronze needed) no doubt also impressed the selection committee. Brunelleschi's panel consists of several cast pieces. Thus, not only would Ghiberti's doors, as proposed, be lighter and more impervious to the elements, but they also represented a significant cost savings. The younger artist's submission clearly had much to recommend it, both stylistically and technically, and the judges awarded the commission to him. Ghiberti's pride in winning the competition is evident in his description of the award, which also reveals the fame and glory increasingly accorded to individual achievement in 15th-century Italy:

To me was conceded the palm of the victory by all the experts and by all who had competed with me. To me the honor was conceded universally and with no exception. To all it seemed that I had at that time surpassed the others without exception, as was recognized by a great council and an investigation of learned men.... There were thirty-four judges from the city and the other surrounding countries. The testimonial of the victory was given in my favor by all.¹

OR SAN MICHELE A second major Florentine sculptural project of the early 1400s was the sculptural decoration of the exterior of Or San Michele, an early-14th-century building prominently located on the main street connecting the Palazzo della Signoria

(FIG. 14-18B; seat of the Signoria, Florence's governing body) and the cathedral (MAP 21-1). At various times, Or San Michele housed a church, a granary, and the headquarters of Florence's guilds. City officials had assigned niches on the building's four sides to specific guilds, instructing each guild to place a statue of its patron saint in its niche. Nearly a century after completion of Or San Michele, however, the guilds had filled only 5 of the 14 niches. In 1406, the Signoria issued a dictum requiring the guilds to comply with the original plan to embellish their assigned niches. A few years later, Florence was once again under siege, this time by King Ladislaus (r. 1399-1414) of Naples. Ladislaus had marched north, occupied Rome and the Papal States (MAP 14-1) by 1409, and threatened to overrun Florence. As they had done when Visconti was at the republic's doorstep, Florentine officials urged citizens to stand firm and defend their city-state from tyranny. Once again, Florence escaped unscathed. Ladislaus, on the verge of military success in 1414, fortuitously died. The guilds may well have viewed this new threat as an opportunity to perform their civic duty by rallying their fellow Florentines while also promoting their own importance and position in Florentine society. By 1423, statues by Ghiberti and other leading Florentine artists were on display in the nine remaining niches of Or San Michele.

NANNI DI BANCO Among the niches filled during the Neapolitan king's siege was the one assigned to the Florentine guild of stone- and woodworkers. They chose a guild member, the sculptor NANNI DI BANCO (ca. 1380–1421), to create four life-size marble statues of the guild's martyred patron saints. These four Christian sculptors had defied an order from Emperor Diocletian (r. 284–305) to carve a statue of a Roman deity. In response, the emperor ordered them put to death. Because they placed their faith above all else, these saints were perfect role models for the 15th-century Florentines whom city leaders exhorted to stand fast in the face of Ladislaus's armies.

Nanni's sculptural group, Four Crowned Saints (FIG. 21-4), is an early Renaissance attempt to solve the problem of integrating figures and space on a monumental scale. The artist's positioning of the figures, which stand in a niche that is in but confers some separation *from* the architecture, furthered the gradual emergence of sculpture from its architectural setting. This process began with works such as the 13th-century statues (FIG. 13-24) on the jambs of the west facade portals of Reims Cathedral. At Or San Michele, the niche's spatial recess presented Nanni di Banco with a dramatic new possibility for the interrelationship of the figures. By placing them in a semicircle within their deep niche and relating them to one another by their postures and gestures, as well as by the arrangement of robes, the Quattrocento sculptor arrived at a unified spatial composition. A remarkable psychological unity also connects these unyielding figures, whose bearing expresses the discipline and integrity necessary to face adversity. As the figure on the right speaks, pointing to his right, the two men opposite listen and the one next to him looks out into space, pondering the meaning of the words and reinforcing the formal cohesion of the figural group with psychological cross-references.

In *Four Crowned Saints*, Nanni also displayed a deep respect for and close study of Roman portrait statues. The emotional intensity of the faces of the two inner saints owes much to the extraordinarily moving portrayals in stone of third-century Roman emperors (FIGS. 7-68 and 7-68A), and the bearded heads of the outer saints reveal a familiarity with second-century imperial portraiture (FIGS. 7-59 and 7-59A). Often, when Renaissance artists sought to

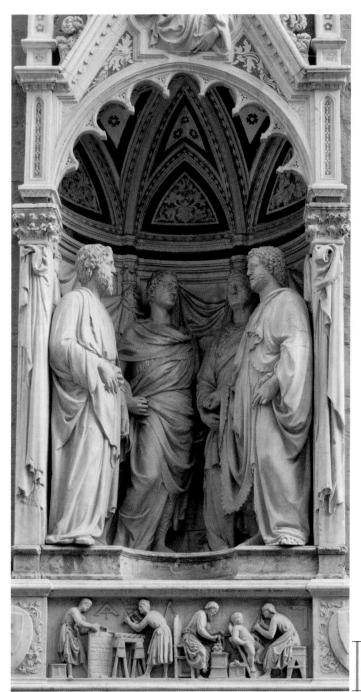

21-4 NANNI DI BANCO, *Four Crowned Saints*, Or San Michele, Florence, Italy, ca. 1410–1416. Marble, figures 6' high. Modern copy in exterior niche. Original sculpture in museum on second floor of Or San Michele, Florence. ■<

Nanni's group representing the four martyred patron saints of Florence's sculptors guild is an early example of Renaissance artists' attempt to liberate statuary from its architectural setting.

portray individual personalities, they turned to ancient Roman models for inspiration, but they did not simply copy them. Rather, they strove to interpret or offer commentary on their classical models in the manner of humanist scholars dealing with classical texts.

DONATELLO Another sculptor who carved statues for Or San Michele's niches was Donato di Niccolo Bardi, called DONATELLO (ca. 1386–1466), who incorporated Greco-Roman sculptural principles in his *Saint Mark* (FIG. **21-5**), executed for the guild of

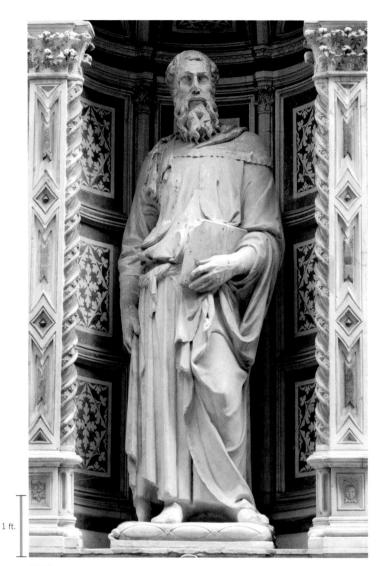

21-5 DONATELLO, Saint Mark, Or San Michele, Florence, Italy, ca. 1411–1413. Marble, figure 7' 9" high. Modern copy in exterior niche. Original sculpture in museum on second floor of Or San Michele, Florence. ■4

In this statue carved for the guild of linen makers and tailors, Donatello introduced classical contrapposto into Quattrocento sculpture. The drapery falls naturally and moves with the body.

linen makers and tailors. In this sculpture, Donatello took a fundamental step toward depicting motion in the human figure by recognizing the principle of weight shift, or contrapposto. Greek sculptors of the fifth century BCE were the first to grasp that the act of standing requires balancing the position and weight of the different parts of the human body, as they demonstrated in works such as Kritios Boy (FIG. 5-34) and Doryphoros (FIG. 5-40). In contrast to earlier sculptors, Greek artists recognized the human body is not a rigid mass but a flexible structure that moves by continuously shifting its weight from one supporting leg to the other, its constituent parts moving in consonance. Donatello reintroduced this concept into Renaissance statuary. As the saint's body "moves," his garment "moves" with it, hanging and folding naturally from and around different body parts so that the viewer senses the figure as a nude human wearing clothing, not as a stone statue with arbitrarily incised drapery. Donatello's Saint Mark is the first Renaissance statue whose voluminous robe (the pride of the Florentine guild that paid for the statue) does not conceal but

21-6 DONATELLO, *Saint George,* Or San Michele, Florence, Italy, ca. 1410–1415. Marble, figure 6′ 10″ high. Modern copy in exterior niche. Original statue in Museo Nazionale del Bargello, Florence. ■4

Donatello's statue for the armorers guild once had a bronze sword and helmet. The warrior saint stands defiantly, ready to spring from his niche to defend Florence, his sword pointed at the spectator.

accentuates the movement of the arms, legs, shoulders, and hips. This development further contributed to the sculpted figure's independence from its architectural setting. Saint Mark's stirring limbs, shifting weight, and mobile drapery suggest impending movement out of the niche.

SAINT GEORGE For the Or San Michele niche of the guild of armorers and swordmakers, Donatello made a statue of *Saint George* (FIG. **21-6**). The saintly knight stands proudly with his shield in front of him. He once held a bronze sword in his right hand and wore a bronze helmet on his head, both fashioned by the sponsoring guild. The statue continues the Gothic tradition of depicting warrior saints on church facades, as seen in the statue of Saint Theodore (FIG. 13-18) on the westernmost jamb of the south *transept* portal of Chartres Cathedral, but here it has a civic role to play. Saint George stands in a defiant manner—ready to spring from his niche to defend Florence against attack from another Visconti or Ladislaus, his sword jutting out threateningly at all

21-7 DONATELLO, Saint George and the Dragon, relief below the statue of Saint George (FIG. 21-6), Or San Michele, Florence, Italy, ca. 1417. Marble, $1' 3\frac{1''}{4} \times 3' 11\frac{1}{4}''$. Modern copy on exterior of Or San Michele. Original relief in Museo Nazionale del Bargello, Florence.

Donatello's relief marks a turning point in Renaissance sculpture. He took a painterly approach, creating an atmospheric effect by using incised lines. The depth of the background cannot be measured.

passersby. The saint's body is taut, and Donatello gave him a face filled with nervous energy.

Directly below the statue's base is Donatello's marble relief representing *Saint George and the Dragon* (FIG. **21-7**). Commissioned about two years after the sculptor installed his statue in the niche, the relief marks a turning point in Renaissance sculpture. Even the landscapes in the baptistery competition reliefs (FIGS. 21-2 and 21-3) are modeled forms seen against a blank background. In *Saint George and the Dragon*, Donatello created an atmospheric effect by using incised lines. It is impossible to talk about a background plane in this work. The landscape recedes into distant space, and the depth of that space cannot be measured. The sculptor conceived the relief as a window onto an infinite vista.

FEAST OF HEROD Donatello's mastery of relief sculpture is also evident in Feast of Herod (FIG. 21-8), a bronze relief on the baptismal font in Siena Cathedral. Some of the figures, especially the dancing Salome (to the right), derive from classical reliefs, but nothing in Greco-Roman art can match the illusionism of Donatello's rendition of this biblical scene. In Donatello's relief, Salome has already delivered the severed head of John the Baptist, which the kneeling executioner offers to King Herod. The other figures recoil in horror in two groups. At the right, one man covers his face with his hand. At the left, Herod and two terrified children shrink back in dismay. The psychic explosion drives the human elements apart, leaving a gap across which the emotional electricity crackles. This masterful stagecraft obscures another drama Donatello was playing out on the stage itself. His Feast of Herod marks the introduction of rationalized perspective in Renaissance art. As in Saint George and the Dragon (FIG. 21-7), Donatello opened the space of the action well into the distance. But here he employed the new mathematically based science of linear perspective to depict two arched courtyards and the groups of attendants in the background.

RENAISSANCE PERSPECTIVE In the 14th century, Italian artists, such as Giotto, Duccio, and the Lorenzetti brothers, had used several devices to indicate distance, but with the development of *linear perspective*, Quattrocento artists acquired a way to make the illusion of distance certain and consistent (see "Linear and Atmospheric Perspective," page 567). In effect, they conceived the picture plane as a transparent window through which the observer looks to see the constructed pictorial world. This discovery was enormously important, for it made possible what has been called the "rationalization of sight." It brought all random and infinitely various visual sensations under a simple rule that could be expressed mathematically. Indeed, Renaissance artists' interest in linear perspective reflects the emergence at this time of modern science itself. Of course, 15th-century artists were not primarily scientists. They simply found perspective an effective way to order and clarify their compositions. Nonetheless, there can be little doubt that linear perspective, with its new mathematical certitude, conferred a kind of aesthetic legitimacy on painting by making the picture measurable and exact. The projection of measurable objects on flat surfaces not only influenced the character of Renaissance paintings but also made possible scale drawings, maps, charts, graphs, and diagrams—means of exact representation that laid the foundation for modern science and technology.

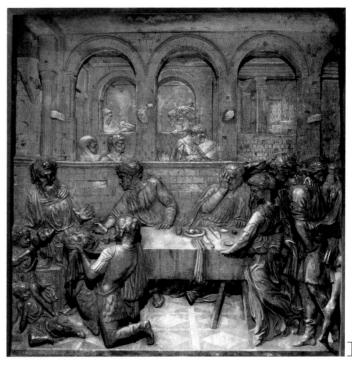

21-8 DONATELLO, *Feast of Herod*, panel on the baptismal font of Siena Cathedral, Siena, Italy, 1423–1427. Gilded bronze, $1' 11\frac{1''}{2} \times 1' 11\frac{1''}{2}$.

Donatello's *Feast of Herod* marked the introduction of rationalized perspective space in Renaissance relief sculpture. Two arched courtyards of diminishing size open the space of the action into the distance.

21-9 LORENZO GHIBERTI, east doors (*Gates of Paradise*), Baptistery of San Giovanni, Florence, Italy, 1425–1452. Gilded bronze, 17' high. Modern replica, 1990. Original panels in Museo dell'Opera del Duomo, Florence. ■•

In Ghiberti's later doors for the Florentine baptistery, the sculptor abandoned the Gothic quatrefoil frames for the biblical scenes (compare FIG. 21-3) and employed painterly illusionistic devices.

The inventor (or rediscoverer) of linear perspective was Filippo Brunelleschi. In his biography of the Florentine artist, written around 1480, Antonio Manetti (1423–1497) emphasized the importance of the scientific basis of Brunelleschi's system:

[Filippo Brunelleschi] propounded and realized what painters today call perspective, since it forms part of that science which, in effect, consists of setting down properly and rationally the reductions and enlargements of near and distant objects as perceived by the eye of man: buildings, plains, mountains, places of every sort and location, with figures and objects in correct proportion to the distance in which they are shown. He originated the rule that is essential to whatever has been accomplished since his time in that area. We do not know whether centuries ago the ancient painters . . . knew about perspective or employed it rationally. If indeed they employed it by rule (I did not previously call it a science without reason) as he did later, . . . [no] records about it have been discovered. . . . Through industry and intelligence [Brunelleschi] either rediscovered or invented it.2

GATES OF PARADISE Lorenzo Ghiberti, Brunelleschi's chief rival in the baptistery competition, was, with Donatello, among the first artists to embrace Brunelleschi's unified system for representing space. Ghiberti's enthusiasm for perspective illusion is on display in the new east doors (FIG. **21-9**) for Florence's baptistery (FIG. 12-27), which the cathedral officials commissioned him to make in 1425. Ghiberti's patrons moved his first pair of doors to the north entrance to make room for the new ones they commissioned him to make for the prestigious east side. Michelangelo later declared Ghiberti's second doors as "so beautiful that they would

do well for the gates of Paradise."³ In the *Gates of Paradise*, as the doors have been called since then, Ghiberti abandoned the quatrefoil frames of Andrea Pisano's south doors (FIG. 14-19) and his own earlier doors and reduced the number of panels from 28 to 10. Each panel contains a relief set in plain molding and depicts an episode from the Old Testament. The complete gilding of the reliefs creates an effect of great splendor and elegance.

The individual panels, such as *Isaac and His Sons* (FIG. **21-10**), clearly recall painting techniques in their depiction of space as well as in their treatment of the narrative. Some exemplify more fully than painting many of the principles the architect and theorist Leon Battista Alberti formulated in his 1435 treatise, *On Painting*. In his relief, Ghiberti created the illusion of space partly through the use of linear perspective and partly by sculptural means. He

Linear and Atmospheric Perspective

S cholars long have noted the Renaissance fascination with perspective. In essence, portraying perspective involves constructing a convincing illusion of space in two-dimensional imagery while unifying all objects within a single spatial system. Renaissance artists were not the first to focus on depicting illusionistic space. Both the Greeks and the Romans were well versed in perspective rendering. Many frescoes of buildings and colonnades (for example, FIG. 7-19, *right*) using a Renaissance-like system of converging lines adorn the walls of Roman houses. However, the Renaissance rediscovery of and interest in perspective contrasted sharply with the portrayal of space during the Middle Ages, when spiritual concerns superseded the desire to depict objects illusionistically.

Renaissance knowledge of perspective included both *linear* perspective and *atmospheric perspective*.

Linear perspective. Developed by Filippo Brunelleschi, linear perspective enables artists to determine mathematically the relative size of rendered objects to correlate them with the visual recession into space. The artist first must identify a horizontal line that marks, in the image, the horizon in the distance (hence the

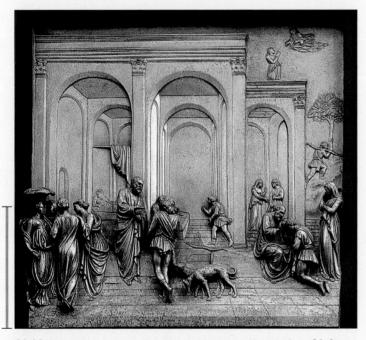

1 ft.

21-10 LORENZO GHIBERTI, *Isaac and His Sons* (detail of FIG. 21-9), east doors (*Gates of Paradise*), Baptistery of San Giovanni, Florence, Italy, 1425–1452. Gilded bronze, 2' $7\frac{1}{2}$ " × 2' $7\frac{1}{2}$ ". Museo dell'Opera del Duomo, Florence.

In this relief, Ghiberti employed linear perspective to create the illusion of distance, but he also used sculptural aerial perspective, with forms appearing less distinct the deeper they are in space. term *horizon line*). The artist then selects a *vanishing point* on that horizon line (often located at the exact center of the line). By drawing *orthogonals* (diagonal lines) from the edges of the picture to the vanishing point, the artist creates a structural grid that organizes the image and determines the size of objects within the image's illusionistic space. Among the works that provide clear examples of linear perspective are Ghiberti's *Isaac and His Sons* (FIGS. 21-10 and 21-11), Masaccio's *Holy Trinity* (FIG. 21-21), and Perugino's *Christ Delivering the Keys of the Kingdom to Saint Peter* (FIG. 21-41).

Atmospheric perspective. Unlike linear perspective, which relies on a structured mathematical system, atmospheric perspective involves optical phenomena. Artists using atmospheric perspective (sometimes called *aerial perspective*) exploit the principle that the farther back the object is in space, the blurrier, less detailed, and bluer it appears. Further, color saturation and value contrast diminish as the image recedes into the distance. Leonardo da Vinci used atmospheric perspective to great effect in works such as *Madonna of the Rocks* (FIG. 22-2) and *Mona Lisa* (FIG. 22-5).

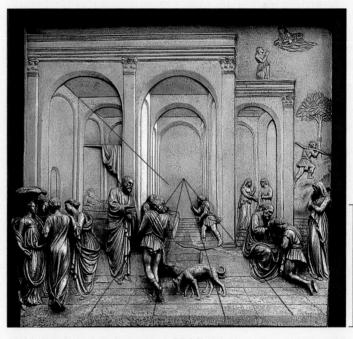

21-11 Perspective diagram of FIG. 21-10. ■

All of the orthogonals of the floor tiles in this early example of linear perspective converge on a vanishing point on the central axis of the composition, but the orthogonals of the architecture do not.

represented the pavement on which the figures stand according to a painter's vanishing-point perspective construction (see "Linear and Atmospheric Perspective," above, and FIG. **21-11**), but the figures themselves appear almost fully in the round. In fact, some of their heads stand completely free. As the eye progresses upward, the relief increasingly flattens, concluding with the architecture in the background, which Ghiberti depicted using barely raised lines. In this manner, the artist created a sort of sculptor's atmospheric perspective, with forms appearing less distinct the deeper they are in space. Regardless of the height of the reliefs, however, the size 1 ft

of each figure decreases in exact correspondence to its distance from the foreground, just as do the dimensions of the floor tiles, as specified in Alberti's treatise.

Ghiberti described the baptistery's east doors as follows:

I strove to imitate nature as closely as I could, and with all the perspective I could produce [to have] excellent compositions rich with many figures. In some scenes I placed about a hundred figures, in some less, and in some more. . . . There were ten stories, all [sunk] in frames because the eye from a distance measures and interprets the scenes in such a way that they appear round. The scenes are in the lowest relief and the figures are seen in the planes; those that are near appear large, those in the distance small, as they do in reality. I executed this entire work with these principles.⁴

In the reliefs of the Gates of Paradise, Ghiberti achieved a greater sense of depth than had previously seemed possible in sculpture. His principal figures do not occupy the architectural space he created for them. Rather, the artist arranged them along a parallel plane in front of the grandiose architecture. (According to Leon Battista Alberti, in his On the Art of Building, the grandeur of the architecture reflects the dignity of the events shown in the foreground.) Ghiberti's figure style mixes a Gothic patterning of rhythmic line, classical poses and motifs, and a new realism in characterization, movement, and surface detail. Ghiberti retained the medieval narrative method of presenting several episodes within a single frame. In Isaac and His Sons, the women in the left foreground attend the birth of Esau and Jacob in the left background. In the central foreground, Isaac sends Esau and his dogs to hunt game. In the right foreground, Isaac blesses the kneeling Jacob as Rebecca looks on. Yet viewers experience little confusion because of Ghiberti's careful and subtle placement of each scene. The figures, in varying degrees of projection, gracefully twist and turn, appearing to occupy and move through a convincing stage space, which Ghiberti deepened by showing some figures from behind. The classicism derives from the artist's close study of ancient art. Ghiberti admired and collected classical sculpture, bronzes, and coins. Their influence appears throughout the panel, particularly in the figure of Rebecca, which Ghiberti based on a popular Greco-Roman statuary type. The emerging practice of collecting classical art in the 15th century had much to do with the incorporation of classical motifs and the emulation of classical style in Renaissance art.

DONATELLO, DAVID The use of perspective systems in relief sculpture and painting represents only one aspect of the Renaissance revival of classical principles and values in the arts. Another was the revival of the freestanding nude statue. The first Renaissance sculptor to portray the nude male figure in statuary was Donatello. He probably cast his bronze David (FIG. 21-12) sometime between 1440 and 1460 for display in the courtyard (FIG. 21-38) of the Medici palace in Florence. In the Middle Ages, the clergy regarded nude statues as both indecent and idolatrous, and nudity in general appeared only rarely in art-and then only in biblical or moralizing contexts, such as the story of Adam and Eve or depictions of sinners in Hell. With David, Donatello reinvented the classical nude. His subject, however, was not a Greco-Roman god, hero, or athlete but the youthful biblical slayer of Goliath who had become the symbol of the Florentine Republic-and therefore an ideal choice of subject for the residence of the most powerful family in Florence. The Medici were aware of Donatello's earlier David in Florence's town hall (FIG. 14-18B), which the artist had produced during the threat of invasion by King Ladislaus. Their selection

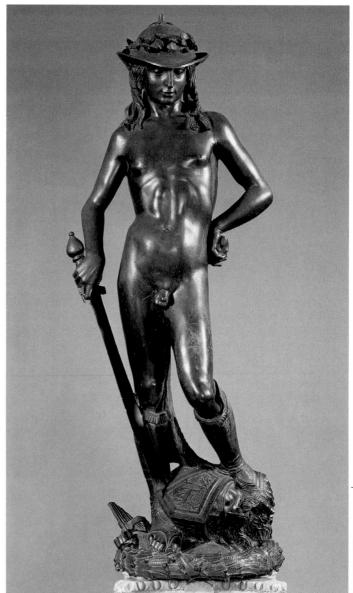

1 ft

21-12 DONATELLO, *David*, ca. 1440–1460. Bronze, 5' $2\frac{1}{4}$ " high. Museo Nazionale del Bargello, Florence.

Donatello's *David* possesses both the relaxed contrapposto and the sensuous beauty of nude Greek gods (FIG. 5-63). The revival of classical statuary style appealed to the sculptor's patrons, the Medici.

of the same subject suggests the Medici identified themselves with Florence or, at the very least, saw themselves as responsible for Florence's prosperity and freedom. The invoking of classical poses and formats also appealed to the Medici as humanists. Donatello's *David* possesses both the relaxed classical contrapposto stance and the proportions and sensuous beauty of the gods (FIG. 5-63) of Praxiteles, a famous Greek sculptor. These qualities were, not surprisingly, absent from medieval figures—and they are also lacking, for different

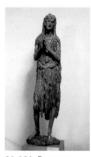

21-12A DONATELLO, Penitent Mary Magdalene, ca. 1455.

reasons, in Donatello's depiction of the aged Mary Magdalene. The contrast between the sculptor's *David* and his *Penitent Mary Mag-dalene* (FIG. **21-12A**) demonstrates the extraordinary versatility of this Florentine master.

21-13 ANDREA DEL VERROCCHIO, *David*, ca. 1465–1470. Bronze, 4' $1\frac{1}{2}$ " high. Museo Nazionale del Bargello, Florence.

Verrocchio's *David*, also made for the Medici, displays a brash confidence. The statue's narrative realism contrasts strongly with the quiet classicism of Donatello's *David* (FIG. 21-12).

VERROCCHIO Another David (FIG. 21-13), by ANDREA DEL VERROCCHIO (1435-1488), one of the most important sculptors during the second half of the 15th century, reaffirms the Medici family's identification with the heroic biblical king and with Florence. A painter as well as a sculptor, Verrocchio directed a flourishing bottega (studio-shop) in Florence that attracted many students, among them Leonardo da Vinci. Verrocchio's David contrasts strongly in its narrative realism with the quiet classicism of Donatello's David. Verrocchio's hero is a sturdy, wiry young apprentice clad in a leather doublet who stands with a jaunty pride. As in Donatello's version, Goliath's head lies at David's feet. He poses like a hunter with his kill. The easy balance of the weight and the lithe, still thinly adolescent musculature, with prominent veins, show how closely Verrocchio read the biblical text and how clearly he knew the psychology of brash young men. The Medici eventually sold Verrocchio's bronze David to the Florentine government

21-14 ANTONIO DEL POLLAIUOLO, *Hercules and Antaeus*, ca. 1470–1475. Bronze, 1' 6" high with base. Museo Nazionale del Bargello, Florence.

The Renaissance interest in classical culture led to the revival of Greco-Roman mythological themes in art. *Hercules and Antaeus* exhibits the stress and strain of the human figure in violent action.

for placement in the Palazzo della Signoria. After the expulsion of the Medici from Florence, civic officials appropriated Donatello's *David* for civic use and moved it to the city hall as well.

POLLAIUOLO As noted in the discussion of Botticelli's *Primavera* (FIG. 21-1), the Renaissance interest in classical culture naturally also led to the revival of Greco-Roman mythological themes in art. The Medici were Florence's leading patrons in this sphere as well. Around 1470, ANTONIO DEL POLLAIUOLO (ca. 1431–1498), who was also an important painter and engraver (FIG. 21-30), received a Medici commission to produce a small-scale sculpture, *Hercules and Antaeus* (FIG. **21-14**). The subject matter, derived from Greek mythology, and the emphasis on human anatomy reflect the Medici preference for humanist imagery. Even more specifically, the Florentine seal had featured Hercules since the end of the 13th century. As commissions such as the two *David* sculptures

demonstrate, the Medici clearly embraced every opportunity to associate themselves with the glory of the Florentine Republic and claimed much of the credit for its preeminence.

In contrast to the placid presentation of Donatello's David (FIG. 21-12), Pollaiuolo's Hercules and Antaeus exhibits the stress and strain of the human figure in violent action. This sculpture departs dramatically from the convention of frontality that had dominated statuary during the Middle Ages and the Early Renaissance. Not quite 18 inches high, Hercules and Antaeus embodies the ferocity and vitality of elemental physical conflict. The group illustrates the wrestling match between Antaeus (Antaios), a giant and son of the goddess Earth, and Hercules (Herakles), a theme the Greek painter Euphronios had represented on an ancient Greek vase (FIG. 5-23) 2,000 years before. According to the Greek myth, each time Hercules threw him down, Antaeus sprang up again, his strength renewed by contact with the earth. Finally, Hercules held him aloft-so Antaeus could not touch the ground-and strangled him around the waist. Pollaiuolo strove to convey the final excruciating moments of the struggle-the strained sinews of the combatants, the clenched teeth of Hercules, and the kicking and screaming of Antaeus. The figures intertwine and interlock as they fight, and the flickering reflections of light on the dark gouged bronze surface contribute to a fluid play of planes and the effect of agitated movement.

TOMB OF LEONARDO BRUNI Given the increased emphasis on individual achievement and recognition that humanism fostered, it is not surprising portraiture enjoyed a revival in the 15th century. In addition to likenesses of elite individuals made during their lifetime, commemorative portraits of the deceased were common in Quattrocento Italy, as in ancient Rome. Leonardo Bruni (1369-1444) of Arezzo was one of the leading Early Renaissance humanist scholars. Around 1403 he wrote a laudatio (essay of praise) in honor of Florence, celebrating the city as the heir of the ancient Roman Republic. His most ambitious work, published in 1429 when he served as Florence's chancellor (1427-1444), was a history of the Florentine Republic. When Bruni died on March 9, 1444, the Signoria ordered a state funeral "according to ancient custom," during which the eminent humanist Giannozzo Manetti (1396-1459) delivered the eulogy and placed a laurel wreath on the head of Bruni's toga-clad corpse. The Florentine government also commissioned BERNARDO ROSSELLINO (1409-1464) to carve a monumental tomb (FIG. 21-15) for the right wall of the nave of Santa Croce (FIG. 1-4) honoring the late chancellor. Rossellino was the most prominent member of a family of stonecutters from Settignano, a town near Florence noted for its quarries.

Rossellino's monument in honor of Leonardo Bruni established the wall tomb as a major genre of Italian Renaissance sculpture. (Later examples include Michelangelo's tombs of the Medici [FIG. 22-16] in Florence and of Pope Julius II [FIGS. 22-14 and 22-15] in Rome.) The tomb is rich in color-white, black, and red marbles with selective gilding. Rossellino based his effigy of Bruni on ancient Roman sarcophagi (FIG. 7-61). The chancellor lies on a funerary bier supported by Roman eagles atop a sarcophagus resting on the foreparts of lions. Bruni, dressed in a toga and crowned with a laurel wreath, as during his state funeral, holds one of his books, probably his history of Florence. The realism of Bruni's head has led many scholars to postulate that Rossellino based his portrait on a wax death mask following ancient Roman practice (see "Roman Ancestor Portraits," Chapter 7, page 185). Two winged Victories hold aloft a plaque with a Latin inscription stating that History mourns the death of Leonardus, Eloquence is now si-

21-15 BERNARDO ROSSELLINO, tomb of Leonardo Bruni, Santa Croce, Florence, Italy, ca. 1444–1450. Marble, 23' 3½" high. ■•

Rossellino's tomb in honor of the humanist scholar and Florentine chancellor Leonardo Bruni combines ancient Roman and Christian motifs. It established the pattern for Renaissance wall tombs.

lenced, and the Greek and Latin muses cannot hold back their tears. Framing the effigy is a round-arched niche with Corinthian pilasters. The base of the tomb is a frieze of *putti* (cupids) carrying garlands, a standard motif on Roman sarcophagi, which also commonly have lions as supports (FIG. 7-70). The classically inspired tomb stands in sharp contrast to the Gothic tomb (FIG. 13-42A) of King Edward II in Gloucester Cathedral. But the Renaissance tomb is a creative variation of classical models, not a copy, and the motifs are a mix of classical and Christian themes. In the lunette beneath

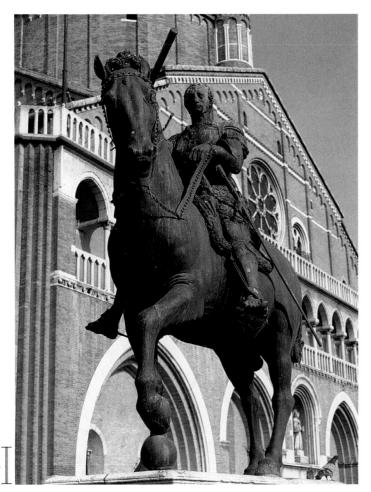

21-16 DONATELLO, *Gattamelata* (equestrian statue of Erasmo da Narni), Piazza del Santo, Padua, Italy, ca. 1445–1453. Bronze, 12' 2" high.

Donatello based his gigantic portrait of a Venetian general on equestrian statues of ancient Roman emperors (FIG. 7-59). Together, man and horse convey an overwhelming image of irresistible strength.

the arch is a tondo of the Madonna and Child between praying angels. Above the arch, two putti hold up a wreath circling the lion of the Florentine Republic. A lion's head is also the central motif in the putto-and-garland frieze below the deceased's coffin.

GATTAMELATA The grandest and most costly Quattrocento portraits in the Roman tradition were over-life-size bronze equestrian statues. The supremely versatile Donatello also excelled in this genre. In 1443, he left Florence for northern Italy to accept a rewarding commission from the Republic of Venice to create a commemorative monument in honor of the recently deceased Venetian condottiere Erasmo da Narni, nicknamed Gattamelata ("honeyed cat," a wordplay on his mother's name, Melania Gattelli). Although Gattamelata's family paid for the general's portrait (FIG. 21-16), the Venetian senate formally authorized its placement in the square in front of the church of Sant'Antonio in Padua, the condottiere's birthplace. Equestrian statues occasionally had been set up in Italy in the late Middle Ages, but Donatello's Gattamelata was the first since antiquity to rival the grandeur of Roman imperial mounted portraits, such as that of Marcus Aurelius (FIG. 7-59), which the artist must have seen in Rome. Donatello's contemporaries, one of whom described Gattamelata as sitting on his horse "with great magnificence like a triumphant Caesar,"⁵ recognized this reference to antiquity. The statue stands on a lofty base, set

21-17 ANDREA DEL VERROCCHIO, *Bartolommeo Colleoni* (equestrian statue), Campo dei Santi Giovanni e Paolo, Venice, Italy, ca. 1481–1496. Bronze, 13' high.

Eager to compete with Donatello's *Gattamelata* (FIG. 21-16), Colleoni provided the funds for his own equestrian statue in his will. The statue stands on a pedestal even taller than Gattamelata's.

apart from its surroundings, celebrating the Renaissance liberation of sculpture from architecture. Massive and majestic, the great horse bears the armored general easily, for, unlike the sculptor of the Marcus Aurelius statue, Donatello did not represent the Venetian commander as superhuman and disproportionately larger than his horse. Gattamelata dominates his mighty steed by force of character rather than sheer size. The Italian rider, his face set in a mask of dauntless resolution and unshakable will, is the very portrait of the Renaissance individualist. Such a man-intelligent, courageous, ambitious, and frequently of humble origincould, by his own resourcefulness and on his own merits, rise to a commanding position in the world. Together, man and horse convey an overwhelming image of irresistible strength and unlimited power-an impression Donatello reinforced visually by placing the left forefoot of the horse on an orb, reviving a venerable ancient symbol for hegemony over the earth (compare FIG. 11-12). The imperial imagery is all the more remarkable because Erasmo da Narni was not a head of state.

BARTOLOMMEO COLLEONI Verrocchio also received a commission to fashion an equestrian statue of another condottiere who fought for the Venetians, Bartolommeo Colleoni (1400–1475). His portrait (FIG. **21-17**) provides a counterpoint to Donatello's statue. Eager to garner the same fame the *Gattamelata* portrait

21-18 GENTILE DA FABRIANO, *Adoration of the Magi*, altarpiece from the Strozzi chapel, Santa Trinità, Florence, Italy, 1423. Tempera on wood, 9' $11'' \times 9'$ 3". Galleria degli Uffizi, Florence.

Gentile was the leading Florentine painter working in the International style. He successfully blended naturalistic details with Late Gothic splendor in color, costume, and framing ornamentation.

achieved, Colleoni provided funds in his will for his own statue. Because both Donatello and Verrocchio executed their statues after the deaths of their subjects, neither artist knew personally the individual he portrayed. The result is a fascinating difference of interpretation (like that between their two *Davids*) as to the demeanor of a professional captain of armies. Verrocchio placed the statue of the bold equestrian general on a pedestal even taller than the one Donatello used for *Gattamelata*, elevating it so viewers could see the dominating, aggressive figure from all approaches to the piazza (the Campo dei Santi Giovanni e Paolo). In contrast with the near repose of *Gattamelata*, the *Colleoni* horse moves in a prancing stride, arching and curving its powerful neck, while the commander seems suddenly to shift his whole weight to the stirrups and rise from the saddle with a violent twist of his body. The artist depicted both horse and rider with an exaggerated tautness—the animal's bulging muscles and the man's fiercely erect and rigid body together convey brute strength. In *Gattamelata*, Donatello created a portrait of grim sagacity. Verrocchio's *Bartolommeo Colleoni* is a portrait of merciless might.

Painting

In Quattrocento Italy, humanism and the celebration of classical artistic values also largely determined the character of panel and mural painting. The new Renaissance style did not, however, immediately displace all vestiges of the Late Gothic style. In particular, the International style, the dominant mode in painting around 1400 (see Chapter 14), persisted well into the 15th century.

Cennino Cennini on Imitation and Emulation in Renaissance Art

A lthough many of the values championed by Renaissance humanists endure to the present day, the premium that modern Western society places on artistic originality is a fairly recent phenomenon. In contrast, imitation and emulation were among the concepts Renaissance artists most valued. Many 15th- and 16thcentury artists, of course, developed unique, recognizable styles, but convention, in terms of both subject matter and representational practices, predominated. In Italian Renaissance art, certain themes, motifs, and compositions appear with great regularity, fostered by training practices that emphasized the importance of tradition for aspiring Renaissance artists.

- Imitation The starting point in a young artist's training (see "Artistic Training in Renaissance Italy," Chapter 14, page 414) was imitation. Italian Renaissance artists believed the best way to learn was to copy the works of masters. Accordingly, much of an apprentice's training consisted of copying exemplary artworks. Leonardo da Vinci filled his sketchbooks with drawings of well-known sculptures and frescoes, and Michelangelo spent days sketching artworks in churches around Florence and Rome.
- **Emulation** The next step was emulation, which involved modeling one's art after that of another artist. Although imitation still provided the foundation for this practice, an artist used features of another's art only as a springboard for improvements or innovations. Thus, developing artists went beyond previous artists and attempted to prove their own competence and skill by improving on established and recognized masters. Comparison and a degree of competition were integral to emulation. To evaluate the "improved" artwork, viewers had to be familiar with the original "model."

Renaissance artists believed developing artists would ultimately arrive at their own unique style through this process of imitation and emulation. Cennino Cennini (ca. 1370–1440) explained the value of this training procedure in a book he published around 1400, *Il Libro dell'Arte (The Artist's Handbook)*, which served as a practical guide to artistic production:

Having first practiced drawing for a while, ... take pains and pleasure in constantly copying the best things which you can find done by the hand of great masters. And if you are in a place where many good masters have been, so much the better for you. But I give you this advice: take care to select the best one every time, and the one who has the greatest reputation. And, as you go on from day to day, it will be against nature if you do not get some grasp of his style and of his spirit. For if you undertake to copy after one master today and after another one tomorrow, you will not acquire the style of either one or the other, and you will inevitably, through enthusiasm, become capricious, because each style will be distracting your mind. You will try to work in this man's way today, and in the other's tomorrow, and so you will not get either of them right. If you follow the course of one man through constant practice, your intelligence would have to be crude indeed for you not to get some nourishment from it. Then you will find, if nature has granted you any imagination at all, that you will eventually acquire a style individual to yourself, and it cannot help being good; because your hand and your mind, being always accustomed to gather flowers, would ill know how to pluck thorns.*

*Translated by Daniel V. Thompson Jr., *Cennino Cennini, The Craftsman's Handbook (Il Libro dell'Arte*), (New York: Dover Publications, 1960; reprint of 1933 ed.), 14–15.

GENTILE DA FABRIANO The leading Quattrocento master of the International Style was GENTILE DA FABRIANO (ca. 1370-1427), who in 1423 painted Adoration of the Magi (FIG. 21-18) as the altarpiece for the family chapel of Palla Strozzi (1372-1462) in the church of Santa Trinità in Florence. At the beginning of the 15th century, the Strozzi family was the wealthiest in the city. The altarpiece, with its elaborate gilded Gothic frame, is testimony to the patron's lavish tastes. So too is the painting itself, with its gorgeous surface and sumptuously costumed kings, courtiers, captains, and retainers accompanied by a menagerie of exotic animals. Gentile portrayed all these elements in a rainbow of color with extensive use of gold. The painting presents all the pomp and ceremony of chivalric etiquette in a religious scene centered on the Madonna and Child. Although the style is fundamentally International Gothic, Gentile inserted striking naturalistic details. For example, the artist depicted animals from a variety of angles and foreshortened the forms convincingly, most notably the horse at the far right seen in a three-quarter rear view. Gentile did the same with human figures, such as the kneeling man removing the spurs from the standing magus in the center foreground. In the left panel of the predella, Gentile painted what may have been the first nighttime Nativity scene with the central light source-the radiant Christ Child-introduced

into the picture itself. Although predominantly conservative, Gentile demonstrated he was not oblivious to Quattrocento experimental trends and could blend naturalistic and inventive elements skillfully and subtly into a traditional composition without sacrificing Late Gothic splendor in color, costume, and framing ornamentation.

MASACCIO The artist who epitomizes the innovative spirit of early-15th-century Florentine painting was Tommaso di ser Giovanni di Mone Cassai, known as MASACCIO (1401-1428). Although his presumed teacher, Masolino da Panicale (see "Italian Artists' Names," Chapter 14, page 405), had worked in the International Style, Masaccio broke sharply from the normal practice of imitating his master's style (see "Cennino Cennini on Imitation and Emulation in Renaissance Art," above). He moved suddenly, within the short span of six years, into unexplored territory. Most art historians recognize no other painter in history to have contributed so much to the development of a new style in so short a time as Masaccio, whose untimely death at age 27 cut short his brilliant career. Masaccio was the artistic descendant of Giotto (see Chapter 14), whose calm, monumental style he carried further by introducing a whole new repertoire of representational devices that generations of Renaissance painters later studied and developed.

21-19 MASACCIO, Tribute Money, Brancacci chapel, Santa Maria del Carmine, Florence, Italy, ca. 1424–1427. Fresco, 8' 4¹/₈" × 19' 7¹/₈".

Masaccio's figures recall Giotto's in their simple grandeur, but they convey a greater psychological and physical credibility. He modeled his figures with light coming from a source outside the picture.

BRANCACCI CHAPEL The frescoes Masaccio painted in the family chapel that Felice Brancacci (1382–1447) sponsored in Santa Maria del Carmine in Florence provide excellent examples of his innovations. In *Tribute Money* (FIG. **21-19**), painted shortly before his death, Masaccio depicted an episode from the Gospel of Matthew (17:24–27). As the tax collector confronts Jesus at the entrance to the Roman town of Capernaum, Jesus directs Saint Peter to the shore of Lake Galilee. There, as Jesus foresaw, Peter finds the tribute coin in the mouth of a fish and returns to pay the tax. Masaccio divided the story into three parts within the fresco. In the center, Jesus, surrounded by his disciples, tells Peter to retrieve the coin from the fish, while the tax collector stands in the foreground, his back to spectators and hand extended, awaiting payment. At the left, in the middle distance, Peter extracts the coin from the fish's mouth, and, at the right, he thrusts the coin into the tax collector's hand.

Masaccio's figures recall Giotto's in their simple grandeur, but they convey a greater psychological and physical credibility. Masaccio created the figures' bulk through modeling not with a flat, neutral light lacking an identifiable source but with a light coming from a specific source outside the picture. The light comes from the right and strikes the figures at an angle, illuminating the parts of the solids obstructing its path and leaving the rest in shadow, producing the illusion of deep sculptural relief. Between the extremes of light and dark, the light appears as a constantly active but fluctuating force highlighting the scene in varying degrees. Giotto used light only to model the masses. In Masaccio's works, light has its own nature, and the masses are visible only because of its direction and intensity. The viewer can imagine the light as playing over forms-revealing some and concealing others, as the artist directs it. The figures in Tribute Money are solemn and weighty, but they also move freely and reveal body structure, as do Donatello's statues. Masaccio's representations adeptly suggest bones, muscles, and the pressures and tensions of joints. Each figure conveys a maximum of contained energy. Tribute Money helps the viewer understand Giorgio Vasari's comment: "[T]he works made before his

[Masaccio's] day can be said to be painted, while his are living, real, and natural." 6

Masaccio's arrangement of the figures is equally inventive. They do not stand in a line in the foreground. Instead, the artist grouped them in circular depth around Jesus, and he placed the whole group in a spacious landscape, rather than in the confined stage space of earlier frescoes. The group itself generates the foreground space and the architecture on the right amplifies it. Masaccio depicted the building in perspective, locating the vanishing point, where all the orthogonals converge, at Jesus' head. He also diminished the brightness of the colors as the distance increases, an aspect of atmospheric perspective. Although ancient Roman painters used aerial perspective (FIG. 7-20), medieval artists had abandoned it. Thus, it virtually disappeared from art until Masaccio and his contemporaries rediscovered it. They came to realize that the light and air interposed between viewers and what they see are two parts of the visual experience called "distance."

In an awkwardly narrow space at the entrance to the Brancacci chapel, to the left of *Tribute Money*, Masaccio painted *Expulsion of Adam and Eve from Eden* (FIG. **21-20**), another fresco displaying the representational innovations of *Tribute Money*. For example, the sharply slanted light from an outside source creates deep relief, with lights placed alongside darks, and acts as a strong unifying agent. Masaccio also presented the figures with convincing structural accuracy, thereby suggesting substantial body weight. Further, the hazy background specifies no locale but suggests a space around and beyond the figures. Adam's feet, clearly in contact with the ground, mark the human presence on earth, and the cry issuing from Eve's mouth voices her anguish. The angel does not force them physically from Eden. Rather, they stumble on blindly, the angel's will and their own despair driving them. The composition is starkly simple, its message incomparably eloquent.

HOLY TRINITY Masaccio's *Holy Trinity* fresco (FIG. **21-21**) in Santa Maria Novella is another of the young artist's masterworks and

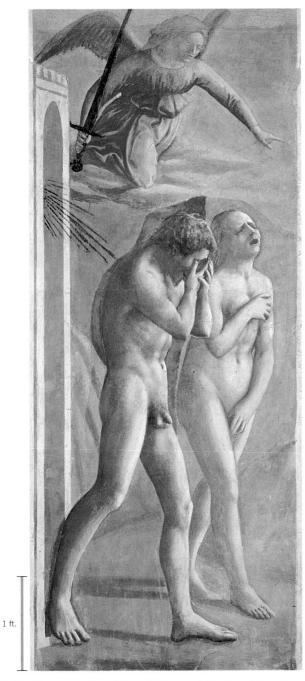

21-20 MASACCIO, *Expulsion of Adam and Eve from Eden*, Brancacci chapel, Santa Maria del Carmine, Florence, Italy, ca. 1424–1427. Fresco, $7' \times 2'$ 11".

Adam and Eve, expelled from Eden, stumble on blindly, driven by the angel's will and their own despair. The hazy background specifies no locale but suggests a space around and beyond the figures.

the premier early-15th-century example of the application of mathematics to the depiction of space. Masaccio painted the composition on two levels of unequal height. Above, in a barrel-vaulted chapel reminiscent of a Roman *triumphal arch* (FIGS. 7-40 and 7-44B; compare FIG. 21-49A), the Virgin Mary and Saint John appear on either side of the crucified Christ. God the Father emerges from behind Christ, supporting the arms of the cross and presenting his son to the worshiper as a devotional object. The dove of the Holy Spirit hovers between God's head and Christ's head. Masaccio also included portraits of the donors of the painting, Lorenzo Lenzi and his wife, who kneel just in front of the *pilasters* framing the chapel's

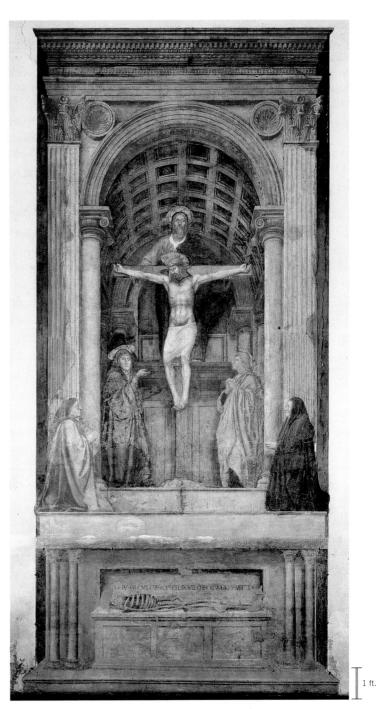

21-21 MASACCIO, *Holy Trinity*, Santa Maria Novella, Florence, Italy, ca. 1424–1427. Fresco, 21' $10\frac{5''}{8} \times 10' 4\frac{3''}{4}$.

Masaccio's pioneering *Holy Trinity* is the premier early-15th-century example of the application of mathematics to the depiction of space according to Brunelleschi's system of perspective.

entrance. Below, the artist painted a tomb containing a skeleton. An inscription in Italian above the skeleton reminds the spectator, "I was once what you are, and what I am you will become."

The illusionism of *Holy Trinity* is breathtaking. In this fresco, Masaccio brilliantly demonstrated the principles and potential of Brunelleschi's new science of perspective. Indeed, some art historians have suggested Brunelleschi may have collaborated with Masaccio. The vanishing point of the composition is at the foot of the cross. With this point at eye level, spectators look up at the Trinity and down at the tomb. About 5 feet above the floor level, the vanishing point pulls the two views together, creating the illusion of a real structure transecting the wall's vertical plane. Whereas the tomb appears to project forward into the church, the chapel recedes visually behind the wall and appears as an extension of the spectator's space. This adjustment of the picture's space to the viewer's position was an important innovation in illusionistic painting that other artists of the Renaissance and the later Baroque period would develop further. Masaccio was so exact in his metrical proportions it is possible to calculate the dimensions of the chapel (for example, the span of the painted vault is 7 feet and the depth of the chapel is 9 feet). Thus, he achieved not only a successful illusion but also a rational measured coherence that is responsible for the unity and harmony of the fresco. Holy Trinity is, however, much more than a demonstration of Brunelleschi's perspective or of the painter's ability to represent fully modeled figures bathed in light. In this painting, Masaccio also powerfully conveyed one of the central tenets of Christian faith. The ascending pyramid of figures leads viewers from the despair of death to the hope of resurrection and eternal life through Christ's crucifixion.

FRA ANGELICO As Masaccio's *Holy Trinity* clearly demonstrates, humanism and religion were not mutually exclusive. In fact, for many Quattrocento Italian artists, humanist concerns were not a primary consideration. The art of FRA ANGELICO (ca. 1400–1455) focused on serving the Roman Catholic Church. In the late 1430s, the abbot of the Dominican monastery of San Marco (Saint Mark) in Florence asked Fra Angelico to produce a series of frescoes for the monastery. The Dominicans (see "Mendicant Orders," Chapter 14, page 404) of San Marco had dedicated themselves to lives of prayer and work, and the religious compound was mostly spare and austere to encourage the monks to immerse themselves in their devotional lives. Fra Angelico's *Annunciation* (FIG. **21-22**) appears at the top of the stairs leading to the friars' cells. Appropriately, Fra Angelico presented the scene of the Virgin Mary and the Archangel Gabriel with simplicity and serenity. The two figures appear in a plain *loggia* resembling the *portico* of San Marco's *cloister*, and the artist painted all the fresco elements with a pristine clarity. As an admonition to heed the devotional function of the images, Fra Angelico included a small inscription at the base of the image: "As you venerate, while passing before it, this figure of the intact Virgin, beware lest you omit to say a Hail Mary." Like most of Fra Angelico's paintings, *Annunciation*, with its simplicity and directness, still has an almost universal appeal and fully reflects the artist's simple, humble character.

ANDREA DEL CASTAGNO Fra Angelico's younger contemporary ANDREA DEL CASTAGNO (ca. 1421-1457) also accepted a commission to produce a series of frescoes for a religious establishment. Castagno's Last Supper (FIG. 21-23) in the refectory (dining hall) of Sant'Apollonia in Florence, a convent for Benedictine nuns, manifests both a commitment to the biblical narrative and an interest in perspective. The lavishly painted room Jesus and his 12 disciples occupy suggests the artist's absorption with creating the illusion of three-dimensional space. However, closer scrutiny reveals inconsistencies, such as how Renaissance perspective systems make it impossible to see both the ceiling from inside and the roof from outside, as Castagno depicted. The two side walls also do not appear parallel. Castagno chose a conventional compositional format, with the figures seated at a horizontally placed table. He derived the apparent self-absorption of most of the disciples and the malevolent features of Judas (who sits alone on the outside of the table) from the Gospel of Saint John, rather than the more familiar version of the last supper recounted in the Gospel of Saint Luke. Castagno's dramatic and spatially convincing depiction of the event no doubt was a powerful presence for the nuns during their daily meals.

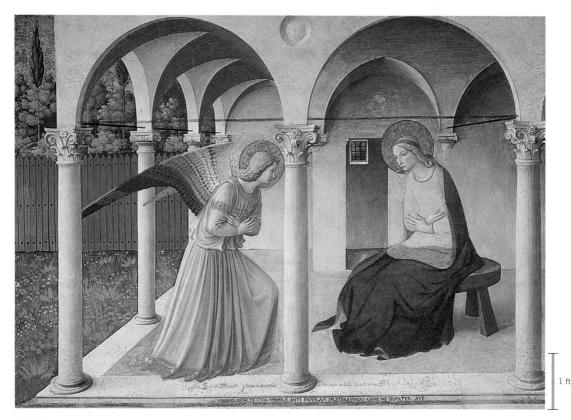

21-22 FRA ANGELICO, Annunciation, San Marco, Florence, Italy, ca. 1438–1447. Fresco, 7' 1" × 10' 6". Painted for the Dominican monks of San Marco, Fra Angelico's fresco is simple and direct. Its figures and architecture have a pristine clarity befitting the fresco's function as a devotional image.

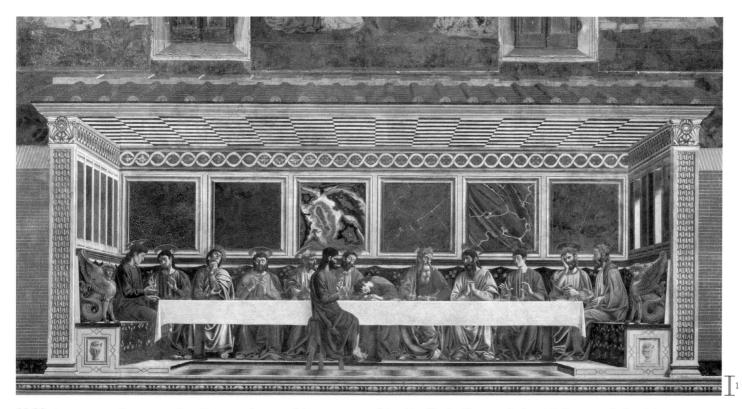

21-23 ANDREA DEL CASTAGNO, Last Supper, refectory of the monastery of Sant'Apollonia, Florence, Italy, 1447. Fresco, 15' 5" × 32'. Judas sits isolated in this Last Supper based on the Gospel of Saint John. The figures are small compared with the setting, reflecting Castagno's preoccupation with the new science of perspective.

FRA FILIPPO LIPPI Another younger contemporary of Fra Angelico, FRA FILIPPO LIPPI (ca. 1406-1469), was also a friar-but there all resemblance ends. Fra Filippo was unsuited for monastic life. He indulged in misdemeanors ranging from forgery and embezzlement to the abduction of a pretty nun, Lucretia, who became his mistress and the mother of his son, the painter Filippino Lippi (1457-1504). Only the intervention of the Medici on his behalf at the papal court preserved Fra Filippo from severe punishment and total disgrace. An orphan, Fra Filippo spent his youth in a monastery adjacent to the church of Santa Maria del Carmine, and when he was still in his teens, he must have met Masaccio there and witnessed the decoration of the Brancacci chapel. Fra Filippo's early work survives only in fragments, but these show he tried to work with Masaccio's massive forms. Later, probably under the influence of Ghiberti's and Donatello's relief sculptures, he developed a linear style that emphasized the contours of his figures and enabled him to suggest movement through flying and swirling draperies.

In a painting from Fra Filippo's later years, *Madonna and Child with Angels* (FIG. **21-24**), the Virgin sits in prayer at a slight angle to the viewer. Her body casts a shadow on the window frame behind her. But the painter's primary interest was not in space but in line, which unifies the composition and contributes to the precise and smooth delineation of forms. The Carmelite brother interpreted his subject in a surprisingly worldly manner. The Madonna

21-24 FRA FILIPPO LIPPI, *Madonna and Child with Angels*, ca. 1460–1465. Tempera on wood, $2' 11\frac{1}{2}'' \times 2' 1''$. Galleria degli Uffizi, Florence.

Fra Filippo, a monk guilty of many misdemeanors, represented the Virgin and Christ Child in a distinctly worldly manner, carrying the humanization of the holy family further than any artist before him.

21-25 PIERO DELLA FRANCESCA, *Resurrection*, Palazzo Comunale, Borgo San Sepolcro, Italy, ca. 1463–1465. Fresco, 7' $4\frac{5}{8}'' \times 6' 6\frac{1}{4}''$.

Christ miraculously rises from his tomb while the Roman guards sleep. The viewer sees the framing portico and the soldiers from below, but has a head-on view of the seminude muscular figure of Christ.

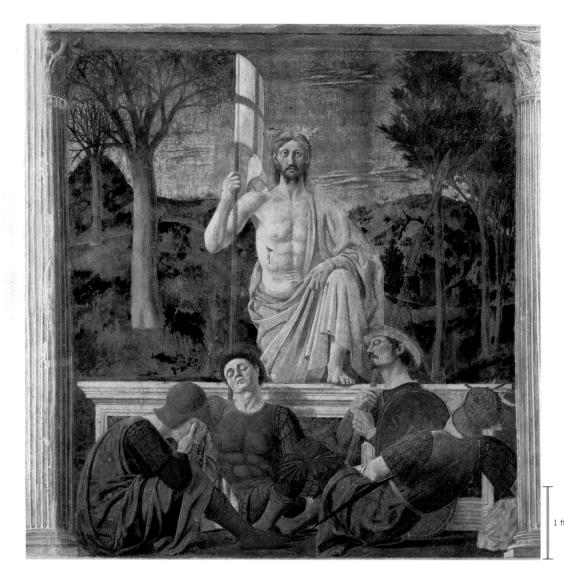

is a beautiful young mother, albeit with a transparent halo, in an elegantly furnished Florentine home, and neither she nor the Christ Child, whom two angels hold up, has a solemn expression. One of the angels, in fact, sports the mischievous, puckish grin of a boy refusing to behave for the pious occasion. Significantly, all figures reflect the use of live models (perhaps Lucretia for the Madonna). Fra Filippo plainly relished the charm of youth and beauty as he found it in this world. He preferred the real in landscape also. The background, seen through the window, incorporates recognizable features of the Arno valley. Compared with the earlier Madonnas by Giotto (FIG. 14-7) and Duccio (FIG. 14-9), this work shows how far artists had carried the humanization of the religious theme. Whatever the ideals of spiritual perfection may have meant to artists in past centuries, Renaissance artists realized those ideals in terms of the sensuous beauty of this world.

PIERO DELLA FRANCESCA One of the most renowned painters in 15th-century Italy was PIERO DELLA FRANCESCA (ca. 1420–1492), a native of Borgo San Sepolcro in southeastern Tuscany, who worked for diverse patrons, including the Medici in Florence and Federico de Montefeltro in Urbino (FIG. 21-43). In Tuscany, his commissions included frescoes of Christ's *Resurrection* (FIG. **21-25**) for the town hall of his birthplace and *Legend of the True Cross* (FIG. **21-25A**) for the church of San Francesco at Arezzo. He painted *Resurrection* at the request of the Borgo San Sepolcro civic council on the wall

facing the entrance to its newly remodeled Palazzo Comunale. Normally, the subjects chosen for city halls were scenes of battles, townscapes, or allegories of enlightened governance, as in Siena's Palazzo Pubblico (FIGS. 14-16, 14-16A, and 14-17). But the San Sepolcro council chose instead a religious subject. The town's name—Holy Sepulcher—derived from the legend that two 10th-century saints, Arcanus and Egidius, brought a fragment of Christ's tomb to the town from the Holy Land. Christ's *Resur*-

rection was also the subject of the central panel of the altarpiece painted between 1346 and 1348 by the Sienese painter Niccolò di Segna for the cathedral of San Sepolcro.

In Piero's *Resurrection*, the viewer witnesses the miracle of the risen Christ through the Corinthian columns of a classical portico (preserved only in part because the painting was trimmed during its installation in a new location). Piero chose a viewpoint corresponding to the viewer's position and depicted the architectural frame at a sharp angle from below. The Roman soldiers who have fallen asleep when they should be guarding the tomb are also seen from below in a variety of foreshortened poses. (The bareheaded guard second from the left with his head resting on Christ's sarcophagus may be a self-portrait of the artist.) The soldiers form the

21-25A PIERO DELLA FRANCESCA, *Legend of the True Cross,* ca. 1450–1455.

21-26 DOMENICO GHIRLANDAIO, Birth of the Virgin, Cappella Maggiore, Santa Maria Novella, Florence, Italy, ca. 1485–1490. Fresco, 24′ 4″ × 14′ 9″. ■4

Ludovica Tornabuoni holds as prominent a place in Ghirlandaio's fresco as she must have held in Florentine society—evidence of the secularization of sacred themes in 15th-century Italian painting.

base of a compositional triangle culminating at Christ's head. For Christ, Piero violated the perspective of the rest of the fresco and used a head-on view of the resurrected savior, imbuing the figure with an iconic quality. Christ's muscular body has the proportions of Greco-Roman nude statues. His pastel cloak stands out prominently from the darker colors of the soldiers' costumes. Christ holds the banner of his victory over death and displays his wounds. His face has portraitlike features. The tired eyes and somber expression are the only indications of his suffering on the cross.

DOMENICO GHIRLANDAIO Although projects undertaken with church, civic, and Medici patronage were significant sources of income for Florentine artists, other wealthy families also offered attractive commissions. Toward the end of the 15th century, DOMENICO GHIRLANDAIO (1449–1494) received the contract for an important project for Giovanni Tornabuoni, one of the wealthiest Florentines of his day. Tornabuoni asked Ghirlandaio to paint a cycle of frescoes depicting scenes from the lives of the Virgin and Saint John the Baptist for the choir of Santa Maria Novella (FIG. 14-6A), the Dominican church where Masaccio had earlier painted his revolutionary *Holy Trinity* (FIG. 21-21). In *Birth of the Virgin* (FIG. **21-26**), Mary's mother, Saint Anne, reclines in a palatial Renaissance room embellished with fine wood inlay and sculpture, while midwives prepare the infant's bath. From the left comes a solemn procession of women led by a young Tornabuoni family member, probably Ludovica, Giovanni's only daughter. Ghirlandaio's composition epitomizes the achievements of Quattrocento Florentine painting: clear spatial representation, statuesque figures, and rational order and logical relations among all figures and objects. If any remnant of earlier traits remains here, it is the arrangement of the figures, which still cling somewhat rigidly to layers parallel to the picture plane. New, however, and in striking contrast to the dignity and austerity of Fra Angelico's frescoes (FIG. 21-22) for the Dominican monastery of San Marco, is the dominating presence of the donor's family in the religious tableau. Ludovica holds as prominent a place in the composition (close to the central axis) as she must have held in Florentine society. Her appearance in the painting (a different female member of the house appears in each fresco) is conspicuous evidence of the secularization of sacred themes. Artists depicted living persons of high rank not only as present at biblical dramas (as Masaccio did in Holy Trinity) but also even stealing the show from the saints-as here, where the Tornabuoni women upstage the Virgin and Child. The display of patrician elegance tempers the biblical narrative and subordinates the fresco's devotional nature.

Ghirlandaio also painted individual portraits of wealthy Florentines. His 1488 panel painting of an aristocratic young woman is

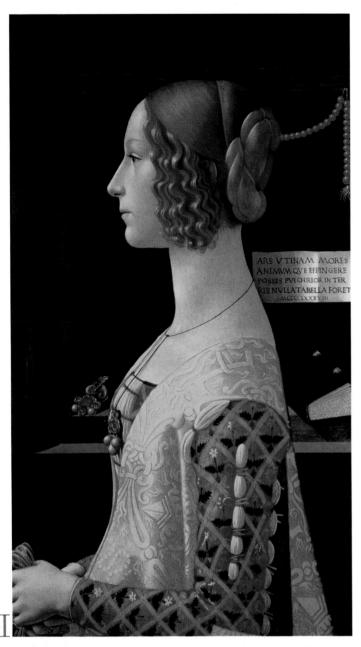

21-27 DOMENICO GHIRLANDAIO, Giovanna Tornabuoni(?), 1488. Oil and tempera on wood, $2' 6'' \times 1' 8''$. Museo Thyssen-Bornemisza, Madrid.

Renaissance artists revived the ancient art of portraiture. This portrait reveals the wealth, courtly manners, and humanistic interest in classical literature that lie behind much 15th-century Florentine art. probably a portrait of Giovanna Tornabuoni (FIG. **21-27**), a member of the powerful Albizzi family and wife of Lorenzo Tornabuoni, one of Lorenzo Medici's cousins. Although artists at this time were beginning to employ three-quarter and full-face views for portraits (FIG. 21-29A) in place of the more traditional profile pose, Ghirlandaio used the older format. This did not prevent him from conveying a character reading of the sitter. His portrait reveals the proud bearing of a sensitive and beautiful young woman. It also tells viewers much about the

advanced state of culture in Florence, the value and careful cultivation of beauty in life and art, the breeding of courtly manners, and the great wealth behind it all. In addition, the painting shows the powerful attraction classical literature held for Italian humanists. In the background, an epitaph (Giovanna Tornabuoni died in childbirth in 1488 at age 20) quotes the ancient Roman poet Martial:

If art could depict character and soul, No painting on earth would be more beautiful.⁷

PAOLO UCCELLO A masterpiece of this secular side of Quattrocento art is *Battle of San Romano* (FIG. **21-28**) by PAOLO UCCELLO (1397–1475), a Florentine painter trained in the International Style. The large panel painting is one of three Lorenzo de' Medici acquired for his bedchamber in the palatial Medici residence (FIGS. 21-37 and 21-38) in Florence. There is some controversy about the date of the painting because documents have been discovered suggesting Lorenzo may have purchased at least two of the paintings from a previous owner instead of commissioning the full series himself. The scenes commemorate the Florentine victory over the Sienese in 1432 and must have been painted no earlier than the mid-1430s if not around 1455, the traditional date assigned to the commission. In the panel illustrated, Niccolò da Tolentino (ca. 1350–1435), a friend and supporter of Cosimo de' Medici, leads

1 in.

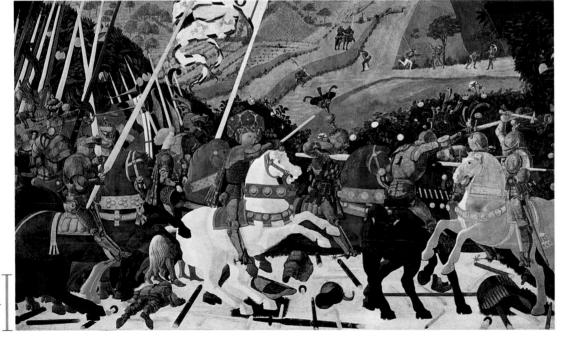

Although the painting focuses on Tolentino's military exploits, it also acknowledges the Medici, albeit in symbolic form. The bright orange fruit behind the raised lances on the left are *mela medica* (Italian, "medicinal apples"). Because the name *Medici* means

the charge against the Sienese.

21-28 PAOLO UCCELLO, Battle of San Romano, ca. 1435 or ca. 1455. Tempera on wood, $6' \times 10'$ 5". National Gallery, London.

In this panel once in Lorenzo de' Medici's bedchamber, Niccolò da Tolentino leads the charge against the Sienese. The foreshortened spears and figures reveal Uccello's fascination with perspective.

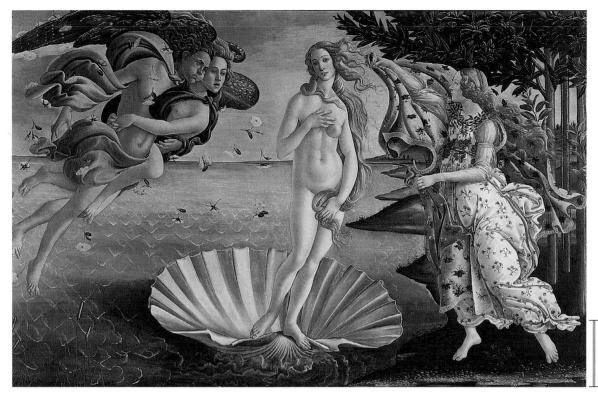

21-29 SANDRO BOTTICELLI, Birth of Venus, ca. 1484–1486. Tempera on canvas, 5′ 9″ × 9′ 2″. Galleria degli Uffizi, Florence.

Inspired by an Angelo Poliziano poem and classical Aphrodite statues (FIG. 5-62), Botticelli revived the theme of the female nude in this elegant and romantic representation of Venus born of sea foam.

1 ft

"doctors," this fruit was a fitting symbol of the family. Orange apples also appear in Botticelli's *Primavera* (FIG. 21-1). Their inclusion here suggests that at least this panel was a Medici commission, if all three were not.

In *Battle of San Romano*, Uccello created a composition that recalls the International style processional splendor of Gentile da Fabriano's *Adoration of the Magi* (FIG. 21-18) yet also reflects Uccello's obsession with perspective. In contrast with Gentile, who emphasized surface decoration, Uccello painted life-size, classically inspired figures arranged in the foreground and, in the background, a receding landscape resembling the low cultivated hillsides between Florence and Lucca. He foreshortened broken spears, lances, and a fallen soldier and carefully placed them along the converging orthogonals of the perspective system to create a base plane akin to a checkerboard, on which he then placed the larger volumes in measured intervals. The rendering of three-dimensional form, used by other painters for representational or expressive purposes, became for Uccello a preoccupation. For him, it had a magic of its own, which he exploited to satisfy his inventive and original imagination.

BOTTICELLI, BIRTH OF VENUS Also painted for the Medici and rivaling Primavera (FIG. 21-1) in fame is Sandro Botticelli's Birth of Venus (FIG. 21-29). The theme was the subject of a poem by Angelo Poliziano (1454-1494), a leading humanist of the day. In Botticelli's lyrical painting of Poliziano's retelling of the Greek myth, Zephyrus, carrying Chloris, blows Venus, born of the sea foam and carried on a cockle shell, to her sacred island, Cyprus. There, the nymph Pomona runs to meet her with a brocaded mantle. The lightness and bodilessness of the winds move all the figures without effort. Draperies undulate easily in the gentle gusts, perfumed by rose petals that fall on the whitecaps. In this painting, unlike in Primavera, Botticelli depicted Venus as nude. As noted earlier, the nude, especially the female nude, was exceedingly rare during the Middle Ages. The artist's use (especially on such a large scale-roughly life-size) of an ancient Venus statue (a Hellenistic variant of Praxiteles' famous Aphrodite of Knidos, FIG. 5-62) as a

model could have drawn harsh criticism. But in the more accommodating Renaissance culture and under the protection of the powerful Medici, the depiction went unchallenged, in part because *Birth of Venus*, which has several mythological figures in common with *Primavera*, is susceptible to a Neo-Platonic reading. Marsilio Ficino (1433–1499), for example, made the case in his treatise *On Love* (1469) that those who embrace the contemplative life of reason—including, of course, the humanists in the Medici circle—will immediately contemplate spiritual and divine beauty whenever they behold physical beauty.

Botticelli's style is clearly distinct from the earnest search many other artists pursued to comprehend humanity and the natural world through a rational, empirical order. Indeed, Botticelli's elegant and beautiful linear style (he was a pupil of Fra Filippo Lippi, FIG. 21-24) seems removed from all the scientific knowledge 15th-century artists had gained in the areas of perspective and anatomy. For example, the seascape in *Birth of Venus* is a flat backdrop devoid of atmospheric perspective. Botticelli's style paralleled the Florentine allegorical pageants that were chivalric tournaments structured around allusions to classical mythology. The same trend

is evident in the poetry of the 1470s and 1480s. Artists and poets at this time did not directly imitate classical antiquity but used the myths, with delicate perception of their charm, in a way still tinged with medieval romance. Ultimately, Botticelli created a style of visual poetry parallel to the love poetry of Lorenzo de' Medici. His paintings possess a lyricism and courtliness that appealed to cultured Florentine patrons, whether the Medici themselves or associates of the family (FIG. **21-29A**).

Young Man Holding a Medal, ca. 1474–1475.

ENGRAVING Although the most prestigious commissions in 15th-century Florence were for large-scale panel paintings and frescoes and for monumental statues and reliefs, some artists also produced important small-scale works, such as Pollaiuolo's

21-30 ANTONIO DEL POLLAIUOLO, Battle of Ten Nudes, ca. 1465. Engraving, $1' 3\frac{1}{8}'' \times 1' 11\frac{1}{4}''$. Metropolitan Museum of Art, New York (bequest of Joseph Pulitzer, 1917).

Pollaiuolo was fascinated by how muscles and sinews activate the human skeleton. He delighted in showing nude figures in violent action and from numerous foreshortened viewpoints.

Hercules and Antaeus (FIG. 21-14). Pollaiuolo also experimented with the new medium of engraving, which northern European artists had pioneered around the middle of the century. But whereas German graphic artists, such as Martin Schongauer (FIG. 20-22), described their forms with hatching that followed the forms, Italian engravers, such as Pollaiuolo, preferred parallel hatching. The former method was in keeping with the general northern European approach to art,

which tended to describe surfaces of forms rather than their underlying structures, whereas the latter better suited the anatomical studies that preoccupied Pollaiuolo and his Italian contemporaries.

Battle of Ten Nudes (FIG. 21-30), like Pollaiuolo's Hercules and Antaeus (FIG. 21-14), reveals the artist's interest in the realistic presentation of human figures in action. Earlier artists, such as Donatello (FIG. 21-12) and Masaccio (FIG. 21-20), had dealt effectively with the problem of rendering human anatomy, but they usually depicted their figures at rest or in restrained motion. As is evident in his engraving as well as in his sculpture, Pollaiuolo took delight in showing violent action. He conceived the body as a powerful machine and liked to display its mechanisms, such as knotted muscles and taut sinews that activate the skeleton as ropes pull levers. To show this to best effect, Pollaiuolo developed a figure so lean and muscular it appears écorché (as if without skin), with strongly accentuated delineations at the wrists, elbows, shoulders, and knees. Battle of Ten Nudes shows this figure type in a variety of poses and from numerous viewpoints, enabling Pollaiuolo to demonstrate his prowess in rendering the nude male figure. In this, he was a kindred spirit of late-sixth-century Greek vase painters, such as Euthymides (FIG. 5-23), who had experimented with foreshortening for the first time in history. Even though the figures in Ten Nudes hack and slash at one another without mercy, they nevertheless seem somewhat stiff and frozen because Pollaiuolo depicted all the muscle groups at maximum tension. Not until several decades later did an even greater anatomist, Leonardo da Vinci, observe that only some of the body's muscle groups participate in any one action, while the others remain relaxed.

Architecture

Filippo Brunelleschi's ability to codify a system of linear perspective derived in part from his skill as an architect. Although according to his biographer, Antonio Manetti, Brunelleschi turned to architecture out of disappointment over the loss to Lorenzo Ghiberti of the commission for the baptistery doors (FIGS. 21-2 and 21-3), he continued to work as a sculptor for several years and received commissions for sculpture as late as 1416. It is true, however, that as the 15th century progressed, Brunelleschi's interest turned increasingly toward architecture. Several trips to Rome (the first in 1402,

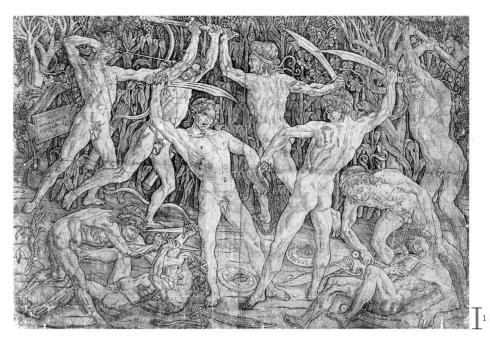

probably with his friend Donatello), where the ruins of ancient Rome captivated him, heightened his fascination with architecture. His close study of Roman monuments and his effort to make an accurate record of what he saw may have been the catalyst that led Brunelleschi to develop his revolutionary system of geometric linear perspective.

OSPEDALE DEGLI INNOCENTI

At the end of the second decade of the 15th century, Brunelleschi received two important architectural commissions in Florence—to construct a dome (FIG. **21-30A**) for the city's late medieval cathedral (FIG. 14-18), and to design the Ospedale degli Innocenti (Hospital of the Innocents, FIG. **21-31**), a home for Florentine orphans and foundlings. The latter commission came from Florence's guild of silk manufacturers and goldsmiths, of which Brunelleschi, a goldsmith, was a member. The

21-30A BRUNELLESCHI, Florence Cathedral dome, 1420–1436. ■●

site chosen for the orphanage, adjacent to the church of the Santissima Annunziata (Most Holy Annunciation), was appropriate. The church housed a miracle-working image of the Annunciation that attracted large numbers of pilgrims. With the construction of the new foundling hospital, the Madonna would now watch over infants as well, assisted by the guild, which supported the orphanage with additional charitable donations.

Most scholars regard Brunelleschi's Ospedale degli Innocenti as the first building to embody the new Renaissance architectural style. As in earlier similar buildings, the facade of the Florentine orphanage is a loggia opening onto the street, a sheltered portico where, in this case, parents could anonymously deliver unwanted children to the care of the foundling hospital. Brunelleschi's arcade consists of a series of round arches on slender Corinthian columns. Each bay is a domed compartment with a *pediment*-capped window above. Both plan and elevation conform to a *module* that embodies the rationality of classical architecture. Each column is 10 *braccia* (approximately 20 feet; 1 braccia, or arm, equals 23 inches) tall. The distance between the columns of the facade and the distance between the columns and the wall are also 10 braccia. Thus, each of the bays is a cubical unit 10 braccia wide, deep, and high. The

21-31 FILIPPO BRUNELLESCHI, Loggia of the Ospedale degli Innocenti (Foundling Hospital; looking northeast), Florence, Italy, begun 1419. ■

Often called the first Renaissance building, the loggia of the orphanage sponsored by Florence's silk and goldsmith guild features a classically austere design based on a module of 10 braccia.

height of the columns also equals the diameter of the arches (except in the two outermost bays, which are slightly wider and serve as framing elements in the overall design). The color scheme, which would become a Brunelleschi hallmark, is austere: white stucco walls with gray *pietra serena* ("serene stone") columns and moldings. In 1487, Andrea della Robbia (1435–1525), nephew of Luca della Robbia (FIG. 21-36A) and his successor as head of the family workshop, added more color to the loggia in the form of a series of *glazed terracotta roundels*, one above each column, depicting a baby in swaddling clothes (no two are identical)—the only indication on the building's facade of its charitable function.

SANTO SPIRITO Begun around 1436 and completed, with some changes, after Brunelleschi's death, Santo Spirito (FIG. **21-32**) is one of two *basilican* churches the architect built in Florence. (The

other is San Lorenzo; FIG. **21-32A**.) Santo Spirito showcases the clarity and classically inspired rationality that characterize Brunelleschi's mature designs. Brunelleschi laid out this *cruciform* building in either multiples or segments of the dome-covered *crossing square*. The aisles, subdivided into small squares

21-32A BRUNELLESCHI, San Lorenzo, ca. 1421–1469. ■◀

covered by shallow, saucer-shaped vaults, run all the way around the flat-roofed central space. They have the visual effect of compressing the longitudinal design into one more comparable to a *central plan*, because the various aspects of the interior resemble one another, no matter where an observer stands. Originally, this centralization effect would have been even stronger. Brunelleschi had planned to extend the aisles across the front of the nave as well, as shown on the plan (FIG. **21-33**, *left*). However, adherence to that design would have de-

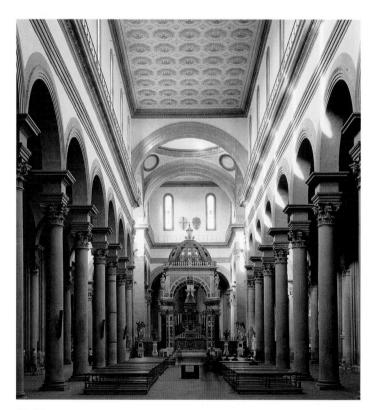

21-32 FILIPPO BRUNELLESCHI, interior of Santo Spirito (looking northeast), Florence, Italy, designed 1434–1436; begun 1446.

The austerity of the decor and the mathematical clarity of the interior of Santo Spirito contrast sharply with the soaring drama and spirituality of the nave arcades and vaults of Gothic churches.

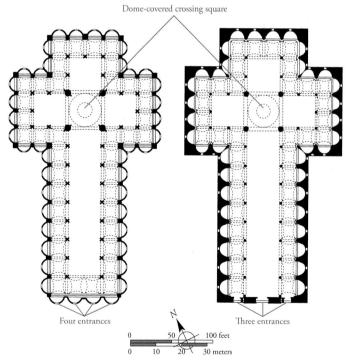

21-33 FILIPPO BRUNELLESCHI, early plan (*left*) and plan as constructed (*right*) of Santo Spirito, Florence, Italy, designed 1434–1436; begun 1446.

Santo Spirito displays the classically inspired rationality of Brunelleschi's mature style in its all-encompassing modular scheme based on the dimensions of the dome-covered crossing square.

Italian Renaissance Family Chapel Endowments

D uring the 14th through 16th centuries in Italy, wealthy families regularly endowed chapels in or adjacent to major churches. These family chapels were usually on either side of the choir near the altar at the church's east end. Particularly wealthy families sponsored chapels in the form of separate buildings constructed adjacent to churches. For example, the Medici Chapel (Old Sacristy) abuts San Lorenzo in Florence. Other powerful banking families the Baroncelli, Bardi, and Peruzzi—

21-34 FILIPPO BRUNELLESCHI, facade of the Pazzi Chapel, Santa Croce, Florence, Italy, begun 1433.

The Pazzi family erected this chapel as a gift to the Franciscan church of Santa Croce. It served as the monks' chapter house and is one of the first independent Renaissance central-plan buildings.

each sponsored chapels in the Florentine church of Santa Croce. The Pazzi family commissioned a chapel (FIGS. 21-34 to 21-36) adjacent to Santa Croce, and the Brancacci family sponsored the decorative program (FIGS. 21-19 and 21-20) of their chapel in Santa Maria del Carmine.

These families endowed chapels to ensure the well-being of the souls of individual family members and ancestors. The chapels served as burial sites and as spaces for liturgical celebrations and commemorative services. Chapel owners sponsored Masses for the dead, praying to the Virgin Mary and the saints for intercession on behalf of their deceased loved ones.

Changes in Christian doctrine prompted these concerted efforts to enhance donors' chances for eternal salvation. Until the 13th century, most Christians believed that after death, souls went either to Heaven or to Hell. In the late 1100s and early 1200s, the concept of Purgatory—a way station between Heaven and Hell where souls could atone for sins before judgment day—increasingly won favor. Pope Innocent III (1198–1216) officially recognized the existence of such a place in 1215. Because Purgatory represented a chance for the faithful to improve the likelihood of eventually gaining admission to Heaven, Christians eagerly embraced this opportunity.

When the Church extended this idea for believers to improve their prospects while alive, charitable work, good deeds, and devotional practices proliferated. Family chapels provided the space

manded four entrances in the facade, instead of the traditional and symbolic three, a feature hotly debated during Brunelleschi's lifetime and changed after his death. Successor builders also modified the appearance of the exterior walls (FIG. 21-33, *right*) by filling in the recesses between the projecting semicircular chapels to convert the original highly sculpted wall surface into a flat one.

The major features of Santo Spirito's interior (FIG. 21-32), however, are much as Brunelleschi designed them. In this modular scheme, as in the loggia of the Ospedale degli Innocenti (FIG. 21-31), a mathematical unit served to determine the dimensions of every aspect of the church. This unit—the crossing bay measuring 20 by 20 braccia—subdivided throughout the plan creates a rhythmic harmony. Fixed ratios also determined the elevation. For example, the nave is twice as high as it is wide, and the arcade and clerestory are of equal height, which means the height of the arcade equals

necessary for the performance of devotional rituals. Most chapels included altars, as well as chalices, vestments, candlesticks, and other objects used in the Mass. Most patrons also commissioned decorations, such as painted altarpieces, frescoes on the walls, and sculptural objects. The chapels were therefore not only expressions of piety and devotion but also opportunities for donors to enhance their stature in the larger community.

the nave's width. Astute observers can read the proportional relationships among the interior's parts as a series of mathematical equations. The austerity of the decor enhances the rationality of the design and produces a restful and tranquil atmosphere. Brunelleschi left no space for expansive wall frescoes that would only detract from the clarity of his architectural scheme. The calculated logic of the design echoes that of ancient Roman buildings, such as the Pantheon (FIG. 7-50, *right*). The rationality of Santo Spirito contrasts sharply, however, with the soaring drama and spirituality of the nave arcades and vaults of Gothic churches (for example, FIGS. 13-19 and 13-20). It even deviates from the design of Florence Cathedral's nave (FIG. 14-18A), whose verticality is restrained in comparison to its northern European counterparts. Santo Spirito fully expresses the new Renaissance spirit that placed its faith in reason rather than in the emotions.

21-35 FILIPPO BRUNELLESCHI, plan of the Pazzi Chapel, Santa Croce, Florence, Italy, begun 1433.

Although the Pazzi Chapel is rectangular, rather than square or round, Brunelleschi created a central plan by placing all emphasis on the dome-covered space at the heart of the building.

PAZZI CHAPEL Brunelleschi's apparent effort to impart a centralized effect to the interior of Santo Spirito suggests that he found intriguing the compact and self-contained qualities of central-plan buildings-for example, the Pantheon (FIGS. 7-49 to 7-51) and the Florentine Baptistery of San Giovanni (FIG. 12-27). He had already explored this interest in his design for the chapel (FIG. 21-34) the Pazzi family donated to the Franciscan church of Santa Croce in Florence (see "Italian Renaissance Family Chapel Endowments," page 584). Brunelleschi began to work on the project around 1423, but construction continued until the 1460s, long after his death. The exterior probably does not reflect Brunelleschi's original design. The loggia, admirable as it is, likely was added as an afterthought, perhaps by the sculptor-architect Giuliano da Maiano (1432–1490). The Pazzi Chapel served as the chapter house (meeting hall) of the local chapter of Franciscan monks. Historians have suggested the monks needed the expansion to accommodate more of their brethren.

Behind the loggia stands one of the first independent Renaissance buildings conceived basically as a central-plan structure. Although the Pazzi Chapel's plan (FIG. **21-35**) is rectangular, rather than square or round, Brunelleschi placed all emphasis on the central dome-covered space. The short barrel-*vault* sections bracing the dome on two sides appear to be incidental appendages. The interior trim (FIG. **21-36**) is Brunelleschi's favorite gray pietra serena, which stands out against the white stuccoed walls and crisply defines the modular relationships of plan and elevation. As he did in his design for the Ospedale degli Innocenti (FIG. 21-31) and later for Santo Spirito (FIG. 21-32), Brunelleschi used a basic unit that enabled him to construct a balanced, harmonious, and regularly proportioned space.

Circular medallions, or *tondi*, in the dome's *pendentives* (see "Pendentives and Squinches," Chapter 9, page 262) consist of glazed

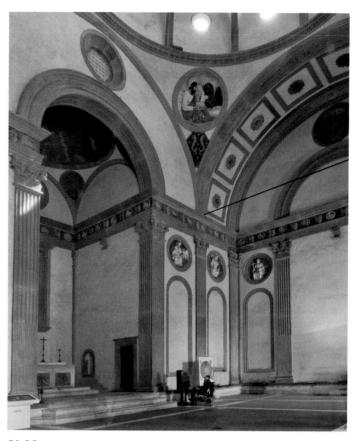

21-36 FILIPPO BRUNELLESCHI, interior of the Pazzi Chapel (looking northeast), Santa Croce, Florence, Italy, begun 1433. ■

The interior trim of the Pazzi Chapel is gray pietra serena, which stands out against the white stuccoed walls and crisply defines the modular relationships of Brunelleschi's plan and elevation.

terracotta reliefs representing the four evangelists. The technique for manufacturing these baked clay reliefs was of recent invention. Around 1430, LUCA DELLA ROBBIA (1400–1482) perfected the application of vitrified (heat-fused) colored potters' glazes to sculpture (FIG. **21-36A**). Inexpensive, durable, and decorative, they became extremely popular and provided the basis for a flourishing

21-36A LUCA DELLA ROBBIA, *Madonna and Child*, ca. 1455–1460.

family business. Luca's nephew Andrea della Robbia produced roundels for Brunelleschi's loggia of the Ospedale degli Innocenti (FIG. 21-31) in 1487, and Andrea's sons, Giovanni della Robbia (1469–1529) and Girolamo della Robbia (1488–1566), carried on this tradition well into the 16th century. Most of the tondi in the Pazzi Chapel are the work of Luca della Robbia himself. Together with the images of the 12 apostles on the pilaster-framed wall panels, they add striking color accents to the tranquil interior.

PALAZZO MEDICI It seems curious that Brunelleschi, the most renowned architect of his time, did not participate in the upsurge of palace building Florence experienced in the 1430s and 1440s. This proliferation of palazzi testified to the stability of the Florentine economy and to the affluence and confidence of the city's leading citizens. Brunelleschi, however, confined his efforts in this field to work on the Palazzo di Parte Guelfa (headquarters of Florence's then-ruling "party") and to a rejected model for a new palace that Cosimo de' Medici intended to build. When the Medici returned to Florence in 1434 after a brief exile imposed upon them by other elite families who resented the Medicis' consolidation of power, Cosimo, aware of the importance of public perception, attempted to maintain a lower profile and to wield his power from behind the scenes. In all probability, this attitude accounted for his rejection of Brunelleschi's design for the Medici residence, which he evidently found too imposing and ostentatious to be politically wise. Cosimo eventually awarded the commission to MICHELOZZO DI BARTOLOMMEO (1396-1472), a young architect who had been Donatello's collaborator in several sculptural enterprises. Although Cosimo passed over Brunelleschi, his architectural style nevertheless deeply influenced Michelozzo. To a limited extent, the Palazzo Medici (FIG. 21-37) reflects Brunelleschian principles.

Later bought by the Riccardi family (hence the name Palazzo Medici-Riccardi), who almost doubled the facade's length in the 18th century, the palace, both in its original and extended form, is a simple, massive structure. Heavy rustication (rough, unfinished masonry) on the ground floor accentuates its strength. Michelozzo divided the building block into stories of decreasing height by using long, unbroken stringcourses (horizontal bands), which give it coherence. Dressed (smooth, finished) masonry on the second level and an even smoother surface on the top story modify the severity of the ground floor and make the building appear progressively lighter as the eye moves upward. The extremely heavy cornice, which Michelozzo related not to the top story but to the building as a whole, dramatically reverses this effect. Like the ancient Roman cornices that served as Michelozzo's models (compare FIGS. 7-32, 7-40, and 7-44B), the Palazzo Medici-Riccardi cornice is a very effective lid for the structure, clearly and emphatically defining its proportions. Michelozzo perhaps also was inspired by the many extant examples of Roman rusticated masonry, and Roman precedents even exist for the juxtaposition of rusticated and dressed stone masonry on the same facade (FIG. 7-34). However,

nothing in the ancient world precisely compares with Michelozzo's design. The Palazzo Medici exemplifies the simultaneous respect for and independence from the antique—features that character-

ize the Early Renaissance in Italy. The classicism and fortresslike appearance

of the palace stand in vivid contrast to

the Late Gothic delicacy of the facade

(FIG. 21-37A) of the so-called Ca d'Oro

("House of Gold"), the roughly contem-

poraneous palace of the wealthy Venetian merchant Marino Contarini. The

comparison underscores the marked

21-37A Ca d'Oro, Venice, 1421-1437. ■◀

regional differences between the art and architecture of Florence and Venice (see Chapter 22).

The heart of the Palazzo Medici is an open colonnaded court (FIG. **21-38**) that clearly shows Michelozzo's debt to Brunelleschi. The round-arched colonnade, although more massive in its proportions, closely resembles Brunelleschi's foundling-hospital loggia (FIG. 21-31) and the nave colonnades of Santo Spirito (FIG. 21-32) and San Lorenzo (FIG. 21-32A). The Palazzo Medici's internal court

21-37 MICHELOZZO DI BARTOLOMMEO, east facade of the Palazzo Medici-Riccardi (looking southwest) Florence, Italy, begun 1445. ■

The Medici palace, with its combination of dressed and rusticated masonry and classical moldings, draws heavily on ancient Roman architecture, but Michelozzo creatively reinterpreted his models.

surrounded by an arcade was the first of its kind and influenced a long line of descendants in Renaissance domestic architecture.

LEON BATTISTA ALBERTI Although he entered the profession of architecture rather late in life, LEON BATTISTA ALBERTI (1404-1472) nevertheless made a remarkable contribution to architectural design. He was the first to study seriously the ancient Roman architectural treatise of Vitruvius (see page 167), and his knowledge of it, combined with his own archaeological investigations, made him the first Renaissance architect to understand classical architecture in depth. Alberti's most influential theoretical work, On the Art of Building (written about 1450, published in 1486), although inspired by Vitruvius, contains much original material. Alberti advocated a system of ideal proportions and believed the central plan was the ideal form for churches. He also considered incongruous the combination of column and arch, which had persisted since Roman times and throughout the Middle Ages. For Alberti, the arch was a wall opening that should be supported only by a section of wall (a pier), not by an independent sculptural element (a column), as in Brunelleschi and Michelozzo's buildings.

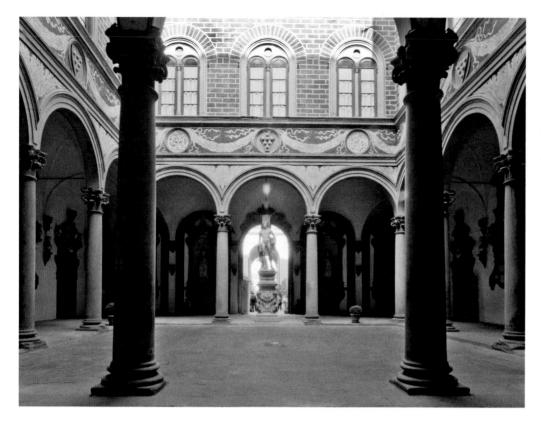

21-38 MICHELOZZO DI BARTOLOMMEO, interior court of the Palazzo Medici-Riccardi (looking northwest), Florence, Italy, begun 1445. ■4

The Medici palace's interior court surrounded by a round-arched colonnade was the first of its kind. The austere design clearly reveals Michelozzo's debt to Brunelleschi (FIG. 21-31).

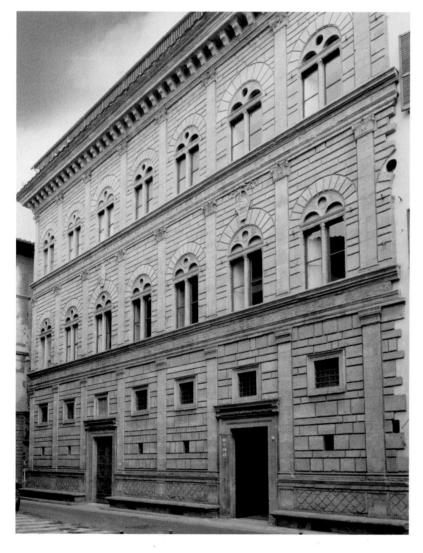

PALAZZO RUCELLAI Alberti's architectural style represents a scholarly application of classical elements to contemporaneous buildings. He designed the Palazzo Rucellai (FIG. 21-39) in Florence, although his pupil and collaborator, Bernardo Rossellino (FIG. 21-15), constructed the building using Alberti's plans and sketches. The facade of the palace is much more severe than that of the Palazzo Medici-Riccardi (FIG. 21-37). Pilasters define each story, and a classical cornice crowns the whole. Between the smooth pilasters are subdued and uniform wall surfaces. Alberti created the sense that the structure becomes lighter in weight toward its top by adapting the ancient Roman manner of using different capitals for each story. He chose Tuscan (the Etruscan variant of the Greek Doric order; FIG. 5-13, *left*, or page xxii in Volume II and Book D) for the ground floor, Composite (the Roman combination of Ionic volutes with the acanthus leaves of the Corinthian; FIG. 5-73 or page xxiii in Volume II and Book D) for the second story,

21-39 LEON BATTISTA ALBERTI and BERNARDO ROSSELLINO, Palazzo Rucellai (looking northwest), Florence, Italy, ca. 1452–1470. ••

Alberti was an ardent student of classical architecture. By adapting the Roman use of different orders for each story, he created the illusion that the Palazzo Rucellai becomes lighter toward its top. and Corinthian for the third floor. Alberti modeled his facade on the most imposing Roman ruin of all, the Colosseum (FIG. 7-37), but he was no slavish copyist. On the Colosseum's facade, the capitals employed are, from the bottom up, Tuscan, Ionic, and Corinthian. Moreover, Alberti adapted the Colosseum's varied surface to a flat facade, which does not allow the deep penetration of the building's mass that is so effective in the Roman structure. By converting his ancient model's *engaged columns* (half-round columns attached to a wall) into shallow pilasters that barely project from the wall, Alberti created a large-meshed linear net. Stretched tightly across the front of his building, it not only unifies the three levels but also emphasizes the wall's flat, two-dimensional qualities.

SANTA MARIA NOVELLA The Rucellai family also commissioned Alberti to design the facade (FIG. 21-40) of the 13thcentury Gothic church of Santa Maria Novella in Florence. Here, Alberti took his cue from a Romanesque design-that of the Florentine church of San Miniato al Monte. Following his medieval model, he designed a small, pseudoclassical, pediment-capped temple front for the facade's upper part and supported it with a pilaster-framed arcade incorporating the six tombs and three doorways of the Gothic building. But in the organization of these elements, Alberti applied Renaissance principles. The height of Santa Maria Novella (to the pediment tip) equals its width. Consequently, the entire facade can be inscribed in a square. Throughout the facade, Alberti defined areas and related them to one another in terms of proportions that can be expressed in simple numerical ratios. For example, the upper structure can be encased in a square one-fourth the size of the main square. The cornice separating the two levels divides the major square in half so that the lower portion of the building is a rectangle twice as wide as it is high. In his treatise, Alberti wrote at length about the necessity of employing harmonic proportions to achieve beautiful buildings. Alberti shared this conviction with Brunelleschi, and this fundamental dependence on classically derived mathematics distinguished their architectural work from that of their medieval predecessors. They believed in the eternal and universal validity of numerical ratios as the source of beauty. In this respect, Alberti and Brunelleschi revived the true spirit of the High Classical age of ancient Greece, as epitomized by the architect Iktinos and the sculptor Polykleitos, who produced

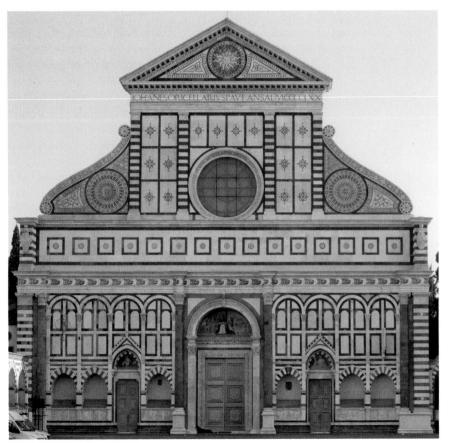

canons of proportions for the perfect temple and the perfect statue (see "The Perfect Temple," and "Polykleitos's Prescription for the Perfect Statue," Chapter 5, pages 105 and 132). Still, it was not only a desire to emulate Vitruvius and the Greek masters that motivated Alberti to turn to mathematics in his quest for beauty. His contemporary, the Florentine humanist Giannozzo Manetti (1396–1459), had argued that Christianity itself possessed the order and logic of mathematics. In his 1452 treatise, *On the Dignity and Excellence of Man*, Manetti insisted Christian religious truths were as selfevident as mathematical axioms.

The Santa Maria Novella facade was an ingenious solution to a difficult design problem. On one hand, it adequately expressed the organization of the structure attached to it. On the other hand, it subjected preexisting and quintessentially medieval features, such as the large round window on the second level, to a rigid geometrical order that instilled a quality of classical calm and reason. This facade also introduced a feature of great historical consequence—the scrolls that simultaneously unite the broad lower and narrow upper levels and screen the sloping roofs over the aisles. With variations, similar spirals appeared in literally hundreds of church facades throughout the Renaissance and Baroque periods.

GIROLAMO SAVONAROLA In the 1490s, Florence underwent a political, cultural, and religious upheaval. Florentine artists and their fellow citizens responded then not only to humanist ideas but also to the incursion of French armies and especially to the preaching of the Dominican monk Girolamo Savonarola (1452–1498), the reformist priest-dictator who denounced the humanistic secularism of the Medici and their artists, philosophers, and poets. Savonarola exhorted the people of Florence to repent their sins, and when Lorenzo de' Medici died in 1492, the priest prophesied the downfall of the city and of Italy and assumed absolute control of the state. As did a large number of citizens, Savon-

arola believed the Medici family's political, social, and religious power had corrupted Florence and invited the scourge of foreign invasion. Savonarola encouraged citizens to burn their classical texts, scientific treatises, and philosophical publications. The Medici fled in 1494. Scholars still debate the significance of Savonarola's brief span of power. Apologists for the undoubtedly sincere monk deny his actions played a role in the decline of Florentine culture at the end of the 15th century. But the puritanical spirit that moved Savonarola must have dampened considerably the enthusiasm for classical antiquity of the Florentine Early Renaissance. Certainly, Savonarola's condemnation of humanism as heretical nonsense, and his banishing of the Medici, Tornabuoni, and other wealthy families from Florence, deprived local artists of some of their major patrons, at least in the short term. There were, however, commissions aplenty for artists elsewhere in Italy.

21-40 LEON BATTISTA ALBERTI, west facade of Santa Maria Novella, Florence, Italy, 1456–1470. ■

Alberti's design for the facade of this Gothic church features a pediment-capped temple front and pilasterframed arcades. Numerical ratios are the basis of the proportions of all parts of the facade.

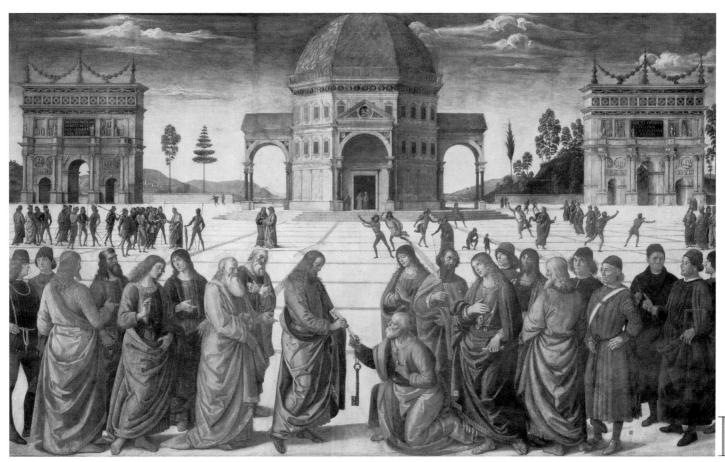

21-41 PERUGINO, *Christ Delivering the Keys of the Kingdom to Saint Peter*, Sistine Chapel, Vatican, Rome, Italy, 1481–1483. Fresco, $11' 5^{\frac{1}{2}''} \times 18' 8^{\frac{1}{2}''}$.

Painted for the Vatican, this fresco depicts the event on which the papacy bases its authority. The converging lines of the pavement connect the action in the foreground with the background.

THE PRINCELY COURTS

Although Florentine artists led the way in creating the Renaissance in art and architecture, the arts flourished throughout Italy in the 15th century. The princely courts in Rome, Urbino, Mantua, and elsewhere also deserve credit for nurturing Renaissance art (see "Italian Princely Courts and Artistic Patronage," page 591). Whether the "prince" was a duke, condottiere, or pope, the considerable wealth the heads of these courts possessed, coupled with their desire for recognition, fame, and power, resulted in major art commissions.

Rome and the Papal States

Although not a secular ruler, the pope in Rome was the head of a court with enormous wealth at his disposal. In the 16th and 17th centuries, the popes became the major patrons of art and architecture in Italy (see Chapters 22 and 24), but even during the Quattrocento, the papacy was the source of some significant artistic commissions.

PERUGINO Between 1481 and 1483, Pope Sixtus IV (r. 1471–1484) summoned a group of artists to Rome to decorate the walls of the newly completed Sistine Chapel (MAP 22-1 and FIG. 22-1). Among the artists the pope employed were Botticelli, Ghirlandaio, and Pietro Vannucci, known as PERUGINO (ca. 1450–1523) because his birthplace was Perugia in Umbria. The project followed immediately the completion of the new Vatican library, which the pope also or-

dered decorated with frescoes by MELOZZO DA FORLÌ (1438–1494; FIG. **21-41A**) and others. Perugino's contribution to the Sistine Chapel fresco cycle was *Christ Delivering the Keys of the Kingdom to Saint Peter* (FIG. **21-41**). The papacy had, from the beginning, based its claim to infallible and total authority over the Roman Catholic Church on this biblical event, and therefore the subject was one of obvious appeal to Sixtus IV. In Perugino's fresco, Christ

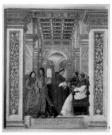

21-41A MELOZZO DA FORLÌ, Sixtus IV Confirming Platina, ca. 1477–1481.

hands the keys to Saint Peter, who stands amid an imaginary gathering of the 12 apostles and Renaissance contemporaries. These figures occupy the apron of a great stage space that extends into the distance to a point of convergence in the doorway of a central-plan temple. (Perugino used parallel and converging lines in the pavement to mark off the intervening space; compare FIGS. 21-10 and 21-11.) Figures in the middle distance complement the near group, emphasizing its density and order by their scattered arrangement. At the corners of the great piazza, duplicate triumphal arches serve as the base angles of a distant compositional triangle whose apex is in the central building. Perugino modeled the arches closely on the Arch of Constantine (FIG. 7-75) in Rome. Although an anachronism in a painting depicting a scene from Christ's life, the arches served to underscore the close ties between Saint Peter and Constantine, the first Christian emperor of Rome and builder of the great basilica (FIG. 8-9) **21-42** LUCA SIGNORELLI, *The Damned Cast into Hell*, San Brizio chapel, Orvieto Cathedral, Orvieto, Italy, 1499–1504. Fresco, 23' wide.

Few figure compositions of the 15th century have the same psychic impact as Signorelli's fresco of writhing, foreshortened muscular bodies tortured by demons in Hell.

over Saint Peter's tomb. Christ and Peter flank the triangle's central axis, which runs through the temple's doorway, the vanishing point of Perugino's perspective scheme. Brunelleschi's new spatial science allowed the Umbrian artist to organize the action systematically. The composition interlocks both two-dimensional and three-dimensional space, and the placement of central actors emphasizes the axial center.

LUCA SIGNORELLI Another Umbrian painter Sixtus IV employed for the decoration of the Sistine Chapel was LUCA SIGNORELLI (ca. 1445-1523), in whose work the fiery passion of Savonarola's sermons found its pictorial equal. Signorelli further developed Pollaiuolo's interest in the depiction of muscular bodies in violent action in a wide variety of poses and foreshortenings. In the San Brizio chapel in the cathedral of the papal city of Orvieto (MAP 14-1), Signorelli painted for Pope Alexander VI (r. 1492-1503) scenes depicting the end of the world, including The Damned Cast into Hell (FIG. 21-42). Few Quattrocento figure compositions equal Signorelli's in psychic impact. Saint Michael and the hosts of Heaven hurl the damned into Hell, where, in a dense, writhing mass, they are vigorously tortured by demons, some winged. The horrible consequences of a sinful life had not been so graphically depicted since Gislebertus carved his vision of Last Judgment (FIG. 12-1) in the west tympanum of Saint-Lazare at Autun around 1130. The figures-nude, lean, and muscular-assume every conceivable posture of anguish. Signorelli was a master both of foreshortening the human figure and depicting bodies in violent movement. Although each figure is clearly a study from a model, Signorelli incorporated the individual studies into a convincing and coherent narrative composition. Terror and rage pass like storms through the wrenched and twisted bodies. The fiends, their hair flaming and their bodies the color of putrefying flesh, lunge at their victims in ferocious frenzy.

Urbino

Under the patronage of Federico da Montefeltro (1422–1482), Urbino, southeast of Florence across the Appenines (MAP 14-1), became an important center of Renaissance art and culture. In fact, the humanist writer Paolo Cortese (1465–1540) described Federico as one of the two greatest artistic patrons of the 15th century (the other was Cosimo de' Medici). Federico was a condottiere so renowned for his military expertise that he was in demand by popes and kings, and soldiers came from across Europe to study under his direction.

PIERO DELLA FRANCESCA One of the artists who received several commissions from Federico was Piero della Francesca, who had already established a major reputation in his native Tuscany. At the Urbino court, Piero produced both official portraits and religious works for Federico, among them a double portrait (FIG. **21-43**) of the count and his second wife, Battista Sforza (1446–1472), and the *Brera Altarpiece* (FIG. **21-43A**), in which Federico kneels before the enthroned Madonna and saints.

21-43A PIERO DELLA FRANCESCA, *Brera Altarpiece*, ca. 1472–1474.

Federico de Montefeltro married Battista Sforza in 1460 when she was 14 years old. The daughter of Alessandro Sforza (1409–1473), lord of Pesaro and brother of the duke of Milan, Battista was a welleducated humanist who proved to be an excellent administrator of Federico's territories during his frequent military campaigns. She gave birth to eight daughters in 11 years and finally, on January 25, 1472, to the male heir for which the couple had prayed. When the countess died of pneumonia five months later at age 26, Federico went into mourning for virtually the rest of his life. He never remarried.

Italian Princely Courts and Artistic Patronage

uring the Renaissance, the absence of a single sovereign ruling all of Italy and the fragmented nature of the independent citystates (MAP 14-1) provided a fertile breeding ground for the ambitions of power-hungry elites. In the 15th century, princely courts proliferated throughout the peninsula. A prince was in essence the lord of a territory, and, despite this generic title, he could have been a duke, marquis, count, cardinal, pope, or condottiere. At this time, major princely courts emerged in papal Rome (FIGS. 21-41, 21-41A, and 21-42), Milan, Naples, Ferrara, Savoy, Urbino (FIGS. 21-43, 21-43A, and 21-44), and Mantua (FIGS. 21-45 to 21-50). Rather than denoting a specific organizational structure or physical entity, the term princely court refers to a power relationship between the prince and the territory's inhabitants based on imperial models. Each prince worked tirelessly to preserve and extend his control and authority, seeking to establish a societal framework of people who looked to him for employment, favors, protection, prestige, and leadership. The importance of these princely courts derived from their role as centers of power and culture.

The efficient functioning of a princely court required a sophisticated administrative structure. Each prince employed an extensive household staff, ranging from counts, nobles, cooks, waiters, stewards, footmen, stable hands, and ladies-in-waiting to dog handlers, leopard keepers, pages, and runners. The duke of Milan had more than 40 chamberlains to attend to his personal needs alone. Each prince also needed an elaborate bureaucracy to oversee political, economic, and military operations and to ensure his continued control. These officials included secretaries, lawyers, captains, ambassadors, and condottieri. Burgeoning international diplomacy and trade made each prince the center of an active and privileged sphere. Their domains extended to the realm of culture, for they saw themselves as more than political, military, and economic leaders. As the wealthiest individuals in their regions, princes possessed the means to commission numerous artworks and buildings. Art functioned in several capacities in the princely courts—as evidence of princely sophistication and culture, as a form of prestige or commemoration, as propaganda, as a demonstration of wealth—in addition to being a source of visual pleasure.

Princes often researched in advance the reputations and styles of the artists and architects they commissioned. Such assurances of excellence were necessary, because the quality of the work reflected not solely on the artist but on the patron as well. Yet despite the importance of individual style, princes sought artists who also were willing, at times, to subordinate their personal styles to work collaboratively on large-scale projects.

Princes bestowed on selected individuals the title of "court artist." Serving as a court artist had its benefits, among them a guaranteed salary (not always forthcoming), living quarters in the palace, liberation from guild restrictions, and, on occasion, status as a member of the prince's inner circle, perhaps even a knighthood. For artists struggling to elevate their profession from the ranks of craftspeople, working for a prince presented a marvelous opportunity. Until the 16th century, artists had limited status, and people considered them in the same class as small shopkeepers and petty merchants. Indeed, at court dinners, artists most often sat with the other members of the salaried household: tailors, cobblers, barbers, and upholsterers. Thus, the possibility of advancement was a powerful and constant incentive.

Princes demanded a great deal from court artists. Artists not only created the frescoes, portraits, and sculptures that have become their legacies but also designed tapestries, seat covers, cos-

> tumes, masks, and decorations for various court festivities. Because princes constantly received ambassadors and dignitaries and needed to maintain a high profile to reinforce their authority, lavish social functions were the norm. Artists often created gifts for visiting nobles and potentates. Recipients judged these gifts on the quality of both the work and the materials. By using expensive materials—gold leaf, silver leaf, lapis lazuli (a rich azure-blue stone imported from Afghanistan), silk, and velvet brocade—and employing the best artists, princes could impress others with their wealth and good taste.

21-43 PIERO DELLA FRANCESCA, Battista Sforza and Federico da Montefeltro, ca. 1472–1474. Oil and tempera on wood in modern frame, each panel 1' $6\frac{1}{2}$ " × 1' 1". Galleria degli Uffizi, Florence.

Piero's portraits of Federico da Montefeltro and his recently deceased wife combine the profile views on Roman coins with the landscape backgrounds of Flemish portraiture (FIG. 20-14).

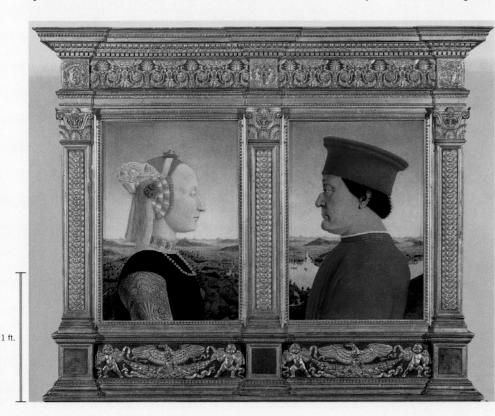

Federico commissioned Piero della Francesca to paint their double portrait shortly after Battista's death to pay tribute to her and to have a memento of their marriage. The present frame is a 19th-century addition. Originally, the two portraits formed a hinged diptych. The format-two bust-length portraits with a landscape background-follows Flemish models, such as the portraits by Hans Memling (FIGS. 20-14 and 20-14A), as does Piero's use of oil-based pigment (see "Tempera and Oil Painting," Chapter 20, page 539). Piero would have been familiar with northern European developments because Federico employed Flemish painters at his court. But Piero depicted the Urbino count and countess in profile, in part to emulate the profile portraits of Roman rulers on coins (FIG. 7-81, *left*) that Renaissance humanists avidly collected, and in part to conceal the disfigured right side of Federico's face. (He lost his right eye and part of the bridge of his nose in a tournament in 1450.) That injury also explains why Federico is on the right in left profile (compare FIG. 21-43A). Roman coins normally show the emperor in right profile, and Renaissance marriage portraits almost always place the husband at the viewer's left.

Piero probably based Battista's portrait on her death mask, and the pallor of her skin may be a reference to her death. Latin inscriptions on the reverse of the two portraits refer to Federico in the present tense and to Battista in the past tense, confirming the posthumous date of her portrait. The backs of the panels also bear paintings. They represent Federico and Battista in triumphal chariots accompanied by personifications of their respective virtues, including Justice, Prudence, and Fortitude (Federico) and Faith, Charity, and Chastity (Battista). The placement of scenes of triumph on the reverse of profile portraits also emulates ancient Roman coinage.

FLAGELLATION Piero may also have painted his most enigmatic work, *Flagellation* (FIG. **21-44**), for Federico da Montefeltro. The setting for the passion drama is the portico of Pontius Pilate's palace in Jerusalem. Curiously, the focus of the composition is not Jesus but the group of three large figures in the foreground, whose identity scholars still debate. Some have described the bearded figure as a Turk and interpreted the painting as a commentary on the capture in 1453 of Christian Constantinople by the Muslims (see Chapter 9). Other scholars, however, identify the three men as biblical figures, including King David, one of whose psalms Christian theologians believed predicted the conspiracy against Jesus. In any case, the three men appear to discuss the event in the background. As Pilate, the seated judge, watches, Jesus, bound to a column topped

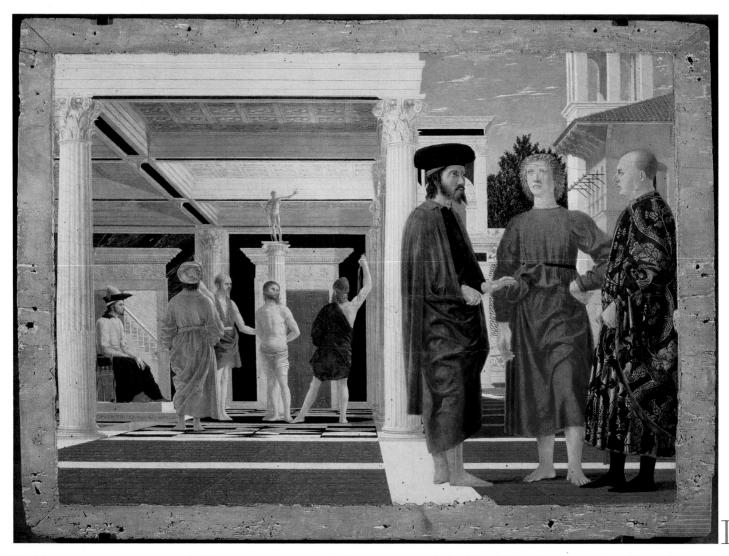

21-44 PIERO DELLA FRANCESCA, *Flagellation*, ca. 1455–1465. Oil and tempera on wood, 1' $11\frac{1}{8}^{"} \times 2' 8\frac{1}{4}^{"}$. Galleria Nazionale delle Marche, Urbino.

In this enigmatic painting, the three unidentified foreground figures appear to be discussing the biblical tragedy taking place in Pilate's palace, which Piero rendered in perfect perspective.

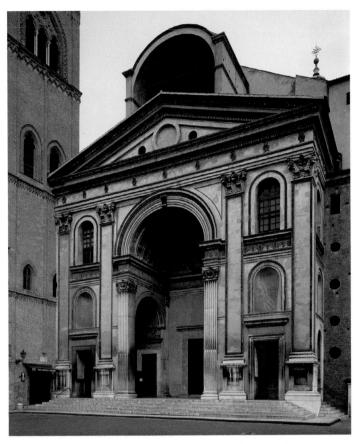

21-45 LEON BATTISTA ALBERTI, west facade of Sant'Andrea, Mantua, Italy, designed 1470, begun 1472.

Alberti's design for Sant'Andrea reflects his study of ancient Roman architecture. Employing a colossal order, the architect combined a triumphal arch and a Roman temple front with pediment.

by a classical statue, is about to be whipped. Piero's perspective is so meticulous the floor pattern can be reconstructed perfectly as a central porphyry (purple marble) circle with surrounding squares composed of various geometric shapes. Whatever the solution to the iconographical puzzle of Piero's Flagellation, the small wood panel reveals a mind cultivated by mathematics. The careful delineation of architecture suggests an architect's vision, certainly that of a man entirely familiar with compass and ruler. Piero planned his compositions almost entirely by his sense of the exact and lucid structures defined by mathematics. He believed the highest beauty resides in forms that have the clarity and purity of geometric figures. Toward the end of his long career, Piero, a skilled geometrician, wrote the first theoretical treatise on systematic perspective, after having practiced the art with supreme mastery for almost a lifetime. His association with the architect Leon Battista Alberti at Ferrara and at Rimini (FIGS. 21-46 and 21-47) around 1450-1451 probably turned his attention fully to perspective (a science in which Alberti was an influential pioneer; see page 566) and helped determine his later, characteristically architectonic compositions. This approach appealed to Federico, a patron fascinated by architectural space and its depiction.

Mantua

Marquis Ludovico Gonzaga (1412–1478) ruled the court of Mantua in northeastern Italy (MAP 14-1) during the mid-15th century. A famed condottiere like Federico de Montefeltro, Gonzaga established his reputation as a fierce military leader while general of the

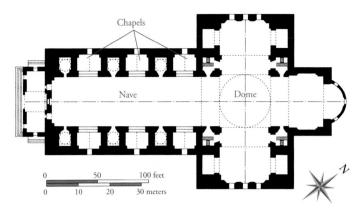

21-46 LEON BATTISTA ALBERTI, plan of Sant'Andrea, Mantua, Italy, designed 1470, begun 1472.

In his architectural treatise, Alberti criticized the traditional basilican plan as impractical. He designed Sant'Andrea as a single huge hall with independent chapels branching off at right angles.

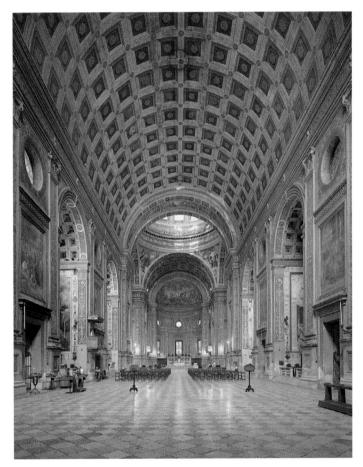

21-47 LEON BATTISTA ALBERTI, interior of Sant'Andrea (looking east), Mantua, Italy, designed 1470, begun 1472.

For the nave of Sant'Andrea, Alberti abandoned the medieval columnar arcade. The tremendous vaults suggest that Constantine's Basilica Nova (FIG. 7-78) in Rome may have served as a prototype.

Milanese armies. The visit of Pope Pius II (r. 1458–1464) to Mantua in 1459 stimulated the marquis's determination to transform his city into one all Italy would envy.

SANT'ANDREA One of the major projects Gonzaga instituted was the redesign and replacement of the 11th-century church of Sant'Andrea (FIGS. **21-45** to **21-47**). Gonzaga turned to the renowned architect Leon Battista Alberti (FIGS. 21-39 and 21-40) for

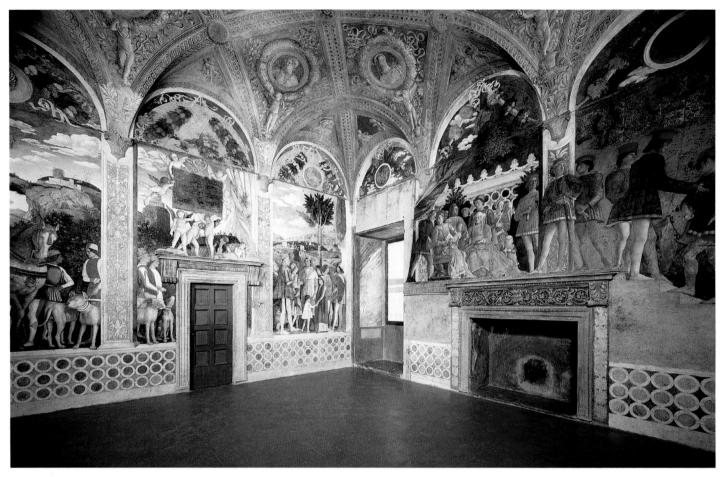

21-48 ANDREA MANTEGNA, interior of the Camera Picta (Painted Chamber), Palazzo Ducale, Mantua, Italy, 1465–1474. Fresco.

Working for Ludovico Gonzaga, who established Mantua as a great art city, Mantegna produced for the duke's palace the first completely consistent, illusionistic decoration of an entire room.

this important commission. The facade (FIG. 21-45) Alberti designed incorporated two major ancient Roman architectural motifs-the temple front and the triumphal arch. The combination was already a familiar feature of Roman buildings still standing in Italy. For example, many triumphal arches, including an Augustan (late first century BCE) arch at Rimini on Italy's northeast coast, feature a pediment over the arcuated passageway and engaged columns, but there is no close parallel in antiquity for Alberti's eclectic and ingenious design. The Renaissance architect's concern for proportion led him to equalize the vertical and horizontal dimensions of the facade, which left it considerably shorter than the church behind it. Because of the primary importance of visual appeal, many Renaissance architects made this concession not only to the demands of a purely visual proportionality in the facade but also to the facade's relation to the small square in front of it, even at the expense of continuity with the body of the building. Yet structural correspondences to the building do exist in Sant'Andrea's facade. The pilasters are the same height as those on the nave's interior walls, and the large barrel vault over the central portal, with smaller barrel vaults branching off at right angles, introduces on a smaller scale the arrangement of the church's nave and chapels (FIGS. 21-46 and 21-47). The facade pilasters, as part of the wall, run uninterrupted through three stories in an early application of the colossal or giant order that became a favorite motif of Michelangelo (see Chapter 22).

The tremendous vaults in the interior of Sant'Andrea suggest Alberti's model may have been Constantine's Basilica Nova (FIG. 7-78) in Rome-erroneously thought in the Middle Ages and Renaissance to be a Roman temple. Consistent with his belief that arches should not be used with freestanding columns, Alberti abandoned the medieval columnar arcade Brunelleschi still used in Santo Spirito (FIG. 21-32) and San Lorenzo (FIG. 21-32A). Thick walls alternating with vaulted chapels, interrupted by a massive dome over the crossing, support the huge coffered barrel vault. Because FILIPPO JUVARA (1678-1736) added the present dome in the 18th century, the effect may be somewhat different from what Alberti planned. Regardless, the vault calls to mind the vast interior spaces and dense enclosing masses of Roman architecture. In his treatise, Alberti criticized the traditional basilican plan (with continuous aisles flanking the central nave) as impractical because the colonnades conceal the ceremonies from the faithful in the aisles. For this reason, he designed a single huge hall (FIG. 21-47) with independent chapels branching off at right angles (FIG. 21-46). This break with a Christian building tradition that had endured for a thousand years was extremely influential in later Renaissance and Baroque church planning.

ANDREA MANTEGNA Like other princes, Ludovico Gonzaga believed an impressive palace was an important visual expression of his authority. One of the most spectacular rooms in the

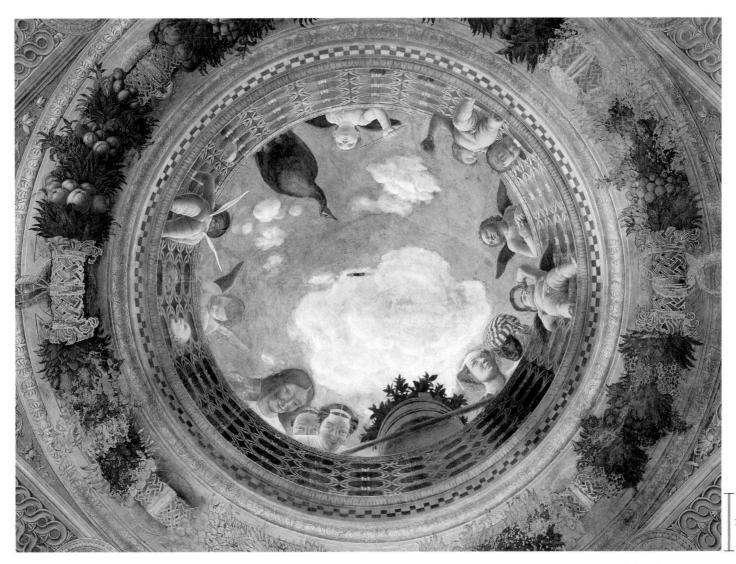

21-49 ANDREA MANTEGNA, ceiling of the Camera Picta (Painted Chamber), Palazzo Ducale, Mantua, Italy, 1465–1474. Fresco, 8' 9" in diameter. 🖿

Inside the Camera Picta, the viewer becomes the viewed as figures gaze into the room from a painted oculus opening onto a blue sky. This is the first perspective view of a ceiling from below.

Palazzo Ducale (ducal palace) is the duke's bedchamber and audience hall, the so-called Camera degli Sposi ("Room of the Newlyweds"), originally the Camera Picta ("Painted Room"; FIGS. **21-48** and **21-49**). ANDREA MANTEGNA (ca. 1431–1506) of Padua took almost nine years to complete the extensive fresco program in which he sought to aggrandize Ludovico Gonzaga and his family. The particulars of each scene are still a matter of scholarly debate, but any viewer standing in the Camera Picta surrounded by the spectacle and majesty of courtly life cannot help but be thoroughly impressed by both the commanding presence and elevated status of the patron and the dazzling artistic skills of Mantegna.

In the Camera Picta, Mantegna performed a triumphant feat by producing the first completely consistent illusionistic decoration of an entire room. By integrating real and painted architectural elements, Mantegna illusionistically dissolved the room's walls in a manner foretelling 17th-century Baroque decoration (see Chapter 24). The Camera Picta recalls the efforts of Italian painters more than 15 centuries earlier at Pompeii and elsewhere to merge mural painting and architecture in frescoes of the so-called Second Style of Roman painting (FIGS. 7-18 and 7-19). Mantegna's *trompe l'oeil* (French, "deceives the eye") design, however, went far beyond anything preserved from ancient Italy. The Renaissance painter's daring experimentalism led him to complete the room's decoration with the first perspective of a ceiling (FIG. 21-49) seen from below (called, in Italian, *di sotto in sù*, "from below upward"). Baroque ceiling decorators later broadly developed this technique. Inside the Camera Picta, the viewer becomes the viewed as figures look down into the room from the painted *oculus* ("eye"). Seen against the convincing illusion of a cloud-filled blue sky, several putti, strongly foreshortened, set the amorous mood of the Room of the Newlyweds, as the painted spectators (who are not identified)

smile down on the scene. The prominent peacock, perched precariously as if ready to swoop down into the room, is an attribute of Juno, Jupiter's bride, who oversees lawful marriages. This brilliant feat of illusionism is the climax of decades of experimentation with perspective representation by numerous Quattrocento artists as well as by Mantegna himself—for example, in his frescoes (FIG. **21-49A**) in the Church of the Eremitani in Padua.

21-49A MANTEGNA, Saint James Led to Martyrdom, 1454–1457.

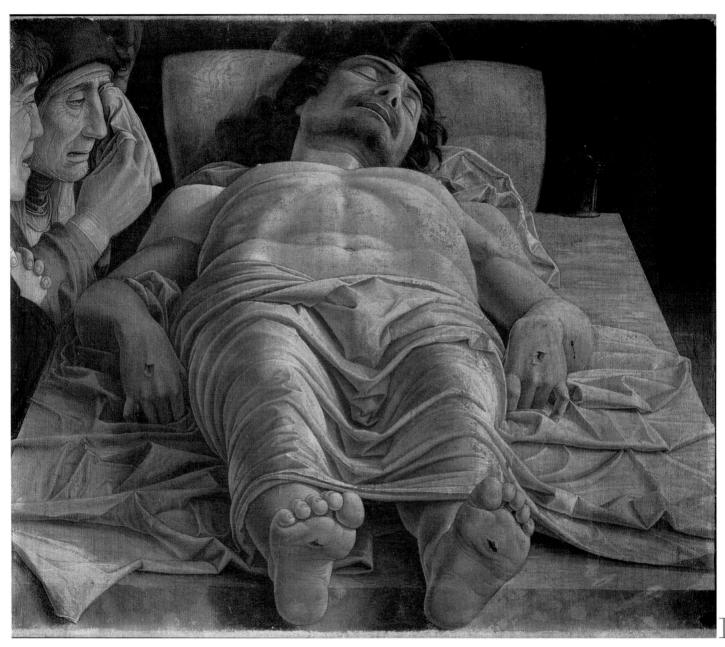

[1 in.

21-50 ANDREA MANTEGNA, Foreshortened Christ (Lamentation over the Dead Christ), ca. 1500. Tempera on canvas, 2' $2\frac{3''}{4} \times 2' 7\frac{7''}{8}$. Pinacoteca di Brera, Milan.

In this work of overwhelming emotional power, Mantegna presented both a harrowing study of a strongly foreshortened cadaver and an intensely poignant depiction of a biblical tragedy.

FORESHORTENED CHRIST One of Mantegna's later paintings (FIG. **21-50**) is another example of the artist's mastery of perspective. In fact, Mantegna seems to have set up for himself difficult problems in perspective simply for the joy he took in solving them. The painting often called *Lamentation over the Dead Christ*, but recorded under the name *Foreshortened Christ* at the time of Mantegna's death, is a work of overwhelming power. At first glance, as its 16th-century title implies, this painting seems to be a strikingly realistic study in foreshortening. Careful scrutiny, however, reveals Mantegna reduced the size of Christ's feet, which, as he clearly knew, would cover much of the body if properly represented according to the rules of perspective, in which the closest objects, people, or body parts are the largest. Thus, tempering naturalism with artistic license, Mantegna presented both a harrowing study of a strongly foreshortened cadaver and an intensely poignant depiction of a biblical tragedy. The painter's harsh, sharp line seems to cut the surface as if it were metal and conveys, by its grinding edge, the theme's corrosive emotion. Remarkably, in the supremely gifted hands of Mantegna, all of Quattrocento science here serves the purpose of devotion.

THE BIG PICTURE

THE RENAISSANCE IN QUATTROCENTO ITALY

FLORENCE

- The fortunate congruence of artistic genius, the spread of humanism, and economic prosperity nourished the flowering of the new artistic culture historians call the Renaissance—the rebirth of classical values in art and life. The greatest center of Renaissance art in the 15th century was Florence, home of the powerful Medici, who were among the most ambitious art patrons in history.
- Some of the earliest examples of the new Renaissance style in sculpture are the statues Nanni di Banco and Donatello made for Or San Michele. Donatello's *Saint Mark* reintroduced the classical concept of contrapposto into Renaissance statuary. His later *David* was the first nude male statue since antiquity. Donatello was also a pioneer in relief sculpture, the first to incorporate the principles of linear and atmospheric perspective, devices also employed brilliantly by Lorenzo Ghiberti in his *Gates of Paradise* for the Florentine baptistery.
- The Renaissance interest in classical culture naturally also led to the revival of Greco-Roman mythological themes in art, for example, Antonio del Pollaiuolo's *Hercules and Antaeus*, and to the revival of equestrian portraits, such as Donatello's *Gattamelata* and Andrea del Verrocchio's *Bartolommeo Colleoni*.
- Although some painters continued to work in the Late Gothic International Style, others broke fresh ground by exploring new modes of representation. Masaccio's figures recall Giotto's, but have a greater psychological and physical credibility, and the light shining on Masaccio's figures comes from a source outside the picture. His *Holy Trinity* epitomizes Early Renaissance painting in its convincing illusionism, achieved through Filippo Brunelleschi's new science of linear perspective, yet it remains effective as a devotional painting in a church setting.
- The secular side of Quattrocento Italian painting is on display in historical works, such as Paolo Uccello's Battle of San Romano and Domenico Ghirlandaio's portrait Giovanna Tornabuoni. The humanist love of classical themes comes to the fore in the works of Sandro Botticelli, whose lyrical Primavera and Birth of Venus were inspired by poetry and Neo-Platonic philosophy.
- Italian architects also revived the classical style. Brunelleschi's Ospedale degli Innocenti showcases the clarity and Roman-inspired rationality of 15th-century Florentine architecture. The model for Leon Battista Alberti's influential 1450 treatise On the Art of Building was a similar work by the ancient Roman architect Vitruvius.

THE PRINCELY COURTS

- Although Florentine artists led the way in creating the Renaissance in art and architecture, the papacy in Rome and the princely courts in Urbino, Mantua, and elsewhere also were major art patrons.
- Among the important papal commissions of the Quattrocento was the decoration of the walls of the Sistine Chapel with frescoes, including Perugino's *Christ Delivering the Keys of the Kingdom to Saint Peter,* a prime example of linear perspective.
- Under the patronage of Federico da Montefeltro, Urbino became a major center of Renaissance art and culture. The leading painter in Federico's employ was Piero della Francesca, a master of color and light and the author of the first theoretical treatise on perspective.
- Mantua became an important art center under Marquis Ludovico Gonzaga, who commissioned Alberti to rebuild the church of Sant'Andrea. Alberti applied the principles he developed in his architectural treatise to the project and freely adapted forms from Roman religious and civic architecture.
- Gonzaga hired Andrea Mantegna to decorate the Camera Picta of the ducal palace, in which the painter produced the first completely consistent illusionistic decoration of an entire room.

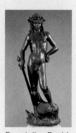

Donatello, *David,* ca. 1440–1460

Masaccio, Holy Trinity, ca. 1424–1427

Brunelleschi, Ospedale degli Innocenti, begun 1419

Piero della Francesca, Battista Sforza and Federico da Montefeltro, 1472–1474

Alberti, Sant'Andrea, Mantua, 1470

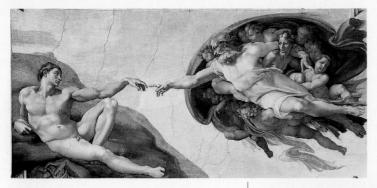

Michelangelo, the Renaissance genius who was primarily a sculptor, reluctantly spent almost four years painting the ceiling of the Sistine Chapel under commission from Pope Julius II.

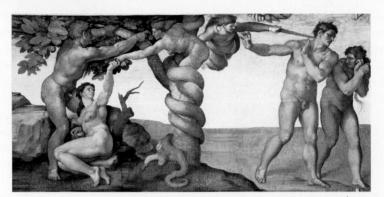

Michelangelo's retelling of the biblical narrative often departed from traditional iconography. In one panel he combined *Temptation* and *Expulsion*, suggesting God's swift punishment for original sin.

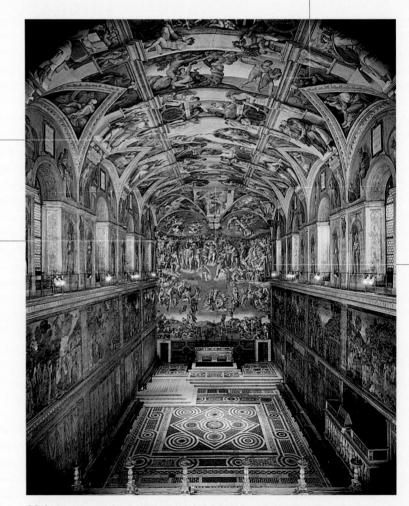

22-1 Interior of the Sistine Chapel (looking west), Vatican City, Rome, Italy, built 1473; ceiling and altar wall frescoes by MICHELANGELO BUONARROTI, 1508–1512 and 1536–1541, respectively. ■4

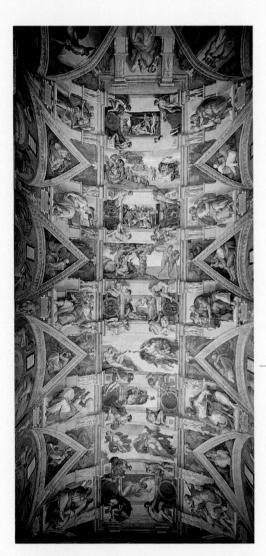

The fresco cycle illustrates the creation and fall of humankind as related in Genesis. Michelangelo always painted with a sculptor's eye. His heroic figures resemble painted statues.

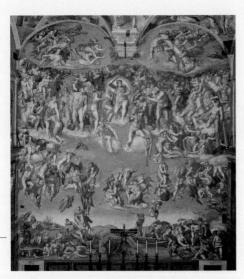

Michelangelo completed his fresco cycle in the Sistine Chapel for another pope— Paul III—with this terrifying vision of the fate awaiting sinners at the *Last Judgment*. It includes his self-portrait.

22

RENAISSANCE AND MANNERISM IN CINQUECENTO ITALY

MICHELANGELO IN THE SERVICE OF JULIUS II

MICHELANGELO BUONARROTI (1475–1564) was the first artist in history whose prodigious talent and brooding personality matched today's image of the temperamental artistic genius. His self-imposed isolation, creative furies, proud independence, and daring innovations led Italians of his era to speak of the charismatic personality of the man and the expressive character of his works in one word—*terribilità*, the sublime shadowed by the awesome and the fearful. Yet, unlike most modern artists, who create works in their studios and offer them for sale later, Michelangelo and his contemporaries produced most of their paintings and sculptures under contract for wealthy patrons who dictated the content—and sometimes the form—of their artworks.

In Italy in the 1500s—the *Cinquecento*—the greatest art patron was the Catholic Church headed by the pope in Rome. Michelangelo's most famous work today—the ceiling of the Sistine Chapel (FIG. 22-1) in the Vatican palace (MAPS 22-1 and 24-1)—was, in fact, a commission he did not want. His patron was Julius II (r. 1503–1513), an immensely ambitious man who sought to extend his spiritual authority into the temporal realm, as other medieval and Renaissance popes had done. Julius selected his name to associate himself with Julius Caesar and found inspiration in ancient Rome. His enthusiasm for engaging in battle earned Julius the designation "warrior-pope," but his ten-year papacy was most notable for his patronage of the arts. He understood well the propagandistic value of visual imagery and upon his election immediately commissioned artworks that would present an authoritative image of his rule and reinforce the primacy of the Catholic Church.

When Julius asked Michelangelo to take on the challenge of providing frescoes for the ceiling of the Sistine Chapel, the artist insisted painting was not his profession (a protest that rings hollow after the fact, but Michelangelo's major works until then had been in sculpture). The artist had no choice, however, but to accept the pope's assignment.

In the Sistine Chapel frescoes, as in his sculpture, Michelangelo relentlessly concentrated his expressive purpose on the human figure. To him, the body was beautiful not only in its natural form but also in its spiritual and philosophical significance. The body was the manifestation of the character of the soul. In the *Creation of Adam, Temptation and Expulsion,* and *Last Judgment* frescoes, Michelangelo represented the body in its most elemental aspect—in the nude or simply draped, with no background and no ornamental embellishment. He always painted with a sculptor's eye for how light and shadow reveal volume and surface. It is no coincidence that many of the figures in the Sistine Chapel seem to be painted statues.

HIGH AND LATE RENAISSANCE

The art and architecture of 16th-century Italy built on the foundation of the Early Renaissance of the 15th century, but no single artistic style characterized Italian 16th-century art, and regional differences abounded, especially between central Italy (Florence and Rome) and Venice. The period opened with the brief era art historians call the High Renaissance—the quarter century between 1495 and the deaths of Leonardo da Vinci in 1519 and Raphael in 1520. The Renaissance style and the interest in classical culture, perspective, proportion, and human anatomy dominated the remainder of the 16th century (the Late Renaissance), but a new style, called Mannerism, challenged Renaissance naturalism almost as soon as Raphael had

been laid to rest (inside the ancient Roman Pantheon, FIG. 7-51). The one constant in Cinquecento Italy is the astounding quality, both technical and aesthetic, of the art and architecture produced.

Indeed, the modern notion of the "fine arts" and the exaltation of the artist-genius originated in Renaissance Italy. Humanist scholars and art patrons alike eagerly adopted the ancient Greek philosopher Plato's view of the nature of poetry and of artistic creation in general: "All good poets . . . compose their beautiful poems not by art, but because they are inspired and possessed. . . . For not by art does the poet sing, but by power divine."¹ In Cinquecento Italy, the pictorial arts achieved the high status formerly held only by poetry. During the High Renaissance, artists first became international celebrities, none more so than Leonardo da Vinci, Raphael, and Michelangelo.

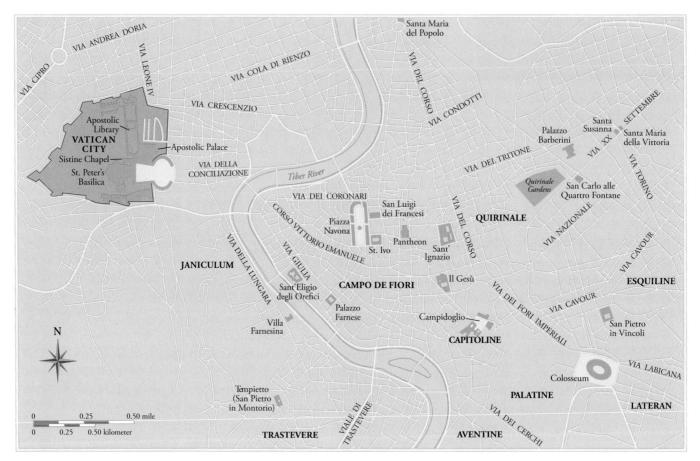

MAP 22-1 Rome with Renaissance and Baroque monuments.

RENAISSANCE AND MANNERISM IN CINQUECENTO ITALY

Giulio Romano

1495 15	20 15	50 1	575	1600
 Leonardo da Vinci paints Last Supper in Milan and Mona Lisa in Florence High Renaissance art emerges in Rome under Pope Julius II Raphael paints School of Athens for the papal apartments Michelangelo carves David for the Palazzo della Signoria in Florence and paints the ceiling 	 Paul III launches the Counter- Reformation Michelangelo paints <i>Last</i> <i>Judgment</i> in the Sistine Chapel In Venice, Titian uses rich colors and establishes oil on canvas as the preferred medium of Western painting Mannerism emerges as an alternative to High Renaissance style in the work of Pontormo, 	 Council of Trent defends religious art Andrea Palladio becomes chief architect of the Venetian Republic Giorgio Vasari publishes <i>Lives</i> of the Most Eminent Painters, Sculptors, and Architects 	 Tintoretto is the leading Venetian Mannerist painter Veronese creates a huge illusionistic ceiling painting for the Doge's Palace Giovanni da Bologna uses spiral compositions for Mannerist statuary groups Construction of Il Gesù in Rome 	

Leonardo da Vinci

Born in the small town of Vinci, near Florence, LEONARDO DA VINCI (1452-1519) trained in the studio of Andrea del Verrocchio (FIGS. 21-13 and 21-17). The quintessential "Renaissance man," Leonardo possessed unequaled talent and an unbridled imagination. Art was but one of his innumerable interests, the scope and depth of which were without precedent. His unquenchable curiosity is evident in the voluminous notes he interspersed with sketches in his notebooks dealing with botany, geology, geography, cartography, zoology, military engineering, animal lore, anatomy, and aspects of physical science, including hydraulics and mechanics. Leonardo stated repeatedly that his scientific investigations made him a better painter. That is undoubtedly the case. For example, Leonardo's in-depth exploration of optics provided him with a thorough understanding of perspective, light, and color. Leonardo was a true artist-scientist. Indeed, his scientific drawings (FIG. 22-6) are themselves artworks.

Leonardo's great ambition in his painting, as well as in his scientific endeavors, was to discover the laws underlying the processes and flux of nature. With this end in mind, he also studied the human body and contributed immeasurably to the fields of physiology and psychology. Leonardo believed reality in an absolute sense is inaccessible and humans can know it only through its changing images. He considered the eyes the most vital organs and sight the most essential function. Better to be deaf than blind, he argued, because through the eyes, individuals can grasp reality most directly and profoundly.

LEONARDO IN MILAN Around 1481, Leonardo left Florence after offering his services to Ludovico Sforza (1451–1508), the son and heir apparent of the ruler of Milan. The political situation in Florence was uncertain, and Leonardo may have felt his particular skills would be in greater demand in Milan, providing him with the opportunity for increased financial security. He devoted most of a letter to Ludovico to advertising his competence and his qualifications as a military engineer, mentioning only at the end his abilities as a painter and sculptor. The letter illustrates the relationship between Renaissance artists and their patrons (see "Michelangelo in the Service of Julius II," page 599) as well as Leonardo's breadth of competence. That he should select expertise in military engineering as his primary attraction for the Sforzas is an index of the period's instability.

And in short, according to the variety of cases, I can contrive various and endless means of offence and defence.... In time of peace I believe I can give perfect satisfaction and to the equal of any other in architecture and the composition of buildings, public and private; and in guiding water from one place to another.... I can carry out sculpture in marble, bronze, or clay, and also I can do in painting whatever may be done, as well as any other, be he whom he may.²

Ludovico accepted Leonardo's offer, and the Florentine artist remained in Milan for almost 20 years.

MADONNA OF THE ROCKS Shortly after settling in Milan, Leonardo painted *Madonna of the Rocks* (FIG. **22-2**) as the central panel of an altarpiece for the chapel of the Confraternity of the Immaculate Conception in San Francesco Grande. The painting builds on Masaccio's understanding and usage of chiaroscuro, the subtle play of light and dark. Modeling with light and shadow and expressing emotional states were, for Leonardo, the heart of painting:

A good painter has two chief objects to paint—man and the intention of his soul. The former is easy, the latter hard, for it must be

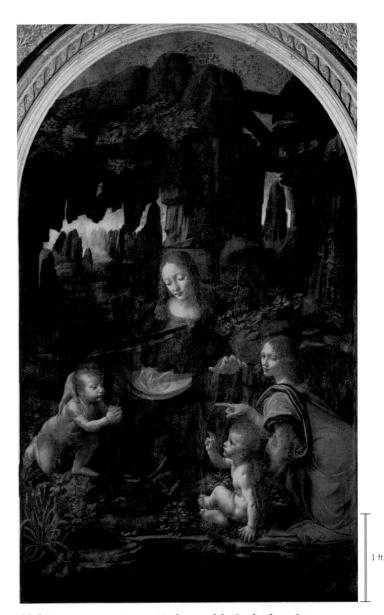

22-2 LEONARDO DA VINCI, *Madonna of the Rocks*, from San Francesco Grande, Milan, Italy, begun 1483. Oil on wood (transferred to canvas), 6' $6\frac{1}{2}'' \times 4'$. Musée du Louvre, Paris.

Leonardo used gestures and a pyramidal composition to unite the Virgin, John the Baptist, the Christ Child, and an angel in this work, in which the figures share the same light-infused environment.

expressed by gestures and the movement of the limbs.... A painting will only be wonderful for the beholder by making that which is not so appear raised and detached from the wall.³

Leonardo presented the figures in *Madonna of the Rocks* in a pyramidal grouping and, more notably, as sharing the same environment. This groundbreaking achievement—the unified representation of objects in an atmospheric setting—was a manifestation of his scientific curiosity about the invisible substance surrounding things. The Madonna, Christ Child, infant John the Baptist, and angel emerge through nuances of light and shade from the halflight of the cavernous visionary landscape. Light simultaneously veils and reveals the forms, immersing them in a layer of atmosphere. Leonardo's effective use of atmospheric perspective is the result in large part of his mastery of the relatively new medium of oil painting, which had previously been used mostly by northern European painters (see "Tempera and Oil Painting," Chapter 20, page 539). The four figures pray, point, and bless, and these acts and

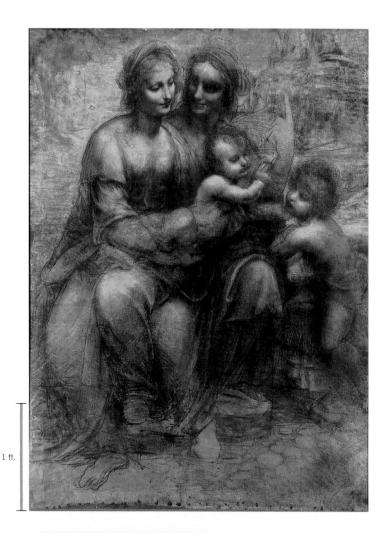

22-3 LEONARDO DA VINCI, cartoon for Madonna and Child with Saint Anne and the Infant Saint John, ca. 1505–1507. Charcoal heightened with white on brown paper, 4' 6" × 3' 3". National Gallery, London.

In this cartoon for a painting of the Madonna and Child and two saints, Leonardo drew a scene of tranquil grandeur filled with monumental figures reminiscent of classical statues. gestures, although their meanings are uncertain, visually unite the individuals portrayed. The angel points to the infant John and, through his outward glance, involves the viewer in the tableau. John prays to the Christ Child, who blesses him in return. The Virgin herself completes the series of interlocking gestures, her left hand reaching toward the Christ Child and her right hand resting protectively on John's shoulder. The melting mood of tenderness, which the caressing light enhances, suffuses the entire composition. By creating an emotionally compelling, visually unified, and spatially convincing image, Leonardo succeeded in expressing "the intention of [man's] soul."

MADONNA AND CHILD CARTOON Leonardo's style fully emerges in *Madonna and Child with Saint Anne and the In-fant Saint John* (FIG. 22-3), a preliminary drawing (*cartoon*) for a painting (see "Renaissance Drawings," page 604) he made in 1505 or shortly thereafter. Here, the glowing light falls gently on the majestic forms in a scene of tranquil grandeur and balance. Leonardo ordered every part of his cartoon with an intellectual pictorial logic that results in an appealing visual unity. The figures are robust and monumental, the stately grace of their movements reminiscent of the Greek statues of goddesses (FIG. 5-49) in the pediments of the

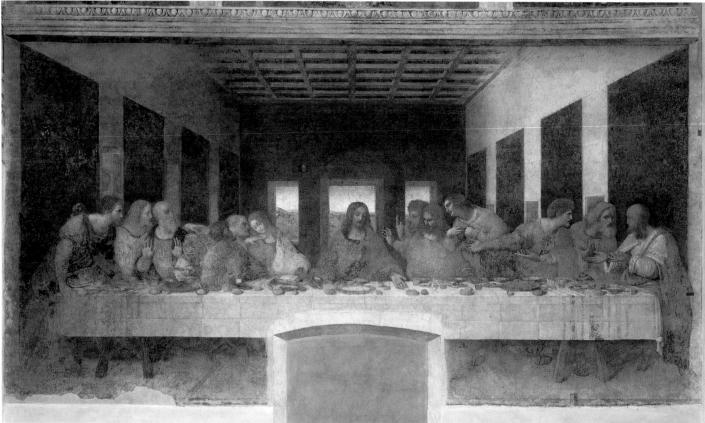

22-4 LEONARDO DA VINCI, Last Supper, ca. 1495–1498. Oil and tempera on plaster, 13' 9" × 29' 10". Refectory, Santa Maria delle Grazie, Milan. Christ has just announced that one of his disciples will betray him, and each one reacts. Christ is both the psychological focus of Leonardo's fresco and the focal point of all the converging perspective lines.

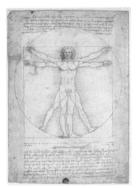

22-3A LEONARDO, Vitruvian Man, ca. 1485–1490.

Parthenon. Leonardo's infusion of the principles of classical art into his designs, however, cannot be attributed to specific knowledge of Greek monuments. He and his contemporaries never visited Greece. Their acquaintance with classical art extended only to Etruscan and Roman monuments, Roman copies of Greek statues in Italy, and ancient texts describing Greek and Roman works of art and architecture, especially Vitruvius's treatise *On Architecture* (FIG. **22-3A**).

LAST SUPPER For the refectory of the church of Santa Maria delle Grazie in Milan, Leonardo painted Last Supper (FIG. 22-4), which both formally and emotionally is Leonardo's most impressive work. Jesus and his 12 disciples sit at a long table placed parallel to the picture plane in a simple, spacious room. The austere setting amplifies the painting's highly dramatic action. Jesus, with outstretched hands, has just said, "One of you is about to betray me" (Matt. 26:21). A wave of intense excitement passes through the group as each disciple asks himself and, in some cases, his neighbor, "Is it I?" (Matt. 26:22). Leonardo visualized a sophisticated conjunction of the dramatic "One of you is about to betray me" with the initiation of the ancient liturgical ceremony of the Eucharist, when Jesus, blessing bread and wine, said, "This is my body, which is given for you. Do this for a commemoration of me.... This is the chalice, the new testament in my blood, which shall be shed for you" (Luke 22:19-20).

In the center, Jesus appears isolated from the disciples and in perfect repose, the calm eye of the swirling emotion around him. The central window at the back, whose curved pediment arches above his head, frames his figure. The pediment is the only curve in the architectural framework, and it serves here, along with the diffused light, as a halo. Jesus' head is the focal point of all converging perspective lines in the composition. Thus, the still, psychological focus and cause of the action is also the perspective focus, as well as the center of the two-dimensional surface. The two-dimensional, the three-dimensional, and the psychodimensional focuses are the same.

Leonardo presented the agitated disciples in four groups of three, united among and within themselves by the figures' gestures and postures. The artist sacrificed traditional iconography to pictorial and dramatic consistency by placing Judas on the same side of the table as Jesus and the other disciples (compare FIG. 21-23). Judas's face is in shadow (the light source in the painting corresponds to the windows in the Milanese refectory). He clutches a money bag in his right hand as he reaches his left forward to fulfill Jesus' declaration: "But yet behold, the hand of him that betrayeth me is with me on the table" (Luke 22:21). The two disciples at the table ends are quieter than the others, as if to bracket the energy of the composition, which is more intense closer to Jesus, whose serenity both halts and intensifies it. The disciples register a broad range of emotional responses, including fear, doubt, protestation, rage, and love. Leonardo's numerous preparatory studies-using live models-suggest he thought of each figure as carrying a particular charge and type of emotion. Like a stage director, he read the Gospel story carefully, and scrupulously cast his actors as the Bible described their roles. In this work, as in his other religious paintings, Leonardo revealed his extraordinary ability to apply his voluminous knowledge about the observable world to the pictorial representation of a religious scene, resulting in a psychologically complex and compelling painting.

Leonardo's *Last Supper* is unfortunately in poor condition today, even after the completion in 1999 of a cleaning and restoration project lasting more than two decades. In a bold experiment, Leonardo had mixed oil and tempera, applying much of it *a secco* (to dried, rather than wet, plaster) in order to create a mural that more closely approximated oil painting on canvas or wood instead of fresco. But because the wall did not absorb the pigment as in the *buon fresco* technique, the paint quickly began to flake (see "Fresco Painting," Chapter 14, page 408). The humidity of Milan further accelerated the deterioration. The restoration involved extensive scholarly, chemical, and computer analysis. Like similar projects elsewhere, however, most notably in the Sistine Chapel (FIGS. 22-1 and 22-18B), this one was not without controversy. One scholar has claimed 80 percent of what is visible today is the work of the modern restorers, not Leonardo.

MONA LISA Leonardo's *Mona Lisa* (FIG. 22-5) is probably the world's most famous portrait. The sitter's identity is still the subject of scholarly debate, but in his biography of Leonardo, Giorgio Vasari asserted she was Lisa di Antonio Maria Gherardini, the wife of Francesco del Giocondo, a wealthy Florentine—hence, "Mona

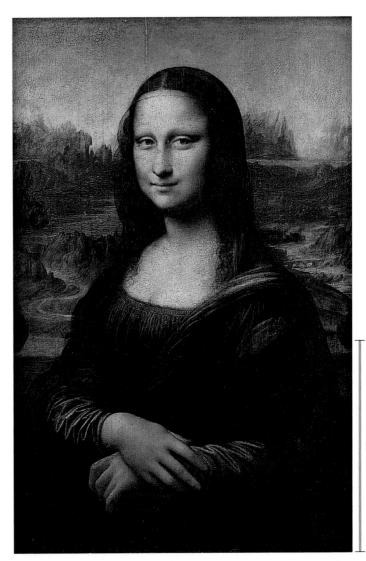

22-5 LEONARDO DA VINCI, *Mona Lisa*, ca. 1503–1505. Oil on wood, 2' $6_4^{1''} \times 1'$ 9". Musée du Louvre, Paris.

Leonardo's skill with chiaroscuro and atmospheric perspective is on display in this new kind of portrait depicting the sitter as an individual personality who engages the viewer psychologically.

n Cinquecento Italy, drawing (or Ldisegno) assumed a position of greater artistic prominence than ever before. Until the late 15th century, the expense of drawing surfaces and their lack of availability limited the production of preparatory sketches. Most artists drew on parchment (prepared from the skins of calves, sheep, and goats) or on vellum (made from the skins of young animals; FIG. 13-31). Because of the high cost of these materials, drawings in the 14th and 15th centuries tended to be extremely detailed and meticulously executed. Artists often drew using a silverpoint stylus (FIG. 20-9) because of the fine line it produced and the sharp point it maintained. The intro-

Renaissance Drawings

22-6 LEONARDO DA VINCI, *The Fetus and Lining of the Uterus*, ca. 1511–1513. Pen and ink with wash over red chalk and traces of black chalk on paper, $1' \times 8\frac{5}{8}''$. Royal Library, Windsor Castle.

The introduction of less expensive paper in the late 15th century enabled artists to draw more frequently. Leonardo's analytical anatomical studies epitomize the scientific spirit of the Renaissance.

duction in the late 15th century of less expensive paper made of fibrous pulp produced for the developing printing industry (see "Woodcuts, Engravings, and Etchings," Chapter 20, page 556) enabled artists to experiment more and to draw with greater freedom. As a result, sketches proliferated. Artists executed these drawings in pen and ink (FIG. 22-6), chalk, charcoal (FIG. 22-3), brush, and graphite or lead.

During the Renaissance, the importance of drawing transcended the mechanical or technical possibilities it afforded artists, however. The term *disegno* referred also to design, an integral component of good art. Design was the foundation of art, and drawing was the fundamental element of design. In his 1607 treatise *L'idea de' pittori, scultori ed architteti*, Federico Zuccari (1542–1609), director of the Accademia di San Luca (Academy of Saint Luke), the Roman painting academy, summed up this philosophy when he stated that drawing is the external physical manifestation (*disegno esterno*) of an internal intellectual idea or design (*disegno interno*).

The design dimension of art production became increasingly important as artists cultivated their own styles. The early stages of artistic training largely focused on imitation and emulation (see "Cennino Cennini on Imitation and Emulation," Chapter 21, page 573), but to achieve widespread recognition, artists had to develop their own styles. Although the artistic community and public at large acknowledged technical skill, the conceptualization of the artwork—its theoretical and formal development—was paramount. Disegno, or design in this case, represented an artist's conceptualization and intention. In the literature of the period, the terms often invoked to praise esteemed artists included *invenzione* (invention), *ingegno* (innate talent), *fantasia* (imagination), and *capriccio* (originality).

1 in.

(an Italian contraction of *ma donna*, "my lady") Lisa." Despite the uncertainty of this identification, Leonardo's portrait is a convincing representation of an individual. Unlike earlier portraits, it does not serve solely as an icon of status. Indeed, Mona Lisa wears no jewelry and holds no attribute associated with wealth. She sits quietly, her hands folded, her mouth forming a gentle smile, and her gaze directed at the viewer. Renaissance etiquette dictated a woman should not look directly into a man's eyes. Leonardo's portrayal of this self-assured young woman without the trappings of power but engaging the audience psychologically is thus quite remarkable.

The enduring appeal of *Mona Lisa* derives in large part from Leonardo's decision to set his subject against the backdrop of a mysterious uninhabited landscape. This setting, with roads and bridges seemingly leading nowhere, recalls that of his *Madonna of the Rocks* (FIG. 22-2). The composition also resembles Fra Filippo Lippi's *Madonna and Child with Angels* (FIG. 21-24) with figures seated in front of a window through which the viewer glimpses a distant landscape. Originally, the artist represented Mona Lisa in a loggia. A later owner trimmed the painting, eliminating the columns, but partial column bases remain to the left and right of Mona Lisa's shoulders.

The painting is darker today than 500 years ago and the colors are less vivid, but *Mona Lisa* still reveals Leonardo's fascination and skill with chiaroscuro and atmospheric perspective. The portrait is a prime example of the artist's famous smoky *sfumato* (misty haziness)—his subtle adjustment of light and blurring of precise planes. ANATOMICAL STUDIES Mona Lisa is also exceptional because Leonardo completed very few paintings. His perfectionism, relentless experimentation, and far-ranging curiosity diffused his efforts. However, the drawings (see "Renaissance Drawings," page 604) in his notebooks preserve an extensive record of his ideas. His interests focused increasingly on science in his later years, and he embraced knowledge of all facets of the natural world. His investigations in anatomy yielded drawings of great precision and beauty of execution. The Fetus and Lining of the Uterus (FIG. 22-6), although it does not meet 21st-century standards for accuracy (for example, Leonardo regularized the uterus's shape to a sphere, and his characterization of the lining is incorrect), was an astounding achievement in its day. Leonardo's analytical anatomical studies epitomize the scientific spirit of the Renaissance, establishing that era as a prelude to the modern world and setting it in sharp contrast to the preceding Middle Ages. Although Leonardo may not have been the first scientist of the modern world (at least not in today's sense of the term), he did originate the modern method of scientific illustration incorporating cutaway views. Scholars have long recognized the importance of his drawings for the development of anatomy as a science, especially in an age predating photographic methods such as X-rays.

Leonardo also won renown in his time as both architect and sculptor, although no extant buildings or sculptures can be definitively attributed to him. From his many drawings of central-plan structures (FIG. **22-6A**), it is evident he shared the interest of other Renaissance architects in this building type. As for Leonardo's sculptures, numerous drawings of monumental equestrian statues survive, and he made a full-scale model for a monument to Francesco Sforza (1401–1466), Ludovico's father. The French used the

22-6A LEONARDO, central-plan church, ca. 1487-1490.

statue as a target and shot it to pieces when they occupied Milan in 1499.

Leonardo left Milan at that time and served for a while as a military engineer for Cesare Borgia (1476–1507), who, with the support of his father, Pope Alexander VI (r. 1492–1503), tried to conquer the cities of the Romagna region in north-central Italy and create a Borgia duchy. Leonardo eventually returned to Milan in the service of the French. At the invitation of King Francis I (FIG. 23-12), he then went to France, where he died at the château of Cloux in 1519.

Raphael

Alexander VI's successor was Julius II (see page 599). Among the many projects the ambitious new pope sponsored were a design for a modern Saint Peter's (FIGS. 22-22 and 22-23) to replace the timber-roofed fourth-century basilica (FIG. 8-9), the decoration of the papal apartments (FIG. 22-9), and the construction of his tomb (FIGS. 22-14 and 22-15), in addition to commissioning Michelangelo to paint the Sistine Chapel ceiling (FIGS. 22-1 and 22-17).

In 1508, Julius II called Raffaello Santi (or Sanzio), known as RAPHAEL (1483–1520) in English, to the papal court in Rome (see "Italian Princely Courts," Chapter 21, page 591). Born in a small town in Umbria near Urbino, Raphael probably learned the rudiments of his art from his father, Giovanni Santi (d. 1494), a painter connected with the ducal court of Federico da Montefeltro (FIG. 21-43), before entering the studio of Perugino (FIG. 21-41) in Perugia. Although strongly influenced by Perugino, Leonardo, and others, Raphael developed an individual style exemplifying the ideals of High Renaissance art.

MARRIAGE OF THE VIRGIN Among Raphael's early works is Marriage of the Virgin (FIG. 22-7), which he painted for the chapel of Saint Joseph in the church of San Francesco in Città di Castello, southeast of Florence. The subject was a fitting one for Saint Joseph. According to the Golden Legend (a 13th-century collection of stories about the lives of the saints), Joseph competed with other suitors for Mary's hand. The high priest was to give the Virgin to whichever suitor presented to him a rod that had miraculously bloomed. Raphael depicted Joseph with his flowering rod in his left hand. In his right hand, Joseph holds the wedding ring he is about to place on Mary's finger. Other virgins congregate at the left, and the unsuccessful suitors stand on the right. One of them breaks his rod in half over his knee in frustration, giving Raphael an opportunity to demonstrate his mastery of foreshortening. The perspective system he used is the one he learned from Perugino (compare FIG. 21-41). The temple in the background is Raphael's version of a centrally planned building, featuring Brunelleschian arcades (FIG. 21-31).

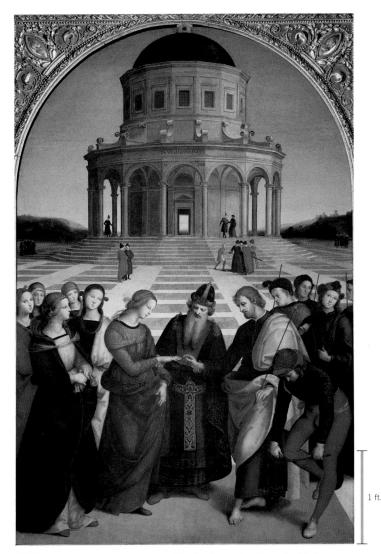

22-7 RAPHAEL, *Marriage of the Virgin*, from the Chapel of Saint Joseph, San Francesco, Città di Castello, Italy, 1504. Oil on wood, 5' $7'' \times 3' 10^{\frac{1}{2}''}$. Pinacoteca di Brera, Milan.

In this early work depicting the marriage of the Virgin to Saint Joseph, Raphael demonstrated his mastery of foreshortening and of the perspective system he learned from Perugino (FIG. 21-41).

22-8 RAPHAEL, Madonna in the Meadow, 1505–1506. Oil on wood, 3' $8\frac{1}{2}'' \times 2' 10\frac{1}{4}''$ Kunsthistorisches Museum, Vienna.

Emulating Leonardo's pyramidal composition (FIG. 22-2) but rejecting his dusky modeling and mystery, Raphael set his Madonna in a well-lit landscape and imbued her with grace, dignity, and beauty.

MADONNA IN THE MEADOW Raphael

spent the four years from 1504 to 1508 in Florence. There, still in his early 20s, he discovered that the painting style he had learned so painstakingly from Perugino was already outmoded (as was Brunelleschi's Early Renaissance architectural style). Florentine crowds flocked to the church of Santissima Annunziata to see Leonardo's recently unveiled cartoon of the Virgin, Christ Child, Saint Anne, and Saint John (probably an earlier version of FIG. 22-3). Under Leonardo's influence, Raphael began to modify the Madonna compositions he had employed in Umbria. In Madonna in the Meadow (FIG. 22-8) of 1505-1506, Raphael adopted Leonardo's pyramidal composition and modeling of faces and figures in subtle chiaroscuro. Yet the Umbrian artist placed the large, substantial figures in a Peruginesque landscape, with his former master's typical feathery trees in the middle ground. Although Raphael experimented with Leonardo's dusky modeling, he tended to return to Perugino's lighter tonalities and blue

22-8A ANDREA DEL SARTO.

Madonna of the Harpies.

1517.

skies. Raphael preferred clarity to obscurity, not fascinated, as Leonardo was, with

mystery. Raphael quickly achieved fame for his Madonnas. His work, as well as Leonardo's, deeply influenced Raphael's slightly younger contemporary, ANDREA DEL SARTO (1486–1530), whose most famous painting is *Madonna of the Harpies* (FIG. **22-8A**).

SCHOOL OF ATHENS Three years after completing *Ma*donna in the Meadow, Raphael received one of the most important painting commissions Julius II awarded—the decoration of the papal apartments in the Apostolic Palace of the Vatican (MAP 24-1). Of the suite's several rooms (*stanze*), Raphael painted the Stanza della Segnatura (Room of the Signature—the papal library, where Julius II signed official documents) and the Stanza d'Eliodoro (Room of Heliodorus—the pope's private audience room, named for one of the paintings there). His pupils completed the others, following his sketches. On the four walls of the Stanza della Segnatura, Raphael presented images symbolizing the four branches of human knowledge and wisdom under the headings *Theology*,

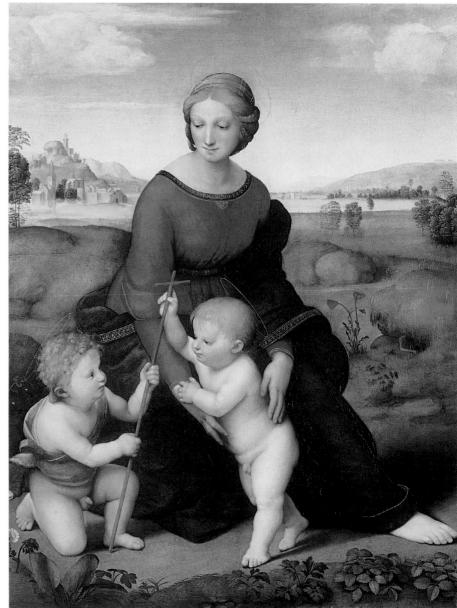

Law (Justice), Poetry, and Philosophy—the learning required of a Renaissance pope. Given Julius II's desire for recognition as both a spiritual and temporal leader, it is appropriate the *Theology* and *Philosophy* frescoes face each other. The two images present a balanced picture of the pope—as a cultured, knowledgeable individual and as a wise, divinely ordained religious authority.

In Raphael's *Philosophy* mural (commonly called *School of Athens*, FIG. **22-9**), the setting is not a "school" but a congregation of the great philosophers and scientists of the ancient world. Raphael depicted these luminaries, revered by Renaissance humanists, conversing and explaining their various theories and ideas. The setting is a vast hall covered by massive vaults that recall ancient Roman architecture, especially the much-admired coffered barrel vaults of the Basilica Nova (FIG. 7-78). Colossal statues of Apollo and Athena, patron deities of the arts and of wisdom, oversee the interactions. Plato and Aristotle are the central figures around whom Raphael carefully arranged the others. Plato holds his book *Timaeus* and points to Heaven, the source of his inspiration, while Aristotle carries his book *Nichomachean Ethics* and gestures toward the earth, from which his observations of reality sprang. Appropriately,

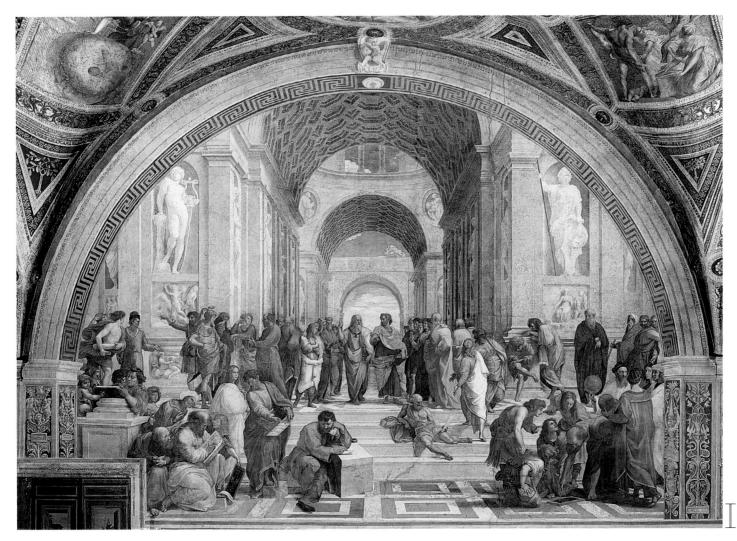

22-9 RAPHAEL, Philosophy (School of Athens), Stanza della Segnatura, Vatican Palace, Rome, Italy, 1509–1511. Fresco, 19' × 27'. 🗨

Raphael included himself in this gathering of great philosophers and scientists whose self-assurance conveys calm reason. The setting recalls the massive vaults of the Basilica Nova (FIG. 7-78).

ancient philosophers, men concerned with the ultimate mysteries that transcend this world, stand on Plato's side. On Aristotle's side are the philosophers and scientists concerned with nature and human affairs. At the lower left, Pythagoras writes as a servant holds up the harmonic scale. In the foreground, Heraclitus (probably a portrait of Michelangelo) broods alone. Diogenes sprawls on the steps. At the right, students surround Euclid, who demonstrates a theorem. Euclid may be a portrait of the architect Bramante, whom Julius II had recently commissioned to design the new church (FIGS. 22-22 and 22-23) to replace Constantine's 1,200-year-old Saint Peter's (FIG. 8-9). (The architectural setting of *School of Athens* approximates Bramante's design for the interior of Saint Peter's; compare FIG. 24-5.) At the extreme right, just to the right of the astronomers Zoroaster and Ptolemy, both holding globes, Raphael included his self-portrait.

The groups appear to move easily and clearly, with eloquent poses and gestures that symbolize their doctrines and present an engaging variety of figural positions. The self-assurance and natural dignity of the figures convey calm reason, balance, and measure—those qualities Renaissance thinkers admired as the heart of philosophy. Significantly, Raphael placed himself among the mathematicians and scientists in *School of Athens*. Certainly, the evolution of pictorial science approached perfection in this fresco in which Raphael convincingly depicted a vast space on a twodimensional surface.

The artist's psychological insight matured along with his mastery of the problems of perspective representation. All the characters in Raphael's School of Athens, like those in Leonardo's Last Supper (FIG. 22-4), communicate moods that reflect their beliefs, and the artist's placement of each figure tied these moods together. From the center, where Plato and Aristotle stand, Raphael arranged the groups of figures in an ellipse with a wide opening in the foreground. Moving along the floor's perspective pattern, the viewer's eye penetrates the assembly of philosophers and continues, by way of the reclining Diogenes, up to the here-reconciled leaders of the two great opposing camps of Renaissance philosophy. The vanishing point falls on Plato's left hand, drawing attention to Timaeus. In the Stanza della Segnatura, Raphael reconciled and harmonized not only the Platonists and Aristotelians but also classical humanism and Christianity, surely a major factor in the fresco's appeal to Julius II.

LEO X Succeeding Julius II as Raphael's patron was Pope Leo X (r. 1513–1521). By this time, Raphael had achieved renown throughout Italy and moved in the highest circles of the papal court. The new pope entrusted the Umbrian artist with so many projects in

22-10 RAPHAEL, Pope Leo X with Cardinals Giulio de' Medici and Luigi de' Rossi, ca. 1517. Oil on wood, $5' \frac{5''}{8} \times 3' 10\frac{7''}{8}$. Galleria degli Uffizi, Florence.

In this dynastic portrait of the Medici pope and two Medici cardinals, Raphael depicted Leo X as an art collector and man of learning. The meticulous details reveal a debt to Netherlandish painting.

Rome, including overseeing construction of

Saint Peter's, that Raphael became a wealthy

man at a young age. Leo himself (Giovanni

de' Medici) was a scion of Italy's most famous

family. The second son of Lorenzo the Mag-

nificent, he received a princely humanistic

education. His election as pope came only a

year after the return of the Medici to Flor-

ence following nearly two decades of exile

(see Chapter 21), and Leo used his position

to advance the family's interests. The portrait

(FIG. 22-10) he commissioned Raphael to paint in 1517—a few years

after the artist portrayed the famed courtier Baldassare Castiglione (FIG. **22-10A**)—is, in essence, a dynastic portrait. Appropriately, the

pope dominates the canvas, seated in his study before a table with

an illuminated 14th-century manuscript, the magnifying glass he required because of his myopia, and a bell engraved with classical

decorative motifs. Raphael portrayed Leo as he doubtless wished

to be represented—as a man of learning and a collector of beauti-

ful objects rather than as a head of state. To the pope's right is his

cousin Cardinal Giulio de' Medici, who became Pope Clement VII

(r. 1523–1534). Behind Leo's chair is Luigi de' Rossi (1474–1519), his

cousin on his mother's side, whom the pope appointed cardinal.

The three men look neither at one another nor at the painter or spectator, but are absorbed in their own thoughts.

Based on a poem by Poliziano, Raphael's fresco depicts Galatea fleeing

from Polyphemus. The painting, made for the banker Agostino Chigi's

private palace, celebrates human beauty and zestful love.

Raphael's mastery of the oil technique is evident in every detail. His depiction of the rich satin, wool, velvet, and fur garments the three men wear skillfully conveys their varied textures. His reproduction of the book on the pope's desk is so meticulous that scholars have been able to identify it as the *Hamilton Bible* in the Berlin Staatsbibliothek, open to folio 400 verso, the beginning of the Gospel of Saint John with illustrations of Christ's passion. The light illuminating the scene comes from the right—from a window reflected in the spherical brass finial of the pope's chair, in which the viewer can also see the indistinct form of the painter. In details such as these, Raphael revealed his knowledge and admiration of earlier Netherlandish painting, especially the work of Jan van Eyck (see Chapter 20).

GALATEA As a star at the papal court, Raphael also enjoyed the patronage of other prominent figures in Rome. Agostino Chigi (1465–1520), an immensely wealthy banker who managed the Vatican's financial affairs, commissioned Raphael to decorate his palace on the Tiber River with scenes from classical mythology. Outstanding among the frescoes Raphael painted in the small but splendid Villa Farnesina is *Galatea* (FIG. **22-11**), which he based on

Italy, ca. 1513. Fresco, 9' 8" × 7' 5".

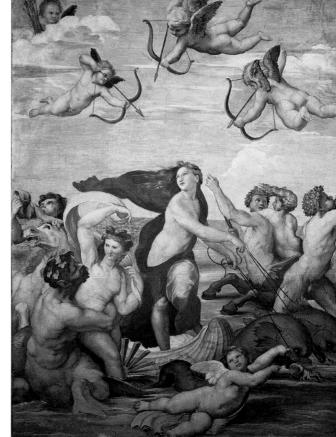

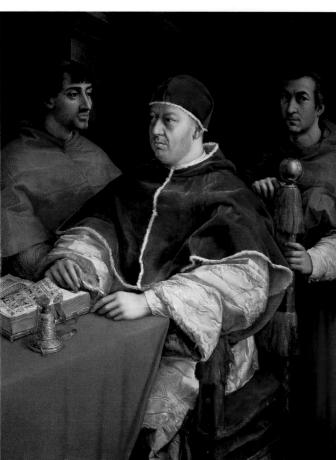

22-10A RAPHAEL

ca. 1514.

Baldassare Castiglione.

1 ft

Leonardo and Michelangelo on Painting versus Sculpture

 ${f B}$ oth Leonardo da Vinci and Michelangelo produced work in a variety of artistic media, earning enviable reputations not just as painters and sculptors but as architects and draftsmen as well. The two disagreed, however, on the relative merits of the different media. In particular, Leonardo, with his intellectual and analytical mind, preferred painting to sculpture, which he denigrated as manual labor. In contrast, Michelangelo, who worked in a more intuitive manner, saw himself primarily as a sculptor. Two excerpts from their writings reveal their positions on the relationship between the two media.

Leonardo da Vinci wrote the following in his so-called *Treatise* on *Painting*:

Painting is a matter of greater mental analysis, of greater skill, and more marvelous than sculpture, since necessity compels the mind of the painter to transform itself into the very mind of nature, to become an interpreter between nature and art. Painting justifies by reference to nature the reasons of the pictures which follow its laws: in what ways the images of objects before the eye come together in the pupil of the eye; which, among objects equal in size, looks larger to the eye; which, among equal colors will look more or less dark or more or less bright; which, among things at the same depth, looks more or less low; which, among those objects placed at equal height, will look more or less high, and why, among objects placed at various distances, one will appear less clear than the other.

This art comprises and includes within itself all visible things such as colors and their diminution, which the poverty of sculpture cannot include. Painting represents transparent objects but the sculptor will show you the shapes of natural objects without artifice. The painter will show you things at different distances with variation of color due to the air lying between the objects and the eye; he shows you mists through which visual images penetrate with difficulty; he shows you rain which discloses within it clouds

Stanzas for the Joust of Giuliano de' Medici by Angelo Poliziano, whose poetry had earlier inspired Botticelli to paint Birth of Venus (FIG. 21-29). In Raphael's fresco, Galatea flees on a shell drawn by leaping dolphins to escape her uncouth lover, the cyclops Polyphemus (painted on another wall by a different artist). Sea creatures and playful cupids surround her. The painting is an exultant song in praise of human beauty and zestful love. Compositionally, Raphael enhanced the liveliness of the image by placing the sturdy figures around Galatea in bounding and dashing movements that always return to her as the energetic center. The cupids, skillfully foreshortened, repeat the circling motion. Raphael conceived his figures sculpturally, and Galatea's body-supple, strong, and vigorously in motion-contrasts with Botticelli's delicate, hovering, almost dematerialized Venus while suggesting the spiraling compositions of Hellenistic statuary (FIG. 5-80). In Galatea, classical myth presented in monumental form, in vivacious movement, and in a spirit of passionate delight resurrects the naturalistic art and poetry of the Greco-Roman world.

with mountains and valleys; he shows the dust which discloses within it and beyond it the combatants who stirred it up; he shows streams of greater or lesser density; he shows fish playing between the surface of the water and its bottom; he shows the polished pebbles of various colors lying on the washed sand at the bottom of rivers, surrounded by green plants; he shows the stars at various heights above us, and thus he achieves innumerable effects which sculpture cannot attain.*

As if in response, although decades later, Michelangelo wrote these excerpts in a letter to Benedetto Varchi (1502–1565), a Florentine poet best known for his 16-volume history of Florence:

I believe that painting is considered excellent in proportion as it approaches the effect of relief, while relief is considered bad in proportion as it approaches the effect of painting.

I used to consider that sculpture was the lantern of painting and that between the two things there was the same difference as that between the sun and the moon. But . . . I now consider that painting and sculpture are one and the same thing.

Suffice that, since one and the other (that is to say, both painting and sculpture) proceed from the same faculty, it would be an easy matter to establish harmony between them and to let such disputes alone, for they occupy more time than the execution of the figures themselves. As to that man [Leonardo] who wrote saying that painting was more noble than sculpture, if he had known as much about the other subjects on which he has written, why, my servingmaid would have written better![†]

*Leonardo da Vinci, *Treatise on Painting*, 51. In Robert Klein and Henri Zerner, *Italian Art 1500–1600: Sources and Documents* (Evanston, Ill.: Northwestern University Press, 1966), 7–8.

[†]Michelangelo to Benedetto Varchi, Rome, 1549. In Klein and Zerner, *Italian Art 1500–1600*, 13–14.

Michelangelo

Although Michelangelo is most famous today as the painter of the Sistine Chapel frescoes (FIG. 22-1), he was also an architect, poet, engineer, and, first and foremost, a sculptor. Michelangelo considered sculpture superior to painting because the sculptor shares in the divine power to "make man" (see "Leonardo and Michelangelo on Painting versus Sculpture," above). Drawing a conceptual parallel to Plato's ideas, Michelangelo believed the image the artist's hand produces must come from the idea in the artist's mind. The idea, then, is the reality the artist's genius has to bring forth. But artists are not the creators of the ideas they conceive. Rather, they find their ideas in the natural world, reflecting the absolute idea, which, for the artist, is beauty. One of Michelangelo's best-known observations about sculpture is that the artist must proceed by finding the idea-the image locked in the stone. By removing the excess stone, the sculptor extricates the idea from the block (FIG. I-16), bringing forth the living form. The artist, Michelangelo felt, works for many

22-12 MICHELANGELO BUONARROTI, *Pietà*, ca. 1498–1500. Marble, 5' $8\frac{1}{2}$ " high. Saint Peter's, Vatican City, Rome.

Michelangelo's representation of Mary cradling Christ's corpse captures the sadness and beauty of the young Virgin but was controversial because the Madonna seems younger than her son.

years to discover this unceasing process of revelation and "arrives late at novel and lofty things."⁴

Michelangelo did indeed arrive "at novel and lofty things," for he broke sharply from the lessons of his predecessors and contemporaries in one important respect. He mistrusted the application of mathematical methods as guarantees of beauty in proportion. Measure and proportion, he believed, should be "kept in the eyes." Vasari quoted Michelangelo as declaring "it was necessary to have the compasses in the eyes and not in the hand, because the hands work and the eye judges."5 Thus, Michelangelo set aside Vitruvius, Alberti, Leonardo, and others who tirelessly sought the perfect measure, and insisted the artist's inspired judgment could identify other pleasing proportions. In addition, Michelangelo argued the artist must not be bound, except by the demands made by realizing the idea. This assertion of the artist's authority was typical of Michelangelo and anticipated the modern concept of the right to a self-expression of talent lim-

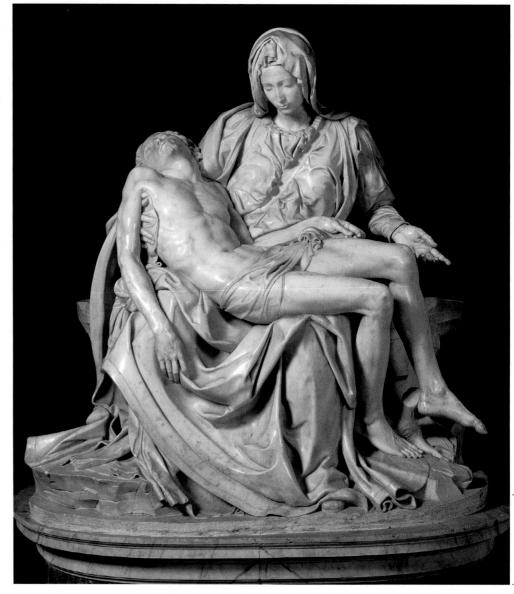

ited only by the artist's own judgment. The artistic license to aspire far beyond the "rules" was, in part, a manifestation of the pursuit of fame and success that humanism fostered. In this context, Michelangelo created works in architecture, sculpture, and painting that departed from High Renaissance regularity. He put in its stead a style of vast, expressive strength conveyed through complex, eccentric, and often titanic forms looming before the viewer in tragic grandeur.

As a youth, Michelangelo was an apprentice in the studio of the painter Domenico Ghirlandaio (FIGS. 21-26 and 21-27), but he left before completing his training. Although Michelangelo later claimed he owed nothing artistically to anyone, he made detailed drawings based on the work of the great Florentines Giotto and Masaccio. Early on, he came to the attention of Lorenzo the Magnificent and studied sculpture under one of Lorenzo's favorite artists, Bertoldo di Giovanni (ca. 1420–1491), a former collaborator of Donatello's. When the Medici fell in 1494, Michelangelo fled Florence for Bologna, where the sculptures of the Sienese artist Jacopo della Quercia (1367–1438) impressed him.

PIETÀ Michelangelo made his first trip to Rome in the summer of 1496, and two years later, still in his early 20s, he produced his

first masterpiece there: a Pietà (FIG. 22-12) for the French cardinal Jean de Bilhères Lagraulas (1439-1499). The cardinal commissioned the statue to be placed in the rotunda attached to the south transept of Old Saint Peter's (FIG. 8-9) in which he was to be buried beside other French churchmen. (The work is now on view in the new church [FIG. 24-4] that replaced the fourth-century basilica.) The theme—Mary cradling the dead body of Christ in her lap—was a staple in the repertoire of French and German artists (FIG. 13-50), and Michelangelo's French patron doubtless chose the subject. The Italian, however, rendered the northern European theme in an unforgettable manner. Michelangelo transformed marble into flesh, hair, and fabric with a sensitivity for texture almost without parallel. The polish and luminosity of the exquisite marble surface can be fully appreciated only in the presence of the original. Breathtaking, too, is the tender sadness of the beautiful and youthful Mary as she mourns the death of her son. In fact, her age-seemingly less than that of Christ-was a subject of controversy from the moment the statue was unveiled. Michelangelo explained Mary's ageless beauty as an integral part of her purity and virginity. Beautiful, too, is the son whom she holds. Christ seems less to have died a martyr's crucifixion than to have drifted off into peaceful sleep in Mary's maternal arms. His wounds are barely visible.

DAVID Michelangelo returned to Florence in 1501. In 1495, during the Medici exile, the Florentine Republic had ordered the transfer of Donatello's *David* (FIG. 21-12) from the Medici residence to the Palazzo della Signoria to join Verrocchio's *David* (FIG. 21-13) there. The importance of David as a civic symbol led the Florence Cathedral building committee to invite Michelangelo to work a great block of marble left over from an earlier aborted commission into still another *David* statue for the Signoria. The colossal statue (FIG. **22-13**)—Florentines referred to it as "the Giant"—Michelangelo created from that block forever assured his reputation as an extraordinary talent. Vasari, for example, extolled the work, claiming

without any doubt [Michelangelo's *David*] has put in the shade every other statue, ancient or modern, Greek or Roman... [The statue] was intended as a symbol of liberty [in front of Florence's city hall], signifying that just as David had protected his people and governed them justly, so whoever ruled Florence should vigorously defend the city and govern it with justice.⁶

Despite the traditional association of David with heroic triumph over a fearsome adversary, Michelangelo chose to represent the young biblical warrior not after his victory, with Goliath's head at his feet (as Donatello and Verrocchio had done), but before the encounter, with David sternly watching his approaching foe. *David* exhibits the characteristic representation of energy in reserve that imbues Michelangelo's later figures with the tension of a coiled spring. The anatomy of David's body plays an important part in this prelude to action. His rugged torso, sturdy limbs, and large hands and feet alert viewers to the triumph to come. Each swelling vein and tightening sinew amplifies the psychological energy of David's pose.

Michelangelo doubtless had the classical nude in mind when he conceived his David. Like many of his colleagues, he greatly admired Greco-Roman statues, in particular the skillful and precise rendering of heroic physique. Without strictly imitating the antique style, the Renaissance sculptor captured in his portrayal of the biblical hero the tension of Lysippan athletes (FIG. 5-65) and the psychological insight and emotionalism of Hellenistic statuary (FIGS. 5-80, 5-81, and 5-89). His David differs from Donatello's and Verrocchio's creations in much the same way later Hellenistic statues departed from their Classical predecessors (see Chapter 5). Michelangelo abandoned the self-contained compositions of the 15th-century David statues by abruptly turning the hero's head toward his gigantic adversary. This David is compositionally and emotionally connected to an unseen presence beyond the statue, a feature also of Hellenistic sculpture (FIG. 5-86). As early as 1501, then, Michelangelo invested his efforts in presenting towering, pent-up emotion rather than calm, ideal beauty. He transferred his own doubts, frustrations, and passions into the great figures he created or planned.

TOMB OF JULIUS II The formal references to classical antiquity in Michelangelo's *David* surely appealed to Julius II, who associated himself with the humanists and with Roman emperors. Thus, this sculpture and the fame that accrued to Michelangelo on its completion called the artist to the pope's attention, leading shortly thereafter to major papal commissions. The first project Julius II commissioned from Michelangelo was the pontiff's tomb, to be placed in Old Saint Peter's. The sculptor's original 1505 design called for a freestanding, two-story structure with some 28 statues. The proposed monument, of unprecedented size (compare FIG. 21-15), would have given Michelangelo the latitude to sculpt

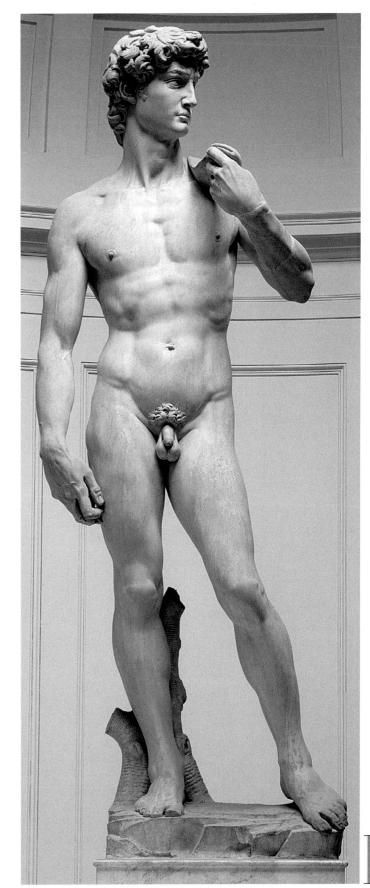

22-13 MICHELANGELO BUONARROTI, *David*, from Piazza della Signoria, Florence, Italy, 1501–1504. Marble, 17' high. Galleria dell'Accademia, Florence.

In this colossal statue, Michelangelo represented David in heroic classical nudity, capturing the tension of Lysippan athletes (FIG. 5-65) and the emotionalism of Hellenistic statuary (FIGs. 5-80 and 5-81).

numerous human figures while providing Julius II with a grandiose memorial that would associate the Cinquecento pope with the first pope, Peter himself. Shortly after Michelangelo began work on this project, the pope interrupted the commission, possibly because funds had to be diverted to the rebuilding of Saint Peter's. After Julius II's death in 1513, Michelangelo reluctantly reduced the scale of the project step-by-step until, in 1542, a final contract specified a simple wall tomb with fewer than one-third of the originally planned figures. Michelangelo completed the tomb in 1545 and saw it placed in San Pietro in Vincoli (MAP 22-1), where Julius II had served as a cardinal before his accession to the papacy. Given Julius's ambitions, it is safe to say that had he seen the final design of his tomb, or known where it would eventually be located, he would have been bitterly disappointed.

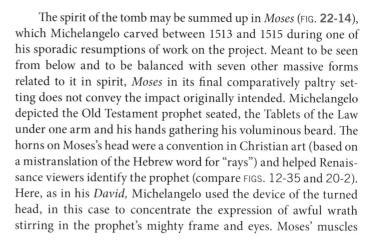

22-14 MICHELANGELO BUONARROTI, *Moses*, from the tomb of Pope Julius II, Rome, Italy, ca. 1513–1515. Marble, 7' $8\frac{1}{2}$ " high. San Pietro in Vincoli, Rome.

Not since Hellenistic times had a sculptor captured as much pent-up energy, both emotional and physical, in a seated statue as Michelangelo did in the over-life-size *Moses* he carved for Julius II's tomb.

22-15 MICHELANGELO BUONARROTI, Bound Slave (Rebellious Slave), from the tomb of Pope Julius II, Rome, Italy, ca. 1513–1516. Marble, $7'\frac{5''}{8}$ high. Musée du Louvre, Paris.

1 ft

For Pope Julius II's grandiose tomb, Michelangelo planned a series of statues of captives or slaves in various attitudes of revolt and exhaustion. This defiant figure exhibits a violent contrapposto.

bulge, his veins swell, and his great legs seem to begin slowly to move. Not since Hellenistic times had a sculptor captured so much pent-up energy—both emotional and physical—in a seated statue (FIGS. 5-86 and 5-89).

Michelangelo also intended to incorporate in the pope's tomb some 20 statues of captives, popularly known as slaves, in various attitudes of revolt and exhaustion. Art historians have traditionally believed *Bound Slave*, or *Rebellious Captive* (FIG. **22-15**), and the unfinished statue shown in FIG. I-16 to be two of those destined for Julius's tomb. Some scholars now doubt this attribution, and some even reject the identification of the statues as "slaves" or "captives." Whatever their identity, these statues, like Michelangelo's *David* and *Moses*, testify to the sculptor's ability to create figures embodying powerful emotional states. In *Bound Slave*, the defiant figure's

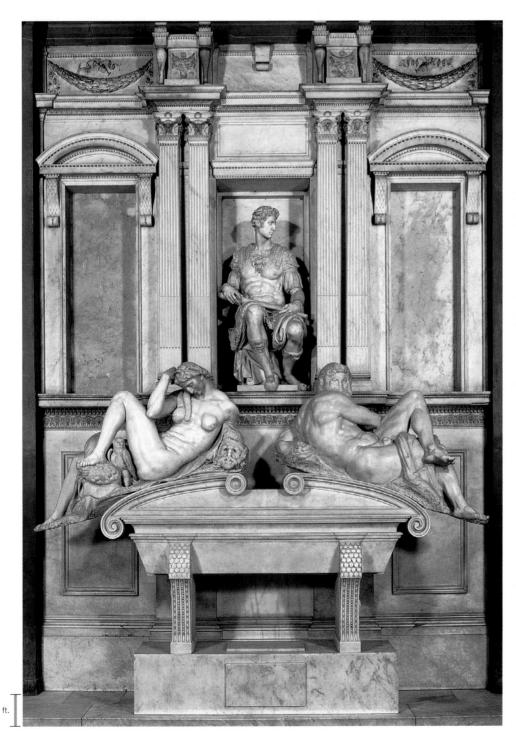

violent contrapposto is the image of frantic but impotent struggle. Michelangelo based his whole art on his conviction that whatever can be said greatly through sculpture and painting must be said through the human figure.

TOMB OF GIULIANO DE' MEDICI Following the death of Julius II, Michelangelo, like Raphael, went into the service of Leo X and his successor, Clement VII. These Medici popes chose not to perpetuate a predecessor's fame by permitting Michelangelo to complete Julius's tomb. Instead, they (Pope Leo X and the thencardinal Giulio de' Medici; FIG. 22-10) commissioned him in 1519 to build a funerary chapel, the New Sacristy, attached to Brunelles-chi's San Lorenzo (FIG. 21-32A) in Florence. At opposite sides of the New Sacristy stand Michelangelo's sculpted tombs of Giuliano

(1478–1516), duke of Nemours (south of Paris), and Lorenzo (1492–1519), duke of Urbino, son and grandson of Lorenzo the Magnificent. Giuliano's tomb (FIG. **22-16**) is compositionally the twin of Lorenzo's. Michelangelo finished neither tomb. Scholars believe he intended to place pairs of recumbent river gods at the bottom of the sarcophagi, balancing the pairs of figures resting on the sloping sides, but Michelangelo's grand design for the tombs remains a puzzle.

According to the traditional interpretation, the arrangement Michelangelo planned, but never completed, mirrors the soul's ascent through the levels of the Neo-Platonic universe. Neo-Platonism, the school of thought based on Plato's idealistic, spiritualistic philosophy, experienced a renewed popularity in the 16th-century humanist community. The lowest level of the tomb, which the river gods represent, would have signified the Underworld of brute matter, the source of evil. The two statues on the sarcophagi would symbolize the realm of time-the specifically human world of the cycles of dawn, day, evening, and night. Humanity's state in this world of time was one of pain and anxiety, of frustration and exhaustion. At left, the muscular female Night-Michelangelo used male models even for his female figures-and, at right, the male Day appear to be chained into

22-16 MICHELANGELO BUONARROTI, tomb of Giuliano de' Medici, New Sacristy (Medici Chapel), San Lorenzo, Florence, Italy, 1519–1534. Marble, central figure 5' 11" high.

Michelangelo's portrait of Giuliano de' Medici in Roman armor depicts the deceased as the model of the active and decisive man. Below are the anguished, twisting figures of Night and Day.

never-relaxing tensions. Both exhibit the anguished twisting of the body's masses in contrary directions seen also in Michelangelo's Bound Slave (FIG. 22-15; compare FIG. 1-16) and in his Sistine Chapel paintings (FIGS. 22-18 and 22-18A). This contortion is a staple of Michelangelo's figural art. Day, with a body the thickness of a great tree and the anatomy of Hercules (or of a reclining Greco-Roman river god that may have inspired Michelangelo's statue), strains his huge limbs against each other, his unfinished visage rising menacingly above his shoulder. Night, the symbol of rest, twists as if in troubled sleep, her posture wrenched and feverish. The artist surrounded her with an owl, poppies, and a hideous mask symbolic of nightmares. Some scholars argue, however, that the Night and Day personifications allude not to humanity's pain but to the life cycle and the passage of time leading ultimately to death.

On their respective tombs, sculptures of Lorenzo and Giuliano appear in niches at the apex of the structures. Transcending worldly existence, they represent the two ideal human types-the contemplative man (Lorenzo) and the active man (Giuliano). Giuliano (FIG. 22-16) sits clad in the armor of a Roman emperor and holds a commander's baton, his head turned alertly as if in council (he looks toward the statue of the Virgin at one end of the chapel). Across the room, Lorenzo appears wrapped in thought, his face in deep shadow. Together, they symbolize the two ways human beings might achieve union with God-through meditation or through the active life fashioned after that of Christ. In this sense, they are not individual portraits. Indeed, Michelangelo declined to sculpt likenesses of Lorenzo and Giuliano. Who, he asked, would care what they looked like in a thousand years? This attitude is consistent with Michelangelo's interests. Throughout his career he demonstrated less concern for facial features and expressions than for the overall human form. The rather generic visages of the two Medici captains of the Church attest to this view. For the artist, the contemplation of what lies beyond the corrosion of time counted more.

SISTINE CHAPEL CEILING When Julius II suspended work on his tomb, the pope offered the bitter Michelangelo the commission to paint the ceiling (FIG. 22-17) of the Sistine Chapel (FIG. 22-1) in 1508. The artist reluctantly assented in the hope the tomb project could be revived. Michelangelo faced enormous difficulties in painting the Sistine ceiling: its dimensions (some 5,800 square feet), its height above the pavement (almost 70 feet), and the complicated perspective problems the vault's height and curve presented, as well as his inexperience in the fresco technique. (Michelangelo had to redo the first section he completed because of faulty preparation of the intonaco; see "Fresco Painting," Chapter 14, page 408.) Yet, in less than four years, Michelangelo produced an extraordinary series of monumental frescoes incorporating his patron's agenda, Church doctrine, and his own interests. In depicting the most august and solemn themes of all, the creation, fall, and redemption of humanity-subjects most likely selected by Julius II with input from Michelangelo and Cardinal Marco Vigerio della Rovere (1446-1516)-Michelangelo spread a colossal

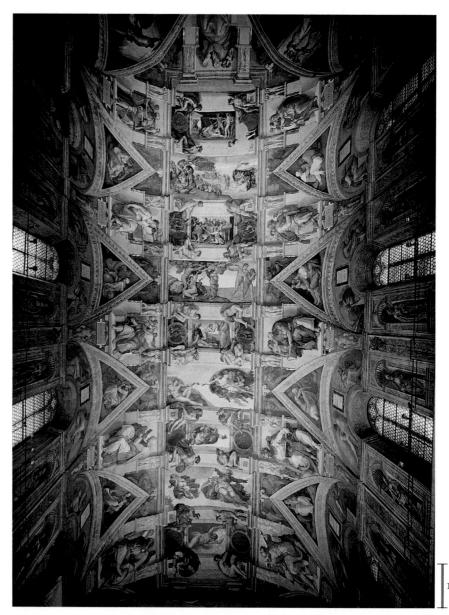

22-17 MICHELANGELO BUONARROTI, ceiling of the Sistine Chapel, Vatican City, Rome, Italy, 1508–1512. Fresco, 128' × 45'. ■4

Michelangelo labored almost four years for Pope Julius II on the frescoes for the ceiling of the Sistine Chapel. He painted more than 300 figures illustrating the creation and fall of humankind.

compositional scheme across the vast surface. He succeeded in weaving together more than 300 figures in an ultimate grand drama of the human race.

A long sequence of narrative panels describing the creation, as recorded in Genesis, runs along the crown of the vault, from *God's Separation of Light and Darkness* (above the altar) to *Drunkenness of Noah* (nearest the entrance to the chapel). Thus, as viewers enter the chapel, look up, and walk toward the altar, they review, in reverse order, the history of the fall of humankind. The Hebrew prophets and ancient sibyls who foretold the coming of Christ appear seated in large thrones on both sides of the central row of scenes from Genesis, where the vault curves down. In the four corner *pendentives*, Michelangelo placed four Old Testament scenes with David, Judith, Haman, and Moses and the Brazen Serpent. Scores of lesser figures also appear. The ancestors of Christ (FIG. 22-18B) fill the triangular compartments above the windows, nude youths punctuate the corners of the central panels, and small pairs of putti in *grisaille* (monochrome painting using shades of gray to imitate sculpture)

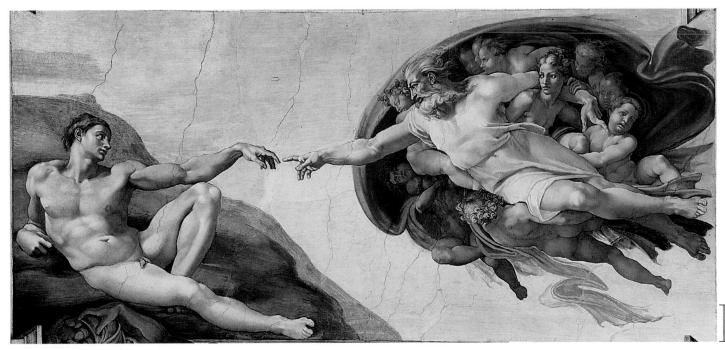

22-18 MICHELANGELO BUONARROTI, *Creation of Adam*, detail of the ceiling of the Sistine Chapel (FIG. 22-17), Vatican City, Rome, Italy, 1511–1512. Fresco, 9' 2" ×18' 8". ■

Life leaps to Adam like a spark from the extended hand of God in this fresco, which recalls the communication between gods and heroes in the classical myths Renaissance humanists admired so much.

support the painted cornice surrounding the entire central corridor. The overall conceptualization of the ceiling's design and narrative structure not only presents a sweeping chronology of Christianity but also is in keeping with Renaissance ideas about Christian history. These ideas included interest in the conflict between good and evil and between the energy of youth and the wisdom of age. The conception of the entire ceiling was astounding in itself, and the articulation of it in its thousands of details was a superhuman achievement.

Unlike Andrea Mantegna's decoration of the ceiling of the Camera Picta (FIGS. 21-48 and 21-49) in Mantua, the strongly marked unifying architectural framework in the Sistine Chapel does not construct "picture windows" framing illusions within them. Rather, the viewer focuses on figure after figure, each sharply outlined against the neutral tone of the architectural setting or the plain background of the panels.

CREATION OF ADAM The two central panels of Michelangelo's ceiling represent *Creation of Adam* (FIG. **22-18**) and *Fall of*

22-18A MICHELANGELO, Fall of Man, ca. 1510.

Man (FIG. **22-18**) and Full of *Man* (FIG. **22-18A**). In both cases, Michelangelo rejected traditional iconographical convention in favor of bold new interpretations of the momentous events. In *Creation of Adam*, God and Adam confront each other in a primordial unformed landscape of which Adam is still a material part, heavy as

earth. The Lord transcends the earth, wrapped in a billowing cloud of drapery and borne up by his powers. Life leaps to Adam like a spark from the extended and mighty hand of God. The communication between gods and heroes, so familiar in classical myth, is here concrete. This blunt depiction of the Lord as ruler of Heaven in the classical, Olympian sense indicates how easily High Renaissance thought joined classical and Christian traditions. Yet the classical trappings do not obscure the essential Christian message. Beneath the Lord's sheltering left arm is a woman, apprehensively curious but as yet uncreated. Scholars traditionally believed she represented Eve, but many now think she is the Virgin Mary (with the Christ Child at her knee). If the second identification is correct, it suggests Michelangelo incorporated into his fresco one of the essential tenets of Christian faith—the belief that Adam's original sin eventually led to the sacrifice of Christ, which in turn made possible the redemption of all humankind (see "Jewish Subjects in Christian Art," Chapter 8, page 238).

As God reaches out to Adam, the viewer's eye follows the motion from right to left, but Adam's extended left arm leads the eye back to the right, along the Lord's right arm, shoulders, and left arm to his left forefinger, which points to the Christ Child's face. The focal point of this right-to-left-to-right movement—the fingertips of Adam and the Lord—is dramatically off-center. Michelangelo replaced the straight architectural axes found in Leonardo's compositions with curves and diagonals. For example, the bodies of the two great figures are complementary—the concave body of Adam fitting the convex body and billowing "cloak" of God. Thus, motion directs not only the figures but also the whole composition. The reclining positions of the figures, the heavy musculature, and the twisting poses are all intrinsic parts of Michelangelo's style.

The photographs of the Sistine Chapel reproduced here record the appearance of Michelangelo's frescoes after the completion of a 12-year cleaning project (1977–1989). The painstaking restoration (FIG. **22-18B**) elicited considerable controversy because it revealed vivid colors that initially shocked art historians, producing accusations the restorers were destroying Michelangelo's masterpieces. That reaction, however, was largely attributable to

22-18B Sistine Chapel restoration, 1977–1989.

the fact that for centuries no one had ever seen Michelangelo's frescoes except covered with soot and grime.

22-19 MICHELANGELO BUONARROTI, Last Judgment, altar wall of the Sistine Chapel, Vatican City, Rome, Italy, 1536-1541. Fresco, 48' × 44'. ■4

Michelangelo completed his fresco cycle in the Sistine Chapel with this terrifying vision of the fate awaiting sinners. Near the center, he placed his own portrait on the flayed skin Saint Bartholomew holds.

THE COUNTER-REFORMATION

Paul III (r. 1534–1549) succeeded Clement VII as pope in 1534 at a time of widespread dissatisfaction with the leadership and policies of the Roman Catholic Church. Led by clerics such as Martin Luther and John Calvin in the Holy Roman Empire (see Chapter 23), early-16th-century reformers directly challenged papal authority, especially regarding secular

issues. Disgruntled Catholics voiced concerns about the sale of *indulgences* (pardons for sins, reducing the time a soul spent in purgatory), nepotism (the appointment of relatives to important positions), and high Church officials pursuing personal wealth. This Reformation movement resulted in the establishment of Protestantism, with sects such as Lutheranism and Calvinism. Central to Protestantism was a belief in personal faith rather than adherence to decreed Church practices and doctrines. Because the Protestants believed the only true religious relationship was the personal relationship between an individual and God, they were, in essence, eliminating the need for Church intercession, which is central to Catholicism.

The Catholic Church, in response, mounted a full-fledged campaign to counteract the defection of its members to Protestantism. Led by Paul III, this response, the Counter-Reformation, consisted of numerous initiatives. The Council of Trent, which met intermittently from 1545 through 1563, was a major component of this effort. Composed of cardinals, archbishops, bishops, abbots, and theologians, the Council of Trent dealt with issues of Church doctrine, including many the Protestants contested. Many papal commissions during this period can be viewed as an integral part of the Counter-Reformation effort. Popes long had been aware of the power of visual imagery to construct and reinforce ideological claims, and 16th-century popes exploited this capability (see "Religious Art in Counter-Reformation Italy," page 617).

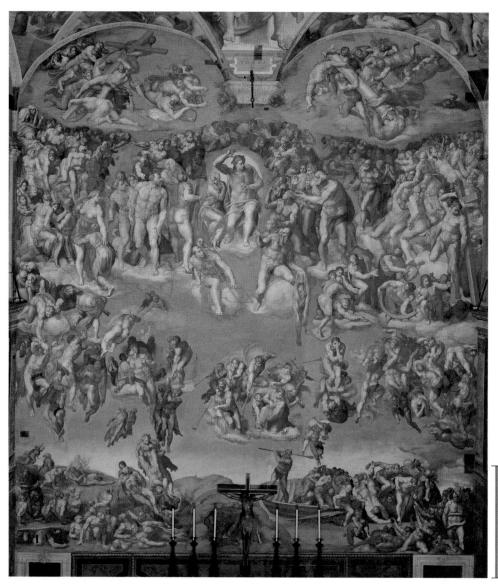

LAST JUDGMENT Among Paul III's first papal commissions was an enormous (48 feet tall) fresco for the Sistine Chapel. Michelangelo agreed to paint *Last Judgment* (FIG. **22-19**) on the chapel's altar (west) wall. Here, the artist depicted Christ as the stern judge of the world—a giant who raises his mighty right arm in a gesture of damnation so broad and universal as to suggest he will destroy all creation. The choirs of Heaven surrounding him pulse with anxiety and awe. Crowded into the space below are trumpeting angels, the ascending figures of the just, and the downward-hurtling figures of the damned. On the left, the dead awake and assume flesh. On the right, demons, whose gargoyle masks and burning eyes revive the demons of Romanesque tympana (FIG. 12-1), torment the damned.

Michelangelo's terrifying vision of the fate awaiting sinners goes far beyond even Signorelli's gruesome images (FIG. 21-42). Martyrs who suffered especially agonizing deaths crouch below the judge. One of them, Saint Bartholomew, who was skinned alive, holds the flaying knife and the skin, its face a grotesque self-portrait of Michelangelo. The figures are huge and violently twisted, with small heads and contorted features. Yet while this immense fresco impresses on viewers Christ's wrath on judgment day, it also holds out hope. A group of saved souls—the elect—crowd around Christ, and on the far right appears a figure with a cross, most likely the Good Thief (crucified with Christ) or a saint martyred by crucifixion, such as Saint Andrew.

Religious Art in Counter-Reformation Italy

B oth Catholics and Protestants took seriously the role of devotional imagery in religious life. However, their views differed dramatically. Catholics deemed art valuable for cultivating piety. Protestants believed religious imagery encouraged idolatry and distracted the faithful from the goal of developing a personal relationship with God (see Chapter 23). As part of the Counter-Reformation effort, Pope Paul III convened the Council of Trent in 1545 to review controversial Church doctrines. At its conclusion in 1563, the Council issued the following edict:

The holy council commands all bishops and others who hold the office of teaching and have charge of the *cura animarum* [literally, "cure of souls"—the responsibility of laboring for the salvation of souls], that in accordance with the usage of the Catholic and Apostolic Church, received from the primitive times of the Christian religion, and with the unanimous teaching of the holy Fathers and the decrees of sacred councils, they above all instruct the faithful diligently in matters relating to intercession and invocation of the saints, the veneration of relics, and the legitimate use of images.... Moreover, that the images of Christ, of the Virgin Mother of God, and of the other saints are to be placed and retained especially in the churches, and that due honor and veneration is to be given them; ... because the honor which is shown them is referred to the prototypes which they represent, so that by means of the images which we kiss and before which we uncover the head and prostrate

UNFINISHED *PIETÀ* Six years after completing the *Last Judg*ment fresco and nearly 50 years after carving the *Pietà* (FIG. 22-12) for the burial chapel of Cardinal Jean de Bilhères Lagraulas, Michelangelo, already in his 70s, began work on another *Pietà* (FIG. **22-20**), this one destined for his own tomb in Santa Maria Maggiore in Rome. For this group, the aged master set for himself an unprecedented technical challenge—to surpass the sculptors of the ancient *Laocoön* (FIG. 5-89) and carve four life-size figures from a single marble block. He did not succeed. Christ's now-missing left leg became detached, perhaps because of a flaw in the marble, and in 1555 Michelangelo abandoned the project and began to smash the statue. His assistants intervened, and he eventually permitted one of them, Tiberio Calcagni (1532–1565), to repair some of the damage and finish the work in part.

In composition and tone, this later *Pietà*—actually a *Deposition* group (see "The Life of Jesus in Art," Chapter 8, pages 240–241, or pages xxx–xxxi in Volume II)—stands in stark contrast to the work of Michelangelo's youth. The composition is vertical with three figures—the Virgin, Mary Magdalene, and Nicodemus supporting the lifeless body of Christ, the slumping form of which may have been inspired by a famous Roman copy of Myron's *Discus*

22-20 MICHELANGELO BUONARROTI, *Pietà*, ca. 1547–1555. Marble, 7' 8" high. Museo dell'Opera del Duomo, Florence.

Left unfinished, this *Pietà*, begun when Michelangelo was in his 70s and intended for his own tomb, includes a self-portrait of the sculptor as Nicodemus supporting the lifeless body of the Savior.

ourselves, we adore Christ and venerate the saints whose likeness they bear. That is what was defined by the decrees of the councils, especially of the Second Council of Nicaea, against the opponents of images.

Moreover, let the bishops diligently teach that by means of the stories of the mysteries of our redemption portrayed in paintings and other representations the people are instructed and confirmed in the articles of faith, which ought to be borne in mind and constantly reflected upon; also that great profit is derived from all holy images, not only because the people are thereby reminded of the benefits and gifts bestowed on them by Christ, but also because through the saints the miracles of God and salutary examples are set before the eyes of the faithful, so that they may give God thanks for those things, may fashion their own life and conduct in imitation of the saints and be moved to adore and love God and cultivate piety. . . . That these things may be the more faithfully observed, the holy council decrees that no one is permitted to erect or cause to be erected in any place or church, howsoever exempt, any unusual image unless it has been approved by the bishop.*

**Canons and Decrees of the Council of Trent*, December 3–4, 1563. Quoted in Robert Klein and Henri Zerner, *Italian Art 1500–1600: Sources and Documents* (Evanston, Ill.: Northwestern University Press, 1966), 120–121.

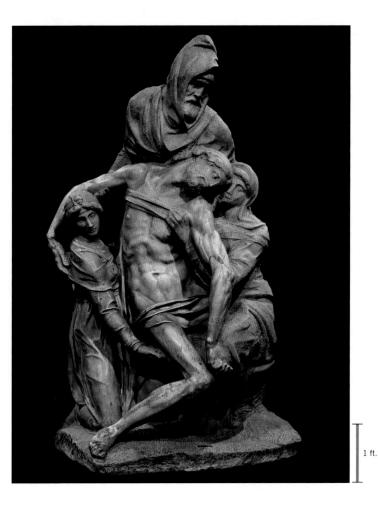

Thrower (FIG. 5-39). The Virgin is now a subsidiary figure, half hidden by her son, whose left leg originally rested on her left thigh, a position suggesting sexual union, which elicited harsh criticism— a possible reason Michelangelo smashed the statue. The undersized Mary Magdalene is in a kneeling position, and her hand does not make contact with Christ's flesh, underscoring the sacred nature of the Savior's body. Forming the apex of the composition is the hooded Nicodemus, a self-portrait of Michelangelo. This late work is therefore very personal in nature. The sculptor placed himself in direct contact with Christ, without the intercession of priests or saints, a heretical concept during the Counter-Reformation and another possible explanation why Michelangelo never completed the statue.

Architecture

Michelangelo was an accomplished architect as well as a sculptor and painter, and his Vatican commissions included designing a new church to replace the basilica Constantine erected over the site

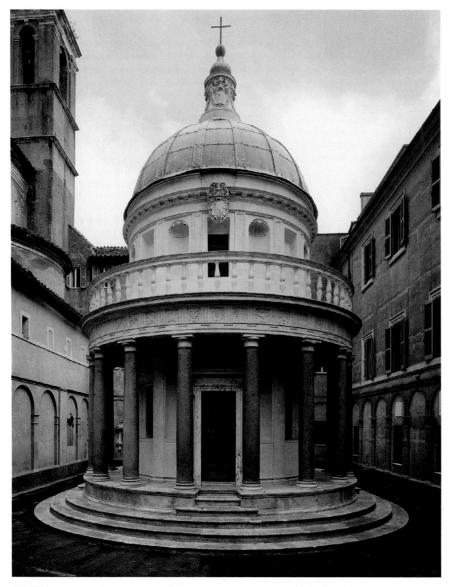

22-21 DONATO D'ANGELO BRAMANTE, Tempietto, San Pietro in Montorio, Rome, Italy, begun 1502.

Contemporaries celebrated Bramante as the first architect to revive the classical style. Roman temples (FIG. 7-4) inspired his "little temple," but Bramante combined the classical parts in new ways.

of Saint Peter's burial place (Old Saint Peter's, FIG. 8-9). By the 15th century, it was obvious the ancient timber-roofed church was insufficient for the needs and aspirations of the Renaissance papacy. Rebuilding the fourth-century basilica would occupy some of the leading architects of Italy for more than a century.

BRAMANTE The first in the distinguished line of architects of the new Saint Peter's was DONATO D'ANGELO BRAMANTE (1444–1514). Born in Urbino and trained as a painter (perhaps by Piero della Francesca), Bramante went to Milan in 1481 and, as Leonardo did, stayed there until the French arrived in 1499. In Milan, he abandoned painting to become his generation's most renowned architect. Under the influence of Filippo Brunelleschi, Leon Battista Alberti, and perhaps Leonardo, all of whom strongly favored the art and architecture of classical antiquity, Bramante developed the High Renaissance form of the central-plan church.

TEMPIETTO The architectural style Bramante championed was, consistent with the humanistic values of the day, based on

ancient Roman models. Bramante's first major work in the classical mode was the small architectural gem known as the Tempietto (FIG. 22-21) on the Janiculum hill overlooking the Vatican. The building received its name because, to contemporaries, it had the look of a small ancient temple. "Little Temple" is, in fact, a perfect nickname for the structure, because the round temples of Roman Italy (FIG. 7-4) directly inspired Bramante's design. King Ferdinand (r. 1479-1516) and Queen Isabella of Spain commissioned the Tempietto to mark the presumed location of Saint Peter's crucifixion. Bramante undertook the project in 1502, but construction may not have begun until the end of the decade. Today the Tempietto stands inside the rectangular cloister of the church of San Pietro in Montorio, but Bramante planned, although never executed, a circular colonnaded courtyard to frame the "temple." His intent was to coordinate the Tempietto and its surrounding portico by aligning the columns of the two structures.

The Tempietto's design is severely rational with its sober circular stylobate (stepped temple platform) and the austere Tuscan style of the colonnade. Bramante achieved a wonderful balance and harmony in the relationship of the parts (dome, drum, and base) to one another and to the whole. Conceived as a tall domed cylinder projecting from the lower, wider cylinder of its colonnade, this small building incorporates all the qualities of a sculptured monument. Bramante's sculptural eye is most evident in the rhythmical play of light and shadow around the columns and balustrade and across the deep-set rectangular windows alternating with shallow shell-capped niches in the cella (central room of a temple), walls, and drum. Although the Tempietto, superficially at least, may resemble a Greek tholos (a circular shrine; FIG. 5-72), and although antique models provided the inspiration for all its details, the combination of parts and details was new and original. (Classical tholoi, for instance, had neither drum nor balustrade.)

One of the main differences between the Early and High Renaissance styles of architecture is the former's emphasis on detailing flat wall surfaces versus the latter's sculptural handling of architectural masses. Bramante's Tempietto initiated the High Renaissance era in architecture. Andrea Palladio, a brilliant theorist as well as a major later 16th-century architect (FIGS. 22-28 to 22-31), included the Tempietto in his survey of ancient temples because Bramante was "the first to bring back to light the good and beautiful architecture that from antiquity to that time had been hidden."⁷ Round in plan and elevated on a base that isolates it from its surroundings, the Tempietto conforms to Alberti's and Palladio's strictest demands for an ideal church.

NEW SAINT PETER'S As noted, Bramante was the architect Julius II selected to design a replacement for the Constantinian basilican church of Old Saint Peter's (FIG. 8-9). The earlier building had fallen into considerable disrepair and, in any event, did not suit this ambitious pope's taste for the colossal. Julius wanted to gain control over all Italy and to make the Rome of the popes the equal of (if not more splendid than) the Rome of the caesars. He intended the new building to serve, as did Constantine's church, as a *martyrium* to mark the apostle's grave, but the pope also hoped to install his own tomb (FIGS. 22-14 and 22-15) in the new Saint Peter's.

Bramante's ambitious design (FIG. **22-22**) for the new church consisted of a cross with arms of equal length, each terminating in an apse. A large dome would have covered the crossing, and smaller domes over subsidiary chapels would have capped the diagonal axes of the roughly square plan. Bramante's design also called for a boldly sculptural treatment of the walls and piers under the dome. The organization of the interior space was complex in the extreme: nine interlocking crosses, five of them supporting domes. The scale of Bramante's Saint Peter's was titanic. The architect boasted he would place the dome of the Pantheon (FIGS. 7-49 to 7-51) over the Basilica Nova (Basilica of Constantine; FIG. 7-78).

A commemorative medal (FIG. **22-23**) by CRISTOFORO FOPPA CARADOSSO (ca. 1452–1526) shows how Bramante planned to accomplish that feat. As in the Pantheon, Saint Peter's dome would be hemispherical, but Bramante broke up the massive unity of the ancient temple by adding two towers and a medley of domes and porticos. In light of Julius II's interest in the Roman Empire, using the Pantheon as a model was entirely appropriate. That Bramante's design for the new Saint Peter's appeared on a commemorative medal is in itself significant. Such medals proliferated in the 15th century, reviving the ancient Roman practice of placing images of important imperial building projects on the reverse side of coins. Roman coins also bore on the fronts portraits of the emperors who commissioned the buildings. Julius II appears on the front of the Caradosso medal.

MICHELANGELO, SAINT PETER'S During Bramante's lifetime, construction of Saint Peter's did not advance beyond the erection of the crossing piers and the lower choir walls. After his death, the work passed from one architect to another and, in 1546, to Michelangelo. With the Church facing challenges to its supremacy, Pope Paul III surely felt a sense of urgency about the completion of this project. Michelangelo's work on Saint Peter's became a long-term show of dedication, thankless and without pay. Among Michelangelo's difficulties was his struggle to preserve and carry through Bramante's original plan (FIG. 22-22), which he praised and chose to retain as the basis for his own

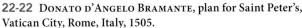

Bramante proposed to replace the Constantinian basilica of Saint Peter's (FIG. 8-9) with a central-plan church featuring a cross with arms of equal length, each of which terminated in an apse.

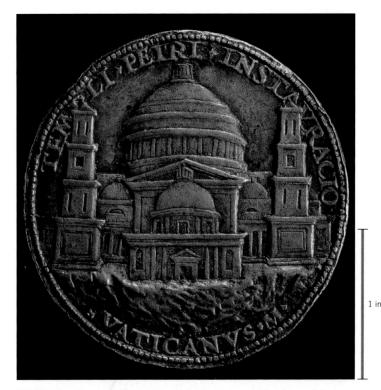

22-23 CRISTOFORO FOPPA CARADOSSO, reverse side of a medal showing Bramante's design for Saint Peter's, 1506. Bronze, $2\frac{1''}{4}$ diameter. British Museum, London.

Bramante's unexecuted 1506 design for Saint Peter's called for a large dome over the crossing, smaller domes over the subsidiary chapels, and a boldly sculptural treatment of the walls and piers.

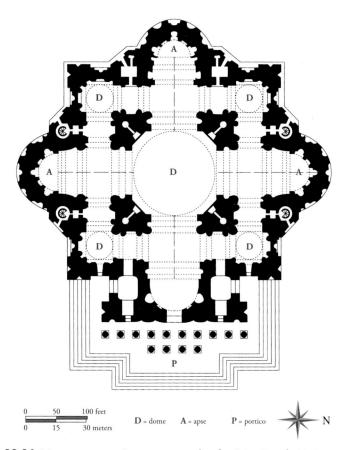

22-24 MICHELANGELO BUONARROTI, plan for Saint Peter's, Vatican City, Rome, Italy, 1546.

In his modification of Bramante's plan (FIG. 22-22), Michelangelo reduced the central component from a number of interlocking crosses to a compact domed Greek cross inscribed in a square.

design (FIG. **22-24**). Michelangelo shared Bramante's conviction that a central plan was the ideal form for a church. Always a sculptor at heart, Michelangelo carried his obsession with human form over to architecture and reasoned that buildings should follow the form of the human body. This meant organizing their units symmetrically around a central axis, as the arms relate to the body or the eyes to the nose. "For it is an established fact," he wrote, "that the members of architecture resemble the members of man. Whoever neither has been nor is a master at figures, and especially at anatomy, cannot really understand architecture."⁸

In his modification of Bramante's plan, Michelangelo reduced the central component from a number of interlocking crosses to a compact domed Greek cross inscribed in a square and fronted with a double-columned portico. Without destroying the centralizing features of Bramante's plan, Michelangelo, with a few strokes of the pen, converted its crystalline complexity into massive, cohesive unity. His treatment of the building's exterior further reveals his interest in creating a unified and cohesive design. Because of later changes to the front of the church, the west (apse) end (FIG. 22-25) offers the best view of Michelangelo's style and intention. His design incorporated the colossal order, the two-story pilasters first seen in more reserved fashion in Alberti's Mantuan church of Sant'Andrea (FIG. 21-45). The giant pilasters seem to march around the undulating wall surfaces, confining the movement without interrupting it. The architectural sculpturing here extends up from the ground through the attic stories and into the drum and dome, unifying the whole building from base to summit.

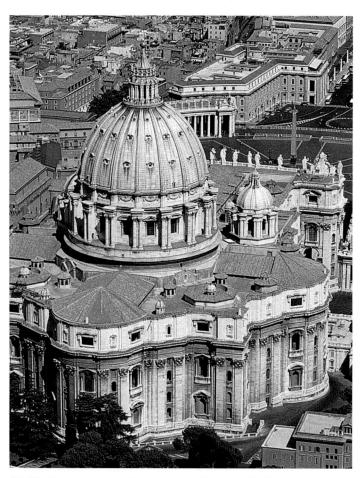

22-25 MICHELANGELO BUONARROTI, Saint Peter's (looking northeast), Vatican City, Rome, Italy, 1546–1564. Dome completed by GIACOMO DELLA PORTA, 1590.

The west end of Saint Peter's offers the best view of Michelangelo's intentions. The giant pilasters of his colossal order march around the undulating wall surfaces of the central-plan building.

The domed west end—as majestic as it is today and as influential as it has been on architecture throughout the centuries—is not quite as Michelangelo intended it. Originally, he had planned a dome with an ogival section, like the one Brunelleschi designed for Florence Cathedral (FIGS. 14-18 and 21-30A). But in his final version, he decided on a hemispherical dome to temper the verticality of the design of the lower stories and to establish a balance between dynamic and static elements. However, when Giacomo della Porta executed the dome (FIGS. 22-25 and 24-4) after Michelangelo's death, he restored the earlier high design, ignoring Michelangelo's later version. Giacomo's reasons were probably the same ones that had impelled Brunelleschi to use an ogival section for the Florentine dome—greater stability and ease of construction. The result is the dome seems to rise from its base, rather than rest firmly on it an effect Michelangelo might not have approved.

PALAZZO FARNESE Another architectural project Michelangelo took over at the request of Paul III was the construction of the lavish private palace the pope had commissioned when he was still Cardinal Alessandro Farnese. The future pope had selected ANTONIO DA SANGALLO THE YOUNGER (1483–1546) to design the Palazzo Farnese (FIG. **22-26**) in Rome. (At Antonio's death in 1546, Michelangelo assumed control of the building's completion, while also overseeing the reorganization of the Capitoline Hill

22-26 ANTONIO DA SANGALLO THE YOUNGER, Palazzo Farnese (looking southeast), Rome, Italy, 1517–1546; completed by MICHELANGELO BUONARROTI, 1546–1550.

Paul III's construction of a lavish private palace in Rome reflects his ambitions for his papacy. The facade features a rusticated central doorway and alternating triangular and segmental pediments.

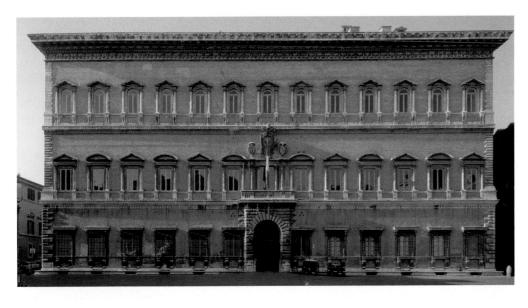

22-27 ANTONIO DA SANGALLO THE YOUNGER, courtyard of the Palazzo Farnese, Rome, Italy, ca. 1517–1546. Third story and attic by MICHELANGELO BUONARROTI, 1546–1550.

The interior courtyard of the Palazzo Farnese set the standard for later Italian palaces. It fully expresses the order, regularity, simplicity, and dignity of the High Renaissance style in architecture.

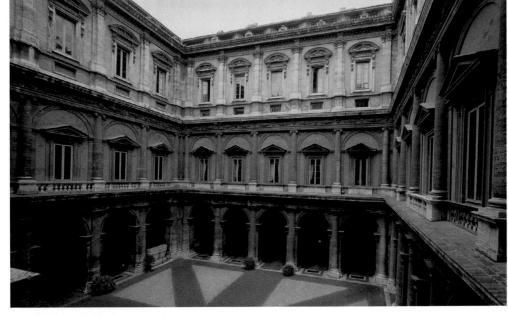

22-26A MICHELANGELO, Campidoglio, Rome, 1538–1564.

[FIG. **22-26A**] for the pope.) Antonio, the youngest of a family of architects, went to Rome around 1503 and became Bramante's draftsman and assistant. He is the perfect example of the professional architect. Indeed, his family constituted an architectural firm, often planning and drafting for other architects.

The broad, majestic front of the Palazzo Farnese asserts to the public the exalted station of a great family. It is significant that Paul chose to enlarge greatly

the original rather modest palace to its present form after his accession to the papacy in 1534, reflecting his ambitions both for his family and for the papacy. Facing a spacious paved square, the facade is the very essence of princely dignity in architecture. The *quoins* (rusticated building corners) and cornice firmly anchor the rectangle of the smooth front, and lines of windows (the central row with alternating triangular and *segmental* [curved] pediments, in Bramante's fashion) mark a majestic march across it. The window frames are not

flush with the wall, as in the Palazzo Medici-Riccardi (FIG. 21-37), but project from its surface, so instead of being a flat, thin plane, the facade is a spatially active three-dimensional mass. The rusticated doorway and second-story balcony, surmounted by the Farnese coat of arms, emphasize the central axis and bring the design's horizontal and vertical forces into harmony. This centralizing feature, absent from the palaces of Michelozzo (FIG. 21-37) and Alberti (FIG. 21-39), is the external opening of a central corridor axis running through the entire building and continuing in the garden beyond. Around this axis, Sangallo arranged the rooms with strict regularity.

The interior courtyard (FIG. **22-27**) displays stately columnframed arches on the first two levels, as in the Colosseum (FIG. 7-37). On the third level, Michelangelo incorporated his sophisticated variation on that theme (based in part on the Colosseum's fourthstory Corinthian pilasters), with overlapping pilasters replacing the weighty columns of Sangallo's design. The Palazzo Farnese set the standard for Italian Renaissance palaces and fully expresses the classical order, regularity, simplicity, and dignity of the High Renaissance.

22-28 ANDREA PALLADIO, Villa Rotonda (formerly Villa Capra; looking south), near Vicenza, Italy, ca. 1550–1570.

The Villa Rotonda has four identical facades, each one resembling a Roman temple with a columnar porch. In the center is a great dome-covered rotunda modeled on the Pantheon (FIG. 7-49).

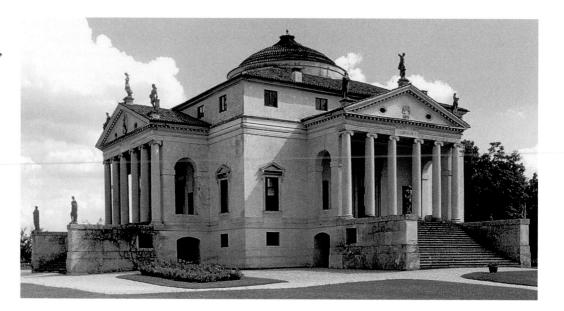

VENICE For centuries a major Mediterranean port, Venice served as the gateway to the Orient. After reaching the height of its commercial and political power during the 15th century, the city saw its fortunes decline in the 16th century. Even so, Venice and the Papal States were the only Italian sovereignties to retain their independence during the century of strife. Either France or Spain dominated all others. Although the discoveries in the New World and the economic shift from Italy to areas such as the Netherlands were largely responsible for the decline of Venice, even more immediate and pressing events drained its wealth and power. After their conquest of Constantinople (see Chapters 9 and 10), the Turks began to vie with the Venetians for control of the eastern Mediterranean. The Ottoman Empire evolved into a constant threat to Venice. Early in the century, the European powers of the League of Cambrai also attacked the Italian port city. Formed and led by Pope Julius II, who coveted Venetian holdings on Italy's mainland, the league included Spain, France, and the Holy Roman Empire, in addition to the Papal States. Despite these challenges, Venice developed a flourishing, independent, and influential school of artists.

ANDREA PALLADIO The chief architect of the Venetian Republic from 1570 until his death a decade later was Andrea di Pietro of Padua, known as ANDREA PALLADIO (1508-1580). (The surname derives from Pallas Athena, Greek goddess of wisdom, an appropriate reference for an architect schooled in the classical tradition of Alberti and Bramante.) Palladio began his career as a stonemason and decorative sculptor in Vicenza. At age 30, however, he turned to architecture, the ancient literature on architecture, engineering, topography, and military science. In order to study the ancient buildings firsthand, Palladio made several trips to Rome. In 1556, he illustrated Daniele Barbaro's edition of Vitruvius's De architectura and later wrote his own treatise on architecture, I quattro libri dell'architettura (The Four Books of Architecture), originally published in 1570. That work had wide-ranging influence on succeeding generations of architects throughout Europe. Palladio's influence outside Italy, most significantly in England and in colonial America (see Chapter 26), was stronger and more lasting than any other architect's.

Palladio accrued his significant reputation from his many designs for villas, built on the Venetian mainland. Nineteen still stand, and they especially influenced later architects. The same spirit that prompted the ancient Romans to build villas in the countryside

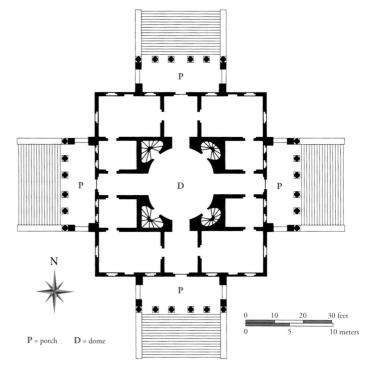

22-29 ANDREA PALLADIO, plan of the Villa Rotonda (formerly Villa Capra), near Vicenza, Italy, ca. 1550–1570.

Andrea Palladio published an influential treatise on architecture in 1570. Consistent with his design theories, all parts of the Villa Rotonda relate to one another in terms of mathematical ratios.

motivated a similar villa-building boom in 16th-century Venice, which, with its very limited space, was highly congested. But a longing for the countryside was not the only motive. Declining fortunes prompted the Venetians to develop their mainland possessions with new land investment and reclamation projects. Citizens who could afford to do so set themselves up as aristocratic farmers and developed swamps into productive agricultural land. The villas were thus aristocratic farms surrounded by service outbuildings (like the much later American plantations, which emulated many aspects of Palladio's architectural style). Palladio generally arranged the outbuildings in long, low wings branching out from the main building and enclosing a large rectangular court area. VILLA ROTONDA Palladio's most famous villa, Villa Rotonda (FIG. 22-28), near Vicenza, is exceptional because the architect did not build it for an aspiring gentleman farmer but for a retired monsignor who wanted a villa for social events. Palladio planned and designed Villa Rotonda, located on a hilltop, as a kind of belvedere (literally "beautiful view"; in architecture, a structure with a view of the countryside or the sea), without the usual wings of secondary buildings. It has a central plan (FIG. 22-29) featuring four identical facades with projecting porches, each of which resembles a Roman Ionic temple. In placing a traditional temple porch in front of a dome-covered unit, Palladio doubtless had the Pantheon (FIG. 7-49) in mind. But, as Bramante did in his Tempietto (FIG. 22-21), Palladio transformed his model into a new design without parallel in antiquity. Each of the villa's four porches is a platform for enjoying a different view of the surrounding landscape. In this design, the central dome-covered rotunda logically functions as a circular reception area from which visitors may turn in any direction for the preferred view. The result is a building with

functional parts systematically related to one another in terms of calculated mathematical relationships. Villa Rotonda embodies all the qualities of self-sufficiency and formal completeness most Renaissance architects sought.

SAN GIORGIO MAGGIORE One of the most dramatically placed buildings in Venice is San Giorgio Maggiore (FIG. **22-30**), directly across the Grand Canal from Piazza San Marco. Palladio began work on the church a few years before he succeeded JACOPO SANSOVINO (1486–1570; FIG. **22-30A**) as Venice's official architect.

Dissatisfied with earlier solutions to the problem of integrating a high central nave and lower aisles into a unified facade design, Palladio solved it by superimposing a tall and narrow classical porch on a low broad one. This solution reflects the building's interior arrangement (FIG. **22-31**) and in that sense is strictly logical, but the

22-30A SANSOVINO, Mint and Library, Venice, begun 1536.

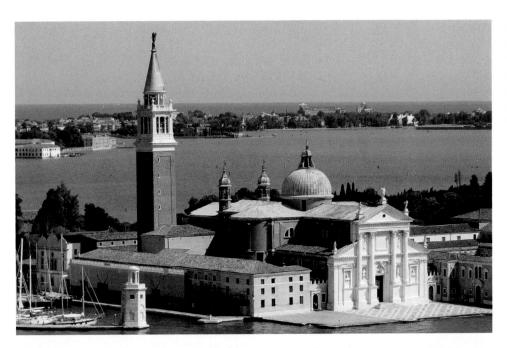

22-30 ANDREA PALLADIO, San Giorgio Maggiore (looking southeast), Venice, Italy, begun 1566.

Dissatisfied with earlier solutions to the problem of integrating a high central nave and lower aisles into a unified facade, Palladio superimposed a tall and narrow classical porch on a low broad one.

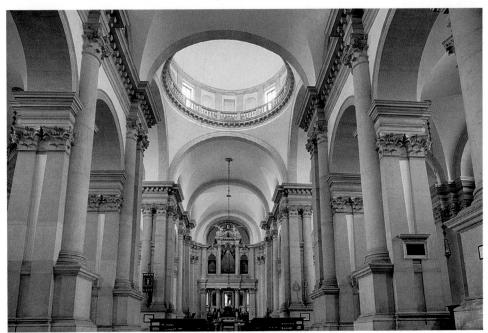

22-31 ANDREA PALLADIO, interior of San Giorgio Maggiore (looking east), Venice, Italy, begun 1566.

In contrast to the somewhat irrational intersection of two temple facades on the exterior of San Giorgio Maggiore, Palladio's interior is strictly logical, consistent with classical architectural theory. intersection of two temple facades is irrational and ambiguous, consistent with contemporaneous developments in Mannerist architecture (see page 632). Palladio's design also created the illusion of threedimensional depth, an effect intensified by the strong projection of the central columns and the shadows they cast. The play of shadow across the building's surfaces, its reflection in the water, and its gleaming white against sea and sky create a remarkably colorful effect. The interior of the church lacks the ambiguity of the facade and exhibits strong roots in High Renaissance architectural style. Light floods the interior and crisply defines the contours of the rich wall decorations, all beautifully and "correctly" profiled—the exemplar of what classical architectural theory meant by "rational" organization.

Venetian Painting

In the 16th century, the Venetians developed a painting style distinct from that of Rome and Florence. Artists in the maritime republic showed a special interest in recording the effect of Venice's soft-colored light on figures and landscapes. The leading Venetian master at the turn of the century was Giovanni Bellini, who contributed significantly to creating the High Renaissance painting style in Venice.

GIOVANNI BELLINI Trained in the International Style by his father, Jacopo, a student of Gentile da Fabriano (FIG. 21-18), GIOVANNI BELLINI (ca. 1430-1516) worked in the family shop and did not develop his own style until after his father's death in 1470. His early independent works show the dominant influence of his brother-in-law Andrea Mantegna (FIGS. 21-48 to 21-50). But in the late 1470s, he came into contact with the work of the Sicilian-born painter Antonello da Messina (ca. 1430-1479). Antonello received his early training in Naples, where he must have encountered Flemish painting and mastered using mixed oil (see "Tempera and Oil Painting," Chapter 20, page 539). This more flexible medium is wider in coloristic range than either tempera or fresco. Antonello arrived in Venice in 1475 and during his two-year stay introduced his Venetian colleagues to the possibilities the new oil technique offered. In Saint Fran-

22-31A BELLINI, Saint Francis in the Desert, ca. 1470–1480.

cis in the Desert (FIG. 22-31A), his most famous work of this

period, Bellini used a mixture of oil and tempera. As a direct result of Bellini's contact with Antonello, Bellini abandoned Mantegna's harsh linear style and developed a sensuous coloristic manner destined to characterize Venetian painting for a century.

SAN ZACCARIA ALTARPIECE Bellini earned great recognition for his many Madonnas, which he painted both in half-length (with or without accompanying saints) on small devotional panels and in full-length on large, monumental altarpieces of the sacra conversazione (holy conversation) type. In the sacra conversazione, which became a popular theme for religious paintings from the middle of the 15th century on, saints from different epochs occupy the same space and seem to converse either with one another or

22-32 GIOVANNI BELLINI, Madonna and Child with Saints (San Zaccaria Altarpiece), 1505. Oil on wood transferred to canvas, 16' $5\frac{1''}{2} \times 7'$ 9". San Zaccaria, Venice.

In this *sacra conversazione* uniting saints from different eras, Bellini created a feeling of serenity and spiritual calm through the harmonious and balanced presentation of color and light.

with the audience. (Raphael employed much the same conceit in his School of Athens, FIG. 22-9, where he gathered Greek philosophers of different eras.) Bellini carried on the tradition in one of his earliest major commissions, the San Zaccaria Altarpiece (FIG. 22-32). The Virgin Mary sits enthroned, holding the Christ Child, with saints flanking her. Bellini placed the group in a carefully painted shrine. Attributes aid the identification of all the saints: Saint Lucy holding a tray with her plucked-out eyes displayed on it; Peter with his key and book; Catherine with the palm of martyrdom and the broken wheel; and Jerome with a book (representing his translation of the Bible into Latin). At the foot of the throne sits an angel playing a viol. The painting radiates a feeling of serenity and spiritual calm. Viewers derive this sense less from the figures (no interaction occurs among them) than from Bellini's harmonious and balanced presentation of color and light. Line is not the chief agent of form, as it generally is in paintings produced in Rome and Florence. Indeed, outlines dissolve in light and shadow. Glowing color produces a soft radiance that envelops the forms with an atmospheric haze and enhances their majestic serenity.

FEAST OF THE GODS Painted a quarter century later, Feast of the Gods (FIG. 22-33) was a collaboration between Bellini and his greatest student, Titian (FIGS. 22-35 to 22-41). Bellini also drew from the work of another pupil, Giorgione (FIG. 22-34), who developed his master's landscape backgrounds into poetic Arcadian reveries. Derived from Arcadia, a region in southern Greece, the term Arcadian referred, by the time of the Renaissance, to an idyllic place of rustic peace and simplicity. After Giorgione's premature death, Bellini embraced his student's interests and, in Feast of the Gods, developed a new kind of mythological painting. The duke of Ferrara, Alfonso d'Este (r. 1505-1534), commissioned this work for the Camerino d'Alabastro (Alabaster Room), a private apartment in the Palazzo Ducale complex. Alfonso hired four painters-Bellini, Titian, Raphael, and Fra Bartolommeo (1472-1517) of Florence-to provide four paintings of related mythological subjects for the room, carefully selected for the duke by the humanist scholar Mario Equicola (1470-1515). Both Raphael and Fra Bartolommeo died before fulfilling the commission. Although for his painting Bellini drew some of the figures from the standard repertoire of Greco-Roman art-most notably, the nymph carrying a vase on her head and the sleeping nymph in the lower right corner-the Olympian gods appear as peasants enjoying a picnic in a shady glade. The ancient literary source was the Roman poet Ovid's Fasti (1:391-440; 6:319-348), which describes the gods banqueting. Satyrs attend the gods, nymphs bring jugs of wine, and couples

engage in love play. At the far right, Priapus lifts the dress of the sleeping nymph with exposed breast. (All four paintings in the Camerino centered on Venus or Bacchus, the Roman gods of love and wine.) The mellow light of a long afternoon glows softly around the gathering, caressing the surfaces of colorful fabrics, smooth flesh, and polished metal. Here, Bellini communicated the delight the Venetian school took in the beauty of texture revealed by the full resources of gently and subtly harmonized color. Behind the warm, lush tones of the figures, a background of cool green tree-filled glades extends into the distance. At the right, a screen of trees creates a verdant shelter. The atmosphere is idyllic, a lush countryside providing a setting for the never-ending pleasure of the immortal gods.

With Bellini, Venetian art became the great complement of the schools of Florence and Rome. The Venetians' instrument was color, that of the Florentines and Romans sculpturesque form. Scholars often distill the contrast between these two approaches down to colorito (colored or painted) versus disegno (drawing and design). Whereas most central Italian artists emphasized careful design preparation based on preliminary drawing (see "Renaissance Drawings," page 604), Venetian artists focused on color and the process of paint application. In addition, the general thematic focus of their work differed. Venetian artists painted the poetry of the senses and delighted in nature's beauty and the pleasures of humanity. Artists in Florence and Rome gravitated toward more intellectual themes-the epic of humanity, the masculine virtues, the grandeur of the ideal, and the lofty conceptions of religion involving the heroic and sublime. Much of the later history of Western art involves a dialogue between these two traditions.

22-33 GIOVANNI BELLINI and TITIAN, *Feast of the Gods*, from the Camerino d'Alabastro, Palazzo Ducale, Ferrara, Italy, 1529. Oil on canvas, 5' 7" \times 6' 2". National Gallery of Art, Washington (Widener Collection).

In *Feast of the Gods*, based on Ovid's *Fasti*, Bellini developed a new kind of mythological painting in which the Olympian deities appear as peasants enjoying a picnic in the soft afternoon light.

High and Late Renaissance 625

22-34 GIORGIONE DA CASTELFRANCO, *The Tempest*, ca. 1510. Oil on canvas, 2' $8\frac{1}{4}$ " \times 2' $4\frac{3}{4}$ ". Galleria dell'Accademia, Venice.

The subject of this painting set in a lush landscape beneath a stormy sky is uncertain, contributing, perhaps intentionally, to the painting's enigmatic quality and intriguing air.

GIORGIONE Describing Venetian art as "poetic" is particularly appropriate, given the development of poesia, or painting meant to operate in a manner similar to poetry. Both classical and Renaissance poetry inspired Venetian artists, and their paintings focused on the lyrical and sensual. Thus, in many Venetian artworks, discerning concrete narratives or subjects is virtually impossible. That is certainly the case with The Tempest (FIG. 22-34), a painting that continues to defy interpretation. It is the greatest work attributed to the short-lived GIORGIONE DA CASTELFRANCO (ca. 1477-1510), the Venetian artist who deserves much of the credit for developing the poetic manner of painting. To an even greater extent than in Bellini's later Feast of the Gods (for which Giorgione's work served as inspiration for his teacher, Bellini), a lush landscape fills most of Giorgione's Tempest. Stormy skies and lightning in the middle background threaten the tranquility of the pastoral setting, however. Pushed off to both sides are the few human figures depicted-a young woman nursing a baby in the right foreground and a man

22-35 TITIAN, Pastoral Symphony, ca. 1508–1511. Oil on canvas, 3' $7\frac{1}{4}'' \times 4' 6\frac{1}{4}''.$ Musée du Louvre, Paris.

Venetian art conjures poetry. In this painting, Titian so eloquently evoked the pastoral mood that the uncertainty about the picture's meaning is not distressing. The mood and rich color are enough.

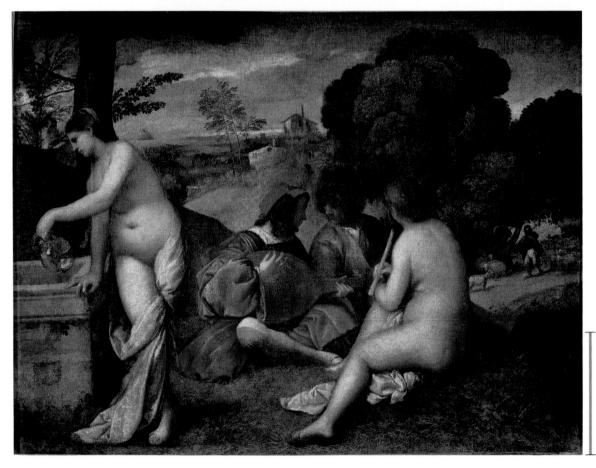

carrying a *halberd* (a combination spear and battle-ax—but he is not a soldier) on the left. Much scholarly debate has centered on the painting's subject, fueled by X-rays of the canvas that revealed Giorgione altered many of the details as work progressed. Most notably, a seated nude woman originally occupied the position where Giorgione subsequently placed the standing man. The changes the painter made have led many art historians to believe Giorgione did not intend the painting to have a definitive narrative, which is appropriate for a Venetian poetic rendering. Other scholars have suggested various mythological and biblical narratives. The uncertainty about the subject contributes to the painting's intriguing air.

TITIAN Giorgione's masterful handling of light and color and his interest in landscape, poetry, and music—Vasari reported he was an accomplished lutenist and singer—influenced not only his much

paint a monumental altarpiece (nearly 23 feet high) for the high altar of the church. In *Assumption of the Virgin* (FIG. **22-36**), a fitting theme for the shrine of the "glorious Saint Mary," Titian's remarkable coloristic sense and his ability to convey light through color are again on display. The subject is the ascent of the Virgin to Heaven on a great white cloud borne aloft by putti. Above, golden clouds, so luminous they seem to glow and radiate light into the church, envelop the Virgin, whose head is on the vertical axis of the composition. God the Father appears above, slightly off-center, awaiting Mary with open arms. Below, closest to the viewer, over-life-size apostles gesticulate wildly as they witness the glorious event. Through his mastery of the oil medium—fresco was not a good choice for Venetian churches because of the dampness and salinity of this city with saltwater streets—Titian used vibrant color to infuse the image with intensity and amplify the drama.

older yet constantly inquisitive master, Bellini, but also his younger contemporary, Tiziano Vecelli, called TITIAN (ca. 1490-1576) in English. Indeed, a masterpiece long attributed to Giorgione-Pastoral Symphony (FIG. 22-35)-is now widely believed to be an early work of Titian. Out of dense shadow emerge the soft forms of figures and landscape. Titian, a supreme colorist and master of the oil medium, cast a mood of tranquil reverie and dreaminess over the entire scene, evoking the landscape of a lost but never forgotten paradise. As in Giorgione's Tempest, the theme is as enigmatic as the lighting. Two nude women, accompanied by two clothed young men, occupy the bountiful landscape through which a shepherd passes. In the distance, a villa crowns a hill. The artist so eloquently evoked the pastoral mood that the viewer does not find the uncertainty about the picture's precise meaning distressing. The mood is enough. The shepherd symbolizes the poet. The pipes and lute symbolize his poetry. The two women accompanying the young men may be thought of as their invisible inspiration, their muses. One turns to lift water from the sacred well of poetic inspiration. The voluptuous bodies of the women, softly modulated by the smoky shadow, became the standard in Venetian art. The fullness of their figures contributes to their effect as poetic personifications of nature's abundance.

ASSUMPTION OF THE VIRGIN On Bellini's death in 1516, the Republic of Venice appointed Titian as its official painter. Shortly thereafter, the prior of the Franciscan basilica of Santa Maria Gloriosa dei Frari commissioned Titian to

22-36 TITIAN, Assumption of the Virgin, 1515–1518. Oil on wood, 22' $7\frac{1}{2}'' \times 11'$ 10". Santa Maria Gloriosa dei Frari, Venice.

Titian won renown for his ability to convey light through color. In this dramatic depiction of the Virgin Mary's ascent to Heaven, the golden clouds seem to glow and radiate light into the church.

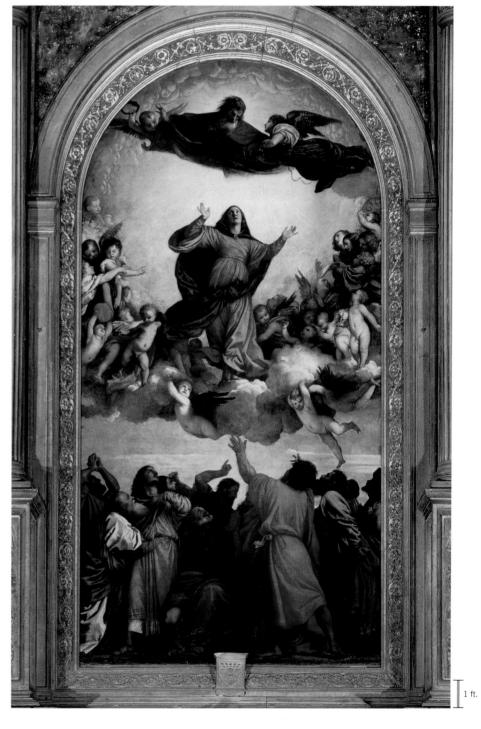

22-37 TITIAN, *Madonna of the Pesaro Family*, 1519–1526. Oil on canvas, 15' $11'' \times 8'$ 10". Pesaro Chapel, Santa Maria Gloriosa dei Frari, Venice.

In this dynamic composition presaging a new kind of pictorial design, Titian placed the figures on a steep diagonal, positioning the Madonna, the focus of the composition, well off the central axis.

PESARO MADONNA A year after installing Assumption of the Virgin in the main altar of the Venetian church of the Frari, Titian received a commission to paint Madonna of the Pesaro Family (FIG. 22-37) for the same church. Jacopo Pesaro (d. 1547), bishop of Paphos in Cyprus and commander of the papal fleet, had led a successful expedition in 1502 against the Turks during the Venetian-Turkish war. He dedicated a family chapel in Santa Maria Gloriosa and donated Titian's altarpiece in gratitude. In a stately sunlit setting in what may be the Madonna's palace in Heaven, Mary receives the commander, who kneels dutifully at the foot of her throne. A soldier (Saint George?) behind the commander carries a banner with the escutcheons (shields with coats of arms) of the Borgia pope, Alexander VI, and of Pesaro. Behind him is a turbaned Turk, a prisoner of war of the Christian forces. Saint Peter appears on the steps of the throne, and Saint Francis introduces other Pesaro family members (all male-Italian depictions of donors in this era typically excluded women and children), who kneel solemnly in the right foreground. Thus, Titian entwined the human and the heavenly, depicting the Madonna and saints honoring the achievements of a specific man. A quite worldly transaction takes place (albeit beneath a heavenly cloud bearing angels) between a queen and her court and loyal servants, consistent with Renaissance protocol and courtly splendor.

A prime characteristic of High Renaissance painting is the massing of monumental figures, singly and in groups, within a weighty and majestic architecture. But here Titian did not compose a horizontal and symmetrical arrangement, as did Leonardo in *Last Supper* (FIG. 22-4) and Raphael in *School of Athens* (FIG. 22-9). Rather, he placed the figures on a steep diagonal, positioning the Madonna, the focus of the composition, well off the central axis. Titian drew attention to her with the perspective lines, the inclination of the figures, and the directional lines of gaze and gesture. The banner inclining toward the left beautifully brings the design into equilibrium, balancing the rightward and upward tendencies of its main direction. This kind of composition is more dynamic than most High Renaissance examples and presaged a new kind of pictorial design—one built on movement rather than rest.

BACCHUS AND ARIADNE After the deaths of Raphael and Fra Bartolommeo, Titian took over their commissions to paint bacchanalian scenes for Alfonso d'Este's Camerino d'Alabastro in addition to his own assignment. Titian also contributed the landscape background to Bellini's *Feast of the Gods* (FIG. 22-33). Completed in 1523, *Meeting of Bacchus and Ariadne* (FIG. 22-38), based on an ancient Latin poem by Catullus, is a roughly six-feet-square canvas in which Bacchus, accompanied by a boisterous group, arrives on the island of Naxos in a leopard-drawn chariot to save Ariadne, whom Theseus had abandoned there. Consistent with the mythological subject, Titian looked to classical art for models and derived one of the figures, the snake-entwined satyr, from the recently unearthed

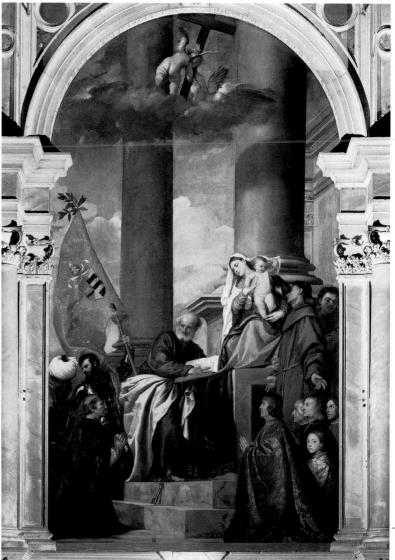

Laocoön (FIG. 5-89), a marble statue that also made an indelible impression on Michelangelo and many others. Titian's rich and luminous colors add greatly to the sensuous appeal of the painting, making it perfect for what Alfonso called his "pleasure chamber."

VENUS OF URBINO In 1538, at the height of his powers, Titian painted the so-called Venus of Urbino (FIG. 22-39) for Guidobaldo II, who became the duke of Urbino the following year (r. 1539–1574). The title (given to the painting later) elevates to the status of classical mythology what is probably a representation of a sensual Italian woman in her bedchamber. Whether the subject is divine or mortal, Titian based his version on an earlier (and pioneering) painting of Venus (not illustrated) by Giorgione. Here, Titian established the compositional elements and the standard for paintings of the reclining female nude, regardless of the many ensuing variations. This "Venus" reclines on the gentle slope of her luxurious pillowed couch. Her softly rounded body contrasts with the sharp vertical edge of the curtain behind her, which serves to direct the viewer's attention to her left hand and pelvis as well as to divide the foreground from the background. At the woman's feet is a slumbering lapdog—where Cupid would be if this were Venus. In the right background, near the window opening onto a landscape, two servants bend over a chest, apparently searching for garments (Renaissance households stored clothing in carved wooden chests

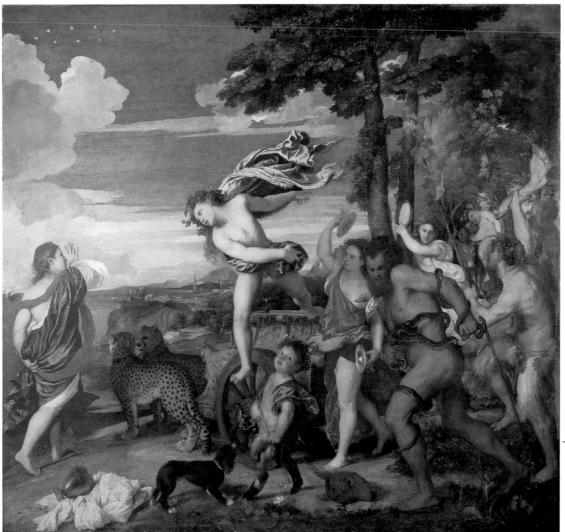

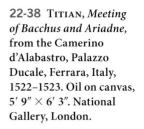

Titian's rich and luminous colors add greatly to the sensuous appeal of this mythological painting in which he based one of the figures on the recently unearthed *Laocoön* (FIG. 5-89).

1 ft.

22-39 TITIAN, Venus of Urbino, 1536–1538. Oil on canvas, 3' 11" × 5' 5". Galleria degli Uffizi, Florence. ■4

Titian established oil color on canvas as the preferred painting medium in Western art. Here, he also set the standard for representations of the reclining female nude, whether divine or mortal.

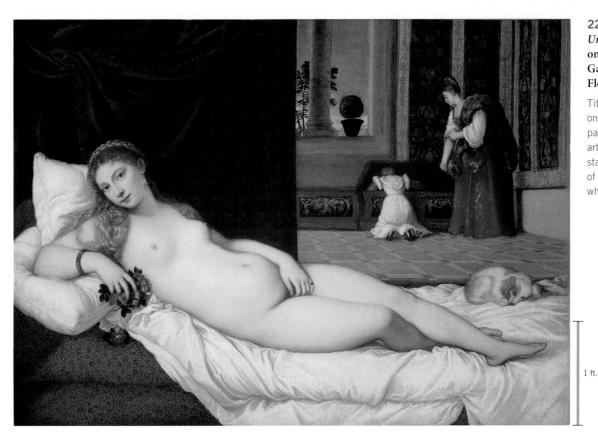

Women in the Renaissance Art World

The Renaissance art world was decidedly male-dominated. Few women could become professional artists because of the many obstacles they faced. In particular, for centuries, training practices mandating residence in a master's house (see "Artists' Guilds," Chapter 14, page 410) precluded women from acquiring the necessary experience. In addition, social proscriptions, such as those preventing women from drawing from nude models, hampered an aspiring woman artist's advancement through the accepted avenues of artistic training.

22-40A FONTANA, Portrait of a Noblewoman, ca. 1580.

Still, some determined Renaissance women surmounted these barriers and produced not only considerable bodies of work but earned enviable reputations as well. One was Sofonisba Anguissola (FIG. 22-47), who was so accomplished she can be considered the first Italian woman to have ascended to the level of international art celebrity. LAVINIA FONTANA (1552–1614; FIG. 22-40A) also achieved notable success, and her paintings constitute the largest surviving body of

work by any woman artist before 1700. Fontana learned her craft from her father, Prospero Fontana (1512–1597), a leading Bolognese painter. (Paternal training was the norm for aspiring women artists.) She was in demand as a portraitist and received commissions from important patrons, including members of the ruling Habsburg family. She even spent time as an official painter to the papal court in Rome.

Perhaps more challenging for women than the road to becoming a professional painter was the mastery of sculpture, made more difficult by the physical demands of the medium. Yet Properzia de' Rossi (ca. 1490–1530) established herself as a professional sculptor and was the only woman artist Giorgio Vasari included in his comprehensive publication, *Lives of the Most Eminent Painters, Sculptors, and Architects.* Active in the early 16th century, she died of the plague in 1530, bringing her promising career to an early end.

Beyond the realm of art production, Renaissance women exerted significant influence as art patrons. Scholars only recently have begun to explore systematically the role of women in commissioning works of art. As a result, current knowledge is sketchy at best but suggests women played a much more extensive role than previously acknowledged. Among the problems researchers face in their quest to clarify women's activities as patrons is that women often wielded their influence and decision-making power behind the scenes. Many of them acquired their positions through marriage. Their power was thus indirect and provisional, based on their husbands' wealth and status. Thus, documentation of the networks within which women patrons operated and of the processes they used to exert power in a society dominated by men is less substantive than for male patrons.

One of the most important Renaissance patrons, male or female, was Isabella d'Este (1474–1539), the marquess of Mantua. The daughter of Ercole d'Este, duke of Ferrara (r. 1471–1505), and brought up in the cultured princely court there, Isabella married Francesco Gonzaga, marquis of Mantua (1466–1519), in 1490. The marriage gave Isabella access to the position and wealth necessary to pursue her interest in becoming a major art patron. An avid collector, she enlisted the aid of agents who scoured Italy for appealing artworks. Isabella

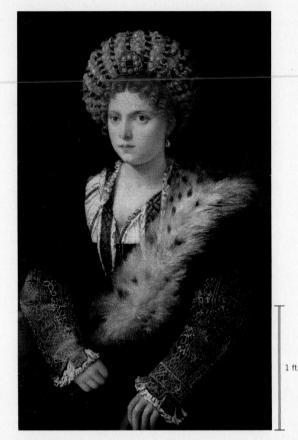

22-40 TITIAN, *Isabella d'Este*, 1534–1536. Oil on canvas, 3' $4\frac{1}{8}'' \times 2' 1\frac{1}{16}''$. Kunsthistorisches Museum, Vienna.

Isabella d'Este was one of the most powerful women of the Renaissance era. When, at age 60, she commissioned Titian to paint her portrait, she insisted the artist depict her in her 20s.

did not limit her collection to painting and sculpture but included ceramics, glassware, gems, cameos, medals, classical texts, musical manuscripts, and musical instruments.

Undoubtedly, Isabella was a proud and ambitious woman well aware of how art could boost her fame and reputation. Accordingly, she commissioned several portraits of herself from the most esteemed artists of her day—Leonardo da Vinci, Andrea Mantegna, and Titian (FIG. 22-40). The detail and complexity of many of her contracts with artists reveal her insistence on control over the artworks.

Other Renaissance women positioned themselves as serious art patrons. One was Caterina Sforza (1462–1509), daughter of Galeazzo Maria Sforza (heir to the duchy of Milan), who married Girolamo Riario (1443–1488) in 1484. The death of her husband, lord of Imola and count of Forli, gave Sforza, who survived him by two decades, access to power denied most women. Another female art patron was Lucrezia Tornabuoni (1425–1482), who married Piero di Cosimo de' Medici (1416–1469), one of many Medici, both men and women, who earned reputations as unparalleled art patrons. Further archival investigation of women's roles in Renaissance Italy undoubtedly will produce more evidence of how women established themselves as patrons and artists and the extent to which they contributed to the flourishing of Renaissance art.

Palma il Giovane on Titian

A n important change occurring in Titian's time was the almost universal adoption of canvas, with its rough-textured surface, in place of wood panels for paintings. Titian's works established oil-based pigment on canvas as the typical medium of the Western pictorial tradition thereafter. Palma il Giovane, one of Titian's students, who completed the *Pietà* (FIG. 22-41) Titian intended for his tomb in Santa Maria Gloriosa dei Frari in Venice, wrote a valuable account of his teacher's working methods and of how Titian used the new medium to great advantage:

22-41 TITIAN and PALMA IL GIOVANE, Pietà, ca. 1570–1576. Oil on canvas, $11' 6'' \times 12' 9''$. Galleria dell'Accademia, Venice.

In this late work characterized by broad brushstrokes and a thick impasto, Titian portrayed himself as the penitent Saint Jerome kneeling before the dead Christ. Titian intended the work for his own tomb.

Titian [employed] a great mass of colors, which served ... as a base for the compositions. . . . I too have seen some of these, formed with bold strokes made with brushes laden with colors, sometimes of a pure red earth, which he used, so to speak, for a middle tone, and at other times of white lead; and with the same brush tinted with red, black and yellow he formed a highlight; and observing these principles he made the promise of an exceptional figure appear in four brushstrokes.... Having constructed these precious foundations he used to turn his pictures to the wall and leave them there without looking at them, sometimes for several months. When he wanted to apply his brush again he would examine them with the utmost rigor . . . to see if he could find any faults.... In this way, working on the figures and revising them, he brought them to the most perfect symmetry that the beauty of art and nature can reveal. . . . [T]hus he gradually covered those quintessential forms with living flesh, bringing them

called *cassoni*) to clothe their reclining nude mistress. Beyond them, a smaller vista opens into a landscape. Titian masterfully constructed the view backward into the room and the division of the space into progressively smaller units.

As in other Venetian paintings, color plays a prominent role in *Venus of Urbino*. The red tones of the matron's skirt and the muted reds of the tapestries against the neutral whites of the matron's sleeves and the kneeling girl's gown echo the deep Venetian reds set off against the pale neutral whites of the linen and the warm ivory gold of the flesh. The viewer must study the picture carefully to realize the subtlety of color planning. For instance, the two deep reds (in the foreground cushions and in the background skirt) play a critical role in the composition as a gauge of distance and as indicators of an implied diagonal opposed to the real one of the reclining figure. Here, Titian used color not simply to record surface appearance but also to organize his placement of forms.

ISABELLA D'ESTE Titian was a highly esteemed portraitist as well and in great demand. More than 50 portraits by his hand survive. One of the best is *Isabella d'Este* (FIG. **22-40**), Titian's portrait of one of the most prominent women of the Renaissance (see "Women in the Renaissance Art World," page 630). Isabella was the sister of Alfonso d'Este, for whom Titian painted three mythological scenes

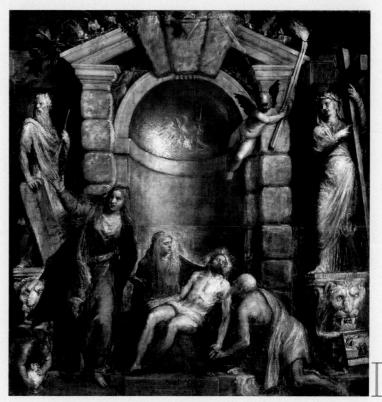

by many stages to a state in which they lacked only the breath of life. He never painted a figure all at once and . . . in the last stages he painted more with his fingers than his brushes.*

*Quoted in Francesco Valcanover, "An Introduction to Titian," in Valcanover, *Titian: Prince of Painters* (Venice: Marsilio Editori, 1990), 23–24.

for the Ferrara ducal palace. At 16, she married Francesco Gonzaga, marquis of Mantua, and through her patronage of art and music was instrumental in developing the Mantuan court into an important cultural center. Portraits by Titian generally emphasize his psychological reading of the subject's head and hands. Thus, Titian sharply highlighted Isabella's face, whereas her black dress fades into the undefined darkness of the background. The unseen light source also illuminates Isabella's hands, and Titian painted her sleeves with incredible detail to further draw viewers' attention to her hands. This portrait reveals not only Titian's skill but the patron's wish too. Painted when Isabella was 60 years old, the portrait depicts her in her 20s—at her specific request. Titian used an earlier likeness of her as his guide, but his portrait is no copy. Rather, it is a distinctive portrayal of his poised and self-assured patron that owes little to its model.

PIETÀ As Michelangelo had done late in his life, Titian began to contemplate death and salvation and around 1570 decided to create a memorial for his tomb. He, too, chose *Pietà* (FIG. **22-41**) as the theme, albeit for a painting, not a statuary group, as in Michelangelo's case (FIG. 22-20). Intended for the altar of his burial chapel in the right aisle of Santa Maria Gloriosa dei Frari in Venice, which housed two of his earlier altarpieces (FIGS. 22-36 and 22-37),

Titian's *Pietà* remained unfinished when he died of the plague in 1576. His assistant, Jacopo Negretti, known as PALMA IL GIOVANE (1548–1628)—Palma the Younger—piously completed the painting.

Titian set the scene of grief over Christ's death in a rusticated niche reminiscent of the bays of Sansovino's Mint (FIG. 22-30A, *left*) on the Canale San Marco. The Virgin cradles her son's body, while Mary Magdalene runs forward with her right arm raised in a gesture of extreme distress. (Echoing her form, but in reverse, is the torch-carrying angel added by Palma.) The other penitent mourner is Saint Jerome, seen from behind kneeling at Christ's side. His head has the features of the aged, balding Titian—another parallel with Michelangelo's *Pietà*. Both artists apparently wanted to portray themselves touching Jesus' body, hoping for their salvation.

For this huge (roughly 12 feet square) canvas, Titian employed one of his favorite compositional devices (compare FIG. 22-37), creating a bold diagonal movement beginning at Jerome's feet and leading through Christ, the Virgin, and Mary Magdalene to the statue of Moses with the Ten Commandments at the left. (The other statue represents the Hellespontine Sibyl. The votive painting leaning against its pedestal depicts Titian and his son Orazio, who also died of the plague in 1576, praying before another Pietà.) But unlike Titian's early and mature works, in which he used smooth and transparent oil glazes, this Pietà, as his other late paintings, features broken brushstrokes and rough, uneven patches of pigment built up like paste (impasto) that catch the light. Many Baroque painters, especially Peter Paul Rubens and Rembrandt van Rijn (see Chapter 25), subsequently adopted Titian's innovative and highly expressive manner of applying thick paint to canvas (see "Palma il Giovane on Titian," page 631).

MANNERISM

The Renaissance styles of Rome, Florence, and Venice dominated Italian painting, sculpture, and architecture for most of the 16th century, but already in the 1520s another style—Mannerism—had emerged in reaction to it. *Mannerism* is a term derived from the Italian word *maniera*, meaning "style" or "manner." In the field of art history, the term *style* usually refers to a characteristic or representative mode, especially of an artist or period (for example, Titian's style or Gothic style). *Style* can also refer to an absolute quality of fashion (for example, someone has "style"). Mannerism's style (or representative mode) is characterized by style (being stylish, cultured, elegant).

Painting

Among the features most closely associated with Mannerism is artifice. Of course, all art involves artifice, in the sense that art is not "natural"-it is something humans fashion. But many artists, including High Renaissance painters such as Leonardo and Raphael, chose to conceal that artifice by using devices such as perspective and shading to make their representations of the world look natural. In contrast, Mannerist painters consciously revealed the constructed nature of their art. In other words, Renaissance artists generally strove to create art that appeared natural, whereas Mannerist artists were less inclined to disguise the contrived nature of art production. This is why artifice is a central feature of discussions about Mannerism, and why Mannerist works can seem, appropriately, "mannered." The conscious display of artifice in Mannerism often reveals itself in imbalanced compositions and unusual complexities, both visual and conceptual. Ambiguous space, departures from expected conventions, and unusual presentations of traditional themes also surface frequently in Mannerist art.

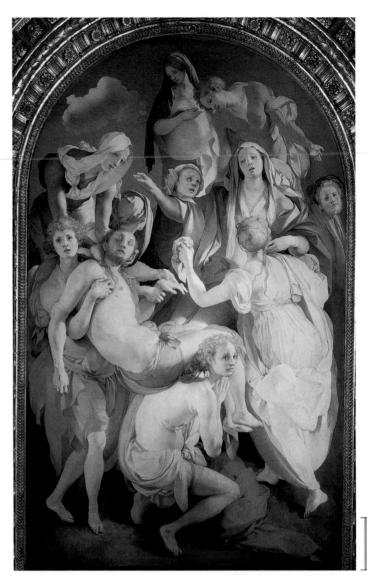

22-42 JACOPO DA PONTORMO, Entombment of Christ, Capponi chapel, Santa Felicità, Florence, Italy, 1525–1528. Oil on wood, 10' 3" × 6' 4". ■4

Mannerist paintings such as this one represent a departure from the compositions of the earlier Renaissance. Instead of concentrating masses in the center of the painting, Pontormo left a void.

PONTORMO Entombment of Christ (FIG. **22-42**) by the Florentine painter Jacopo Carucci, known as JACOPO DA PONTORMO (1494–1557) after his birthplace, exhibits almost all the stylistic features characteristic of Mannerism's early phase in painting—as does *Fall of the Rebel Angels* (FIG. **22-42A**) by Pontormo's older contemporary DOMENICO BECCAFUMI (1481–1551). Christ's descent from the cross and subsequent entombment had frequently been depicted in art (see "The Life of Jesus in Art," Chapter 8, pages 240–241, or on pages xxs–xxsi in Volume II and Book D),

22-42A BECCAFUMI, *Fall* of the Rebel Angels, ca. 1524.

and Pontormo exploited the familiarity 16th-century viewers would have had by playing off their expectations. For example, he omitted from the painting both the cross and Christ's tomb, and consequently scholars debate whether he meant to represent *Descent from the Cross* or *Entombment*. Also, instead of presenting the action as taking place across the perpendicular picture plane, as artists such as Raphael and Rogier van der Weyden (FIG. 20-8) had done in their paintings of these episodes from Christ's passion, Pontormo rotated the conventional figural groups along a vertical axis. As a result, the Virgin Mary falls back (away from the viewer) as she releases her dead son's hand. Unlike High Renaissance artists, who had concentrated their masses in the center of the painting, Pontormo left a void. This emptiness accentuates the grouping of hands filling that hole, calling attention to the void-symbolic of loss and grief. The artist enhanced the painting's ambiguity with the curiously anxious glances the figures cast in all directions. (The bearded young man at the upper right who gazes at the viewer is probably a self-portrait of Pontormo.) Athletic bending and twisting characterize many of the figures, with distortions (for example, the torso of the foreground figure bends in an anatomically impossible way), elastic elongation of the limbs, and heads rendered as uniformly small and oval. The contrasting colors, primarily light blues and pinks, add to the dynamism and complexity of the work. The painting represents a departure from the balanced, harmoniously structured compositions of the High Renaissance.

PARMIGIANINO Girolamo Francesco Maria Mazzola of Parma, known as PARMIGIANINO (1503–1540), achieved a reputation as a gifted painter while still in his teens. When he was 21, a visit to a barber's shop, where he saw his reflection in a convex mirror, inspired him to paint a self-portrait (FIG. **22-43**) of unique format with the intention of presenting it to Pope Clement VII as a demonstration of his virtuosity. According to Vasari, the pope proclaimed the work a "marvel," and Parmigianino, who possessed charm and good looks as well as artistic talent, quickly became the favorite painter of the elite in Rome, the successor to Raphael, who had died just four years before Parmigianino's arrival at the papal court.

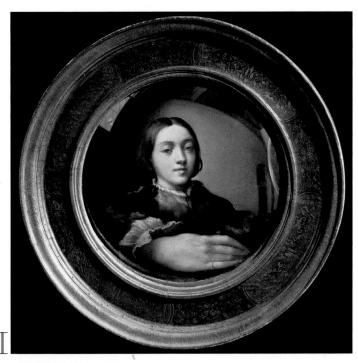

22-43 PARMIGIANINO, Self-Portrait in a Convex Mirror, 1524. Oil on wood, $9\frac{5^n}{8}$ diameter. Kunsthistorisches Museum, Vienna.

Painted to impress Pope Clement VII with his virtuosity, Parmigianino's self-portrait brilliantly reproduces the young Mannerist's distorted appearance as seen in a barber's convex mirror.

To imitate the appearance of a convex mirror, Parmigianino had a carpenter prepare a section of a wooden sphere of the same size and shape as a barber's mirror (about 10 inches in diameter) and used oil glazes to produce a surface luster that heightens the illusion of the viewer looking into a mirror and not at a painting. The viewer in this case is also the painter, whose handsome countenance Vasari described as an angel's, not a man's. The pope remarked that Parmigianino's portrait of himself in his studio was "astonishing" in its success in creating the appearance of someone gazing at his reflection. As in a real convex mirror, the artist's face-at the center of the reflective surface and some distance from it-is free of distortion, but his hand and sleeve are of exaggerated size. The emphasis on the hand no doubt is also a statement on Parmigianino's part about the supreme importance of the painter's hand in fashioning an artwork. That emphasis on artifice as the essence of painting is the core principle of Mannerism.

MADONNA WITH THE LONG NECK Parmigianino's bestknown work, however, is *Madonna with the Long Neck* (FIG. **22-44**), which exemplifies the elegant stylishness that was a principal aim

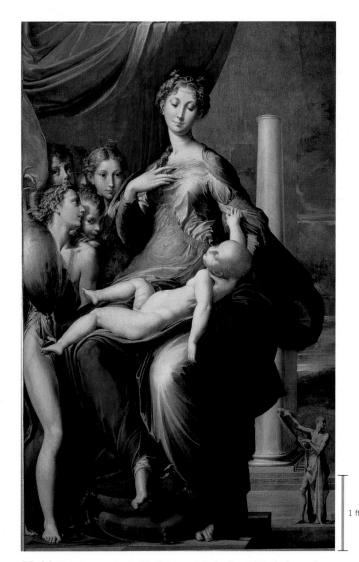

22-44 PARMIGIANINO, *Madonna with the Long Neck*, from the Baiardi chapel, Santa Maria dei Servi, Parma, Italy, 1534–1540. Oil on wood, 7' $1'' \times 4' 4''$. Galleria degli Uffizi, Florence.

Parmigianino's Madonna displays the stylish elegance that was a principal aim of Mannerism. Mary has a small oval head, a long slender neck, attenuated hands, and a sinuous body.

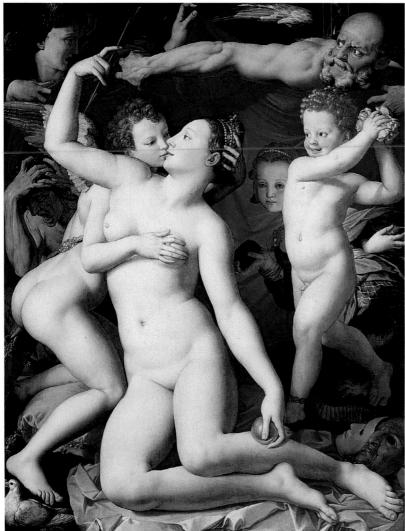

22-45 BRONZINO, Venus, Cupid, Folly, and Time, ca. 1546. Oil on wood, 4' $9\frac{1}{2}'' \times 3' 9\frac{3}{4}''$. National Gallery, London.

In this painting of Cupid fondling his mother Venus, Bronzino demonstrated a fondness for learned allegories with lascivious undertones. As in many Mannerist works, the meaning is ambiguous.

of Mannerism. In Parmigianino's hands, this traditional, usually sedate, religious subject became a picture of exquisite grace and precious sweetness. The Madonna's small oval head, her long and slender neck, the otherworldly attenuation and delicacy of her hand, and the sinuous, swaying elongation of her frame-all are marks of the aristocratic, sumptuous courtly taste of Mannerist artists and patrons alike. Parmigianino amplified this elegance by expanding the Madonna's form as viewed from head to toe. On the left stands a bevy of angelic creatures, melting with emotions as soft and smooth as their limbs. On the right, the artist included a line of columns without capitals and an enigmatic figure with a scroll, whose distance from the foreground is immeasurable and ambiguous-the antithesis of rational Renaissance perspective diminution of size with distance.

Although the elegance and sophisticated beauty of the painting are due in large part to the Madonna's attenuated limbs, that exaggeration is not solely decorative in purpose. Madonna with the Long Neck takes its subject from a simile in medieval hymns comparing the Virgin's neck with a great ivory tower or column, such as the one Parmigianino depicted to the right of the Madonna.

BRONZINO Venus, Cupid, Folly, and Time (FIG. 22-45), by Agnolo di Cosimo, called BRONZINO (1503-1572), also displays all the chief features of Mannerist painting. A pupil of Pontormo, Bronzino was a Florentine and painter to the first grand duke of Tuscany, Cosimo I de' Medici (r. 1537-1574). In this painting, which Cosimo commissioned as a gift for King Francis I of France (FIG. 23-12), Bronzino demonstrated the Mannerists' fondness for learned allegories that often had lascivious undertones, a shift from the simple and monumental statements and forms of the High Renaissance. Bronzino depicted Cupid-here an adolescent who has reached puberty, not an infant-fondling his mother, Venus, while Folly prepares to shower them with rose petals. Time, who appears in the upper right corner, draws back the curtain to reveal the playful incest in progress. Other figures in the painting represent other human qualities and emotions, including Envy. The masks, a favorite device of the Mannerists, symbolize deceit. The picture seems to suggest that love-accompanied by envy and plagued by inconstancy—is foolish and that lovers will discover its folly in time. But as in many Mannerist paintings, the meaning here is ambiguous, and interpretations of the painting vary. Compositionally, Bronzino placed the figures around the front plane, and they almost entirely block the space. The contours are strong and sculptural, the surfaces of enamel smoothness. Of special interest are the heads, hands, and feet, for the Mannerists considered the extremities the carriers of grace, and the clever depiction of them as evidence of artistic skill.

ELEANORA OF TOLEDO In 1540, Cosimo I de' Medici married Eleanora of Toledo (1519-1562), daughter of Charles V's viceroy in Naples, and thereby cemented an important alliance with the Spanish court. Several years later Cosimo asked Bronzino to paint Eleanora and their second son, Giovanni (FIG. 22-46), who then was about three years old. Bronzino painted dozens of portraits of members of the Medici family, but never portrayed Eleanora with any of her daughters (she and Cosimo had three daughters as well as eight sons). This

painting therefore should be seen as a formal dynastic portrait intended to present the duke's wife as the mother of one of his heirs.

As in other Bronzino portraits (FIG. 22-46A), the subjects appear aloof and emotionless. Bronzino idealized both Eleanora and Giovanni, giving both of them perfect features and blemishless skin that glows like alabaster. Eleanora's figure takes up most of

the panel's surface, and Bronzino further underscored her primacy by lightening the blue background around her head, creating a halolike frame for her face and perhaps associating the mother and son with the Madonna and Christ Child. Seated with one arm around Giovanni and the other resting on her lap, Eleanora looks out at the viewer with cool detachment. She is richly attired in a brocaded gown and wears a costly pearl necklace and a tiara. The painter reproduced the various tex-

22-46A BRONZINO. Portrait of a Young Man. ca. 1530–1545. 🔳

tures of fabric, jewels, hair, and flesh with supreme skill. The boy stands stiffly, staring forward, suppressing all playful thoughts in

22-46 BRONZINO, *Eleanora of Toledo and Giovanni de' Medici*, ca. 1546. Oil on wood, 3' $9\frac{1}{4}'' \times 3' 1\frac{3}{4}''$. Galleria degli Uffizi, Florence.

Bronzino was the official portraitist of Grand Duke Cosimo de' Medici. His portrayal of Cosimo's Spanish wife and their second son features rich costumes and coolly detached personalities.

order to behave as expected on this formal occasion. Bronzino's portrayal of Eleanora and Giovanni is in some ways less a portrait of a mother and child than of a royal audience.

SOFONISBA ANGUISSOLA The aloof formality of Bronzino's dynastic portrait is much relaxed in the portraiture of SOFONISBA ANGUISSOLA (ca. 1532-1625) of Cremona in northern Italy. Anguissola introduced a new kind of group portrait of irresistible charm, characterized by an informal intimacy and subjects that are often moving, conversing, or engaged in activities. Like many of the other works she produced before emigrating to Spain in 1559, the portrait illustrated here (FIG. 22-47) represents members of her family. Against a neutral ground, Anguissola placed her two sisters and brother in an affectionate pose meant not for official display but for private showing. The sisters, wearing matching striped gowns, flank their brother, who caresses a lapdog. The older sister (at the left) summons the dignity required for the occasion, while the boy looks quizzically at the portraitist with an expression of naive curiosity, and the other girl diverts her attention toward something or someone to the painter's left.

> Anguissola's use of relaxed poses and expressions, her sympathetic personal presentation, and her graceful treatment of the forms brought her international acclaim (see "Women in the Renaissance Art World," page 630). She received praise from the aged Michelangelo, was court painter to Phillip II (r. 1556–1598) of Spain, and, at the end of her life, gave advice on art to a young admirer of her work, Anthony Van Dyck (FIG. 25-5), the great Flemish master.

22-47 SOFONISBA ANGUISSOLA, Portrait of the Artist's Sisters and Brother, ca. 1555. Oil on wood, $2' 5\frac{1''}{4} \times 3' 1\frac{1''}{2}$. Methuen Collection, Corsham Court, Wiltshire.

Anguissola was the leading woman artist of her time. Her contemporaries admired her use of relaxed poses and expressions in intimate and informal group portraits such as this one of her family.

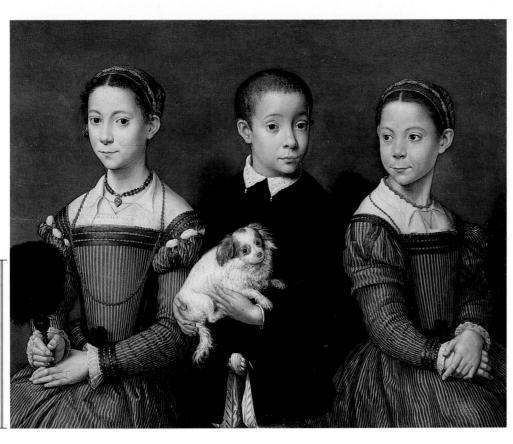

1 ft

Mannerism 635

22-48 TINTORETTO, Last Supper, 1594. Oil on canvas, 12' × 18' 8". San Giorgio Maggiore, Venice.

Tintoretto adopted many Mannerist pictorial devices to produce oil paintings imbued with emotional power, depth of spiritual vision, glowing Venetian color schemes, and dramatic lighting.

TINTORETTO Vene-

tian painting of the later 16th century built on established High Renaissance Venetian ideas, but incorporated many elements of the Mannerist style. Jacopo Robusti, known as TINTORETTO (1518–1594), claimed to be a student of Titian and aspired to

combine Titian's color with Michelangelo's drawing, but art historians consider Tintoretto the outstanding Venetian representative of Mannerism. He adopted many Mannerist pictorial devices, which he employed to produce works imbued with dramatic power, depth of spiritual vision, and glowing Venetian color schemes.

Toward the end of Tintoretto's life, his art became spiritual, even visionary, as solid forms melted away into swirling clouds

of dark shot through with fitful light. In Tintoretto's *Last Supper* (FIG. **22-48**), painted for the right wall next to the high altar in Andrea Palladio's church of San Giorgio Maggiore (FIG. 22-31), the figures appear in a dark interior illuminated by a single light in the upper left of the image. The shimmering halos establish the biblical nature of the scene. The ability of this dramatic scene to engage viewers was fully in keeping with Counter-Reformation ideals

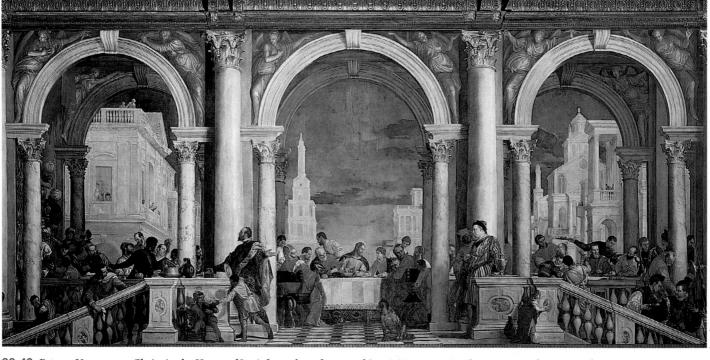

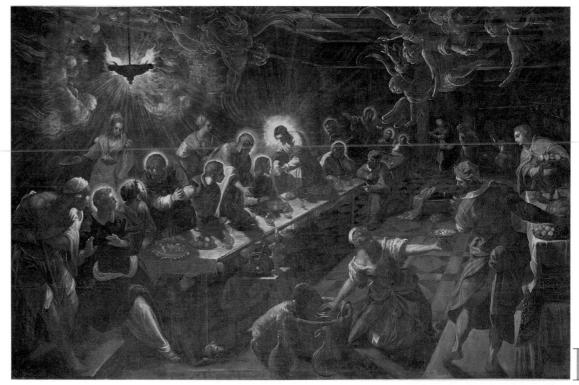

22-49 PAOLO VERONESE, *Christ in the House of Levi*, from the refectory of Santi Giovanni e Paolo, Venice, Italy, 1573. Oil on canvas, 18' 3" × 42'. Galleria dell'Accademia, Venice.

Veronese's paintings feature superb color and majestic classical settings. The Catholic Church accused him of impiety for including dogs and dwarfs near Christ in this work originally titled Last Supper.

(see "Religious Art in Counter-Reformation Italy," page 617) and the Catholic Church's belief in the didactic nature of religious art.

Tintoretto's Last Supper incorporates many Mannerist devices, including an imbalanced composition and visual complexity. In terms of design, the contrast with Leonardo's Last Supper (FIG. 22-4) is both extreme and instructive. Leonardo's composition, balanced and symmetrical, parallels the picture plane in a geometrically organized and closed space. The figure of Christ is the tranquil center of the drama and the perspective focus. In Tintoretto's painting, Christ is above and beyond the converging perspective lines racing diagonally away from the picture surface, creating disturbing effects of limitless depth and motion. The viewer locates Tintoretto's Christ via the light flaring, beaconlike, out of darkness. The contrast of the two pictures reflects the direction Renaissance painting took in the 16th century, as it moved away from architectonic clarity of space and neutral lighting toward the dynamic perspectives and dramatic chiaroscuro of the coming Baroque.

VERONESE Among the great Venetian masters was Paolo Caliari of Verona, called PAOLO VERONESE (1528–1588). Whereas Tintoretto gloried in monumental drama and deep perspectives, Veronese specialized in splendid pageantry painted in superb color and set within majestic classical architecture. Like Tintoretto, Veronese painted on a huge scale, with canvases often as large as 20 by 30 feet or more. His usual subjects, painted for the refectories of wealthy monasteries, afforded him an opportunity to display magnificent companies at table.

Veronese painted *Christ in the House of Levi* (FIG. **22-49**), originally called *Last Supper*, for the dining hall of Santi Giovanni e Paolo in Venice. In a great open loggia framed by three monumental arches, Christ sits at the center of the splendidly garbed elite of Venice. In the foreground, with a courtly gesture, the very image of gracious grandeur, the chief steward welcomes guests. Robed lords, their colorful retainers, dogs, and dwarfs crowd into the spa-

cious loggia. Painted during the Counter-Reformation, this depiction prompted criticism from the Catholic Church. The Holy Office of the Inquisition accused Veronese of impiety for painting lowly creatures so close to the Lord, and it ordered him to make changes at his own expense. Reluctant to do so, he simply changed the painting's title, converting the subject to a less solemn one. As Palladio looked to the example of classically inspired High Renaissance architecture, so Veronese returned to High Renaissance composition, its symmetrical balance, and its ordered architectonics. His shimmering colors span the whole spectrum, although he avoided solid colors in favor of half shades (light blues, sea greens, lemon yellows, roses, and violets), creating veritable flowerbeds of tone.

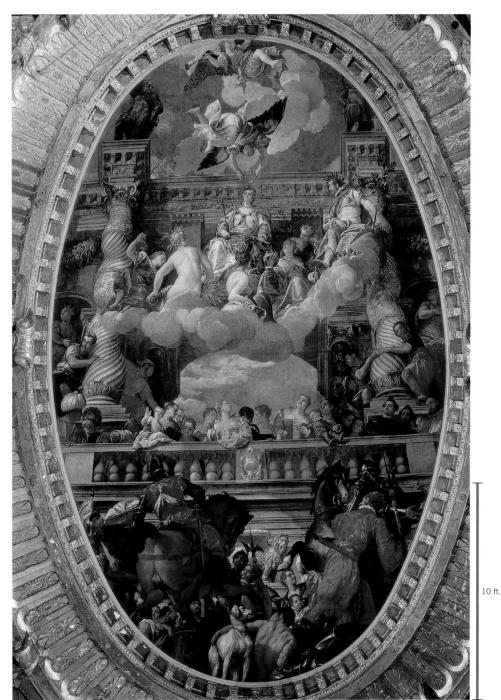

22-50 PAOLO VERONESE, *Triumph of Venice*, ca. 1585. Oil on canvas, 29' $8'' \times 19'$. Hall of the Grand Council, Doge's Palace, Venice.

Veronese's immense oval ceiling painting presents a tableau of Venice crowned by Fame amid columns, clouds, and personifications. Baroque painters adopted this 45-degree view from the ground.

The Venetian Republic employed both Tintoretto and Veronese to decorate the grand chambers and council rooms of the Doge's Palace (FIG. 14-21). A great and popular decorator, Veronese revealed himself a master of imposing illusionistic ceiling compositions, such as *Triumph of Venice* (FIG. **22-50**). Here, within an oval frame, he presented Venice, crowned by Fame, enthroned between two great twisted columns in a balustraded loggia, garlanded with clouds, and attended by figures symbolic of its glories. Unlike Mantegna's *di sotto in sù* (FIG. 21-49) perspective, Veronese's is not a projection directly up from below, but at a 45-degree angle to spectators, a technique used by many later Baroque decorators (see Chapter 24).

22-51 CORREGGIO, Assumption of the Virgin, 1526–1530. Fresco, 35' $10'' \times 37'$ 11". Parma Cathedral, Parma.

Working long before Veronese, Correggio, the teacher of Parmigianino, won little fame in his day, but his illusionistic ceiling designs, such as this one in Parma Cathedral, inspired many Baroque painters.

CORREGGIO One painter who developed a unique personal style almost impossible to classify was Antonio Allegri, known as Correggio (ca. 1489-1534) from his birthplace, near Parma. The teacher of Parmigianino, Correggio pulled together many stylistic trends, including those of Leonardo, Raphael, and the Venetians. Working more than a half century before Veronese, Correggio's most enduring contribution was his development of illusionistic ceiling perspectives. In Parma Cathedral, he painted away the entire dome with his Assumption of the Virgin (FIG. 22-51). Opening up the cupola, the artist showed worshipers a view of the sky, with concentric rings of clouds where hundreds of soaring figures perform a wildly pirouetting dance in celebration of the Assumption. Versions of these angelic creatures became permanent tenants of numerous Baroque churches in later centuries. Correggio was also an influential painter of religious panels, anticipating in them many other Baroque compositional devices. Correggio's Assumption of the Virgin predates Veronese's Triumph of Venice by more than a half century, but contemporaries expressed little appreciation for his achievement. Later, during the 17th century, Baroque painters recognized him as a kindred spirit.

Sculpture

Mannerism extended beyond painting. Artists translated its principles into sculpture and architecture as well.

BENVENUTO CELLINI Among those who made their mark as Mannerist sculptors was BENVENUTO CELLINI (1500–1571), the author of a fascinating autobiography. It is difficult to imagine a medieval artist composing an autobiography. Only in the Renaissance, with the birth of the notion of individual artistic genius, could a work such as Cellini's (or Vasari's *Lives*)

22-52 BENVENUTO CELLINI, Saltcellar of Francis I, 1540–1543. Gold, enamel, and ebony, $10\frac{1''}{4} \times 1' 1\frac{1''}{8}$. Stolen in 2003 from the Kunsthistorisches Museum, Vienna.

Famed as a master goldsmith, Cellini fashioned this costly saltcellar for the table of Francis I of France. The elongated proportions of the figures clearly reveal Cellini's Mannerist approach to form.

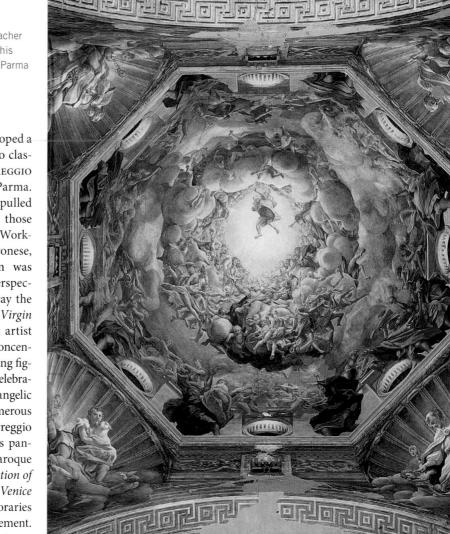

North Michael

22-52A CELLINI, Genius of Fontainebleau, 1542–1543.

have been conceived and written. Cellini's literary self-portrait presents him not only as a highly accomplished artist but also as a statesman, soldier, and lover, among many other roles. He was, first of all, a goldsmith, but only one of his major works in that medium survives, the saltcellar (FIG. **22-52**)

he made for the royal table of Francis I (FIG. 23-12). The king had hired Cellini with a retainer of an annual salary, supplemented by fees for the works he produced, for example, his Genius of Fontainebleau (FIG. 22-52A) for the royal hunting lodge outside Paris. The price Francis paid Cellini for the luxurious gold-and-enamel saltcellar illustrated here was almost 50 percent greater than the artist's salary for the year. Neptune and Tellus (or, as Cellini named them, Sea-the source of salt-and Land) recline atop an ebony base decorated with relief figures of Dawn, Day, Twilight, Night, and the four winds-some based on Michelangelo's statues in the Medici Chapel (FIG. 22-16) in San Lorenzo. The boat next to Neptune's right leg contained the salt, and the triumphal arch (compare FIG. 7-75) next to the right leg of the earth goddess held the pepper. The elongated proportions of the figures, especially the slim, small-breasted figure of Tellus, whom ancient artists always represented as a matronly woman (FIG. 7-30), reveal Cellini's Mannerist approach to form.

GIOVANNI DA BOLOGNA The lure of Italy drew a brilliant young Flemish sculptor, Jean de Boulogne, to Italy, where he practiced his art under the equivalent Italian name of GIOVANNI DA BOLOGNA (1529-1608). Giovanni's Abduction of the Sabine Women (FIG. 22-53) exemplifies Mannerist principles of figure composition. Drawn from the legendary history of early Rome, the group of figures received its current title-relating how the Romans abducted wives for themselves from the neighboring Sabines-only after its exhibition. Earlier, it was Paris Abducting Helen, among other mythological titles. In fact, Giovanni did not intend to depict any particular subject. He created the group as a demonstration piece. His goal was to achieve a dynamic spiral figural composition involving an old man, a young man, and a woman, all nude in the tradition of ancient statues portraying deities and mythological figures. Although Giovanni would have known Antonio Pollaiuolo's Hercules and Antaeus (FIG. 21-14), whose Greek hero lifts his opponent off the ground, he turned directly to ancient sculpture for inspiration, especially to Laocoön (FIG. 5-89). Abduction of the Sabine Women includes references to that universally admired statue in the crouching old man and in the woman's up-flung arm. The three bodies interlock on a vertical axis, creating an ascending spiral movement.

To appreciate the sculpture fully, the viewer must walk around it, because the work changes radically according to the viewing point. One factor contributing to the shifting imagery is the prominence of open spaces passing through the masses (for example, the space between an arm and a body), which have as great an effect as the solids. This sculpture was the first large-scale group since classical antiquity designed to be seen from multiple viewpoints, in striking contrast to Pollaiuolo's group, which the artist fashioned to be seen from the angle shown in FIG. 21-14. Giovanni's figures do not break out of this spiral vortex but remain as if contained within a cylinder. Nonetheless, they display athletic flexibility and Michelangelesque potential for action.

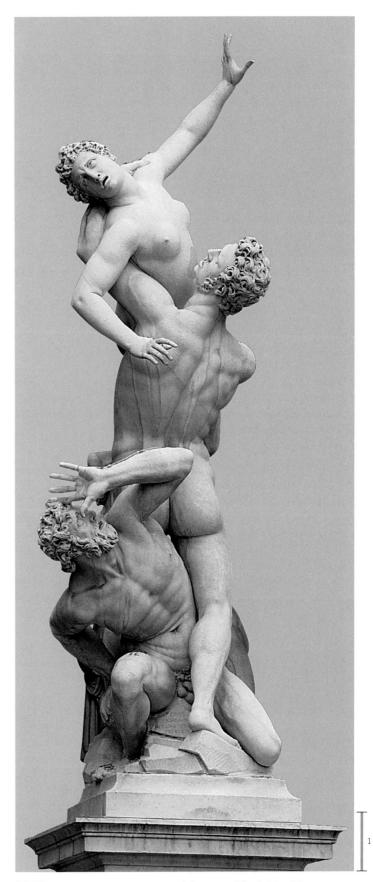

22-53 GIOVANNI DA BOLOGNA, Abduction of the Sabine Women, Loggia dei Lanzi, Piazza della Signoria, Florence, Italy, 1579–1583. Marble, 13' 5½" high. ■

This sculpture was the first large-scale group since classical antiquity designed to be seen from multiple viewpoints. The three bodies interlock to create a vertical spiral movement.

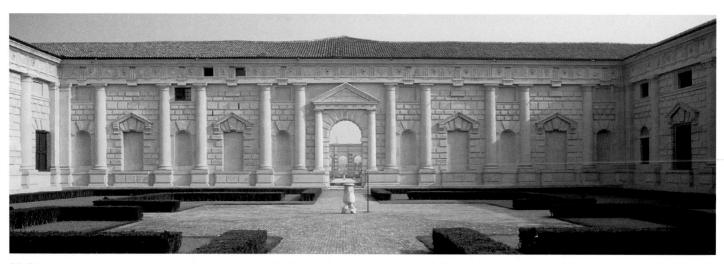

22-54 GIULIO ROMANO, courtyard of the Palazzo del Tè (looking southeast), Mantua, Italy, 1525-1535.

he found a patron in Duke Federigo

Gonzaga (r. 1530-1540), for whom

he built and decorated (FIG. 22-54A)

the Palazzo del Tè between 1525 and 1535. Gonzaga intended the palace

to serve as both suburban summer

residence and stud farm for his fa-

mous stables. Originally planned

as a relatively modest country villa,

Giulio's building so pleased his pa-

tron that Gonzaga soon commis-

sioned the architect to enlarge the

structure. In a second building cam-

The Mannerist divergences from architectural convention, for example, the slipping triglyphs, are so pronounced in the Palazzo del Tè that they constitute a parody of Bramante's classical style.

Architecture

Mannerist architects used classical architectural elements in a highly personal and unorthodox manner, rejecting the balance, order, and stability that were the hallmarks of the High Renaissance style, and aiming instead to reveal the contrived nature of architectural design.

GIULIO ROMANO Applying that anticlassical principle was the goal of GIULIO ROMANO (ca. 1499–1546) when he designed the Palazzo del Tè (FIG. 22-54) in Mantua and, with it, formulated almost the entire architectural vocabulary of Mannerism. Early in his career, Giulio was Raphael's chief assistant in decorating the Vatican stanze. After Raphael's premature death in 1520, Giulio became his master's artistic executor, completing Raphael's unfinished frescoes and panel paintings. In 1524, Giulio went to Mantua, where

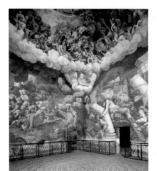

22-54A GIULIO ROMANO, Fall of the Giants, 1530–1532.

paign, Giulio expanded the villa to a palatial scale by adding three wings, which he placed around a square central court. This oncepaved court, which functions both as a passage and as the focal point of the design, has a nearly urban character. Its surrounding buildings form a self-enclosed unit with a large garden, flanked by a stable, attached to it on the east side.

Giulio's Mannerist style is on display in the facades facing the palace's courtyard (FIG. 22-54), where the divergences from architectural convention are pronounced. Indeed, the Palazzo del Tè constitutes an enormous parody of Bramante's classical style, a veritable Mannerist manifesto announcing the artifice of architectural design. In a building laden with structural surprises and contradictions, the courtyard is the most unconventional of all. The keystones (central voussoirs), for example, either have not fully settled or seem to be slipping from the arches-and, more eccentric still, Giulio even placed voussoirs in the pediments over the rectangular niches, where no arches exist. The massive Tuscan columns flanking these niches carry incongruously narrow architraves. That these architraves break midway between the columns stresses their apparent structural insufficiency, and they seem unable to support the weight of the triglyphs of the Doric frieze above (see "Doric and Ionic Orders," Chapter 5, page 116, or on page xxii in Volume II and Book D), which threaten to crash down on the head of anyone foolish enough to stand beneath them. To be sure, only a highly sophisticated observer can appreciate Giulio's witticism. Recognizing some quite subtle departures from the norm presupposes a thorough familiarity with the established rules of classical architecture. That the duke delighted in Giulio's mannered architectural inventiveness speaks to his cultivated taste.

LAURENTIAN LIBRARY Although he personifies the High Renaissance artist, Michelangelo, like Giulio Romano, also experimented with architectural designs that flouted most of the classical rules of order and stability. The restless nature of Michelangelo's genius is evident in the vestibule (FIG. 22-55) he designed for the Medici library adjoining the Florentine church of San Lorenzo. The Laurentian Library had two contrasting spaces Michelangelo had to unite: the long horizontal of the library proper and the vertical of the vestibule. The need to place the vestibule windows up high (at the level of the reading room) determined the narrow verticality of the vestibule's elevation and proportions. Much taller than it is wide, the vestibule gives the impression of a vertically compressed, shaftlike space. Anyone schooled exclusively in the classical architecture of Bramante and the High Renaissance would have been appalled by Michelangelo's indifference here to classical norms in proportion and in the application of the rules of the classical orders. For example, he used columns in pairs and sank them into the walls, where they perform no supporting function. Michelangelo also split columns in halves around corners. Elsewhere, he placed scroll corbels on the walls beneath columns. They seem to

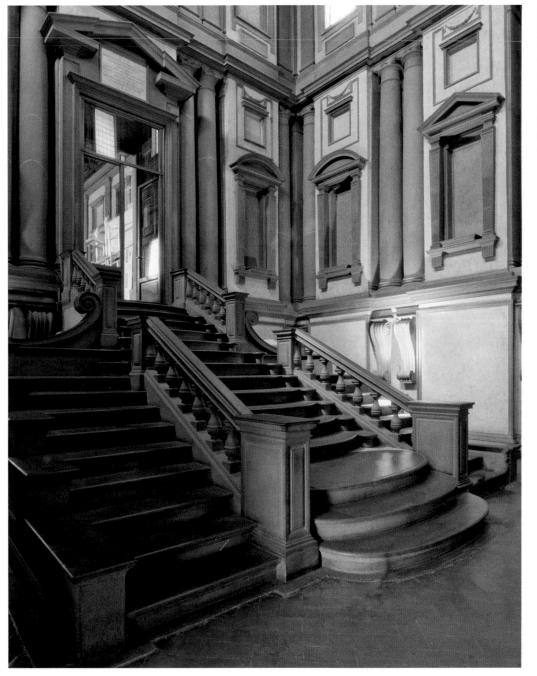

22-55 MICHELANGELO BUONARROTI, vestibule of the Laurentian Library, Florence, Italy, 1524-1534; staircase, 1558-1559. ■

With his customary independence of spirit, Michelangelo, working in a Mannerist mode in the Laurentian Library vestibule, disposed willfully of almost all the rules of classical architecture.

hang from the moldings, holding up nothing. He arbitrarily broke through pediments as well as through cornices and stringcourses. He sculpted pilasters that taper downward instead of upward. In short, the High Renaissance master, working in a Mannerist mode, disposed willfully and abruptly of classical architecture. Moreover, in the vast, flowing stairway (the latest element of the vestibule) that protrudes tonguelike into the room from the "mouth" of the doorway to the library, Michelangelo foreshadowed the dramatic movement of Baroque architecture (see Chapter 24). With his customary trailblazing independence of spirit, Michelangelo created an interior space that conveyed all the strains and tensions found in his statuary and in his painted figures. Michelangelo's art began in the style of the Quattrocento, developed into the epitome of High Renaissance art, and, at the end, moved toward Mannerism. He was 89 when he died in 1564, still hard at work on Saint Peter's and other projects. Few artists, then or since, could escape his influence.

IL GESÙ Probably the most influential building of the later Cinquecento was the mother church of the Jesuit order. The activity of the Society of Jesus, known as the Jesuits, was an important component of the Counter-Reformation. Ignatius of Loyola (1491– 1556), a Spanish nobleman who dedicated his life to the service of God, founded the Jesuit order. He attracted a group of followers, and in 1540 Pope Paul III formally recognized his group as a religious order. The Jesuits were the papacy's invaluable allies in its quest to reassert the supremacy of the Catholic Church. Particularly successful in the field of education, the order established numerous schools. In addition, its members were effective missionaries and carried the message of Catholicism to the Americas, Asia, and Africa.

As a major participant in the Counter-Reformation, the Jesuit order needed a church appropriate to its new prominence. Because Michelangelo was late in providing the designs for their church,

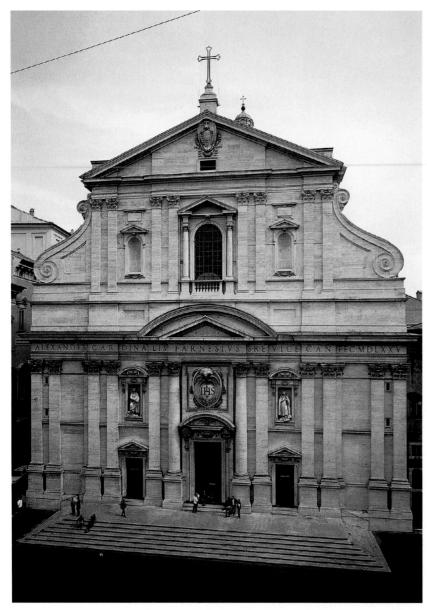

22-56 GIACOMO DELLA PORTA, west facade of Il Gesù, Rome, Italy, ca. 1575–1584.

In Giacomo della Porta's innovative design, the march of pilasters and columns builds to a climax at the central bay. Many Roman Baroque church facades are architectural variations of II Gesù.

22-57 GIACOMO DA VIGNOLA, plan of Il Gesù, Rome, Italy, 1568.

Giacomo da Vignola's plan for II Gesù, with its exceptionally wide nave with side chapels instead of aisles—ideal for grand processions—won wide acceptance in the Catholic world.

called Il Gesù, or Church of Jesus, in 1568 the Jesuits turned to GIACOMO DELLA PORTA (ca. 1533–1602), who was responsible for the facade (FIG. **22-56**)—and who later designed the dome of Saint Peter's (FIG. 22-25)—and GIACOMO DA VIGNOLA (1507–1573), who designed the ground plan (FIG. **22-57**).

The plan of Il Gesù reveals a monumental expansion of Alberti's scheme for Sant'Andrea (FIGS. 21-46 and 21-47) in Mantua. Here, the nave takes over the main volume of space, making the structure a great hall with side chapels. A dome emphasizes the approach to the altar. The wide acceptance of the Gesù plan in the Catholic world, even in modern times, speaks to its ritual efficacy. The opening of the church building into a single great hall provides an almost theatrical setting for large promenades and processions (which combined social with priestly functions). Above all, the ample space could accommodate the great crowds that gathered to hear the eloquent preaching of the Jesuits.

The facade of Il Gesù was also not entirely original, but it too had an enormous influence on later church design. The union of the lower and upper stories, achieved by scroll buttresses, harks back to Alberti's Santa Maria Novella (FIG. 21-40). Its classical pediment is familiar in Alberti's work (FIG. 21-45), as well as in that of Palladio (FIGS. 22-28 and 22-30). The paired pilasters appear in Michelangelo's design for Saint Peter's (FIG. 22-25). Giacomo della Porta skillfully synthesized these existing motifs and unified the two stories. The horizontal march of the pilasters and columns builds to a dramatic climax at the central bay, and the bays of the facade snugly fit the nave-chapel system behind them. Many Roman church facades of the 17th century are architectural variations on della Porta's design. Chronologically and stylistically, Il Gesù belongs to the Late Renaissance, but its enormous influence on later churches marks it as one of the significant monuments for the development of Italian Baroque church architecture, discussed in Chapter 24.

THE BIG PICTURE

RENAISSANCE AND MANNERISM IN CINQUECENTO ITALY

HIGH AND LATE RENAISSANCE 1495-1600

- During the High (1495–1520) and Late (1520–1600) Renaissance periods in Italy, artists, often in the employ of the papacy, further developed the interest in classical cultures, perspective, proportion, and human anatomy that had characterized Quattrocento Italian art.
- The major regional artistic centers were Florence and Rome in central Italy and Venice in the north. Whereas most Florentine and Roman artists emphasized careful design preparation based on preliminary drawing (*disegno*), Venetian artists focused on color and the process of paint application (*colorito*).
- Leonardo da Vinci, the quintessential "Renaissance man," won renown as a painter for his *sfumato* (misty haziness) and for his psychological insight in depicting biblical narrative (*Last Supper*) and contemporary personalities (*Mona Lisa*).
- Raphael favored lighter tonalities than Leonardo and clarity over obscurity. His sculpturesque figures appear in landscapes under blue skies (*Madonna of the Meadows*) or in grandiose architectural settings rendered in perfect perspective (*School of Athens*).
- Michelangelo was a pioneer in several media, including architecture, but his first love was sculpture. He carved (*David, Moses*) and painted (Sistine Chapel ceiling) emotionally charged figures with heroic physiques, preferring pent-up energy to Raphael's calm, ideal beauty.
- The leading architect of the early 16th century was Bramante, who championed the classical style of the ancients. He based his design for the Tempietto—the first High Renaissance building—on antique models, but the combination of parts was new and original.
- Andrea Palladio, an important theorist as well as architect, carried on Bramante's classical style during the Late Renaissance. Renowned for his villa designs, he had a lasting influence upon later European and American architecture.
- The greatest master of the Venetian painting school was Titian, famed for his rich surface textures and dazzling display of color in all its nuances. In paintings such as *Meeting of Bacchus and Ariadne*, he established oil color on canvas as the standard medium of the Western pictorial tradition.

MANNERISM 1520-1600

- Mannerism emerged in the 1520s in reaction to the High Renaissance style of Leonardo and Raphael. A prime feature of Mannerist art is artifice. Renaissance painters generally strove to create art that appeared natural, whereas Mannerist artists were less inclined to disguise the contrived nature of art production. Ambiguous space, departures from expected conventions, and unusual presentations of traditional themes are hallmarks of Mannerist painting.
- Parmigianino's Madonna with the Long Neck epitomizes the elegant stylishness of Mannerist painting. The elongated proportions of the figures, the enigmatic line of columns without capitals, and the ambiguous position of the figure with a scroll are the antithesis of High Renaissance classical proportions, clarity of meaning, and rational perspective.
- Mannerism was also a sculptural style. Benvenuto Cellini created a costly saltcellar for the table of the French king Francis I. The figures, based on antique statuary, have the slim waists and long limbs that appealed to Mannerist taste.
- The leading Mannerist architect was Giulio Romano, who rejected the balance, order, and stability of the High Renaissance style. In the Palazzo del Tè in Mantua, which he also decorated with frescoes, the divergences from architectural convention parody Bramante's classical style and include triglyphs that slip out of the Doric frieze.

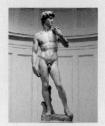

Michelangelo, David, 1501–1504

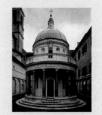

Bramante, Tempietto, Rome, begun 1502

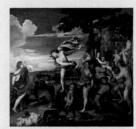

Titian, *Meeting of Bacchus* and Ariadne, 1522–1523

Parmigianino, Madonna with the Long Neck, 1534–1540

Cellini, Saltcellar of Francis I, 1540–1543

Garden of Earthly Delights is Bosch's most enigmatic painting, but scholars agree it depicts Paradise in the left and central panels and Hell in the right wing. At the left, God as Christ presents Eve to Adam.

In the fantastic sunlit landscape that is Bosch's Paradise, scores of nude people in the prime of life blithely cavort. The oversize fruits are fertility symbols, and the scene celebrates procreation.

In the inky darkness of Bosch's Hell are unidentifiable objects that are imaginative variations on chemical apparatus of the day. Alchemy is a prominent theme of the work.

23-1 HIERONYMUS BOSCH, Garden of Earthly Delights, 1505–1510. Oil on wood, center panel 7' $2\frac{5''}{8} \times 6' 4\frac{3''}{4}$, each wing 7' $2\frac{5''}{8} \times 3' 2\frac{1''}{4}$. Museo del Prado, Madrid.

The horrors of Hell include beastly creatures devouring people, and sinners enduring tortures tailored to their conduct while alive. A glutton vomits eternally. A miser defecates gold coins.

23

HIGH RENAISSANCE AND MANNERISM IN NORTHERN EUROPE AND SPAIN

EARTHLY DELIGHTS IN THE NETHERLANDS

The leading Netherlandish painter of the early 16th century was HIERONYMUS BOSCH (ca. 1450–1516), one of the most fascinating and puzzling artists in history. Bosch's most famous painting, the *Garden of Earthly Delights* (FIG. 23-1), is also his most enigmatic, and no interpretation has ever won universal acceptance. Although the work is a monumental triptych, which would suggest a religious function as an altarpiece, *Garden of Earthly Delights* was on display in the palace of Henry III of Nassau, regent of the Netherlands, no later than seven years after its completion. This suggests the triptych was a secular commission, and some scholars have proposed that given the work's central themes of sex and procreation, the painting may commemorate a wedding. Marriage was a familiar theme in Netherlandish painting (FIGS. 20-6 and 20-10). Any similarity to earlier paintings ends there, however. Whereas Jan van Eyck and Petrus Christus grounded their depictions of betrothed couples in 15th-century life and custom, Bosch's image portrays a visionary world of fantasy and intrigue—a painted world without close parallel until the advent of Surrealism more than 400 years later (see Chapter 29).

In the left panel, God (in the form of Christ) presents Eve to Adam in a landscape, presumably the Garden of Eden. Bosch's wildly imaginative setting includes an odd pink fountainlike structure in a body of water and an array of fanciful and unusual animals, including a giraffe, an elephant, and winged fish.

The central panel is a continuation of Paradise, a sunlit landscape filled with nude people, all in the prime of youth, blithely cavorting amid bizarre creatures and unidentifiable objects. The youths play with abandon. Some stand on their hands or turn somersaults. The numerous fruits and birds (fertility symbols) in the scene suggest procreation, and, indeed, many of the figures pair off as couples.

In contrast to the orgiastic overtones of the central panel is the terrifying image of Hell in the right wing, where viewers must search through the inky darkness to find all of the fascinating though repulsive details Bosch recorded. Beastly creatures devour people, while other condemned souls endure tortures tailored to their conduct while alive. A glutton must vomit eternally. A miser defecates gold coins. A spidery monster fondles a promiscuous woman. Scholars have traditionally interpreted Bosch's triptych as a warning of the fate awaiting the sinful, decadent, and immoral, but as a secular work, *Garden of Earthly Delights* may have been intended for a learned audience fascinated by *alchemy*—the study of seemingly magical chemical changes. Details throughout the triptych are based on chemical apparatus of the day, which Bosch knew well because his in-laws were pharmacists.

NORTHERN EUROPE IN THE 16TH CENTURY

The dissolution of the Burgundian Netherlands in 1477 led in the early 16th century to a realignment in the European geopolitical landscape (MAP **23-1**). France and the Holy Roman Empire absorbed the former Burgundian territories and increased their power. But by the end of the century, through calculated marriages, military exploits, and ambitious territorial expansion, Spain was the dominant European state. Throughout the Continent, monarchs increasingly used art and architecture to glorify their reigns and to promote a stronger sense of cultural and political unity among their subjects, thereby laying the foundation for today's European nations. Wealthy merchants also cultivated art as a status symbol, as the commissioning and collecting of artworks became less and less the exclusive province of the aristocracy. Some artists, most notably Albrecht Dürer (FIGS. 23-4 to 23-7), became successful businessmen themselves by selling their works to the public.

These important societal changes occurred against the backdrop of a momentous religious crisis. Concerted attempts to reform Western Christendom led to the Reformation and the establishment of Protestantism (as distinct from Catholicism), which in turn prompted the Catholic Church's response, the Counter-Reformation (see Chapter 22). Ultimately, the Reformation split the Western Church in half and produced a hundred years of civil war between Protestants and Catholics. But the tumultuous religious conflict engulfing 16th-century Europe did not prevent—and may, in fact, have accelerated—the exchange of intellectual and artistic ideas, because artists frequently moved from one area to another in search of religious freedom and lucrative commissions. Catholic Italy and the (mostly) Protestant Holy Roman Empire shared in a lively commerce—economic and cultural—and 16th-century art throughout

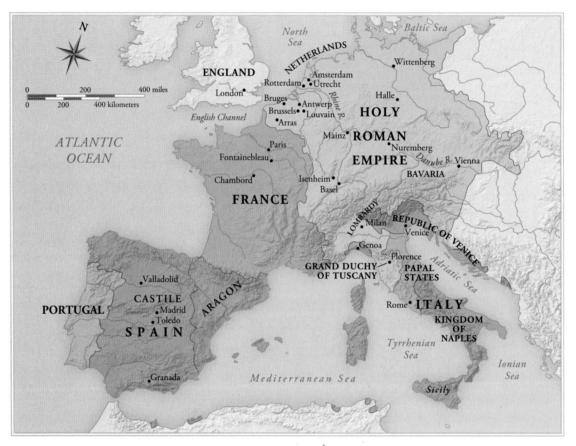

MAP 23-1 Europe in the early 16th century.

1500

HIGH RENAISSANCE AND MANNERISM IN NORTHERN EUROPE AND SPAIN

	1530	1560	1600
In Catholic countries, commissions for religious works, such as the <i>Isenheim</i> <i>Altarpiece</i> , continue, but, consistent with Reformation values, Protestant patrons prefer secular themes, including portraiture, classical mythology, and the macabre Albrecht Dürer, master printmaker, becom the first international art celebrity outside Italy	genre paintings I Hans Holbein, Caterina van Hemessen, Levina Teerlinc achieve renown as portr	n Netherlandish artist of the mid-16th century, produces masterful landscap that nonetheless focus on human act lar I Greek-born El Greco settles in Toledo and creates paintings that are a uniq personal mix of Byzantine and Italiar	bes ivities uely 1

Europe was a major beneficiary of that exchange. Humanism filtered up from Italy and spread throughout northern Europe. Northern humanists, like their southern counterparts, cultivated knowledge of classical cultures and literature, but they focused more on reconciling humanism with Christianity.

Among the most influential of these "Christian humanists" were the Dutch-born Desiderius Erasmus (1466-1536) and the Englishman Thomas More (1478-1535). Erasmus demonstrated his interest in both Italian humanism and religion with his "philosophy of Christ," emphasizing education and scriptural knowledge. Both an ordained priest and avid scholar, Erasmus published his most famous essay, In Praise of Folly, in 1509. In this widely read work, he satirized not just the Church but various social classes as well. His ideas were to play an important role in the development of the Reformation, but he consistently declined to join any of the Reformation sects. Equally erudite was Thomas More, who served King Henry VIII (r. 1509-1547). Henry eventually ordered More's execution because of his opposition to England's break with the Catholic Church. In France, François Rabelais (ca. 1494-1553), a former monk who advocated rejecting stagnant religious dogmatism, disseminated the humanist spirit.

The turmoil emerging during the 16th century lasted well into the 17th century and permanently affected the face of Europe. The concerted challenges to established authority and the persistent philosophical inquiry eventually led to the rise of new political systems (for example, the nation-state) and new economic systems (such as capitalism).

HOLY ROMAN EMPIRE

Although at the opening of the 16th century, many in the Holy Roman Empire (MAP 23-1) expressed dissatisfaction with the Church in Rome, Martin Luther had not yet posted the *Ninety-five Theses* that launched the Protestant Reformation. The Catholic clergy in Germany still offered artists important commissions to adorn churches and other religious institutions.

MATTHIAS GRÜNEWALD Matthias Neithardt, known conventionally as MATTHIAS GRÜNEWALD (ca. 1480–1528), worked for the archbishops of Mainz in several capacities, from court painter and decorator to architect, hydraulic engineer, and superintendent of works. Grünewald eventually moved to northern Germany, where he settled at Halle in Saxony. Around 1510, he began work on the *Isenheim Altarpiece* (FIG. **23-2**), a complex and fascinating monument reflecting Catholic beliefs and incorporating several references to Catholic doctrines, such as the lamb (symbol of the son of God), whose wound spurts blood into a chalice in the *Crucifixion* scene (FIG. 23-2, *top*) on the exterior of the altarpiece.

Created for the monastic hospital order of Saint Anthony of Isenheim, the *Isenheim Altarpiece* takes the form of a wooden shrine (carved around 1505 by NIKOLAUS HAGENAUER, active 1493–1538) featuring large gilded and polychromed statues of Saints Anthony Abbot, Augustine, and Jerome in the main zone and smaller statues of Christ and the 12 apostles in the predella (FIG. 23-2, *bottom*). To Hagenauer's centerpiece, Grünewald added two pairs of painted moveable wings that open at the center. Hinged at the sides, one pair stands directly behind the other. Grünewald painted the exterior panels of the first pair (visible when the altarpiece is closed, FIG. 23-2, *top*) between 1510 and 1515: *Crucifixion* in the center, *Saint Sebastian* on the left, *Saint Anthony Abbot* on the right, and *Lamentation* in the predella. When these exterior wings are open, four additional scenes (not illustrated)—*Annunciation, Angelic Concert, Madonna and Child,* and *Resurrection*—appear. Opening this second pair of wings exposes Hagenauer's interior shrine, flanked by Grünewald's panels depicting *Meeting of Saints Anthony and Paul* and *Temptation of Saint Anthony* (FIG. 23-2, *bottom*).

The placement of this altarpiece in the choir of a church adjacent to the monastery's hospital dictated much of the imagery. Saints associated with the plague and other diseases and with miraculous cures, such as Saints Anthony and Sebastian, appear prominently in the *Isenheim Altarpiece*. Grünewald's panels specifically address the themes of dire illness and miraculous healing and accordingly emphasize the suffering of the order's patron saint, Anthony. The painted images served as warnings, encouraging increased devotion from monks and hospital patients. They also functioned therapeutically by offering some hope to the afflicted. Indeed, Saint Anthony's legend emphasized his dual role as vengeful dispenser of justice (by inflicting disease) and benevolent healer.

One of the most memorable scenes is Temptation of Saint Anthony (FIG. 23-2, bottom right). It is a terrifying image of the five temptations, depicted as an assortment of ghoulish and bestial creatures in a dark landscape, attacking the saint. In the foreground Grünewald painted a grotesque image of a man, whose oozing boils, withered arm, and distended stomach all suggest a horrible disease. Medical experts have connected these symptoms with ergotism (a disease caused by ergot, a fungus that grows especially on rye). Although doctors did not discover the cause of this disease until about 1600, people lived in fear of its recognizable symptoms (convulsions and gangrene). The public referred to this illness as "Saint Anthony's Fire," and it was one of the major diseases treated at the Isenheim hospital. The gangrene often compelled amputation, and scholars have noted that the two moveable halves of the altarpiece's predella (FIG. 23-2, top), if slid apart, make it appear as if Christ's legs have been amputated. The same observation applies to the two main exterior panels. Due to the off-center placement of the cross, opening the left panel "severs" one arm from the crucified figure.

Thus, Grünewald carefully selected and presented his altarpiece's iconography to be particularly meaningful for viewers at this hospital. In the interior shrine, the artist balanced the horrors of the disease and the punishments awaiting those who did not repent with scenes such as Meeting of Saints Anthony and Paul, depicting the two saints, healthy and aged, conversing peacefully. Even the exterior panels (the closed altarpiece; FIG. 23-2, top) convey these same concerns. Crucifixion emphasizes Christ's pain and suffering, but the knowledge that this act redeemed humanity tempers the misery. In addition, Saint Anthony appears in the right wing as a devout follower of Christ who, like Christ and for Christ, endured intense suffering for his faith. Saint Anthony's appearance on the exterior thus reinforces the themes Grünewald intertwined throughout this entire work-themes of pain, illness, and death, as well as those of hope, comfort, and salvation. Grünewald also brilliantly used color to enhance the effect of the painted scenes of the altarpiece. He intensified the contrast of horror and hope by playing subtle tones and soft harmonies against shocking dissonances of color.

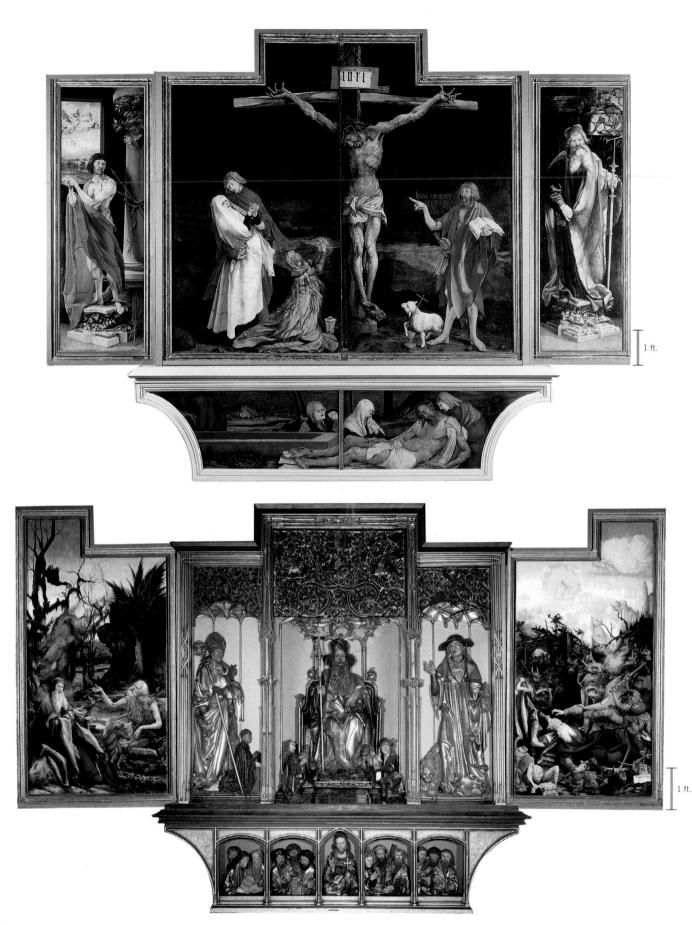

23-2 MATTHIAS GRÜNEWALD, *Isenheim Altarpiece* (closed, *top*; open, *bottom*), from the chapel of the Hospital of Saint Anthony, Isenheim, Germany, ca. 1510–1515. Oil on wood, center panel 9' $9\frac{1}{2}'' \times 10'$ 9", each wing 8' $2\frac{1}{2}'' \times 3' \frac{1}{2}''$, predella 2' $5\frac{1}{2}'' \times 11'$ 2". Shrine carved by NIKOLAUS HAGENAUER, ca. 1505. Painted and gilt limewood, 9' $9\frac{1}{2}'' \times 10'$ 9". Musée d'Unterlinden, Colmar.

Befitting its setting in a monastic hospital, Matthias Grünewald's *Isenheim Altarpiece* includes painted panels depicting suffering and disease but also miraculous healing, hope, and salvation.

HANS BALDUNG GRIEN The son of a prosperous attorney and the brother of a university professor, HANS BALDUNG GRIEN (ca. 1484–1545) chose to pursue painting and printmaking as a profession rather than the law or letters. He settled in Strasbourg, a center of humanistic learning, where he enjoyed a long and successful career. Baldung produced some religious works, although none on the scale of the *Isenheim Altarpiece*. His reputation rested primarily on his exploration of nontraditional subjects, such as witchcraft.

Witches' Sabbath (FIG. **23-3**) is a chiaroscuro woodcut, a recent German innovation. The technique requires the use of two blocks of wood instead of one. The printmaker carves and inks one block in the usual way in order to produce a traditional black-and-white print (see "Woodcuts, Engravings, and Etchings," Chapter 20, page 556). Then the artist cuts a second block consisting of broad highlights to be inked in grays or colors and printed over the first block's impression. Chiaroscuro woodcuts therefore incorporate some of the qualities of painting and feature tonal subtleties absent in traditional woodcuts.

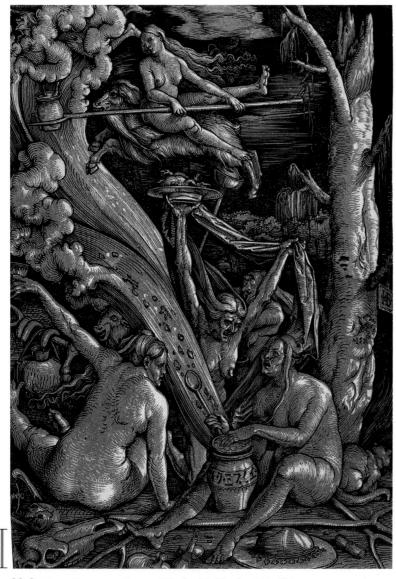

23-3 HANS BALDUNG GRIEN, Witches' Sabbath, 1510. Chiaroscuro woodcut, 1' $2\frac{1}{8}'' \times 10\frac{1}{4}''$. British Museum, London.

Baldung's woodcut depicts witches gathered around a cauldron containing a secret potion. One witch flies mounted backward on a goat, suggesting witchcraft is the inversion of Christianity.

Witchcraft was a counter-religion in the 15th and 16th centuries involving magical rituals, secret potions, and devil worship. Witches prepared brews they inhaled or rubbed into their skin, sending them into hallucinogenic trances in which they allegedly flew through the night sky on broomsticks or goats. The popes condemned all witches, and Church inquisitors vigorously pursued these demonic heretics and subjected them to torture to wrest confessions from them. Witchcraft fascinated Baldung, and he turned to the subject repeatedly. For him and his contemporaries, witches were evil forces in the world, threats to man—as was Eve herself, whom Baldung also frequently depicted as a temptress responsible for original sin.

In Witches' Sabbath, Baldung depicted a night scene in a forest featuring a coven of naked witches. Female nudity and macabre scenes were persistent elements in Baldung's art (compare FIG. 23-3A). These themes were popular with the public, who avidly purchased his relatively inexpensive prints. The coven in

23-3A BALDUNG GRIEN, Death and the Maiden, 1509–1511.

this woodcut includes both young seductresses and old hags. They gather around a covered jar from which a fuming concoction escapes into the air. One young witch rides through the night sky on a goat. She sits backward—Baldung's way of suggesting witchcraft is the inversion of the true religion, Christianity.

ALBRECHT DÜRER The dominant artist of the early 16th century in the Holy Roman Empire was ALBRECHT DÜRER (1471–1528) of Nuremberg. Dürer was the first artist outside Italy to become an international celebrity. He traveled extensively, visiting and studying in Colmar, Basel, Strasbourg, Venice, Antwerp, and Brussels, among other locales. As a result of these travels, Dürer met many of the leading humanists and artists of his time, including Erasmus of Rotterdam and the Venetian master Giovanni Bellini (FIGS. 22-31A, 22-32, and 22-33). A man of exceptional talents and tremendous energy, Dürer achieved widespread fame in his own time and has enjoyed a lofty reputation ever since.

Fascinated with the classical ideas of the Italian Renaissance, Dürer was among the first Northern Renaissance artists to travel to Italy expressly to study Italian art and its underlying theories at their source. After his first journey in 1494–1495 (the second was in 1505–1506), he incorporated many Italian developments into his art. Art historians have acclaimed Dürer as the first artist north of the Alps to understand fully the basic aims of the Renaissance in Italy. Like Leonardo da Vinci, Dürer wrote theoretical treatises on a variety of subjects, such as perspective, fortification, and the ideal in human proportions. Unlike Leonardo, he both finished and published his writings. Dürer also was the first northern European artist to leave a record of his life and career through his correspondence, a detailed and eminently readable diary, and a series of self-portraits.

SELF-PORTRAITS Dürer's earliest preserved selfportrait—a silverpoint drawing now in the Albertina in Vienna—dates to 1484, when he was only 13, two years before he began his formal education as an apprentice in the workshop of Michel Wolgemut (FIG. 20-21). In 1498, a few years after his first visit to Italy, he painted a likeness of himself in the

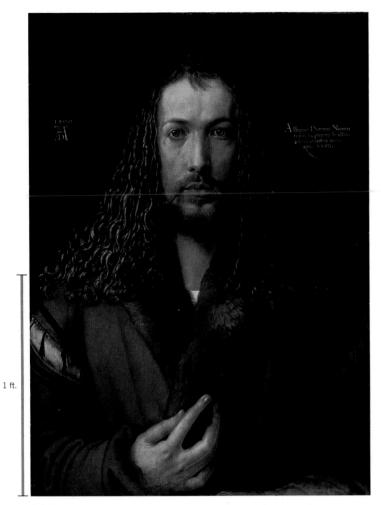

23-4 ALBRECHT DÜRER, *Self-Portrait*, 1500. Oil on wood, 2' $2\frac{4''}{4} \times 1' 7\frac{4''}{4}$. Alte Pinakothek, Munich.

Dürer here presents himself as a frontal Christlike figure reminiscent of medieval icons. It is an image of the artist as a divinely inspired genius, a concept inconceivable before the Renaissance.

Italian mode—a seated half-length portrait in three-quarter view in front of a window through which the viewer sees a landscape. The *Self-Portrait* reproduced here (FIG. **23-4**), painted just two years later, is markedly different in character. Inscribed with his monogram and the date (*left*) and four lines (*right*) stating the painting depicts him at age 28, the

panel portrays the artist in a fur-trimmed

23-4A DÜRER, Great Piece of Turf, 1503.

coat in a rigid frontal posture against a dark background. Dürer has a short beard and shoulder-length hair, and the portrait intentionally evokes medieval devotional images of Christ. The position of Dürer's right hand resembles but does not duplicate (which would have been blasphemous) Christ's standard gesture of blessing in Byzantine icons (FIG. 9-33). The focus on the hand is also a reference to the artist's hand as a creative instrument. Doubtless deeply affected by the new humanistic view that had emerged in Renaissance Italy of the artist as a divinely inspired genius, Dürer responded by painting himself as a Christlike figure. He also embraced Italian artists' interest in science, as is evident in his botanically accurate 1503 watercolor study *Great Piece of Turf* (FIG. **23-4A**). FALL OF MAN Dürer's fame in his own day, as today, rested more on his achievements as a printmaker than as a painter. Trained as a goldsmith by his father before he took up painting and printmaking, he developed an extraordinary proficiency in handling the burin, the engraving tool. This technical ability, combined with a feeling for the form-creating possibilities of line, enabled him to produce a body of graphic work few artists have rivaled for quality and number. Dürer created numerous book illustrations. He also circulated and sold prints in single sheets, which people of ordinary means could buy, expanding his audience considerably. Aggressively marketing his prints with the aid of an agent, Dürer became a wealthy man from the sale of these works. His wife, who served as his manager, and his mother also sold his prints at markets. Through his graphic works, he exerted strong influence throughout northern Europe and also in Italy. The lawsuit Dürer brought in 1506 against an Italian artist for copying his prints reveals his business acumen. Scholars generally regard this lawsuit as the first in history over artistic copyright.

One of Dürer's early masterpieces, *Fall of Man (Adam and Eve;* FIG. **23-5**), represents the first distillation of his studies of the Vitruvian theory of human proportions (compare FIG. 22-3A), a theory based on arithmetic ratios. Clearly outlined against the dark

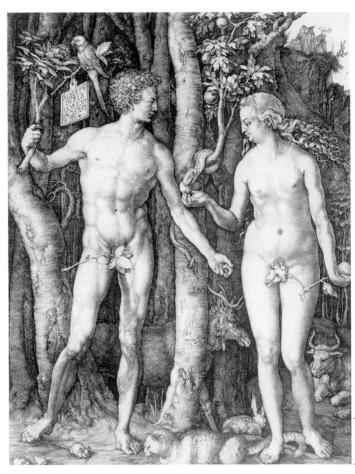

23-5 ALBRECHT DÜRER, Fall of Man (Adam and Eve), 1504. Engraving, $9\frac{7''}{8} \times 7\frac{5''}{8}$. Museum of Fine Arts, Boston (centennial gift of Landon T. Clay).

Dürer was the first Northern Renaissance artist to achieve international celebrity. *Fall of Man*, with two figures based on ancient statues, reflects his studies of the Vitruvian theory of human proportions.

23-5A DÜRER, Knight, Death, and the Devil, 1513.

background of a northern European forest, the two idealized figures of Adam and Eve stand in poses reminiscent of specific classical statues probably known to Dürer through graphic representations. Preceded by numerous geometric drawings in which the artist attempted to systematize sets of ideal human proportions in balanced contrapposto poses, the final print presents Dürer's concept of the "perfect" male and female figures. Yet he tempered this idealization with naturalism, demonstrating his

well-honed observational skills in his rendering of the background foliage and animals (compare FIGS. 23-4A and 23-5A). The gnarled bark of the trees and the feathery leaves authenticate the scene, as do the various creatures skulking underfoot. The animals populating the print are symbolic. The choleric cat, the melancholic elk, the sanguine rabbit, and the phlegmatic ox represent humanity's temperaments based on the "four humors," body fluids that were the basis of theories developed by the ancient Greek physician Hippocrates

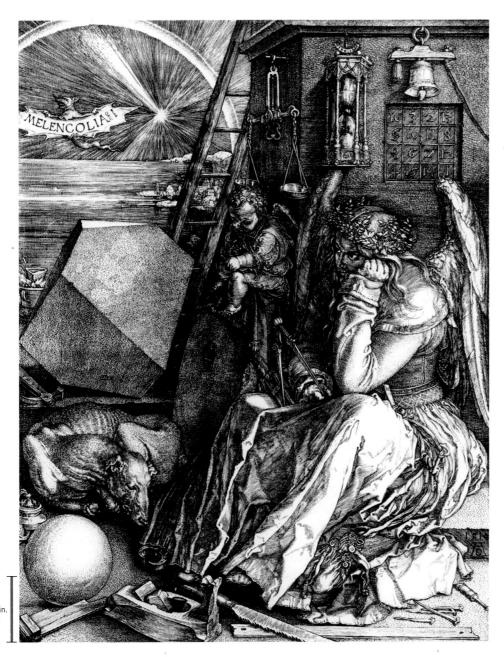

and practiced in medieval physiology. The tension between cat and mouse in the foreground symbolizes the relation between Adam and Eve at the crucial moment in *Fall of Man*.

MELENCOLIA I Dürer took up the theme of the four humors, specifically melancholy, in one of his most famous engravings, *Melencolia I* (FIG. **23-6**), which many scholars regard as a kind of self-portrait of Dürer's artistic psyche as well as a masterful example of the artist's ability to produce a wide range of tonal values and textures. (Erasmus praised Dürer as "the Apelles [the most renowned ancient Greek painter] of black lines,"¹ and the German artist's mastery of all aspects of printmaking is evident also in his woodcuts, for example, FIG. I-9.)

The Italian humanist Marsilio Ficino (1433–1499) had written an influential treatise (*De vita triplici*, 1482–1489) in which he asserted that artists were distinct from the population at large because they were born under the sign of the planet Saturn, named for the ancient Roman god. They shared that deity's melancholic temperament because they had an excess of black bile, one of the four body

> humors, in their systems. Artists therefore were "saturnine"-eccentric and capable both of inspired artistic frenzy and melancholic depression. Raphael had depicted Michelangelo in the guise of the brooding Heraclitus in his School of Athens (FIG. 22-9), and Dürer used a similarly posed female figure for his winged personification of Melancholy in Melencolia I. (In 1510, in De occulta philosophia, Heinrich Cornelius Agrippa of Nettesheim [1486-1535] identified three levels of melancholy. The first was artistic melancholy, which explains the Roman numeral on the banner carried by the bat-a creature of the dark-in Dürer's engraving.) All around the brooding figure of Melancholy are the tools of the artist and builder (compare FIG. 13-32)-compass, hammer, nails, and saw among them-but they are useless to the frustrated artist while he is suffering from melancholy. Melancholy's face is obscured by shadow, underscoring her state of mind, but Dürer also included a burst of light on the far horizon behind the bat, an optimistic note suggesting artists can overcome their depression and produce works of genius-such as this engraving.

23-6 ALBRECHT DÜRER, *Melencolia I*, 1514. Engraving, $9\frac{3''}{8} \times 7\frac{1}{2}''$. Victoria & Albert Museum, London.

In this "self-portrait" of his artistic personality, Dürer portrayed Melancholy as a brooding winged woman surrounded by the tools of the artist and builder but incapable of using them.

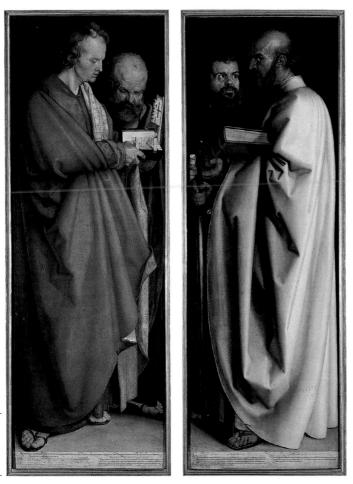

23-7 Albrecht Dürer, *Four Apostles*, 1526. Oil on wood, each panel 7′ 1″ × 2′ 6″. Alte Pinakothek, Munich. ■•

Dürer's support for Lutheranism surfaces in his portraitlike depictions of four saints on two painted panels. Peter, representative of the pope in Rome, plays a secondary role behind John the Evangelist.

FOUR APOSTLES Dürer's major work in the oil medium is Four Apostles (FIG. 23-7), a two-panel oil painting he produced without commission and presented to the city fathers of Nuremberg in 1526 to be hung in the city hall. Saints John and Peter appear on the left panel, Mark and Paul on the right. In addition to showcasing Dürer's mastery of the oil technique, of his brilliant use of color and light and shade, and of his ability to imbue the four saints with individual personalities and portraitlike features, Four Apostles documents Dürer's support for the German theologian Martin Luther (1483-1546), who sparked the Protestant Reformation. Dürer conveyed his Lutheran sympathies by his positioning of the figures. He relegated Saint Peter (as representative of the pope in Rome) to a secondary role by placing him behind John the Evangelist. John assumed particular prominence for Luther because of the evangelist's focus on Christ's person in his Gospel. In addition, Peter and John both read from the Bible, the single authoritative source of religious truth, according to Luther. Dürer emphasized the Bible's centrality by depicting it open to the passage "In the beginning was the Word, and the Word was with God, and the Word was God" (John 1:1). At the bottom of the panels, Dürer included quotations from the four apostles' books, using Luther's German translation of the New Testament. The excerpts warn against the coming of perilous times and the preaching of false prophets who will distort God's word.

LUTHER AND THE REFORMATION The Protestant Reformation, which came to fruition in the early 16th century, had its roots in long-term, growing dissatisfaction with Catholic Church leadership. The deteriorating relationship between the faithful and the Church of Rome's hierarchy stood as an obstacle for the millions who sought a meaningful religious experience. Particularly damaging was the perception that the Roman popes concerned themselves more with temporal power and material wealth than with the salvation of Church members. The fact that many 15th-century popes and cardinals came from wealthy families, such as the Medici (FIG. 22-10), intensified this perception. It was not only those at the highest levels who seemed to ignore their spiritual duties. Archbishops, bishops, and abbots began to accumulate numerous offices, thereby increasing their revenues but making it more difficult for them to fulfill all of their responsibilities. By 1517, dissatisfaction with the Church had grown so widespread that Luther felt free to challenge papal authority openly by posting in Wittenberg his Ninety-five Theses, in which he enumerated his objections to Church practices, especially the sale of indulgences. Indulgences were Church-sanctioned remittances (or reductions) of time Catholics had to spend in Purgatory for confessed sins. The increasing frequency of their sale suggested that those who could afford to purchase indulgences were buying their way into Heaven.

Luther's goal was significant reform and clarification of major spiritual issues, but his ideas ultimately led to the splitting of Christendom. According to Luther, the Catholic Church's extensive ecclesiastical structure needed casting out, for it had no basis in scripture. The Bible and nothing else could serve as the foundation for Christianity. Luther declared the pope the Antichrist (for which the pope excommunicated him), called the Church the "whore of Babylon," and denounced ordained priests. He also rejected most of Catholicism's sacraments other than baptism and communion, decrying them as obstacles to salvation (see "Catholic and Protestant Views of Salvation," page 653, and FIG. 23-8). Luther maintained that for Christianity to be restored to its original purity, the Church needed cleansing of all the doctrinal impurities that had collected through the ages. Luther advocated the Bible as the source of all religious truth. The Bible—the sole scriptural authority-was the word of God, which did not exist in the Church's councils, law, and rituals. Luther facilitated the lay public's access to biblical truths by producing the first translation of the Bible in a vernacular language.

ART AND THE REFORMATION In addition to doctrinal differences, Catholics and Protestants took divergent stances on the role of visual imagery in religion. Catholics embraced church decoration as an aid to communicating with God (see "Religious Art in Counter-Reformation Italy," Chapter 22, page 617). In contrast, Protestants believed images of Christ, the Virgin, and saints could lead to idolatry and distracted viewers from focusing on the real reason for their presence in church—to communicate directly with God. Because of this belief, Protestant churches were relatively bare, and the extensive church pictorial programs found especially in Italy but also in northern Europe (FIGS. 20-19, 20-20, and 23-2) were not as prominent in Protestant churches.

The Protestant concern over the role of religious imagery at times escalated to outright *iconoclasm*—the objection to and destruction of religious imagery. In encouraging a more personal relationship with God, Protestant leaders spoke out against much of the religious art being produced. In his 1525 tract *Against the*

.

Catholic and Protestant Views of Salvation

A central concern of the Protestant reformers was the question of how Christians achieve salvation. Rather than perceive salvation as something for which weak and sinful humans must constantly strive through good deeds performed under the watchful eye of a punitive God, Martin Luther argued that faithful individuals attained redemption solely by God's bestowal of his grace. Therefore, people cannot earn salvation. Further, no ecclesiastical machinery with all its miraculous rites and indulgent forgivenesses could save sinners face-to-face with God. Only absolute faith in Christ could redeem sinners and ensure salvation. Redemption by faith alone, with the guidance of scripture, was the fundamental doctrine of Protestantism.

In *Law and Gospel* (FIG. 23-8), a woodcut dated about a dozen years after Luther set the Reformation in motion with his *Ninety-five Theses*, Lucas Cranach the Elder gave visual expression to the doctrinal differences between Protestantism and Catholicism. Cranach contrasted Catholicism (based on Old Testament law, according

to Luther) and Protestantism (based on the Gospel belief in God's grace) in two images separated by a centrally placed tree. On the left half, judgment day has arrived, as represented by Christ's appearance at the top of the scene, hovering amid a cloud halo and accompanied by angels and saints. Christ raises his left hand in the traditional gesture of damnation, and, below, a skeleton drives off a terrified person to burn for eternity in Hell. This person tried to live a good and honorable life, but despite his efforts, he fell short. Moses stands to the side, holding the tablets of the law-the Ten Commandments Catholics follow in their attempt to attain salvation. In contrast to this Catholic reliance on good works and clean living, Protestants emphasized God's grace as the source of redemption. Accordingly, God showers the sinner in the right half of the print with grace, as streams of blood flow from the crucified Christ. At the far left are Adam and Eve, whose original sin necessitated Christ's sacrifice. In the lower right corner of the woodcut, Christ emerges from the tomb and promises salvation to all who believe in him.

23-8 LUCAS CRANACH THE ELDER, Law and Gospel, ca. 1530. Woodcut, $10\frac{5''}{8} \times 1'\frac{3''}{4}$. British Museum, London.

Lucas Cranach was a close friend of Martin Luther, whose *Ninety-five Theses* launched the Reformation in 1517. This woodcut contrasts Catholic and Protestant views of how to achieve salvation.

Heavenly Prophets in the Matter of Images and Sacraments, Martin Luther explained his attitude toward religious imagery:

I approached the task of destroying images by first tearing them out of the heart through God's Word and making them worthless and despised.... For when they are no longer in the heart, they can do no harm when seen with the eyes.... I have allowed and not forbidden the outward removal of images. . . . And I say at the outset that according to the law of Moses no other images are forbidden than an image of God which one worships. A crucifix, on the other hand, or any other holy image is not forbidden.²

Two influential Protestant theologians based in Switzerland— Ulrich Zwingli (1484–1531) and French-born John Calvin (Jean Cauvin, 1509–1564)—were more vociferous in cautioning their followers about the potentially dangerous nature of religious imagery. Zwingli and Calvin's condemnation of religious imagery often led to eruptions of iconoclasm. Particularly violent waves of iconoclastic fervor swept Basel, Zurich, Strasbourg, and Wittenberg in the 1520s. In an episode known as the Great Iconoclasm, bands of Calvinists visited Catholic churches in the Netherlands in 1566, shattering stained-glass windows, smashing statues, and destroying paintings and other artworks they perceived as idolatrous. These strong reactions to art not only reflect the religious fervor of the time but also serve as dramatic demonstrations of the power of art—and of how much art mattered.

LUCAS CRANACH THE ELDER The artist most closely associated with the Protestant Reformation and with Martin Luther in particular was LUCAS CRANACH THE ELDER (1472–1553). Cranach and Luther were godfathers to each other's children, and many scholars have dubbed Cranach "the painter of the Reformation." Cranach was also an accomplished graphic artist who used the new, inexpensive medium of prints on paper to promote

Lutheran ideology (FIG. 23-8). Cranach's work encompasses a wide range of themes, however. For example, for aristocratic Saxon patrons he produced a large number of paintings of classical myths featuring female nudes in suggestive poses. One classical theme he depicted several times was Judgment of Paris, of which the small panel (FIG. 23-9) now in Karlsruhe is the best example. Homer records the story, but Cranach's source was probably the second-century CE Roman author Lucian's elaboration of the tale. Mercury chose a handsome young shepherd named Paris to be the judge of a beauty contest among three goddesses-Juno, wife of Jupiter; Minerva, Jupiter's virgin daughter and goddess of wisdom and war; and Venus, the goddess of love (see "The Gods and Goddesses of Mount Olympus," Chapter 5, page 107, or on page xxix in Volume II and Book D). According to Lucian, each goddess attempted to bribe Paris with rich rewards if he chose her. Venus won by offering Paris the most beautiful woman in the world, Helen of Troy, and thus set in motion the epic war between the Greeks and Trojans recounted in Homer's Iliad.

Cranach's painting could never be confused with an ancient depiction of the myth. The setting is a German landscape with a Saxon castle in the background, and the seated shepherd is a knight in full armor wearing a fashionable hat. Mercury, an aged man (as he never is in ancient art), also wearing armor, bends over to draw Paris's attention to the three goddesses.

They are nude save for their transparent veils, their fine jewelry, and, in the case of Juno, an elegant hat. Loosely based on classical representations of the Three Graces (compare FIG. 21-1)—ancient artists did not depict Juno or Minerva undressed—Cranach's goddesses do not have the proportions (or modesty) of Praxiteles' *Aphro*-

23-9 LUCAS CRANACH THE ELDER, *Judgment of Paris*, 1530. Oil on wood, 1' $1\frac{1}{2}^{"} \times 9\frac{1}{2}^{"}$. Staatliche Kunsthalle, Karlsruhe.

For aristocratic German patrons, Cranach painted many classical myths featuring seductive female nudes. In his *Judgment of Paris*, the Greek shepherd is a knight in armor in a Saxon landscape. *dite of Knidos* (FIG. 5-62). Slender, with small heads and breasts and long legs, they pose seductively before the judge. Venus performs a dance for Paris, but he seems indifferent to all three goddesses. Only the rearing horse appears to be excited by the spectacle—a touch of humor characteristic of Cranach.

ALBRECHT ALTDORFER As elsewhere in 16th-century Europe, some artists in the Holy Roman Empire worked in the employ of rulers, and their work promoted the political agendas of their patrons. In 1529, for example, the duke of Bavaria, Wilhelm IV (r. 1508–1550), commissioned ALBRECHT ALTDORFER (ca. 1480–1538) to paint *Battle of Issus* (FIG. **23-10**) at the commencement of his military campaign against the invading Turks. The panel depicts Alexander the Great's defeat of King Darius III of Persia in 333 BCE at a town called Issus on the Pinarus River. Altdorfer announced the subject—which the Greek painter Philoxenos of Eretria (FIG. 5-70) had represented two millennia before—in the Latin inscription suspended in the sky. The parallels between the historical and contemporary conflicts were no doubt significant

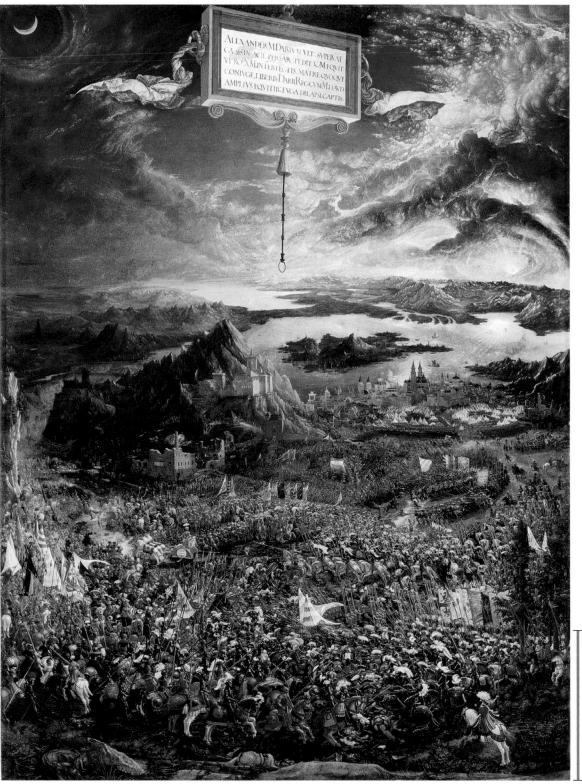

23-10 ALBRECHT ALTDORFER, Battle of Issus, 1529. Oil on wood, 5' $2\frac{1''}{4} \times 3' 11\frac{1}{4}''$. Alte Pinakothek, Munich.

Interweaving history and 16th-century politics, Albrecht Altdorfer painted Alexander the Great's defeat of the Persians for a patron who had just embarked on a military campaign against the Turks.

to the duke. Both involved Western societies engaged in battles against Eastern foes with different values—the Persians in antiquity and the Turks in 1528. Altdorfer reinforced this connection by attiring the figures in 16th-century armor and depicting them engaged in contemporary military alignments.

Battle of Issus also reveals Altdorfer's love of landscape. The battle takes place in an almost cosmological setting. From a bird's-eye view, the clashing armies swarm in the foreground. In the distance, craggy mountain peaks rise next to still bodies of water. Amid swirling clouds, a blazing sun descends. Although the spectacular

topography may appear invented, Altdorfer derived his depiction of the landscape from maps. Specifically, he set the scene in the eastern Mediterranean with a view from Greece to the Nile in Egypt. In addition, Altdorfer may have acquired his information about this battle from the German scholar Johannes Aventinus (1477–1534), whose account of Alexander's victory describes the bloody daylong battle. Appropriately, given Alexander's designation as the "sun god," the sun sets over the victorious Greeks on the right, while a small crescent moon (a symbol of ancient Persia) hovers in the upper left corner over the retreating enemy forces.

1 ft.

23-11 HANS HOLBEIN THE YOUNGER, *The French Ambassadors*, 1533. Oil and tempera on wood, 6' $8'' \times 6' 9^{\frac{1}{2}''}$. National Gallery, London.

In this double portrait, Holbein depicted two humanists with a collection of objects reflective of their worldliness and learning, but he also included an anamorphic skull, a reminder of death.

HANS HOLBEIN Also in the employ of the rich and powerful for much of his career was HANS HOLBEIN THE YOUNGER (ca. 1497–1543), who excelled as a portraitist. Trained by his father, Holbein produced portraits consistent with the northern European tradition of close realism that had emerged in 15th-century Flemish art (see Chapter 20). The surfaces of Holbein's paintings are as lustrous as enamel, and the details are exact and exquisitely drawn. Yet he also incorporated Italian ideas about monumental composition and sculpturesque form.

Holbein began his artistic career in Basel, where he knew Erasmus of Rotterdam. Because of the immediate threat of a religious civil war in Basel, Erasmus suggested Holbein leave for England and gave him a recommendation to Thomas More, chancellor of England under Henry VIII. Holbein quickly obtained important commissions, for example, to paint a double portrait of the French ambassadors to England, Jean de

23-11A HOLBEIN THE YOUNGER, *Henry VIII*, 1540.

Dinteville and Georges de Selve (FIG. **23-11**), and within a few years of his arrival, he became the official painter to the English court, producing numerous portraits of Henry VIII (FIG. **23-11A**).

The French Ambassadors (FIG. 23-11) exhibits Holbein's considerable talents—his strong sense of composition, his subtle linear patterning, his gift for portraiture, his marvelous sensitivity to color, and his faultless

technique. The two men, both ardent humanists, stand at opposite ends of a side table covered with an oriental rug and a collection of objects reflective of their worldliness and their interest in learning and the arts. These include mathematical and astronomical models and implements, a lute with a broken string, compasses, a sundial, flutes, globes, and an open hymnbook with Luther's translation of *Veni, Creator Spiritus* and of the Ten Commandments.

Of particular interest is the long gray shape that slashes diagonally across the picture plane and interrupts the stable, balanced, and serene composition. This form is an *anamorphic image*, a distorted image recognizable only when viewed with a special device, such as a cylindrical mirror, or by looking at the painting at an acute angle. In this case, if the viewer stands off to the right, the gray slash becomes a skull. Although scholars disagree on the skull's precise meaning, it certainly refers to death. Artists commonly incorporated skulls into paintings as reminders of mortality. Indeed, Holbein depicted a skull on the metal medallion on Jean de Dinteville's hat. Holbein may have intended the skulls, in conjunction with the crucifix that appears half hidden behind the curtain in the upper left corner, to encourage viewers to ponder death and resurrection.

This painting may also allude to the growing tension between secular and religious authorities. Jean de Dinteville was a titled

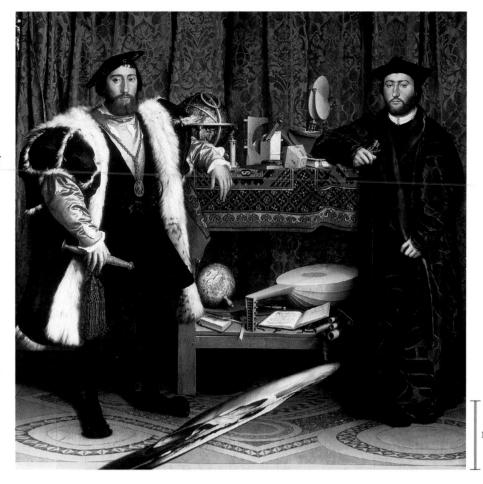

landowner, Georges de Selve a bishop. The inclusion of Luther's translations next to the lute with the broken string (a symbol of discord) may subtly refer to this religious strife. In any case, *The French Ambassadors* is a painting of supreme artistic achievement. Holbein rendered the still-life objects with the same meticulous care as he did the men themselves, the woven design of the deep emerald curtain behind them, and the floor tiles, drawn in perfect perspective.

FRANCE

As *The French Ambassadors* illustrates, France in the early 16th century continued its efforts to secure widespread recognition as a political power and cultural force. The French kings were major patrons of art and architecture.

FRANCIS I Under the rule of Francis I (r. 1515–1547), the French established a firm foothold in Milan and its environs. Francis waged a campaign (known as the Habsburg-Valois Wars) against Charles V (the Spanish king and Holy Roman emperor; r. 1516–1558), which occupied him from 1521 to 1544. These wars involved disputed territories—southern France, the Netherlands, the Rhineland, northern Spain, and Italy—and reflect France's central role in the shifting geopolitical landscape.

The French king also took a strong position in the religious controversies of his day. By the mid-16th century, the split between Catholics and Protestants had become so pronounced that subjects often felt compelled either to accept the religion of their sovereign or emigrate to a territory where the sovereign's religion corresponded with their own. France was predominantly Catholic, and in 1534, Francis declared Protestantism illegal. The state persecuted its Protestants, the Huguenots, a Calvinist sect, and drove them underground. (Calvin fled from France to Switzerland two years later.) The Huguenots' commitment to Protestant Calvinism eventually led to one of the bloodiest religious massacres in European history when the Huguenots and Catholics clashed in Paris in August 1572. The violence quickly spread throughout France with the support of many nobles, which presented a serious threat to the king's authority.

In art as well as politics and religion, Francis I was a dominant figure. To elevate his country's cultural profile, he invited several esteemed Italian artists to his court, Leonardo da Vinci among them (see Chapter 22). Under Francis, the Church, the primary patron of art and architecture in medieval France, yielded that position to the French monarchy.

JEAN CLOUET As the rulers of antiquity had done, Francis commissioned portraits of himself to assert his authority. The finest is the portrait (FIG. **23-12**) JEAN CLOUET (ca. 1485–1541) painted about a decade after Francis became king. It portrays the French monarch as a worldly ruler magnificently bedecked in silks and brocades, wearing a gold chain with a medallion of the Order of Saint Michael, a French order Louis XI founded in 1469. Legend has it that Francis (known as the "merry monarch") was a great lover and the hero of hundreds of "gallant" deeds. Appropriately, he appears suave and confident, with his hand resting on the pommel of a dagger. Despite the careful detail, the portrait also exhibits an elegantly formalized quality, the result of Clouet's suppression of modeling, which flattens features, seen particularly in Francis's neck. The disproportion between the king's small head and his broad body, swathed in heavy layers of fabric, adds to the formalized nature.

Francis and his court favored art that was at once elegant, erotic, and unorthodox. Appropriately, Mannerism appealed to them most, and Francis thus brought Benvenuto Cellini (FIGS. 22-52 and 22-52A) to France with the promise of a lucrative retainer. He put two prominent Florentine Mannerists—Rosso Fiorentino and Francesco Primaticcio—in charge of decorating the new royal palace at Fontainebleau.

CHÂTEAU DE CHAMBORD Francis I also indulged his passion for building by commissioning several large *châteaux*, among them the Château de Chambord (FIG. **23-13**). Reflecting more peaceful times, these châteaux, developed from medieval castles, served as country houses for royalty, who usually built them near forests for use as hunting lodges. Many, including Chambord, still featured protective surrounding moats, however. Construction of the Château de Chambord began in 1519, but Francis I never saw its

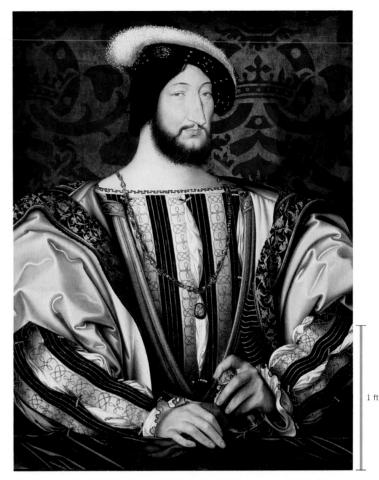

23-12 JEAN CLOUET, Francis I, ca. 1525–1530. Tempera and oil on wood, $3' 2'' \times 2' 5''$. Musée du Louvre, Paris.

Clouet's portrait of Francis I in elegant garb reveals the artist's attention to detail but also the flattening of features and disproportion between head and body, giving the painting a formalized quality.

completion. Chambord's plan, originally drawn by a pupil of Giuliano da Sangallo (FIGS. 22-26 and 22-27), includes a central square block with four corridors, in the shape of a cross, and a broad central staircase that gives access to groups of rooms—ancestors of the modern suite of rooms or apartments. At each of the four corners, a

23-13 Château de Chambord (looking northwest), Chambord, France, begun 1519.

French Renaissance châteaux, which developed from medieval castles, served as country houses for royalty. King Francis I's Château de Chambord reflects Italian palazzo design, but it has a Gothic roof.

23-14 PIERRE LESCOT, west wing of the Cour Carré (Square Court, looking west) of the Louvre, Paris, France, begun 1546.

Lescot's design for the Louvre palace reflects the Italian Renaissance classicism of Bramante, but the decreasing height of the stories, large windows, and steep roof are northern European features.

round tower punctuates the square plan. From the exterior, Chambord presents a carefully contrived horizontal accent on three levels, with continuous moldings separating its floors. Windows align precisely, one exactly over another. The Italian Renaissance palazzo served as the model for this matching of horizontal and vertical features, but above the third level the structure's lines break chaotically into a jumble of high dormers, chimneys, and lanterns that recall soaring, ragged Gothic silhouettes on the skyline.

LOUVRE, PARIS Chambord, despite its Italian elements, is essentially a French building. During the reign of Francis's successor, Henry II (r. 1547-1559), however, translations of Italian architectural treatises appeared, and Italian architects themselves came to work in France. Moreover, the French turned to Italy for study and travel. These exchanges caused a more extensive revolution in style than had transpired earlier, although certain French elements derived from the Gothic tradition persisted. This incorporation of Italian architectural ideas characterizes the redesigned Louvre in Paris, originally a medieval palace and fortress (FIG. 20-16). Since Charles V's renovation of the Louvre in the mid-14th century, the castle had fallen into a state of disrepair. Francis I initiated the project to update and expand the royal palace, but died before the work was well under way. His architect, PIERRE LESCOT (1510-1578), continued under Henry II and produced the classical style most closely associated with 16th-century French architecture.

Lescot and his associates were familiar with the architectural style of Bramante and his school. In the west wing of the Cour Carré (Square Court; FIG. **23-14**) of the Louvre, each of the stories forms a complete order, and the cornices project enough to furnish a strong horizontal accent. The arcading on the ground story reflects the ancient Roman use of arches and produces more shadow than in the upper stories due to its recessed placement, thereby strengthening the design's visual base. On the second story, the pilasters rising from bases and the alternating curved and angular pediments supported by consoles have direct antecedents in several High Renaissance palaces (for example, FIG. 22-26). Yet the decreasing height of the stories, the scale of the windows (proportionately much larger

than in Italian Renaissance buildings), and the steep roof are northern European elements. Especially French are the pavilions jutting from the wall. A motif the French long favored—double columns framing a niche—punctuates the pavilions. The richly ar-

23-14A GOUJON, Fountain of the Innocents, 1547–1549.

ticulated wall surfaces feature relief sculptures by JEAN GOUJON (ca. 1510–1565), who had previously collaborated with Lescot on the Fountain of the Innocents (FIG. **23-14A**) in Paris. Other northern European countries imitated this French classical manner—its double-columned pavilions, tall and wide windows, profuse statuary, and steep roofs—although with local variations. The modified classicism the French produced became the model for building projects north of the Alps through most of the 16th century.

THE NETHERLANDS

With the demise of the duchy of Burgundy in 1477 and the division of that territory between France and the Holy Roman Empire, the Netherlands at the beginning of the 16th century consisted of 17 provinces (corresponding to modern Holland, Belgium, and Luxembourg). The Netherlands was among the most commercially advanced and prosperous European countries. Its extensive network of rivers and easy access to the Atlantic Ocean provided a setting conducive to overseas trade, and shipbuilding was one of the most profitable enterprises. The region's commercial center shifted toward the end of the 15th century, partly because of the buildup of silt in the Bruges estuary. Traffic relocated to Antwerp, which became the hub of economic activity in the Netherlands after 1510. As many as 500 ships a day passed through Antwerp's harbor, and large trading companies from England, the Holy Roman Empire, Italy, Portugal, and Spain established themselves in the city.

During the second half of the 16th century, Philip II of Spain (r. 1556–1598) controlled the Netherlands. Philip had inherited the region from his father Charles V, and he sought to force the

entire population to become Catholic. His heavy-handed tactics and repressive measures led in 1579 to revolt and the formation of two federations: the Union of Arras, a Catholic union of southern Netherlandish provinces, which remained under Spanish dominion, and the Union of Utrecht, a Protestant union of northern provinces, which became the Dutch Republic (MAP 25-1).

Large-scale altarpieces and other religious works continued to be commissioned for Catholic churches, but with the rise of Protestantism in the Netherlands, artists increasingly favored secular subjects. Netherlandish art of this period provides a wonderful glimpse into the lives of various strata of society, from nobility to peasantry, capturing their activities, environment, and values.

JAN GOSSAERT As in the Holy Roman Empire and France, developments in Italian Renaissance art interested many Netherlandish artists. JAN GOSSAERT (ca. 1478–1535) was one of those

23-15 JAN GOSSAERT, Neptune and Amphitrite, ca. 1516. Oil on wood, 6' $2'' \times 4' \frac{3''}{4}$. Gemäldegalerie, Staatliche Museen zu Berlin, Berlin.

Dürer's *Fall of Man* (FIG. 23-5) inspired the poses of Gossaert's classical deities, but the architectural setting is probably based on sketches of ancient buildings Gossaert made during his trip to Rome.

who traveled to Italy and became fascinated with classical antiquity and mythology (FIG. **23-15**), although he also painted traditional Christian themes (FIG. **23-15A**). Giorgio Vasari, the Italian artist and biographer and Gossaert's contemporary, wrote that "Jean Gossart [*sic*] of Mabuse

23-15A GOSSAERT, *Saint Luke Drawing the Virgin,* ca. 1520–1525.

was almost the first who took from Italy into Flanders the true method of making scenes full of nude figures and poetical inventions,"³ although Gossaert derived much of his classicism from Albrecht Dürer.

Indeed, Dürer's Fall of Man (FIG. 23-5) inspired the composition and poses in Gossaert's Neptune and Amphitrite (FIG. 23-15). However, in contrast to Dürer's exquisitely small engraving, Gossaert's painting is more than six feet tall and four feet wide. The artist executed the painting with characteristic Netherlandish polish, skillfully drawing and carefully modeling the figures. Gossaert depicted the sea god with his traditional attribute, the trident, and wearing a laurel wreath and an ornate conch shell in place of Dürer's fig leaf. Amphitrite is fleshy and, like Neptune, stands in a contrapposto stance. The architectural frame, which resembles the cella of a classical temple (FIG. 5-46), is an unusual mix of Doric and Ionic elements and bucrania (ox skull decorations), a common motif in ancient architectural ornamentation.

Gossaert likely based the classical setting on sketches he had made of ancient buildings while in Rome. He had traveled to Italy with Philip, bastard of Burgundy, this painting's patron. A Burgundian admiral (hence the Neptune reference), Philip became a bishop and kept this work in the innermost room of his castle.

QUINTEN MASSYS Antwerp's growth and prosperity, along with its wealthy merchants' propensity for collecting and purchasing art, attracted artists to the city. Among them was QUINTEN MASSYS (ca. 1466–1530), who became Antwerp's leading master after 1510. The son of a Louvain blacksmith, Massys demonstrated a willingness to explore the styles and modes of a variety of models, from Jan van Eyck and Rogier van der Weyden to Albrecht Dürer, Hieronymous Bosch, and Leonardo da Vinci. Yet his eclecticism was subtle and discriminating, enriched by an inventiveness that gave a personal stamp to his paintings.

23-16 QUINTEN MASSYS, Money-Changer and His Wife, 1514. Oil on wood, $2' \ 3\frac{3}{4}'' \times 2' \ 2\frac{3}{8}''$. Musée du Louvre, Paris.

Massys's depiction of a secular financial transaction is also a commentary on Netherlandish values. The banker's wife shows more interest in the moneyweighing than in her prayer book.

In Money-Changer and His Wife (FIG. 23-16), Massys presented a professional man transacting business. He holds scales, checking the weight of coins on the table. The artist's detailed rendering of the figures, setting, and objects suggests a fidelity to observable fact, and provides insight into developing commercial practices. But Money-Changer and His Wife is also a commentary on Netherlandish values and mores. The painting highlights the financial transactions that were an increasingly prominent part of 16th-century secular life in the Netherlands and that distracted Christians from their religious duties. The banker's wife, for example, shows more interest in watching her husband weigh money than in reading her prayer book. Massys incorporated into his painting numerous references to the importance of a moral, righteous, and spiritual life, including a carafe with

water and a candlestick, traditional religious symbols. The couple ignores them, focusing solely on money. On the right, through a window, an old man talks with another man, a reference to idleness and gossip. The reflected image in the convex mirror on the counter offsets this image of sloth and foolish chatter. There, a man

PIETER AERTSEN This tendency to inject reminders about spiritual well-being into paintings of everyday life emerges again in *Butcher's Stall* (FIG. **23-17**) by PIETER AERTSEN (ca. 1507–1575), who worked in Antwerp for more than three decades. At first glance, this painting appears to be a descriptive *genre* scene (one from daily

1 ft.

1 in

reads what is most likely a Bible or prayer book. Behind him is a church steeple. An inscription on the original frame (now lost) read, "Let the balance be just and the weights equal" (Lev. 19:36), an admonition that applies both to the money-changer's professional conduct and the eventual last judgment. Nonetheless, the couple in this painting has tipped the balance in favor of the pursuit of wealth.

23-17 PIETER AERTSEN, Butcher's Stall, 1551. Oil on wood, $4' \frac{3''}{8} \times 6' 5\frac{3''}{4}$. Uppsala University Art Collection, Uppsala.

Butcher's Stall appears to be a genre painting, but in the background, Joseph leads a donkey carrying Mary and the Christ Child. Aertsen balanced images of gluttony with allusions to salvation.

life). On display is an array of meat products—a side of a hog, chickens, sausages, a stuffed intestine, pig's feet, meat pies, a cow's head, a hog's head, and hanging entrails. Also visible are fish, pretzels, cheese, and butter. As did Massys, Aertsen embedded strategically placed religious images in his painting. In the background, Joseph leads a donkey carrying Mary and the Christ Child. The holy family stops to offer alms to a beggar and his son, while the people behind the holy family wend their way toward a church. Furthermore, the crossed fishes on the platter and the pretzels and wine in the rafters on the upper left all refer to "spiritual food" (pretzels were often served as bread during Lent). Aertsen accentuated these allusions to salvation through Christ by contrasting them to their oppositea life of gluttony, lust, and sloth. He represented this degeneracy with the oyster and mussel shells (which Netherlanders believed possessed aphrodisiacal properties) scattered on the ground on the painting's right side, along with the people seen eating and carousing nearby under the roof. Underscoring the general theme is the placard at the right advertising land for sale-Aertsen's moralistic reference to a recent scandal involving the transfer of land from an Antwerp charitable institution to a land speculator. The sign appears directly above the vignette of the Virgin giving alms to the beggar.

CATERINA VAN HEMESSEN With the accumulation of wealth in the Netherlands, portraits increased in popularity. The self-portrait (FIG. **23-18**) by CATERINA VAN HEMESSEN (1528–1587)

in.

23-18 CATERINA VAN HEMESSEN, Self-Portrait, 1548. Oil on wood, 1' $\frac{3''}{4} \times 9\frac{7''}{8}$. Kunstmuseum Basel, Basel.

In this first known northern European self-portrait by a woman, Caterina van Hemessen represented herself as a confident artist momentarily interrupting her work to look out at the viewer.

is the first known northern European self-portrait by a woman. Here, she confidently presented herself as an artist who interrupts her work to gaze at the viewer. She holds brushes, a palette, and a *maulstick* (a stick used to steady the hand while painting) in her left hand, and delicately applies pigment to the canvas with her right hand. The artist ensured proper identification (and credit) through the inscription in the painting: "Caterina van Hemessen painted me / 1548 / her age 20." Professional women artists remained unusual in the 16th century in large part because of the difficulty in obtaining formal training (see "The Artist's Profession in Flanders," Chapter 20, page 545). Caterina was typical in having been trained by her father, Jan Sanders van Hemessen (ca. 1500–1556), a well-known painter.

LEVINA TEERLINC Another Netherlandish woman who achieved a successful career as an artist was LEVINA TEERLINC (1515–1576) of Bruges. She established such a high reputation that Henry VIII and his successors invited her to England to paint miniatures for them. There, she was a formidable rival of some of her male contemporaries at the court, such as Holbein (FIG. 23-11A), and received greater compensation for her work than they did for theirs. Teerlinc's considerable skill is evident in a life-size portrait (FIG. **23-19**) attributed to her, which depicts Elizabeth I as a composed, youthful princess. Daughter of Henry VIII and Anne

23-19 Attributed to LEVINA TEERLINC, *Elizabeth I as a Princess*, ca. 1559. Oil on wood, 3' $6\frac{3}{4}'' \times 2' 8\frac{1}{4}''$. Royal Collection, Windsor Castle, Windsor.

Teerlinc received greater compensation for her work for the British court than did her male contemporaries. Her considerable skill is evident in this life-size portrait of Elizabeth I as a young princess. 23-20 JOACHIM PATINIR, Landscape with Saint Jerome, ca. 1520–1524. Oil on wood, 2' $5\frac{1}{8''} \times 2' 11\frac{2}{8''}$. Museo del Prado, Madrid.

Joachim Patinir, a renowned Netherlandish landscape painter, subordinated the story of Saint Jerome to the depiction of craggy rock formations, verdant rolling fields, and expansive bodies of water.

Boleyn, Elizabeth was probably in her late 20s when she posed for this portrait. Appropriate to her station in life, Elizabeth wears an elegant brocaded gown, extravagant jewelry, and a headdress based on a style her mother popularized.

That van Hemessen and Teerlinc enjoyed such success is a testament to their determination and skill, given the difficulties women faced in a profession dominated by men. Women also played an important role as patrons in 16th-century northern Europe. Politically powerful women such as Margaret of Austria (regent of the Netherlands during the early 16th century; 1480–1530) and Mary of Hungary (queen consort of Hungary; 1505–1558) were avid collectors and patrons, and contributed significantly to the thriving state of the arts. As did other art patrons, these women collected and commissioned art not only for the aesthetic pleasure it provided but also for the status it bestowed on them and the cultural sophistication it represented.

JOACHIM PATINIR In addition to portrait and genre painting, landscape painting flourished in the Netherlands. Particularly well known for his landscapes was JOACHIM PATINIR (d. 1524). In fact, the word *Landschaft* (landscape) first emerged in German literature as a characterization of an artistic category when Dürer described Patinir as a "good landscape painter." In *Landscape with Saint Jerome* (FIG. **23-20**), Patinir subordinated the saint, who removes a thorn from a lion's paw in the foreground, to the exotic and detailed landscape. Craggy rock formations, verdant rolling fields, villages with church steeples, expansive bodies of water, and a dramatic sky fill most of the panel. Patinir amplified the sense of distance by masterfully using color to enhance the visual effect of recession and advance. **PIETER BRUEGEL THE ELDER** The greatest Netherlandish painter of the mid-16th century was PIETER BRUEGEL THE ELDER (ca. 1528–1569). Influenced by Patinir, Bruegel was also a landscape painter, but in his paintings, no matter how huge a slice of the world he depicted, human activities remain the dominant theme. As did many of his contemporaries, Bruegel traveled to Italy, where he probably spent almost two years, going as far south as Sicily. Unlike other artists, however, Bruegel chose not to incorporate classical elements into his paintings.

Bruegel's Netherlandish Proverbs (FIG. 23-21) depicts a Netherlandish village populated by a wide range of people (nobility, peasants, and clerics). From a bird's-eye view, the spectator encounters a mesmerizing array of activities reminiscent of the topsy-turvy scenes of Bosch (FIG. 23-1), but the purpose and meaning of Bruegel's anecdotal details are clear. By illustrating more than a hundred proverbs in this one painting, the artist indulged his Netherlandish audience's obsession with proverbs and passion for detailed and clever imagery. As the viewer scrutinizes the myriad vignettes within the painting, Bruegel's close observation and deep understanding of human nature become apparent. The proverbs depicted include, on the far left, a man in blue gnawing on a pillar ("He bites the column"—an image of hypocrisy). To his right, a man "beats his head against a wall" (an ambitious idiot). On the roof a man "shoots one arrow after the other, but hits nothing" (a shortsighted fool). In the far distance, the "blind lead the blind"-a subject to which Bruegel returned several years later in one of his most famous paintings (not illustrated).

In contrast to Patinir's Saint Jerome, lost in the landscape, the myriad, raucous cast of characters of Bruegel's *Netherlandish Proverbs* fills the panel, so much so the artist almost shut out the sky. *Hunters in the Snow* (FIG. **23-22**) and *Fall of Icarus*

23-21 PIETER BRUEGEL THE ELDER, Netherlandish Proverbs, 1559. Oil on wood, 3' $10'' \times 5' 4\frac{1}{8}''$. Gemäldegalerie, Staatliche Museen zu Berlin, Berlin.

In this painting of a Netherlandish village, Bruegel indulged his audience's obsession with proverbs and passion for clever imagery, and demonstrated his deep understanding of human nature.

23-22 PIETER BRUEGEL THE ELDER, Hunters in the Snow, 1565. Oil on wood, 3' $10\frac{1''}{8} \times 5' 3\frac{3''}{4}$. Kunsthistorisches Museum, Vienna.

In *Hunters in the Snow*, one of a series of paintings illustrating different seasons, Bruegel draws the viewer diagonally deep into the landscape by his mastery of line, shape, and composition.

23-22A BRUEGEL THE ELDER, Fall of Icarus, ca. 1555-1556. (FIG. **23-22A**) are very different in character and illustrate the dynamic variety of Bruegel's work. *Hunters* is one of a series of six paintings (some scholars think there were originally twelve) illustrating seasonal changes. The series grew out of the tradition of depicting seasons and

peasants in Books of Hours (FIGS. 20-15 and 20-16). The painting shows human figures and landscape locked in winter cold, reflect-

ing the particularly severe winter of 1565, when Bruegel produced the work. The weary hunters return with their hounds, women build fires, skaters skim the frozen pond, and the town and its church huddle in their mantle of snow. Bruegel rendered the landscape in an optically accurate manner. It develops smoothly from foreground to background and draws the viewer diagonally into its depths. The painter's consummate skill in using line and shape and his subtlety in tonal harmony make this one of the great landscape paintings in Western art.

SPAIN

Spain's ascent to power in Europe began in the mid-15th century with the marriage of Isabella of Castile (1451-1504) and Ferdinand of Aragon (1452-1516) in 1469. By the end of the 16th century, Spain had emerged as the dominant European power. Under the Habsburg rulers Charles V and Philip II, the Spanish Empire controlled a territory greater in extent than any ever known-a large part of Europe, the western Mediterranean, a strip of North Africa, and vast expanses in the New World. Spain acquired many of its New World colonies through aggressive overseas exploration. Among the most notable conquistadors sailing under the Spanish flag were Christopher Columbus (1451-1506), Vasco Nuñez de Balboa (ca. 1475-1517), Ferdinand Magellan (1480-1521), Hernán Cortés (1485-1547), and Francisco Pizarro (ca. 1470-1541). The Habsburg Empire, enriched by New World plunder, supported the most powerful military force in Europe. Spain defended and then promoted the interests of the Catholic Church in its battle against the inroads of the Protestant Reformation. Indeed, Philip II earned the title "Most Catholic King." Spain's crusading spirit, nourished by centuries of war with Islam, engaged body and soul in forming the most Catholic civilization of Europe and the Americas. In the 16th century, for good or for ill, Spain left the mark of its power, religion, language, and culture on two hemispheres.

COLEGIO DE SAN GREGORIO During the 15th century and well into the 16th, a Late Gothic style of architecture, the Plateresque, prevailed in Spain. *Plateresque* derives from the Spanish word *platero* (silversmith), and delicately executed ornamentation resembling metalwork is the defining characteristic of the

23-23A Casa de Montejo, Mérida, 1549. Plateresque style. The Colegio de San Gregorio (Seminary of Saint Gregory; FIG. **23-23**) in the Castilian city of Valladolid handsomely exemplifies the Plateresque manner, which Spanish expansion into the Western Hemisphere also brought to "New Spain" (FIG. **23-23A**). Great carved retables, like the German altarpieces that influenced them (FIGS. 20-19, 20-20, and 23-2, *bottom*), appealed to church patrons and architects in Spain, and the portals of Plateresque facades often resemble elegantly carved retables set into an otherwise blank wall. The Plateresque entrance of San

Gregorio is a lofty sculptured stone screen bearing no functional relation to the architecture behind it. On the entrance level, lacelike tracery reminiscent of Moorish design hems the flamboyant ogival arches. (Spanish hatred of the Moors did not prevent Spanish architects from adapting Moorish motifs.) A great screen, paneled into sculptured compartments, rises above the tracery. In the center, the branches of a huge pomegranate tree (symbolizing Granada, the Moorish capital of Spain the Habsburgs captured in 1492; see Chapter 10) wreathe the coat of arms of King Ferdinand and Queen Isabella. Cupids play among the tree branches, and, flanking the central panel, niches frame armed pages of the court, heraldic wild men symbolizing aggression, and armored soldiers, attesting to Spain's proud new militancy. In typical Plateresque and Late Gothic fashion, the activity of a thousand intertwined motifs unifies the whole design, which, in sum, creates an exquisitely carved panel greatly expanded in scale from the retables that inspired it.

EL ESCORIAL Under Philip II, the Plateresque style gave way to an Italian-derived classicism that also characterized

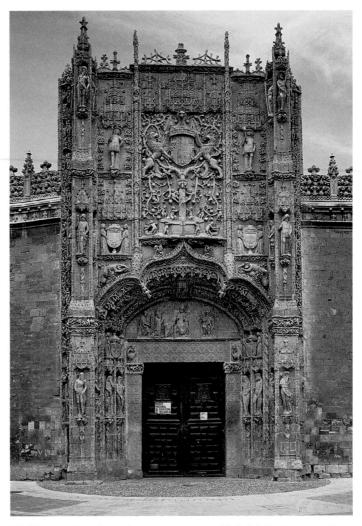

23-23 Portal, Colegio de San Gregorio, Valladolid, Spain, ca. 1498.

The Plateresque architectural style takes its name from *platero* (Spanish, "silversmith"). At the center of this portal's Late Gothic tracery is the coat of arms of King Ferdinand and Queen Isabella.

16th-century French architecture (FIG. 23-13). The Italian style is on display in the expansive complex called El Escorial (FIG. **23-24**), which JUAN BAUTISTA DE TOLEDO (d. 1567) and JUAN DE HERRERA (ca. 1530–1597), principally the latter, constructed for Philip II. In his will, Charles V stipulated that a "dynastic pantheon" be built to house the remains of past and future monarchs of Spain. Philip II, obedient to his father's wishes, chose a site some 30 miles northwest of Madrid in rugged terrain with barren mountains. Here, he built El Escorial, not only a royal mausoleum but also a church, a monastery, and a palace. Legend has it that the gridlike plan for the enormous complex, 625 feet wide and 520 feet deep, symbolized the gridiron on which Saint Lawrence, El Escorial's patron saint, suffered his martyrdom.

The vast structure is in keeping with Philip's austere character, his passionate Catholic religiosity, his proud reverence for his dynasty, and his stern determination to impose his will worldwide. He insisted that in designing El Escorial, the architects focus on simplicity of form, severity in the whole, nobility without arrogance, and majesty without ostentation. The result is a classicism of Doric severity, ultimately derived from Italian architecture and with the grandeur of Saint Peter's (FIGS. 24-3 and 24-4) implicit in the scheme, but unique in European architecture.

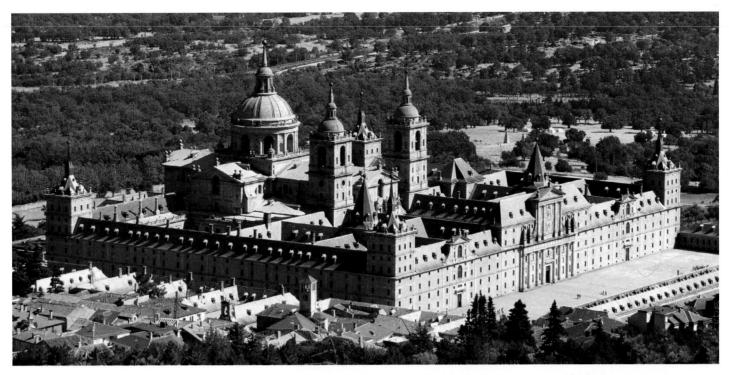

23-24 JUAN DE HERRERA and JUAN BAUTISTA DE TOLEDO, aerial view (looking southeast) of El Escorial, near Madrid, Spain, 1563-1584.

Conceived by Charles V and built by Philip II, El Escorial is a royal mausoleum, church, monastery, and palace in one. The complex is classical in style with severely plain walls and massive towers.

Only the three entrances, with the dominant central portal framed by superimposed orders and topped by a pediment in the Italian fashion, break the long sweep of the structure's severely plain walls. Massive square towers punctuate the four corners. The stress on the central axis, with its subdued echoes in the two flanking portals, anticipates the three-part organization of later Baroque facades (see Chapter 24). The construction material for the entire complex (including the church)—granite, a difficult stone to work-conveys a feeling of starkness and gravity. The church's massive facade and the austere geometry of the interior complex, with its blocky walls and ponderous arches, produce an effect of overwhelming strength and weight. The entire complex is a monument to the collaboration of a great king and remarkably understanding architects. El Escorial stands as the overpowering architectural expression of Spain's spirit in its heroic epoch and of the character of Philip II, the extraordinary ruler who directed it.

EL GRECO Reflecting the increasingly international character of European art as well as the mobility of artists, the greatest Spanish painter of the era was not a Spaniard. Born on Crete, Domenikos Theotokopoulos, called EL GRECO (ca. 1547–1614), emigrated to Italy as a young man. In his youth, he absorbed the traditions of Late Byzantine frescoes and mosaics. While still young, El Greco went to Venice, where he worked in Titian's studio, although Tintoretto's paintings seem to have made a stronger impression on him (see Chapter 22). A brief trip to Rome explains the influences of Roman and Florentine Mannerism on his work. By 1577, he had left for Spain to spend the rest of his life in Toledo.

El Greco's art is a strong personal blending of Byzantine and Mannerist elements. The intense emotionalism of his paintings, which naturally appealed to Spanish piety, and a great reliance on and mastery of color bound him to 16th-century Venetian art and to Mannerism. El Greco's art was not strictly Spanish (although it appealed to certain sectors of that society), for it had no Spanish antecedents and little effect on later Spanish painters. Nevertheless, El Greco's hybrid style captured the fervor of Spanish Catholicism.

Burial of Count Orgaz (FIG. 23-25), painted in 1586 for the church of Santo Tomé in El Greco's adoptive home, Toledo, vividly expressed that fervor. El Greco based the painting on the legend that the count of Orgaz, who had died some three centuries before and who had been a great benefactor of Santo Tomé, was buried in the church by Saints Stephen and Augustine, who miraculously descended from Heaven to lower the count's body into its sepulcher. In the painting, El Greco carefully distinguished the terrestrial and celestial spheres. The brilliant Heaven that opens above irradiates the earthly scene. The painter represented the terrestrial realm with a firm realism, whereas he depicted the celestial, in his quite personal manner, with elongated undulating figures, fluttering draperies, and a visionary swirling cloud. Below, the two saints lovingly lower the count's armor-clad body, the armor and heavy draperies painted with all the rich sensuousness of the Venetian school. A solemn chorus of personages dressed in black fills the background. In the carefully individualized features of these figures (who include El Greco himself in a self-portrait, and his young son, Jorge Manuel, as well as the priest who commissioned the painting and the Spanish king Philip II), El Greco demonstrated he was also a great portraitist.

The upward glances of some of the figures below and the flight of an angel above link the painting's lower and upper spheres. The action of the angel, who carries the count's soul in his arms as Saint John and the Virgin intercede for it before the throne of Christ, reinforces this connection. El Greco's deliberate change in style to distinguish between the two levels of reality gives the viewer an opportunity to see the artist's early and late manners in the same work, one below the other. His relatively sumptuous and realistic presentation of the earthly sphere is still strongly rooted in Venetian art,

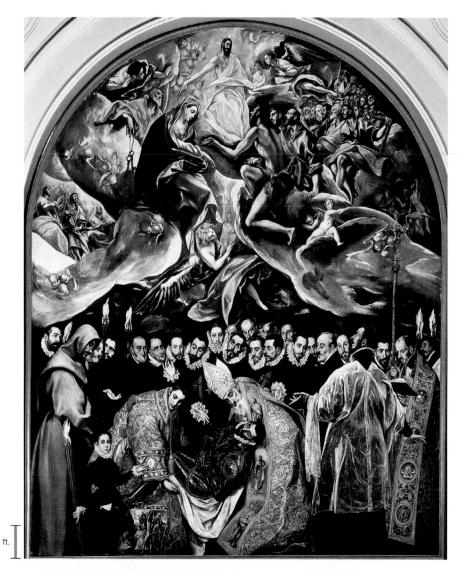

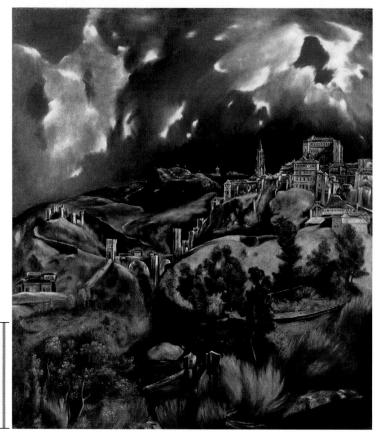

1 ft

23-25 EL GRECO, *Burial of Count Orgaz*, 1586. Oil on canvas, $16' \times 12'$. Santo Tomé, Toledo.

El Greco's art is a blend of Byzantine and Italian Mannerist elements. His intense emotional content captured the fervor of Spanish Catholicism, and his dramatic use of light foreshadowed the Baroque style.

but the abstractions and distortions El Greco used to show the immaterial nature of the heavenly realm characterize his later style. His elongated figures existing in undefined spaces, bathed in a cool light of uncertain origin, explain El Greco's usual classification as a Mannerist, but it is difficult to apply that label to him without reservation. Although he used Mannerist formal devices, El Greco's primary concerns were emotion and conveying his religious fervor or arousing that of others. The forcefulness of his paintings is the result of his unique, highly developed expressive style.

VIEW OF TOLEDO El Greco's singular vision is equally evident in one of his latest works, *View of Toledo* (FIG. **23-26**), the only pure landscape he ever painted. As does so much of El Greco's work, this painting breaks sharply with tradition. The Greekborn artist depicted the Spanish city from a nearby hilltop and drew attention to the great spire of Toledo's cathedral by leading the viewer's eye along the diagonal line of the bridge crossing the Tajo and continuing with the city's walls. El Greco knew Toledo intimately, and every building is recognizable, although he rearranged some of their positions, moving, for example, the Alcazar palace to the right of the cathedral. Yet he rendered no structure in me-

ticulous detail, as most Renaissance painters would have done, and the color palette is not true to nature but limited to greens and grays. The atmosphere is eerie. Dramatic bursts of light in the stormy sky cast a ghostly pall over the city. The artist applied oil pigment to canvas in broad brushstrokes typical of his late, increasingly abstract painting style, with the result that the buildings and trees do not have sharp contours and almost seem to shake.

Art historians have compared *View of Toledo* to Giorgione da Castelfranco's *Tempest* (FIG. 22-34) and the dramatic lighting to works by Tintoretto (FIG. 22-48), and indeed, El Greco's Venetian training is evident. Still, the closest parallels lie not in the past but in the future—in paintings such as Vincent van Gogh's *Starry Night* (FIG. 28-18) and in 20th-century Expressionism and Surrealism (see Chapter 29). El Greco's art is impossible to classify using conventional labels. Although he had ties to Mannerism and foreshadowed developments of the Baroque era in Spain and Italy—examined in the next chapter—he was a singular artist with a unique vision.

23-26 EL GRECO, *View of Toledo*, ca. 1610. Oil on canvas, 3' $11\frac{3''}{4} \times 3' 6\frac{3''}{4}$. Metropolitan Museum of Art, New York (H. O. Havemeyer Collection. Bequest of Mrs. H. O. Havemeyer, 1929).

View of Toledo is the only pure landscape El Greco ever produced. The dark, stormy sky casts a ghostly pall over the city. The painting exemplifies the artist's late, increasingly abstract style.

THE BIG PICTURE

HIGH RENAISSANCE AND MANNERISM IN NORTHERN EUROPE AND SPAIN

HOLY ROMAN EMPIRE

- Widespread dissatisfaction with the Church in Rome led to the Protestant Reformation, splitting Christendom in half. Protestants objected to the sale of indulgences and rejected most of the sacraments of the Catholic Church. They also condemned ostentatious church decoration as a form of idolatry that distracted the faithful from communication with God.
- As a result, Protestant churches were relatively bare, but art, especially prints, still played a role in Protestantism. Lucas Cranach the Elder, for example, effectively used visual imagery to contrast Catholic and Protestant views of salvation in his woodcut *Law and Gospel*.
- The greatest printmaker of the Holy Roman Empire was Albrecht Dürer, who was also a painter. Dürer was the first artist outside Italy to become an international celebrity. His work ranged from biblical subjects to botanical studies. *Fall of Man* reflects Dürer's studies of the Vitruvian theory of human proportions and of classical statuary. Dürer's engravings rival painting in tonal quality.
- Other German artists, such as Albrecht Altdorfer, achieved fame as landscape painters. Hans Holbein was a renowned portraitist who became court painter in England. His *French Ambassadors* portrays two worldly humanists and includes a masterfully rendered anamorphic skull.

FRANCE

- King Francis I fought against Holy Roman Emperor Charles V and declared Protestantism illegal in France. An admirer of Italian art, he invited several prominent Italian painters and sculptors to work at his court and decorate his palace at Fontainebleau.
- French architecture of the 16th century mixes Italian and Northern Renaissance elements, as in Pierre Lescot's design of the renovated Louvre palace and Francis's château at Chambord, which combines classical motifs derived from Italian palazzi with a Gothic roof silhouette.

THE NETHERLANDS

- The Netherlands was one of the most commercially advanced and prosperous countries in 16th-century Europe. Much of Netherlandish art of this period provides a picture of contemporary life and values.
- Pieter Aertsen of Antwerp, for example, painted *Butcher's Stall*, which seems to be a straightforward genre scene but includes the holy family offering alms to a beggar in the background, providing a stark contrast between gluttony and religious piety.
- Landscapes were the specialty of Joachim Patinir. Pieter Bruegel's repertory also included landscape painting. His *Hunters in the Snow* is one of a series of paintings depicting seasonal changes and the activities associated with them, as in traditional Books of Hours.
- Women artists of the period include Caterina van Hemessen, who painted the earliest northern European self-portrait of a woman, and Levina Teerlinc, who produced portraits for the English court.

SPAIN

- At the end of the 16th century, Spain was the dominant power in Europe with an empire greater in extent than any ever known, including vast territories in the New World.
- The Spanish Plateresque style of architecture takes its name from *platero* (silversmith) and features delicate ornamentation resembling metalwork.
- Under Philip II the Plateresque style gave way to an Italian-derived classicism, seen at its best in El Escorial, a royal mausoleum, monastery, and palace complex near Madrid.
- The leading painter of 16th-century Spain was the Greek-born El Greco, who combined Byzantine style, Italian Mannerism, and the religious fervor of Catholic Spain in works such as *Burial of Count Orgaz*.

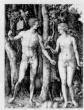

Dürer, Fall of Man, 1504

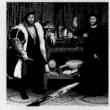

Holbein, *The French Ambassadors*, 1533

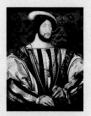

Clouet, *Francis I,* ca. 1525–1530

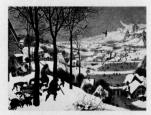

Bruegel, Hunters in the Snow, 1565

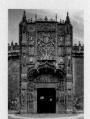

Colegio de San Gregorio, Valladolid, ca. 1498

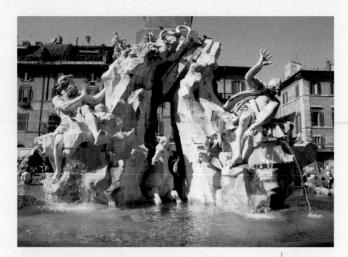

As water flows from a travertine grotto supporting an ancient Egyptian obelisk, Bernini's marble personifications of major rivers of four continents twist and gesticulate emphatically.

Crowning the grotto is Pope Innocent X's coat of arms and atop the obelisk is the Pamphili family's dove symbolizing the Holy Spirit and Christianity's triumph in all parts of the then-known world.

Each of the four rivers has an identifying attribute. The Ganges (Asia), easily navigable, holds an oar. The Plata (Americas) has a hoard of coins, signifying the wealth of the New World.

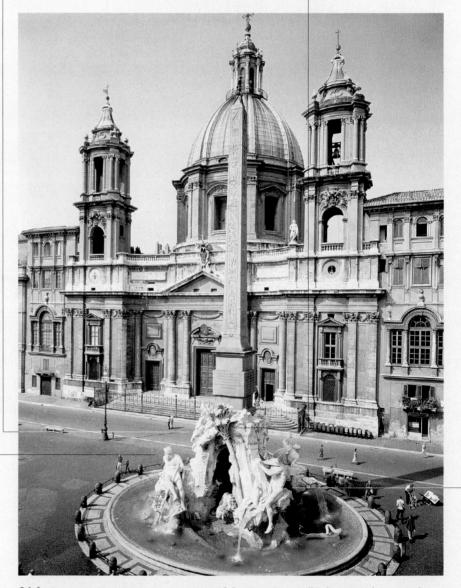

24-1 GIANLORENZO BERNINI, Fountain of the Four Rivers (looking southwest with Sant'Agnese in Agone in the background), Piazza Navona, Rome, Italy, 1648–1651.

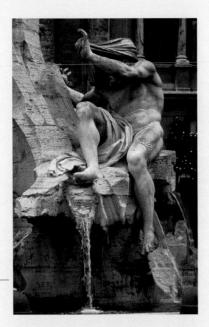

The Danube (Europe) gazes awestruck at the papal arms, and the Nile (Africa) covers his face—Bernini's acknowledgment that the Nile's source was unknown to Europeans at the time.

THE BAROQUE IN ITALY AND SPAIN

24

BAROQUE ART AND SPECTACLE

One of the most popular tourist attractions in Rome is the Fountain of the Four Rivers (FIG. 24-1) in Piazza Navona by GIANLORENZO BERNINI (1598–1680). Architect, painter, sculptor, playwright, and stage designer, Bernini was one of the most important and imaginative artists of the Baroque era in Italy and its most characteristic and sustaining spirit. Nonetheless, the fountain's patron, Pope Innocent X (r. 1644–1655), did not want Bernini to win this commission. Bernini had been the favorite sculptor of the Pamphili pope's predecessor, Urban VIII (r. 1623–1644), who spent so extravagantly on art and himself and his family that he nearly bankrupted the Vatican treasury. Innocent emphatically opposed the excesses of the Barberini pope and shunned Bernini, awarding new papal commissions to other sculptors and architects. Bernini was also in disgrace at the time because of his failed attempt to erect bell towers for the new facade (FIG. 24-3) of Saint Peter's. When Innocent announced a competition for a fountain in Piazza Navona (MAP 22-1), site of the Pamphili family's palace and parish church, Sant'Agnese in Agone (FIG. 24-1, *rear*), he pointedly did not invite Bernini to submit a design. However, the renowned sculptor succeeded in having a model of his proposed fountain placed where the pope would see it. When Innocent examined it, he was so captivated he declared the only way anyone could avoid employing Bernini was not to look at his work.

Bernini's bold design, executed in large part by his assistants, called for a sculptured travertine grotto supporting an ancient obelisk Innocent had transferred to Piazza Navona from the circus of the Roman emperor Maxentius (r. 305–312) on the Via Appia. The piazza was once the site of the stadium of Domitian (r. 81–96), a long and narrow arena for athletic contests, which explains the piazza's unusual shape and the church's name (*agone* means "foot race" in Italian). Water rushes from the artificial grotto into a basin filled with marble statues personifying major rivers of four continents—the Danube (Europe), Nile (Africa), Ganges (Asia), and Plata (Americas). The reclining figures twist and gesticulate, consistent with Baroque taste for movement and drama. The Nile covers his face—Bernini's way of acknowledging the Nile's source was unknown at the time. The Rio de la Plata has a hoard of coins, signifying the wealth of the New World. The Ganges, easily navigable, holds an oar. The Danube, awestruck, reaches up to the papal coat of arms. A second reference to Innocent X is the Pamphili dove at the apex of the obelisk, which also symbolizes the Holy Spirit and the triumph of Christianity in all parts of the then-known world. The scenic effect of the cascading water would have been heightened whenever Piazza Navona was flooded for festival pageants. Bernini's fountain epitomizes the Baroque era's love for uniting art and spectacle.

"BAROQUE" ART AND ARCHITECTURE

Art historians traditionally describe 17th-century European art as Baroque, but the term is problematic because the period encompasses a broad range of styles and genres. Although its origin is unclear, "Baroque" may have come from the Portuguese word barroco, meaning an irregularly shaped pearl. Use of the term can be traced to the late 18th century, when critics disparaged the Baroque period's artistic production, in large part because of perceived deficiencies in comparison with the art of the Italian Renaissance. Over time, this negative connotation faded, but the term stuck. "Baroque" remains useful to describe the distinctive new style that emerged during the early 1600s-a style of complexity and drama seen especially in Italian art of this period. Whereas Renaissance artists reveled in the precise, orderly rationality of classical models, Baroque artists embraced dynamism, theatricality, and elaborate ornamentation, all used to spectacular effect, often on a grandiose scale, as in Bernini's Four Rivers Fountain (FIG. 24-1).

ITALY

Although in the 16th century the Roman Catholic Church launched the Counter-Reformation in response to—and as a challenge to—the Protestant Reformation, the considerable appeal of Protestantism continued to preoccupy the popes throughout the 17th century. The Treaty of Westphalia (see Chapter 25) in 1648 had formally recognized the principle of religious freedom, serving to validate Protestantism (predominantly in the German states). With the Catholic Church as the leading art patron in 17th-century Italy, the aim of much of Italian Baroque art was to restore Roman Catholicism's predominance and centrality. The Council of Trent, one 16th-century Counter-Reformation initiative, firmly resisted Protestant objections to using images in religious worship, insisting on their necessity for teaching the laity (see "Religious Art in Counter-Reformation Italy," Chapter 22, page 617). Baroque art in Italy was therefore often overtly didactic.

Architecture and Sculpture

Italian 17th-century art and architecture, especially in Rome, embodied the renewed energy of the Counter-Reformation and communicated it to the populace. At the end of the 16th century, Pope Sixtus V (r. 1585–1590) had played a key role in the Catholic Church's lengthy campaign to reestablish its preeminence. He

24-2 CARLO MADERNO, facade of Santa Susanna (looking north), Rome, Italy, 1597–1603.

Santa Susanna's facade is one of the earliest manifestations of the Baroque spirit. The rhythm of the columns and pilasters mounts dramatically toward the emphatically stressed vertical axis.

augmented the papal treasury and intended to rebuild Rome as an even more magnificent showcase of Church power. Between 1606 and 1667, several strong and ambitious popes—Paul V, Urban VIII, Innocent X, and Alexander VII—made many of Sixtus V's dreams a reality. Rome still bears the marks of their patronage everywhere.

SANTA SUSANNA The facade (FIG. **24-2**) CARLO MADERNO (1556–1629) designed at the turn of the century for the Roman church of Santa Susanna stands as one of the earliest manifestations of the

THE BAROQUE IN ITALY AND SPAIN

1600 1	625 16	50 16	575	1700
 Paul V commissions Maderno to complete Saint Peter's Carracci introduces quadro riportato fresco painting in the Palazzo Farnese Caravaggio pioneers tenebrism in Baroque painting Bernini creates David and Apollo and Daphne for Cardinal Scipione Borghese 	woman artist of the 17th	 Bernini designs the colonnaded oval piazza in front of Saint Peter's Murillo creates the canonical image of the <i>Virgin of the Immaculate Conception</i> Velázquez paints <i>Las Meninas</i> 	 Gaulli and Pozzo paint illusionistic ceiling frescoes in II Gesù and Sant'Ignazio Guarini brings the Baroque architectural style of Rome to Turin 	

4

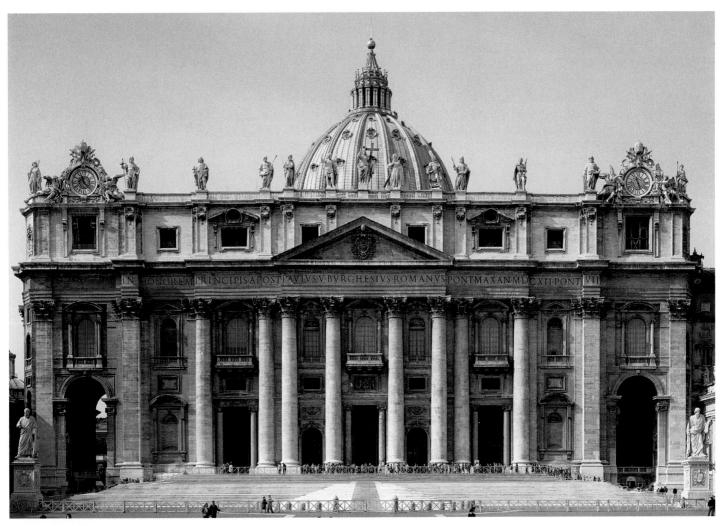

24-3 CARLO MADERNO, east facade of Saint Peter's, Vatican City, Rome, Italy, 1606-1612.

For the facade of Saint Peter's, Maderno elaborated on his design for Santa Susanna (FIG. 24-2), but the two outer bays with bell towers were not part of his plan and detract from the verticality he sought.

Baroque artistic spirit. In its general appearance, Maderno's facade resembles Giacomo della Porta's immensely influential design for Il Gesù (FIG. 22-56), the church of the Jesuits in Rome. But the later facade has a greater verticality that concentrates and dramatizes the major features of its model. The tall central section projects forward from the horizontal lower story, and the scroll buttresses connecting the two levels are narrower and set at a sharper angle. The elimination of an arch framing the pediment over the doorway further enhances the design's vertical thrust. The rhythm of Santa Susanna's vigorously projecting columns and pilasters mounts dramatically toward the emphatically stressed central axis. The recessed niches, which contain statues and create pockets of shadow, heighten the sculptural effect.

MADERNO AND SAINT PETER'S The drama inherent in Santa Susanna's facade appealed to Pope Paul V (r. 1605–1621), who commissioned Maderno in 1606 to complete Saint Peter's in Rome. As the symbolic seat of the papacy, the church Constantine originally built over the first pope's tomb (see Chapter 8) was the very emblem of Western Christendom. In light of Counter-Reformation concerns, the Baroque popes wanted to conclude the already century-long rebuilding project and reap the prestige embodied in the mammoth new church. In many ways Maderno's facade (FIG. 24-3) is a gigantic expansion of the elements of Santa Susanna's first level. But the compactness and verticality of the smaller church's facade are not as prominent because Saint Peter's enormous breadth counterbalances them. Mitigating circumstances must be taken into consideration when assessing this design, however. Because Maderno had to match the preexisting core of an incomplete building, he did not have the luxury of formulating a totally new concept for Saint Peter's. Moreover, the facade's two outer bays with bell towers were not part of Maderno's original design. Hence, had the facade been constructed according to the architect's initial concept, it would have exhibited greater verticality and visual coherence.

Maderno's plan (MAP **24-1**) also departed from the Renaissance central plans for Saint Peter's designed by Bramante (FIG. 22-22) and, later, by Michelangelo (FIG. 22-24). Paul V asked Maderno to add three nave bays to the earlier nucleus because Church officials had decided the central plan was too closely associated with ancient temples, such as the Pantheon (FIG. 7-49). Further, the spatial organization of the longitudinal basilican plan of the original

24-4 Aerial view of Saint Peter's (looking west), Vatican City, Rome, Italy. Piazza designed by GIANLORENZO BERNINI, 1656–1667.

The dramatic gesture of embrace Bernini's colonnade makes as worshipers enter Saint Peter's piazza symbolizes the welcome the Catholic Church wished to extend during the Counter-Reformation.

fourth-century church (FIG. 8-9) reinforced the symbolic distinction between clergy and laity and also was much better suited for religious processions. Lengthening the nave, however, pushed the dome farther back from the facade, and all but destroyed the effect Michelangelo had planned-a structure pulled together and dominated by its dome. When viewed at close range, the dome barely emerges above the facade's soaring frontal plane. Seen from farther back (FIG. 24-3), it appears to have no drum. Visitors must move back quite a distance from the front (or fly over the church, FIG. 24-4) to see the dome and drum together. Today, visitors to the Vatican can appreciate the effect Michelangelo intended only by viewing Saint Peter's from the back (FIG. 22-25).

BERNINI AND SAINT PETER'S

Old Saint Peter's had a large forecourt, or *atrium* (FIG. 8-9, *right*), in front of the church proper, and in the mid-17th century, Gianlorenzo Bernini, who had long before established his reputation as a supremely gifted architect and sculptor (see page 669), received the prestigious commission to construct a monumental colonnade-framed *piazza* (plaza; FIG. **24-4**) in front of Mader-

no's facade. Bernini's design had to incorporate two preexisting structures on the site—an obelisk the ancient Romans had brought from Egypt (which Pope Sixtus V had moved to its present location in 1585 as part of his vision of Christian triumph in Rome) and a fountain Maderno constructed in front of the church. Bernini coopted these features to define the long axis of a vast oval embraced by two colonnades joined to Maderno's facade. Four rows of huge Tuscan columns make up the two colonnades, which terminate in classical temple fronts. The colonnades extend a dramatic gesture of embrace to all who enter the piazza, symbolizing the welcome the Roman Catholic Church gave its members during the Counter-Reformation. Bernini himself referred to his colonnades as the welcoming arms of Saint Peter's.

Beyond their symbolic resonance, the colonnades served visually to counteract the natural perspective and bring the facade closer to the viewer. (Bernini's mastery of perspective in architecture

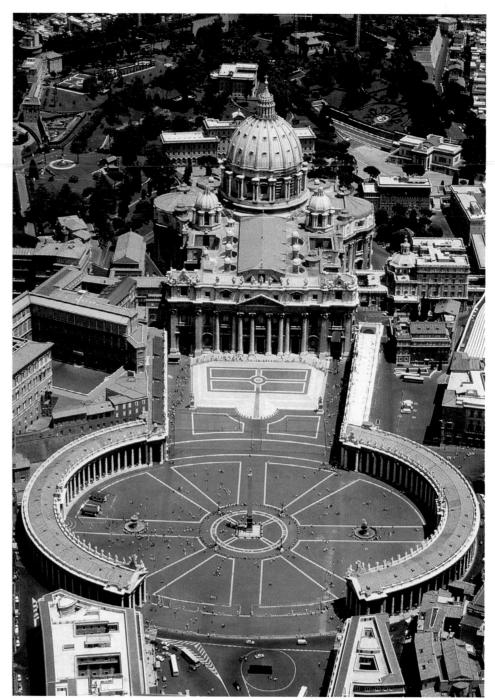

is even more evident in his contemporaneous design for the Scala Regia [FIG. 24-4A] of the Vatican palace, a project he undertook at the

request of Pope Alexander VII [r. 1655– 1667].) Emphasizing the facade's height in this manner, Bernini subtly and effectively compensated for its extensive width. Thus, a Baroque transformation expanded the compact central designs of Bramante and Michelangelo into a dynamic complex of axially ordered elements that reach out and enclose spaces of vast dimension. By its sheer scale and theatricality, the completed Saint Peter's fulfilled the desire of the Counter–Reformation Church to present an awe-inspiring and authoritative vision of itself.

24-4A BERNINI, Scala Regia, Vatican, 1663–1666.

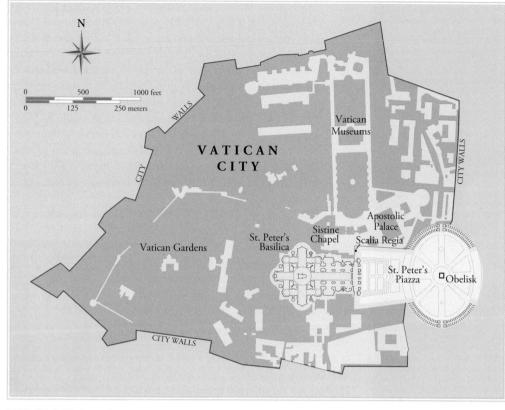

MAP 24-1 Vatican City.

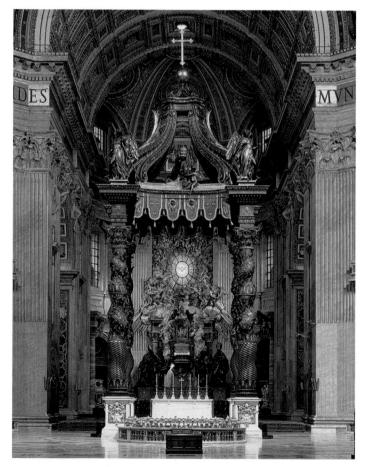

24-5 GIANLORENZO BERNINI, baldacchino (looking west), Saint Peter's, Vatican City, Rome, Italy, 1624–1633.

Bernini's baldacchino serves both functional and symbolic purposes. It marks Saint Peter's tomb and the high altar, and it visually bridges human scale to the lofty vaults and dome above.

BALDACCHINO Prior to being invited to design the piazza in front of Saint Peter's, Bernini had won the commission to erect a gigantic bronze baldacchino (FIG. 24-5) under Giacomo della Porta's dome (FIG. 22-25). Completed between 1624 and 1633, the canopylike structure (baldacco is Italian for "silk from Baghdad," such as for a cloth canopy) stands almost 100 feet high (the height of an average eight-story building) and serves both functional and symbolic purposes. It marks the high altar and the tomb of Saint Peter, and it visually bridges human scale to the lofty vaults and dome above. Further, for worshipers entering the nave of the huge church, it provides a dramatic, compelling presence at the crossing. Its columns also create a visual frame for the elaborate sculpture representing the throne of Saint Peter (the Cathedra Petri) at the far end of Saint Peter's (FIG. 24-5, rear). On a symbolic level, the structure's decorative elements speak to the power of the Cath-

olic Church and of Pope Urban VIII. Partially fluted and wreathed with vines, the baldacchino's four spiral columns are Baroque versions of the comparable columns of the ancient baldacchino over the same spot in Old Saint Peter's, thereby invoking the past to reinforce the primacy of the Roman Catholic Church in the 17th century. At the top of the vine-entwined columns, four colossal angels stand guard at the upper corners of the canopy. Forming the canopy's apex are four serpentine brackets that elevate the orb and the cross. Since the time of Constantine (FIG. 7-81, *right*; compare FIG. 9-2), the orb and the cross had served as symbols of the Church's triumph. The baldacchino also features numerous bees, symbols of Urban VIII's family, the Barberini. The structure effectively gives visual form to the triumph of Christianity and the papal claim to doctrinal supremacy.

The construction of the baldacchino was itself a remarkable feat. Each of the bronze columns consists of five sections cast from wood models using the *lost-wax process* (see "Hollow-Casting Life-Size Bronze Statues," Chapter 5, page 130). Although Bernini did some of the work himself, including cleaning and repairing the wax molds and doing the final cleaning and *chasing* (engraving and embossing) of the bronze casts, he contracted out much of the project to experienced bronze-casters and sculptors. The superstructure is predominantly cast bronze, although some of the sculptural elements are brass or wood. The enormous scale of the baldacchino required a considerable amount of bronze. On Urban VIII's orders, workmen dismantled the portico of the Pantheon (FIG. 7-49) to acquire the bronze for the baldacchino—ideologically appropriate, given the Church's rejection of polytheism.

The concepts of triumph and grandeur permeate every aspect of the 17th-century design of Saint Peter's. Suggesting a great and solemn procession, the main axis of the complex traverses the piazza (marked by the central obelisk) and enters Maderno's nave. It comes to a temporary halt at the altar beneath Bernini's baldacchino, but it continues on toward its climactic destination at another great altar in the apse.

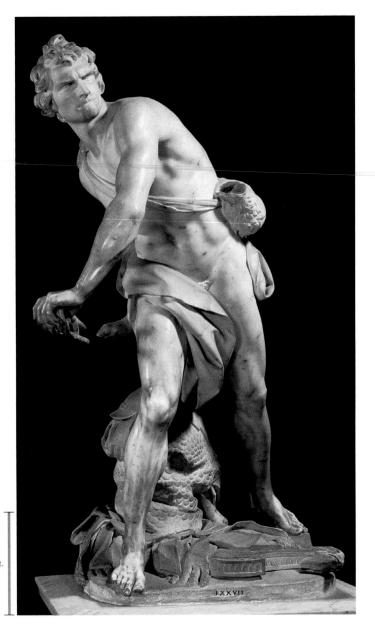

24-6 GIANLORENZO BERNINI, *David*, 1623. Marble, 5′ 7″ high. Galleria Borghese, Rome. ■

Bernini's sculptures are expansive and theatrical, and the element of time plays an important role in them. His emotion-packed *David* seems to be moving through both time and space.

DAVID Bernini's baldacchino is, like his Four Rivers Fountain (FIG. 24-1), a masterpiece of the sculptor's craft even more than the architect's. In fact, although Bernini achieved an international reputation as an architect, his fame rests primarily on his sculpture. The biographer Filippo Baldinucci (1625–1696) observed: "[T]here was perhaps never anyone who manipulated marble with more facility and boldness. He gave his works a marvelous softness . . . making the marble, so to say, flexible." Bernini's sculpture is expansive and theatrical, and the element of time usually plays an important role in it, as in the pronounced movement of the personified rivers—and the cascading water—in his Piazza Navona fountain.

A sculpture that predates both the Four Rivers Fountain and Saint Peter's baldacchino is Bernini's *David* (FIG. **24-6**). The Baroque master surely knew the Renaissance statues of the biblical hero fashioned by Donatello (FIG. 21-12), Verrocchio (FIG. 21-13), and Michelangelo (FIG. 22-13). Bernini's *David* differs fundamentally from those earlier masterpieces, however. Michelangelo portrayed David before his encounter with his gigantic adversary, and Donatello and Verrocchio depicted David after his triumph over Goliath. Bernini chose to represent the combat itself and aimed to catch the split-second of maximum action. Bernini's *David*, his muscular legs widely and firmly planted, begins the violent, pivoting motion that will launch the stone from his sling. (A bag full of stones is at David's left hip, suggesting he thought the fight would be tough and long.) Unlike Myron, the fifth-century BCE Greek sculptor who froze his *Discus Thrower* (FIG. 5-39) at a fleeting moment of inaction, Bernini selected the most dramatic of an implied sequence of poses, requiring the viewer to think simultaneously of the continuum and of this tiny fraction of it. The suggested continuum imparts a dynamic quality to the statue. In Bernini's *David*, the energy con-

fined in Michelangelo's figures (FIGS. 22-14 and 22-15) bursts forth. The Baroque statue seems to be moving through time and through space. This kind of sculpture cannot be inscribed in a cylinder or confined in a niche. Its unrestrained action demands space around it. Nor is it self-sufficient in the Renaissance sense, as its pose and attitude direct attention beyond it to the unseen Goliath. Bernini's *David* moves out into the space surrounding it, as do Apollo and Daphne in the marble group (FIG. **24-6A**) he carved for the same patron, Cardinal Scipione Borghese (1576–1633). Further, the expression

24-6A BERNINI, Apollo and Daphne, 1623–1624.

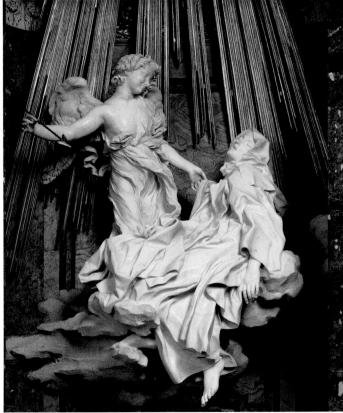

24-7 GIANLORENZO BERNINI, *Ecstasy of Saint Teresa*, Cornaro chapel, Santa Maria della Vittoria, Rome, Italy, 1645–1652. Marble, height of group 11′ 6″. ■4

The passionate drama of Bernini's depiction of Saint Teresa correlated with the ideas of Ignatius Loyola, who argued that the re-creation of spiritual experience would encourage devotion and piety.

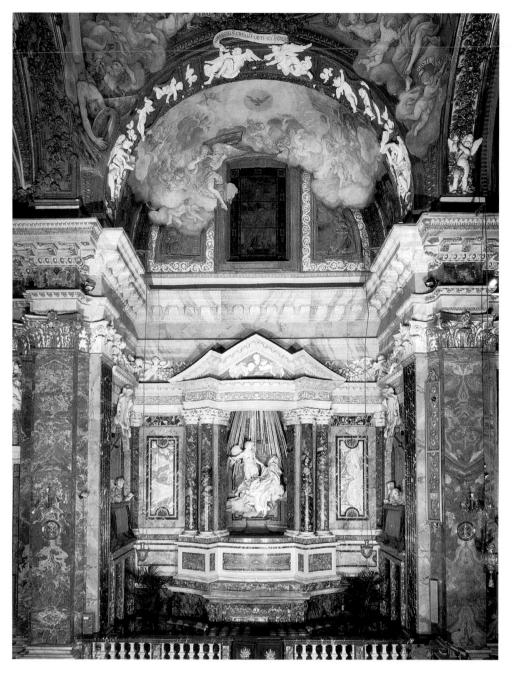

of intense concentration on David's face contrasts vividly with the classically placid visages of Donatello's and Verrocchio's versions and is more emotionally charged even than Michelangelo's. The tension in David's face augments the dramatic impact of Bernini's sculpture.

ECSTASY OF SAINT TERESA Another work displaying the motion and emotion that are hallmarks of Italian Baroque art is Bernini's *Ecstasy of Saint Teresa* (FIG. **24-7**) in the Cornaro chapel (FIG. **24-8**) of the Roman church of Santa Maria della Vittoria. The work exemplifies the Baroque master's refusal to limit his statues to firmly defined spatial settings. For this commission, Bernini marshaled the full capabilities of architecture, sculpture, and painting to charge the entire chapel with palpable tension. In the Cornaro chapel, Bernini drew on the considerable knowledge of the theater he derived from writing plays and producing stage designs. The marble sculpture that serves as the chapel's focus depicts Saint Teresa of Avila (1515–1582), a nun of the Carmelite order and one of the great mystical saints of the Spanish Counter-Reformation. Her

24-8 GIANLORENZO BERNINI, Cornaro chapel, Santa Maria della Vittoria, Rome, Italy, 1645–1652.

In the Cornaro chapel, Bernini, the quintessential Baroque artist, marshaled the full capabilities of architecture, sculpture, and painting to create an intensely emotional experience for worshipers.

conversion occurred after the death of her father, when she fell into a series of trances, saw visions, and heard voices. Feeling a persistent pain, she attributed it to the fire-tipped arrow of divine love an angel had thrust repeatedly into her heart. In her writings, Saint Teresa described this experience as making her swoon in delightful anguish.

In Bernini's hands, the entire Cornaro chapel became a theater for the production of this mystical drama. The niche in which it takes place appears as a shallow proscenium (the part of the stage in front of the curtain) crowned with a broken Baroque pediment and ornamented with polychrome marble. On either side of the chapel, sculpted portraits of members of the family of Cardinal Federico Cornaro (1579-1673) watch the heavenly drama unfold from choice balcony seats. Bernini depicted the saint in ecstasy, unmistakably a mingling of spiritual and physical passion, swooning back on a cloud, while the smiling angel aims his arrow. The

sculptor's supreme technical virtuosity is evident in the visual differentiation in texture among the clouds, rough nun's cloth, gauzy material, smooth flesh, and feathery wings—all carved from the same white marble. Light from a hidden window of yellow glass pours down on golden rays suggesting the radiance of Heaven, whose painted representation covers the vault.

The passionate drama of Bernini's *Ecstasy of Saint Teresa* correlated with the ideas disseminated earlier by Ignatius Loyola (1491–1556), who founded the Jesuit order in 1534 and whom the Catholic Church canonized as Saint Ignatius in 1622. In his book *Spiritual Exercises*, Ignatius argued that the re-creation of spiritual experiences in artworks would do much to increase devotion and piety. Thus, theatricality and sensory impact were useful vehicles for achieving Counter-Reformation goals (see "Religious Art in Counter-Reformation Italy," Chapter 22, page 617). Bernini was a devout Catholic, which undoubtedly contributed to his understanding of those goals. His inventiveness, technical skill, sensitivity to his patrons' needs, and energy made him the quintessential Italian Baroque artist.

24-9 FRANCESCO BORROMINI, facade of San Carlo alle Quattro Fontane (looking south), Rome, Italy, 1638–1641.

Borromini rejected the notion that a church should have a flat frontispiece. He set San Carlo's facade in undulating motion, creating a dynamic counterpoint of concave and convex elements.

SAN CARLO ALLE QUATTRO FONTANE

As gifted as Bernini was as an architect, FRANCESCO BORROMINI (1599-1667) took Italian Baroque architecture to even greater dramatic heights. In the little church of San Carlo alle Quattro Fontane (Saint Charles at the Four Fountains; FIG. 24-9), Borromini went much further than any of his predecessors or contemporaries in emphasizing a building's sculptural qualities. Although Maderno incorporated sculptural elements in his designs for the facades of Santa Susanna (FIG. 24-2) and Saint Peter's (FIG. 24-3), those church fronts still develop along relatively lateral planes. Borromini set his facade in undulating motion, creating a dynamic counterpoint of concave and convex elements on two levels (for example, the sway of the cornices). He enhanced the three-dimensional effect with deeply recessed niches. This facade is not the traditional flat frontispiece that defines a building's outer limits. It is a pulsating, engaging

screen inserted between interior and exterior space, designed not to separate but to provide a fluid transition between the two. In fact, San Carlo has not one but two facades, underscoring the functional interrelation of the building and its environment. The second facade, a narrow bay crowned with its own small tower, turns away from the main facade and, following the curve of the street, faces an intersec-

24-9A GUARINI, Palazzo Carignano, Turin, 1679–1692.

tion. Borromini's innovative style had an enormous influence on later Baroque architects throughout Italy. The Palazzo Carignano (FIG. **24-9A**) in Turin, for example, designed by GUARINO GUARINI (1624–1683), depends heavily on Borromini's work in Rome.

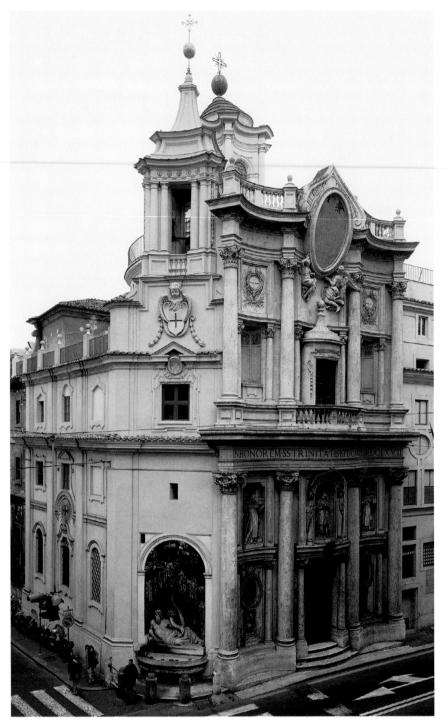

The interior of San Carlo alle Quattro Fontane is not only Borromini's ingenious response to an awkward site but also a provocative variation on the theme of the centrally planned church. In plan (FIG. **24-10**), San Carlo is a hybrid of a *Greek cross* (a cross with four arms of equal length) and an oval, with a long axis between entrance and apse. The side walls move in an undulating flow that reverses the facade's motion. Vigorously projecting columns define the space into which they protrude just as much as they accent the walls to which they are attached. Capping this molded interior space is a deeply coffered oval dome (FIG. **24-11**) that seems to float on the light entering through windows hidden in its base. Rich variations on the basic theme of the oval—dynamic curves relative to the static circle create an interior that flows from entrance to altar, unimpeded by the segmentation so characteristic of Renaissance buildings.

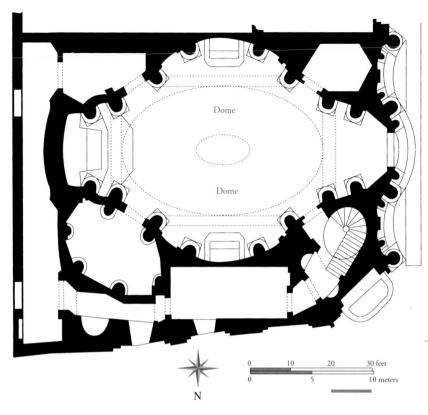

24-10 FRANCESCO BORROMINI, plan of San Carlo alle Quattro Fontane, Rome, Italy, 1638–1641.

The plan of San Carlo is a hybrid of a Greek cross and an oval. The walls pulsate in a way that reverses the facade's movement. The molded, dramatically lit space flows from entrance to altar.

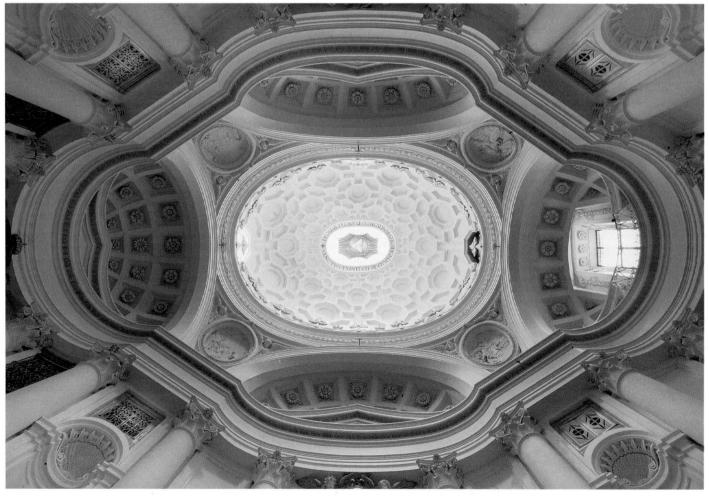

24-11 FRANCESCO BORROMINI, San Carlo alle Quattro Fontane (view into dome), Rome, Italy, 1638-1641.

In place of a traditional round dome, Borromini capped the interior of San Carlo with a deeply coffered oval dome that seems to float on the light entering through windows hidden in its base.

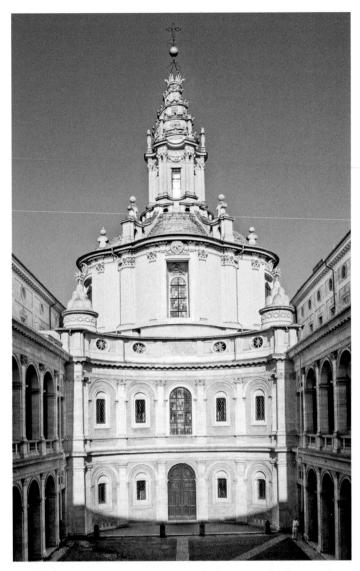

24-12 FRANCESCO BORROMINI, Chapel of Saint Ivo (looking east), College of the Sapienza, Rome, Italy, begun 1642.

In characteristic fashion, Borromini played concave against convex forms on the upper level of the Chapel of Saint Ivo. Pilasters restrain the forces that seem to push the bulging forms outward.

CHAPEL OF SAINT IVO Borromini carried the unification of interior space even further in the Chapel of Saint Ivo (FIG. **24-12**) at the east end of the courtyard of the College of the Sapienza (Wisdom) in Rome. In his characteristic manner, Borromini played concave against convex forms on the upper level of the chapel's exterior. The arcaded courtyard, which frames the lower levels of the chapel's facade, had already been constructed when Borromini began work, and he adjusted his design to achieve a harmonious merging of the new and older parts of the college. Above the inward-curving lower two stories of the Saint Ivo chapel rises a convex drumlike structure that supports the dome's lower parts. Clusters of pilasters restrain the forces that seem to push the bulging forms outward. Buttresses above the pilasters curve upward to brace a tall, ornate lantern topped by a spiral that, screwlike, seems to fasten the structure to the sky.

The centralized plan (FIG. **24-13**) of the interior of the Saint Ivo chapel is that of a star with rounded points and apses on all sides. Indentations and projections along the angled curving walls create a highly complex plan, with all the elements fully reflected in the

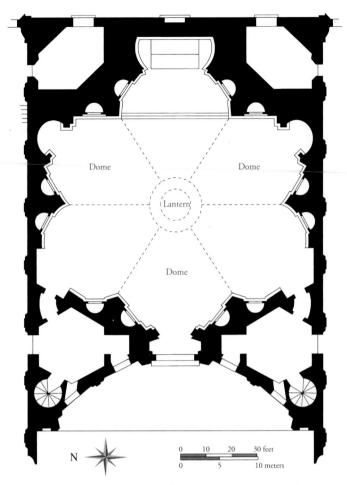

24-13 FRANCESCO BORROMINI, plan of the Chapel of Saint Ivo, College of the Sapienza, Rome, Italy, begun 1642.

The interior elevation of Borromini's Saint Ivo chapel fully reflects all the elements of its highly complex plan, which is star-shaped with rounded points and apses on all sides.

interior elevation. From floor to lantern, the wall panels rise in a continuously tapering sweep halted only momentarily by a single horizontal cornice (FIG. **24-14**). Thus, the dome is not a separate unit placed on a supporting block, as in Renaissance buildings. It is an organic part that evolves out of and shares the qualities of the sup-

porting walls, and it cannot be separated from them. This carefully designed progression up through the lantern creates a dynamic and cohesive shell that encloses and energetically molds a scalloped fragment of space. Few architects have matched Borromini's ability to translate extremely complicated designs into masterfully unified structures, but some later architects, including Guarini, an accomplished mathematician as well as architect, designed even more complex domes (FIG. **24-14A**).

24-14A GUARINI, Chapel of the Holy Shroud, Turin, 1667–1694.

Painting

Although architecture and sculpture provided the most obvious vehicles for manipulating space and creating theatrical effects, painting continued to be an important art form in 17th-century Italy. Among the most noted Italian Baroque painters were Annibale Carracci and Caravaggio, whose styles, although different, were both thoroughly in accord with the period.

ANNIBALE CARRACCI A native of Bologna, ANNIBALE CARRACCI (1560–1609) received much of his training at an art academy founded there by several members of his family, among them his cousin Ludovico Carracci (1555–1619) and brother Agostino Carracci (1557–1602). The Bolognese academy was the first signifi-

24-14 FRANCESCO BORROMINI, Chapel of Saint Ivo (view into dome), College of the Sapienza, Rome, Italy, begun 1642.

Unlike Renaissance domes, Borromini's Baroque dome is an organic part that evolves out of and shares the qualities of the supporting walls, and it cannot be separated from them.

cant institution of its kind in the history of Western art. The Carracci established it on the premises that art can be taught—the basis of any academic philosophy of art—and that art instruction must include the classical and Renaissance traditions in addition to the study of anatomy and life drawing.

In Flight into Egypt (FIG. 24-15), based on the biblical narrative from Matthew 2:13–14, Annibale Carracci created the "ideal" or "classical" landscape, in which nature appears ordered by divine law and human reason. Tranquil hills and fields, quietly gliding streams, serene skies, unruffled foliage, shepherds with their flocks—all the props of the pastoral scene and mood familiar in Venetian Renaissance paintings

(FIG. 22-35)—expand to fill the picture space in *Flight into Egypt* and similar paintings. Carracci regularly included screens of trees in the foreground, dark against the sky's even light. In contrast to many Renaissance artists, he did not create the sense of deep space through linear perspective but rather by varying light and shadow

24-15 ANNIBALE CARRACCI, Flight into Egypt, 1603–1604. Oil on canvas, $4' \times 7'$ 6". Galleria Doria Pamphili, Rome.

Carracci's landscapes idealize antiquity and the idyllic life. Here, the pastoral setting takes precedence over the narrative of Mary, the Christ Child, and Saint Joseph wending their way slowly to Egypt.

24-16 ANNIBALE CARRACCI, Loves of the Gods, ceiling frescoes in the gallery, Palazzo Farnese (FIG. 22-26), Rome, Italy, 1597–1601. ■4

On the shallow curved vault of this gallery in the Palazzo Farnese, Carracci arranged the mythological scenes in a quadro riportato format resembling easel paintings on a wall.

to suggest expansive atmosphere. In *Flight into Egypt*, streams or terraces, carefully placed one above the other and narrowed, zigzag through the terrain, leading the viewer's eyes back to the middle ground. There, many Venetian Renaissance landscape artists depicted walled towns or citadels, towers, temples, monumental tombs, and villas (as Carracci did in *Flight into Egypt*). These constructed environments captured idealized antiquity and the idyllic life. Although the artists often took the subjects for these classically rendered scenes from religious or heroic stories, they favored pastoral landscapes over narratives. Here, Annibále greatly diminished the size of Mary, the Christ Child, and Saint Joseph, who simply become part of the landscape as they wend their way slowly to Egypt after having been ferried across a stream.

LOVES OF THE GODS Carracci's most notable works are his frescoes (FIG. **24-16**) in the Palazzo Farnese in Rome. Cardinal Odoardo Farnese (1573–1626), a wealthy descendant of Pope Paul III, who built the palace (FIG. 22-26) in the 16th century, commissioned Annibale to decorate the ceiling of the palace's gallery to celebrate the wedding of the cardinal's brother. Appropriately, the title of the fresco's iconographic program is *Loves of the Gods* interpretations of the varieties of earthly and divine love in classical mythology.

Carracci arranged the scenes in a format resembling framed easel paintings on a wall, but in the Farnese gallery the paintings cover a shallow curved vault. The term for this type of simulation of easel painting for ceiling design is *quadro riportato* (transferred framed painting). By adapting the northern European and Venetian tradition of easel painting to the Florentine and Roman fresco tradition, Carracci reoriented the direction of painting in central Italy. He made quadro riportato fashionable for more than a century.

Flanking the framed pictures are polychrome seated nude youths, who turn their heads to gaze at the scenes around them, and

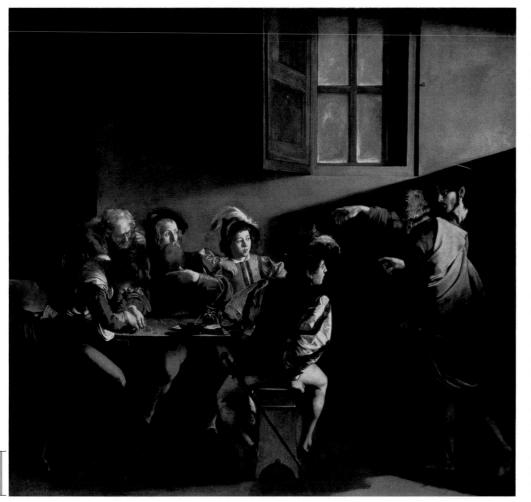

standing Atlas figures painted to resemble marble statues. Carracci derived these motifs from the Sistine Chapel ceiling (FIG. 22-17), but he did not copy Michelangelo's figures. Notably, the chiaroscuro of the Farnese gallery frescoes differs for the pictures and the figures surrounding them. Carracci modeled the figures inside the panels in an even light. In contrast, light from beneath illuminates the outside figures, as if they were tangible three-dimensional beings or statues lit by torches in the gallery below. This interest in illusion, already manifest in the Renaissance, continued in the grand ceiling compositions (FIGS. 24-21 to 24-24) of the mature Baroque. In the crown of the vault, the long panel, *Triumph of Bacchus*, is an ingenious mixture of Raphael's drawing style and lighting and Titian's more sensuous and animated figures. Carracci succeeded in adjusting their authoritative styles to create something of his own—no easy achievement.

CARAVAGGIO Michelangelo Merisi, known as CARAVAGGIO (1573–1610) after his northern Italian birthplace, developed a unique style that had tremendous influence throughout Europe. His outspoken disdain for the classical masters (probably more rhetorical than real) drew bitter criticism from many painters, one of whom denounced him as the "anti-Christ of painting." Giovanni Pietro Bellori (1613–1696), the most influential critic of the age and an admirer of Annibale Carracci, believed Caravaggio's refusal to emulate the models of his distinguished predecessors threatened the whole classical tradition of Italian painting that had reached its zenith in Raphael's work (see "Giovanni Pietro Bellori on Annibale Carracci and Caravaggio," page 682). Yet despite this criticism and the problems in Caravaggio's troubled life (police records

24-17 CARAVAGGIO, Calling of Saint Matthew, ca. 1597–1601. Oil on canvas, $11' 1'' \times 11' 5''$. Contarelli chapel, San Luigi dei Francesi, Rome.

The stark contrast of light and dark was a key feature of Caravaggio's style. Here, Christ, cloaked in mysterious shadow, summons Levi the tax collector (Saint Matthew) to a higher calling.

are an important source of information about the artist), Caravaggio received many commissions, both public and private, and numerous painters paid him the supreme compliment of borrowing from his innovations. His influence on later artists, as much outside Italy as within, was immense. In his art, Caravaggio injected naturalism into both religion and the classics, reducing them to human dramas played out in the harsh and dingy settings of his time and place. The unidealized figures he selected from

the fields and the streets of Italy, however, were effective precisely because of their familiarity.

CALLING OF SAINT MATTHEW An early Caravaggio masterpiece, *Calling of Saint Matthew* (FIG. **24-17**), is one of two large canvases honoring Saint Matthew the artist created for the Contarelli chapel in San Luigi dei Francesi (Saint Louis of the French) in

Rome. Caravaggio received the commission for the San Luigi paintings upon the recommendation of Cardinal Del Monte, for whom the artist had recently painted *Musicians* (FIG. **24-17A**). The commonplace setting of the painting—a tavern with unadorned walls—is typical of Caravaggio. Into this mundane environment, cloaked in mysterious shadow and almost unseen, Christ, identifiable

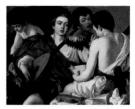

24-17A CARAVAGGIO, *Musicians*, ca. 1595.

initially only by his indistinct halo, enters from the right. With a commanding gesture, he summons Levi, the Roman tax collector, to a higher calling. The astonished Levi—his face highlighted for the viewer by the beam of light emanating from an unspecified source above Christ's head and outside the picture—points to himself in disbelief. Although Christ's extended arm is reminiscent of the Lord's in Michelangelo's *Creation of Adam* (FIG. 22-18), the position of his hand and wrist is similar to Adam's. This reference was highly appropriate, because the Church considered Christ to be the second Adam. Whereas Adam was responsible for the fall of humankind, Christ is the vehicle of its redemption. The conversion of Levi (who became Matthew) brought his salvation.

Giovanni Pietro Bellori on Annibale Carracci and Caravaggio

The written sources to which art historians turn as aids in understanding the art of the past are invaluable, but they reflect the personal preferences and prejudices of the writers. Pliny the Elder, for example, claimed in the first century CE that "art ceased" after the death of Alexander the Great—a remark usually interpreted as expressing his disapproval of Hellenistic art in contrast to Classical art (see Chapter 5).* Giorgio Vasari, the biographer and champion of Italian Renaissance artists, condemned Gothic art as "monstrous and barbarous," and considered medieval art in general a distortion of the noble art of the Greeks and Romans (see Chapter 13).[†] Giovanni Pietro Bellori, the leading biographer of Baroque artists, similarly recorded his admiration for Renaissance classicism as well as his distaste for Mannerism and realism in his opposing evaluations of Annibale Carracci and Caravaggio.

In the opening lines of his *Vita* (Life) of Carracci, Bellori praised "the divine Raphael . . . [whose art] raised its beauty to the summit, restoring it to the ancient majesty of . . . the Greeks and the Romans" and lamented that soon after, "artists, abandoning the study of nature, corrupted art with the *maniera*, that is to say, with the fantastic idea based on practice and not on imitation." But fortunately, Bellori observed, just "when painting was drawing to its end," Annibale Carraccci rescued "the declining and extinguished art."[‡]

Bellori especially lauded Carracci's Palazzo Farnese frescoes (FIG. 24-16):

No one could imagine seeing anywhere else a more noble and magnificent style of ornamentation, obtaining supreme excellence in the compartmentalization and in the figures and executed with the grandest manner in the design with the just proportion and the great strength of chiaroscuro. . . . Among modern works they have no comparison.[§]

In contrast, Bellori characterized Caravaggio as talented and widely imitated but misguided in his rejection of classicism in favor of realism. [Caravaggio] began to paint according to his own inclinations; not only ignoring but even despising the superb statuary of antiquity and the famous paintings of Raphael, he considered nature to be the only subject fit for his brush. As a result, when he was shown the most famous statues of [the ancient sculptors] Phidias [FIG. 5-46] and Glykon [FIG. 5-66] in order that he might use them as models, his only answer was to point toward a crowd of people, saying that nature had given him an abundance of masters.... [W]hen he came upon someone in town who pleased him he made no attempt to improve on the creations of nature."

[Caravaggio] claimed that he imitated his models so closely that he never made a single brushstroke that he called his own, but said rather that it was nature's. Repudiating all other rules, he considered the highest achievement not to be bound to art. For this innovation he was greatly acclaimed, and many talented and educated artists seemed compelled to follow him . . . Nevertheless he lacked *invenzione*, decorum, *disegno*, or any knowledge of the science of painting. The moment the model was taken from him, his hand and his mind became empty. . . . Thus, as Caravaggio suppressed the dignity of art, everybody did as he pleased, and what followed was contempt for beautiful things, the authority of antiquity and Raphael destroyed. . . . Now began the imitation of common and vulgar things, seeking out filth and deformity.⁺⁺

*Pliny, Natural History, 25.52.

[†]Giorgio Vasari, Introduzione alle tre arti del disegno (1550), ch. 3.

^{*}Giovanni Pietro Bellori, *Le vite de' pittori, scultori e architetti moderni* (Rome, 1672). Translated by Catherine Enggass, *The Lives of Annibale and Agostino Carracci by Giovanni Pietro Bellori* (University Park: Pennsylvania University Press, 1968), 5–6.

[§]Ibid., 33.

"Translated by Howard Hibbard, *Caravaggio* (New York: Harper & Row, 1983), 362.

⁺⁺ Ibid., 371–372.

CONVERSION OF SAINT PAUL A piercing ray of light illuminating a world of darkness and bearing a spiritual message is also a central feature of *Conversion of Saint Paul* (FIG. 24-18), which Caravaggio painted for the Cerasi chapel in Santa Maria del Popolo. He depicted the saint-to-be at the moment of his conversion, flat on his back with his arms thrown up. In the background, an old groom seems preoccupied with caring for the horse. At first inspection, little here suggests the momentous significance of the unfolding spiritual event. The viewer could be witnessing a mere stable accident, not a man overcome by a great miracle. Although many of his contemporaries criticized Caravaggio for departing from traditional depictions of religious scenes, the eloquence and humanity with which he imbued his paintings impressed many others.

To compel worshipers' interest and involvement in Paul's conversion, Caravaggio employed a variety of ingenious formal devices. Here, as in the slightly later *Entombment* (FIG. 24-18A), he used a perspective and a chiaroscuro intended to bring viewers as close as possible to the scene's space and action, almost as if they

were participants. The low horizon line augments the sense of inclusion. Further, Caravaggio designed *Conversion of Saint Paul* for its specific location on the chapel wall, positioned at the line of sight of an average-height person standing at the chapel entrance. The sharply lit figures emerge from the dark background as if illuminated by the light from the chapel's windows. The lighting resembles that of a stage production and is analogous to the rays in Bernini's *Ecstasy of Saint Teresa* (FIGS. 24-7 and 24-8).

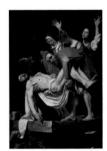

24-18A CARAVAGGIO, Entombment, ca. 1603.

Caravaggio's figures are still heroic with powerful bodies and clearly delineated contours in the Renaissance tradition, but the stark and dramatic contrast of light and dark, which at first shocked and then fascinated his contemporaries, obscures the more traditional aspects of his style. Art historians call Caravaggio's use of dark settings enveloping their occupants—which profoundly

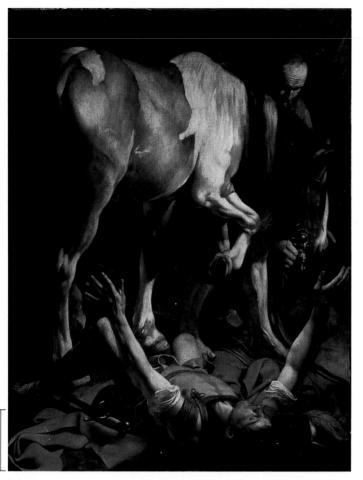

24-18 CARAVAGGIO, Conversion of Saint Paul, ca. 1601. Oil on canvas, 7' 6" \times 5' 9". Cerasi chapel, Santa Maria del Popolo, Rome.

Caravaggio used perspective, chiaroscuro, and dramatic lighting to bring viewers into this painting's space and action, almost as if they were participants in Saint Paul's conversion to Christianity.

influenced European art, especially in Spain and the Netherlands *tenebrism*, from the Italian word *tenebroso*, or "shadowy" manner. In Caravaggio's work, tenebrism also contributed greatly to the essential meaning of his pictures. In *Conversion of Saint Paul*, the dramatic spotlight shining down upon the fallen Paul is the light of divine revelation converting him to Christianity.

ARTEMISIA GENTILESCHI Caravaggio's combination of naturalism and drama appealed both to patrons and artists, and he had many followers. Among them was the most celebrated woman artist of the era, ARTEMISIA GENTILESCHI (ca. 1593–1653), whose father Orazio (1563–1639), her teacher, was himself strongly influenced by Caravaggio. The daughter's successful career, pursued in Florence, Venice, Naples, and Rome, helped disseminate Caravaggio's style throughout the peninsula.

In *Judith Slaying Holofernes* (FIG. **24-19**), Gentileschi adopted the tenebrism and what might be called the "dark" subject matter Caravaggio favored. Significantly, she chose a narrative involving a heroic woman, a favorite theme of hers. The story, from the book of Judith, relates the delivery of Israel from the Assyrians. Having succumbed to Judith's charms, the Assyrian general Holofernes invited her to his tent for the night. When he fell asleep, Judith cut off his head. In this version of the scene (Gentileschi produced more than one painting of the subject), Judith and her maidservant behead Holofernes. Blood spurts everywhere as the two women

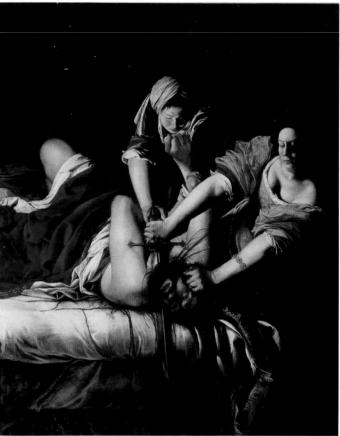

24-19 ARTEMISIA GENTILESCHI, Judith Slaying Holofernes, ca. 1614–1620. Oil on canvas, 6′ 6¹/₃″ × 5′ 4″. Galleria degli Uffizi, Florence. ■(

Narratives involving heroic women were a favorite theme of Gentileschi. In *Judith Slaying Holofernes*, the dramatic lighting of the action in the foreground emulates Caravaggio's tenebrism.

summon all their strength to wield the heavy sword. The tension and strain are palpable. The controlled highlights on the action in the foreground recall Caravaggio's work and heighten the drama here as well.

LA PITTURA During the brief period Orazio Gentileschi was the official painter of the English king Charles I (r. 1625–1649), Artemisia painted perhaps her most unusual work, an allegory of Painting (*La Pittura*; FIG. **24-20**). Most art historians believe the painting, which was in the collection of the king at the time of his execution in 1649, is a self-portrait.

Gentileschi's personified image of Painting as a woman closely follows the prescription for representing *La Pittura* in a widely circulated handbook by Cesare Ripa (d. 1622) called *Iconologia*, published in 1593. Until the 16th century, only Poetry and Music had a fixed iconography. The inclusion of Painting in Ripa's handbook reflects the newly elevated status painters held during the Renaissance. He describes *La Pittura* as a beautiful woman with disheveled hair painting with her brush in one hand and holding her palette in the other. She wears a gold chain with a pendant in the form of a mask, because masks imitate faces and painting is the art of imitation. The chain symbolizes the continuous linkage of master to pupil from generation to generation. Gentileschi incorporated all of these traits into her painting, but instead of representing *La Pittura* as a frontal, emblematic figure, she portrayed her as actively

The Letters of Artemisia Gentileschi

rtemisia Gentileschi (FIG. 24-20) A was the most renowned woman painter in Europe during the first half of the 17th century and the first woman ever admitted to membership in Florence's Accademia del Disegno (Academy of Design). As did other women who could not become apprentices in all-male studios (see "The Artist's Profession," Chapter 20, page 545), she learned her craft from her father. Never forgotten in subsequent centuries, Artemisia's modern fame stems from the seminal 1976 exhibition Women Artists: 1550-1950,* which opened a new chapter in feminist art history.

24-20 ARTEMISIA GENTILESCHI, Self-Portrait as the Allegory of Painting, ca. 1638–1639. Oil on canvas, 3' $2\frac{7''}{8} \times 2' 5\frac{5''}{8}$. Royal Collection, Kensington Palace, London.

Gentileschi here portrayed herself in the guise of *La Pittura* (Painting) with brush and palette. To paint a self-portrait from the side, Gentileschi had to set up a pair of mirrors to record her features.

In addition to scores of paintings created for wealthy patrons, among them the king of England and the grand duke of Tuscany, Gentileschi left behind 28 letters, some of which reveal she believed patrons treated her differently because of her gender. Three 1649 letters written in Naples to Don Antonio Ruffo (1610–1678) in Messina make her feelings explicit.

I fear that before you saw the painting you must have thought me arrogant and presumptuous. . . . [I]f it were not for Your Most Illustrious Lordship . . . I would not have been induced to give it for one hundred and sixty, because everywhere else I have been I was paid one hundred *scudi* per figure. . . . You think me pitiful, because a woman's name raises doubts until her work is seen.[†]

I was mortified to hear that you want to deduct one third from the already very low price that I had asked. . . . It must be that in your heart Your Most Illustrious Lordship finds little merit in me.[‡]

As for my doing a drawing and sending it, [tell the gentleman who wishes to know the price for a painting that] I have made a solemn vow never to send my drawings because people have cheated me. In particular, just today I found myself [in the situation] that, having done a drawing of souls in Purgatory for the Bishop of St. Gata, he, in order to spend less, commissioned another painter to do the painting using my work. If I were a man, I can't imagine it would have turned out this way, because when the concept has been real-

engaged in her craft, seen from her left side. The viewer's eye follows the line of her left arm through the curve of her shoulders and right arm to her right hand, the instrument of artistic genius. It is noteworthy that the canvas in this painting is blank. This is not a self-portrait of the artist at work on a specific painting (compare FIGS. 23-18, 25-11, 26-15, and 26-16) but a portrait of Gentileschi as Painting herself.

In almost all Renaissance and Baroque self-portraits, the artist gazes at the viewer. The frontal view not only provides the fullest view of the artist's features, but it is also the easiest to paint because the artist needs only to look in a mirror in order to record his or her features (FIG. 22-43). To create this self-portrait, however, Gentileschi had to set up two mirrors in order to paint her likeness from

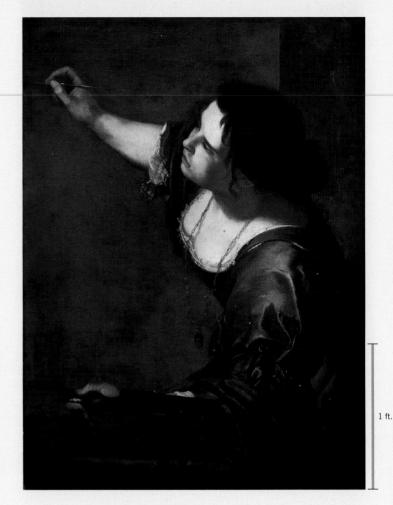

ized and defined with lights and darks, and established by means of planes, the rest is a trifle.[§]

*Ann Sutherland Harris and Linda Nochlin, *Women Artists: 1550–1950* (Los Angeles: Los Angeles County Museum of Art, 1976), 118–124. *Letter dated Janary 30, 1649. Translated by Mary D. Garrard, *Artemisia Gentileschi: The Image of the Female Hero in Italian Baroque Art* (Princeton, N.J.: Princeton University Press, 1989), 390. *Letter dated October 23, 1649. Ibid., 395–396. *Letter dated November 13, 1649. Ibid., 397–398.

an angle, a highly original break from tradition and an assertion of her supreme skill in a field dominated by men (see "The Letters of Artemisia Gentileschi," above).

GUIDO RENI Caravaggio was not the only early-17th-century painter to win a devoted following. GUIDO RENI (1575–1642), known to his many admirers as "the divine Guido," trained in the Bolognese art academy founded by the Carracci family. The influence of Annibale Carracci and Raphael is evident in *Aurora* (FIG. **24-21**), a ceiling fresco in the Casino Rospigliosi in Rome. Aurora (Dawn) leads Apollo's chariot, while the Hours dance about it. Guido conceived *Aurora* as a quadro riportato, following the format of the paintings in Annibale's *Loves of the Gods* (FIG. 24-16), and

24-21 GUIDO RENI, Aurora, ceiling fresco in the Casino Rospigliosi, Rome, Italy, 1613–1614.

The "divine Guido" conceived Aurora as a quadro riportato, reflecting his training in the Bolognese art academy. The scene of Dawn leading Apollo's chariot derives from ancient Roman reliefs.

provided the quadro with a complex and convincing illusionistic frame. The fresco exhibits a fluid motion, soft modeling, and sure composition, although without Raphael's sculpturesque strength. It is an intelligent interpretation of the Renaissance master's style. Consistent with the precepts of the Bolognese academy, the painter also looked to antiquity for models. The ultimate sources for the *Aurora* composition were Roman reliefs (FIG. 7-42) and coins depicting emperors in triumphal chariots accompanied by flying Victories and other personifications.

PIETRO DA CORTONA The experience of looking up at a painting is different from viewing a painting hanging on a wall. The considerable height and the expansive scale of most ceiling frescoes induce a feeling of awe. Patrons who wanted to burnish their public image or control their legacy found monumental ceiling frescoes to be perfect vehicles. In 1633, Pope Urban VIII commissioned a ceiling fresco for the Gran Salone (the main reception hall) of the Palazzo Barberini in Rome. The most important decorative commission of the 1630s, the lucrative assignment went to PIETRO DA CORTONA (1596–1669), a Tuscan architect and painter who had moved to Rome two decades before. The grandiose and spectacular Triumph of the Barberini (FIG. 24-22) overwhelms spectators with

24-22 PIETRO DA CORTONA, *Triumph of the Barberini*, ceiling fresco in the Gran Salone, Palazzo Barberini, Rome, Italy, 1633–1639.

In this dramatic ceiling fresco, Divine Providence appears in a halo of radiant light directing Immortality, holding a crown of stars, to bestow eternal life on the family of Pope Urban VIII.

24-23 GIOVANNI BATTISTA GAULLI, *Triumph of the Name of Jesus*, ceiling fresco with stucco figures on the nave vault of Il Gesù (FIG. 22-56), Rome, Italy, 1676–1679.

In the nave of II Gesù, gilded architecture opens up to offer the faithful a glimpse of Heaven. To heighten the illusion, Gaulli painted figures on stucco extensions that project outside the painting's frame.

the glory of the Barberini family (and Urban VIII in particular). The iconographic program for this fresco, designed by the poet Francesco Bracciolini (1566–1645), centered on the accomplishments of the Barberini. Divine Providence appears in a halo of radiant light directing Immortality, holding a crown of stars, to bestow eternal life on the family. The virtues Faith, Hope, and Charity hold aloft a gigantic laurel wreath (also a symbol of immortality), which frames three bees (the Barberini family's symbols, which also appeared in Bernini's baldacchino, FIG. 24-5). Also present are the papal tiara and keys announcing the personal triumphs of Urban VIII.

GIOVANNI BATTISTA GAULLI The dazzling spectacle of ceiling frescoes also proved very effective for commissions illustrating religious themes. Church authorities realized paintings high above the ground offered perfect opportunities to impress on worshipers the glory and power of the Catholic Church. In conjunction with the theatricality of Italian Baroque architecture and sculpture, monumental frescoes on church ceilings contributed to creating transcendent spiritual environments well suited to the needs of the Catholic Church in Counter-Reformation Rome.

Triumph of the Name of Jesus (FIG. **24-23**) in the nave of Il Gesù (FIGS. 22-56 and 22-57) vividly demonstrates the dramatic impact Baroque ceiling frescoes could have. As the mother church of the Jesuit order, Il Gesù played a prominent role in Counter-

Reformation efforts. In this immense fresco by GIOVANNI BATTISTA GAULLI (1639–1709), gilded architecture opens up in the center of the ceiling to offer the faithful a stunning glimpse of Heaven. Gaulli represented Jesus as a barely visible monogram (IHS) in a blinding radiant light floating heavenward. In contrast, sinners experience a violent descent back to Earth. The painter glazed the gilded architecture to suggest shadows, thereby enhancing the scene's illusionistic quality. To further heighten the illusion, Gaulli painted many of the sinners on three-dimensional stucco extensions projecting outside the painting's frame.

FRA ANDREA POZZO Another master of ceiling decoration was FRA ANDREA POZZO (1642–1709), a lay brother of the Jesuit order and a master of perspective, on which he wrote an influential treatise. Pozzo designed and executed the vast ceiling fresco *Glorification of Saint Ignatius* (FIG. **24-24**) for the church of Sant'Ignazio in Rome. Like II Gesù, Sant'Ignazio was a prominent Counter-Reformation church because of its dedication to the founder of the Jesuit order. The Jesuits played a major role in Catholic education and sent legions of missionaries to the New World and Asia. As

Gaulli did in Il Gesù, Pozzo created the illusion of Heaven opening up above the congregation. To accomplish this, the artist painted an extension of the church's architecture into the vault so the roof seems to be lifted off. As Heaven and Earth commingle, Christ receives Saint Ignatius in the presence of figures personifying the four corners of the world. A disk in the nave floor marks the spot where the viewer should stand to gain the whole perspective illusion. For worshipers looking up from this point, the vision is complete. They find themselves in the presence of the heavenly and spiritual.

The effectiveness of Italian Baroque religious art depended on the drama and theatricality of individual images, as well as on the interaction and fusion of architecture, sculpture, and painting. Sound enhanced this experience. Architects designed churches with acoustical effects in mind, and in an Italian Baroque church filled with music, the power of both image and sound must have been immensely moving. Through simultaneous stimulation of both the senses of sight and hearing, the faithful might well have been transported into a trancelike state that would, indeed, as the great English poet John Milton (1608–1674) eloquently stated in *Il Penseroso* (1631), "bring all Heaven before [their] eyes."²

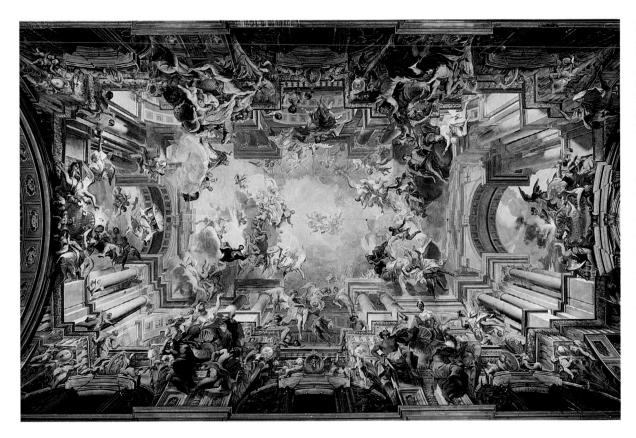

24-24 FRA ANDREA POZZO, *Glorification of Saint Ignatius*, ceiling fresco in the nave of Sant'Ignazio, Rome, Italy, 1691–1694.

By merging real and painted architecture, Pozzo created the illusion the vaulted ceiling of Sant'Ignazio has been lifted off and the nave opens to Heaven above the worshipers' heads.

SPAIN

During the 16th century, Spain had established itself as an international power. The Habsburg kings had built a dynastic state encompassing Portugal, part of Italy, the Netherlands, and extensive areas of the New World (see Chapters 23 and 35). By the beginning of the 17th century, however, the Habsburg Empire was struggling, and although Spain mounted an aggressive effort during the Thirty Years' War (see Chapter 25), by 1660 the imperial age of the Spanish Habsburgs was over. In part, the demise of the Habsburg Empire was due to economic woes. The military campaigns Philip III (r. 1598–1621) and his son Philip IV (r. 1621–1665) waged during the Thirty Years' War were costly and led to higher taxes. The increasing tax burden placed on Spanish subjects in turn incited revolts and civil war in Catalonia and Portugal in the 1640s, further straining an already fragile economy.

Painting

Although the dawn of the Baroque period found the Spanish kings struggling to maintain control of their dwindling empire, both Philip III and Philip IV realized the prestige great artworks brought and the value of visual imagery in communicating to a wide audience. Thus, both of them continued to spend lavishly on art.

JUAN SÁNCHEZ COTÁN One painter who made a major contribution to the development of Spanish art, although he did not receive any royal commissions, was JUAN SÁNCHEZ COTÁN (1560–1627). Born in Orgaz, outside Toledo, Sánchez Cotán moved to Granada and became a Carthusian monk in 1603. Although he painted religious subjects, his greatest works are the *still lifes* (paintings of artfully arranged inanimate objects) he produced before entering monastic life (and never thereafter). Few in number, they nonetheless established still-life painting as an important genre in 17th-century Spain. Still Life with Game Fowl (FIG. 24-25) is one of Sánchez Cotán's most ambitious compositions, but it conforms to the pattern he adopted for all of his still lifes. A niche or a window—the artist clearly wished the setting to be indeterminate—fills the entire surface of the canvas. At the bottom, fruits and vegetables, including a melon—cut open with a slice removed—rest on a ledge. Above, suspended on strings from a nail or hook outside the frame, are a quince and four game fowl. All are meticulously rendered and

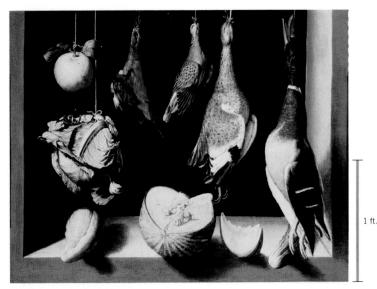

24-25 JUAN SÁNCHEZ COTÁN, *Still Life with Game Fowl*, ca. 1600–1603. Oil on canvas, 2' $2\frac{3''}{4} \times 2' 10\frac{7''}{8}$. Art Institute of Chicago, Chicago (gift of Mr. and Mrs. Leigh B. Block).

Sánchez Cotán established still life as an important genre in Spain. His compositions feature brightly illuminated fruits, vegetables, and birds, hanging or on a ledge, against a dark background.

brightly illuminated, enhancing the viewer's sense of each texture, color, and shape, yet the background is impenetrable shadow. The sharp and unnatural contrast between light and dark imbues the still life with a sense of mystery absent, for example, in Dutch still-life paintings (FIGS. 23-17, 25-1, 25-22, and 25-23). There may, in fact, be a spiritual reference. Sánchez Cotán once described his 11 paintings of fruits, vegetables, and birds as "offerings to the Virgin"—probably a reference to the Virgin as the *fenestra coeli* ("window to Heaven") and the source of spiritual food for the faithful.

BARTOLOMÉ ESTEBAN MURILLO In the 17th century, Spain maintained its passionate commitment to Catholic orthodoxy, and as in Counter-Reformation Italy, Spanish Ba-

roque artists sought ways to move viewers and to encourage greater devotion and piety. BARTOLOMÉ ESTEBAN MURILLO (1617–1682), for example, formulated the canonical image of the Virgin of the Immaculate Conception (FIG. **24-25A**), in which Mary is a beautiful young woman ascending to Heaven. But scenes of death and martyrdom also had great appeal in Spain. They provided artists with opportunities both to depict extreme emotion and to elicit passionate feelings in viewers. Spain prided itself on its saints—Saint Teresa

24-25A MURILLO, Immaculate Conception, ca. 1661–1670.

of Avila (FIG. 24-8) and Saint Ignatius Loyola (FIG. 24-24) were both Spanish-born—and martyrdom scenes surfaced frequently in Spanish Baroque art. JOSÉ DE RIBERA As a young man, José (JUSEPE) DE RIBERA (ca. 1588-1652) emigrated to Naples and fell under the spell of Caravaggio, whose innovative style he introduced to Spain. Emulating Caravaggio, Ribera made naturalism and compelling drama primary ingredients of his paintings, which often embraced brutal themes, reflecting the harsh times of the Counter-Reformation and the Spanish taste for stories showcasing courage and devotion. Ribera's Martyrdom of Saint Philip (FIG. 24-26) is grim and dark in subject and form. Scorning idealization of any kind, Ribera represented Philip's executioners hoisting him into position after tying him to a cross, the instrument of Christ's own martyrdom. The saint's rough, heavy body and swarthy, plebeian features express a kinship between him and his tormentors, who are similar to the types of figures found in Caravaggio's paintings. The patron of this painting is unknown, but it is possible Philip IV commissioned the work, because Saint Philip was the king's patron saint.

FRANCISCO DE ZURBARÁN Another prominent Spanish painter of dramatic works was FRANCISCO DE ZURBARÁN (1598–1664), whose primary patrons throughout his career were rich Spanish monastic orders. Many of his paintings are quiet and contemplative, appropriate for prayer and devotional purposes. Zurbarán painted *Saint Serapion* (FIG. **24-27**) as a devotional image for the funerary chapel of the monastic Order of Mercy in Seville. The saint, who participated in the Third Crusade of 1196, suffered martyrdom while preaching the Gospel to Muslims. According to one account, the monk's captors tied him to a tree and then tortured and decapitated him. The Order of Mercy dedicated itself

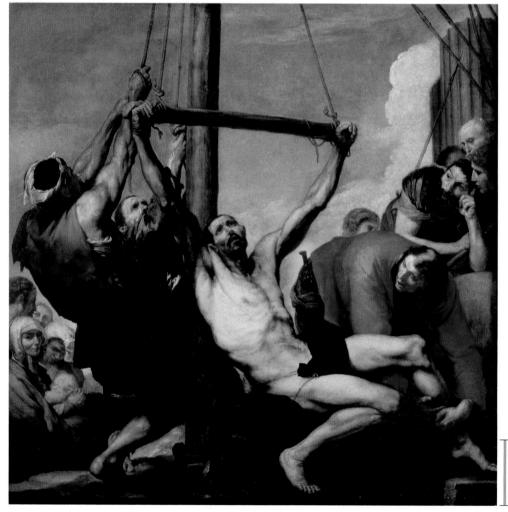

24-26 JOSÉ DE RIBERA, *Martyrdom* of Saint Philip, ca. 1639. Oil on canvas, 7' 8" × 7' 8". Museo del Prado, Madrid.

Martyrdom scenes were popular in Counter-Reformation Spain. Scorning idealization of any kind, Ribera represented Philip's executioners hoisting him into position to die on a cross.

24-27 FRANCISCO DE ZURBARÁN, Saint Serapion, 1628. Oil on canvas, 3' $11\frac{1''}{2} \times 3' 4\frac{3''}{4}$. Wadsworth Atheneum Museum of Art, Hartford (The Ella Gallup Sumner and Mary Catlin Sumner Collection Fund).

The light shining on Serapion calls attention to his tragic death and increases the painting's dramatic impact. The monk's coarse features label him as common, evoking empathy from a wide audience.

to self-sacrifice, and Serapion's membership in this order amplified the resonance of Zurbarán's painting. In *Saint Serapion*, the monk emerges from a dark background and fills the foreground. The bright light shining on him calls attention to the saint's tragic death and increases the dramatic impact of the image. In the background are two barely visible tree branches. A small note next to the saint identifies him for viewers. The coarse features of the Spanish monk label him as common, no doubt evoking empathy from a wide audience.

DIEGO VELÁZQUEZ The foremost Spanish painter of the Baroque age—and the greatest beneficiary of royal patronage—was DIEGO VELÁZQUEZ (1599–1660). An early work, *Water Carrier of Seville* (FIG. **24-28**), painted when Velázquez was only about 20 years old, already reveals his impressive command of the painter's craft. In

this genre scene that seems to convey a deeper significance, Velázquez rendered the figures with clarity and dignity, and

his careful and convincing depiction of the water jugs in the foreground, complete with droplets of water, adds to the scene's credibility. The plebeian nature of the figures and the contrast of darks and lights again reveal the influence of Caravaggio, whose work Velázquez had studied.

As did many other Spanish artists, Velázquez produced religious pictures, for example, *Christ on the Cross* (FIG. **24-28A**), as well as genre scenes, but his renown in his day rested primarily on the works he painted for King Philip IV (see "Velázquez and Philip IV," page 690). After the king appointed Velázquez court painter, the artist largely abandoned both religious and genre subjects in favor of royal portraits (FIG. **24-28B**) and canvases recording historical events.

24-28A VELÁZQUEZ, *Christ on the Cross,* ca. 1631–1632.

24-28B VELÁZQUEZ, Philip IV, 1644.

24-28 DIEGO VELÁZQUEZ, *Water Carrier of Seville*, ca. 1619. Oil on canvas, 3' $5\frac{1''}{2} \times 2' 7\frac{1''}{2}$. Victoria & Albert Museum, London.

In this early work—a genre scene that seems to convey a deeper significance—the contrast of darks and lights, and the plebian nature of the figures, reveal Velázquez's debt to Caravaggio.

1 ft.

Velázquez and Philip IV

Trained in Seville, Diego Velázquez was quite young when he came to the attention of Philip IV. The painter's immense talent impressed the king, and Philip named him chief court artist and palace chamberlain, a position that also involved overseeing the rapidly growing royal art collection and advising the king on acquisitions and display. Among the works in Philip IV's possession were paintings by Titian, Annibale Carracci, Guido Reni, Albrecht Dürer, and Velázquez's famous Flemish contemporary, Peter Paul Rubens (see Chapter 25).

With the exception of two extended trips to Italy and a few excursions, Velázquez remained in Madrid for the rest of his life. His

close relationship with Philip IV and his high office as chamberlain gave him prestige and a rare opportunity to fulfill the promise of his genius. One sign of Velázquez's fertile imagination as well as mastery of the brush is that he was able to create timeless artworks out of routine assignments to commemorate the achievements of his patron, as he did in his record of the Spanish victory over the Dutch in 1625 (*Surrender of Breda*, FIG. 24-29). Velázquez also painted dozens of portraits of Philip IV (FIG. 24-28B) and his family and retinue, including *Las Meninas* (FIG. 24-30), one of the greatest paintings in the history of Western art, a work Philip admired so much he displayed it in his personal office.

24-29 DIEGO

VELÁZQUEZ, Surrender of Breda, 1634–1635. Oil on canvas, 10' 1" \times 12' $\frac{1}{2}$ '. Museo del Prado, Madrid.

As Philip IV's court artist, Velázquez produced many history paintings, including fictional representations such as this one depicting the Dutch mayor of Breda surrendering to the Spanish general.

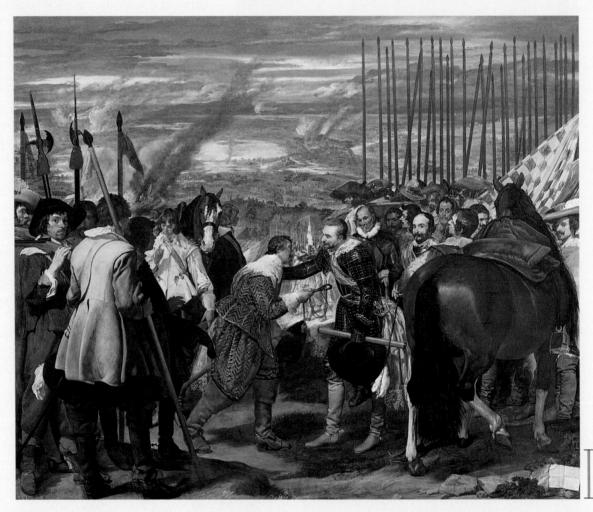

SURRENDER OF BREDA In 1635, Velázquez painted *Surrender of Breda* (FIG. **24-29**) as part of an extensive program of decoration for the Hall of Realms in Philip IV's new secondary pleasure palace in Madrid, the Palacio del Buen Retiro. The huge canvas (more than 12 feet long and almost as tall) was one of 10 paintings celebrating recent Spanish military successes around the globe. It commemorates the Spanish victory over the Dutch at Breda in 1625. Among the most troublesome situations for Spain was the conflict in the Netherlands. Determined to escape Spanish control, the northern Netherlands broke from the Habsburg Empire in the

late 16th century. Skirmishes continued to flare up along the border between the northern (Dutch) and southern (Spanish) Netherlands, and in 1625 Philip IV sent General Ambrogio di Spínola to Breda to reclaim the town for Spain.

Velázquez depicted the victorious Spanish troops, organized and well armed, on the right side of the painting. In sharp contrast, the defeated Dutch on the left appear bedraggled and disorganized. In the center foreground, the mayor of Breda, Justinus of Nassau, hands the city's keys to the Spanish general—although no encounter of this kind ever occurred. Velázquez's fictional record of the event glorifies not only the strength of the Spanish military but the benevolence of Spínola as well. Velázquez did not portray the Spanish general astride his horse, lording over the vanquished Dutch mayor, but rather painted him standing and magnanimously stopping Justinus from kneeling. Indeed, the terms of surrender were notably lenient, and Spínola allowed the Dutch to retain their arms—which they used to recapture the city in 1637. *LAS MENINAS* After an extended visit to Rome from 1648 to 1651, Velázquez returned to Spain. In 1656, he painted his greatest work, *Las Meninas (The Maids of Honor;* FIG. **24-30**). The setting is the artist's studio in the palace of the Alcázar, the official royal residence in Madrid. After the death of Prince Baltasar Carlos in 1646, Philip IV ordered part of the prince's chambers converted into a studio for Velázquez. The painter represented himself stand-

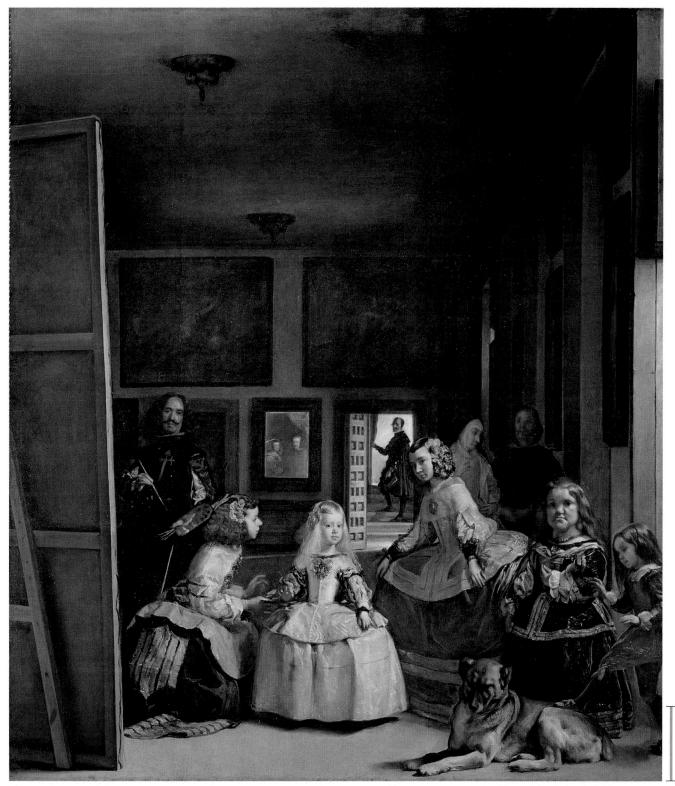

24-30 DIEGO VELÁZQUEZ, Las Meninas (The Maids of Honor), 1656. Oil on canvas, 10′ 5″ × 9′. Museo del Prado, Madrid. ■ Velázquez intended this huge and complex work, with its cunning contrasts of real, mirrored, and picture spaces, to elevate both himself and the profession of painting in the eyes of Philip IV. ing before a large canvas. The young Infanta (Princess) Margarita appears in the foreground with her two maids-in-waiting, her favorite dwarfs, and a large dog. In the middle ground are a woman in widow's attire and a male escort. In the background, a chamberlain stands in a brightly lit open doorway. Scholars have been able to identify everyone in the room, including the two meninas and the dwarfs.

Las Meninas is noteworthy for its visual and narrative complexity. Indeed, art historians have yet to agree on any particular reading or interpretation. A central issue preoccupying scholars has been what, exactly, is taking place in *Las Meninas*. What is Velázquez depicting on the huge canvas in front of him? He may be painting this very picture—an informal image of the infanta and her entourage. Alternately, Velázquez may be painting a portrait of King Philip IV and Queen Mariana, whose reflections appear in the mirror on the far wall. If so, that would suggest the presence of the king and queen in the viewer's space, outside the confines of the picture. Other scholars have proposed that the mirror image is not a reflection of the royal couple standing in Velázquez's studio but a reflection of the portrait the artist is in the process of painting on the canvas before him. This question will probably never be definitively resolved.

More generally, Las Meninas is Velázquez's attempt to elevate both himself and his profession. As first painter to the king and as chamberlain of the palace, Velázquez was conscious not only of the importance of his court office but also of the honor and dignity belonging to his profession as a painter. Throughout his career, Velázquez hoped to be ennobled by royal appointment to membership in the ancient and illustrious Order of Santiago (Saint James). Because he lacked a sufficiently noble lineage, he gained entrance only with difficulty at the very end of his life, and then only through the pope's dispensation. In the painting, Velázquez wears the order's red cross on his doublet, painted there, legend says, by Philip IV. In all likelihood, Velázquez painted it. In the artist's mind, Las Meninas might have embodied the idea of the great king visiting his studio, as Alexander the Great visited the studio of the painter Apelles in ancient times. The figures in the painting all appear to acknowledge the royal presence. Placed among them in equal dignity is Velázquez, face-to-face with his sovereign.

The location of the completed painting reinforced this act of looking—of seeing and being seen. *Las Meninas* hung in Philip IV's personal office in another part of the palace. Thus, although occasional visitors admitted to the king's private quarters may have seen this painting, Philip was the primary audience. Each time he stood before the canvas, he again participated in the work as the probable subject of Velázquez's painting within the painting and as the object of the figures' gazes. In *Las Meninas*, Velázquez elevated the art of painting, in the person of the painter, to the highest status. The king's presence enhanced this status—either in person as the viewer of *Las Meninas* or as a reflected image in the painting itself. The paintings that appear in *Las Meninas* further reinforced this celebration of the painter's craft. On the wall above the doorway and the mirror, two faintly recognizable pictures are copies made by Velázquez's son-in-law, Juan del Mazo (ca. 1612–1667), of paintings by Peter Paul Rubens. The paintings depict the immortal gods as the source of art. Ultimately, Velázquez sought ennoblement not for himself alone but for his art as well.

Las Meninas is extraordinarily complex visually. Velázquez's optical report of the event, authentic in every detail, pictorially summarizes the various kinds of images in their different levels and degrees of reality. He portrayed the realities of image on canvas, of mirror image, of optical image, and of the two painted images. This work—with its cunning contrasts of real spaces, mirrored spaces, picture spaces, and pictures within pictures—itself appears to have been taken from a large mirror reflecting the entire scene. This would mean the artist did not paint the princess and her suite as the main subjects of *Las Meninas* but himself in the process of painting them. *Las Meninas* is a pictorial summary and a commentary on the essential mystery of the visual world, as well as on the ambiguity that results when different states or levels interact or are juxtaposed.

Velázquez employed several devices in order to achieve this visual complexity. For example, the extension of the composition's pictorial depth in both directions is noteworthy. The open doorway and its ascending staircase lead the eye beyond the artist's studio, and the mirror and the outward glances of several of the figures incorporate the viewer's space into the picture as well. (Compare how the mirror in Jan van Eyck's *Giovanni Arnolfini and His Wife* [FIG. 20-6] similarly incorporates the area in front of the canvas into the picture, although less obviously and without a comparable extension of space beyond the rear wall of the room.) Velázquez also masterfully observed and represented form and shadow. Instead of putting lights abruptly beside darks, following Caravaggio, Velázquez allowed a great number of intermediate values of gray to come between the two extremes. His matching of tonal gradations approached effects later discovered in the age of photography.

The inclusion of the copies of two Rubens paintings hanging on the wall in Velázquez's studio is the Spanish master's tribute to the great Flemish painter, one of the towering figures who made the 17th century one of the most important in the history of art in northern Europe. The works of Rubens, Rembrandt, and the other leading Baroque painters, sculptors, and architects of Flanders, the Dutch Republic, France, and England are the subject of Chapter 25.

THE BIG PICTURE

THE BAROQUE IN ITALY AND SPAIN

ITALY

- Art historians call the art of 17th-century Italy and Spain *Baroque*, a term that probably derives from the Portuguese word for an irregularly shaped pearl. Baroque art is dynamic and theatrical in vivid contrast to the precision and orderly rationality of Renaissance classicism.
- Baroque architects emphatically rejected the classical style. Gianlorenzo Bernini's colonnade framing the piazza in front of Saint Peter's is not a traditional rectangular atrium but two curving arms welcoming worshipers.
- Francesco Borromini emphasized the sculptural qualities of buildings. The facades of his churches—for example, San Carlo alle Quattro Fontane—are not flat frontispieces but undulating surfaces that provide a fluid transition from exterior to interior space. The interiors of his buildings pulsate with energy and feature complex domes that grow organically from curving walls.
- Guarino Guarini brought Borromini's innovative Baroque architectural style to Turin and designed even more complex domes than those the Roman master created.
- Bernini achieved even greater renown as a sculptor. His David represents the biblical hero in action, hurling stones at Goliath. In Ecstasy of Saint Teresa, Bernini marshaled the full capabilities of architecture, sculpture, and painting to create an intensely emotional experience for worshipers, consistent with the Counter-Reformation principle of using artworks to inspire devotion and piety.
- In painting, Caravaggio broke new ground by employing stark and dramatic contrasts of light and dark (tenebrism) and by setting religious scenes in everyday locales filled with rough-looking common people. An early masterpiece, *Calling of Saint Matthew*, for example, takes place in an ordinary tavern.
- Caravaggio's combination of drama and realism attracted both admiring followers, including Artemisia Gentileschi, the leading woman painter of the 17th century, and harsh critics. The biographer Giovanni Pietro Bellori, for example, deplored Caravaggio's abandonment of the noble style of Raphael and the ancients and his "suppression of the dignity of art." He preferred the more classical style of Annibale Carracci and the Bolognese art academy.
- Illusionistic ceiling paintings were very popular in Baroque Italy. The major ceiling painters were Pietro da Cortona, Giovanni Battista Gaulli, and Fra Andrea Pozzo. In Sant'Ignazio in Rome, Pozzo created the illusion that Heaven is opening up above worshipers' heads by merging the church's architecture with the painted nave vault.

Borromini, San Carlo alle Quattro Fontane, Rome, 1638–1641

Bernini, *Ecstasy of* Saint Teresa, 1645–1652

Caravaggio, *Calling of Saint Matthew,* ca. 1597–1601

Pozzo, Glorification of Saint Ignatius, 1691–1694

SPAIN

- Although the power of the Habsburg kings declined during the 17th century, the royal family, which was devoutly Catholic, continued to spend lavishly on art. Spanish artists eagerly embraced the drama and emotionalism of Italian Baroque art. Scenes of death and martyrdom were popular in Counter-Reformation Spain. Painters such as José de Ribera and Francisco de Zurbarán adopted Caravaggio's lighting and realism to produce moving images of martyred saints.
- The greatest Spanish Baroque painter was Diego Velázquez, court painter to Philip IV. Velázquez painted themes ranging from genre and religious subjects to royal portraits and historical events. His masterwork, *Las Meninas*, is extraordinarily complex and mixes real spaces, mirrored spaces, picture spaces, and pictures within pictures. It is a celebration of the art of painting itself.

Velázquez, Las Meninas, 1656

In the 17th century, an important new class of patrons emerged in the Dutch Republic—successful merchants who took pride in their material possessions, the fruit of worldwide trade.

Claesz's mastery of the oil medium is evident in details such as the glass ball on the left side of the table, in which the viewer sees the reflected image of the artist painting this still life.

Dutch Baroque still-life paintings are meticulously crafted images that are both scientific in their accurate portrayal of devices such as this timepiece and poetic in their beauty and lyricism.

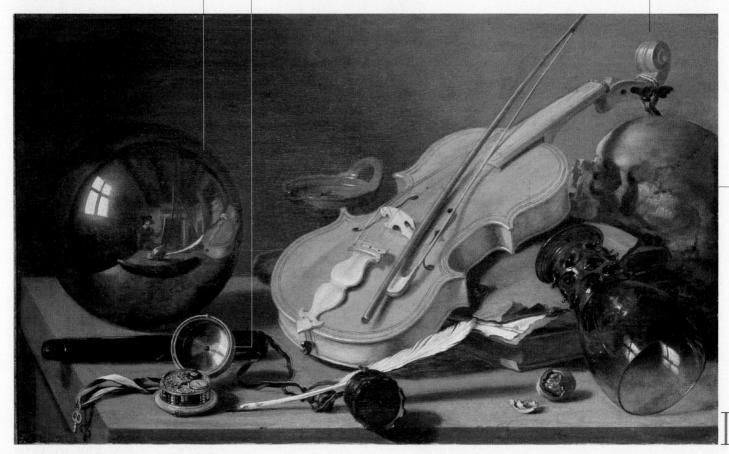

25-1 PIETER CLAESZ, Vanitas Still Life, 1630s. Oil on panel, 1' 2" × 1' 11¹/₂". Germanisches Nationalmuseum, Nuremberg.

THE BAROQUE IN Northern Europe

25

Calvinist morality tempered Dutch citizens' delight in accumulated wealth. In this vanitas still life, the skull and timepiece are *mementi mori*, reminders of life's transience.

STILL-LIFE PAINTING IN THE DUTCH REPUBLIC

In 1648, after decades of continuous border skirmishes with the Spaniards, the northern Netherlands achieved official recognition as the United Provinces of the Netherlands (the Dutch Republic; MAP 25-1). The new independent republic owed its ascendance largely to its success in international trade. Dutch ships laden with goods roamed the world, sailing as far as North and South America, western Africa, China, Japan, and the Pacific islands.

Peter Mundy, a widely traveled Englishman, commented in 1640 on the irony that the Dutch Republic produced almost nothing on its own land yet enjoyed great wealth and could afford rare commodities from around the world:

For although the land (and that with much labour) is brought only to pasture . . . yet by means of their shipping they are plentifully supplied with what the earth affords for the use of man . . . from any part of the world . . . Europe, Asia, Africa or America . . . with the most precious and rich commodities of those parts.¹

The prosperous Dutch were justifiably proud of their accomplishments, and the popularity of still-life paintings—particularly images of accumulated goods—reflected this pride. These paintings of worldly possessions marked the emergence of an important new class of art patrons—wealthy merchants—who had tastes distinctly different from those of the leading patrons elsewhere in Baroque Europe, namely royalty and the Catholic Church. Dutch still lifes, which were well suited to the Protestant ethic rejecting most religious art, are among the finest ever painted. They are meticulously crafted images both scientific in their optical accuracy and poetic in their beauty and lyricism.

One of the best Dutch paintings of this genre is *Vanitas Still Life* (FIG. **25-1**) by PIETER CLAESZ (1597–1660), in which the painter presented the material possessions of a prosperous household strewn across a tabletop or dresser. The ever-present morality and humility central to the Calvinist faith tempered Dutch pride in worldly goods, however. Thus, although Claesz fostered the appreciation and enjoyment of the beauty and value of the objects he depicted, he also reminded the viewer of life's transience by incorporating references to death. Art historians call works of this type *vanitas* (vanity) paintings, and each feature a *memento mori* (reminder of death). In *Vanitas Still Life*, references to mortality include the skull, timepiece, tipped glass, and cracked walnut. All suggest the passage of time or something or someone that was here but now is gone. Claesz emphasized this element of time (and demonstrated his technical virtuosity) by including a self-portrait reflected in the glass ball on the left side of the table. He appears to be painting this still life. But in an apparent challenge to the message of inevitable mortality that vanitas paintings convey, the portrait serves to immortalize the artist.

WAR AND TRADE IN NORTHERN EUROPE

During the 17th and early 18th centuries, numerous geopolitical shifts occurred in Europe as the fortunes of individual countries waxed and waned. Pronounced political and religious friction resulted in widespread unrest and warfare. Indeed, between 1562 and 1721, all of Europe was at peace for a mere four years. The major conflict of this period was the Thirty Years' War (1618–1648), which ensnared Spain, France, Sweden, Denmark, the Netherlands, Germany, Austria, Poland, the Ottoman Empire, and the Holy Ro-

man Empire. Although the outbreak of the war had its roots in the conflict between militant Catholics and militant Protestants, the driving force quickly shifted to secular, dynastic, and nationalistic concerns. Among the major political entities vying for expanded power and authority in Europe were the Bourbon dynasty of France and the Habsburg dynasties of Spain and the Holy Roman Empire. The war, which concluded with the Treaty of Westphalia in 1648, was largely responsible for the political restructuring of Europe (MAP 25-1). As a result, the United Provinces of the Netherlands (the Dutch Republic), Sweden, and France expanded their authority. Spanish and Danish power diminished. In addition

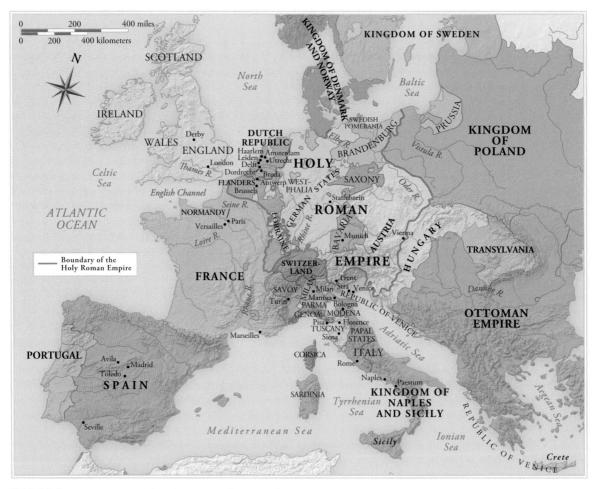

MAP 25-1 Europe in 1648 after the Treaty of Westphalia.

THE BAROQUE IN NORTHERN EUROPE

1600	1625	1650	1675	1700
 Peter Paul Ruber leading painter in Flanders The founding of Amsterdam in 16 an era of Dutch p in international t In the northern N Calvinist patrons scenes, portraits, still lifes 	a Catholic for his group p Dutch burghers the Bank of I Rembrandt, the io9 initiates Dutch Baroque oreeminence is also a maste rade I The Treaty of V letherlands, concludes the favor genre War in 1648	ortraits of Dutch artists s landscape pa e foremost I Jan Vermeer painter, obscura as ar r of etching domestic inte Vestphalia I Nicholas Pou	inting I Sir Christoph uses a camera Saint Paul's (n aid in painting London eriors ussin champions and manner"	llace at Versailles er Wren designs

to reconfiguring territorial boundaries, the Treaty of Westphalia in essence granted freedom of religious choice throughout Europe. This treaty thus marked the abandonment of the idea of a united Christian Europe, and accepted the practical realities of secular political systems. The building of today's nation-states was emphatically under way.

The 17th century also brought heightened economic competition to Europe. Much of the foundation for worldwide mercantilism-extensive voyaging and geographic exploration, improved cartography, and advances in shipbuilding-had been laid in the previous century. In the 17th century, however, changes in financial systems, lifestyles, and trading patterns, along with expanding colonialism, fueled the creation of a worldwide marketplace. The Dutch founded the Bank of Amsterdam in 1609, which eventually became the center of European transfer banking. By establishing a system in which merchant firms held money on account, the bank relieved traders of having to transport precious metals as payment. Trading practices became more complex. Rather than simple reciprocal trading, triangular trade (trade among three parties) allowed for a larger pool of desirable goods. Exposure to an ever-growing array of goods affected European diets and lifestyles. Coffee (from island colonies) and tea (from China) became popular beverages during the early 17th century. Equally explosive was the growth of sugar use. Sugar, tobacco, and rice were slave crops, and the slave trade expanded to meet the demand for these goods. Traders captured and enslaved Africans and shipped them to European colonies and the Americas to provide the requisite labor force for producing these commodities.

The resulting worldwide mercantile system permanently changed the face of Europe. The prosperity international trade generated affected social and political relationships, necessitating new rules of etiquette and careful diplomacy. With increased disposable income, more of the newly wealthy spent money on art, significantly expanding the market for artworks, especially small-scale paintings for private homes.

FLANDERS

In the 16th century, the Netherlands had come under the crown of Habsburg Spain when Emperor Charles V retired, leaving the Spanish kingdoms, their Italian and American possessions, and the Netherlandish provinces to his only legitimate son, Philip II (r. 1556–1598). (Charles bestowed his imperial title and German lands on his brother.) Philip's repressive measures against the Protestants led the northern provinces to break from Spain and set up the Dutch Republic. The southern provinces remained under Spanish control and retained Catholicism as their official religion. The political distinction between modern Holland and Belgium more or less reflects this original separation, which in the 17th century signaled not only religious but also artistic differences.

Painting

The leading art of 17th-century Flanders (the Spanish Netherlands) was painting. Flemish Baroque painters retained close connections to the Baroque art of Catholic Europe. The Dutch schools of painting developed their own subjects and styles, consistent with their reformed religion and the new political, social, and economic structure of the Dutch Republic.

PETER PAUL RUBENS The greatest 17th-century Flemish painter was PETER PAUL RUBENS (1577-1640), a towering figure in the history of Western art. Rubens built on the innovations of the Italian Renaissance and Baroque masters to formulate the first truly pan-European painting style. Rubens's art is an original and powerful synthesis of the manners of many masters, especially Michelangelo, Titian, Carracci, and Caravaggio. His style had wide appeal, and his influence was international. Among the most learned individuals of his time, Rubens possessed an aristocratic education and a courtier's manner, diplomacy, and tact, which, with his facility for language, made him the associate of princes and scholars. He became court painter to the dukes of Mantua (descended from Mantegna's patrons), friend of King Philip IV (r. 1621-1665) of Spain and his adviser on collecting art, painter to Charles I (r. 1625-1649) of England and Marie de' Medici (1573-1642) of France, and permanent court painter to the Spanish governors of Flanders. Rubens also won the confidence of his royal patrons in matters of state, and they often entrusted him with diplomatic missions of the highest importance. Rubens employed scores of associates and apprentices to produce a steady stream of paintings for an international

clientele. In addition, he functioned as an art dealer, buying and selling contemporary artworks and classical antiquities for royal and aristocratic clients throughout Europe, who competed with one another in amassing vast collections of paintings and sculptures, one of which

25-1A BRUEGHEL and RUBENS, Allegory of Sight, ca. 1617–1618.

became the subject of a painting (FIG. **25-1A**) by Rubens and JAN BRUEGEL THE ELDER (1568–1625). Rubens's many enterprises made him a rich man, able to afford a magnificent townhouse in Antwerp and a castle in the countryside. Rubens, like Raphael, was a successful and renowned artist, a consort of kings, a shrewd man of the world, and a learned philosopher.

ELEVATION OF THE CROSS Rubens departed Flanders for Italy in 1600 and remained there until 1608. During these years, he studied the works of Italian Renaissance and Baroque masters and laid the foundations of his mature style. Shortly after returning home, he painted *Elevation of the Cross* (FIG. **25-2**) for the church of Saint Walburga in Antwerp. Later moved to the city's cathedral, the altarpiece is one of numerous commissions for religious works Rubens received at this time. By investing in sacred art, Flemish churches sought to affirm their allegiance to Catholicism and Spanish Habsburg rule after a period of Protestant iconoclastic fervor in the region.

Rubens's interest in Italian art, especially the works of Michelangelo and Caravaggio, is evident in the Saint Walburga triptych. The choice of this episode from the passion cycle provided Rubens with the opportunity to depict heavily muscled men in unusual poses straining to lift the heavy cross with Christ's body nailed to it. Here, as in his *Lion Hunt* (FIG. I-14), Rubens, deeply impressed by Michelangelo's twisting sculpted and painted figures, showed his prowess in representing foreshortened anatomy and the contortions of violent action. Rubens placed the body of Christ on the cross as a diagonal that cuts dynamically across the picture while inclining back into it. The whole composition seethes with a power that comes from strenuous exertion, from elastic human sinew taut with effort. The tension is emotional as well as physical, as reflected

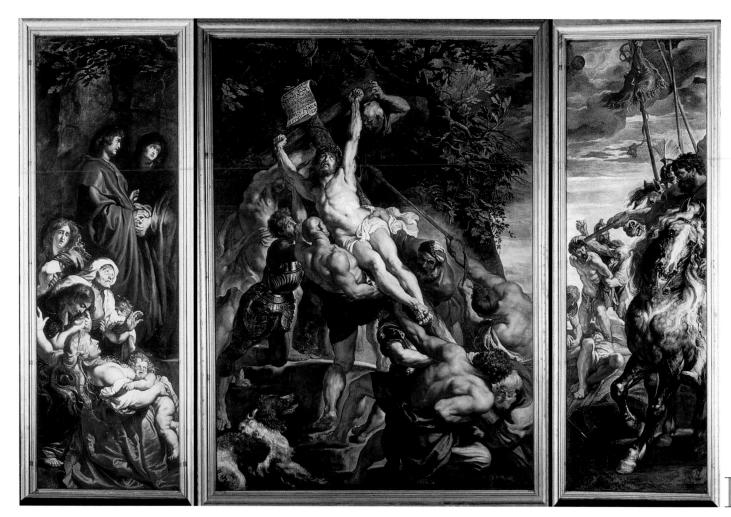

25-2 PETER PAUL RUBENS, *Elevation of the Cross*, from Saint Walburga, Antwerp, 1610. Oil on wood, center panel 15' $1\frac{7''}{8} \times 11' 1\frac{1}{2}''$, each wing 15' $1\frac{7''}{8} \times 4' 11''$. Antwerp Cathedral, Antwerp.

In this triptych, Rubens explored foreshortened anatomy and violent action. The whole composition seethes with a power that comes from heroic exertion. The tension is emotional as well as physical.

not only in Christ's face but also in the features of his followers. Bright highlights and areas of deep shadow inspired by Caravaggio's tenebrism, hallmarks of Rubens's work at this stage of his career, enhance the drama.

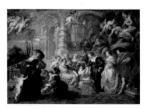

25-2A RUBENS, *Garden of Love*, 1630–1632.

Although Rubens later developed a much subtler coloristic style in paintings such as *Garden of Love* (FIG. **25-2A**), the human body in action, draped or undraped, male or female, remained the focus of his art. This interest, combined with his voracious intellect, led Rubens to copy the works of classical antiquity and of the Italian masters.

During his last two years in Rome (1606 to 1608), Rubens made many black-chalk drawings of great artworks, including figures in Michelangelo's Sistine Chapel frescoes (FIG. 22-17) and the ancient marble group (FIG. 5-89) of Laocoön and his two sons. In a Latin treatise he wrote titled *De imitatione statuarum* (*On the Imitation of Statues*), Rubens stated: "I am convinced that in order to achieve the highest perfection one needs a full understanding of the [ancient] statues, indeed a complete absorption in them; but one must make judicious use of them and before all avoid the effect of stone."² MARIE DE' MEDICI Rubens's interaction with royalty and aristocracy provided him with an understanding of the ostentation and spectacle of Baroque (particularly Italian) art that appealed to the wealthy and privileged. Rubens, the born courtier, reveled in the pomp and majesty of royalty. Likewise, those in power embraced the lavish spectacle that served the Catholic Church so well in Italy. The magnificence and splendor of Baroque imagery reinforced the authority and right to rule of the highborn. Among Rubens's royal patrons was Marie de' Medici, a member of the famous Florentine house and widow of Henry IV (r. 1589-1610), the first Bourbon king of France. She commissioned Rubens to paint a series of huge canvases memorializing and glorifying her career. Between 1622 and 1626, Rubens, working with amazing creative energy, produced with the aid of his many assistants 21 historicalallegorical pictures designed to hang in the queen's new palace, the Luxembourg, in Paris.

In Arrival of Marie de' Medici at Marseilles (FIG. **25-3**), a 13-foot-tall tableau, Marie disembarks at that southern French port after her sea voyage from Italy. An allegorical personification of France, draped in a cloak decorated with the *fleur-de-lis* (the floral symbol of French royalty; compare FIG. 25-24), welcomes her. The sea and sky rejoice at the queen's safe arrival. Neptune

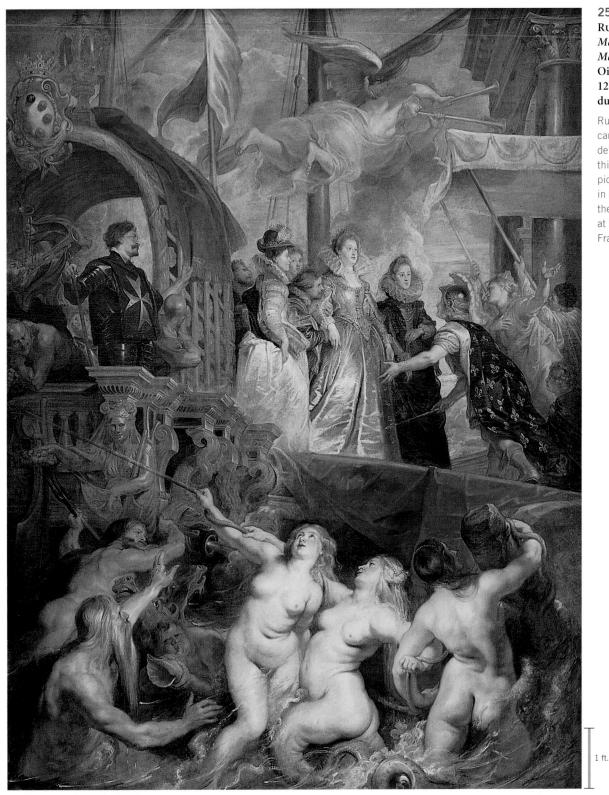

25-3 PETER PAUL RUBENS, Arrival of Marie de' Medici at Marseilles, 1622–1625. Oil on canvas, $12' 11\frac{1}{2}'' \times 9' 7''$. Musée du Louvre, Paris.

Rubens painted 21 large canvases glorifying Marie de' Medici's career. In this historical-allegorical picture of robust figures in an opulent setting, the sea and sky rejoice at the queen's arrival in France.

and the Nereids (daughters of the sea god Nereus) salute her, and the winged and trumpeting personified Fame swoops overhead. Conspicuous in the galley's opulently carved stern-castle, under the Medici coat of arms, stands the imperious commander of the vessel, the only immobile figure in the composition. In black and silver, this figure makes a sharp accent amid the swirling tonality of ivory, gold, and red. Rubens enriched the surfaces with a decorative splendor that pulls the whole composition together. The audacious vigor that customarily enlivens the painter's figures, beginning with the monumental, twisting sea creatures, vibrates through the entire design.

CONSEQUENCES OF WAR Rubens's diplomatic missions gave him great insight into European politics, and he never ceased

Rubens on Consequences of War

In the ancient and medieval worlds, artists rarely wrote commentaries on the works they produced. (The Greek sculptor Polykleitos is a notable exception; see "Polykleitos's Prescription for the Perfect Statue," Chapter 5, page 132.) Beginning with the Renaissance, however, the increased celebrity artists enjoyed and the ready availability of paper encouraged artists to record their intentions in letters to friends and patrons.

In March 1638, Peter Paul Rubens wrote a letter to Justus Sustermans (1597–1681), court painter of Grand Duke Ferdinando II de' Medici of Tuscany, explaining his *Consequences of War* (FIG. 25-4) and his attitude toward the European military conflicts of his day.

The principal figure is Mars, who has left the open temple of Janus (which in time of peace, according to Roman custom, remained closed) and rushes forth with shield and blood-stained sword, threatening the people with great disaster. He pays little heed to Venus, his mistress, who, accompanied by Amors and Cupids, strives with caresses and embraces to hold him. From the other side, Mars is dragged forward by the Fury Alekto, with a torch in her hand. Near by are monsters personifying Pestilence and Famine, those inseparable partners of War. On the ground, turning her back, lies a woman with a broken lute, representing Harmony, which is

incompatible with the discord of War. There is also a mother with her child in her arms, indicating that fecundity, procreation and charity are thwarted by War, which corrupts and destroys everything. In addition, one sees an architect thrown on his back, with his instruments in his hand, to show that which in time of peace is constructed for the use and ornamentation of the City, is hurled to the ground by the force of arms and falls to ruin. I believe, if I remember rightly, that you will find on the ground, under the feet of Mars a book and a drawing on paper, to imply that he treads underfoot all the arts and letters. There ought also to be a bundle of darts or arrows, with the band which held them together undone; these when bound form the symbol of Concord. Beside them is the caduceus and an olive branch, attribute of Peace; these are also cast aside. That grief-stricken woman clothed in black, with torn veil, robbed of all her jewels and other ornaments, is the unfortunate Europe who, for so many years now, has suffered plunder, outrage, and misery, which are so injurious to everyone that it is unnecessary to go into detail. Europe's attribute is the globe, borne by a small angel or genius, and surmounted by the cross, to symbolize the Christian world.*

*Translated by Kristin Lohse Belkin, *Rubens* (London: Phaidon, 1998), 288–289.

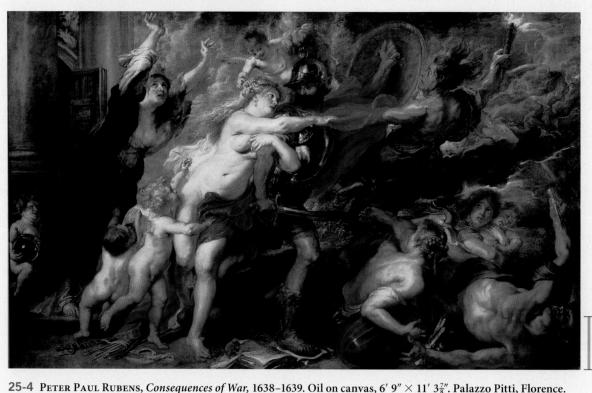

1 ft.

Since the Renaissance, artists have left behind many letters shedding light on their lives and work. In a 1638 letter, Rubens explained the meaning of each figure in this allegorical painting.

to promote peace. Throughout most of his career, however, war was constant. When commissioned in 1638 to produce a painting (FIG. **25-4**) for Ferdinando II de' Medici, the grand duke of Tuscany (r. 1621–1670), Rubens took the opportunity to express his at-

titude toward the Thirty Years' War (see "Rubens on *Consequences* of *War*," above). The fluid articulation of human forms in this work and the energy emanating from the chaotic scene are hallmarks of Rubens's mature style.

ANTHONY VAN DYCK Most of the leading painters of the next generation in Flanders were at one time Rubens's assistants. The master's most famous pupil was ANTHONY VAN DYCK (1599–1641). Early on, the younger man, unwilling to be overshadowed by Rubens's undisputed stature, left his native Antwerp for Genoa and then London, where he became court portraitist to Charles I. Although Van Dyck created dramatic compositions of high quality, his specialty became the portrait. He developed a courtly manner of great elegance that influenced many artists throughout Europe and resounded in English portrait painting well into the 19th century.

25-5 ANTHONY VAN DYCK, Charles I Dismounted, ca. 1635. Oil on canvas, 8' $11'' \times 6' 11\frac{1}{2}''$. Musée du Louvre, Paris.

Van Dyck specialized in court portraiture. In this painting, he depicted the absolutist monarch Charles I at a sharp angle so the king, a short man, appears to be looking down at the viewer.

In one of his finest works, *Charles I Dismounted* (FIG. **25-5**), the ill-fated English king stands in a landscape with the Thames River in the background. An equerry and a page attend him. The portrait is a stylish image of relaxed authority, as if the king is out for a casual ride in his park, but no one can mistake the regal poise and the air of absolute authority that Charles's Parliament resented and was soon to rise against. Here, the king turns his back on his attendants as he surveys his domain. Van Dyck's placement of the monarch is exceedingly artful. He stands off center but balances the composition with a single keen glance at the viewer. Van Dyck even managed to portray Charles I, who was of short stature, in a position to look down on the observer.

CLARA PEETERS Some Flemish 17th-century artists specialized in still-life painting, as did Sánchez Cotán (FIG. 24-25) in Spain. A pioneer of this genre was CLARA PEETERS (1594–ca. 1657), a native of Antwerp who spent time in Holland and laid the groundwork for Pieter Claesz (FIG. 25-1) and other Dutch masters of still-life painting, including Willem Kalf (FIG. 25-22) and Rachel Ruysch (FIG. 25-23). Peeters won renown for her depictions

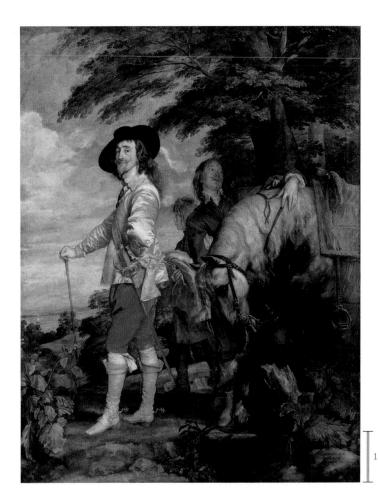

of food and flowers together, and for still lifes featuring bread and fruit, known as *breakfast pieces*. In *Still Life with Flowers, Goblet, Dried Fruit, and Pretzels* (FIG. **25-6**), Peeters's considerable skills are on full display. One of a series of four paintings, each of which depicts a typical early-17th-century meal, this breakfast piece re-

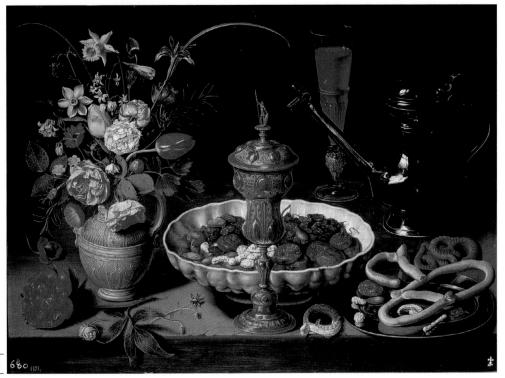

veals Peeters's virtuosity in depicting a wide variety of objects convincingly, from the smooth, reflective surfaces of the glass and silver goblets to the soft petals of the blooms in the vase. Peeters often painted the objects in her still lifes against a dark background, thereby negating any sense of deep space (compare FIG. 24-25). In this breakfast piece, she enhanced the sense of depth in the foreground by placing the leaves of the flower on the stone ledge as though they were encroaching into the viewer's space.

25-6 CLARA PEETERS, Still Life with Flowers, Goblet, Dried Fruit, and Pretzels, 1611. Oil on panel, $1' 7\frac{3''}{4} \times 2' 1\frac{1}{4}''$. Museo del Prado, Madrid.

Clara Peeters was a pioneer of still-life painting. Although a Flemish artist, she spent time in Holland and laid the groundwork for many Dutch artists (FIGS. 25-1, 25-22, and 25-23).

DUTCH REPUBLIC

With the founding of the Bank of Amsterdam in 1609, Amsterdam emerged as the financial center of the Continent. In the 17th century, the city had the highest per capita income in Europe. The Dutch economy also benefited enormously from the country's expertise on the open seas, which facilitated establishing far-flung colonies. By 1650, Dutch trade routes extended to North America, South America, the west coast of Africa, China, Japan, Southeast Asia, and much of the Pacific. Due to this prosperity and in the absence of an absolute ruler, political power increasingly passed into the hands of an urban patrician class of merchants and manufacturers, especially in cities such as Amsterdam, Haarlem, and Delft. All of these bustling cities were located in Holland (the largest of the seven United Provinces), which explains why historians informally use the name "Holland" to refer to the entire country.

Ter Brugghen, van Honthorst, Hals, Leyster

Religious differences were a major consideration during the northern Netherlands' insistent quest for independence during the 16th and early 17th centuries. Whereas Spain and the southern Netherlands were Catholic, the people of the northern Netherlands were predominantly Protestant. The prevailing Calvinism demanded a puritanical rejection of art in churches, and thus artists produced relatively little religious art in the Dutch Republic at this time (especially compared with the volume of commissions created in the wake of the Counter-Reformation in areas dominated by Catholicism; see Chapter 24).

HENDRICK TER BRUGGHEN Some artists in the Dutch Republic did produce religious art, however. HENDRICK TER BRUGGHEN (1588–1629) of Utrecht, for example, painted *Calling* of Saint Matthew (FIG. **25-7**) in 1621 after returning from a trip to Italy, selecting as his subject a theme Caravaggio had painted (FIG. 24-17) for the church of San Luigi dei Francesi in Rome. The moment of the narrative chosen and the naturalistic depiction of

the figures echo Caravaggio's work. But although ter Brugghen was an admirer of the Italian master, he dispensed with Caravaggio's stark contrasts of dark and light and instead presented the viewer with a more colorful palette of soft tints. Further, the Dutch painter compressed the figures into a small but well-lit space, creating an intimate effect compared with Caravaggio's more spacious setting.

MERCANTILIST PATRONAGE Given the absence of an authoritative ruler and the Calvinist concern for the potential misuse of religious art, commissions

25-7 HENDRICK TER BRUGGHEN, Calling of Saint Matthew, 1621. Oil on canvas, $3' 4'' \times 4' 6''$. Centraal Museum, Utrecht.

Although middle-class patrons in the Protestant Dutch Republic preferred genre scenes, still lifes, and portraits, some artists, including Hendrick ter Brugghen, also painted religious scenes. from royalty or the Catholic Church, prominent in the art of other countries, were uncommon in the United Provinces. With the new prosperity, however, an expanding class of merchants with different tastes emerged as art patrons. In contrast to Italian, Spanish, and Flemish Baroque art, 17th-century Dutch art centered on genre scenes, landscapes, portraits of middle-class men and women, and still lifes, all of which appealed to the newly prosperous Dutch merchants (see "Still-Life Painting in the Dutch Republic," page 695, and "Middle-Class Patronage and the Art Market in the Dutch Republic," page 703).

GERRIT VAN HONTHORST Typical of 17th-century Dutch genre scenes is Supper Party (FIG. 25-8) by GERRIT VAN HONTHORST (1590-1656). In this painting, van Honthorst presented an informal gathering of unidealized figures. While a musician serenades the group, his companions delight in watching a young woman feeding a piece of chicken to a man whose hands are both occupied—one holds a jug and the other a glass. Van Honthorst spent several years in Italy, and while there he carefully studied Caravaggio's work, as did fellow Utrecht painter Hendrick ter Brugghen. The Italian artist's influence surfaces in the mundane tavern setting and the nocturnal lighting of Supper Party. Fascinated by nighttime effects, van Honthorst frequently placed a hidden light source in his pictures and used it as a pretext to work with dramatic and starkly contrasting dark and light effects. Seemingly lighthearted genre scenes were popular in Baroque Holland, but Dutch viewers could also interpret them moralistically. For example, Supper Party can be read as a warning against the sins of gluttony (represented by the man on the right) and lust (the woman feeding the glutton is, in all likelihood, a prostitute with her aged procuress at her side). Or perhaps the painting represents the loose companions of the Prodigal Son (Luke 15:13)-panderers and prostitutes drinking, singing, strumming, and laughing. Strict Dutch Calvinists no doubt approved of such interpretations. Others simply took delight in the immediacy of the scenes and skill of artists such as van Honthorst.

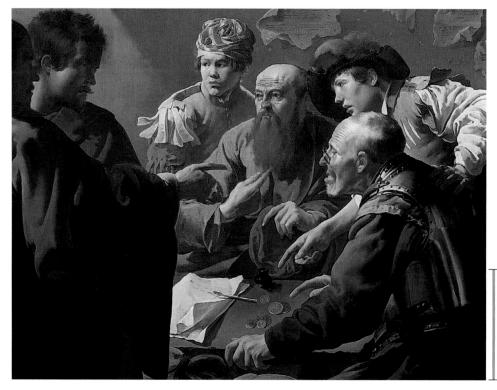

1 ft

Middle-Class Patronage and the Art Market in the Dutch Republic

Throughout history, the wealthy have been the most avid art collectors. Indeed, the money necessary to commission major artworks from leading artists can be considerable. During the 17th century in the Dutch Republic, however, the prosperity a large proportion of the population enjoyed significantly expanded the range of art patrons. As a result, one distinguishing hallmark of Dutch art production during the Baroque period was how it catered to the tastes of a middle-class audience, broadly defined. An aristocracy and an upper class of ship owners, rich businesspeople, high-ranking officers, and directors of large companies still existed, and these groups continued to be major patrons of the arts. But with the expansion of the Dutch economy, traders, craftspeople, bureaucrats, and soldiers also commissioned and collected art.

Although steeped in the morality and propriety central to the Calvinist ethic, members of the Dutch middle class sought ways to announce their success and newly acquired status. House furnishings, paintings, tapestries, and porcelain were among the items they collected and displayed in their homes. The Calvinist disdain for excessive ostentation, however, led Dutch collectors to favor small, low-key works—portraits of bourgeois men and women (FIGS. 25-9, 25-10, 25-12, and 25-13), still lifes (FIGS. 25-1, 25-22, and 25-23), genre scenes (FIGS. 25-8, 25-19, and 25-21), and landscapes (FIGS. 25-17, 25-18, 25-18A, and 25-18B). This focus contrasted with the Italian Baroque penchant for large-scale, dazzling ceiling frescoes and opulent room decoration (see Chapter 24). Indeed, the stylistic, as opposed to the chronological, designation "Baroque" is ill suited to these 17th-century northern European artworks.

It is risky to generalize about the spending and collecting habits of the Dutch middle class, but probate records, contracts, and archived inventories reveal some interesting facts. These records suggest an individual earning between 1,500 and 3,000 guilders a year

1 ft

could live quite comfortably. A house could be purchased for 1,000 guilders. Another 1,000 guilders could buy all the necessary furnishings for a middle-class home, including a significant amount of art, particularly paintings. Although there was, of course, considerable variation in prices, many artworks were very affordable. Prints, for example, were extremely cheap because of the high number of copies artists produced of each picture. Paintings of interior and genre scenes were relatively inexpensive in 17th-century Holland, perhaps costing one or two guilders each. Small landscapes fetched between three and four guilders. Commissioned portraits were the most costly. The size of the work and quality of the frame, as well as the reputation of the artist, were other factors in determining the price of a painting, regardless of the subject.

With the exception of portraits, Dutch artists produced most of their paintings for an anonymous market, hoping to appeal to a wide audience. To ensure success, artists in the United Provinces adapted to the changed conditions of art production and sales. They marketed their paintings in many ways, selling their works directly to buyers who visited their studios and through art dealers, exhibitions, fairs, auctions, and even lotteries. Because of the uncertainty of these sales mechanisms (as opposed to the certainty of an ironclad contract for a commission from a church or king), artists became more responsive to market demands. Specialization became common among Dutch artists. For example, painters might limit their practice to portraits, still lifes, or landscapes—the most popular genres among middle-class patrons.

Artists did not always sell their paintings. Frequently they used their work to pay off loans or debts. Tavern debts, in particular, could be settled with paintings, which may explain why many art dealers (such as Jan Vermeer and his father before him) were also innkeepers. This connection between art dealing and other

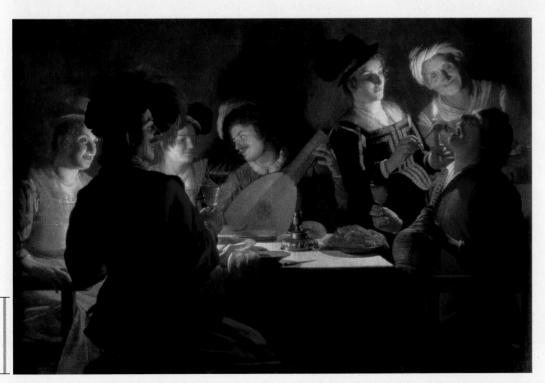

businesses eventually solidified, and innkeepers, for example, often would have art exhibitions in their taverns hoping to make a sale. The institutions of today's open art market—dealers, galleries, auctions, and estate sales owe their establishment to the emergence in the 17th century of a prosperous middle class in the Dutch Republic.

25-8 GERRIT VAN HONTHORST, Supper Party, 1620. Oil on canvas, $4' 8'' \times 7'$. Galleria degli Uffizi, Florence.

Genre scenes were popular subjects among middle-class Dutch patrons. Gerrit van Honthorst's *Supper Party* may also have served as a Calvinist warning against the sins of gluttony and lust. FRANS HALS Many Dutch artists excelled in portraiture in response to popular demand. FRANS HALS (ca. 1581-1666), the leading painter in Haarlem, was one of those who made portraits his specialty. Portrait artists traditionally relied heavily on convention-for example, specific poses, settings, attire, and furnishings-to convey a sense of the sitter. Because the subject was usually someone of status or note, such as a pope, king, duchess, or wealthy banker, the artist's goal was to produce an image appropriate to the subject's station in life. With the increasing number of Dutch middle-class patrons, portrait painting became more challenging. The Calvinists shunned ostentation, instead wearing subdued and dark clothing with little variation or decoration, and the traditional conventions became inappropriate and thus unusable. Despite these difficulties, or perhaps because of them, Hals produced lively portraits that seem far more relaxed than traditional formulaic portraiture. He injected an engaging spontaneity into his images and conveyed the individuality of his sitters as well. His manner of execution intensified the casualness, immediacy, and intimacy in his paintings. Because the touch of Hals's brush was as light and fleeting as the moment he captured the pose, the figure, the highlights on clothing, and the facial expression all seem instantaneously created.

ARCHERS OF SAINT HADRIAN Hals's most ambitious portraits reflect the widespread popularity in the Dutch Republic of vast canvases commemorating the participation of Dutch burghers in civic organizations. These commissions presented greater difficul-

ties to the painter than requests to depict a single sitter. Hals rose to the challenge and achieved great success with this new portrait genre. His *Archers of Saint Hadrian* (FIG. **25-9**) is typical in that the subject is one of the many Dutch civic militia groups that claimed credit for liberating the Dutch Republic from Spain. As other companies did, the Archers met on their saint's feast day in dress uniform for a grand banquet. The celebrations sometimes lasted an entire week, prompting an ordinance limiting them to three or four days. These events often included sitting for a group portrait.

In Archers of Saint Hadrian, Hals attacked the problem of how to represent each militia member satisfactorily yet retain action and variety in the composition. Whereas earlier group portraits in the Netherlands were rather ordered and regimented images, Hals sought to enliven the depictions. In his portrait of the Saint Hadrian militiamen, each member is both part of the troop and an individual with a distinct physiognomy. The sitters' movements and moods vary markedly. Some engage the viewer directly. Others look away or at a companion. Some are stern, others animated. Each archer is equally visible and clearly recognizable. The uniformity of attire-black military dress, white ruffs, and sashes-did not deter Hals from injecting spontaneity into the work. Indeed, he used those elements to create a lively rhythm extending throughout the composition and energizing the portrait. The impromptu effectthe preservation of every detail and fleeting facial expression-is, of course, the result of careful planning. Yet Hals's vivacious brush appears to have moved instinctively, directed by a plan in his mind but not traceable in any preparatory scheme on the canvas.

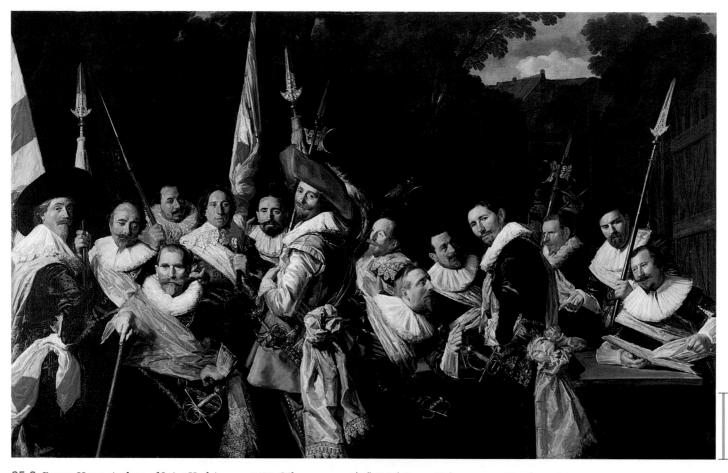

25-9 FRANS HALS, Archers of Saint Hadrian, ca. 1633. Oil on canvas, 6' 9" × 11'. Frans Halsmuseum, Haarlem. ■ In this brilliant composition, Hals succeeded in solving the problem of portraying each individual in a group portrait while retaining action and variety in the painting as a whole.

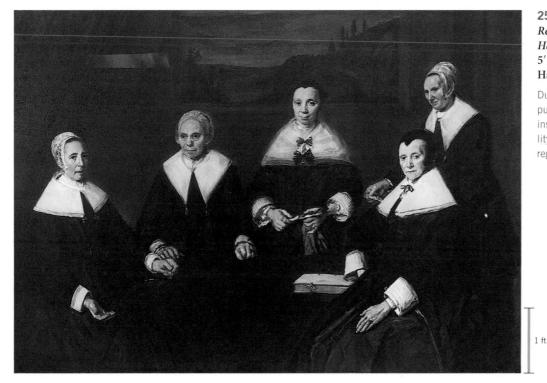

25-10 FRANS HALS, The Women Regents of the Old Men's Home at Haarlem, 1664. Oil on canvas, $5' 7'' \times 8' 2''$. Frans Halsmuseum, Haarlem.

Dutch women played a major role in public life as regents of charitable institutions. A stern puritanical sensibility suffuses Hals's group portrait of the regents of Haarlem's old men's home.

WOMEN REGENTS OF HAARLEM Hals also produced group portraits of Calvinist women engaged in charitable work. The finest is The Women Regents of the Old Men's Home at Haarlem (FIG. 25-10). Although Dutch women had primary responsibility for the welfare of the family and the orderly operation of the home, they also populated the labor force in the cities. Among the more prominent roles educated Dutch women played in public life were as regents of orphanages, hospitals, old age homes, and prisons. In Hals's portrait, the Haarlem regents sit quietly in a manner becoming of devout Calvinists. Unlike the more relaxed, seemingly informal character of his other group portraits, a stern, puritanical, and composed sensibility suffuses Hals's portrayal of these regents. The women-all carefully distinguished as individuals-gaze out from the painting with expressions ranging from dour disinterest to kindly concern. The somber and virtually monochromatic (onecolor) palette, punctuated only by the white accents of the clothing, contributes to the painting's restraint. Both the coloration and the mood of Hals's portrait are appropriate for this commission. Portraying the Haarlem regents called for a very different kind of portrait from those Hals made of men at festive militia banquets.

JUDITH LEYSTER Some of Hals's students developed thriving careers of their own as portraitists. One was JUDITH LEYSTER (1609-1660), whose Self-Portrait (FIG. 25-11) reveals the strong training she received. It is detailed, precise, and accurate but also imbued with the spontaneity found in her master's works. In her portrait, Leyster succeeded at communicating a great deal about herself. She depicted herself as an artist, seated in front of a painting on an easel. The palette in her left hand and brush in her right announce the painting as her creation. She thus invites the viewer to evaluate her skill, which both the fiddler on the canvas and the image of herself demonstrate as considerable. Although she produced a wide range of paintings, including still lifes and floral pieces, her specialty was genre scenes such as the comic image seen on the easel. Leyster's quick smile and relaxed pose as she stops her work to meet the viewer's gaze reveal her self-assurance. Although presenting herself as an artist, Leyster did not paint herself wearing

the traditional artist's smock, as her more famous contemporary Rembrandt did in his 1659–1660 self-portrait (FIG. 25-15). Her elegant attire distinguishes her socially as a member of a well-to-do family, another important aspect of Leyster's identity.

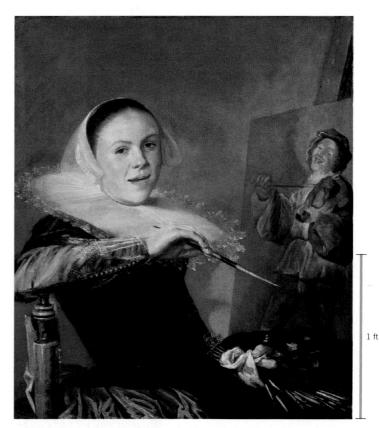

25-11 JUDITH LEYSTER, *Self-Portrait*, ca. 1630. Oil on canvas, 2' $5\frac{3''}{8} \times 2' 1\frac{5''}{8}$. National Gallery of Art, Washington, D.C. (gift of Mr. and Mrs. Robert Woods Bliss).

Although presenting herself as an artist specializing in genre scenes, Leyster wears elegant attire instead of a painter's smock, placing her socially as a member of a well-to-do family.

Rembrandt

REMBRANDT VAN RIJN (1606–1669), Hals's younger contemporary and the leading Dutch painter of his time, was an undisputed genius—an artist of great versatility, a master of light and shadow, and a unique interpreter of the Protestant conception of scripture. Born in Leiden, he moved to Amsterdam around 1631, where he could attract a more extensive clientele than possible in his native city. Rembrandt had trained as a history painter in Leiden, but in Amsterdam he immediately entered the lucrative market for portraiture and soon became renowned for that genre.

ANATOMY LESSON OF DR. TULP In a painting he completed shortly after he arrived in Amsterdam, Anatomy Lesson of Dr. Tulp (FIG. 25-12), Rembrandt deviated even further from the traditional staid group portrait than had Hals. Despite Hals's determination to enliven his portraits, he still evenly spread his subjects across the canvas. In contrast, Rembrandt chose to portray the members of the surgeons' guild (who commissioned this group portrait) clustered on the painting's left side. In the foreground appears the corpse Dr. Tulp, a noted physician, is in the act of dissecting. Rembrandt diagonally placed and foreshortened the corpse, activating the space by disrupting the strict horizontal, planar orientation typical of traditional portraiture. He depicted each of the "students" specifically, and although they wear virtually identical attire, their poses and facial expressions suggest the varying degrees of intensity with which they watch Dr. Tulp's demonstration-or ignore it. One, at the apex of Rembrandt's triangular composition of bodies, gazes at the viewer instead of at the operating table. Another directs his attention to the open book (an anatomy manual) at the cadaver's feet. Rembrandt produced this painting when he was 26 and just beginning his career. His innovative approach to group portraiture is therefore all the more remarkable.

NIGHT WATCH Rembrandt amplified the complexity and energy of the group portrait in *The Company of Captain Frans Banning Cocq* (FIG. **25-13**), better known as *Night Watch*. This more

commonly used title is a misnomer, however. The painting is not of a nocturnal scene. Rembrandt used light in a masterful way, and dramatic lighting certainly enhances the image. Still, the painting's darkness (which explains the commonly used title) is the result of the varnish the artist used, which darkened considerably over time. It was not the painter's intention to portray his subjects moving about at night.

This painting was one of many civic-guard group portraits Dutch artists produced during this period.

25-12 REMBRANDT VAN RIJN, Anatomy Lesson of Dr. Tulp, 1632. Oil on canvas, 5' $3\frac{3''}{4} \times 7' 1\frac{1''}{4}$. Mauritshuis, The Hague.

In this early work, Rembrandt used an unusual composition, arranging members of Amsterdam's surgeons' guild clustered on one side of the painting as they watch Dr. Tulp dissect a corpse. From the limited information available about the commission, it appears the two officers, Captain Frans Banning Cocq and Lieutenant Willem van Ruytenburch, along with 16 members of their militia, contributed to Rembrandt's fee. (Despite the prominence of the girl just to the left of center, scholars have yet to ascertain her identity.) *Night Watch* was one of six paintings by different artists commissioned by various groups around 1640 for the assembly and banquet hall of Amsterdam's new Musketeers Hall, the largest and most prestigious interior space in the city. Unfortunately, in 1715, when city officials moved Rembrandt's painting to Amsterdam's town hall, they trimmed it on all sides, leaving an incomplete record of the artist's resolution of the challenge of portraying this group.

Even in its truncated form, *The Company of Captain Frans Banning Cocq* succeeds in capturing the excitement and frenetic activity of men preparing for a parade. Comparing this militia group portrait with Hals's *Archers of Saint Hadrian* (FIG. 25-9) reveals Rembrandt's inventiveness in enlivening what was, by then, becoming a conventional format for Dutch group portraits. Rather than present assembled men posed in orderly fashion, the younger artist chose to portray the company members rushing about in the act of organizing themselves, thereby animating the image considerably. At the same time, he managed to record the three most important stages of using a musket—loading, firing, and readying the weapon for reloading—details that must have pleased his patrons.

RETURN OF THE PRODIGAL SON The Calvinist injunction against religious art did not prevent Rembrandt from making a series of religious paintings and prints. In the Dutch Republic, paintings depicting biblical themes were not objects of devotion, but they still brought great prestige, and Rembrandt and other artists vied to demonstrate their ability to narrate holy scripture in dramatic new ways. One of Rembrandt's earliest biblical paintings, *Blinding of Samson* (FIG. **24-13A**), reveals the young artist's debt to Rubens and Caravaggio. His mature works, however, differ markedly from the

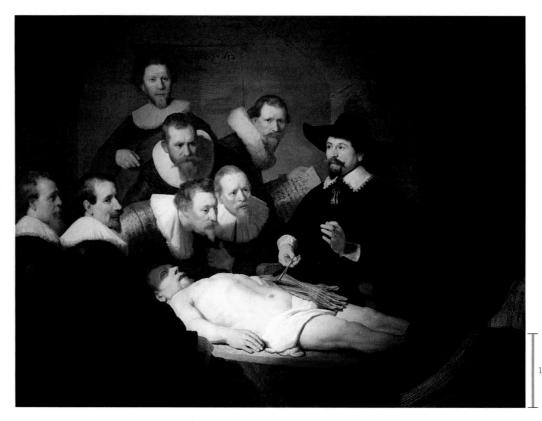

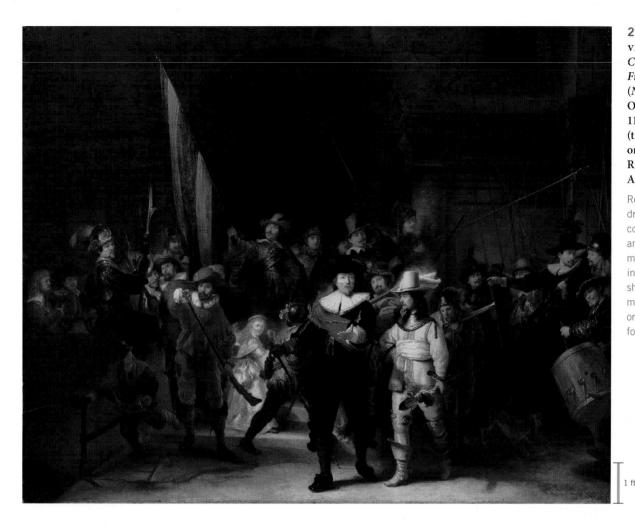

25-13 REMBRANDT VAN RIJN, The Company of Captain Frans Banning Cocq (Night Watch), 1642. Oil on canvas, $11' 11'' \times 14' 4''$ (trimmed from original size). Rijksmuseum, Amsterdam.

Rembrandt's dramatic use of light contributes to the animation of this militia group portrait in which the artist showed the company members rushing to organize themselves for a parade.

25-13A REMBRANDT, Blinding of Samson, 1636.

The Dutch artist's psychological insight and his profound sympathy for human affliction produced, at the end of his life, one of the most moving pictures in all religious art, *Return of the Prodigal Son* (FIG. **25-14**). In this biblical parable, the younger of two sons leaves his home and squanders his wealth on a life of sin. When he becomes poor and hungry and sees the error of his ways, he returns

(FIG. 24-24).

religious art of Baroque Italy and Flanders. Rembrandt had a special interest in probing the states of the human soul. The spiritual stillness of his later religious paintings is that of inward-turning contemplation, far from the choirs and trumpets and the heav-

enly tumult of Bernini (FIG. 24-7) or Pozzo

home. In Rembrandt's painting, the forgiving father tenderly embraces his lost son, who crouches before him in weeping contrition, while three figures, immersed to varying degrees in the soft shadows, note the lesson of mercy. The light, everywhere mingled with shadow, directs the viewer's attention by illuminating the father and son and largely veiling the witnesses. Its focus is the beautiful, spiritual face of the old man. Secondarily, the light touches the contrasting stern face of the foremost witness. The painting demonstrates the degree to which Rembrandt developed a personal style completely in tune with the simple eloquence of the biblical passage.

25-14 REMBRANDT VAN RIJN, Return of the Prodigal Son, ca. 1665. Oil on canvas, 8' 8" \times 6' 9". Hermitage Museum, Saint Petersburg.

The spiritual stillness of Rembrandt's religious paintings is that of inward-turning contemplation, in vivid contrast to the heavenly tumult of Italian Baroque Counter-Reformation works.

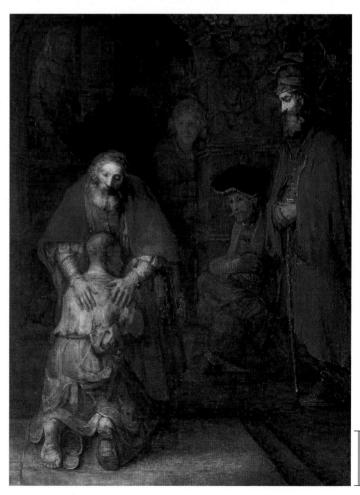

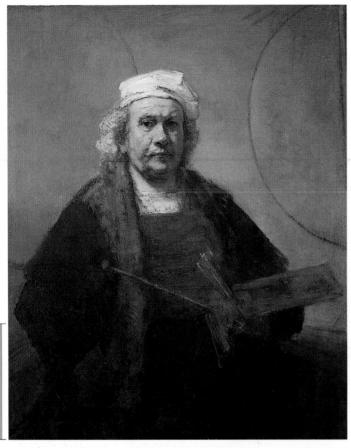

25-15 REMBRANDT VAN RIJN, *Self-Portrait*, ca. 1659–1660. Oil on canvas, 3' $8\frac{3^{\prime\prime}}{4} \times 3'$ 1". Kenwood House, London (Iveagh Bequest).

In this late self-portrait, Rembrandt's interest in revealing the soul is evident in the attention given to his expressive face. The controlled use of light and the nonspecific setting contribute to this focus.

GRADATIONS OF LIGHT From the few paintings by Rembrandt discussed thus far, it should be clear the artist's use of light is among the hallmarks of his style. Rembrandt's pictorial method involved refining light and shade into finer and finer nuances until they blended with one another. Earlier painters' use of abrupt lights and darks gave way, in the work of artists such as Rembrandt and Velázquez (FIGS. 24-28 to 24-30), to gradation. Although these later artists sacrificed some of the dramatic effects of sharp chiaroscuro, a greater fidelity to appearances more than offsets those sacrifices. In fact, the recording of light in small gradations is closer to reality because the eye perceives light and dark not as static but as always subtly changing.

In general, Renaissance artists represented forms and faces in a flat, neutral modeling light (even Leonardo's shading is of a standard kind). They represented the *idea* of light, rather than showed how humans perceive light. Artists such as Rembrandt discovered gradations of light and dark as well as degrees of differences in pose, in the movements of facial features, and in psychic states. They arrived at these differences optically, not conceptually or in terms of some ideal. Rembrandt found that by manipulating the direction, intensity, and distance of light and shadow, and by varying the surface texture with tactile brushstrokes, he could render subtle nuances of character and mood, both in individuals and whole scenes. He discovered for the modern world that variation of light and shade, subtly modulated, can be read as emotional differences. In the visible world, light, dark, and the wide spectrum of values between the two are charged with meanings and feelings that sometimes are independent of the shapes and figures they modify. The theater and the photographic arts have used these discoveries to great dramatic effect.

SELF-PORTRAITS Rembrandt carried over the spiritual quality of his religious works into his later portraits (FIGS. **25-15** and **25-15A**) by the same means—what could be called the "psychology of light." Light and dark are not in conflict in his portraits. They are reconciled, merging softly and subtly to produce the visual equivalent of quietness. Their prevailing mood is one of tranquil meditation, of philosophical resignation, of musing recollection—indeed, a whole cluster of emotional tones heard only in silence.

25-15A REMBRANDT, Self-Portrait, 1658.

In his self-portrait now in Kenwood House (FIG. 25-15), the light source outside the upper left of the painting bathes the painter's face in soft highlights, leaving the lower part of his body in shadow. The artist depicted himself as possessing dignity and strength, and the portrait serves as a summary of the many stylistic and professional concerns that occupied him throughout his career. Rembrandt's distinctive use of light is evident, as is the assertive brushwork suggesting his confidence and self-assurance. He presented himself as a working artist holding his brushes, palette, and maulstick (compare FIG. 23-18) and wearing his studio garb-a smock and painter's turban. The circles on the wall behind him (the subject of much scholarly debate) may allude to a legendary sign of artistic virtuosity-the ability to draw a perfect circle freehand. Rembrandt's abiding interest in revealing the human soul emerges here in his careful focus on his expressive visage. His controlled use of light and the nonspecific setting contribute to this focus. Further, X-rays of the painting have revealed that Rembrandt originally depicted himself in the act of painting. His final resolution, with the viewer's attention drawn to his face, produced a portrait not just of the artist but of the man as well. Indeed, Rembrandt's nearly 70 self-portraits in various media have no parallel in sheer quantity. They reflect the artist's deeply personal connection to his craft.

ETCHINGS Rembrandt's virtuosity also extended to the graphic media, especially etching (see "Woodcuts, Engravings, and Etchings," Chapter 20, page 556). Many printmakers adopted etching after its perfection early in the 17th century, because the technique afforded greater freedom than engraving in drawing the design. The etcher covers a copper plate with a layer of wax or varnish, and then incises the design into this surface with a pointed tool, exposing the metal below but not cutting into its surface. Next, the artist immerses the plate in acid, which etches, or eats away, the exposed parts of the metal, acting in the same way the burin does in engraving. The medium's softness gives etchers greater carving freedom than woodcutters and engravers have working directly in more resistant wood and metal. If Rembrandt had never painted, he still would be renowned, as he principally was in his lifetime, for his prints. Prints were a major source of income for Rembrandt, as they were for Albrecht Dürer (see Chapter 23), and he often reworked the plates so they could be used to produce a new issue or edition. This constant reworking was unusual within the context of 17thcentury printmaking practices.

25-16 REMBRANDT VAN RIJN, Christ with the Sick around Him, Receiving the Children (Hundred-Guilder Print), ca. 1649. Etching, $11'' \times 1'$ $3\frac{1}{4''}$.

Rembrandt's mastery of the newly perfected medium of etching is evident in his expert use of light and dark to draw attention to Christ as he preaches compassionately to the blind and lame.

HUNDRED-GUILDER PRINT One of Rembrandt's most celebrated etchings is Christ with the Sick around Him, Receiving the Children (FIG. 25-16). Indeed, the title by which this work has been known since the early 18th century, Hundred-Guilder Print, refers to the high sale price it brought during Rembrandt's lifetime. (As noted, a comfortable house could be purchased for 1,000 guilders.) Christ with the Sick demonstrates the artist's mastery of all aspects of the printmaker's craft, for Rembrandt used both engraving and etching to depict the figures and the setting. As in his other religious works, Rembrandt suffused this print with a deep and abiding piety, presenting the viewer not the celestial triumph of the Catholic Church but the humanity and humility of Jesus. Christ appears in the center preaching compassionately to, and simultaneously blessing, the blind, the lame, and the young, who are spread throughout the composition in a dazzling array of standing, kneeling, and lying positions. Also present is a young man in elegant garments with his head in his hand, lamenting Christ's insistence that the wealthy need to give their possessions to the poor in order to gain entrance to Heaven. The tonal range of the print is remarkable. At the right, the figures near the city gate are in deep shadow. At the left, the figures, some rendered almost exclusively in outline, are in bright light-not

Pierpont Morgan Library, New York.

the light of day but the illumination radiating from Christ himself. A second, unseen source of light comes from the right and casts the shadow of the praying man's arms and head onto Christ's tunic. Technically and in terms of its humanity, Hundred-Guilder Print is Rembrandt's supreme achievement as a printmaker.

Cuyp and Ruisdael

Due to topography and politics, the Dutch had a unique relationship to the land, one that differed from attitudes of people living in other European countries. After gaining independence from Spain, the Dutch undertook an extensive reclamation project lasting almost a century. Dikes and drainage systems cropped up across the countryside. Because of the effort expended on these endeavors, the Dutch developed a distinctly direct relationship to the land. The reclamation also affected Dutch social and economic life. The marshy and swampy nature of much of the terrain made it less desirable for large-scale exploitation, so the extensive feudal landowning system elsewhere in Europe never developed in the United Provinces. Most Dutch families owned and worked their own farms, cultivating a feeling of closeness to the land. Consequently, landscape scenes abound in 17th-century Dutch art.

25-17 AELBERT CUYP, Distant View of Dordrecht, with a Milkmaid and Four Cows, and Other Figures (The "Large Dort"), late 1640s. Oil on canvas, 5' $1'' \times 6' 4\frac{7}{8}$ ". National Gallery, London.

Unlike idealized Italian Renaissance landscapes, Cuyp's painting portrays a particular locale. The cows, shepherds, and milkmaid refer to the Dutch Republic's important dairy industry.

AELBERT CUYP One Dutch artist who established his reputation as a specialist in landscape painting was AELBERT CUYP (ca. 1620–1691). His works were the products of careful observation and a deep respect for and understanding of Dutch topography. *Distant View of Dordrecht, with a Milkmaid and Four Cows, and Other Figures* (FIG. **25-17**) reveals Cuyp's substantial skills. Unlike the idealized classical landscapes in many Italian Renaissance paintings, this landscape is particularized. The church in the background, for example, is a faithful representation of the Grote Kerk in

Dordrecht. The dairy cows, shepherds, and milkmaid in the foreground refer to a cornerstone of Dutch agriculture—the demand for dairy products such as butter and cheese, which increased with the development of urban centers. The credibility of this and similar paintings rests on Cuyp's pristine rendering of each detail.

JACOB VAN RUISDAEL Depicting the Dutch landscape with precision and sensitivity was also a specialty of JACOB VAN RUISDAEL (ca. 1628–1682). In *View of Haarlem from the Dunes at*

Overveen (FIG. 25-18), Ruisdael provided an overarching view of this major Dutch city. The specificity of the artist's image-the Saint Bavo church in the background, the numerous windmills that refer to the land reclamation efforts, and the figures in the foreground stretching linen to be bleached (a major industry in Haarlem)-reflects the pride Dutch painters took in recording their homeland and the activities of their fellow citizens. Nonetheless, in this painting the inhabitants and dwellings are so minuscule they blend into the land itself, unlike the figures in Cuyp's view of Dordrecht. Moreover, the horizon line is low, so the sky fills almost three-quarters of the picture space, and the sun illuminates the landscape only in patches, where

25-18 JACOB VAN RUISDAEL, View of Haarlem from the Dunes at Overveen, ca. 1670. Oil on canvas, 1' $10'' \times 2'$ 1". Mauritshuis, The Hague.

In this painting, Ruisdael succeeded in capturing a specific, realistic view of Haarlem, its windmills, and Saint Bavo church, but he also imbued the landscape with a quiet serenity approaching the spiritual.

it has broken through the clouds above. In *View of Haarlem*, Ruisdael not only captured the appearance of a specific locale but also succeeded in imbuing the work with a quiet serenity that is almost spiritual. Less typical of his work, but also one of the great landscape paintings of the 17th century, is Ruisdael's allegorical *Jewish Cemetery* (FIG. **25-18A**).

25-18A RUISDAEL, Jewish Cemetery, ca. 1655–1660.

Vermeer

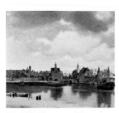

25-18B VERMEER, View of Delft, ca. 1661.

Although he also painted landscapes, such as *View of Delft* (FIG. **25-18B**), JAN VERMEER (1632–1675) made his reputation as a painter of interior scenes, another popular subject among middle-class patrons. These paintings offer the viewer glimpses into the private lives of prosperous, responsible, and cultured citizens of the United Provinces. Despite his fame as a painter today, Ver-

meer derived much of his income from his work as an innkeeper and art dealer in Delft (see "Middle-Class Patronage and the Art Market," page 703), and he completed no more than 35 paintings that can be definitively attributed to him. He began his career as a painter of biblical and historical themes but soon abandoned those traditional subjects in favor of domestic scenes. Flemish artists of the 15th century also had painted domestic interiors, but sacred personages often occupied those scenes (for example, FIG. 20-1). In contrast, Vermeer and his contemporaries composed neat, quietly opulent interiors of Dutch middle-class dwellings with men, women, and children engaging in household tasks or at leisure. Women are the primary occupants of Vermeer's homes, and his paintings are highly idealized depictions of the social values of Dutch burghers.

WOMAN HOLDING A BALANCE In one of Vermeer's finest canvases, *Woman Holding a Balance* (FIG. **25-19**), a beautiful young woman wearing a veil and a fur-trimmed jacket stands in

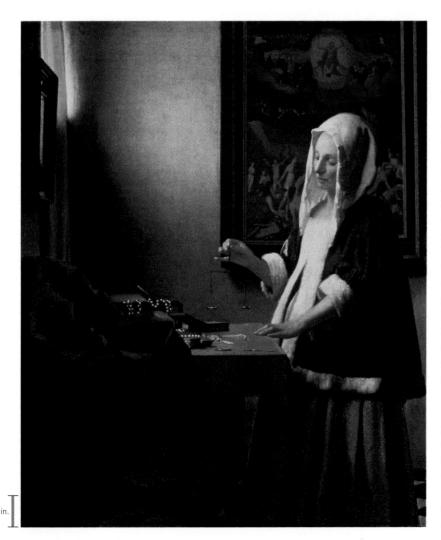

a room in her home. Light coming from a window illuminates the scene, as in many of the artist's paintings. The woman stands before a table on which are spread her most precious possessions-pearl necklaces, gold chains, and gold coins, which reflect the sunlight that also shines on the woman's face and the fingers of her right hand. In fact, the perspective orthogonals direct the viewer's attention neither to the woman's head nor to her treasures but to the hand in which she holds a balance for weighing gold. The scales, however, are emptyin perfect balance, the way Ignatius of Loyola advised Catholics (Vermeer was a Catholic convert in the Protestant Dutch Republic) to lead a temperate, self-aware life and to balance one's sins with virtuous behavior. The mirror on the wall may refer to self-knowledge, but it may also symbolize, as do the pearls and gold, the sin of vanity. Bolstering that interpretation is the large framed Last Judgment painting on the back wall in which Christ, weigher of souls, appears in a golden aureole directly above the young woman's head. Therefore, this serene domestic scene is pregnant with hidden meaning. The woman holds the scales in balance and contemplates the kind of life (one free from the temptations of worldly riches) she must lead in order to be judged favorably on judgment day.

Vermeer, like Rembrandt, was a master of pictorial light and used it with immense virtuosity. He could render space so convincingly through his depiction of light that in his works the picture surface functions as an invisible glass pane through which the viewer looks into the constructed illusion. Art historians believe Vermeer used as tools both mirrors and the *camera obscura*, an ancestor of the modern camera based on passing light through a tiny

> pinhole or lens to project an image on a screen or the wall of a room. (In later versions, artists projected the image on a ground-glass wall of a box whose opposite wall contained the pinhole or lens.) Vermeer did not simply copy the camera's image, however. Instead, the camera obscura and the mirrors helped him obtain results he reworked compositionally, placing his figures and the furniture of a room in a beautiful stability of quadrilateral shapes. Vermeer's compositions evoke a matchless classical serenity. Enhancing this quality are colors so true to the optical facts and so subtly modulated they suggest Vermeer was far ahead of his time in color science. For example, Vermeer realized shadows are not colorless and dark, adjoining colors affect each other, and light is composed of colors. Thus, he painted reflections off of surfaces in colors modified by others nearby. Some scholars have suggested Vermeer also perceived the phenomenon modern photographers call "circles of confusion," which appear on out-of-focus negatives. Vermeer could have seen them in images projected by the camera obscura's primitive lenses. He approximated these effects with light dabs that, in close view, give the impression of an image slightly "out of focus." When the observer draws back a step, however, as if adjusting the lens, the color spots cohere, giving an astonishingly accurate illusion of the third dimension.

25-19 JAN VERMEER, *Woman Holding a Balance*, ca. 1664. Oil on canvas, $1' 3\frac{5''}{8} \times 1' 2''$. National Gallery of Art, Washington, D.C. (Widener Collection).

Vermeer's woman holding empty scales in perfect balance, ignoring pearls and gold on the table, is probably an allegory of the temperate life. On the wall behind her is a *Last Judgment* painting.

25-20 JAN VERMEER, Allegory of the Art of Painting, 1670–1675. Oil on canvas, $4' 4'' \times 3' 8''$. Kunsthistorisches Museum, Vienna.

Dutch painters often specialized in domestic scenes, but Vermeer's mother-in-law described this work as the "Art of Painting." Vermeer's tribute to his craft includes a model holding Clio's attributes.

THE ART OF PAINTING Vermeer's stylistic precision and commitment to his profession are evident in Allegory of the Art of Painting (FIG. **25-20**). The artist himself appears in the painting, with his back to the viewer and dressed in "historical" clothing (reminiscent of Burgundian attire). He is hard at work on a painting of the model standing before him wearing a laurel wreath and holding a trumpet and book, traditional attributes of Clio, the muse of history. The map of the provinces (an increasingly common wall adornment in Dutch homes) on the back wall serves as yet another reference to history. As

1666

in Woman Holding a Balance and The Letter (FIG. 25-20A), another of Vermeer's domestic scenes, the viewer is outside the space of the action, looking in through the drawn curtain, which also separates the artist in his studio from the rest of the house. Some

art historians have suggested the light radiating from an unseen window on the left, illuminating

both the model and the canvas being painted, alludes to the light of artistic inspiration. Accordingly, many scholars have interpreted this painting as an allegory—a reference to painting inspired by history. Vermeer's mother-in-law confirmed this allegorical reading in 1677 while seeking to retain the painting after the artist's death, when 26 of his works were scheduled to be sold to pay his widow's debts. She listed the painting in her written claim as "the piece . . . wherein the Art of Painting is portrayed."³

Steen

Whereas Vermeer's paintings reveal the charm and beauty of Dutch domesticity, the works of JAN STEEN (ca. 1625–1679) provide a counterpoint. In *Feast of Saint Nicholas* (FIG. **25-21**), instead of depicting a tidy, calm Dutch household, Steen opted for a scene of chaos and disruption. Saint Nicholas has just visited this residence, and the children are in an uproar as they search their shoes for the

25-21 JAN STEEN, *Feast of Saint Nicholas*, ca. 1660–1665. Oil on canvas, 2' $8_4^{1''} \times 2' 3_4^{3''}$. Rijksmuseum, Amsterdam.

Steen's lively scene of Dutch children discovering their Christmas gifts may also have an allegorical dimension. *Feast of Saint Nicholas* probably alludes to selfishness, pettiness, and jealousy.

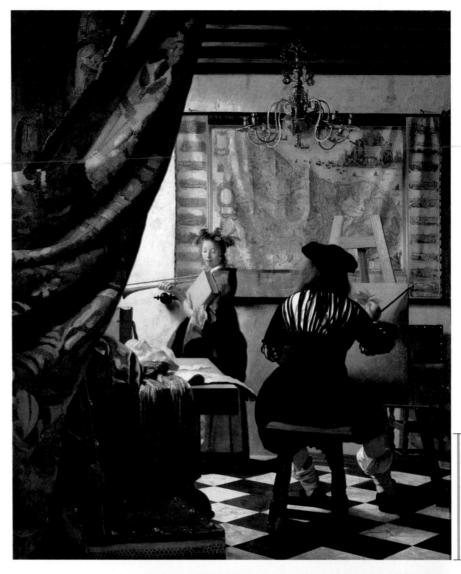

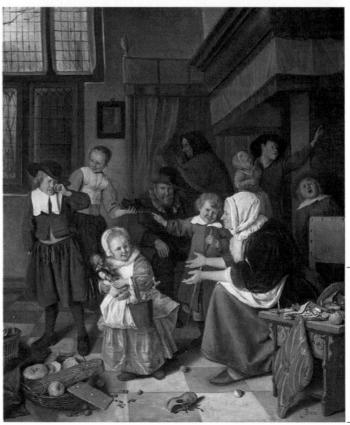

1 ft

Christmas gifts he has left. Some children are delighted. The little girl in the center clutches her gifts, clearly unwilling to share with the other children despite her mother's pleas. Others are disappointed. The boy on the left is in tears because he received only a birch rod. An appropriately festive atmosphere reigns, which contrasts sharply with the decorum prevailing in Vermeer's works. As do the paintings of other Dutch artists, Steen's lively scenes often take on an allegorical dimension and moralistic tone. Steen frequently used children's activities as satirical comments on foolish adult behavior. Feast of Saint Nicholas is not his only allusion to selfishness, pettiness, and jealousy.

Kalf and Ruysch

As already discussed (see "Still-Life Painting in the Dutch Republic," page 695), Dutch patrons had a keen interest in still lifes. In addition to Peter Claesz (FIG. 25-1), the leading Dutch still-life painters included Willem Kalf and Rachel Ruysch.

WILLEM KALF As Dutch prosperity increased, precious objects and luxury items made their way into still-life paintings. Still Life with a Late Ming Ginger Jar (FIG. 25-22) by WILLEM KALF (1619-1693) reflects the wealth Dutch citizens had accrued and the painter's exquisite skills, both technical and aesthetic. Kalf highlighted the breadth of Dutch maritime trade through his depiction of the Indian floral carpet and the Chinese jar used to store ginger (a luxury item). He delighted in recording the lustrous sheen of fabric and the light glinting off reflective surfaces. As is evident in this image, Kalf's works present an array of ornamental objects, such as the Venetian and Dutch glassware and the silver dish. The inclusion of the watch, Mediterranean peach, and peeled lemon suggests this work, like Claesz's Vanitas Still Life (FIG. 25-1), is also a vanitas painting, consistent with Calvinist values.

RACHEL RUYSCH As living objects that soon die, flowers, particularly cut blossoms, appeared frequently in vanitas paintings. However, floral painting as a distinct genre also flourished in the Dutch Republic. One of the leading practitioners of this art was RACHEL RUYSCH (1663-1750), who from 1708 to 1716 served as court painter to the elector Palatine (the ruler of the Palatinate, a former division of Bavaria) in Düsseldorf, Germany. Ruysch's father was a professor of botany and anatomy, which may account for her interest in and knowledge of plants and insects. She acquired an international reputation for her lush paintings, such as Flower Still Life (FIG. 25-23). In this canvas, the lavish floral arrangement is so full, many of the blossoms seem to be spilling out of the vase. Ruysch's careful arrangement of the painting's elements is evident in her composing the flowers to create a diagonal running from the lower left to the upper right corner of the canvas, offsetting the opposing diagonal of the table edge.

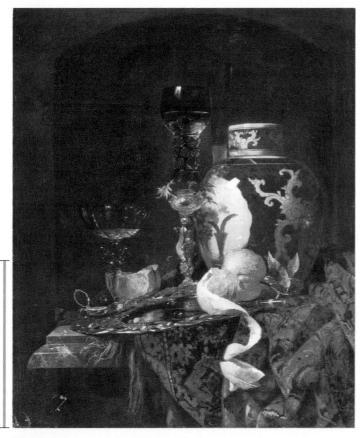

1 ft.

The opulent objects, especially the Indian carpet and Chinese jar, attest to the prosperous Dutch maritime trade. Kalf's inclusion of a watch suggests this painting may be a vanitas still life.

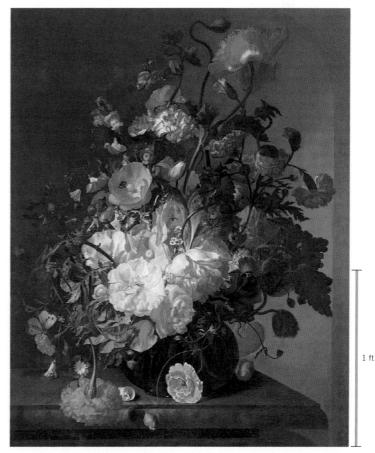

25-23 RACHEL RUYSCH, Flower Still Life, after 1700. Oil on canvas, 2' $5\frac{3''}{4} \times 1' 11\frac{7''}{8}$. Toledo Museum of Art, Toledo (purchased with funds from the Libbey Endowment, gift of Edward Drummond Libbey).

Flower paintings were very popular in the Dutch Republic. Ruysch achieved international renown for her lush paintings of floral arrangements, noted also for their careful compositions.

FRANCE

In France, monarchical authority had been increasing for centuries, culminating in the reign of Louis XIV (r. 1661–1715), who sought to determine the direction of French society and culture. Although its economy was not as expansive as the Dutch Republic's, France became Europe's largest and most powerful nation in the 17th century. Against this backdrop, the arts flourished.

Louis XIV

The preeminent French art patron of the 17th century was King Louis XIV himself. Determined to consolidate and expand his power, Louis was a master of political strategy and propaganda. He established a carefully crafted and nuanced relationship with the nobility, granting them sufficient benefits to keep them pacified but simultaneously maintaining rigorous control to avoid insurrection or rebellion. He also ensured subservience by anchoring his rule in *divine right* (belief in a king's absolute power as God's will), rendering Louis's authority incontestable. So convinced was Louis of his importance and centrality to the French kingdom that he eagerly adopted the title "le Roi Soleil" ("the Sun King"). Like the sun, Louis XIV was the center of the universe.

The Sun King's desire for control extended to all realms of French life, including art. Louis and his principal adviser, Jean-Baptiste Colbert (1619–1683), strove to organize art and architecture in the service of the state. They understood well the power of art as propaganda and the value of visual imagery for cultivating a public persona, and they spared no pains to raise great symbols and monuments to the king's absolute power. Louis and Colbert sought to regularize taste and establish the classical style as the preferred French manner. The founding of the Royal Academy of Painting and Sculpture in 1648 served to advance this goal.

PORTRAITURE Louis XIV maintained a workshop of artists, each with a specialization—for example, faces, fabric, architecture, landscapes, armor, or fur. Thus, many of the king's portraits were a group effort, but the finest is the work of one artist. *Louis XIV*

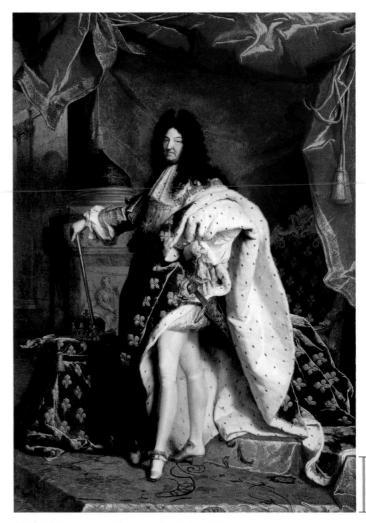

25-24 HYACINTHE RIGAUD, *Louis XIV*, 1701. Oil on canvas, 9′ 2″ × 6′ 3″. Musée du Louvre, Paris. ■4

In this portrait set against a stately backdrop, Rigaud portrayed the 5' 4" Sun King wearing red high-heeled shoes and with his ermine-lined coronation robes thrown over his left shoulder.

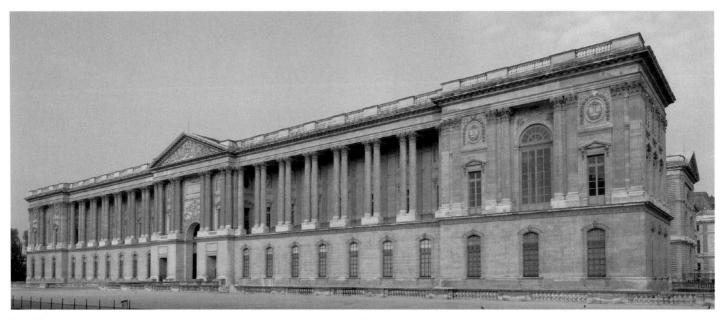

25-25 CLAUDE PERRAULT, LOUIS LE VAU, and CHARLES LE BRUN, east facade of the Louvre (looking southwest), Paris, France, 1667–1670. The design of the Louvre's east facade is a brilliant synthesis of French and Italian classical elements, including a central pavilion resembling an ancient temple front with a pediment.

(FIG. 25-24) by HYACINTHE RIGAUD (1659-1743) successfully conveys the image of an absolute monarch. The king, age 63 when Rigaud painted this work, stands with his left hand on his hip and gazes directly at the viewer. His elegant ermine-lined fleur-de-lis coronation robes (compare FIG. 25-3) hang loosely from his left shoulder, suggesting an air of haughtiness. Louis also draws his garment back to expose his legs. (The king was a ballet dancer in his youth and was proud of his well-toned legs.) The portrait's majesty derives in large part from the composition. The Sun King is the unmistakable focal point of the image, and Rigaud placed him so he seems to look down on the viewer. (Louis XIV was only five feet four inches tall-a fact that drove him to invent the red-heeled shoes he wears in the portrait.) The carefully detailed environment in which the king stands also contributes to the painting's stateliness and grandiosity. Indeed, when the king was not present, Rigaud's portrait, which hung over the throne, served in his place, and courtiers knew never to turn their backs on the painting.

THE LOUVRE The first great architectural project Louis XIV and his adviser Colbert undertook was the closing of the east side of the Louvre's Cour Carré (FIG. 23-14), left incomplete by Pierre Lescot in the 16th century. The king summoned Gianlorenzo Bernini (see Chapter 24) from Rome to submit plans, but Bernini envisioned an Italian palace on a monumental scale, which would have involved the demolition of all previous work. His plan rejected, Bernini indignantly returned to Rome. Louis then turned to three French architects—CLAUDE PERRAULT (1613–1688), LOUIS LE VAU (1612-1670), and CHARLES LE BRUN (1619-1690)-for the Louvre's east facade (FIG. 25-25). The design is a brilliant synthesis of French and Italian classical elements, culminating in a new and definitive formula. The facade has a central and two corner projecting columnar pavilions resting on a stately podium. The central pavilion is in the form of a classical temple front. To either side is a giant colonnade of paired columns, resembling the columned flanks of a temple folded out like wings. The designers favored an even roofline, balustraded and broken only by the central pediment, over the traditional French pyramidal roof of the Louvre's west wing (FIG. 23-14). The emphatically horizontal sweep of the 17th-century facade brushed aside all memory of Gothic verticality. The stately proportions and monumentality of the Baroque design were both an expression of the new official French taste and a symbol of centrally organized authority.

VERSAILLES PALACE Work on the Louvre barely had begun when Louis XIV decided to convert a royal hunting lodge at Versailles, south of Paris, into a great palace. He assembled a veritable army of architects, decorators, sculptors, painters, and landscape designers under the general management of Charles Le Brun. In their hands, the conversion of a simple lodge into the palace of Versailles (FIG. **25-26**) became the greatest architectural project of the age—a defining statement of French Baroque style and an undeniable symbol of Louis XIV's power and ambition.

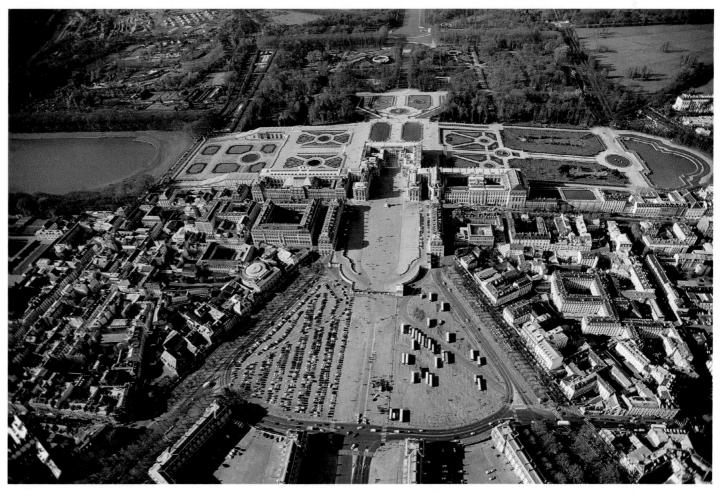

25-26 JULES HARDOUIN-MANSART, CHARLES LE BRUN, and ANDRÉ LE NÔTRE, aerial view of the palace and gardens (looking northwest), Versailles, France, begun 1669.

Louis XIV ordered his architects to convert a royal hunting lodge at Versailles into a gigantic palace and park with a satellite city whose three radial avenues intersect in the king's bedroom.

25-27 JULES HARDOUIN-MANSART and CHARLES LE BRUN, Galerie des Glaces (Hall of Mirrors), palace of Versailles, Versailles, France, ca. 1680.

This hall overlooks the Versailles park from the second floor of Louis XIV's palace. Hundreds of mirrors illusionistically extend the room's width and once reflected gilded and jeweled furnishings.

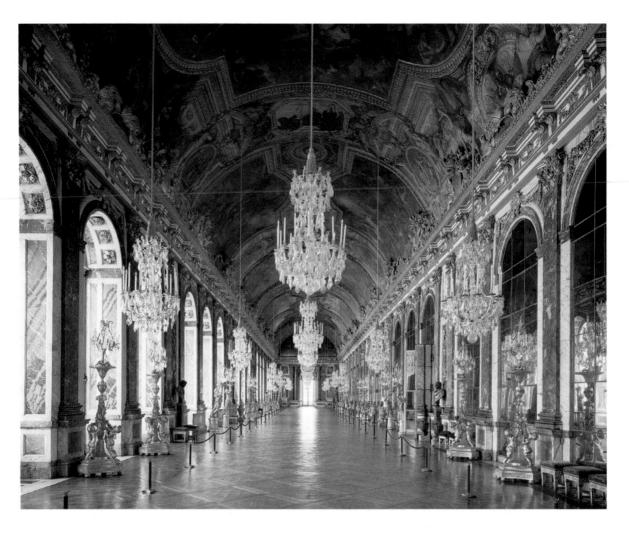

Planned on a gigantic scale, the project called not only for a large palace flanking a vast park but also for the construction of a satellite city to house court and government officials, military and guard detachments, courtiers, and servants (undoubtedly to keep them all under the king's close supervision). Le Brun laid out this town to the east of the palace along three radial avenues that converge on the palace. Their axes, in a symbolic assertion of the ruler's absolute power over his domains, intersected in the king's spacious bedroom, which served as an official audience chamber. The palace itself, more than a quarter mile long, is perpendicular to the dominant east-west axis running through the associated city and park.

Every detail of the extremely rich decoration of the palace's interior received careful attention. The architects and decorators designed everything from wall paintings to doorknobs in order to reinforce the splendor of Versailles and to exhibit the very finest sense of artisanship. Of the literally hundreds of rooms within the palace, the most famous is the Galerie des Glaces, or Hall of Mirrors (FIG. 25-27), designed by JULES HARDOUIN-MANSART (1646-1708) and Le Brun. This hall overlooks the park from the second floor and extends along most of the width of the central block. Although deprived of its original sumptuous furniture, which included gold and silver chairs and bejeweled trees, the Galerie des Glaces retains much of its splendor today. Hundreds of mirrors, set into the wall opposite the windows, alleviate the hall's tunnel-like quality and illusionistically extend the width of the room. The mirror, that ultimate source of illusion, was a favorite element of Baroque interior design. Here, it also enhanced the dazzling extravagance of the great festivals Louis XIV was so fond of hosting.

VERSAILLES PARK The enormous palace might appear unbearably ostentatious were it not for its extraordinary setting in a vast park, which makes the palace seem almost an adjunct. From the Galerie des Glaces, the king and his guests could enjoy a sweeping vista down the park's tree-lined central axis and across terraces, lawns, pools, and lakes toward the horizon. The park of Versailles, designed by ANDRÉ LE NÔTRE (1613–1700), must rank among the world's greatest artworks in both size and concept. Here, the French architect transformed an entire forest into a park. Although its geometric plan may appear stiff and formal, the park in fact offers an almost unlimited assortment of vistas, as Le Nôtre used not only the multiplicity of natural forms but also the terrain's slightly rolling contours with stunning effectiveness.

The formal gardens near the palace provide a rational transition from the frozen architectural forms to the natural living ones. Here, the elegant shapes of trimmed shrubs and hedges define the tightly designed geometric units. Each unit is different from its neighbor and has a focal point in the form of a sculptured group, a pavilion, a reflecting pool, or perhaps a fountain. Farther away from the palace, the design loosens as trees, in shadowy masses, screen or frame views of open countryside. Le Nôtre carefully composed all vistas for maximum effect. Light and shadow, formal and informal, dense growth and open meadows—all play against one another in unending combinations and variations. No photograph or series of photographs can reveal the design's full richness. The park unfolds itself only to those walking through it. In this respect, it is a temporal artwork. Its aspects change with the time of day, the seasons, and the relative position of the observer.

25-28 FRANÇOIS GIRARDON and THOMAS REGNAUDIN, *Apollo Attended by the Nymphs*, Grotto of Thetis, Park of Versailles, Versailles, France, ca. 1666–1672. Marble, life-size.

Girardon's study of ancient sculpture and Poussin's figure compositions influenced the design of this mythological group in a grotto above a dramatic waterfall in the gardens of Versailles.

GROTTO OF THETIS For the Grotto of Thetis above a dramatic waterfall in the gardens of Versailles, FRANÇOIS GIRARDON (1628-1715) designed Apollo Attended by the Nymphs (FIG. 25-28). Both stately and graceful, the nymphs have a compelling charm as they minister to the god Apollo at the end of the day. (The three nymphs in the background are the work of THOMAS REGNAUDIN [1622-1706].) Girardon's close study of Greco-Roman sculpture heavily influenced his design of the figures, and the figure compositions of the most renowned French painter of the era, Nicholas Poussin (FIG. 25-31), inspired their arrangement. Since Apollo was often equated with the sun god (see "The Gods and Goddesses of Mount Olympus," Chapter 5, page 107, or page xxix in Volume II and Book D), the group refers obliquely to Louis XIV as the Roi Soleil. This doubtless helped to assure the work's success at court. Girardon's classical style and mythological symbolism well suited France's glorification of royal majesty.

ROYAL CHAPEL In 1698, Hardouin-Mansart received the commission to add a Royal Chapel to the Versailles palace complex. The chapel's interior (FIG. 25-29) is essentially rectangular, but because its apse is as high as the nave, the fluid central space takes on a curved Baroque quality. However, the light entering through the large clerestory windows lacks the directed dramatic effect of the Italian Baroque, instead illuminating the interior's precisely chiseled details brightly and evenly. Pier-supported arcades carry a majestic row of Corinthian columns defining the royal gallery. The royal pew is at the rear, accessible directly from the king's apartments. Amid the restrained decoration, only the illusionistic ceiling paintings, added in 1708 and 1709 by ANTOINE COYPEL (1661-1722), suggest the drama and complexity of Italian Baroque art.

As a symbol of absolute power, Versailles has no equal. It also expresses, in the most monumental terms of its age, the rationalistic creed—based on scientific advances, such as the physics of Sir Isaac

25-29 JULES HARDOUIN-MANSART, interior of the Royal Chapel, with ceiling decorations by ANTOINE COYPEL, palace of Versailles, Versailles, France, 1698–1710.

Because the apse is as high as the nave, the central space of the Royal Chapel at Versailles has a curved Baroque quality. Louis XIV could reach the royal pew directly from his apartments.

25-30 JULES HARDOUIN-MANSART, Église du Dôme (looking north), Church of the Invalides, Paris, France, 1676–1706. ■

Hardouin-Mansart's church marries the Italian and French architectural styles. The grouping of the orders is similar to the Italian Baroque manner but without the dramatic play of curved surfaces.

Newton (1642–1727) and the mathematical philosophy of René Descartes (1596–1650)—that all knowledge must be systematic and all science must be the consequence of the intellect imposed on matter. The majestic and rational design of Versailles proudly proclaims the mastery of human intelligence (and the mastery of Louis XIV) over the disorderliness of nature.

ÉGLISE DU DÔME, PARIS Another of Hardouin-Mansart's masterworks, the Église du Dôme (FIG. **25-30**), or Church of the Invalides, in Paris, also marries the Italian Baroque and French classical architectural styles. An intricately composed domed square of great scale, the church adjoins the veterans hospital Louis XIV

established for the disabled soldiers of his many wars. Two firmly separated levels, the upper one capped by a pediment, compose the frontispiece. The grouping of the orders and of the bays they frame is not unlike that in Italian Baroque architecture but without the dramatic play of curved surfaces characteristic of many 17th-century Italian churches, for example, Borromini's San Carlo (FIG. 24-9) in Rome. The compact facade is low and narrow in relation to the vast drum and dome, seeming to serve simply as a base for them. The overpowering dome, conspicuous on the Parisian skyline, is itself expressive of the Baroque love for dramatic magnitude, as is the way its designer aimed for theatrical effects of light and space. The dome consists of three shells, the lowest cut off so a visitor to the interior looks up through it to the one above, which is filled with light from hidden windows in the third, outermost dome. CHARLES DE LA FOSSE (1636-1716) painted the second dome in 1705 with an Italianinspired representation of the heavens opening up to receive Saint Louis, patron of France (see "Louis IX, the Saintly King," Chapter 13, page 385).

Poussin

Louis XIV's embrace of classicism enticed many French artists to study Rome's ancient and Renaissance monuments. But even before the Sun King ascended to the throne in 1661, NICOLAS POUSSIN (1594-1665) of Normandy had spent most of his life in Rome, where he produced grandly severe paintings modeled on those of Titian and Raphael. He also carefully formulated a theoretical explanation of his method and was ultimately responsible for establishing classical painting as an important ingredient of 17th-century French art (see "Poussin's Notes for a Treatise on Painting," page 719). His classical style presents a striking contrast to the contemporaneous Baroque style of his Italian counterparts in Rome (see Chapter 24), underscoring the multifaceted character of the art of 17th-century Europe.

ET IN ARCADIA EGO Poussin's *Et in Arcadia Ego* (*Even in Arcadia, I* [am present]; FIG. **25-31**) exemplifies the "grand manner" of painting the artist advocated. It features a lofty subject rooted in the classical world and figures based on antique statuary. Rather than depicting dynamic movement and intense emotions, as his Italian contemporaries in Rome did, Poussin emulated the rational order and stability of Raphael's paintings. Domi-

nating the foreground are three shepherds living in the idyllic land of Arcadia. They study an inscription on a tomb as a statuesque female figure quietly places her hand on the shoulder of one of them. She may be the spirit of death, reminding these mortals, as does the inscription, that death is found even in Arcadia, supposedly a spot of paradisiacal bliss. The countless draped female statues surviving in Italy from Roman times supplied the models for this figure, and the posture of the youth with one foot resting on a boulder derives from Greco-Roman statues of Neptune, the sea god, leaning on his trident. The classically compact and balanced grouping of the figures, the even light, and the thoughtful and reserved mood complement Poussin's classical figure types.

Poussin's Notes for a Treatise on Painting

As the leading proponent of classical painting in 17th-century Rome, Nicolas Poussin outlined the principles of classicism in notes for an intended treatise on painting, left incomplete at his death. In those notes, Poussin described the essential ingredients necessary to produce a beautiful painting in "the grand manner":

The grand manner consists of four things: subject-matter or theme, thought, structure, and style. The first thing that, as the foundation of all others, is required, is that the subject-matter shall be grand, as are battles, heroic actions, and divine things. But assuming that the subject on which the painter is laboring is grand, his next consideration is to keep away from minutiae . . . [and paint only] things magnificent and grand . . . Those who elect mean subjects take refuge in them because of the weakness of their talents.*

The idea of beauty does not descend into matter unless this is prepared as carefully as possible. This preparation consists of three things: arrangement, measure, and aspect or form. Arrangement means the relative position of the parts; measure refers to their size; and form consists of lines and colors. Arrangement and relative position of the parts and making every limb of the body hold its natural place are not sufficient unless measure is added, which gives to each limb its correct size, proportionate to that of the whole body [compare "Polykleitos's Prescription for the Perfect Statue," Chapter 5, page 132], and unless form joins in, so that the lines will be drawn with grace and with a harmonious juxtaposition of light and shadow.[†]

Poussin applied these principles in paintings such as *Et in Arcadia Ego* (FIG. 25-31), a work peopled with perfectly proportioned statuesque figures attired in antique garb.

*Translated by Robert Goldwater and Marco Treves, eds., *Artists on Art*, 3d ed. (New York: Pantheon Books, 1958), 155. 'Ibid., 156.

25-31 NICOLAS POUSSIN, Et in Arcadia Ego, ca. 1655. Oil on canvas, 2' 10" × 4'. Musée du Louvre, Paris.

Poussin was the leading proponent of classicism in 17th-century Rome. His "grand manner" paintings are models of "arrangement and measure" and incorporate figures inspired by ancient statuary.

1 ft

25-32 NICOLAS POUSSIN, Landscape with Saint John on Patmos, 1640. Oil on canvas, $3' 3\frac{1}{2}'' \times 4' 5\frac{5}{8}''$. Art Institute of Chicago, Chicago (A. A. Munger Collection).

Poussin placed Saint John in a classical landscape amid broken columns, an obelisk, and a ruined temple, suggesting the decay of great civilizations and the coming of the new Christian era.

SAINT JOHN ON PATMOS In *Et in Arcadia Ego*, monumental figures dominate the landscape setting, but the natural world looms large in many of Poussin's paintings. *Landscape with Saint John on Patmos* (FIG. **25-32**) is one of a pair of canvases Poussin painted for Gian Maria Roscioli (d. 1644), secretary to Pope Urban VIII. The second landscape represents Saint Matthew, reclining in right profile, who faced Saint John when the two canvases, now in different museums on different continents, hung side by side in Rome. An eagle stands behind John, just as an angel, Matthew's attribute, stands beside him. John, near the end of his life on the Greek island of Patmos, composed the book of Revelation, his account of the end of the world and the second coming of Christ, a prophetic

vision of violent destruction and the last

judgment. Poussin's setting, however, is

a serene classical landscape beneath a

sunny sky. (He created a similar setting

in Burial of Phocion [FIG. 25-32A], which

he painted later in the decade.) Saint

John reclines in the foreground, posed

like a Greco-Roman river god, amid

25-32A POUSSIN, Burial of Phocion, 1648.

shattered columns and a pedestal for a statue that disappeared long ago. In the middle ground, two oak trees frame the ruins of a classical temple and an Egyptian obelisk, many of which the Romans brought to their capital from the Nile and the popes reused in their building projects, for example, in the piazza in front of Saint Peter's (FIG. 24-4) and in Bernini's Fountain of the Four Rivers (FIG. 24-1). The decaying buildings suggest the decline of great empires—to be replaced by Christianity in a new era. In the distance are hills, sky, and clouds, all of which Poussin represented with pristine clarity, ignoring the rules of atmospheric perspective. His landscapes are not portraits of specific places, as are the Dutch landscapes of Ruisdael (FIG. 25-18) and Vermeer (FIG. 25-18B). Rather, they are imaginary settings constructed according to classical rules of design. Poussin's clouds, for example, echo the contours of his hills.

Claude Lorrain

Claude Gellée, called CLAUDE LORRAIN (1600–1682) after his birthplace in the duchy of Lorraine, rivaled Poussin in fame. Claude modulated in a softer style Poussin's disciplined rational art, with its sophisticated revelation of the geometry of landscape. Unlike the figures in Poussin's pictures, those in Claude's landscapes tell no dramatic story, point out no moral, praise no hero, and celebrate no saint. Indeed, the figures in Claude's paintings often appear to be added as mere excuses for the radiant landscape itself. For the French artist, painting involved essentially one theme—the beauty of a broad sky suffused with the golden light of dawn or sunset glowing through a hazy atmosphere and reflecting brilliantly off rippling water.

In Landscape with Cattle and Peasants (FIG. **25-33**), the figures in the right foreground chat in animated fashion. In the left foreground, cattle relax contentedly. In the middle ground, cattle amble slowly away. The well-defined foreground, distinct middle ground, and dim background recede in serene orderliness, until all form dissolves in a luminous mist. Atmospheric and linear perspective reinforce each other to turn a vista into a typical Claudian vision, an ideal classical world bathed in sunlight in infinite space (compare FIG. I-12).

Claude's formalizing of nature with balanced groups of architectural masses, screens of trees, and sheets of water followed the great tradition of classical landscape. It began with the backgrounds of Venetian paintings (FIGS. 22-33 to 22-35) and continued in the art of Annibale Carracci (FIG. 24-15) and Poussin (FIGS. 25-32 and 25-32A). Yet Claude, like the Dutch painters, studied the light and the atmospheric nuances of nature, making a unique contribution. He recorded carefully in hundreds of sketches the look of the Roman countryside, its gentle terrain accented by stone-pines, cypresses, and poplars and by the ever-present ruins of ancient aqueducts, tombs, and towers. He made these the fundamental elements of his compositions. Travelers could understand the picturesque beauties of the outskirts of Rome in Claude's landscapes.

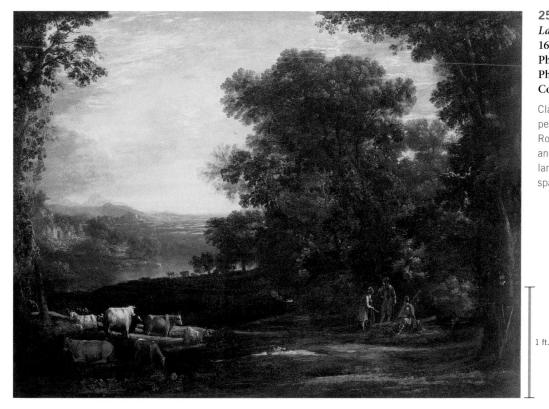

25-33 CLAUDE LORRAIN, Landscape with Cattle and Peasants, 1629. Oil on canvas, 3' $6'' \times 4' \ 10^{\frac{1}{2}''}$. Philadelphia Museum of Art, Philadelphia (George W. Elkins Collection).

Claude used atmospheric and linear perspective to transform the rustic Roman countryside filled with peasants and animals into an ideal classical landscape bathed in sunlight in infinite space.

Claude achieved his marvelous effects of light by painstakingly placing tiny value gradations, which imitated, though on a very small scale, the range of values of outdoor light and shade. Avoiding the problem of high-noon sunlight overhead, Claude preferred, and convincingly represented, the sun's rays as they gradually illuminated the morning sky or, with their dying glow, set the pensive mood of evening. Thus, he matched the moods of nature with those of human subjects. Claude's infusion of nature with human feeling and his recomposition of nature in a calm equilibrium greatly appealed to many landscape painters of the 18th and early 19th centuries.

1 ft

Le Nain, Callot, La Tour

Although classicism was an important element of French art during the 17th and early 18th centuries, not all artists embraced the "grand manner."

LOUIS LE NAIN The works of LOUIS LE NAIN (ca. 1593–1648) have more in common with contemporaneous Dutch art than Renaissance or ancient art. Nevertheless, subjects that in Dutch painting were opportunities for boisterous good humor (FIG. 25-21), Le Nain treated with somber stillness. *Family of Country People*

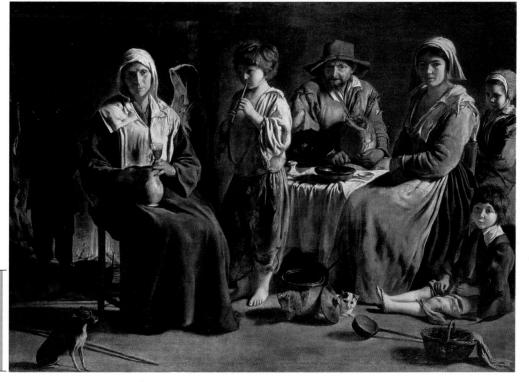

(FIG. **25-34**) reflects the thinking of 17th-century French social theorists who celebrated the natural virtue of peasants who worked the soil. Le Nain's painting expresses the grave dignity of one peasant family made stoic and resigned by hardship. These drab country folk surely had little reason for merriment. The peasant's lot, never easy, was miserable during the Thirty Years' War.

25-34 LOUIS LE NAIN, *Family of Country People*, ca. 1640. Oil on canvas, 3' $8'' \times 5'$ 2". Musée du Louvre, Paris.

Le Nain's painting expresses the grave dignity of a peasant family made stoic by hardship. It reflects 17th-century French social theory, which celebrated the natural virtue of those who worked the soil.

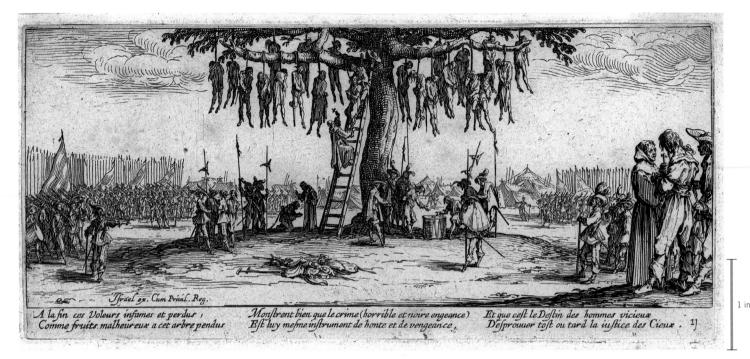

25-35 JACQUES CALLOT, Hanging Tree, from the Miseries of War series, 1629–1633. Etching, $3\frac{3}{4}'' \times 7\frac{4}{4}''$. Biliothèque Nationale, Paris.

Callot's *Miseries of War* etchings were among the first realistic pictorial records of the human disaster of military conflict. *Hanging Tree* depicts a mass execution of thieves in the presence of an army.

The anguish and frustration of the peasantry, suffering from the cruel depredations of unruly armies living off the countryside, often erupted in violent revolts that the same armies savagely suppressed. This family, however, is pious, docile, and calm. Because Le Nain depicted peasants with dignity and quiet resignation, despite their harsh living conditions, some scholars have suggested he intended his paintings to please wealthy urban patrons.

JACQUES CALLOT Two other prominent artists from Lorraine were Jacques Callot and Georges de La Tour. JACQUES CALLOT (ca. 1592–1635) conveyed a sense of military life during these troubled times in a series of prints called *Miseries of War*. Callot confined himself almost exclusively to the art of etching and was widely influential—Rembrandt was among those who knew and learned from his work. Callot perfected the medium of etching, developing a very hard surface for the copper plate to enable fine and precise delineation with the needle. His quick, vivid touch and faultless drawing produced panoramas sparkling with sharp details of life—and death—despite their small size (roughly 4 by 7 inches). In the *Miseries of War* series, he observed these details coolly, presenting without comment images based on events he must have witnessed in the wars in Lorraine.

In *Hanging Tree* (FIG. **25-35**), Callot depicted a mass execution of thieves (identified in the text at the bottom of the etching). The event takes place in the presence of a disciplined army, drawn up on parade with banners, muskets, and lances, their tents in the background. Hanged men sway in clusters from the branches of a huge cross-shaped tree. A monk climbs a ladder, holding up a crucifix to a man while the executioner adjusts the noose around the man's neck. At the foot of the ladder, another victim kneels to receive absolution. Under the crucifix tree, men roll dice on a drumhead, hoping to win the belongings of the executed. (This is probably an allusion to the soldiers who cast lots for the garments of the crucified Christ.) In the right foreground, a hooded priest consoles a bound man. Callot's *Miseries of War* etchings are among the first realistic pictorial records of the human disaster of armed conflict.

GEORGES DE LA TOUR France, unlike the Dutch Republic, was a Catholic country, and religious themes, although not as common as in Italian and Spanish Baroque art (see Chapter 24), occupied some 17th-century French painters. Among the French artists who painted biblical subjects was GEORGES DE LA TOUR (1593-1652). His work, particularly his use of light, suggests a familiarity with Caravaggio's art, which he may have learned about from painters in Utrecht, such as ter Brugghen and van Honthorst (FIGS. 25-7 and 25-8). Although La Tour used the devices of Caravaggio's Dutch followers, his effects are strikingly different from theirs. His Adoration of the Shepherds (FIG. 25-36) makes use of the night setting favored by the Utrecht school, much as van Honthorst portrayed it. But here, the light, its source shaded by an old man's hand, falls upon a very different company in a very different mood. A group of humble men and women, coarsely clad, gather in prayerful vigil around a luminous baby Jesus. Without the aid of the title, this work might be construed as a genre piece, a narrative of some event from peasant life. Nothing in the environment, placement, poses, dress, or attributes of the figures distinguishes them as the Virgin Mary, Joseph, Christ Child, or shepherds. The artist did not even paint halos. The light is not spiritual but material: it comes from a candle. La Tour's scientific scrutiny of the effects of light, as it throws precise shadows on surfaces intercepting it, nevertheless had religious intention and consequence. The light illuminates a group of ordinary people held in a mystic trance induced by their witnessing the miracle of the incarnation. In this timeless tableau of simple people, La Tour eliminated the dogmatic significance and traditional iconography of the incarnation. Still, these people

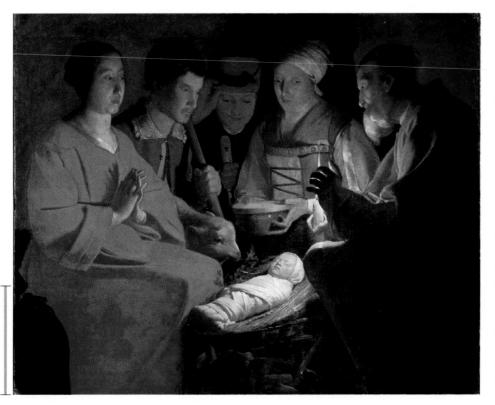

reverently contemplate something they regard as holy. The devout of any religious persuasion can read this painting, regardless of their familiarity with the biblical account.

1 ft

The supernatural calm pervading *Adoration of the Shepherds* is characteristic of the mood of Georges de La Tour's art. He achieved this by eliminating motion and emotive gesture (only the light is dramatic), by suppressing surface detail, and by simplifying body volumes. These stylistic traits are among those associated with classical and Renaissance art. Thus, several apparently contradictory elements meet in the work of La Tour: classical composure, fervent spirituality, and genre realism.

25-36 GEORGES DE LA TOUR, Adoration of the Shepherds, 1645–1650. Oil on canvas, $3' 6'' \times 4' 6''$. Musée du Louvre, Paris.

Without the aid of the title, this candlelit nighttime scene could be a genre piece instead of a biblical narrative. La Tour did not even paint halos around the heads of the holy figures.

ENGLAND

In England, in sharp distinction to France, the common law and the Parliament kept royal power in check. England also differed from France (and Europe in general) in other significant ways. Although an important part of English life, religion was not the contentious issue it was on the Continent. The religious affiliations of the English included Catholicism, Anglicanism, Protestantism, and Puritanism (the English version of Calvinism). In the economic realm, England was the one country (other than the Dutch Republic) to take advantage of the opportunities overseas trade offered. As an island, Britain (which after 1603 consisted of

England, Wales, and Scotland), like the Dutch Republic, possessed a large and powerful navy, as well as excellent maritime capabilities.

Jones and Wren

In the realm of art, the most significant English achievements were in the field of architecture, much of it, as in France, incorporating classical elements.

INIGO JONES The most important English architect of the first half of the 17th century was INIGO JONES (1573–1652), architect to Kings James I (r. 1603–1625) and Charles I (FIG. 25-5). Jones

spent considerable time in Italy. He greatly admired the classical authority and restraint of Andrea Palladio's structures and studied with great care his treatise on architecture (see Chapter 22). Jones took many motifs from Palladio's villas and palaces, and he adopted Palladio's basic design principles for his own architecture. The nature of his achievement is evident in the buildings he designed for his royal patrons, among them the Banqueting House (FIG. **25-37**) at Whitehall in London. For this structure, a symmetrical block of great clarity and dignity,

25-37 INIGO JONES, Banqueting House (looking northeast), Whitehall, London, England, 1619–1622.

Jones was a great admirer of the classical architecture of Palladio, and he adopted motifs from the Italian architect's villas and palaces for the buildings he designed for his royal patrons.

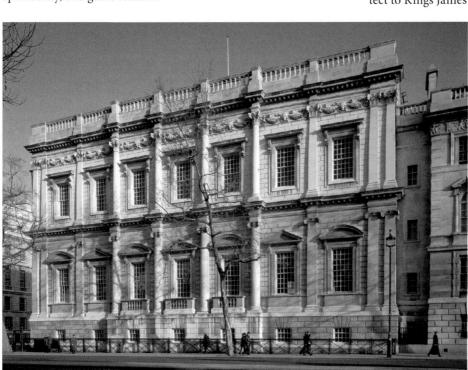

25-38 SIR CHRISTOPHER WREN, west facade of Saint Paul's Cathedral, London, England, 1675–1710.

Wren's cathedral replaced an old Gothic church. The facade design owes much to Palladio (FIG. 22-30) and Borromini (FIG. 24-12). The great dome recalls Saint Peter's in Rome (FIGS. 22-25 and 24-4).

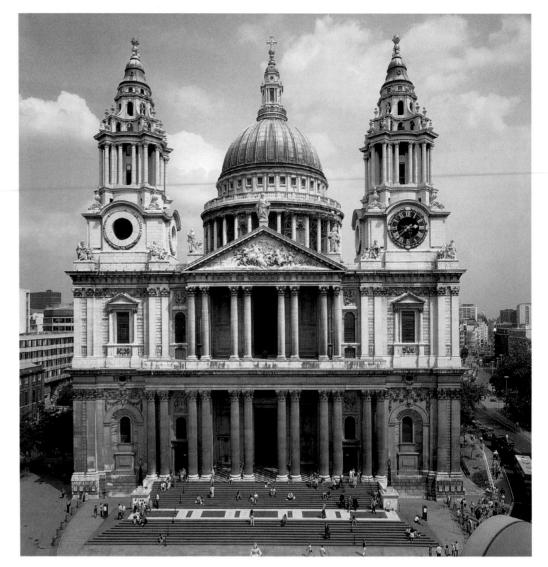

Jones superimposed two orders, using columns in the center and pilasters near the ends. The balustraded roofline, uninterrupted in its horizontal sweep, antedates the Louvre's east facade (FIG. 25-25) by more than 40 years. Palladio would have recognized and approved all of the design elements, but the building as a whole is not a copy of his work. Although relying on the revered Italian's architectural vocabulary and syntax, Jones retained his independence as a designer. For two centuries his influence in English architecture was almost as authoritative as Palladio's.

CHRISTOPHER WREN London's majestic Saint Paul's Cathedral (FIG. **25-38**) is the work of England's most renowned architect, CHRISTOPHER WREN (1632–1723). A mathematical genius and skilled engineer whose work won Isaac Newton's praise, Wren became professor of astronomy in London at age 25. Mathematics led to architecture, and Charles II (r. 1649–1685) asked Wren to prepare a plan for restoring the old Gothic church of Saint Paul. Wren proposed to remodel the building based on Roman structures. Within a few months, the Great Fire of London, which destroyed the old structure and many churches in the city in 1666, gave Wren his opportunity. Although Jones's work strongly influenced him, Wren also traveled in France, where the splendid palaces and state buildings being created in and around Paris at the time of the competition for the Louvre design must have impressed him. Wren also closely studied prints illustrating Baroque architecture in Italy. In Saint Paul's, he harmonized Palladian, French, and Italian Baroque features.

In view of its size, the cathedral was built with remarkable speed—in little more than 30 years—and Wren lived to see it completed. The building's form underwent constant refinement during construction, and Wren did not determine the final appearance of the towers until after 1700. In the splendid skyline composition, two foreground towers act effectively as foils to the great dome. Wren must have known similar schemes Italian architects had devised for Saint Peter's (FIG. 24-4) in Rome to solve the problem of the relationship between the facade and dome. Certainly, the influence of Borromini (FIG. 24-12) is evident in the upper levels and lanterns of the towers. The lower levels owe a debt to Palladio (FIG. 22-30), and the superposed paired columnar porticos recall the Louvre's east facade (FIG. 25-25). Wren's skillful eclecticism brought all these foreign features into a monumental unity.

Wren designed many other London churches after the Great Fire. Even today, Wren's towers and domes punctuate the skyline of London. Saint Paul's dome is the tallest of all. Wren's legacy was significant and long-lasting, both in England and in colonial America (see Chapter 26).

THE BAROQUE IN NORTHERN EUROPE

FLANDERS

- I In the 17th century, Flanders remained Catholic and under Spanish control. Flemish Baroque art is more closely tied to the Baroque art of Italy than is the art of much of the rest of northern Europe.
- The leading Flemish painter of this era was Peter Paul Rubens, whose work and influence were international in scope. A diplomat as well as an artist, he counted kings and queens among his patrons and friends. His paintings exhibit Baroque splendor in color and ornament, and feature robust and foreshortened figures in swirling motion.

DUTCH REPUBLIC

- The Dutch Republic received official recognition of its independence from Spain in the Treaty of Westphalia of 1648. Worldwide trade and banking brought prosperity to its predominantly Protestant citizenry, which largely rejected church art in favor of private commissions of portraits, genre scenes, landscapes, and still lifes.
- Frans Hals produced innovative portraits of middle-class patrons in which a lively informality replaced the formulaic patterns of traditional portraiture. Aelbert Cuyp and Jacob van Ruisdael specialized in landscapes depicting specific places, not idealized Renaissance settings. Peter Claesz, Willem Kalf, and others painted vanitas still lifes featuring meticulous depictions of worldly goods amid reminders of death.
- Rembrandt van Rijn, the greatest Dutch artist of the age, treated a broad range of subjects, including religious themes and portraits. His oil paintings are notable for their dramatic impact and subtle gradations of light and shade as well as the artist's ability to convey human emotions. Rembrandt was also a master printmaker renowned for his etchings.
- Jan Vermeer specialized in painting the occupants of serene, comfortable Dutch homes. His convincing representation of interior spaces depended in part on his employment of the camera obscura. Vermeer was also a master of light and color and understood shadows are not colorless.

FRANCE AND ENGLAND

- The major art patron in 17th-century France was the Sun King, the absolutist monarch Louis XIV, who expanded the Louvre and built a gigantic palace-and-garden complex at Versailles featuring sumptuous furnishings and sweeping vistas. Among the architects Louis employed were Charles Le Brun and Jules Hardouin-Mansart, who succeeded in marrying Italian Baroque and French classical styles.
- The leading French proponent of classical painting was Nicolas Poussin, who spent most of his life in Rome and championed the "grand manner" of painting. This style called for heroic or divine subjects and classical compositions with figures often modeled on ancient statues.
- I Claude Lorraine, whose fame rivaled Poussin's, specialized in classical landscapes rendered in linear and atmospheric perspective. His compositions often incorporated ancient ruins.
- In 17th-century England, architecture was the most important art form. Two architects who achieved international fame were Inigo Jones and Christopher Wren, who harmonized the architectural principles of Andrea Palladio with the Italian Baroque and French classical styles.

Rubens, Consequences of War, 1638–1639

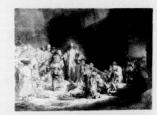

Rembrandt, Hundred-Guilder Print, ca. 1649

Vermeer, Woman Holding a Balance, ca. 1664

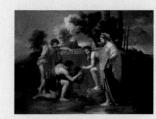

Poussin, *Et in Arcadia Ego,* ca. 1655

Wren, Saint Paul's, London, 1675–1710

NOTES

Introduction

- Quoted in George Heard Hamilton, Painting and Sculpture in Europe, 1880– 1940, 6th ed. (New Haven, Conn.: Yale University Press, 1993), 345.
- 2. Quoted in *Josef Albers: Homage to the Square* (New York: Museum of Modern Art, 1964), n.p.

Chapter 20

1. Francisco de Hollanda, *De pintura antigua* (1548), quoted in Robert Klein and Henri Zerner, *Italian Art, 1500–1600: Sources and Documents* (Englewood Cliffs, N.J.: Prentice-Hall, 1966), 33.

Chapter 21

- Ghiberti, I commentarii, II. Quoted in Elizabeth Gilmore Holt, ed., A Documentary History of Art, I: The Middle Ages and the Renaissance (Princeton, N.J.: Princeton University Press, 1981), 157–158.
- Translated by Catherine Enggass, in Howard Saalman, ed., Antonio Manetti, Life of Brunelleschi (University Park: Pennsylvania State University Press, 1970), 42.
- Giorgio Vasari, Life of Lorenzo Ghiberti. Translated by Gaston du C. de Vere, ed., Giorgio Vasari, Lives of the Painters, Sculptors, and Architects (New York: Knopf, 1996), 1: 304.
- 4. Ghiberti, I commentarii, II. Quoted in Holt, 161.
- Quoted in H. W. Janson, *The Sculpture of Donatello* (Princeton, N.J.: Princeton University Press, 1965), 154.
- 6. Vasari, Life of Masaccio. Translated by Gaston du C. de Vere, 1: 318.
- 7. Martial, Epigrams, 10.32.

Chapter 22

- Plato, *Ion*, 534. Translated by Benjamin Jowett, *The Dialogues of Plato*, 4th ed., vol. 1 (Oxford: Clarendon Press, 1953), 107–108.
- Da Vinci to Ludovico Sforza, ca. 1480–1481. In Elizabeth Gilmore Holt, ed., *A Documentary History of Art* (Princeton: Princeton University Press, 1981), I: 274–275.
- 3. Quoted in Anthony Blunt, *Artistic Theory in Italy*, 1450–1600 (London: Oxford University Press, 1964), 34.

- Quoted in James M. Saslow, *The Poetry of Michelangelo: An Annotated Transla*tion (New Haven, Conn.: Yale University Press, 1991), 407.
- 5. Giorgio Vasari, *Lives of the Painters, Sculptors, and Architects.* Translated by Gaston du C. de Vere (New York: Knopf, 1996), 2: 736.
- Quoted in A. Richard Turner, Renaissance Florence: The Invention of a New Art (New York: Abrams, 1997), 163.
- 7. Quoted in Bruce Boucher, Andrea Palladio: The Architect in His Time (New York: Abbeville Press, 1998), 229.
- Quoted in Robert J. Clements, *Michelangelo's Theory of Art* (New York: New York University Press, 1961), 320.

Chapter 23

- Translated by Erwin Panofsky, in Wolfgang Stechow, Northern Renaissance Art 1400–1600: Sources and Documents (Evanston, Ill.: Northwestern University Press, 1989), 123.
- 2. Translated by Bernhard Erling, in Stechow, 129-130.
- 3. Giorgio Vasari, *Lives of the Painters, Sculptors, and Architects.* Translated by Gaston du C. de Vere (New York: Knopf, 1996), 2: 863.

Chapter 24

- Filippo Baldinucci, Vita del Cavaliere Giovanni Lorenzo Bernini (1681). Translated by Robert Enggass, in Enggass and Jonathan Brown, Italian and Spanish Art 1600–1750: Sources and Documents (Evanston, Ill.: Northwestern University Press, 1992), 116.
- 2. John Milton, Il Penseroso (1631, published 1645), 166.

Chapter 25

- 1. Quoted in Julie Berger Hochstrasser, *Still Life and Trade in the Dutch Golden Age* (New Haven, Conn.: Yale University Press, 2007), 16.
- 2. Translated by Kristin Lohse Belkin, Rubens (London: Phaidon, 1998), 47.
- Albert Blankert, Johannes Vermeer van Delft 1632–1675 (Utrecht: Spectrum, 1975), 133, no. 51. Translated by Bob Haak, The Golden Age: Dutch Painters of the Seventeenth Century (New York: Abrams, 1984), 450.

GLOSSARY

Note: Text page references are in parentheses. References to bonus image online essays are in blue.

- **abstract**—Non-representational; forms and colors arranged without reference to the depiction of an object. (5)
- **additive light**—Natural light, or sunlight, the sum of all the wavelengths of the visible *spectrum*. See also *subtractive light*. (7)
- **additive sculpture**—A kind of sculpture *technique* in which materials (for example, clay) are built up or "added" to create form. (11) **aerial perspective**—See *perspective*. (567)

- **aisle**—The portion of a *basilica* flanking the *nave* and separated from it by a row of *columns* or *piers*. (12)
- **alchemy**—The study of seemingly magical changes, especially chemical changes. (645)
- **altarpiece**—A panel, painted or sculpted, situated above and behind an altar. See also *retable*. (404)
- amphitheater—Greek, "double theater." A Roman building type resembling two Greek theaters put together. The Roman amphitheater featured a continuous elliptical cavea (Latin, "hollow place or cavity") around a central arena, where bloody gladitorial combats and other boisterous events took place. (401)
- **anamorphic image**—A distorted image that must be viewed by some special means (such as a mirror) to be recognized. (656)
- apse—A recess, usually semicircular, in the wall of a building, commonly found at the east end of a church. (413)
- arcade—A series of arches supported by piers or columns. (413, 20-4A)
- **Arcadian** (adj.)—In Renaissance and later art, depictions of an idyllic place of rural peace and simplicity. Derived from Arcadia, an ancient district of the central Peloponnesos in southern Greece. (625)
- **arch**—A curved structural member that spans an opening and is generally composed of wedge-shaped blocks (*voussoirs*) that transmit the downward pressure laterally. (413, 20-4A)
- **architrave**—The *lintel* or lowest division of the *entablature;* also called the epistyle. (640)
- **armature**—The crossed, or diagonal, *arches* that form the skeletal framework of a *Gothic rib vault*. In sculpture, the framework for a clay form. (11)

- **arriccio**—In *fresco* painting, the first layer of rough lime plaster applied to the wall. (408)
- atmospheric perspective—See perspective. (567)
- **atrium**—The central reception room of a Roman house that is partly open to the sky. Also the open, *colonnaded* court in front of and attached to a Christian *basilica*. (672)
- **attribute**—(n.) The distinctive identifying aspect of a person, for example, an object held, an associated animal, or a mark on the body. (v.) To make an *attribution*. (5)
- attribution—Assignment of a work to a maker or makers. (6)
- **baldacchino**—A canopy on *columns*, frequently built over an altar. The term derives from *baldacco*. (673)
- baldacco—Italian, "silk from Baghdad." See baldacchino. (673)
- **baldric**—A sashlike belt worn over one shoulder and across the chest to support a sword. (24-28B)
- **Baroque**—The traditional blanket designation for European art from 1600 to 1750. The stylistic term *Baroque*, which describes art that features dramatic theatricality and elaborate ornamentation in contrast to the simplicity and orderly rationality of *Renaissance* art, is most appropriately applied to Italian art of this period. The term derives from *barroco*. (670)
- barrel vault—See vault. (585)
- **barroco**—Portuguese, "irregularly shaped pearl." See *Baroque*. (670)
- **base**—In ancient Greek architecture, the molded projecting lowest part of *Ionic* and *Corinthian columns.* (*Doric* columns do not have bases.) See also *column, pilaster, shaft, Tuscan column.*
- **basilica** (adj. **basilican**)—In Roman architecture, a public building for legal and other civic proceedings, rectangular in plan with an entrance usually on a long side. In Christian architecture, a church somewhat resembling the Roman basilica, usually entered from one end and with an *apse* at the other. (413, 583)

bas-relief—See relief. (12)

battlement—A low parapet at the top of a circuit wall in a fortification. (416)

- **bay**—The space between two columns, or one unit in the *nave arcade* of a church; also, the passageway in an arched gate. (411, 413)
- **belvedere**—Italian, "beautiful view." A building or other structure with a view of a *landscape* or seascape. (623)
- bottega—An artist's studio-shop. (569)
- braccia—Italian, "arm." A unit of measurement; 1 braccia equals 23 inches. (582)
- **breakfast piece**—A *still life* that includes bread and fruit. (701)
- **breviary**—A Christian religious book of selected daily prayers and Psalms. (550)
- bucranium (pl. bucrania)—Latin, "bovine skull." A common motif in classical architectural ornament. (1-16A)
- buon fresco—See fresco. (408, 603)
- burgher—A middle-class citizen. (28-32A)
- **burin**—A pointed tool used for *engraving* or *incising*. (556)
- **bust**—A freestanding sculpture of the head, shoulders, and chest of a person. (12)
- **buttress**—An exterior masonry structure that opposes the lateral thrust of an *arch* or a *vault*. A *pier* buttress is a solid mass of masonry. A *flying buttress* consists typically of an inclined member carried on an arch or a series of arches and a solid buttress to which it transmits lateral thrust. (12)
- **caduceus**—In ancient Greek mythology, a magical rod entwined with serpents, the attribute of Hermes (Roman, Mercury), the messenger of the gods. (559)
- camera obscura—Latin, "dark room." An ancestor of the modern camera in which a tiny pinhole, acting as a lens, projects an image on a screen, the wall of a room, or the groundglass wall of a box; used by artists in the 17th, 18th, and early 19th centuries as an aid in drawing from nature. (711)
- **campanile**—A bell tower of a church, usually, but not always, freestanding. (416)
- **canon**—A rule, for example, of proportion. The ancient Greeks considered beauty to be a matter of "correct" proportion and sought a canon of proportion, for the human figure and for buildings. The fifth-century BCE sculptor Polykleitos wrote the *Canon*, a treatise incorporating

his formula for the perfectly proportioned statue. (10)

- **canonized**—Declared a saint by the Catholic Church. (14-5A)
- **capital**—The uppermost member of a *column*, serving as a transition from the *shaft* to the *lintel*. In *classical* architecture, the form of the capital varies with the *order*. (402)
- **capriccio**—Italian, "originality." One of several terms used in Italian *Renaissance* literature to praise the originality and talent of artists. (604)
- **cartoon**—In painting, a full-size preliminary drawing from which a painting is made. (408)
- **carving**—A *technique* of sculpture in which the artist cuts away material (for example, from a stone block) in order to create a *statue* or a *relief.* (11)
- **cassone** (pl. **cassoni**)—A carved chest, often painted or gilded, popular in *Renaissance* Italy for the storing of household clothing. (631)
- **casting**—A sculptural *technique* in which the artist pours liquid metal, plaster, clay, or another material into a *mold*. When the material dries, the sculptor removes the cast piece from the mold. (11)
- **cathedral**—A bishop's church. The word derives from *cathedra*, referring to the bishop's chair. (412)
- **cella**—The chamber at the center of an ancient temple. (618)
- **centauromachy**—In ancient Greek mythology, the battle between the Greeks and *centaurs*. (120)
- **chancel arch**—The arch separating the chancel (the *apse* or *choir*) or the *transept* from the *nave* of a basilica or church. (413)
- **chapter house**—The meeting hall in a *monastery*. (585)
- chartreuse—A Carthusian *monastery*. (537)
- chasing—The engraving or embossing of metal.
 (673)
- **château** (pl. **châteaux**)—French, "castle." A luxurious country residence for French royalty, developed from medieval castles. (657)
- cherub—A chubby winged child angel. (552)
- **chiaroscuro**—In drawing or painting, the treatment and use of light and dark, especially the gradations of light that produce the effect of *modeling*. (409)
- chiaroscuro woodcut—A *woodcut* technique using two blocks of wood instead of one. The printmaker carves and inks one block in the usual way in order to produce a traditional black-and-white print. Then the artist cuts a second block consisting of broad highlights that can be inked in gray or color and printed over the first block's impression. (649)
- **choir**—The space reserved for the clergy and singers in the church, usually east of the *transept* but, in some instances, extending into the *nave*. (12)
- **chronology**—In art history, the dating of art objects and buildings. (2)
- Cinquecento—Italian, "500," that is, the 1500s or 16th century. (599)
- cire perdue—See lost-wax process. (673)

- city-state—An independent, self-governing city. (406)
- **Classical**—The art and culture of ancient Greece between 480 and 323 BCE. Lowercase *classical* refers more generally to Greco-Roman art and culture. (402)
- **clerestory**—The windowed part of a building that rises above the roofs of the other parts. The oldest known clerestories are Egyptian. In Roman *basilicas* and medieval churches, clerestories are the windows that form the *nave*'s uppermost level below the timber ceiling or the *vaults*. (413, 20-4A)
- cluster pier—See compound pier. (14-12A)
- **collage**—A composition made by combining on a flat surface various materials, such as newspaper, wallpaper, printed text and illustrations, photographs, and cloth. (8)
- **colonnade**—A series or row of *columns*, usually spanned by *lintels*.
- **color**—The value, or tonality, of a color is the degree of its lightness or darkness. The intensity, or saturation, of a color is its purity, its brightness or dullness. See also *primary colors, secondary colors,* and *complementary colors.* (7)
- colorito—Italian, "colored" or "painted." A term used to describe the application of paint. Characteristic of the work of 16th-century Venetian artists who emphasized the application of paint as an important element of the creative process. Central Italian artists, in contrast, largely emphasized *disegno*—the careful design preparation based on preliminary drawing. (625)
- **colossal order**—An architectural design in which the *columns* or *pilasters* are two or more stories tall. Also called a giant order. (594)
- **column**—A vertical, weight-carrying architectural member, circular in cross-*section* and consisting of a *base* (sometimes omitted), a *shaft*, and a *capital*. (10, 402)
- **complementary colors**—Those pairs of *colors*, such as red and green, that together embrace the entire *spectrum*. The complement of one of the three *primary colors* is a mixture of the other two. (7)
- **compline**—The last prayer of the day in a *Book of Hours*. (550)
- **compose**—See *composition*. (7)
- **Composite capital**—A capital combining *Ionic volutes* and *Corinthian* acanthus leaves, first used by the ancient Romans. (587, 21-36A)
- **composition**—The way in which an artist organizes *forms* in an artwork, either by placing shapes on a flat surface or arranging forms in space. (7)
- **compound pier**—A *pier* with a group, or cluster, of attached *shafts*, especially characteristic of *Gothic* architecture. (14-12A)
- **condottiere** (pl. **condottieri**)—An Italian mercenary general. (560)
- **confraternity**—In Late Antiquity, an association of Christian families pooling funds to purchase property for burial. In late medieval Europe, an organization founded by laypersons who dedicated themselves to strict religious observances. (404)

- **connoisseur**—An expert in *attributing* artworks to one artist rather than another. More generally, an expert on artistic *style*. (6)
- **contour line**—In art, a continuous line defining the outer shape of an object. (7)
- **contrapposto**—The disposition of the human figure in which one part is turned in opposition to another part (usually hips and legs one way, shoulders and chest another), creating a counterpositioning of the body about its central axis. Sometimes called "weight shift" because the weight of the body tends to be thrown to one foot, creating tension on one side and relaxation on the other. (564)
- **corbel**—A projecting wall member used as a support for some element in the superstructure. Also, *courses* of stone or brick in which each course projects beyond the one beneath it. Two such walls, meeting at the topmost course, create a corbeled *arch* or corbeled *vault*. (416, 640)
- **Corinthian capital**—A more ornate form than *Doric* or *Ionic*; it consists of a double row of acanthus leaves from which tendrils and flowers grow, wrapped around a bell-shaped *echinus*. Although this *capital* form is often cited as the distinguishing feature of the Corinthian *order*, no such order exists, in strict terms, but only this type of capital used in the *Ionic* order. (402, 587)
- **cornice**—The projecting, crowning member of the *entablature* framing the *pediment*; also, any crowning projection. (586)
- **corona civica**—Latin, "civic crown." A Roman honorary wreath worn on the head. (7)
- **course**—In masonry construction, a horizontal row of stone blocks.
- covenant—In Judaism and Christianity, a binding agreement between God and humans. (561)
- **crossing**—The space in a *cruciform* church formed by the intersection of the *nave* and the *transept*. (14-18A)
- cross-hatching—See *hatching*. (555)
- **crossing square**—The area in a church formed by the intersection (*crossing*) of a *nave* and a *transept* of equal width, often used as a standard *module* of interior proportion. (583)
- cruciform—Cross-shaped. (583)
- **cupola**—An exterior architectural feature composed of a cylindrical wall with a shallow cap; a *dome*. (638)
- **cutaway**—An architectural drawing that combines an exterior view with an interior view of part of a building. (12)
- **dharma**—In Buddhism, moral law based on the Buddha's teaching. (423)
- di sotto in sù—Italian, "from below upward." A *perspective* view seen from below. (595, 637)
- diptych—A two-paneled painting or *altarpiece*; also, an ancient Roman, Early Christian, or Byzantine hinged writing tablet, often of ivory and carved on the external sides. (540)
- disegno—Italian, "drawing" and "design." *Renaissance* artists considered drawing to be the external physical manifestation (*disegno esterno*) of an internal intellectual idea of design (*disegno interno*). (604, 625)

- **divine right**—The belief in a king's absolute power as God's will. (714)
- **documentary evidence**—In art history, the examination of written sources in order to determine the date of an artwork, the circumstances of its creation, or the identity of the artist(s) who made it. (2)
- **dome**—A hemispherical *vault*; theoretically, an *arch* rotated on its vertical axis. (14-18A)
- **donor portrait**—A portrait of the individual(s) who commissioned (donated) a religious work, for example, an *altarpiece*, as evidence of devotion. (535)
- **Doric**—One of the two systems (or *orders*) invented in ancient Greece for articulating the three units of the elevation of a *classical* building—the platform, the *colonnade*, and the superstructure (*entablature*). The Doric order is characterized by, among other features, *capitals* with funnel-shaped *echinuses*, *columns* without *bases*, and a *frieze* of *triglyphs* and *metopes*. See also *Ionic*. (587, 640)
- **dressed masonry**—Stone blocks shaped to the exact dimensions required, with smooth faces for a perfect fit. (586)
- **drypoint**—An *engraving* in which the design, instead of being cut into the plate with a *burin*, is scratched into the surface with a hard steel "pencil." See also *etching*, *intaglio*. (556)

duomo—Italian, "cathedral." (417)

- **echinus**—The convex element of a capital directly below the usually thin slab of the uppermost portion of the *capital* of a *column*. See also *Doric*.
- écorché—The representation of a nude body as if without skin. (582)
- edition—A set of impressions taken from a single print surface. (556)
- elevation—In architecture, a head-on view of an external or internal wall, showing its features and often other elements that would be visible beyond or before the wall. (12, 413)
- **engaged column**—A half-round *column* attached to a wall. See also *pilaster*. (588)
- **engraving**—The process of *incising* a design in hard material, often a metal plate (usually copper); also, the print or impression made from such a plate. (555, 556)
- entablature—The part of a building above the *columns* and below the roof. The entablature has three parts: *architrave, frieze,* and *pediment.* See also *architrave, cornice, Doric, lonic.*
- escutcheon—An emblem bearing a coat of arms. (628)
- etching—A kind of *engraving* in which the design is *incised* in a layer of wax or varnish on a metal plate. The parts of the plate left exposed are then etched (slightly eaten away) by the acid in which the plate is immersed after incising. See also *drypoint, intaglio.* (556)
- Eucharist—In Christianity, the partaking of the bread and wine, which believers hold to be either Christ himself or symbolic of him. (538)
- **facade**—Usually, the front of a building; also, the other sides when they are emphasized architecturally. (412)

- fantasia—Italian, "imagination." One of several terms used in Italian *Renaissance* literature to praise the originality and talent of artists. (604) fenestra coeli—Latin, "window to Heaven." (688)
- **feudalism**—The medieval political, social, and economic system held together by the relationship between landholding *liege lords* and the vassals who were granted tenure of a portion of their land and in turn swore allegiance to the liege lord. (536)
- finial—A crowning ornament. (541)
- **florin**—The denomination of gold coin of *Renaissance* Florence that became an international currency for trade. (417)
- flying buttress—See buttress. (12, 20-4A)
- **fons vitae**—Latin, "fountain of life." A symbolic fountain of everlasting life. (538)
- **foreshortening**—The use of *perspective* to represent in art the apparent visual contraction of an object that extends back in space at an angle to the perpendicular plane of sight. (10, 401)
- **form**—In art, an object's shape and structure, either in two dimensions (for example, a figure painted on a surface) or in three dimensions (such as a *statue*). (7)
- **formal analysis**—The visual analysis of artistic *form*. (7)
- **freestanding sculpture**—See sculpture in the round. (12)
- **fresco**—Painting on lime plaster, either dry (dry fresco, or fresco secco) or wet (true, or buon, fresco). In the latter method, the pigments are mixed with water and become chemically bound to the freshly laid lime plaster. Also, a painting executed in either method. (408, 409)
- fresco secco-See fresco. (408, 603)
- **Friday mosque**—A city's main *mosque*, designed to accommodate the entire *Muslim* population for the Friday noonday prayer. Also called the great mosque or congregational mosque.
- **frieze**—The part of the *entablature* between the *architrave* and the *cornice*; also, any sculptured or painted band in a building. See also *Doric, entablature, Ionic, triglyph.*
- **genius**—Latin, "spirit." In art, the personified spirit of a person or place. (22-52A)
- genre—A style or category of art; also, a kind of painting that realistically depicts scenes from everyday life. (5)
- **gesso**—Plaster mixed with a binding material, used as the base coat for paintings on wood panels. (545)
- giant order—See *colossal order*. (594)
- **gigantomachy**—In ancient Greek mythology, the battle between gods and giants. (22-54A)
- giornata (pl. giornate)—Italian, "day." The section of plaster that a *fresco* painter expects to complete in one session. (408)
- **glaze**—A vitreous coating applied to pottery to seal and decorate the surface; it may be colored, transparent, or opaque, and glossy or *matte*. In *oil painting*, a thin, transparent, or semitransparent layer applied over a *color* to alter it slightly. (539, 583)
- **gold leaf**—Gold beaten into tissue-paper-thin sheets that then can be applied to surfaces. (405)

- **gorget**—A neck pendant, usually made of shell. (517)
- **Gothic**—Originally a derogatory term named after the Goths, used to describe the history, culture, and art of western Europe in the 12th to 14th centuries. Typically divided into periods designated Early (1140–1194), High (1194–1300), and Late (1300–1500).
- **graver**—An *engraving* tool. See also *burin*. (556) **Greek cross**—A cross with four arms of equal
- length. (620, 676)
- **grisaille**—A monochrome painting done mainly in neutral grays to simulate sculpture. (409, 614, 20-8A)
- groin vault—See vault. (14-12A)
- **ground line**—In paintings and *reliefs*, a painted or carved baseline on which figures appear to stand. (20, 31)
- **guild**—An association of merchants, craftspersons, or scholars in medieval and *Renaissance* Europe. (410)
- halberd—A combination spear and battle-ax. (626)
- harpies—Mythological creatures of the underworld. (22-8A)
- hatching—A series of closely spaced drawn or engraved parallel lines. Cross-hatching employs sets of lines placed at right angles. (555)
- **hierarchy of scale**—An artistic convention in which greater size indicates greater importance. (11, 14-16A)
- high relief—See *relief*. (12)
- horizon line—See perspective. (567)
- hue—The name of a color. See also primary colors, secondary colors, and complementary colors. (7)
- **humanism**—In the *Renaissance*, an emphasis on education and on expanding knowledge (especially of *classical* antiquity), the exploration of individual potential and a desire to excel, and a commitment to civic responsibility and moral duty. (407)
- icon—A portrait or image; especially in Byzantine churches, a panel with a painting of sacred personages that are objects of veneration. In the visual arts, a painting, a piece of sculpture, or even a building regarded as an object of veneration. (405)
- iconoclasm—The destruction of religious or sacred images. In Byzantium, the period from 726 to 843 when there was an imperial ban on such images. The destroyers of images were known as iconoclasts. Those who opposed such a ban were known as iconophiles. (543, 652)
- iconoclast—See iconoclasm. (543, 652)
- iconography—Greek, the "writing of images." The term refers both to the content, or subject, of an artwork and to the study of content in art. It also includes the study of the symbolic, often religious, meaning of objects, persons, or events depicted in works of art. (5)
- **illuminated manuscript**—A luxurious handmade book with painted illustrations and decorations. (405)
- **illusionism** (adj. **illusionistic**)—The representation of the three-dimensional world on a twodimensional surface in a manner that creates

the illusion that the person, object, or place represented is three-dimensional. See also *perspective*. (8)

- **impasto**—A layer of thickly applied pigment. (632)
- **impost block**—The uppermost block of a wall or *pier* beneath the *springing* of an *arch*. (21-31A)
- **incise**—To cut into a surface with a sharp instrument; also, a method of decoration, especially on metal and pottery. (556)
- indulgence—A religious pardon for a sin committed. (616, 652)
- ingegno—Italian, "innate talent." One of several terms used in Italian *Renaissance* literature to praise the originality and talent of artists. (604)
- intaglio—A graphic technique in which the design is *incised*, or scratched, on a metal plate, either manually (*engraving*, *drypoint*) or chemically (*etching*). The incised lines of the design take the ink, making this the reverse of the *woodcut* technique. (556)
- intensity—See color. (7)
- internal evidence—In art history, the examination of what an artwork represents (people, clothing, hairstyles, and so on) in order to determine its date. Also, the examination of the *style* of an artwork to identify the artist who created it. (3)
- International style—A *style* of 14th- and 15thcentury painting begun by Simone Martini, who adapted the French *Gothic* manner to Sienese art fused with influences from northern Europe. This style appealed to the aristocracy because of its brilliant *color*, lavish costumes, intricate ornamentation, and themes involving splendid processions of knights and ladies. Also, a style of 20th-century architecture associated with Le Corbusier, whose elegance of design came to influence the look of modern office buildings and skyscrapers. (413)
- **intonaco**—In *fresco* painting, the last layer of smooth lime plaster applied to the wall; the painting layer. (408)
- **invenzione**—Italian, "invention." One of several terms used in Italian *Renaissance* literature to praise the originality and talent of artists. (604)
- **Ionic**—One of the two systems (or *orders*) invented in ancient Greece for articulating the three units of the elevation of a *classical* building: the platform, the *colonnade*, and the superstructure (*entablature*). The Ionic order is characterized by, among other features, *volutes*, *capitals*, *columns* with *bases*, and an uninterrupted *frieze*. (587)
- keystone—See voussoir. (640)
- **landscape**—A picture showing natural scenery, without narrative content. (5, 416)
- Landschaft—German, "landscape." (662)
- lateral section—See section. (12)
- laudatio—Latin, "essay of praise." (570)
- **liege lord**—In *feudalism*, a landowner who grants tenure of a portion of his land to a *vassal*. (334)
- **line**—The extension of a point along a path, made concrete in art by drawing on or chiseling into a *plane*. (7)
- linear perspective—See perspective. (565, 567)

- **lintel**—A horizontal *beam* used to span an opening. See also *architrave*, *capital*, *tympanum*.
- **loggia**—A gallery with an open *arcade* or a *colonnade* on one or both sides. (576, 14-19A)
- longitudinal section—See section. (12)
- **lost-wax (cire perdue) process**—A bronze*casting* method in which a figure is *modeled* in wax and covered with clay; the whole is fired, melting away the wax (French, *cire perdue*) and hardening the clay, which then becomes a *mold* for molten metal. (673)
- low relief—See relief. (12)
- lunette—A semicircular area (with the flat side down) in a wall over a door, niche, or window; also, a painting or *relief* with a semicircular frame. (551)
- machicolated gallery—A gallery in a defensive tower with holes in the floor to allow stones or hot liquids to be dumped on enemies below. (416)
- **magus** (pl. **magi**)—One of the three wise men from the East who presented gifts to the infant Jesus. (240)
- maniera—Italian, "style" or "manner." See Mannerism. (632, 682)
- **maniera greca**—Italian, "Greek manner." The Italo-Byzantine painting *style* of the 13th century. (404, 14-7A)
- Mannerism—A *style* of later *Renaissance* art that emphasized "artifice," often involving contrived imagery not derived directly from nature. Such artworks showed a self-conscious stylization involving complexity, caprice, fantasy, and polish. Mannerist architecture tended to flout the *classical* rules of order, stability, and symmetry, sometimes to the point of parody. (632).
- martyrium—A shrine to a Christian martyr. (619)
- **martyr**—A person who chooses to die rather than deny his or her religious belief. See also *martyrium, saint.*
- **mass**—The bulk, density, and weight of matter in *space*. (8)
- **matins**—In Christianity, early morning prayers. (550)
- **matte**—In painting, pottery, and photography, a dull finish. (538)
- **maulstick**—A stick used to steady the hand while painting. (661)
- **mausoleum**—A monumental tomb. The name derives from the mid-fourth-century BCE tomb of Mausolos at Halikarnassos, one of the Seven Wonders of the ancient world. (537)
- medium (pl. media)—The material (for example, marble, bronze, clay, *fresco*) in which an artist works; also, in painting, the vehicle (usually liquid) that carries the pigment. (7)
- megalith (adj. megalithic)—Greek, "great stone." A large, roughly hewn stone used in the construction of monumental prehistoric structures.
- **mela medica**—Italian, "medicinal apples" (oranges). The emblem of the Medici family of *Renaissance* Florence. (580)
- **memento mori**—Latin, "reminder of death." In painting, a reminder of human mortality, usually represented by a skull. (695)
- mendicants—In medieval Europe, friars belonging to the Franciscan and Dominican or-

ders, who renounced all worldly goods, lived by contributions of laypersons (the word *mendicant* means "beggar"), and devoted themselves to preaching, teaching, and doing good works. (404)

- **metope**—The square panel between the *triglyphs* in a *Doric frieze*, often sculpted in *relief*.
- modeling—The shaping or fashioning of threedimensional forms in a soft material, such as clay; also, the gradations of light and shade reflected from the surfaces of matter in space, or the illusion of such gradations produced by alterations of value in a drawing, painting, or print. See also *chiaroscuro*, *Constructivism*. module (adj. modular)—A basic unit of which the dimensions of the major parts of a work are multiples. The principle is used in sculpture and other art forms, but it is most often employed in architecture, where the module may be the dimensions of an important part of a building, such as the diameter of a *column*. (10, 582)
- mold—A hollow form for *casting*. (11)
- **monastery**—A group of buildings in which monks live together, set apart from the secular community of a town. (537)
- **monastic**—Relating to life in a *monastery.* (404, 537)
- **monastic order**—An organization of monks living according to the same rules, for example, the Benedictine, Franciscan, and Dominican orders. (404)
- **monochrome (**adj. **monochromatic**)—One color. (705)
- mural—A wall painting. (407, 408, 409)
- **mystery play**—A dramatic enactment of the holy mysteries of the Christian faith performed at church portals and in city squares. (409, 538)
- **mystic marriage**—A spiritual marriage of a woman with Christ. (549)
- naos—See cella. (618)
- **naturalism**—The style of painted or sculptured representation based on close observation of the natural world that was at the core of the *classical* tradition. (401)
- **nave**—The central area of an ancient Roman *basilica* or of a church, demarcated from *aisles* by *piers* or *columns*. (413, 20-4A)
- nipote—Italian, "nephew." (21-41A)
- **oculus** (pl. **oculi**)—Latin, "eye." The round central opening of a *dome*. Also, a small round window in a *Gothic cathedral*. (14-6A)
- **ogee arch**—An *arch* composed of two doublecurving lines meeting at a point. (420)
- ogive (adj. ogival)—The diagonal *rib* of a *Gothic vault*; a pointed, or Gothic, *arch.* (402, 21-31A)
- **oil painting**—A painting *technique* using oilbased pigments that rose to prominence in northern Europe in the 15th century and is now the standard medium for painting on canvas. (538)
- order—In *classical* architecture, a *style* represented by a characteristic design of the *columns* and *entablature*. See also *capital*, *Corinthian capital*, *Doric*, *Ionic*.
- parallel hatching—See hatching. (555)

- **parapet**—A low, protective wall along the edge of a balcony, roof, or bastion. (416)
- patron—The person or entity that pays an artist to produce individual artworks or employs an artist on a continuing basis. (6)
- **pediment**—In *classical* architecture, the triangular space (gable) at the end of a building, formed by the ends of the sloping roof above the *colonnade*; also, an ornamental feature having this shape. (582)
- **pendentive**—A concave, triangular section of a hemisphere, four of which provide the transition from a square area to the circular base of a covering *dome*. Although pendentives appear to be hanging (pendant) from the dome, they in fact support it. (585, 614)

period style—See style. (3)

- **personification**—An *abstract* idea represented in bodily form. (5)
- **perspective**—A method of presenting an illusion of the three-dimensional world on a twodimensional surface. In linear perspective, the most common type, all parallel lines or surface edges converge on one, two, or three vanishing points located with reference to the eye level of the viewer (the horizon line of the picture), and associated objects are rendered smaller the farther from the viewer they are intended to seem. Atmospheric, or aerial, perspective creates the illusion of distance by the greater diminution of color intensity, the shift in color toward an almost neutral blue, and the blurring of contours as the intended distance between eye and object increases. (8, 409, 547, 565, 567)
- **physical evidence**—In art history, the examination of the materials used to produce an artwork in order to determine its date. (2)
- piano nobile—Italian, "noble floor." The main (second) floor of a building. (21-37A)
- piazza—Italian, "plaza." (672)
- **pier**—A vertical, freestanding masonry support. (12)
- **Pietà**—A painted or sculpted representation of the Virgin Mary mourning over the body of the dead Christ. (544)
- **pilaster**—A flat, rectangular, vertical member projecting from a wall of which it forms a part. It usually has a *base* and a *capital* and is often fluted. (575)
- **pillar**—Usually a weight-carrying member, such as a *pier* or a *column*; sometimes an isolated, freestanding structure used for commemorative purposes.
- **pinnacle**—In *Gothic* churches, a sharply pointed ornament capping the *piers* or flying *buttresses*; also used on church *facades*. (411, 413)
- plan—The horizontal arrangement of the parts of a building or of the buildings and streets of a city or town, or a drawing or diagram showing such an arrangement. In an axial plan, the parts of a building are organized longitudinally, or along a given axis; in a central plan, the parts of the structure are of equal or almost equal dimensions around the center. (12)
 plane—A flat surface. (7)
- Plateresque—A style of Spanish architecture characterized by elaborate decoration based

on *Gothic*, Italian *Renaissance*, and Islamic sources; derived from the Spanish word *platero*, meaning "silversmith." (664)

- platero—See Plateresque. (664)
- **poesia**—A term describing "poetic" art, notably Venetian *Renaissance* painting, which emphasizes the lyrical and sensual. (626)
- **pointed arch**—A narrow *arch* of pointed profile, in contrast to a semicircular arch. (3, 402, 420, 21-31A)
- **polyptych**—An *altarpiece* composed of more than three sections. (538)
- **portico**—A roofed *colonnade;* also an entrance porch. (576)
- **predella**—The narrow ledge on which an *altarpiece* rests on an altar. (411)
- **prefiguration**—In Early Christian art, the depiction of Old Testament persons and events as prophetic forerunners of Christ and New Testament events. (547, 561)
- **primary colors**—Red, yellow, and blue—the *colors* from which all other colors may be derived. (7)
- print—An artwork on paper, usually produced
 in multiple impressions. (556)
- **proportion**—The relationship in size of the parts of persons, buildings, or objects, often based on a *module*. (10)
- **proscenium**—The part of a theatrical stage in front of the curtain. (675)
- **provenance**—Origin or source. (3)
- psalter—A book containing the Psalms. (550)
- **pulpit**—A raised platform in a church or mosque on which a priest or *imam* stands while leading the religious service. (402)
- punchwork—Tooled decorative work in gold leaf.
 (412)
- **putto** (pl. **putti**)—A cherubic young boy. (570)
- **quadrifrons**—Latin, "four-fronted." An *arch* with four equal *facades* and four arched *bays*. (23-14A)
- **quadro riportato**—A ceiling design in which painted scenes are arranged in panels that resemble framed pictures transferred to the surface of a shallow, curved *vault*. (680)
- **quatrefoil**—A shape or plan in which the parts assume the form of a cloverleaf. (419)
- **Quattrocento**—Italian, "400," that is, the 1400s or 15th century. (559)
- **quoins**—The large, sometimes *rusticated*, usually slightly projecting stones that often form the corners of the exterior walls of masonry buildings. (621)
- refectory—The dining hall of a Christian monastery. (576)
- regional style—See style. (3)
- **relief**—In sculpture, figures projecting from a background of which they are part. The degree of relief is designated high, low (bas), or sunken. In the last, the artist cuts the design into the surface so that the highest projecting parts of the image are no higher than the surface itself. (556)
- relief sculpture—See relief. (12)
- Renaissance—French, "rebirth." The term used to describe the history, culture, and art of 14th- through 16th-century western Europe

during which artists consciously revived the *classical* style. (401, 406)

- **renovatio**—Latin, "renewal." During the Carolingian period, Charlemagne sought to revive the culture of ancient Rome (renovatio imperi Romani). (402)
- **retable**—An architectural screen or wall above and behind an altar, usually containing painting, sculpture, or other decorations. See also *altarpiece*. (538)
- **rib**—A relatively slender, molded masonry *arch* that projects from a surface. In *Gothic* architecture, the ribs form the framework of the *vaulting*. A diagonal rib is one of the ribs that form the X of a *groin vault*. A transverse rib crosses the *nave* or *aisle* at a 90° angle. (12, 21-31A)
- **rib vault**—A *vault* in which the diagonal and transverse *ribs* compose a structural skeleton that partially supports the masonry blocks that fill the area between the *ribs* of a *groin vault*. (14-5A)
- **Romanesque**—"Roman-like." A term used to describe the history, culture, and art of medieval western Europe from ca. 1050 to ca. 1200. (413, 588)
- **rose window**—A circular *stained-glass* window. (412)
- **rotunda**—The circular area under a *dome;* also a domed round building. (538)

roundel—See tondo. (585)

- **rusticate (n. rustication)**—To give a rustic appearance by roughening the surfaces and beveling the edges of stone blocks to emphasize the joints between them. Rustication is a technique employed in ancient Roman architecture, and was also popular during the *Renaissance*, especially for stone *courses* at the ground-floor level. (586)
- sacra conversazione—Italian, "holy conversation." A style of *altarpiece* painting popular after the middle of the 15th century, in which *saints* from different epochs are joined in a unified space and seem to be conversing either with one another or with the audience. (624)
- sacra rappresentazione (pl. sacre rappresentazioni)—Italian, "holy representation." A more elaborate version of a *mystery play* performed for a lay audience by a *confraternity*. (409)
- saint—From the Latin word sanctus, meaning "made holy by God." Applied to persons who suffered and died for their Christian faith or who merited reverence for their Christian devotion while alive. In the Roman Catholic Church, a worthy deceased Catholic who is canonized by the pope. (402)
- sarcophagus (pl. sarcophagi)—Greek, "consumer of flesh." A coffin, usually of stone. (402) saturation—See color. (7)
- school—A chronological and stylistic classification of works of art with a stipulation of place.(6)
- scudi—Italian, "shields." A coin denomination in 17th-century Italy. (684)
- sculpture in the round—Freestanding figures, carved or modeled in three dimensions. (12)

secco—Italian, "dry." See also *fresco*. (408)

- **secondary colors**—Orange, green, and purple, obtained by mixing pairs of *primary colors* (red, yellow, blue). (7)
- **section**—In architecture, a diagram or representation of a part of a structure or building along an imaginary *plane* that passes through it vertically. Drawings showing a theoretical slice across a structure's width are lateral sections. Those cutting through a building's length are longitudinal sections. See also *elevation* and *cutaway*. (12)
- segmental pediment—A pediment with a curved instead of a triangular cornice. (621)
- **sfumato**—Italian, "smoky." A smokelike haziness that subtly softens outlines in painting; particularly applied to the paintings of Leonardo da Vinci and Correggio. (539, 604)
- shaft—The tall, cylindrical part of a column between the capital and the base. See also capital, column, compound pier.
- sibyl—A Greco-Roman mythological prophetess. (540)
- signoria—The governing body in the Republic of Florence. (563)
- silverpoint—A *stylus* made of silver, used in drawing in the 14th and 15th centuries because of the fine *line* it produced and the sharp point it maintained. (545, 604)
- sinopia—A burnt-orange pigment used in *fresco* painting to transfer a *cartoon* to the *arriccio* before the artist paints the plaster. (408)
- **space**—In art history, both the actual area an object occupies or a building encloses, and the *illusionistic* representation of space in painting and sculpture. (8)
- spectrum—The range or band of visible colors in natural light. (7)
- stained glass—In Gothic architecture, the colored glass used for windows. (12)

statue—A three-dimensional sculpture. (12)

- stigmata—In Christian art, the wounds Christ received at his crucifixion that miraculously appear on the body of a *saint*. (405)
- still life—A picture depicting an arrangement of inanimate objects. (5)
- stretcher bar—One of a set of wooden bars used to stretch canvas to provide a taut surface for painting. (543)
- stringcourse—A raised horizontal *molding*, or band, in masonry. Its principal use is ornamental but it usually reflects interior structure. (586)
- **style**—A distinctive artistic manner. Period style is the characteristic style of a specific time. Regional style is the style of a particular geographical area. Personal style is an individual artist's unique manner. (3)
- stylistic evidence—In art history, the examination of the *style* of an artwork in order to determine its date or the identity of the artist. (3)
- **stylobate**—The uppermost course of the platform of a *classical* Greek temple, which supports the *columns*. (618)

- **stylus**—A needlelike tool used in *engraving* and *incising*; also, an ancient writing instrument used to inscribe clay or wax tablets. (545, 556, 604)
- **subtractive light**—The painter's light in art; the light reflected from pigments and objects. See also *additive light.* (7)
- **subtractive sculpture**—A kind of sculpture technique in which materials are taken away from the original mass; *carving*. (11)
- **symbol**—An image that stands for another image or encapsulates an idea. (5)
- **technique**—The processes artists employ to create *form*, as well as the distinctive, personal ways in which they handle their materials and tools. (7)
- **tempera**—A *technique* of painting using pigment mixed with egg yolk, glue, or casein; also, the *medium* itself. (404, 538, 539)
- **tenebrism**—Painting in the "shadowy manner," using violent contrasts of light and dark, as in the work of Caravaggio. The term derives from *tenebroso.* (683)
- tenebroso—Italian, "shadowy." See *tenebrism*. (683)
- terminus ante quem—Latin, "point [date] before which." (2)
- terminus post quem—Latin, "point [date] after which." (2)
- **terracotta**—Hard-baked clay, used for sculpture and as a building material. It may be *glazed* or painted. (414)
- **texture**—The quality of a surface (rough, smooth, hard, soft, shiny, dull) as revealed by light. In represented texture, a painter depicts an object as having a certain texture even though the pigment is the real texture. (8)
- **thrust**—The outward force exerted by an *arch* or a *vault* that must be counterbalanced by a *buttress*. (21-31A)
- **toga**—The garment worn by an ancient Roman male citizen. (176)
- tonality—See color. (7)
- **tondo** (pl. **tondi**)—A circular painting or *relief* sculpture. (585)
- **tracery**—Ornamental stonework for holding *stained glass* in place, characteristic of *Gothic cathedrals*. In plate tracery, the glass fills only the "punched holes" in the heavy ornamental stonework. In bar tracery, the stained-glass windows fill almost the entire opening, and the stonework is unobtrusive. (414)
- tramezzo—A screen placed across the *nave* of a church to separate the clergy from the lay audience. (14-6A)
- **transept**—The part of a church with an axis that crosses the *nave* at a right angle. (14-5A)
- **transubstantiation**—The transformation of the Eucharistic bread and wine into the body and blood of Christ. (24-18A)
- trefoil arch—A triple-lobed arch. (402)
- **triforium**—In a *Gothic cathedral*, the gallery below the *clerestory*; occasionally, the *arcades* are filled with *stained glass*. (20-4A)

- **triglyph**—A triple projecting, grooved member of a *Doric frieze* that alternates with *metopes*. (640)
- **triptych**—A three-paneled painting, ivory plaque, or *altarpiece*. Also, a small, portable shrine with hinged wings used for private devotion. (415)
- **trompe l'oeil**—French, "fools the eye." A form of *illusionistic* painting that aims to deceive viewers into believing they are seeing real objects rather than a representation of those objects. (595, 24-14A)
- true fresco—See fresco. (408, 409)
 - tunnel vault-See vault. (12, 585)
 - **Tuscan column**—The standard type of Etruscan *column*. It resembles ancient Greek *Doric* columns but is made of wood, is unfluted, and has a *base*. Also a popular motif in *Renaissance* and *Baroque* architecture. (587, 618)
 - **tympanum** (pl. **tympana**)—The space enclosed by a *lintel* and an *arch* over a doorway. (538, 590, 14-12A)

value—See color. (7)

- vanishing point—See perspective. (547, 567)
- vanitas—Latin, "vanity." A term describing paintings (particularly 17th-century Dutch *still lifes*) that include references to death. (695, 23-3A)
- vault (adj. vaulted)-A masonry roof or ceiling constructed on the arch principle, or a concrete roof of the same shape. A barrel (or tunnel) vault, semicylindrical in cross-section, is in effect a deep arch or an uninterrupted series of arches, one behind the other, over an oblong space. A quadrant vault is a half-barrel vault. A groin (or cross) vault is formed at the point at which two barrel vaults intersect at right angles. In a ribbed vault, there is a framework of ribs or arches under the intersections of the vaulting sections. A sexpartite vault is one whose ribs divide the vault into six compartments. A fan vault is a vault characteristic of English Perpendicular Gothic architecture, in which radiating ribs form a fanlike pattern. (12)
- vellum—Calfskin prepared as a surface for writing or painting. (604)
- volume—The space that mass organizes, divides, or encloses. (8)
- **volute**—A spiral, scroll-like form characteristic of the ancient Greek *Ionic* and the Roman *Composite capital*. See also *Ionic*.
- **voussoir**—A wedge-shaped stone block used in the construction of a true *arch*. The central voussoir, which sets the arch, is called the keystone. (640)
- **weld**—To join metal parts by heating, as in assembling the separate parts of a *statue* made by *casting*. (11)
- **woodcut**—A wooden block on the surface of which those parts not intended to *print* are cut away to a slight depth, leaving the design raised; also, the printed impression made with such a block. (554, 556)

BIBLIOGRAPHY

This list of books is very selective but comprehensive enough to satisfy the reading interests of the beginning art history student and general reader. Significantly expanded from the previous edition, the 14th edition bibliography can also serve as the basis for undergraduate research papers. The resources listed range from works that are valuable primarily for their reproductions to those that are scholarly surveys of schools and periods or monographs on individual artists. The emphasis is on recent in-print books and on books likely to be found in college and municipal libraries. No entries for periodical articles appear, but the bibliography begins with a list of some of the major journals that publish art historical scholarship in English.

Selected Periodicals

African Arts American Art American Indian Art American Journal of Archaeology Antiquity Archaeology Archives of American Art Archives of Asian Art Ars Orientalis Art Bulletin Art History Art in America Art Journal Artforum International Artnews Burlington Magazine Gesta History of Photography Journal of Roman Archaeology Journal of the Society of Architectural Historians Journal of the Warburg and Courtauld Institutes Latin American Antiquity October Oxford Art Journal Women's Art Journal

General Studies

- Baxandall, Michael. Patterns of Intention: On the Historical Explanation of Pictures. New Haven, Conn.: Yale University Press, 1985.
- Bindman, David, ed. The Thames & Hudson Encyclopedia of British Art. London: Thames & Hudson, 1988.
- Boström, Antonia. *The Encyclopedia of Sculpture*. 3 vols. London: Routledge, 2003.
- Broude, Norma, and Mary D. Garrard, eds. *The Expanding Discourse: Feminism and Art History*. New York: Harper Collins, 1992.
- Bryson, Norman. Vision and Painting: The Logic of the Gaze. New Haven, Conn.: Yale University Press, 1983.
- Bryson, Norman, Michael Ann Holly, and Keith Moxey. Visual Theory: Painting and Interpretation. New York: Cambridge University Press, 1991.
- Burden, Ernest. *Illustrated Dictionary of Architecture*. 2d ed. New York: McGraw-Hill, 2002.
- Büttner, Nils. Landscape Painting: A History. New York: Abbeville, 2006.
- Carrier, David. A World Art History and Its Objects. University Park: Pennsylvania State University Press, 2009.

Chadwick, Whitney. *Women, Art, and Society.* 4th ed. New York: Thames & Hudson, 2007.

- Cheetham, Mark A., Michael Ann Holly, and Keith Moxey, eds. *The Subjects of Art History: Historical Objects in Contemporary Perspective*. New York: Cambridge University Press, 1998.
- Chilvers, Ian, and Harold Osborne, eds. *The Oxford Dictionary of Art.* 3d ed. New York: Oxford University Press, 2004.
- Corbin, George A. Native Arts of North America, Africa, and the South Pacific: An Introduction. New York: Harper Collins, 1988.
- Crouch, Dora P., and June G. Johnson. Traditions in Architecture: Africa, America, Asia, and Oceania. New York: Oxford University Press, 2000.
- Curl, James Stevens. Oxford Dictionary of Architecture and Landscape Architecture. 2d ed. New York: Oxford University Press, 2006.
- Duby, Georges, ed. Sculpture: From Antiquity to the Present. 2 vols. Cologne: Taschen, 1999.
- Encyclopedia of World Art. 17 vols. New York: McGraw-Hill, 1959–1987.
- Fielding, Mantle. *Dictionary of American Painters, Sculptors, and Engravers.* 2d ed. Poughkeepsie, N.Y.: Apollo, 1986.
- Fine, Sylvia Honig. Women and Art: A History of Women Painters and Sculptors from the Renaissance to the 20th Century. Rev. ed. Montclair, N.J.: Alanheld & Schram, 1978.
- Fleming, John, Hugh Honour, and Nikolaus Pevsner. The Penguin Dictionary of Architecture and Landscape Architecture. 5th ed. New York: Penguin, 2000.
- Frazier, Nancy. *The Penguin Concise Dictionary of Art History*. New York: Penguin, 2000.
- Freedberg, David. *The Power of Images: Studies in the History and Theory of Response*. Chicago: University of Chicago Press, 1989.
- Gaze, Delia., ed. *Dictionary of Women Artists.* 2 vols. London: Routledge, 1997.
- Hall, James. Hall, James. *Dictionary of Subjects and Symbols in Art.* 2d ed. Boulder, Colo.: Westview, 2008.
- Harris, Anne Sutherland, and Linda Nochlin. Women Artists: 1550–1950. Los Angeles: Los Angeles County Museum of Art; New York: Knopf, 1977.
- Hauser, Arnold. The Sociology of Art. Chicago: University of Chicago Press, 1982.
- Hults, Linda C. The Print in the Western World: An Introductory History. Madison: University of Wisconsin Press, 1996.

- Kemp, Martin. The Science of Art: Optical Themes in Western Art from Brunelleschi to Seurat. New Haven, Conn.: Yale University Press, 1990.
- Kostof, Spiro, and Gregory Castillo. A History of Architecture: Settings and Rituals. 2d ed. Oxford: Oxford University Press, 1995.
- Kultermann, Udo. *The History of Art History*. New York: Abaris, 1993.
- Lucie-Smith, Edward. *The Thames & Hudson Dictionary of Art Terms*. 2d ed. New York: Thames & Hudson, 2004.
- Moffett, Marian, Michael Fazio, and Lawrence Wadehouse. A World History of Architecture. Boston: McGraw-Hill, 2004.
- Morgan, Anne Lee. Oxford Dictionary of American Art and Artists. New York: Oxford University Press, 2008.
- Murray, Peter, and Linda Murray. A Dictionary of Art and Artists. 7th ed. New York: Penguin, 1998.
- Nelson, Robert S., and Richard Shiff, eds. *Critical Terms for Art History.* Chicago: University of Chicago Press, 1996.
- Pazanelli, Roberta, ed. The Color of Life: Polychromy in Sculpture from Antiquity to the Present. Los Angeles: J. Paul Getty Museum, 2008.
- Penny, Nicholas. *The Materials of Sculpture*. New Haven, Conn.: Yale University Press, 1993.
- Pevsner, Nikolaus. A History of Building Types. London: Thames & Hudson, 1987. Reprint of 1979 ed.
 ——. An Outline of European Architecture. 8th ed.
- Baltimore: Penguin, 1974. Pierce, James Smith. From Abacus to Zeus: A Hand-
- *book of Art History.* 7th ed. Upper Saddle River, N.J.: Pearson Prentice Hall, 1998.
- Placzek, Adolf K., ed. *Macmillan Encyclopedia of Architects*. 4 vols. New York: Macmillan, 1982.
- Podro, Michael. *The Critical Historians of Art*. New Haven, Conn.: Yale University Press, 1982.
- Pollock, Griselda. Vision and Difference: Femininity, Feminism, and Histories of Art. London: Routledge, 1988.
- Pregill, Philip, and Nancy Volkman. Landscapes in History Design and Planning in the Eastern and Western Traditions. 2d ed. Hoboken, N.J.: Wiley, 1999.
- Preziosi, Donald, ed. The Art of Art History: A Critical Anthology. New York: Oxford University Press, 1998.
- Read, Herbert. The Thames & Hudson Dictionary of Art and Artists. Rev. ed. New York: Thames & Hudson, 1994.
- Reid, Jane D. The Oxford Guide to Classical Mythology in the Arts 1300–1990s. 2 vols. New York: Oxford University Press, 1993.

- Rogers, Elizabeth Barlow. Landscape Design: A Cultural and Architectural History. New York: Abrams, 2001.
- Roth, Leland M. Understanding Architecture: Its Elements, History, and Meaning. 2d ed. Boulder, Colo.: Westview, 2006.

Schama, Simon. The Power of Art. New York: Ecco, 2006.

- Slatkin, Wendy. Women Artists in History: From Antiquity to the 20th Century. 4th ed. Upper Saddle River, N.J.: Prentice Hall, 2000.
- Steer, John, and Antony White. Atlas of Western Art History: Artists, Sites, and Monuments from Ancient Greece to the Modern Age. New York: Facts on File, 1994.
- Stratton, Arthur. The Orders of Architecture: Greek, Roman, and Renaissance. London: Studio, 1986.
- Summers, David. Real Spaces: World Art History and the Rise of Western Modernism. London: Phaidon, 2003.
- Sutton, Ian. Western Architecture: From Ancient Greece to the Present, New York: Thames & Hudson, 1999.
- Trachtenberg, Marvin, and Isabelle Hyman. Architecture, from Prehistory to Post-Modernism. 2d ed. Upper Saddle River, N.J.: Prentice Hall, 2003.
- Turner, Jane, ed. *The Dictionary of Art.* 34 vols. New ed. New York: Oxford University Press, 2003.
- Watkin, David. A History of Western Architecture. 4th ed. London: Laurence King, 2010.
- West, Shearer. *Portraiture*. New York: Oxford University Press, 2004.
- Wittkower, Rudolf. *Sculpture Processes and Principles*. New York: Harper & Row, 1977.
- Wren, Linnea H., and Janine M. Carter, eds. Perspectives on Western Art: Source Documents and Readings from the Ancient Near East through the Middle Ages. New York: Harper & Row, 1987.
- Zijlmans, Kitty, and Wilfried van Damme, eds. World Art Studies: Exploring Concepts and Approaches. Amsterdam: Valiz, 2008.

Chapter 14: Late Medieval Italy

- Bomford, David. Art in the Making: Italian Painting before 1400. London: National Gallery, 1989.
- Borsook, Eve, and Fiorelli Superbi Gioffredi. *Italian Altarpieces 1250–1550: Function and Design.* Oxford: Clarendon, 1994.
- Bourdua, Louise. *The Franciscans and Art Patronage in Late Medieval Italy*. New York: Cambridge University Press, 2004.
- Cole, Bruce. Sienese Painting: From Its Origins to the Fifteenth Century. New York: Harper Collins, 1987.
- Derbes, Anne. Picturing the Passion in Late Medieval Italy: Narrative Painting, Franciscan Ideologies, and the Levant. New York: Cambridge University Press, 1996.
- Derbes, Anne, and Mark Sandona, eds. *The Cambridge Companion to Giotto*. New York: Cambridge University Press, 2004.
- Hills, Paul. *The Light of Early Italian Painting*. New Haven, Conn.: Yale University Press, 1987.
- Maginnis, Hayden B. J. *Painting in the Age of Giotto: A Historical Reevaluation.* University Park: Pennsylvania State University Press, 1997.
- Meiss, Millard. Painting in Florence and Siena after the Black Death. Princeton, N.J.: Princeton University Press, 1976.
- Moskowitz, Anita Fiderer. *Italian Gothic Sculpture, c. 1250–c. 1400.* Cambridge: Cambridge University Press, 2001.
- ------. Nicola & Giovanni Pisano: The Pulpits: Pious Devotion, Pious Diversion. London: Harvey Miller, 3005.
- Norman, Diana, ed. Siena, Florence, and Padua: Art, Society, and Religion 1280–1400. New Haven, Conn.: Yale University Press, 1995.
- Poeschke, Joachim. Italian Frescoes: The Age of Giotto, 1280–1400. New York: Abbeville, 2005.

- Pope-Hennessy, John. *Italian Gothic Sculpture*. 3d ed. Oxford: Phaidon, 1986.
- Stubblebine, James H. Duccio di Buoninsegna and His School. Princeton, N.J.: Princeton University Press, 1979.
- White, John. Art and Architecture in Italy: 1250–1400. 3d ed. New Haven, Conn.: Yale University Press, 1993.
- ———. Duccio: Tuscan Art and the Medieval Workshop. London: Thames & Hudson, 1979.

Renaissance Art, General

- Adams, Laurie Schneider. *Italian Renaissance Art.* Boulder, Colo.: Westview, 2001.
- Andrés, Glenn M., John M. Hunisak, and Richard Turner. *The Art of Florence*. 2 vols. New York: Abbeville, 1988.
- Campbell, Gordon. *The Grove Encyclopedia of Northern Renaissance Art.* New York: Oxford University Press, 2009.
- ——. Renaissance Art and Architecture. New York: Oxford University Press, 2005.
- Campbell, Lorne. *Renaissance Portraits: European Portrait-Painting in the Fourteenth, Fifteenth, and Sixteenth Centuries.* New Haven, Conn.: Yale University Press, 1990.
- Christian, Kathleen, and David J. Drogin, eds. *Patronage and Italian Renaissance Sculpture*. New York: Ashgate, 2010.
- Cole, Bruce. Italian Art, 1250–1550: The Relation of Renaissance Art to Life and Society. New York: Harper & Row, 1987.
- ——. The Renaissance Artist at Work: From Pisano to Titian. New York: Harper Collins, 1983.
- Cranston, Jodi. *The Poetics of Portraiture in the Italian Renaissance*. New York: Cambridge University Press, 2000.
- Frommel, Christoph Luitpold. *The Architecture of the Italian Renaissance*. London: Thames & Hudson, 2007.
- Furlotti, Barbara, and Guido Rebecchini. The Art of Mantua: Power and Patronage in the Renaissance. Los Angeles: J. Paul Getty Museum, 2008.
- Hall, Marcia B. Color and Meaning: Practice and Theory in Renaissance Painting. Cambridge: Cambridge University Press, 1992.
- Hartt, Frederick, and David G. Wilkins. *History of Italian Renaissance Art.* 7th ed. Upper Saddle River, N.J.: Prentice Hall, 2010.
- Haskell, Francis, and Nicholas Penny. Taste and the Antique: The Lure of Classical Sculpture 1500–1900. New Haven, Conn.: Yale University Press, 1981.
- Kent, F. W., and Patricia Simons, eds. Patronage, Art, and Society in Renaissance Italy. Canberra: Humanities Research Centre and Clarendon Press, 1987.
- King, Catherine E. Renaissance Women Patrons: Wives and Widows in Italy, c. 1300–1550. Manchester: Manchester University Press, 1998.
- Levey, Michael. *Florence: A Portrait.* Cambridge, Mass.: Harvard University Press, 1998.
- Lubbock, Jules. *Storytelling in Christian Art from Giotto to Donatello*. New Haven, Conn.: Yale University Press, 2006.
- Paoletti, John T., and Gary M. Radke. Art, Power, and Patronage in Renaissance Italy. Upper Saddle River, N.J.: Prentice Hall, 2005.

Partridge, Loren. Art of Renaissance Florence, 1400– 1600. Berkeley and Los Angeles: University of California Press, 2009.

- Pope-Hennessy, John. Introduction to Italian Sculpture. 3d ed. 3 vols. New York: Phaidon, 1986.
- Richardson, Carol M., Kim W. Woods, and Michael W. Franklin, eds. *Renaissance Art Reconsidered: An Anthology of Primary Sources.* Malden, Mass.: Blackwell, 2007.
- Smith, Jeffrey Chipps. *The Northern Renaissance*. New York: Phaidon, 2004.

- Snyder, James, Larry Silver, and Henry Luttikhuizen. Northern Renaissance Art: Painting, Sculpture, the Graphic Arts from 1350 to 1575. Upper Saddle River, N.J.: Prentice Hall, 2005.
- Strinati, Claudio, and Pomeroy, Jordana. *Italian Women* Artists from Renaissance to Baroque. Milan: Skira, 2007.
- Thomson, David. Renaissance Architecture: Critics, Patrons, and Luxury. Manchester: Manchester University Press, 1993.
- Tinagli, Paola. Women in Italian Renaissance Art: Gender, Representation, Identity. Manchester: Manchester University Press, 1997.
- Wittkower, Rudolf. Architectural Principles in the Age of Humanism. 4th ed. London: Academy, 1988.
- Woods, Kim W. *Making Renaissance Art.* New Haven, Conn.: Yale University Press, 2007.
- ———. Viewing Renaissance Art. New Haven, Conn.: Yale University Press, 2007.
- Woods-Marsden, Joanna. Renaissance Self-Portraiture: The Visual Construction of Identity and the Social Status of the Artist. New Haven, Conn.: Yale University Press, 1998.

Chapter 20: Late Medieval and Early Renaissance Art in Northern Europe

- Ainsworth, Maryan W., and Maximiliaan P. J. Martens. Petrus Christus, Renaissance Master of Bruges. New York: Metropolitan Museum of Art, 1994.
- Art from the Court of Burgundy: The Patronage of Philip the Bold and John the Fearless 1364–1419. Cleveland: Cleveland Museum of Art, 2004.
- Baxandall, Michael. The Limewood Sculptors of Renaissance Germany. New Haven, Conn.: Yale University Press, 1980.
- Borchert, Till-Holger. Age of Van Eyck: The Mediterranean World and Early Netherlandish Painting, 1430–1530. New York: Thames & Hudson, 2002.
- Brinkmann, Bodo. Konrad Witz. Ostfildern: Hatje Cantz, 2011.
- Campbell, Lorne. The Fifteenth-Century Netherlandish Schools. London: National Gallery Publications, 1998.
 ——. Van der Weyden. London: Chaucer, 2004.
- Châtelet, Albert. *Early Dutch Painting*. New York: Konecky, 1988.
- Friedlander, Max J. Early Netherlandish Painting. 14 vols. New York: Praeger/Phaidon, 1967–1976.
- ——. From Van Eyck to Bruegel. 3d ed. Ithaca, N.Y.: Cornell University Press, 1981.
- Harbison, Craig. The Mirror of the Artist: Northern Renaissance Art in Its Historical Context. New York: Abrams, 1995.
- Jacobs, Lynn F. Early Netherlandish Carved Altarpieces, 1380–1550: Medieval Tastes and Mass Marketing. Cambridge: Cambridge University Press, 1998.
- Kemperdick, Stephan. Rogier van der Weyden. Cologne: H. F. Ullmann, 2007.
- Kemperdick, Stephan, and Jocen Sander, eds. The Master of Flémalle and Rogier van der Weyden. Ostfildern: Hatje Cantz, 2009.
- Lane, Barbara G. The Altar and the Altarpiece: Sacramental Themes in Early Netherlandish Painting. New York: Harper & Row, 1984.
- Meiss, Millard. French Painting in the Time of Jean de Berry: The Limbourgs and Their Contemporaries. New York: Braziller, 1974.
- Michiels, Alfred. Hans Memling. London: Parkstone, 2008.
- Müller, Theodor. Sculpture in the Netherlands, Germany, France, and Spain: 1400–1500. New Haven, Conn.: Yale University Press, 1986.
- Nash, Susie. Northern Renaissance Art. New York: Oxford University Press, 2008.
- Pächt, Otto. Early Netherlandish Painting from Rogier van der Wayden to Gerard David. New York: Harvey Miller, 1997.

- Panofsky, Erwin. Early Netherlandish Painting: Its Origins and Character. 2 vols. Cambridge, Mass.: Harvard University Press, 1966.
- Parshall, Peter, ed. *The Woodcut in Fifteenth-Century Europe*. New Haven, Conn.: Yale University Press, 2009.
- Parshall, Peter, and Rainer Schoch. Origins of European Printmaking: Fifteenth-Century Woodcuts and Their Public. New Haven, Conn.: Yale University Press, 2005.
- Prevenier, Walter, and Wim Blockmans. *The Burgundian Netherlands*. Cambridge: Cambridge University Press, 1986.

Tomlinson, Amanda. Van Eyck. London: Chaucer, 2007.

Wolfthal, Diane. The Beginnings of Netherlandish Canvas Painting, 1400–1530. New York: Cambridge University Press, 1989.

Chapter 21: The Renaissance in Quattrocento Italy

- Ahl, Diane Cole. *Fra Angelico*. New York: Phaidon, 2008. ——, ed. *The Cambridge Companion to Masaccio*. New York: Cambridge University Press, 2002.
- Ames-Lewis, Francis. Drawing in Early Renaissance Italy. 2d ed. New Haven, Conn.: Yale University Press, 2000.
- ——. The Intellectual Life of the Early Renaissance Artist. New Haven, Conn.: Yale University Press, 2000.
- Baxandall, Michael. Painting and Experience in Fifteenth-Century Italy: A Primer in the Social History of Pictorial Style. 2d ed. New York: Oxford University Press, 1988.
- Bober, Phyllis Pray, and Ruth Rubinstein. Renaissance Artists and Antique Sculpture: A Handbook of Sources. Oxford: Oxford University Press, 1986.
- Borsook, Eve. The Mural Painters of Tuscany. New York: Oxford University Press, 1981.
- Cole, Alison. Virtue and Magnificence: Art of the Italian Renaissance Courts. New York: Abrams, 1995.
- Cole, Bruce. *Masaccio and the Art of Early Renaissance Florence.* Bloomington: Indiana University Press, 1980.
- Dempsey, Charles. *The Portrayal of Love: Botticelli's* Primavera and Humanist Culture at the Time of *Lorenzo the Magnificent*. Princeton, N.J.: Princeton University Press, 1992.
- Edgerton, Samuel Y., Jr. *The Heritage of Giotto's Geometry: Art and Science on the Eve of the Scientific Revolution.* Ithaca, N.Y.: Cornell University Press, 1991.
- ------. The Renaissance Rediscovery of Linear Perspective. New York: Harper & Row, 1976.
- Gilbert, Creighton, ed. Italian Art 1400–1500: Sources and Documents. Evanston, Ill.: Northwestern University Press, 1992.
- Goldthwaite, Richard A. *The Building of Renaissance Florence: An Economic and Social History.* Baltimore: Johns Hopkins University Press, 1980.
- Goy, Richard J. Building Renaissance Venice: Patrons, Architects, and Builders c. 1430–1500. New Haven, Conn.: Yale University Press, 2006.
- Heydenreich, Ludwig H. Architecture in Italy, 1400–1500. 2d ed. New Haven, Conn.: Yale University Press, 1996.
- Hollingsworth, Mary. Patronage in Renaissance Italy: From 1400 to the Early Sixteenth Century. Baltimore: Johns Hopkins University Press, 1994.
- Holmes, Megan. Fra Filippo Lippi: The Carmelite Painter. New Haven, Conn.: Yale University Press, 1999.
- Kemp, Martin. Behind the Picture: Art and Evidence in the Italian Renaissance. New Haven, Conn.: Yale University Press, 1997.
- Kempers, Bram. Painting, Power, and Patronage: The Rise of the Professional Artist in the Italian Renaissance. London: Penguin, 1992.
- Kent, Dale. Cosimo de' Medici and the Florentine Renaissance: The Patron's Oeuvre. New Haven, Conn.: Yale University Press, 2000.

- Lieberman, Ralph. *Renaissance Architecture in Venice*. New York: Abbeville, 1982.
- Lindow, James R. The Renaissance Palace in Florence: Magnificence and Splendour in Fifteenth-Century Italy. Burlington Vt.: Ashgate, 2007.
- Manca, Joseph. Andrea Mantegna and the Italian Renaissance. New York: Parkstone, 2006.
- McAndrew, John. Venetian Architecture of the Early Renaissance. Cambridge, Mass.: MIT Press, 1980.
- Murray, Peter. *Renaissance Architecture*. New York: Electa/Rizzoli, 1985.
- Olson, Roberta J. M. *Italian Renaissance Sculpture*. London: Thames & Hudson, 1992.
- Osborne, June. *Urbino: The Story of a Renaissance City.* Chicago: University of Chicago Press, 2003.
- Poeschke, Joachim. Donatello and His World: Sculpture of the Italian Renaissance. New York: Abrams, 1993.
- Radke, Gary M., ed. *The Gates of Paradise: Lorenzo Ghiberti's Renaissance Masterpiece*. New Haven, Conn.: Yale University Press, 2007.
- Seymour, Charles. *Sculpture in Italy:* 1400–1500. New Haven, Conn.: Yale University Press, 1992.
- Turner, A. Richard. *Renaissance Florence: The Invention of a New Art.* New York: Abrams, 1997.

Wackernagel, Martin. The World of the Florentine Renaissance Artist: Projects and Patrons, Workshops and Art Market. Princeton, N.J.: Princeton University Press, 1981.

- Welch, Evelyn. Art and Society in Italy 1350–1500. Oxford: Oxford University Press, 1997.
- White, John. *The Birth and Rebirth of Pictorial Space*. 3d ed. Boston: Faber & Faber, 1987.
- Wright, Alison. The Pollaiuolo Brothers: The Arts of Florence and Rome. New Haven, Conn.: Yale University Press, 2005.
- Zöllner, Frank. Sandro Botticelli. New ed. New York: Prestel, 2009.

Chapter 22: Renaissance and Mannerism in Cinquecento Italy

- Beltramini, Guido, and Howard Burns. Palladio. London: Royal Academy, 2008.
- Blunt, Anthony. *Artistic Theory in Italy, 1450–1600.* London: Oxford University Press, 1975.
- Brambilla Barcilon, Pinnin. *Leonardo: The Last Supper.* Chicago: University of Chicago Press, 2001.

Brock, Maurice. Bronzino. Paris: Flammarion, 2002.

- Brown, David Alan, and Sylvia Ferino-Pagden, eds. Bellini, Giorgione, Titian, and the Renaissance of Venetian Painting. New Haven, Conn.: Yale University Press, 2006.
- Brown, Patricia Fortini. Art and Life in Renaissance Venice. New York: Abrams, 1997.

Cole, Bruce. *Titian and Venetian Painting*, 1450–1590. Boulder, Colo.: Westview, 2000.

Cooper, Tracy E. Palladio's Venice: Architecture and Society in a Renaissance Republic. New Haven, Conn.: Yale University Press, 2005.

- Cranston, Jodi. *The Muddled Mirror: Materiality and Figuration in Titian's Later Paintings*. University Park, Pa.: Pennsylvania State University Press, 2010.
- Dal Pozzolo, Enrico. Giorgione. Milan: Motta, 2010.
- De Vecchi, Pierluigi. Raphael. New York: Abbeville, 2002.
- Ekserdjian, David. *Correggio*. New Haven, Conn.: Yale University Press, 1997.

———. Parmigianino. New Haven, Conn.: Yale University Press, 2006.

- Falomir, Miguel, ed. *Tintoretto*. Madrid: Museo Nacional del Prado, 2007.
- Ferino-Pagden, Sylvia, and Giovanna Nepi Scirè. Giorgione: Myth and Enigma. Milan: Skira, 2004.
- Franklin, David. Painting in Renaissance Florence, 1500– 1550. New Haven, Conn.: Yale University Press, 2001.
- Freedberg, Sydney J. Painting in Italy: 1500–1600. 3d ed. New Haven, Conn.: Yale University Press, 1993.

- Goffen, Rona. Piety and Patronage in Renaissance Venice: Bellini, Titian, and the Franciscans. New Haven, Conn.: Yale University Press, 1986.
- ——. Renaissance Rivals: Michelangelo, Leonardo, Raphael, Titian. New Haven, Conn.: Yale University Press, 2002.
- Hall, Marcia B. After Raphael: Painting in Central Italy in the Sixteenth Century. Cambridge: Cambridge University Press, 1999.
- . Rome. Artistic Centers of the Italian Renaissance. New York: Cambridge University Press, 2005.
 . The Sacred Image in the Age of Art: Titian,
- *Tintoretto, Barocci, El Greco, Caravaggio.* New Haven, Conn.: Yale University Press, 2011.
- ——, ed. The Cambridge Companion to Raphael. New York: Cambridge University Press, 2005.
- Hollingsworth, Mary. Patronage in Sixteenth Century Italy. London: John Murray, 1996.
- Holt, Elizabeth Gilmore, ed. A Documentary History of Art. Vol. 2, Michelangelo and the Mannerists. Rev. ed. Princeton, N.J.: Princeton University Press, 1982.
- Humfrey, Peter. Painting in Renaissance Venice. New Haven, Conn.: Yale University Press, 1995.
 —. Titian. London: Phaidon, 2007.
- Huse, Norbert, and Wolfgang Wolters. The Art of Renaissance Venice: Architecture, Sculpture, and Painting. Chicago: University of Chicago Press, 1990.
- Ilchman, Frederick, ed. Titian, Tintoretto, Veronese: Rivals in Renaissance Venice. Boston: Museum of Fine Arts, 2009.
- Kliemann, Julian-Matthias, and Michael Rohlmann. Italian Frescoes: High Renaissance and Mannerism, 1510-1600. New York: Abbeville, 2004.
- Levey, Michael. *High Renaissance*. New York: Viking Penguin, 1978.
- Lotz, Wolfgang. Architecture in Italy, 1500–1600. 2d ed. New Haven, Conn.: Yale University Press, 1995.
- Meilman, Patricia, ed. *The Cambridge Companion to Titian*. New York: Cambridge University Press, 2004.
- Nichols, Tom. *Tintoretto: Tradition and Identity*. London: Reaktion, 2004.
- Partridge, Loren. *The Art of Renaissance Rome*. New York: Abrams, 1996.
- Pietrangeli, Carlo, André Chastel, John Shearman, John O'Malley, S.J., Pierluigi de Vecchi, Michael Hirst, Fabrizio Mancinelli, Gianluigi Colalucci, and Franco Bernbei. *The Sistine Chapel: The Art, the History, and the Restoration.* New York: Harmony, 1986.
- Pilliod, Elizabeth. Pontormo, Bronzino, Allori: A Genealogy of Florentine Art. New Haven, Conn.: Yale University Press, 2001.
- Pope-Hennessy, John. Italian High Renaissance and Baroque Sculpture. 3d ed. 3 vols. Oxford: Phaidon, 1986.
- Rosand, David. *Painting in Cinquecento Venice: Titian, Veronese, Tintoretto.* New Haven, Conn.: Yale University Press, 1982.
- Rowe, Colin, and Leon Satkowski. *Italian Architecture of the 16th Century*. New York: Princeton Architectural Press, 2002.
- Shearman, John K. G. *Mannerism*. Baltimore: Penguin, 1978.
- ———. Only Connect... Art and the Spectator in the Italian Renaissance. Princeton, N.J.: Princeton University Press, 1990.
- Summers, David. *Michelangelo and the Language of Art.* Princeton, N.J.: Princeton University Press, 1981.
- Talvacchia, Bette. Raphael. London: Phaidon, 2007. Tronzo, William, ed. St. Peter's in the Vatican. New
- York: Cambridge University Press, 2005.
- Wilde, Johannes. Venetian Art from Bellini to Titian. Oxford: Clarendon, 1981.
- Williams, Robert. Art, Theory, and Culture in Sixteenth-Century Italy: From Techne to Metatechne. New York: Cambridge University Press, 1997.

Chapter 23: High Renaissance and Mannerism in Northern Europe and Spain

- Ainsworth, Maryan W. Man, Myth, and Sensual Pleasures: Jan Gossart's Renaissance. The Complete Works. New York: Metropolitan Museum of Art, 2010.
- Bartrum, Giulia, ed. Albrecht Dürer and His Legacy: The Graphic Work of a Renaissance Artist. Princeton, N. J.: Princeton University Press, 2003.
- Bätschmann, Oskar, and Pascal Griener. *Hans Holbein*. Princeton, N. J.: Princeton University Press, 1997.
- Blunt, Anthony. Art and Architecture in France, 1500– 1700. Rev. ed. New Haven, Conn.: Yale University Press, 1999.
- Brinkmann, Bodo, ed. Cranach. London: Royal Academy of Arts, 2008.
- Buck, Stephanie, and Jochen Sander. *Hans Holbein the Younger: Painter at the Court of Henry VIII.* New York: Thames & Hudson, 2004.
- Chapius, Julien. Tilman Riemenschneider: Master Sculptor of the Late Middle Ages. Washington, D.C.: National Gallery of Art, 1999.
- Chastel, André. French Art: The Renaissance, 1430-1620. Paris: Flammarion, 1995.
- Davies, David, and John H. Elliott. *El Greco*. London: National Gallery, 2003.
- Dixon, Laurinda. Bosch. New York: Phaidon, 2003.
- Farago, Claire, ed. Reframing the Renaissance: Visual Culture in Europe and Latin America, 1450–1650. New Haven, Conn.: Yale University Press, 1995.
- Foister, Susan. *Holbein and England*. New Haven, Conn.: Paul Mellon Centre for British Art, 2005.
- Gibson, W. S. "Mirror of the Earth": The World Landscape in Sixteenth-Century Flemish Painting. Princeton, N.J.: Princeton University Press, 1989.
- Harbison, Craig. The Mirror of the Artist: Northern Renaissance Art in Its Historical Context. New York: Abrams, 1995.
- Koerner, Joseph Leo. *The Reformation of the Image*. Chicago: University of Chicago Press, 2004.
- Landau, David, and Peter Parshall. *The Renaissance Print: 1470–1550.* New Haven, Conn.: Yale University Press, 1994.
- Price, David Hotchkiss. Albrecht Dürer's Renaissance: Humanism, Reformation, and the Art of Faith. Ann Arbor: University of Michigan Press, 2003.
- Roberts-Jones, Philippe, and Françoise Roberts-Jones. Pieter Bruegel. New York: Abrams, 2002.
- Silver, Larry. *Hieronymous Bosch*. New York: Abbeville, 2006.
- Smith, Jeffrey C. German Sculpture of the Later Renaissance, c. 1520–1580: Art in an Age of Uncertainty. Princeton, N.J.: Princeton University Press, 1993.
- Stechow, Wolfgang. Northern Renaissance Art, 1400– 1600: Sources and Documents. Evanston, Ill.: Northwestern University Press, 1989.
- Zerner, Henri. Renaissance Art in France: The Invention of Classicism. Paris: Flammarion, 2003.

Baroque Art, General

- Blunt, Anthony, ed. Baroque and Rococo: Architecture and Decoration. Cambridge: Harper & Row, 1982.
- Harris, Ann Sutherland. Seventeenth-Century Art & Architecture. Upper Saddle River, N.J.: Prentice Hall, 2005.
- Harrison, Charles, Paul Wood, and Jason Gaiger, eds. Art in Theory, 1648–1815: An Anthology of Changing Ideas. Oxford: Blackwell, 2000.
- Held, Julius, and Donald Posner. 17th- and 18th-Century Art: Baroque Painting, Sculpture, Architecture. New York: Abrams, 1971.
- Lagerlöf, Margaretha R. *Ideal Landscape: Annibale Carracci, Nicolas Poussin, and Claude Lorrain.* New Haven, Conn.: Yale University Press, 1990.

- Lawrence, Cynthia, ed. Women and Art in Early Modern Europe: Patrons, Collectors, and Connoisseurs. University Park: Pennsylvania State University Press, 1997.
- Lemerle, Frédérique, and Yves Pauwels. Baroque Architecture, 1600-1750. Paris: Flammarion, 2008.
- Minor, Vernon Hyde. Baroque & Rococo: Art & Culture. New York, Abrams, 1999.
- Norberg-Schulz, Christian. Baroque Architecture. New York: Rizzoli, 1986.
- ——. Late Baroque and Rococo Architecture. New York: Electa/Rizzoli, 1985.
- Toman, Rolf. Baroque: Architecture, Sculpture, Painting. Cologne: Könemann, 1998.

Chapter 24: The Baroque in Italy and Spain

- Bissel, R. Ward. Artemisia Gentileschi and the Authority of Art. University Park: Pennsylvania State University Press, 1999.
- Brown, Jonathan. *The Golden Age of Painting in Spain*. New Haven, Conn.: Yale University Press, 1991.
- ——. Velázquez: Painter and Courtier. New Haven, Conn.: Yale University Press, 1988.
- Christiansen, Keith, and Judith W. Mann. Orazio and Artemisia Gentileschi. New York: Metropolitan Museum of Art, 2001.
- Enggass, Robert, and Jonathan Brown. *Italy and Spain*, 1600–1750: Sources and Documents. Upper Saddle River, N.J.: Prentice Hall, 1970.
- Freedberg, Sydney J. Circa 1600: A Revolution of Style in Italian Painting. Cambridge, Mass.: Harvard University Press, 1983.
- Fried, Michael. *The Moment of Caravaggio*. Princeton, N.J.: Princeton University Press, 2010.
- Haskell, Francis. *Patrons and Painters: A Study in the Relations between Italian Art and Society in the Age of the Baroque.* Rev. ed. New Haven, Conn.: Yale University Press, 1980.
- Krautheimer, Richard. *The Rome of Alexander VII, 1655–1677.* Princeton, N.J.: Princeton University Press, 1985.
- Montagu, Jennifer. *Roman Baroque Sculpture: The Industry of Art.* New Haven, Conn.: Yale University Press, 1989.
- Puglisi, Catherine. Caravaggio. London: Phaidon, 2000.
- Schroth, Sarah, and Ronni Baer. El Greco to Velazquez: Art during the Reign of Philip III. Boston: Museum of Fine Arts, 2008.
- Strinati, Claudio, and Pomeroy, Jordana. Italian Women Artists from Renaissance to Baroque. Milan: Skira, 2007.
- Tomlinson, Janis. From El Greco to Goya: Painting in Spain 1561–1828. Upper Saddle Ridge, N.J.: Prentice Hall, 1997.
- Tronzo, William, ed. St. Peter's in the Vatican. New York: Cambridge University Press, 2005.
- Varriano, John. Caravaggio: The Art of Realism. University Park: Pennsylvania University Press, 2006.
 ———. Italian Baroque and Rococo Architecture. New
- York: Oxford University Press, 1986.
- Wittkower, Rudolf. Art and Architecture in Italy 1600– 1750. 6th ed. 3 vols. Revised by Joseph Connors and Jennifer Montagu. New Haven, Conn.: Yale University Press, 1999.

Chapter 25: The Baroque in Northern Europe

- Alpers, Svetlana. The Art of Describing: Dutch Art in the Seventeenth Century. Chicago: University of Chicago Press, 1984.
- ——. The Making of Rubens. New Haven, Conn.: Yale University Press, 1995.
- ———. Rembrandt's Enterprise: The Studio and the Market. Chicago: University of Chicago Press, 1988. Belkin, Kristin Lohse. Rubens. London: Phaidon, 1998.
- Biesboer, Pieter, Martina Brunner-Bulst, Henry D. Gregory, and Christian Klemm. *Pieter Claesz: Master of Haarlem Still Life.* Zwolle: Waanders, 2005.

- Blunt, Anthony. Art and Architecture in France, 1500– 1700. Rev. ed. New Haven, Conn.: Yale University Press, 1999.
- Brown, Christopher. Scenes of Everyday Life: Dutch Genre Painting of the Seventeenth Century. London: Faber & Faber, 1984.
- Bryson, Norman. Word and Image: French Painting of the Ancien Régime. Cambridge: Cambridge University Press, 1981.
- Carr, Dawson W., ed. Velázquez. London: National Gallery, 2006.
- Chapman, Perry. Rembrandt's Self-Portraits: A Study in 17th-Century Identity. Princeton, N.J.: Princeton University Press, 1990.
- Chastel, André. French Art: The Ancien Régime, 1620– 1775. New York: Flammarion, 1996.
- Chong, Alan, and Wouter Kloek. *Still-Life Paintings* from the Netherlands, 1550–1720. Zwolle: Waanders, 1999.
- Franits, Wayne. Dutch Seventeenth-Century Genre Painting: Its Stylistic and Thematic Evolution. New Haven, Conn.: Yale University Press, 2008.
- ——, ed. The Cambridge Companion to Vermeer. New York: Cambridge University Press, 2001.
- Haak, Bob. The Golden Age: Dutch Painters of the Seventeenth Century. New York: Abrams, 1984.
- Hochstrasser, Julie Berger. *Still Life and Trade in the Dutch Golden Age*. New Haven, Conn.: Yale University Press, 2007.
- Keazor, Henry. Nicholas Poussin, 1594–1665. Cologne: Taschen, 2007.
- Kiers, Judikje, and Fieke Tissink. *Golden Age of Dutch Art: Painting, Sculpture, Decorative Art.* New York: Thames & Hudson, 2000.
- Liedtke, Walter. Vermeer: The Complete Paintings. Antwerp: Ludion, 2008.
- ------. A View of Delft: Vermeer and His Contemporaries. Zwolle: Wanders, 2000.
- Mérot, Alain. French Painting in the Seventeenth Century. New Haven, Conn.: Yale University Press, 1995.
- Muller, Sheila D., ed. *Dutch Art: An Encyclopedia*. New York: Garland, 1997.
- North, Michael. Art and Commerce in the Dutch Golden Age. New Haven, Conn.: Yale University Press, 1997.
- Olson, Todd P. *Poussin and France*. New Haven, Conn.: Yale University Press, 2000.
- Rosenberg, Jakob, Seymour Slive, and E. H. ter Kuile. Dutch Art and Architecture, 1600–1800. New Haven, Conn.: Yale University Press, 1979.
- Schama, Simon. The Embarrassment of Riches: An Interpretation of Dutch Culture in the Golden Age. Berkeley: University of California Press, 1988.
- Schroth, Sarah, and Ronni Baer, eds. El Greco to Velázquez: Art during the Reign of Philip III. Boston: Museum of Fine Arts, 2008.
- Slatkes, Leonard J., and Wayne Franits. The Paintings of Hendrick ter Brugghen 1588-1629: Catalogue Raisonné. Philadelphia: John Benjamins, 2007.
- Stechow, Wolfgang. Dutch Landscape Painting of the 17th Century. 3d ed. Oxford: Phaidon, 1981.
- Summerson, John. *Inigo Jones*. New Haven, Conn.: Yale University Press, 2000.
- Vlieghe, Hans. *Flemish Art and Architecture*, 1585–1700. New Haven, Conn.: Yale University Press, 1998.
- Westermann, Mariët. *Rembrandt*. London: Phaidon, 2000. ——. A Worldly Art: The Dutch Republic 1585–1718.
- New Haven, Conn.: Yale University Press, 1996. Zega, Andres, and Bernd H. Dams. Palaces of the Sun King: Versailles, Trianon, Marly: The Châteaux of
- Louis XIV. New York: Rizzoli, 2002.
- Zell, Michael. Reframing Rembrandt: Jews and the Christian Image in Seventeenth-Century Amsterdam. Berkeley: University of California Press, 2002.

CREDITS

Before 1300—xx: © John Burge/Cengage Learning; xxi top: © 2008 Fred S. Kleiner; bottom lt: © James E. Packer; bottom rt: © Scala/Art Resource, NY; xxii all: John Burge/Cengage Learning; xxii top lt: © Saskia Ltd.; top rt: © Scala/Art Resource, NY; bottom lt: © Jonathan Poore/Cengage Learning; bottom rt: Copyrt: Photo Henri Stierlin, Geneve; xxiv lt: © John Burge/Cengage Learning; to Jonathan Poore/ Cengage Learning; xxv top lt, bottom lt: © Cengage Learning; top rt, bottom rt: © Jonathan Poore/Cengage Learning; xxvi lt: Copyrt: Photo Henri Stierlin, Geneve; rt: © Alinari/Art Resource, NY; bottom: © Cengage Learning; xxvii lt to rt: © Nimatallah/Art Resource, NY; © Royal Ontario Museum; © Réunion des Musées Nationaux/Art Resource, NY; © Scala/Art Resource, NY; xxviii lt: © Erich Lessing/Art Resource, NY; rt: akg-images/Bildarchiv Monheim; xxix lt: © Scala/Art Resource, NY; rt: STUDIO KONTOS/PHOTOSTOCK; xxx all: Freer Gallery of Art, Smithsonian Institution, Washington, DC. Purchase, F1949.9a d; xxxi lt: © V Muthuraman/Photolibrary; rt: © Dinodia Photos/Alamy.

Introduction-Opener: © The Metropolitan Museum of Art/Art Resource, NY; 1-2: © The Clyfford Still Estate. Photo: akg images; I-3: © Paul Maeyaert/The Bridgeman Art Library International; I-4: akg-images/Rabatti-Domingie; I-5: National Gallery of Art, Alfred Stieglitz Collection, Bequest of Georgia O'Keeffe 1987.58.3; I-6: Art © Estate of Ben Shahn/Licensed by VAGA, New York, NY. Photo: Whitney Museum of American Art, New York. (gift of Edith and Milton Lowenthal in memory of Juliana Force); I-7: © Jonathan Poore/Cengage Learning; I-8: akg-images; I-9: © The Metropolitan Museum of Art/Art Resource, NY; I-10: Courtesy Saskia Ltd., © Dr. Ron Wiedenhoeft; I-11: © 2011 The Josef and Anni Albers Foundation/Artists Rights Society (ARS), New York. Photo: © Whitney Museum of American Art; I-12: National Gallery, London. NG14. Bought, 1824; I-13: Photograph © 2011 Museum of Fine Arts, Boston; I-14: © bpk, Berlin/Staatsgemaeldesammlungen, Munich, Germany/ Art Resource, NY; I-15: Jürgen Liepe, Berlin; I-16: © Nimatallah/Art Resource, NY; I-17: © Scala/Art Resource, NY; I-18: © Cengage Learning; I-19a: © National Library of Australia, Canberra, Australia/The Bridgeman Art Library International; I-19b: Public Domain.

Chapter 14-Opener: © Scala/Art Resource, NY; timeline: © Scala/Art Resource, NY; 14-2: © Jonathan Poore/Cengage Learning; 14-3: © Jonathan Poore/Cengage Learning; 14-4: © Scala/Art Resource, NY; 14-5: © Scala/Art Resource, NY; 14-5B: © Erich Lessing/Art Resource, NY; 14-5A: © Alinari/Art Resource, NY; 14-6: © Scala/ Ministero per i Beni e le Attività culturali/Art Resource, NY; 14-6A: Photo by Ralph Lieberman; 14-6B: © Scala/Art Resource, NY; 14-7: © Summerfield Press/Corbis Art/ Corbis; 14-8: © Scala/Art Resource, NY; 14-8A: © Alinari/Art Resource, NY; 14-8B: © Alinari/Art Resource, NY; 14-9: © Scala/Art Resource, NY; 14-10: © Scala/Art Resource, NY; 14-10A: © Scala/Art Resource, NY; 14-11: © Scala/Art Resource, NY; 14-12: © Jonathan Poore/Cengage Learning; 14-12A: © Jonathan Poore/Cengage Learning; 14-13: Canali Photobank; 14-14: © Scala/Art Resource, NY; 14-15: © Jonathan Poore/Cengage Learning; 14-16: © Scala/Art Resource, NY; 14-16A: © Scala/ Art Resource, NY; 14-17: © Scala/Art Resource, NY; 14-18: © Alinari/Art Resource, NY; 14-18A: © MUZZI FABIO/CORBIS SYGMA; 14-18B: © Jonathan Poore/Cengage Learning; 14-19: © The Bridgeman Art Library; 14-19A: © Scala/Art Resource, NY; 14-20: © Jonathan Poore/Cengage Learning; 14-21: © Bednorz-Images; UNF 14-1: © Scala/Art Resource, NY; UNF 14-2: © Jonathan Poore/Cengage Learning; UNF 14-3: © Scala/Art Resource, NY; UNF 14-4: © Scala/Art Resource, NY; UNF 14-5: © age fotostock/SuperStock.

Chapter 20—**Opener:** Image copyright © The Metropolitan Museum of Art/Art Resource, NY; **Map 20-1:** © Cengage Learning; **timeline:** Image copyright © The Metropolitan Museum of Art/Art Resource, NY; **10-2:** © Erich Lessing/Art Resource, NY; **20-2A:** © Jonathan Poore/Cengage Learning; **20-3a:** © Erich Lessing/Art Resource, NY; **20-3b:** © Erich Lessing/Art Resource, NY; **20-4:** © Scala/Art Resource, NY; **20-5A:** © Bildarchiv Preussischer Kulturbesitz/Art Resource, NY; **20-7:** © Erich Lessing/Art Resource, NY; **20-6:** © Erich Lessing/Art Resource, NY; **20-7:** Copyright © National Gallery, London; **20-8:** © Erich Lessing/Art Resource, NY; **20-8A:**

© Jonathan Poore/Cengage Learning; 20-9: Photograph © 208 Museum of Fine Arts, Boston; 20-9A: Copyright © 1999 Board of Trustees, National Gallery of Art, Washington, D.C.; 20-10: Image copyright © The Metropolitan Museum of Art/Art Resource, NY; 20-11A_a © Giraudon/Art Resource, NY; 20-11: The Art Archive/St Peters Church Louvain/Picture Desk; 20-11A_b © Scala/Art Resource, NY.; 20-12: © Scala/ Art Resource, NY; 20-13: © Erich Lessing/Art Resource, NY; 20-14: © Erich Lessing/ Art Resource, NY; 20-14A: Image copyright © The Metropolitan Museum of Art/Art Resource, NY; 20-14B: Image copyright © The Metropolitan Museum of Art/Art Resource, NY; 20-15: © Réunion des Musées Nationaux/Art Resource, NY; 20-16: © Réunion des Musées Nationaux/Art Resource, NY; 20-16A: The Art Archive/ Osterreichisches National Bibliothek Vienna/Eileen Tweedy/Picture Desk; 20-17a: © Bildarchiv Preussischer Kulturbesitz/Art Resource, NY; 20-17b: © Scala/Art Resource, NY; 20-18: Musee d'Art et d'Histoire, Geneva; 20-18A: Photo Credit: © Erich Lessing/Art Resource, NY; 20-19: © Erich Lessing/Art Resource, NY; 20-20A: John Rylands University Library, University of Manchester, Manchester.; 20-20: © Erich Lessing/Art Resource, NY; 20-21: © Historical Picture Archive/Corbis; 20-22: © Scala/ Art Resource, NY; UNF 20-01: © Erich Lessing/Art Resource, NY; UNF 20-2: Image copyright © The Metropolitan Museum of Art/Art Resource, NY; UNF 20-3: © Erich Lessing/Art Resource, NY; UNF 20-4: © Réunion des Musées Nationaux/Art Resource, NY; UNF 20-5: Historical Picture Archive/CORBIS

Chapter 21-Opener: © Scala/Art Resource, NY; timeline: © Scala/Art Resource, NY; Map 21-1: © Cengage Learning; 21-2: © Erich Lessing/Art Resource, NY; 21-3: © Erich Lessing/Art Resource, NY; 21-4, 21-5, 21-6, 21-7, 21-8: © Jonathan Poore/ Cengage Learning; 21-9: © Scala/Art Resource, NY; 21-10: © Jonathan Poore/Cengage Learning; 21-12: © Scala/Art Resource, NY; 21-12A: akg-images/Rabatti - Domingie; 21-13: © Scala/Art Resource, NY; 21-14: © Scala/Art Resource, NY; 21-15: © Jonathan Poore/Cengage Learning; 21-16: Elio Ciol/Corbis; 21-17: © 2010 Fred Kleiner; 21-18: © Erich Lessing/Art Resource, NY; 21-19: © Scala/Art Resource, NY; 21-20: Canali Photobank, Italy; 21-21: © Erich Lessing/Art Resource, NY; 21-22: Canali Photobank, Italy; 21-23: © Scala/Art Resource, NY; 21-24: Canali Photobank, Italy; 21-25: © Scala/Art Resource, NY; 21-25A: © Nicolo Orsi Battaglini/Art Resource, NY; 21-26: © Scala/Art Resource; 21-27: © The Bridgeman Art Library; 21-28: © National Gallery, London/Art Resource, NY; 21-29: Summerfield Press Ltd.; 21-29A: akg-images/ Rabatti - Domingie; 21-30: Image copyright © The Metropolitan Museum of Art/Art Resource, NY; 21-30A, 21-31: © Jonathan Poore/Cengage Learning; 21-32: © Alinari/ Art Resource, NY; 21-32A: © The Bridgeman Art Library; 21-33: © Cengage Learning; 21-35: © Cengage Learning; 21-34, 21-36, 21-36A, 21-37, 21-38, 21-39, 21-40: © Jonathan Poore/Cengage Learning; 21-37A: © 2010 Fred Kleiner; 21-41: © Scala/Art Resource, Inc.; 21-41A: © Scala/Art Resource, NY; 21-42: © Scala/Art Resource, NY; 21-43A: © Scala/Art Resource, NY; 21-43: © Scala/Ministero per i Beni e le Attività culturali/Art Resource, NY; 21-44: © Scala/Art Resource, NY; 21-45: © Alinari/Art Resource, NY; 21-46: © Cengage Learning; 21-47: Canali Photobank, Italy; 21-48: © Scala/Art Resource, NY; 21-49: © Scala/Art Resource, NY; 21-49A: © Alinari/The Bridgeman Art Library; 21-50: © Erich Lessing/Art Resource, NY; UNF 21-01: © Scala/Art Resource, NY; UNF 21-2: © Erich Lessing/Art Resource, NY; UNF 21-3: © Jonathan Poore/Cengage Learning; UNF 21-4: © Scala/Ministero per i Beni e le Attività culturali/Art Resource, NY; UNF 21-5: © Alinari/Art Resource, NY

Chapter 22—Opener: Canali Photobank; (detail 1): Photo Vatican Museums; (detail 2): © Bracchietti-Zigrosi/Vatican Museums; (detail 3): Vatican Museums and Galleries, Vatican City, Italy/The Bridgeman Art Library International; (detail 4): akg-images/Electa; timeline: akg-images/Electa; 22-2: © Erich Lessing/Art Resource, NY; 22-3: The Art Archive/National Gallery London/Eileen Tweedy/Picture Desk; 22-4: © Alinari/Art Resource, NY; 22-3A: © Scala/Art Resource, NY; 22-5: © Réunion des Musées Nationaux/Art Resource, NY; 22-6: Collection @ 2011 Her Majesty Queen Elizabeth II; 22-6A: Bibliothèque de l'Institut de France/© Réunion des Musées Nationaux/Art Resource, NY; 22-7: © Erich Lessing/Art Resource, NY; 22-8: © Erich Lessing/Art Resource, NY; 22-8A: © Scala/Art Resource, NY; 22-9: © M. Sarri 1983/ Photo Vatican Museums; 22-10: © Scala/Ministero per i Beni e le Attività culturali/Art Resource, NY; 22-10A: © Erich Lessing/Art Resource, NY; 22-11: © Scala/Art Resource, NY; 22-12: © Araldo de Luca/CORBIS; 22-13: © Arte & Immagini srl/Corbis; 22-14: © Scala/Art Resource, NY; 22-15: © Scala/Art Resource, NY; 22-16: © Scala/ Art Resource, NY; 22-17: Photo Vatican Museums; 22-18: © Bracchietti-Zigrosi/ Vatican Museums; 22-18A: Vatican Museums and Galleries, Vatican City, Italy/The Bridgeman Art Library International; 22-18B_1: Vatican Museums and Galleries, Vatican City, Italy/The Bridgeman Art Library International; 22-19: akg-images/ Electa; 22-20: © Erich Lessing/Art Resource, NY; 22-21: © Scala/Art Resource, NY; 22-22: © Cengage Learning; 22-23: © The Trustees of the British Museum/Art Resource, NY; 22-24: © Cengage Learning; 22-25: © Guido Alberto Rossi/Photolibrary; 22-26: © Alinari Archives/Corbis; 22-26A: © Guido Alberto Rossi/Photolibrary; 22-27: © Alinari Archives/Corbis; 22-28: © Mark Edward Smith/Photolibrary; 22-29: © Cengage Learning; 22-30: © 2010 Fred Kleiner; 22-30A: © Scala/Art Resource, NY; 22-31: © John Heseltine/Corbis; 22-31A: © The Frick Collection, NY. 1915.1.3; 22-32: © Scala/Art Resource, NY; 22-33: © 1999 Board of Trustees, National Gallery of Art, Washington, D.C.; 22-34: Cameraphoto Arte, Venice/Art Resource, NY; 22-35: © Erich Lessing/Art Resource, NY; 22-36: © Scala/Art Resource, NY; 22-37: © Scala/ Art Resource, NY; 22-38: © Erich Lessing/Art Resource, NY; 22-39: © Scala/Ministero per i Beni e le Attività culturali/Art Resource, NY; 22-40: © Erich Lessing/Art Resource, NY; 22-40A: Photograph © 2011 National Museum of Women in the Arts; 22-41: © Scala/Art Resource, NY; 22-42: © Scala/Art Resource, NY; 22-42A: The Art Archive/Pinacoteca Nazionale di Siena/Alfredo Dagli Orti/Picture Desk; 22-43: © Erich Lessing/Art Resource, NY; 22-44: © Scala/Art Resource, NY; 22-45: © Nåtional Gallery, London; 22-46A: Image copyright © The Metropolitan Museum of Art/ Art Resource, NY; 22-46: © The Bridgeman Art Library International; 22-47: © The Bridgeman Art Library International; 22-48: © Scala/Art Resource, NY; 22-49: © Scala/Art Resource, NY; 22-50: Canali Photobank, Italy; 22-51: © Alinari/Art Resource, NY; 22-52: © Erich Lessing/Art Resource, NY; 22-52A: © Lauros/Giraudon/ The Bridgeman Art Library; 22-53: 0 206 Fred S. Kleiner; 22-54: Superstock/Photolibrary; 22-54A: © Scala/Art Resource, NY; 22-55: © Jonathan Poore/Cengage Learning; 22-56: The Art Archive/Gianni Dagli Orti/Picture Desk; 22-57: © Cengage Learning; UNF 22-01: © Arte & Immagini srl/Corbis; UNF 22-2: © Scala/Art Resource, NY; UNF 22-3: © Erich Lessing/Art Resource, NY; UNF 22-4: © Scala/Art Resource, NY; UNF 22-5: © Erich Lessing/Art Resource, NY.

Chapter 23-Opener: © Institut Amatller D'art Hispànic; (all details) akg-images/ Electa; timeline: © Institut Amatller D'art Hispànic; 23-2: © Musée Unterlinden, Colmar Musée Unterlinden, Colmar Inv. 88.RP.139; 23-3: © The Trustees of the British Museum/Art Resource, NY; 23-3A: © Erich Lessing/Art Resource, NY; 23-4: akgimages; 23-4A: © Graphische Sammlung Albertina, Vienna, Austria/The Bridgeman Art Library; 23-5: Photograph © 2011 Museum of Fine Arts, Boston; 23-5A: © The Trustees of The British Museum/Art Resource, NY; 23-6: © Victoria & Albert Museum, London/Art Resource, NY; 23-7a: © Bildarchiv Preussischer Kulturbesitz/Art Resource, NY; 23-7b: © Bildarchiv Preussischer Kulturbesitz/Art Resource, NY; 23-8: © The Trustees of The British Museum; 23-9: Staatliche Kunsthalle, Karlsruhe.; 23-10: © Bildarchiv Preussischer Kulturbesitz/Art Resource, NY; 23-11: © National Gallery, London/Art Resource, NY; 23-11A: © Scala/Art Resource, NY; 23-12: © Réunion des Musées Nationaux/Art Resource, NY; 23-13: © Jonathan Poore/Cengage Learning; 23-14: © Jonathan Poore/Cengage Learning; 23-14A: © 209 Fred. S. Kleiner; 23-15: © Bildarchiv Preussischer Kulturbesitz/Art Resource, NY; 23-15A: © Erich Lessing/ Art Resource, NY; 23-16: © Réunion des Musées Nationaux/Art Resource, NY; 23-17: Uppsala University Art Collection; 23-18: Oeffentliche Kunstsammlung Basel, photo Martin Bühler; 23-19: The Royal Collection © 2011 Her Majesty Queen Elizabeth II; 23-20: © Erich Lessing/Art Resource, NY; 23-21: © Bildarchiv Preussischer Kulturbesitz/Art Resource, NY; 23-22: Kunsthistorisches Museum, Vienna; 23-22A: © Scala/ Art Resource, NY; 23-23: © Institut Amatller D'art Hispànic; 23-23A: © John Elk III; 23-24: © Adam Woolfitt/Photolibrary; 23-25: © Scala/Art Resource, NY; 23-26: © The Metropolitan Museum of Art/Art Resource, NY; UNF 23-01: Photograph © 2011 Museum of Fine Arts, Boston; UNF 23-2: © National Gallery, London/Art

Resource, Ny; **UNF 23-3:** © Réunion des Musées Nationaux/Art Resource, NY; **UNF 23-4:** Kunsthistorisches Museum, Vienna; **UNF 23-5:** © Institut Amatller D'art Hispànic.

Chapter 24—Opener: The Art Archive/Gianni Dagli Orti/Picture Desk; (detail 1): © Massimo Listri/Corbis; (detail 2): © 2011 Fred Kleiner; (detail 3): © Vanni/Art Resource, NY; (detail 4): akg-images/Gerard Degeorge; timeline © Vanni/Art Re source, NY; 24-2: akg-images/Pirozzi; 24-3: © Andrea Jemolo/Corbis; 24-4: © Cuboimages/Photolibrary; 24-4A: Canali Photobank, Italy; 24-5: akg-images/Joseph Martin; Map 24-1: © Cengage Learning; 24-6: © Scala/Art Resource, NY; 24-6A: © Araldo de Luca/Corbis; 24-7: © Araldo de Luca; 24-8: akg-images/Pirozzi; 24-9: © Scala/Art Resource, NY; 24-9A: © Scala/Art Resource, NY; 24-11: © Bednorz-Images; 24-12: © Raimund Kutter/Photolibrary; 24-13: © Cengage Learning; 24-14A: © Alinari/The Bridgeman Art Library; 24-14: © Scala/Ministero per i Beni e le Attività culturali/Art Resource, NY; 24-15: © Alinari/Art Resource, NY; 24-16: © Scala/Art Resource, NY; 24-17: © Scala/Art Resource, NY; 24-17A: Image copyright © The Metropolitan Museum of Art/Art Resource, NY; 24-18A: © Scala/Art Resource, NY; 24-18: © Scala/Art Resource, NY; 24-19: © Alinari/Art Resource, NY; 24-20: The Royal Collection © 2011 Her Majesty Queen Elizabeth II; 24-21: © Nimatallah/Art Resource, NY; 24-22: © The Bridgeman Art Library International; 24-23: © Scala/Art Resource, NY; 24-24: Summerfield Press Ltd.; 24-25: © Erich Lessing/Art Resource, NY; 24-25A: © Erich Lessing/Art Resource, NY; 24-26: © Erich Lessing/Art Resource, NY; 24-27: © Wadsworth Atheneum Museum of Art/Art Resource, NY; 24-28: © Victoria & Albert Museum, London/Art Resource, NY; 24-28A: © Scala/Art Resource, NY; 24-28B: © 2011 The Frick Collection, NY; 24-29: © Scala/Art Resource, NY; 24-30: © Erich Lessing/Art Resource, NY; UNF 24-01: © Bednorz-Images; UNF 24-2: © Araldo de Luca; UNF 24-3: © Jonathan Poore/Cengage Learning; UNF 24-4: Summerfield Press Ltd.; UNF 24-5: © Erich Lessing/Art Resource, NY.

Chapter 25-Opener: akg-images; timeline: akg-images; 25-01A: © Erich Lessing/Art Resource, NY; 25-2: IRPA-KIK, Brussels, www.kikirpa.be; 25-2A: © Erich Lessing/Art Resource, NY; 25-3: © Erich Lessing/Art Resource, NY; 25-4: © Scala/Art Resource, NY; 25-5: © Réunion des Musées Nationaux/Art Resource, NY; 25-6: © Scala/Art Resource, NY; 25-7: Centraal Museum, Utrecht, photo Ernst Moritz, The Hague; 25-8: © Alinari/The Bridgeman Art Library; 25-9: Frans Halsmuseum, Haarlem; 25-10: Frans Halsmuseum, Haarlem; 25-11: National Gallery of Art; 25-12: © Erich Lessing/Art Resource, NY; 25-13: © The Bridgeman Art Library; 25-13A: akg-images; 25-14: © The Bridgeman Art Library; 25-15: © English Heritage Photo Library/The Bridgeman Art Library International; 25-15A: © 2011 The Frick Collection, NY. 196.1.97; 25-16: © The Pierpont Morgan Library/Art Resource, NY; 25-17: © National Gallery, London/Art Resource, NY; 25-18: Mauritshuis, The Hague; 25-18A: © Erich Lessing/Art Resource, NY; 25-18B: © Giraudon/The Bridgeman Art Library; 25-19: National Gallery of Art; 25-20: © Erich Lessing/Art Resource, NY; 25-20A: akg-images; 25-21: Rijksmuseum, Amsterdam; 25-22: The Bridgeman Art Library International; 25-23: The Toledo Museum of Art, OH. Purchased with funds from the Libbey Endowment, Gift of Edward Drummond Libbey, 1956.57; 25-24: © Réunion des Musées Nationaux/Art Resource, NY; 25-25: © Jonathan Poore/Cengage Learning; 25-26: © Yann Arthus-Bertrand/Altitude; 25-27: © Massimo Listri/ Corbis; 25-28: g Bernard Annebicque/CORBIS SYGMA; 25-29: akg-images/Paul M. R. Maeyaert; 25-30: © Jonathan Poore/Cengage Learning; 25-31: © Erich Lessing/Art Resource, NY; 25-32: Photograph: The Art Institute of Chicago.; 25-32A: © Scala/Art Resource, NY; 25-33: Photo copyright © Philadelphia Museum of Art, E1950-2-1; 25-34: © Réunion des Musées Nationaux/Art Resource, NY; 25-35: © Erich Lessing, Art Resource, NY; 25-36: © Erich Lessing/Art Resource, NY; 25-37: © Angelo Hornak/ CORBIS; 25-38: © Angelo Hornak/CORBIS; UNF 25-01: © Scala/Art Resource, NY; UNF 25-2: © The Pierpont Morgan Library/Art Resource, NY; UNF 25-3: National Gallery of Art; UNF 25-4: © Erich Lessing/Art Resource, NY; UNF 25-5: © Angelo Hornak/CORBIS

MUSEUM INDEX

Note: Figure numbers in blue indicate bonus images.

A

Aachen (Germany): Domschatzkammer: Aachen Gospels, 5 Amsterdam (Netherlands) Riiksmuseum

The Company of Captain Frans Banning Cocq (Night Watch) (Rembrandt), 707 Feast of Saint Nicholas (Steen), 712

The Letter (Vermeer), 25-20A Antwerp (Belgium)

Antwerp Cathedral: Elevation of the Cross (Rubens), 698

Koninklijk Museum voor Schone Kunsten: Virgin and Child, Melun Diptych (Fouquet), 552

Arezzo (Italy): San Francesco: Finding and Proving of the True Cross, Legend of the True Cross (Piero della Francesca), 21-24A

Assisi (Italy): San Francesco: Saint Francis Preaching to the Birds (Saint Francis Master) (fresco), 14-5B

Autun (France): Saint-Lazare: Last Judgment (Gislebertus), 5

В

Basel (Switzerland): Kunstmuseum Basel: Self-Portrait (van Hemessen), 661 Beaune (France): Hôtel-Dieu: Last Judgment Altarpiece (Rogier van der Weyden), 20-8A Berlin (Germany)

Staatlich Museen zu Berlin: Étienne Chevalier and Saint Stephen, Melun Diptych (Fouquet), 552 Staatliche Museen zu Berlin Madonna in a Church (van Eyck), 20-4A Neptune and Amphitrite (Gossaert), 659 Netherlandish Proverbs (Bruegel the Elder), 663

Borgo San Sepolcro (Italy): Palazzo Comunale: Resurrection (Piero della Francesca), 578 Boston, Massachusetts (U.S.A.)

Museum of Fine Arts Fall of Man (Adam and Eve) (Dürer), 650

Saint Luke Drawing the Virgin (Rogier van der Weyden), 545

Waves at Matsushima (Korin), 9 Bruges (Belgium)

Hospitaal Sint Jan: Saint John Altarpiece (Memling), 548

Memlingmuseum: Diptych of Martin van Nieuwenhove (Memling), 549

Brussels (Belgium) Musées Royaux des Beaux-Arts de Belgique Fall of Icarus (Bruegel the Elder), 23-22A

Justice of Otto III (Bouts), 20-11A Wrongful Beheading of the Count (Bouts), 20-11A

С

Cairo (Egypt): Egyptian Museum: Hesire, relief from his tomb at Saqqara (relief sculpture), 10 Canberra (Australia): National Library of Australia: Portrait of Te Pehi Kupe (Sylvester), 13 Chantilly (France): Musée Condé: Les Très

Riches Heures du Duc de Berry (Limbourg brothers), 550, 551 Chicago, Illinois (U.S.A.)

Art Institute of Chicago Landscape with Saint John on Patmos (Poussin), 720

Still Life with Game Fowl (Sánchez Cotán), 687

Colmar (France): Musée d'Unterlinden: Isenheim Altarpiece (Grünewald), 648

Cologne (Germany):

Wallraf-Richartz-Museum: Madonna in the Rose Garden

(Lochner), 20-18A Corte di Mamiano (Italy): Fondazione

Magnani Rocca: Saint Anthony Tormented by Demons (Schongauer), 556

Creglingen (Germany): parish church: Assumption of the Virgin, Creglingen Altarpiece (Riemenschneider), 555

D

Detroit, Michigan (U.S.A.): Detroit Institute of Arts: Jewish Cemetery (Ruisdael), 25-18A Dijon (France) Chartreuse de Champmol Virgin and Child, saints, and donors (Sluter) (sculpture), 20-2A Well of Moses (Sluter), 537 Musée des Beaux-Arts: Retable de Champmol (Broederlam), 539

F

(Lippi), 577

Florence (Italy) Baptistery of San Giovanni: doors (Pisano) (relief sculpture), 418 Galleria degli Uffizi Adoration of the Magi, Santa Trinitá, Florence (Gentile da Fabriano), 572 Annunciation altarpiece, Siena Cathedral (Martini and Memmi), 413 Battista Sforza and Federico da Montefeltro (Piero della Francesca), 591 Birth of Venus (Botticelli), 581 Eleanora of Toledo and Giovanni de' Medici (Bronzino), 635 Judith Slaying Holofernes (Gentileschi), 683 Madonna and Child with Angels

Madonna Enthroned with Angels and Prophets, Santa Trinitá, Florence (Cimabue), 406 Madonna of the Harpies (Andrea del Sarto), 22-8A Madonna with the Long Neck (Parmigianino), 633 Pope Leo X with Cardinals Giulio de' Medici and Luigi de' Rossi (Raphael), 608 Portinari Altarpiece (Hugo van der Goes), 547 Primavera (Botticelli), 558 Supper Party (van Honthorst), 703 Venus of Urbino (Titian), 629 Young Man Holding a Medal of Cosimo de' Medici (Botticelli), 21-29A Galleria dell'Accademia David (Michelangelo Buonarroti), 611 unfinished statue (Michelangelo), 11 Loggia dei Lanzi, Piazza della Signoria: Abduction of the Sabine Women (Giovanni da Bologna), 639 Museo dell'Opera del Duomo Gates of Paradise, Baptistery of San Giovanni, Florence (Ghiberti), 566, Penitent Mary Magdalene (Donatello), 21-12A Pietá (unfinished) (Michelangelo Buonarroti), 617 Museo Nazionale del Bargello David (Donatello), 568 David (Verrocchio), 569 Hercules and Antaeus (Pollaiuolo), 569 Sacrifice of Isaac (Brunelleschi), 562 Sacrifice of Isaac (Ghiberti), 562 Saint George (Donatello), 564 Saint George and the Dragon, Or San Michele (Donatello), 565 Or San Michele Four Crowned Saints (Nanni di Banco), 563 Madonna and Child (della Robbia), 21-36A Saint Mark (Donatello), 564 tabernacle (Orcagna), 14-19A Palazzo Pitti: Consequences of War (Rubens), 700 San Lorenzo: tomb of Giuliano de' Medici (Michelangelo Buonarroti), 613 San Marco: Annunciation (Fra Angelico), 576 Sant'Apollonia: Last Supper (Andrea del Castagno), 577 Santa Croce: tomb of Leonardo Bruni (Rossellino), 570

Madonna Enthroned (Giotto), Church

of Ognissanti, Florence, 407

Santa Felicitá: Entombment of Christ (Pontormo), 632

Santa Maria del Carmine Expulsion of Adam and Eve from Eden (Masaccio), 575 Tribute Money (Masaccio), 574 Santa Maria Gloriosa dei Frari: Madonna of the Pesaro Family (Titian), 628 Santa Maria Novella Birth of the Virgin (Ghirlandaio), 579 Holy Trinity (Masaccio), 575 Frankfurt (Germany): Städelsches

Kunstinstitut: Blinding of Samson (Rembrandt), 25-13A

G

Ghent (Belgium): Saint Bavo Cathedral: Ghent Altarpiece (van Eyck and van Eyck), 540, 541 Gloucester (England): Gloucester Cathedral: Tomb of Edward II, 570

н

Haarlem (Netherlands) Frans Halsmuseum Archers of Saint Hadrian (Hals), 704 The Women Regents of the Old Men's Home at Haarlem (Hals), 705 The Hague (Netherlands) Mauritshuis Anatomy Lesson of Dr. Tulp (Rembrandt), 706 View of Delft (Vermeer), 25-18B View of Haarlem from the Dunes at Overveen (Ruisdael), 710 Hartford, Connecticut (U.S.A.): Wadsworth

Athaneum Museum of Art: Saint Serapion (Zurbarán), 689

Indianapolis, Indiana (U.S.A.): Indianapolis Museum of Art: Still Life with a Late Ming Ginger Jar (Kalf), 713

K

Karlsruhe (Germany): Staatliche Kunsthalle: Judgment of Paris (Cranach), 654

L

London (England) British Museum Law and Gospel (Lucas Cranach the Elder), 653 medal showing Bramante's design for Saint Peter's (Caradosso), 619 Witches' Sabbath (Baldung Grien), 649 Kenwood House: Self-Portrait, ca. 1659-1660 (Rembrandt), 708 National Gallery Battle of San Romano (Uccello), 580 Distant View of Dordrecht, with a Milkmaid and Four Cows, and Other Figures (The "Large Dort") (Cuyp), 710

London (England) (continued) National Gallery (continued) Embarkation of the Queen of Sheba (Claude Lorrain), 9 The French Ambassadors (Holbein the Younger), 656 Giovanni Arnolfini and His Wife (van Eyck), 542 Madonna and Child with Saint Anne and the Infant Saint John, cartoon for (Leonardo da Vinci), 602 Man in a Red Turban (van Eyck), 543 Meeting of Bacchus and Ariadne (Titian), 629 Venus, Cupid, Folly, and Time (Bronzino), 634 Royal Collection, Kensington Palace: Self-Portrait as the Allegory of Painting (La Pittura) (Gentileschi), 684 Royal Library, Windsor Castle: The Fetus and Lining of the Uterus (Leonardo da Vinci), 604 Victoria & Albert Museum Melencolia I (Dürer), 651 Water Carrier of Seville (Velázquez), 689 Louvain (Belgium): Saint Peter's: Altarpiece of the Holy Sacrament (Bouts), 547 M Madrid (Spain) Museo del Prado: Deposition (Rogier van der Weyden), 544 Museo Thyssen-Bornemisza: Giovanna Tornabuoni(?) (Ghirlandaio), 580 Prado Allegory of Sight (Brueghel the Elder and Rubens), 25-1A Christ on the Cross (Velázquez), 24-28A Garden of Earthly Delights (Bosch), 644 Garden of Love (Rubens), 25-2A Immaculate Conception of the Escoria (Murillo), 24-2 Landscape with Saint Jerome (Patinir), 662 Martyrdom of Saint Philip (Ribera), 688 Las Meninas (The Maids of Honor) (Velázquez), 691 Still Life with Flowers, Goblet, Dried Fruit, and Pretzels (Peeters), 701 Surrender of Breda (Velázquez), 690 Manchester (England): John Rylands University Library, University of Manchester: Buxheim Saint Christopher, 20-21A Mantua (Italy) Palazzo del Tè: Fall of the Giants from Mount Olympus (Giulio Romano), 22-54A Palazzo Ducale: Camera Picta (Painted Chamber) (Mantegna), 595 Milan (Italy) Pinacoteca di Brera Brera Altarpiece (Enthroned Madonna and Saints Adored by Federico da Montefeltro) (Piero della Francesca), 21-43A Foreshortened Christ (Lamentation over the Dead Christ) (Mantegna), 596 Marriage of the Virgin (Raphael), 605 Santa Maria delle Grazie: Last Supper (Leonardo da Vinci), 602 Genius of Fontainebleau (Cellini), Munich (Germany) Louis XIV (Rigaud), 714 Alte Pinakothek Battle of Issus (Altdorfer), 655 Madonna of the Rocks (Leonardo da Four Apostles (Dürer), 652 Lion Hunt (Rubens), 10 Mona Lisa (Leonardo da Vinci), 603 Self-Portrait (Dürer), 650 Money-Changer and His Wife (Massys), Glyptothek: bust of Augustus wearing the corona civica (sculpture), 7 Pastoral Symphony (Titian), 626

Pescia (Italy): San Francesco: Saint Francis New York, New York (U.S.A.) Frick Collection Philadelphia, Pennsylania (U.S.A.): King Philip IV of Spain (Velázquez), 4-28B Saint Francis in the Desert (Bellini), 22-32A Self-Portrait, 1658 (Rembrandt), 25-15A Metropolitan Museum of Art Battle of Ten Nudes (Pollaiuolo), 582 The Four Horsemen of the Apocalypse (Dürer), 6 A Goldsmith in His Shop (Petrus Christus), 546 king on horseback with attendants, Benin (bronze sculpture), xiii Knight, Death, and the Devil (Dürer), Mérode Altarpiece (Campin, Master of Flémalle), 534 Musicians (Caravaggio), 24-17A Portrait of a Young Man with a Book (Bronzino), 22-46A Tommaso Portinari and Maria Baroncelli (Memling), 20-14A View of Toledo (El Greco), 666 Pierpont Morgan Library: Hundred-Guilder Print (Christ with the Sick around Him, Receiving the Children) (Rembrandt), 709 Whitney Museum of American Art Homage to the Square: "Ascending" (Albers), 8 The Passion of Sacco and Vanzetti (Shahn), 4 Nuremberg (Germany): Germanisches Nationalmuseum: Vanitas Still Life (Claesz), 694 0 Orvieto (Italy): Orvieto Cathedral: The Damned Cast into Hell (Signorelli), 590 р Padua (Italy) Arena Chapel (Cappella Scrovegni) Betrayal of Jesus (Giotto), 14-81 Entry into Jerusalem (Giotto), 400 Lamentation (Giotto), 408 Last Judgment (Giotto), 400 Chiesa degli Eremitani: Saint James Led to Martyrdom (Mantegna), 21-49A Piazza del Santo: Gattamelata (Donatello), 571 Paris (France) Bibliothèque de l'Institut de France: project for a central-plan church (Leonardo da Vinci), 22-6A Bibliothèque Nationale: *Hanging Tree* (Callot), 722 Musée du Louvre Adoration of the Shepherds (La Tour), 723 Arrival of Marie de' Medici at Marseilles (Rubens), 699 Baldassare Castiglione (Raphael), Bound Slave (Rebellious Captive) (Michelangelo Buonarroti), 612 Burial of Phocion (Poussin), 25-324 Charles I Dismounted (Van Dyck), 701 Et in Arcadia Ego (Poussin), 719 Family of Country People, 721 Francis I (Clouet), 657

Vinci), 601

660

Pisa (Italy) baptistery: Annunciation, Nativity, and Adoration of the Shepherds (Nicola Pisano), 403 Camposanto: Triumph of Death (Traini or Buffalmacco), 419 Pistoia (Italy): baptistery: Annunciation, Nativity, and Adoration of Shepherds (Giovanni Pisano), 403 R Reggio Calabria (Italy): Museo Nazionale della Magna Grecia: head of a warrior, sea off Riace (sculpture), 11 Rome (Italy) Casino Rospigliosi: Aurora (Reni), 685 Galleria Borghese Apollo and Daphne (Bernini), 24-6A David (Bernini), 674 Galleria Doria Pamphili: Flight into Egypt (Carracci), 679 Galleria Nazionale d'Arte Antica: Henry VIII (Holbein the Younger), 23-11A Il Gesù: Triumph of the Barberini (Pietro da Cortona), 686 Musei Vaticani Entombment (Caravaggio), 24-18A Pope Sixtus IV Confirming Platina as Librarian (Melozzo da Forlì), 21-41A Palazzo Barberini: Triumph of the Barberini (Pietro da Cortona), 685 Palazzo Farnese: Loves of the Gods (Carracci), 680 Saint Peter's: Pietá (Michelangelo

Altarpiece (Berlinghieri), 404

Philadelphia Museum of Art:

(Claude Lorrain), 721

Landscape with Cattle and Peasants

Buonarroti), 610 San Luigi dei Francesci: Calling of Saint Matthew (Caravaggio), 681 San Pietro in Vincoli: Moses (Michelangelo), 612 Sant'Ignazio: Glorification of Saint Ignatius (Pozzo), 687 Santa Maria del Popolo: Conversion of Saint Paul (Caravaggio), 683

Santa Maria della Vittoria: Ecstacy of Saint Teresa (Bernini), 674 Sistine Chapel, Vatican ceiling (Michelangelo Buonarroti), 598, 614, 615, 22-188 Christ Delivering the Keys of the Kingdom to Saint Peter, 589 Last Judgment (Michelangelo Buonarroti), 598, 616

Villa Farnesina: Galatea (Raphael), 608

Saint Petersburg (Russia): Hermitage Museum: Return of the Prodigal Son (Rembrandt), 707 Siena (Italy) Museo dell'Opera del Duomo Birth of the Virgin, Siena Cathedral (Lorenzetti), 415 Maestá altarpiece (Duccio), Siena Cathedral, 411, 14-10A Palazzo Pubblico Allegory of Good Government (Lorenzetti), 14-16A Effects of Good Government in the City and in the Country (Lorenzetti), 416, 417 Pinacoteca Nazionale: Fall of the Rebel Angels (Beccafumi), 22-42A Siena Cathedral: Feast of Herod (Donatello), 565

Т

Toledo (Spain): Santo Tomé: Burial of Count Orgaz (El Greco), 666

Toledo, Ohio (U.S.A.): Toledo Museum of Art: Flower Still Life (Ruysch), 713 Trastavere (Italy): Santa Cecilia: Last Judgment (Cavallini), 14-7A

U

Uppsala (Sweden): Uppsala University Art Collection: Butcher's Stall (Aertsen), 660 Urbino (Italy): Galleria Nazionale delle Marche: Flagellation (Piero della Francesca), 592 Utrecht (Netherlands): Centraal Museum:

Calling of Saint Matthew (ter Brugghen), 702

v

Venice (Italy) Campo dei Santi Giovanni e Paolo: Bartolommeo Colleoni (Verrocchio), 571 Doge's Palace: Triumph of Venice (Veronese), 637 Galleria dell'Accademia Christ in the House of Levi (Veronese), 636 Pietá (Titian and Palma il Giovane), 631 The Tempest (Giorgione da Castelfranco), 626 Vitruvian Man (Leonardo da Vinci), San Giorgio Maggiore: Last Supper (Tintoretto), 636 San Zaccaria: Madonna and Child with Saints (San Zaccaria Altarpiece) (Bellini), 624 Versailles (France): palace of Versailles: Apollo Attended by the Nymphs (Girardon and Regnaudin), 717 Vienna (Austria) Albertina: Great Piece of Turf (Dürer), Kunsthistorisches Museum Allegory of the Art of Painting (Vermeer), 712 Death and the Maiden (Baldung Grien), 23-3A Hunters in the Snow (Bruegel the Elder), 663 Isabella d'Este (Titian), 630 Madonna in the Meadow (Raphael), 606 Saint Luke Drawing the Virgin Mary (Gossaert), 23-15 Saltcellar of Francis I (Cellini) (stolen), 638 Self-Portrait in a Convex Mirror (Parmigianino), 633 Österreichische Nationalbibliothek: Mary of Burgundy at Prayer (Master of Mary of Burgundy), 20-15L

Washington, D.C. (U.S.A.) Hirshhorn Museum and Sculpture Garden: 1948-C (Still), 2 National Gallery of Art Feast of the Gods (Bellini and Titian), 625 Jack in the Pulpit No. 4 (O'Keeffe), 4 Portrait of a Lady (Rogier van der Weyden), 20-9A Self-Portrait (Leyster), 705 Woman Holding a Balance (Vermeer), 711 National Museum of Women in the Arts: Portrait of a Noblewoman (Fontana), 22-40A Wiltshire (England): Corsham Court: Portrait of the Artist's Sisters and Brother (Anguissola), 635

Windsor (England): Royal Collection, Windsor Castle: Elizabeth I as a Princess (attr. Teerlinc), 661

SUBJECT INDEX

Notes:

• Page numbers in italics indicate illustrations. • Page numbers in italics followed by b indicate bonus images in the text. • Page numbers in italics followed by map indicate maps.

• Figure numbers in blue indicate bonus images.

Numbers

20th century art. See late 20th century European and American art 1948-C (Still), 1, 2

A a secco. See fresco secco Aachen Gospels, 5, 5 Abbey in the Oak Forest (Friedrich), 25-18A Abduction of the Sabine Women (Giovanni da Bologna), 639, 639 Abraham and Isaac, 561-562 Achilles Painter, 6 acoustics, 686 Acropolis, Athens. See Parthenon Adam and Eve in Burgundian/Flemish late medieval/ early Renaissance art, 540, 546 in Italian Cinquecento Renaissance art, 615, 22-18. in Italian Quattrocento Renaissance art, 574, 575 in Northern European High Renaissance/ Mannerist art, 644, 645, 650-651, 653 additive light, 7 additive sculpture, 11 Adoration of the Lamb, 540 Adoration of the Magi, 548, 573 Adoration of the Magi, Santa Trinitá, Florence (Gentile da Fabriano), 572, 573, 581 Adoration of the Shepherds, 403-404, 547, 548, 722-723 Adoration of the Shepherds (La Tour), 722-723, 723 Adoration of the Shepherds, Portinari Altarpiece (Hugo van der Goes), 547, 548 aerial perspective. See atmospheric perspective Aertsen, Pieter: Butcher's Stall, 660-661, 660 African Americans: Harlem Renaissance, 20-40A African art: Benin. See Benin art African sculpture: Benin, xvi, 11, 12 Against the Heavenly Prophets in the Matter of Images and Sacraments (Luther), 652-653 Agrippa of Nettesheim, Heinrich Cornelius, 651 aisles, 12 Albers, Josef: Homage to the Square, 8, 8 Alberti, Leon Battista, 566, 568, 586-587 and Leonardo da Vinci, 22-6A On the Art of Building, 568, 586, 588 Palazzo Rucellai, Florence, 587-588, 587 Sant'Andrea, Mantua, 593-594, 593, 593, 642 West facade, Santa Maria Novella, Florence, 588, 588, 642, 14-6A alchemy, 644, 645 Alexander VI (Pope), 590, 605 Alexander VII (Pope), 670, 672, 24-4A, 24-25A

Alexander Mosaic (Battle of Issus) Anne, Saint, 579 (Philoxenos of Eretria), 654 Alexander the Great: Battle of Issus, 654-655 Allegory of Good Government, Palazzo Pubblico, Siena (Lorenzetti), 416b, 14-16A Allegory of Sight (Brueghel the Elder and Rubens), 697, 697b, 25-1A Allegory of the Art of Painting (Vermeer), 712, 712 altar of the Virgin Mary, church of Saint Mary, Kraków (Stoss), 554, 554 Altarpiece of Saint Peter, Cathedral of Saint Peter, Geneva (Witz), 552–553, 553 Altarpiece of the Holy Sacrament, Saint Peter's, Louvain (Bouts), 546-547, 547 altarpieces in Burgundian/Flemish late medieval/ early Renaissance art, 534, 535, 538, 539, 540-541, 546-548, 20-8A in Holy Roman Empire late medieval/early Renaissance art, 552-553, 554, 555 in Italian 14th century art, 410, 411-412, 413-415 in Italian Cinquecento Renaissance art, 624-625, 627 in Italian late medieval art, 404-405 in Italian Quattrocento Renaissance art, 572, 573, 590, 21-43 in Northern European High Renaissance/ Mannerist art, 647, 648 Altdorfer, Albrecht: Battle of Issus, 654-655, 655 Amedeo, Emanuele Filiberto, 24-9A American art (U.S. art). See American Modernism; late 20th century European and American art American Modernism Harlem Renaissance and, 20-40A O'Keeffe and Shahn, 4 Amiens Cathedral (Robert de Luzarches, Thomas de Cormont, and Renaud de Cormont), 418 Amor. See Eros apses amphitheaters, 401 anamorphic images, 656 anatomy. See human figure Anatomy Lesson of Dr. Tulp (Rembrandt), 706, 706 Andrea del Castagno: Last Supper, Sant'Apollonia, Florence, 576, 577 Andrea del Sarto: Madonna of the Harpies, 606, 606b, 22-8A Andrea di Cione. See Orcagna, Andrea Anguissola, Sofonisba, 630 Portrait of the Artist's Sisters and Brother, 635, 635 animals in Italian Quattrocento Renaissance art, 573

in Northern European High Renaissance/ Mannerist art, 651

Annunciation, Nativity, and Adoration of Shepherds, pulpit, Sant'Andrea, Pistoia (Giovanni Pisano), 403–404, 403

Annunciation, Nativity, and Adoration of the Shepherds, baptistery pulpit, Pisa (Nicola Pisano), 403, 403, 415 Annunciation, San Marco, Florence (Fra

Angelico), 576, 576, 579 Annunciation altarpiece, Siena Cathedral (Martini and Memmi), 413-415, 413

Annunciation to Mary in Burgundian/Flemish late medieval/ early Renaissance art, 534, 535, 538, 539, 540, 20-4A

in Italian 14th century art, 413-415 in Italian late medieval art, 403-404 in Italian Ouattrocento Renaissance art,

576 Annunciation to the Shepherds, 548

Anthony, Saint, 647, 20-8A Antonello da Messina, 624

Aphrodite (Venus) (Greek/Roman deity) in Flemish Baroque art, 25-1A in Italian Cinquecento Renaissance art,

625, 628, 629, 631 in Italian Mannerist art, 634 in Italian Quattrocento Renaissance art,

558, 559, 581 in Northern European High Renaissance/ Mannerist art, 654

Aphrodite of Knidos (Praxiteles), 581, 654 Apollo (Greek/Roman deity): in Baroque art,

- 717, 24-6A Apollo and Daphne (Bernini), 674-675, 674b, 24-6A
- Apollo Belvedere, 24-6A

apostles

in Italian Quattrocento Renaissance art, 585

See also four evangelists

apprenticeship, 414, 545

in Italian 13th century architecture, 14-5A in Italian 14th century architecture, 413

arcades

in Gothic architecture, 20-4A in Italian 13th century architecture, 14-6A in Italian 14th century architecture, 413, 14 - 18A

- in Italian Cinquecento Renaissance architecture, 22-30A
- in Italian Quattrocento Renaissance architecture, 582

in Northern European High Renaissance/ Mannerist architecture, 658

Arcadian art, 625

Arch of Constantine, Rome, 589 Archers of Saint Hadrian (Hals), 704, 704, 706 arches

chancel, 413

14-18B in Italian Cinquecento Renaissance art, 621, 22-30A in Italian late medieval architecture, 402 in Italian Quattrocento Renaissance architecture, 586, 586-587, 594, 21-31A ogee, 420 trefoil, 402, 14-18B See also arcades; pointed arches architectural drawings, 12, 12 architecture Baroque. See Baroque architecture drawings, 12, 12 Gothic. See Gothic architecture High Renaissance/Mannerist, 657-658, 664-665, 23-23A Italian 13th century, 3-4, 402, 14-5A, 14-6A Italian 14th century, 412-413, 415-416, 417-419, 420, 14-12A, 14-18A, 14-18B, 14-19A Italian Cinquecento Renaissance, 605, 618-624, 22-6A, 22-26A, 22-30A Italian Mannerist, 640-642 Italian Quattrocento Renaissance, 582-588, 593-594, 21-31A, 21-32A, 21-37A Architettura civile (Guarini), 24-9A architraves, 640 Arena Chapel (Cappella Scrovegni), Padua (Giotto), 400, 401, 408, 409, 412, 14-8A, 14-8B, 14-10A Arezzo (Italy): San Francesco, 21-24A Ariadne, 628, 629 Aristotle, 560, 606-607, 23-4A armature, 11 Arnolfo di Cambio Florence Cathedral (Santa Maria del Fiore), Florence, 417, 14-18A Palazzo della Signoria (Palazzo Vecchio), Florence, 417, 417b, 14-18B Arrest of Jesus. See Betrayal of Jesus arriccio, 408 Arrival of Marie de' Medici at Marseilles (Rubens), 698-699, 699 Art and Society boxes artist's profession in Flanders, 545 Dutch Baroque art market, 703 family chapel endowments, 584 Italian artists' names, 405 princely courts, 591 Renaissance artistic training, 414 Renaissance women, 630 Velázquez and Philip IV, 690 art as a political tool Baroque era, 673, 685-686, 687, 698 and Counter-Reformation, 616, 637 Italian Cinquecento, 599 Italian Quattrocento, 591 Northern European High Renaissance/ Mannerism, 646

in Italian 13th century architecture, 14-6A

in Italian 14th century architecture, 420,

art history, 1-13 on chronology, 2-3 and definitions of art, 2 and other disciplines, 12-13 on patronage, 6-7 purposes of, 1-2 on style, 3-5 on subjects, 5-6 terminology, 7-12 art market 14th century Italy, 410 Baroque era, 697, 703 and printmaking, 650, 708 See also artist's profession; patronage Artemis (Diana) (Greek/Roman deity), 22-52A artifice, 632, 633, 640 artist's profession, 1 Baroque era, 679, 692, 703 late medieval/early Renaissance Flanders, 545-546 and princely courts, 591 Renaissance training, 414, 545, 573, 630 See also artists, recognition of artists, recognition of 14th century Italy, 411 and attribution, 6 Baroque era, 700, 25-15A Italian Cinquecento Renaissance, 604 late medieval/early Renaissance Northern Europe, 542, 543 Renaissance, 600, 638-639 Artists on Art boxes Cennini, 573 Gentileschi, 684 painting vs. sculpture, 609 Palma il Giovane on Titian, 631 Poussin, 719 Rubens, 700 Assisi (Italy): San Francesco, 405, 405b, 407, 14-5A, 14-5B, 14-7 Assumption of the Virgin (Correggio), Parma Cathedral, 638, 638 Assumption of the Virgin (Titian), 627, 627 Assumption of the Virgin (Triadi), 627, 627 Assumption of the Virgin, Creglingen Altarpiece (Riemenschneider), 554, 555 Athanadoros: Laocoön and his sons (sculpture), 617, 628, 639, 698 Athens (Greece) Kritios Boy (sculpture), 563 Parthenon. See Parthenon atmospheric perspective, 567, 574, 601, 604, 720, 20-1 atrium/atria, 672 attributes (of persons), 5 four evangelists, 5 attribution, 6 Augustinian order, 404 Augustus (Roman emperor), 6, 7, 13 Aurora, Casino Rospigliosi, Rome (Reni), 684-685.685 Autun (France). See Saint-Lazare Aventinus, Johannes, 655 B Bacchus. See Dionysos baldacchino (baldacco), 673 Baldassare Castiglione (Raphael), 608, 608b,

Baldinucci, Filippo, 674, 24-4A baldric, 24-28B Baldung Grien, Hans Death and the Maiden, 649b, 23-3A Witches' Sabbath, 649, 649 Banqueting House, Whitehall, London (Jones), 723-724, 723 baptisteries Italian late medieval, 402-403 Italian Quattrocento Renaissance, 560 - 562See also Baptistery of San Giovanni, Florence Baptistery of San Giovanni, Florence and Brunelleschi, 585 competition, 560-562, 562, 582 doors (Pisano), 418-419, 418, 561 Gates of Paradise (Ghiberti), 566-568, 566, 567 baptistery pulpit, Pisa (Nicola Pisano), 402-403, 402, 403, 415 Baroncelli, Maria, 20-14A

English, 724 French, 714, 715-716, 717-718 Italian, 668, 669, 670-673, 676-678, Birth of the Virgin, Santa Maria Novella, 24-4A, 24-9A, 24-14A Baroque art, 670 English, 723-724, 725 Flemish, 10, 696-701, 696map, 725, 25-1A, 25-2A and Italian Mannerist art, 638, 641 Spanish, 687-692, 693, 24-25A, 24-28A, and Titian, 632 See also Dutch Baroque art; French Baroque art; Italian Baroque art barrel vaults (tunnel vaults) in Italian Baroque architecture, 24-4A in Italian Quattrocento Renaissance architecture, 585, 594 barroco. See Baroque art Bartholomew, Saint, 616 Bartolommeo Colleoni (Verrocchio), 571-572, 571, 23-5A bas-relief sculpture, 12 Basilica Nova, Rome, 594, 619 basilicas Italian 13th century, 14-6A Italian 14th century, 413 Italian Quattrocento Renaissance, 583 Battista Sforza and Federico da Montefeltro (Piero della Francesca), 590, 591, 592 Battle of Heraclius and Chosroes, Legend of the True Cross (Piero della Francesca), 578, 578b, 21-24A Battle of Issus (Alexander Mosaic) (Philoxenos of Eretria), 654 Battle of Issus (Altdorfer), 654-655, 655 Battle of San Romano (Uccello), 580-581, 580 Battle of Ten Nudes (Pollaiuolo), 581-582 battlements, 416 Bautista de Toledo, Juan: El Escorial, Madrid, 664-665, 665 bays, 411 in Italian 14th century architecture, 413, 14-18A Beaune (France): Hôtel-Dieu, 20-8A Beauvais Cathedral, 3-4, 3, 12 Beccafumi, Domenico Fall of the Rebel Angels, 632, 632b, 22-42A Fall of the Rebel Angels (later version), Belleville Breviary (Pucelle), 550 Bellini, Giovanni and Dürer, 649 Feast of the Gods, 625, 625, 626, 628 life of, 624 Madonna and Child with Saints (San Zaccaria Altarpiece), 543, 624–625, 624 Saint Francis in the Desert, 624, 624b, Bellori, Giovanni Pietro, 681, 682 belvedere, 623 Benin art: sculpture, xvi, 11, 12 Bening, Alexander, 551, 20-15A Berlinghieri, Bonaventura: Saint Francis Altarpiece, San Francesco, Pescia, 404-405, 404, 14-5B Bernard de Soissons. See Reims Cathedral Bernini, Gianlorenzo Apollo and Daphne, 674–675, 674b, 24-6A baldacchino, Saint Peter's, 673, 673 Cornaro chapel, Santa Maria della Vittoria, Rome, 674, 675, 675 David, 674-675, 674 Ecstacy of Saint Teresa, 674, 675, 682 Fountain of the Four Rivers, Rome, 668, 669,670 piazza, Saint Peter's, Rome, 672, 672 plan for Louvre, Paris, 715 Scala Regia, Vatican Palace, Rome, 672, 672b. 24-4A Bertoldo di Giovanni, 610 Betraval of Jesus in Italian 14th century art, 400, 401, 412, 14-8B in Italian Cinquecento Renaissance art, 603 Betrayal of Jesus, Arena Chapel, Padua

(Giotto), 400, 401, 14-8E

Betrayal of Jesus, Maestá altarpiece, Siena

Cathedral (Duccio), 412, 412, 14-8B

Baroque architecture

Bible

and Protestant Reformation, 652

See also Christianity; Gospels; Jesus, life of

Florence (Ghirlandaio) (fresco), 579, 579

Birth of the Virgin, Siena Cathedral (Lorenzetti), 415, 415 Birth of Venus (Botticelli), 581, 581, 609 Black Death, 406, 416, 419, 14-19A Blinding of Samson (Rembrandt), 706-707, 707b, 25-13A Boccaccio, Giovanni, 406, 407, 560 Bonaventura, Saint, 14-5B Book of the Courtier (Castiglione), 22-10A books Byzantine, 405 Carolingian, 5 French late medieval/early Renaissance, **550–551,** 20-15A Books of Hours, 550-551, 663, 20-15A Borghese, Scipione, 674-675, 24-6A Borgia, Cesare, 605 Borgo San Sepolcro (Italy): Palazzo Comunale, 578-579, 578 Borluut, Isabel, 540 Borromini, Francesco Chapel of Saint Ivo, Rome, 678, 678, 679 and Guarini, 24-9A San Carlo alle Quattro Fontane, Rome, 676, 676, 677, 718, 24-9/ Sant'Agnese in Agone, Rome, 668 and Wren, 724 Bosch, Hieronymus: Garden of Earthly Delights, 644, 645 bottegas, 569 Botticelli, Sandro Birth of Venus, 581, 581, 609 Primavera, 558, 559, 581 Sistine Chapel, 589 Young Man Holding a Medal of Cosimo de' Medici, 21-29 Bound Slave (Rebellious Captive) (Michelangelo Buonarroti), 612, 613, 614 Bouts, Dirk Justice of Otto III, 546b, 547, 20-11A Last Supper, Altarpiece of the Holy Sacrament, Saint Peter's, Louvain, 546-547, 547 Wrongful Beheading of the Count, 546b, braccia, 582 Bramante, Donato d'Angelo and Giulio Romano, 640 and Leonardo da Vinci, 22-6A and Lescot, 658 plan for Saint Peter's, Rome, 607, 618, 619, 619, 671, 22-6A and Sangallo, 621 and Sansovino, 22-30A Tempietto, Rome, 618-619, 618, 623, 22-6A Brancacci, Felice, 574 Brancacci Chapel, Santa Maria del Carmine, Florence, 574, 574, 575, 584 breakfast pieces, 701 Brera Altarpiece (Enthroned Madonna and Saints Adored by Federico da Montefeltro) (Piero della Francesca), 590, 590b, 21-43A breviaries, 550 Broederlam, Melchior, 539 Retable de Champmol, 538, 539 bronze casting Greek Early/High Classical period, 11 Italian Baroque, 673 Italian Mannerist, 22-52A Italian Quattrocento Renaissance, 560-562,568 Bronzino (Agnolo di Cosimo) Eleanora of Toledo and Giovanni de' Medici, 634-635, 635 Portrait of a Young Man with a Book, 634b. 22-46A Venus, Cupid, Folly, and Time, 634, 634 Bruegel the Elder, Jan: Allegory of Sight, 697, 697b, 25-1A Bruegel the Elder, Pieter Fall of Icarus, 662-663, 663b, 23-22A Hunters in the Snow, 662-663, 663 Netherlandish Proverbs, 662, 663 Bruges (Belgium), 537 Hospitaal Sint Jan, 548-549, 548

Brunelleschi, Filippo and Alberti, 588 Florence Cathedral dome, 582, 582b, 620, Ospedale degli Innocenti (Foundling Hospital), Florence, 410, 582-583, 583, and Palazzo Medici-Riccardi, 585-586 Pazzi Chapel, Santa Croce, Florence, 584, 584, 585, 585, 585, 21-36 and perspective, 566, 567, 575, 582 Sacrifice of Isaac, 561-562, 562 San Lorenzo, Florence, 583b, 594, 613-614, 613, 21-37A Santo Spirito, Florence, 583-584, 583, 583, 586, 594, 21-31A Bruni, Leonardo, 570 Bruno, Saint, 537 bubonic plague (Black Death), 406, 416, 419, bucranium/bucrania, 659 Buffalmacco, Buonamico: Triumph of Death, 419-420, 419 buon fresco, 408, 603 See also fresco painting Buonarroti, Michelangelo. See Michelangelo Buonarroti Burgundian/Flemish late medieval/early Renaissance art, 534, 535, 536-549, 557 Chartreuse de Champmol, 537-538, 20-2A Hugo van der Goes, 547-548 Memling, 548-549, 20-14A Petrus Christus, 546 Rogier van der Weyden, 544-546, 20-8A societal contexts, 536-537 van Eyck, 538, 540-543, 20-4A Burial of Count Orgaz (El Greco), 665-666, 666 Burial of Phocion (Poussin), 720, 720b, 25-32A burials. See funerary customs burin, 556 bust of Augustus wearing the corona civica (sculpture), 6, 7 busts, 12 Butcher's Stall (Aertsen), 660-661, 660 buttressing in Italian Baroque architecture, 678 in Italian Quattrocento Renaissance art, See also flying buttresses Buxheim Saint Christopher, 554, 554b, 20-21A Byzantine art and El Greco, 665 and Italian 13th century art, 404-405, 406 and Italian 14th century art, 409, 411 maniera greca, 404-405, 407, 14-7A, 14-8B C Ca d'Oro (Palazzo Contarini), Venice, 586, 586b, 21-37A caduceus, 559 Calcagni, Tiberio, 617 Caliari, Paolo. See Veronese

Calling of Matthew, 681, 702, 24-17A Calling of Saint Matthew (Caravaggio), 681, 681. 24-17/ Calling of Saint Matthew (ter Brugghen),

702, 702 Callot, Jacques: Hanging Tree, Miseries of

War, 722, 722 Calvin, John, 616, 653-654

Calvinism, 616, 653-654, 702, 703, 704, 705, 713

camera obscura, 711, 25-18B Camera Picta (Painted Chamber), Palazzo Ducale, Mantua (Mantegna), 594-596, 594, 595, 615 Camerino d'Alabastro, Palazzo Ducale,

Ferrara, 625, 628, 629 campaniles, 416, 418 Campidoglio, Rome (Michelangelo

Buonarroti), 620-621, 621b, 22-26A Campin, Robert, 544

See also Master of Flémalle Camposanto, Pisa, 419-420, 419 Canon (Polykleitos). See Doryphoros

canonization, 14-5A canons, 10

of Polykleitos, 588, 700

capitalism, 536

capitals (of columns) in Italian late medieval architecture, 402 See also Composite capitals; Corinthian capitals Cappella della Santissima Sindone (Chapel of the Holy Shroud), Turin (Guarini), 678, 678b, 24-14A Cappella Scrovegni (Arena Chapel), Padua (Giotto), 400, 401, 408, 409, 412, 14-8A, 14-8B, 14-10A capriccio, 604 Caradosso, Cristoforo Foppa: medal showing Bramante's design for Saint Peter's, 619, 619 Caravaggio (Michelangelo Merisi) Calling of Saint Matthew, 681, 681, 24-17A Conversion of Saint Paul, 682-683, 683 Entombment, 682, 682b, 24-18A and La Tour, 722 Musicians, 681, 681b, 24-17A and Rembrandt, 706, 25-13A and Ribera, 688 and Rubens, 697, 698 and ter Brugghen, 702 Christ and van Honthorst, 702 and Velázquez, 689, 692 Carlo Emanuele II (duke of Savoy), 24-9A, 24-14A Carmelite order, 404 Carolingian art: books, 5 Carracci, Agostino, 679 Carracci, Annibale and Claude Lorrain, 720 Flight into Egypt, 679–680, 679 Loves of the Gods, Palazzo Farnese, Rome, 680–681, 680 and Poussin, 25-32A and Reni, 684 and Rubens, 697 Carracci, Ludovico, 679 Carthusian order, 537–538 cartoons (preliminary drawings), 408, 602 - 603carving, 11 Casa de Montejo, Mérida, 664b, 23-23A Casino Rospigliosi, Rome, 684-685, 685 cassone/cassoni, 628, 631 Castiglione, Baldassare, 22-10A casting, 11 See also bronze casting Cathedral of Saint Peter, Geneva, 552-553 cathedrals (duomo), 412, 417 See also specific cathedrals Catherine of Alexandria, Saint, 549, 624 Catullus, 628 Cavallini, Pietro, 407, 14-5B Last Judgment, Santa Cecilia, Trastevere, 407b, 409, 14-7A cella, 618 Cellini, Benvenuto autobiography, 638-639 Genius of Fontainebleau, 639, 639b, 22-52A and Northern European High Renaissance/Mannerist art, 657, 3-14A Saltcellar of Francis I, 638, 639, 22-52A Cenni di Pepo. See Cimabue Cennini, Cennino, 414, 539, 573 central plans in Italian Baroque architecture, 678 in Italian Cinquecento Renaissance architecture, 605, 620, 623, 22-6A in Italian Quattrocento Renaissance architecture, 583, 585, 586 Cerveteri (Italy): Herakles wrestling Antaios (Euphronios) (vase painting), 570 Chambord (France): Château de Chambord, 657-658,657 chancel arches, 413 Chapel of Saint Ivo, Rome (Borromini), 678, 678, 679 Chapel of the Holy Shroud (Cappella della Santissima Sindone), Turin (Guarini), 678, 678b, 24-14A chapter houses, 585 Charlemagne (Holy Roman Emperor), 402 Charles I (king of England), 697, 701, 723 Charles I Dismounted (Van Dyck), 701, 701 Charles II (king of England), 724 Charles V (Holy Roman Emperor), 656, 664 Donatello, 568, 571

Charles the Bold (duke of Burgundy), 555 Chartres Cathedral: South transept sculpture, 564 chartreuse, 537 Chartreuse de Champmol, Dijon (Drouet de Dammartin), 537-538, 537, 20-2A chasing, 673 Château de Chambord, 657-658, 657 châteaux, 657 cherubs, 552 Chevalier, Étienne, 552 chiaroscuro in Italian 14th century art, 409 in Italian Baroque art, 681, 682 in Italian Cinquecento Renaissance art, 601, 604, 606, 22-8A in Italian Mannerist art, 637 chiaroscuro woodcuts, 649 Chiesa degli Eremitani, Padua, 596b, 21-49A Chigi, Agostino, 608-609 chivalry, 414 choir, 12 Chosroes II (Sasanian king), 21-24A in Dutch Baroque art, 709 See also Jesus, life of; Passion of Christ; Pietás; Resurrection of Christ Christ Delivering the Keys of the Kingdom to Saint Peter, Sistine Chapel (Perugino), 589-590, 589, 22-18B Christ in the House of Levi (Veronese), 636, 637 Christ on the Cross (Velázquez), 689, 689b, 24-28A Christ with the Sick around Him, Receiving the Children (Hundred-Guilder Print) (Rembrandt), 709, 709 Christianity Counter-Reformation, 616, 617, 637, 641, 646, 670, 672, 675, 686, 24-18A Great Schism, 404, 536, 21-41A Purgatory, 584 on salvation, 653 See also Byzantine art; Early Christian art; four evangelists; medieval art; Protestant Reformation; Renaissance Christopher, Saint, 20-21A chronology, 2-3 Church of Jesus (Il Gesù), Rome (della Porta and Vignola), 641-642, 642, 671, 686, 686 Church of Ognissanti, Florence, 407-408, 407, 1 Church of the Invalides (Église du Dôme), Paris (Hardouin-Mansart), 718, 718 Cicero, 407 Cimabue, 410, 14-5B and Giotto, 407 Madonna Enthroned with Angels and Prophets, Santa Trinitá, Florence, 406, 406 Cinquecento, 599 See also Italian Cinquecento Renaissance art; Italian Mannerism circles of confusion, 711 cire perdue. See lost-wax process city planning. See urban planning city-states, 406 Claesz, Pieter and Peeters, 701 Vanitas Still Life, 694, 695, 713 Claesz van Ruijven, Pieter, 25-18B classical art, 402 See also classical influences on later art; Greek art; Roman art classical influences on Italian Cinquecento Renaissance art architecture, 618, 623, 22-30A Bellini, 625 Giorgione, 626 Leonardo da Vinci, 602-603 Michelangelo Buonarroti, 611, 615 Raphael, 606-607, 608-609 Titian, 628 classical influences on Italian Quattrocento Renaissance art architecture, 584, 586, 587-588, 594, 21-31A Botticelli, 558, 559, 581 The Company of Captain Frans Banning Cocq

Ghiberti, 562 Ghirlandaio, 580 humanism and, 560 Mantegna, 21-49A Nanni, 563 Piero della Francesca, 592, 21-24A Pollaiuolo, 569, 570 classical influences on later art Burgundian/Flemish late medieval/early Renaissance art, 543 Flemish Baroque art, 698 French Baroque art, 717, 718, 720 Italian 14th century art, 402, 409, 415 Italian Baroque art, 680-681, 684-685, 24-6A Italian Cinquecento Renaissance art. See classical influences on Italian Cinquecento Renaissance art Italian late medieval art, 401, 402, 403 Italian Quattrocento Renaissance art. See classical influences on Italian Quattrocento Renaissance art Northern European High Renaissance/ Mannerist art, 651, 654, 23-14A, 23-15A, 23-2 See also humanism classical orders. See Doric order; Ionic order Claude Lorrain (Claude Gellée) Embarkation of the Queen of Sheba, 8, 9 Landscape with Cattle and Peasants, 720-721, 721 Clement V (Pope), 404 Clement VII (Antipope), 404 Clement VII (Pope), 614, 633 clerestories in Gothic architecture, 20-4A in Italian late medieval architecture, 413, 14-6A cloisters, 576 Clouet, Jean: Francis I, 657, 657 cluster piers. See compound piers Cocq, Frans Banning, 706 Colbert, Jean-Baptiste, 714, 715 Colegio de San Gregorio, Vallodolid, 664-665, 664 collage, 8 Colleoni, Bartolommeo, 571-572 Cologne Cathedral (Gerhard of Cologne), 418 colonialism: in the Americas, 664, 23-23A colonnades in Italian Baroque architecture, 672 in Italian Quattrocento Renaissance architecture, 586 See also columns color, 7-8 in Burgundian/Flemish late medieval/ early Renaissance art, 540 in Dutch Baroque art, 702, 711 in Holy Roman Empire late medieval/ early Renaissance art, 20-18A in Italian 14th century architecture, 14-12A in Italian 14th century art, 409, 412, 14-8B in Italian Cinquecento Renaissance art, 625, 627, 628, 631 in Italian Mannerist art, 633, 636, 22-46A in Italian Quattrocento Renaissance art, 583, 585, 21-31A, 21-36A, 21-43A in Northern European High Renaissance/ Mannerist art, 647 in Op Art, 8 theory of, 7 colorito, 625 colossal order (giant order), 594, 620 Colosseum, Rome, 587-588, 22-30A Columbus, Christopher, 664 columns, 10 capitals. See capitals (of columns) engaged. See engaged columns in Italian Baroque architecture, 671, 672, 673, 676 in Italian Cinquecento Renaissance architecture, 618, 22-30A in Italian late medieval architecture, 402 in Italian Mannerist architecture, 640, 642 in Spanish High Renaissance/Mannerist architecture, 23-23A Tuscan, 587, 618, 640, 22-30A

(Night Watch) (Rembrandt), 706, 707

in Flemish Baroque art, 697, 699, 701 in French Baroque art, 715, 717 in Holy Roman Empire late medieval/ early Renaissance art, 554, 20-18A in Italian 13th century art, 403-404, 406 in Italian 14th century art, 409, 411, 14-8A, 14-8B, 14-16A in Italian Baroque art, 682, 24-18A in Italian Cinquecento Renaissance art, 601-602, 603, 606, 607, 609, 614, 615, 617-618, 628, 632, 20-8A in Italian late medieval art, 401 in Italian Mannerist art, 632, 633, 637, 639, 22-42A, 22-54/ in Italian Quattrocento Renaissance art, 563, 565, 574, 577, 578-579, 579, 581, 589-590, 593 in Northern European High Renaissance/ Mannerist art, 663 in Spanish Baroque art, 692 compound piers, 14-12A condottieri, 560, 571-572, 590, 593 confraternities, 404, 409, 14-19A connoisseurs, 6 conquistadores, 664 Consequences of War (Rubens), 699-700, 700 Constantine (Roman emperor), 589-590 Constantinople (Istanbul) (Turkey): fall of (1453), 622 Contarini, Marino, 586, 21-37A continuous narration, 20-11A contour lines, 7 contrapposto in Italian Cinquecento Renaissance art, 613, 22-8/ in Italian Quattrocento Renaissance art, 564, 568, 21-12A in Northern European High Renaissance/ Mannerist art, 651, 659 in Spanish Baroque art, 24-28A Conversion of Saint Paul (Caravaggio), 682-683, 683 corbels, 416, 640, 640-641 Córdoba (Spain): Great Mosque, 24-14A Corinthian capitals and Composite capitals, 587 in Italian late medieval architecture, 402 in Italian Quattrocento Renaissance architecture, 582 Cornaro, Federico, 675 Cornaro chapel, Santa Maria della Vittoria, Rome (Bernini), 674, 675, 675 cornices, 586, 587, 658, 676, 678 corona civica, 7 Coronation of the Virgin, 20-4A Correggio (Antonio Allegri): Assumption of the Virgin, 638, 638 Cortés, Hernán, 664 Cortese, Paolo, 590 Cosimo, Angolo di. See Bronzino Council of Trent (1545-1563), 616, 617, 670 Counter-Reformation, 616, 617, 637, 641, 646, 670, 672, 675, 686, 24-18A covenants, 561 Coypel, Antoine: Royal Chapel, palace of Versailles, 717-718, 717 Cranach, Lucas the Elder Judgment of Paris, 654, 654 Law and Gospel, 653, 653 Creation of Adam, Sistine Chapel ceiling (Michelangelo Buonarroti), 598, 615, 615, 681 Creglingen Altarpiece (Riemenschneider), 554, 555 the Cross, 5 cross vaults. See groin vaults cross-hatching, 555 crossing, 14-18A crossing squares, 583

complementary colors, 7

compose. See composition

20-8A, 20-9A

25-13A, 25-18B

in El Greco's art, 665

Composite capitals, 587, 21-36A

in Burgundian/Flemish late medieval/

early Renaissance art, 544, 548,

in Dutch Baroque art, 702, 704, 706, 713,

compline, 550

composition, 7

Crucifixion in Burgundian/Flemish late medieval/ early Renaissance art, 544, 20-4A in Northern European High Renaissance/ Mannerist art, 647, 648 in Spanish Baroque art, 24-28A Crucifixion, Isenheim Altarpiece (Grünewald), 647, 648 cruciform shape, 583 Cupid. See Eros cupolas, 638 cutaways (views), 12, 605 Cuyp, Aelbert: Distant View of Dordrecht, with a Milkmaid and Four Cows, and Other Figures (The "Large Dort"), 710,

710

D d'Este, Alfonso (duke of Ferrara), 625, 628 d'Este, Isabella, 630, 631 da Vinci, Leonardo. See Leonardo da Vinci Daddi, Bernardo: Madonna and Child Enthroned with Saints, Or San Michele, Florence, 419, 419b, 14-19A The Damned Cast into Hell, Orvieto Cathedral (Signorelli), 590, 590, 616 Dante Alighieri, 406, 412, 560 dating (of art). See chronology David (Bernini), 674-675, 674 David (Donatello), Medici palace, Florence, 568, 568, 611, 674, 675 David (Donatello), town hall, Florence, 568 David (Michelangelo Buonarroti), 611, 611, 674,675 David (Verrocchio), 569, 569, 611, 674, 675 De imitatione statuarum (Rubens), 698 De occulta philosophia (Agrippa of Nettesheim), 651 De vita triplici (Ficino), 651 death in Baroque art, 688, 695, 718, 25-18A in Burgundian/Flemish late medieval/ early Renaissance art, 20-8A in Italian 14th century art, 419-420 in Northern European High Renaissance/ Mannerist art, 656, 23-3A, 23-5A See also Black Death; funerary customs Death and Assumption of the Virgin, altar of the Virgin Mary, church of Saint Mary, Kraków (Stoss), 554, 554 Death and the Maiden (Baldung Grien), 649b, 23-3A Decameron (Boccaccio), 406 deities. See religion and mythology Del Monte, Francesco Maria Bourbon, 681, 24-17A Delivery of the Keys to Peter, 567, 589-590, della Porta, Giacomo: Il Gesù (Church of Jesus), Rome, 641-642, 642, 671, 686, 686 della Robbia, Andrea: roundels, Ospedale degli Innocenti (Foundling Hospital), Florence, 583, 585, 21-36A della Robbia, Giovanni, 585 della Robbia, Girolamo, 585 della Robbia, Luca: Madonna and Child, Or San Michele, 585, 585b, 21-36A della Rovere, Marco Vigerio, 614 Deposition (of the body of Jesus from the Cross), 544-545, 617-618 Deposition (Rogier van der Weyden), 544-545, 544 Descartes, René, 718 di sotto in sù, 595, 637 Diana. See Artemis Dijon (France): Chartreuse de Champmol (Drouet de Dammartin), 537-538, 537, 20-2A Diogenes, 607 Dionysos (Bacchus) (Greek/Roman deity): in Italian Cinquecento Renaissance art, 625, 628, 629 Diptych of Martin van Nieuwenhove (Memling), 549, 549 diptychs, 540 disegno, 604, 625 See also drawings Diskobolos (Discus Thrower) (Myron), 617-618,674 Claesz, 694, 695

and Four Cows, and Other Figures (The "Large Dort") (Cuyp), 710, 710 Divine Comedy (Dante), 406, 560 divine right, 714 documentary evidence, 2 Doge's Palace, Venice, 420, 420, 637, 22-30A Domenico Veneziano, 405 domes in Baroque architecture, 672, 678, 718, 724, 24-14A in Italian 14th century architecture, 14-18A in Italian Cinquecento Renaissance architecture, 619, 620 in Italian Mannerist architecture, 642 in Italian Quattrocento Renaissance architecture, 21-31A in Northern European High Renaissance/ Mannerist architecture, 23-14A Dominic de Guzman (Saint Dominic), 404 Dominican order, 404, 420, 576, 14-6A Donatello (Donato de Niccolo Bardi) David, Medici palace, Florence, 568, 568, 611, 674, 675 David, town hall, Florence, 568 Feast of Herod, Siena Cathedral, 565, 565 Gattamelata, 571, 571, 572, 23-5A and Lippi, 577 Penitent Mary Magdalene, 568, 568b, 21-12A, 21-24A Saint George, Or San Michele, 564-565, 564 Saint George and the Dragon, Or San Michele, 565, 565 Saint Mark, Or San Michele, 563-564, 564 donor portraits in Burgundian/Flemish late medieval/ early Renaissance art, 535, 537, 540, 541, 542, 547-548, 549, 20-4A, 20-8A in French late medieval/early Renaissance art, 552 in Italian Cinquecento Renaissance art, 628 in Italian Quattrocento Renaissance art, 575, 579 See also patronage Doric order in Italian Mannerist architecture, 640 and Tuscan order, 587 Doryphoros (Spear Bearer) (Polykleitos), 563 dragons: in Italian Quattrocento Renaissance art, 565 drama: mystery plays, 409, 538, 548 drapery in Burgundian/Flemish late medieval/ early Renaissance art, 538 in Holy Roman Empire late medieval/ early Renaissance art, 554, 20-21A in Italian 13th century art, 403, 404, 406 in Italian 14th century art, 408, 411, 412 in Italian Quattrocento Renaissance art, 564, 577 drawings Italian Cinquecento Renaissance, 602-603, 604, 605, 22-3A Northern European High Renaissance/ Mannerist, 649-650 dressed masonry, 586, 22-30A Drouet de Dammartin: Chartreuse de Champmol, Dijon, 537-538, 537, 20-2A Drunken Silenus (Rubens), 25-1A drypoint, 556 Duccio di Buoninsegna, 410 Maestá altarpiece, Siena Cathedral, 410, 411-412, 411, 412b, 412, 578, 14-8B, 14-10A duomo. See cathedrals Dürer, Albrecht, 649-652, 23-3A Fall of Man (Adam and Eve), 650-651, 650, 659, 23-3A financial success of, 646, 650 Four Apostles, 652, 652 The Four Horsemen of the Apocalypse, 6, 6,7 Great Piece of Turf, 650, 650b, 23-4A Knight, Death, and the Devil, 651b, 23-5A and Lochner, 20-18A Melencolia I, 651, 651 Self-Portrait, 649-650, 650, 23-11A Dutch Baroque art, 696map, 702-713, 725

Distant View of Dordrecht, with a Milkmaid

Cuyp, 710 Hals, 704-705 Kalf, 713 Leyster, 705 Rembrandt, 706-709, 25-13A, 25-15A Ruisdael, Jacob van, 710, 25-18A Ruysch, 713 societal contexts, 695, 696-697, 702, 709 Steen, 712-713 ter Brugghen, 702 timeline, 696 van Honthorst, 702, 703 Vermeer, 711-712, 25-18B, 25-20A Dutch High Renaissance/Mannerist art, 658-663,667 E Early Christian art: and Italian late medieval art, 14-7A écorché, 582 Ecstacy of Saint Teresa (Bernini), 674, 675, 682 edition, 556 Edo period Japanese painting, 8-9 Effects of Good Government in the City and in the Country, Palazzo Pubblico, Siena (Lorenzetti), 416, 416, 417 egg tempera. See tempera Église du Dôme (Church of the Invalides), Paris (Hardouin-Mansart), 718, 718 Egyptian sculpture: Predynastic, 10 El Greco (Doménikos Theotokópoulos) Burial of Count Orgaz, 665-666, 666 View of Toledo, 666, 666 Eleanora of Toledo and Giovanni de' Medici (Bronzino), 634-635, 635 Elevation of the Cross (Rubens), 697-698, 698 elevations (architectural), 12, 413 See also arcades; clerestories; naves; triforium Eligius, Saint, 546 Elizabeth I (queen of England), 661-662 Elizabeth I as a Princess (attr. Teerlinc), 661-662, 661 Embarkation of the Queen of Sheba (Claude Lorrain), 8, 9 emotionalism in Baroque art, 675, 697-698, 706, 708, in Burgundian/Flemish late medieval/ early Renaissance art, 544-545, 20-8A in El Greco's art, 666 in Holy Roman Empire late medieval/ early Renaissance art, 554 in Italian 13th century art, 404 in Italian 14th century art, 409, 412, 419 in Italian Cinquecento Renaissance art, 601, 602, 603, 607, 610, 611, 613 in Italian Quattrocento Renaissance art, 561-562, 575, 590, 596, 21-12A emulation, 573 engaged columns: in Italian Quattrocento Renaissance architecture, 588 English art: Baroque, 723-724, 725 engraving Holy Roman Empire late medieval/early Renaissance, 555, 556

Italian Quattrocento Renaissance, 581-582 Northern European High Renaissance/ Mannerist, 650, 651, 23-5A

entablature, 22-30A Enthroned Madonna and Saints Adored by Federico da Montefeltro (Brera Altarpiece) (Piero della Francesca), 590, 590b, 21-43A

Entombment (Caravaggio), 682, 682b, 24-18A Entombment (of the body of Jesus), 632-633, 22-42A, 24-18A

See also Lamentation

Entombment of Christ (Pontormo), 632-633, 632, 22-42A

Entry into Jerusalem, 400, 401, 412, 14-8A, 14-10A

Entry Into Jerusalem, Arena Chapel, Padua (Giotto), 400, 401, 412, 14-8A, 14-10A

Entry into Jerusalem, Maestá altarpiece, Siena Cathedral (Duccio), 412, 412b, 14-10A equestrian statue of Marcus Aurelius, Rome,

571, 22-26A Equicola, Mario, 625

Erasmus, Desiderius, 647, 649, 651

Eros (Amor, Cupid) (Greek/Roman deity) in Italian Baroque art, 24-17A in Italian Mannerist art, 634 in Italian Quattrocento Renaissance art, 558, 559, 609 See also putti eroticism in Italian Baroque art, 24-17A in Italian Mannerist art, 634 in Northern European High Renaissance/ Mannerist art, 645 El Escorial (Herrera and Baustista de Toledo), Madrid, 664-665, 665 escutcheons, 628 Et in Arcadia Ego (Poussin), 718, 719, 719 etching, 556, 708-709, 722, 23-5A Étienne Chevalier and Saint Stephen, Melun Diptych (Fouquet), 552, 552 Eucharist (Mass) in Burgundian/Flemish late medieval/ early Renaissance art, 538, 547 in Italian Baroque art, 24-18A in Italian Cinquecento Renaissance art, 603 Euclid, 607 Euphronios: Herakles wrestling Antaios, Cerveteri (vase painting), 570 European interwar Modernism. See Surrealism European prewar Modernism: German Expressionism and El Greco, 666 Euthymides, 582 evangelists. See four evangelists Eve. See Adam and Eve Expressionism, German: and El Greco, 666 Expulsion of Adam and Eve from Eden, Santa Maria del Carmine, Florence (Masaccio), 574, 575, 22-18A F

facades

in Italian 14th century architecture, 412 in Italian Quattrocento Renaissance architecture, 594 face. See human face Fall of Icarus (Bruegel the Elder), 662-663, 663b, 23-22A Fall of Man (Adam and Eve) (Dürer), 650-651, 650, 659, 23-3A Fall of Man, Sistine Chapel ceiling (Michelangelo Buonarroti), 598, 615, 615b, 22-18A Fall of the Giants from Mount Olympus, Palazzo del Tè, Mantua (Giulio Romano), 640b, 22-54A Fall of the Rebel Angels (Beccafumi), 632, 632b, 22-42A Fall of the Rebel Angels (later version) (Beccafumi), 22-42A family chapels, 574, 575, 584, 585 Family of Country People (Le Nain), 721-722, 721 fantasia, 604 Farnese, Odoardo, 680 Fasti (Ovid), 625 Feast of Herod, Siena Cathedral (Donatello), 565, 565 Feast of Saint Nicholas (Steen), 712-713, 712 Feast of the Gods (Bellini and Titian), 625, 625, 626, 628 Federal Arts Project (U.S.A.), 20-40A Federico da Montefeltro, 590, 592, 605, 21-43A fenestra coeli, 688 Ferdinand II (king of Aragon), 618 Ferrara (Italy): Camerino d'Alabastro, Palazzo Ducale, 625, 628, 629 The Fetus and Lining of the Uterus (Leonardo da Vinci), 604, 605 feudalism, 536 fiber arts. See textiles Ficino, Marsilio, 581, 651 Finding and Proving of the True Cross, Legend of the True Cross, Cappella Maggiore (Piero della Francesca), 578, 578b, 21-24A finials, 541 Fiorentino, Rosso, 657 fire and architecture, 724 Flagellation (Piero della Francesca), 592-593, 592, 21-24A Flagellation of Jesus, 592-593, 21-24A Flavian Amphitheater. See Colosseum, Rome Flemish Baroque art, 10, 696-701, 696map, 725, 25-1A, 25-2A Flemish late medieval/early Renaissance art. See Burgundian/Flemish late medieval/ early Renaissance art fleurs-de-lis, 698 Flight into Egypt, 538, 539, 548, 661, 679-680 Flight into Egypt (Carracci), 679-680, 679 Florence (Italy) 14th century art, 417-419, 14-18A, 14-18B, 14-19A Church of Ognissanti, 407-408, 407, 14-19A Or San Michele, 419, 419b, 562-565, 563, 564, 565, 14-19A, 21-36A Ospedale degli Innocenti (Foundling Hospital) (Brunelleschi), 410, 582-583, 583, 21-36A Palazzo della Signoria (Palazzo Vecchio) (Arnolfo di Cambio), 417, 417b, 14-18B, 21-37A Palazzo di Parte Guelfa, 585 Palazzo Medici-Riccardi (Michelozzo di Bartolommeo), 585-586, 586, 587, 621, 21-37A Palazzo Rucellai (Alberti and Rossellino), 587-588, 587 San Lorenzo, 583b, 594, 613–614, 613, San Marco, 576, 576 San Miniato al Monte, 588 Sant'Apollonia, 576, 577 Sant'Egidio, 548 Santa Maria del Carmine, 574, 574, 575, 584 Santa Maria Gloriosa dei Frari, 627, 627, 628, 628 Santa Trinitá, 406, 406, 572, 573 Santo Spirito (Brunelleschi), 583-584, 583, 583, 586, 594, 21-31A See also Baptistery of San Giovanni; Florence Cathedral; Florentine 14th century art; Florentine Quattrocento Renaissance painting; Florentine Quattrocento Renaissance sculpture; Santa Croce; Santa Maria Novella Florence Cathedral (Santa Maria del Fiore) (Arnolfo di Cambio), Florence, 410, 417-418, 560, 584 campanile (Giotto di Bondone), 417, 418 dome (Brunelleschi), 582, 582b, 620, 21-31A Florentine 14th century art, 417-419, 14-18A, 14-18B, 14-19A Florentine Quattrocento Renaissance painting, 572-581 Andrea del Castagno, 576, 577 Botticelli, 558, 559, 581, 21-29A Fra Angelico, 576 Gentile da Fabriano, 572, 573 Ghirlandaio, 579-580 Lippi, 577-578 Masaccio, 573-576 Piero della Francesca, 578-579, 21-24A Uccello, 580-581 Florentine Quattrocento Renaissance sculpture, 560-572 Baptistery of San Giovanni competition, 560-562, 582 David (Verrocchio), 569 David, Medici palace, Florence (Donatello), 568, 611, 674, 675 della Robbia, 585, 21-36A equestrian statues, 571-572 Gates of Paradise (Ghiberti), 566-568 Or San Michele, 562-565, 563, 564, 565, 21-36A Penitent Mary Magdalene (Donatello), 568, 21-12A, 21-24A perspective in, 566-568 Pollaiuolo, 569-570 tomb of Leonardo Bruni (Rossellino), 570-571 florins, 417 Flower Still Life (Ruysch), 713, 713 flying buttresses, 12 in Gothic architecture, 20-4A fons vitae, 538 Fontana, Lavinia, 630 funerary customs: Italian Quattrocento Portrait of a Noblewoman, 630b, 22-40A Fontana, Prospero, 630, 22-40A

Foreshortened Christ (Lamentation over the Dead Christ) (Mantegna), 596, 596, Gabriel, Archangel 21-49A foreshortening, 10 in Baroque art, 10, 697, 706 Galatea, Villa Farnesina, Rome (Raphael), in Italian 14th century art, 401, 409, 14-8B Galerie des Glaces, palace of Versailles in Italian Cinquecento Renaissance art, 22-18A in Italian Quattrocento Renaissance art, galleries, machicolated, 416 578, 581, 582, 595, 596 Garden of Earthly Delights (Bosch), 644, 645 form, 7 formal analysis, 7 Fountain of the Four Rivers, Rome (Bernini), 668, 669, 670 Fountain of the Innocents, Paris, 658, 658b, 23-14A Fountain of the Innocents, Paris (Goujon), 658, 658b, 23-14A Fouquet, Jean: Melun Diptych, 552, 552 Four Apostles (Dürer), 652, 652 Four Books of Architecture (I quatro libri dell'architettura) (Palladio), 622 Four Crowned Saints, Or San Michele (Nanni di Banco), 563, 563 four evangelists attributes of, 5 in Italian Quattrocento Renaissance art, 585 The Four Horsemen of the Apocalypse (Dürer), 6, 6, 7 Fourment, Hélène, 25-2A Fra Angelico, 405 Annunciation, San Marco, Florence, 576, 576. 579 Fraga Philip (King Philip IV of Spain) (Velázquez), 689, 689b, 24-28B frames, 543 Francis I (Clouet), 657, 657 Francis I (king of France), 605, 639, 656-657, Francis of Assisi, Saint, 404-405, 624, 628, 14-5A, 14-5B, 22-32/ Franciscan order, 404, 405, 14-6A Francisco de Hollanda, 545 Frederick II (Holy Roman Emperor), 402 freestanding sculpture. See sculpture in the round The French Ambassadors (Holbein the Younger), 656, 656 French Baroque art, 714-723, 725 Callot, 722 Claude Lorrain, 8, 9, 720-721 La Tour, 722-723 Le Nain, 721-722 palace of Versailles, 715–718 portraiture, 714-715 Poussin, 718-720, 25-32A societal contexts, 714, 722 French Gothic art architecture, 2-3, 12 and Italian 14th century art, 407, 411, 419, 14-12/ French High Renaissance/Mannerist art, 656-658, 667, 23-14 French late medieval/early Renaissance art, 550-552, 557, 20-1 French Royal Academy of Painting and Sculpture. See Royal Academy of Painting and Sculpture French/Spanish Romanesque sculpture: Gislebertus, 5, 11, 12, 590 fresco painting Italian 13th century, 14-5A, 14-5B Italian 14th century, 400, 401, 408, 409, 416-417, 419-420, 14-8A, 14-8B Italian Baroque, 680-681, 684-687 Italian Cinquecento Renaissance, 598, 607, 608-609, 614-616, 22-18A, 22-18B Italian Mannerist, 638, 22-54A Italian Quattrocento Renaissance, 574-576, 578-579, 589-590, 594-596, 21-24A, 21-41A, 21-49A See also fresco secco; mural painting fresco secco, 408, 603 Friedrich, Caspar David: Abbey in the Oak Forest, 25-18A

Renaissance, 570

Garden of Love (Rubens), 698, 698b, 25-2A Gates of Paradise, Baptistery of San Giovanni, Florence (Ghiberti), 566-568, 566, 567 Gattamelata (Donatello), 571, 571, 572, 23-5A Gaucher de Reims. See Reims Cathedral Gaulli, Giovanni Battista: Triumph of the Name of Jesus, Il Gesù, Rome, 686, 686 Gellée, Claude. See Claude Lorrain Geneva (Switzerland): Cathedral of Saint Peter, 552-553 genius, 22-52A Genius of Fontainebleau (Cellini), 639, 639b, genre subjects, 5, 551, 660, 660-661, 689, 702, 705, 23-22A Gentile da Fabriano Adoration of the Magi, Santa Trinitá, Florence, 572, 573, 581 and Bellini, 624 Gentileschi, Artemisia Judith Slaying Holofernes, 683, 683, 25-13A letters of, 684 La Pittura (Self-Portrait as the Allegory of Painting), 683-684, 684 Gentileschi, Orazio, 683 German art. See German Expressionism; Holy Roman Empire . . . art; Northern European . . . art German Expressionism: and El Greco, 666 gesso, 545 Ghent (Belgium): Saint Bavo Cathedral, 540-541, 540, 541 Ghent Altarpiece (van Eyck and van Eyck), 538, 540-541, 540, 541, 543, 20-8A Ghiberti, Lorenzo Gates of Paradise, Baptistery of San Giovanni, Florence, 566-568, 566, 567 and Lippi, 577 Sacrifice of Isaac, 561, 562, 562 Ghirlandaio, Domenico Birth of the Virgin, Santa Maria Novella, Florence (fresco), 579, 579 Giovanna Tornabuoni(?), 579-580, 580 and Hugo van der Goes, 548 and Michelangelo Buonarroti, 610 Sistine Chapel, 589 Giacomo della Porta: dome, Saint Peter's, Rome, 620, 620 Giambologna. See Giovanni da Bologna giant order. See colossal order gigantomachy, 22-54A Giorgione da Castelfranco, 405, 625 The Tempest, 626-627, 626, 666 giornata/giornate, 408 Giotto di Bondone, 407-409, 14-7A Arena Chapel, Padua, 400, 401, 408, 409, 412, 14-8A, 14-8B, 14-10A campanile, Santa Maria del Fiore (Florence Cathedral), Florence, 417, 418 Madonna Enthroned, Church of Ognissanti, Florence, 407-408, 407, 578, 14-19A and Masaccio, 573, 574 and Michelangelo Buonarroti, 610 and Andrea Pisano, 419 and Saint Francis Master, 14-5B Giovanna Tornabuoni(?) (Ghirlandaio), 579-580, 580 Giovanni Arnolfini and His Wife (van Eyck), 541-542, 542, 692, 20-14 Giovanni da Bologna (Jean de Boulogne): Abduction of the Sabine Women, 639, 639 Girardon, François: Apollo Attended by the Nymphs, palace of Versailles, 717, 717, 24-6A Gislebertus: Last Judgment, Saint-Lazare, 5, 11, 12, 590

G

(Hardouin-Mansart and Le Brun), 716,

in Italian 14th century art, 414

See also Annunciation to Mary

608-609, 608

716

Giulio Romano, 405 Fall of the Giants from Mount Olympus, 640b, 22-54A Palazzo del Tè, Mantua, 640, 640, 22-54A glazed terracotta roundels, 583 glazes (in painting), 539 Glorification of Saint Ignatius (Pozzo), Sant'Ignazio, Rome, 686, 687 Gloucester Cathedral, 570 gods/goddesses. See religion and mythology gold leaf, 405, 412 Golden Legend (Jacobus de Voragine), 605, 21-12A, 21-24A A Goldsmith in His Shop (Petrus Christus), 546, 546 Gonzaga, Federigo (duke of Mantua), 640, Gonzaga, Francesco (marquis of Mantua), 630, 631 Gonzaga, Ludovico, 593–595 Gospels Aachen Gospels, 5, 5 See also four evangelists Gossaert, Jan Neptune and Amphitrite, 659, 659 Saint Luke Drawing the Virgin Mary, 659b, 23-15A Gothic architecture cathedrals, 20-4A French, 2-3, 12 Gothic art and Burgundian/Flemish late medieval/ early Renaissance art, 20-4A French. See French Gothic art and Holy Roman Empire late medieval/ early Renaissance art, 554 and Italian Quattrocento Renaissance art, 573, 586, 21-31A, 21-37A Goujon, Jean relief sculptures, Fountain of the Innocents, Paris, 658, 658b, 23-14A relief sculptures, Louvre, Paris, 658 graphic arts. See printmaking Great Iconoclasm (1566), 654 Great Mosque, Córdoba, 24-14A Great Piece of Turf (Dürer), 650, 650b, 23-4A Great Schism, 404, 536, 21-41A Greco-Roman influences. See classical influences on later art Greek art Archaic period, 570 Early/High Classical period, 11 Late Classical period, 654 See also classical influences on later art Greek cross, 620, 676 Greek religion and mythology. See classical influences on later art; specific Greek/ Roman deities Greek sculpture: Early/High Classical period, 11 Gregory IX (Pope), 14-5A grisaille, 409, 614, 20-8A groin vaults (cross vaults): in Italian 14th century architecture, 14-12A Grotto of Thetis, palace of Versailles, 717, 24-6A Grünewald, Matthias: Isenheim Altarpiece, 647, 648 Guarini, Guarino Architettura civile, 24-9A Cappella della Santissima Sindone (Chapel of the Holy Shroud), Turin, 678, 678b, 24-14A Palazzo Carignano, Turin, 676, 676b, 24-9A Santa Maria Divina Providencia, Lisbon, 24-14A guilds Burgundian/Flemish late medieval/early Renaissance, 545, 546 Italian 14th century, 410, 414 Italian Quattrocento Renaissance, 560, 561, 563 Gutenberg, Johannes, 554 Н Hagenauer, Nikolaus: shrine, Hospital of

Saint Anthony, Isenheim, 647, 648 Hagesandros: Laocoön and his sons (sculpture), 617, 628, 639, 698 halberd, 626, 626-627

halos in Burgundian/Flemish late medieval/ early Renaissance art, 538 in Italian 13th century art, 405 in Italian 14th century art, 412, 414 in Italian Cinquecento Renaissance art, 603 in Italian Mannerist art, 637 Hals, Frans Archers of Saint Hadrian, 704, 704, 706 The Women Regents of the Old Men's Home at Haarlem, 705, 705 Hanging Tree (Callot), 722, 722 Hardouin-Mansart, Jules Église du Dôme, Paris, 718, 718 Galerie des Glaces, palace of Versailles, 716, 716 Royal Chapel, palace of Versailles, 717-718, 717 Harlem Renaissance, 20-40A harmony. See proportion harpies, 22-84 hatching, 555, 582, 23-5A head of a warrior, sea off Riace (sculpture), 11, 11 Helena, Saint, 21-24A Henry II (king of France), 658, 23-14A Henry VIII (Holbein the Younger), 656, 656b, 661, 23-11A Henry VIII (king of England), 647, 656 Hera (Juno) (Greek/Roman deity), 25-15A Heraclitus, 607 Heraclius (Byzantine emperor), 21-24A Herakles (Hercules) (Greek/Roman hero): in Italian Quattrocento Renaissance art, 569-570, 639 Herakles wrestling Antaios (Euphronios), Cerveteri (vase painting), 570 Hercules. See Herakles Hercules and Antaeus (Pollaiuolo), 569-570, 569, 639 Herrera, Juan de: El Escorial, Madrid, 664-665, 665 Hesire, relief from his tomb at Saqqara (relief sculpture), 10, 10, 12 hierarchy of scale, 11 in African art, xvi in Burgundian/Flemish late medieval/ early Renaissance art, 548 in Italian 14th century art, 14-16A High Renaissance, 600, 619, 621, 624, 628, 637, 22-30A Spanish High Renaissance/Mannerist art, 664-666, 667, 23-23A See also Italian Cinquecento Renaissance art; Northern European High Renaissance/Mannerist art high-relief sculpture, 12 Hippocrates, 651 Holbein the Younger, Hans The French Ambassadors, 656, 656 Henry VIII, 656, 656b, 661, 23-11A and Teerlinc, 661 Holy Roman Empire High Renaissance/ Mannerist art, 647-656, 667 Altdorfer, 654-655 Baldung Grien, 649, 23-3A Cranach the Elder, 653, 654 Dürer, 6, 649-652, 23-5A Grünewald, 647-648 Holbein the Younger, 656, 23-11A and the Protestant Reformation, 652-654 Holy Roman Empire late medieval/early Renaissance art, 552-556, 557, 20-18A, 20-21A Holy Trinity (Masaccio), 567 Holy Trinity, Santa Maria Novella, Florence (Masaccio) (fresco), 574-576, 575 Homage to the Square (Albers), 8, 8 Homage to the Square: "Ascending" (Albers), 8,8 Homer: on the judgment of Paris, 654 horizon line, 567 Hospitaal Sint Jan, Bruges, 548-549, 548 Hospital of Saint Anthony, Isenheim, shrine: Hagenauer, Nikolaus, 647, 648 Hôtel-Dieu, Beaune, 20-8A Hours of Jeanne d'Evreux (Pucelle), 550 Hours of Mary of Burgundy (Master of Mary of Burgundy), 551, 551b, 20-15A hue, 7

Hugo van der Goes: Portinari Altarpiece, 547-548, 547 Huguenots, 656-657 human face in Baroque art, 698, 704, 706, 708, 25-15A in Burgundian/Flemish late medieval/ early Renaissance art, 20-9A in Italian 13th century art, 403 in Italian 14th century art, 411, 14-8A, 14-8B in Italian Quattrocento Renaissance art, 565, 579, 21-12A in Northern European High Renaissance/ Mannerist art, 23-11A human figure in Baroque art, 669, 674, 682, 698, 24-28A in Burgundian/Flemish late medieval/ early Renaissance art, 538, 20-2A in El Greco's art, 666 in French/Spanish Romanesque art, 11 Greek canon, 588, 700 in Italian 13th century art, 403-404 in Italian 14th century art, 408, 412 in Italian Cinquecento Renaissance art, 599, 602-603, 607, 609, 611, 612-614, 615, 627, 628, 22-3A, 22-18A in Italian Mannerist art, 633, 634, 639, in Italian Quattrocento Renaissance art, 562, 563, 564, 568, 570, 574, 582 in Northern European High Renaissance/ Mannerist art, 650-651, 654, 659, 23-14A humanism, 560 and Italian Cinquecento Renaissance art, 607 and Italian late medieval art, 406-407, 412 and Italian Quattrocento Renaissance art, 581, 588 and Northern European High Renaissance/ Mannerist art, 647, 650, 656 See also classical influences on later art Hundred Years' War, 536, 550, 552 Hundred-Guilder Print (Christ with the Sick around Him, Receiving the Children) (Rembrandt), 709, 709 Hunters in the Snow (Bruegel the Elder), 662-663, 663 I quatro libri dell'architettura (The Four Books of Architecture) (Palladio), 622 iconoclasm, 543, 652, 654 iconography, 5 Renaissance, 683-684 Iconologia (Ripa), 683 icons, 405 L'idea de' pittori, scultori ed architteti (Zuccari), 604 Ignatius of Loyola, Saint, 641, 675, 688, 711 Iktinos, 588 See also Parthenon Il Gesù (Church of Jesus) (della Porta and Vignola), Rome, 641-642, 642, 671, 686, 686 Iliad (Homer), 654 illuminated manuscripts, 405 Byzantine, 405 French late medieval/early Renaissance, 550-551, 20-15A See also books illusionism, 8 in Burgundian/Flemish late medieval/ early Renaissance art, 538, 543, 546, 550 in Italian 14th century art, 408, 409, 415 in Italian Baroque art, 681, 686, 24-14A in Italian Mannerist art, 637, 638 in Italian Quattrocento Renaissance art, 562, 565, 575-576, 595-596, 21-41A, 21-43A, 21-49A in Pompeian/Vesuvius area art, 595 See also perspective illustrated books. See books; illuminated manuscripts imitation, 573 Immaculate Conception of the Escoria (Murillo), 688, 688b, 24-25A impasto, 632 imperialism. See colonialism

impost blocks, 21-31A In Praise of Folly (Erasmus), 647 incising, 556 indulgences, 616, 652 ingegno, 604 Inghelbrecht, Peter, 534, 535 Innocent III (Pope), 584 Innocent X (Pope), 669, 670 intaglio, 556 intensity, 7 internal evidence, 3 International Style (medieval Europe), 413-414, 572, 573, 581 intonaco, 408 invenzione, 604 Ionic order and Composite capitals, 587 in Italian Cinquecento Renaissance architecture, 22-30A Isaac, Abraham and, 561-562 Isaac and His Sons, Gates of Paradise, Baptistery of San Giovanni, Florence (Ghiberti), 566-567, 567 Isabella (queen of Castile), 618 Isabella d'Este (Titian), 630, 630, 631, 22-40A Isenheim (Germany): Hospital of Saint Anthony, 647, 648 Isenheim Altarpiece (Grünewald), 647, 648 Islamic art: Spanish High Renaissance/ Mannerist architecture and, 664 Istanbul. See Constantinople Italian 13th century art, 3-4, 402-406, 421, 14-6A Italian 14th century art, 406-420, 421 Cavallini, 407, 409, 14-74 Florence (Florentine), 417-419, 14-18A, 14-18B, 14-19A Giotto di Bondone, 400, 401, 407-409, 14-7A, 14-8A, 14-8B Pisa, 419-420 Siena, 409, 411-416, 417, 14-10A, 14-12A, 14-16A societal contexts, 406-407, 409, 410, 14-16A Venice, 420 Italian Baroque art, 670-686, 673map, 693 architecture, 668, 669, 670-673, 676-678, 24-4A, 24-9A, 24-14A painting. See Italian Baroque painting Rembrandt and, 25-13A sculpture, 673, 674-675, 24-6A timeline, 670 Italian Baroque painting Caravaggio, 681-683, 24-17A, 24-18A Carracci, 679-681, 682 Gaulli, 686 Gentileschi, 683-684 Pietro da Cortona, 685-686 Pozzo, 686, 687 Reni, 684-685 Italian Cinquecento Renaissance art, 600-632, 600map, 643 Andrea del Sarto, 22-8A architecture, 605, 618-624, 22-6A, 22-26A, 22-30A and Dürer, 649, 23-5A and Flemish Baroque art, 698 Leonardo da Vinci, 601-605, 22-3A, 22-6A Michelangelo Buonarroti, 11, 598, 599, 609-618, 619-621, 22-18A, 22-18B, 22-26A painting. See Italian Cinquecento Renaissance painting Raphael, 605-609, 22-10, societal contexts, 600, 622 timeline, 600 Italian Cinquecento Renaissance painting Andrea del Sarto, 22-8A Bellini, 624-625, 22-32A Giorgione, 626-627 Leonardo da Vinci, 601-602, 603-604 Michelangelo Buonarroti, 598, 599, 614-616, 22-18A, 22-18B Raphael, 605-609, 22-10A Titian, 627-629, 630, 631-632 Italian late medieval art, 400-421, 405map 13th century, 402-406, 421, 14-6A 14th century. See Italian 14th century art societal contexts, 404, 406-407 timeline, 402 See also Renaissance

Italian Mannerism, 600map, 632-642, 643 architecture, 640-642 and El Greco, 665 and Francis I, 657 and Goujon, 23-14A painting, 632-638, 22-42A, 22-46A, 22-54A sculpture, 638-639, 22-52A timeline, 600 Italian Quattrocento Renaissance art, 558-597 Florence, 560-588, 561map, 597 architecture, 582-588, 593-594, 21-31A, 21-32A, 21-37A engraving, 581-582 painting. See Florentine Quattrocento Renaissance painting sculpture. See Florentine Quattrocento Renaissance sculpture princely courts, 589-596, 597, 21-41A, 21-43A, 21-49A societal contextss, 560, 561, 563, 584, 588 timeline, 560 Venice, 21-37A **J** Jack in the Pulpit No. 4 (O'Keeffe), 4, 4 Jacobus de Voragine, 21-12A, 21-24A Jacopo della Quercia, 610 jambs, 20-2A James, Saint, 21-49A James I (king of England), 723 Jan van Haeght, 20-11A Japanese painting: Edo period, 8–9 Jean d'Orbais. See Reims Cathedral Jean de Boulogne. See Giovanni da Bologna Jean de Loup. See Reims Cathedral Jerome, Saint, 624, 632, 662 Jerusalem: in Italian 14th century art, 14-10A Jesuit order (Society of Jesus), 641-642, 686 Jesus, life of, 411 See also Christ; Passion of Christ; specific events jewelry. See metalwork Jewish Cemetery (Ruisdael), 710, 710b, 25-18A John the Baptist, Saint in Burgundian/Flemish late medieval/ early Renaissance art, 540, 20-8A in Italian Cinquecento Renaissance art, 601-602 in Italian Quattrocento Renaissance art, 21-43A John the Evangelist, Saint in Baroque art, 720 in Burgundian/Flemish late medieval/ early Renaissance art, 540, 544 in Italian 14th century art, 409 in Italian Quattrocento Renaissance art, 21-43A in Northern European High Renaissance/ Mannerist art, 652 Jones, Inigo: Banqueting House, Whitehall, London, 723-724, 723 Joseph, Saint, 535, 605 Joseph of Arimathea, 544 Judas Iscariot. See Betrayal of Jesus Judgment Day. See Last Judgment Judgment of Paris (Cranach), 654, 654 Judith Slaying Holofernes (Gentileschi), 683, 683, 25-1 Julius II (Pope), 599, 605, 611-612, 614, 619, 622, 22-18A Juno. See Hera Juno (Rembrandt), 25-15A Justice of Otto III (Bouts), 546b, 547, 20-11A Juvara, Filippo: dome, Sant'Andrea, 594 K

K Kalf, Willem and Peeters, 701 Still Life with a Late Ming Ginger Jar, 713, 713 Kallikrates. See Parthenon keystones. See voussoirs king on horseback with attendants, Benin (bronze sculpture), xvi, 11, 12 King Philip IV of Spain (Fraga Philip) (Velázquez), 689, 689b, 24-28B Knidos (Greece): Aphrodite of Knidos (Praxiteles), 581 Knight, Death, and the Devil (Dürer), 651b, 23-5A Koberger, Anton: Nuremberg Chronicle, 554-555, 555 Korin: Waves at Matsushima, 8-9, 9 Kraków (Poland): Saint Mary, 554, 554 Kritios Boy, Athens (sculpture), 564 Krul, Jan Harmensz, 25-20A

L

La Fosse, Charles de: dome, Église du Dôme (Church of the Invalides), Paris (Hardouin-Mansart), 718 La Tour, Georges de: Adoration of the Shepherds, 722-723, 723 La Zecca. See Mint, Piazza San Marco, Venice Ladislaus (king of Naples), 563 Lagraulas, Jean de Bilhères, 610 Lamentation (over the body of Jesus) in Italian 14th century art, 401, 408, 409, in Italian Quattrocento Renaissance art, 596 See also Entombment Lamentation, Arena Chapel, Padua (Giotto), 401, 408, 409, 14-8/ Lamentation, Saint Pantaleimon, Nerezi (wall painting), 409 Lamentation over the Dead Christ (Foreshortened Christ) (Mantegna), 596, 596, 21-49A lancet windows, 14-5A landscape painting, 5 Baroque, 8, 9, 709, 710, 720-721, 25-18A, Burgundian/Flemish late medieval/early Renaissance, 538, 539 El Greco, 666 Holy Roman Empire late medieval/early Renaissance, 553 Italian Baroque, 679-680 Italian Cinquecento Renaissance, 604, 606, 615, 625, 626, 627, 22 Italian late medieval, 409, 412, 416, 417, 4-5B, 14-10A Italian Quattrocento Renaissance, 565, 574, 578, 581, 592, 21-29 Northern European High Renaissance/ Mannerist, 655, 662-663, 23-Landscape with Cattle and Peasants (Claude Lorrain), 720-721, 721 Landscape with Saint Jerome (Patinir), 662, 662 Landscape with Saint John on Patmos (Poussin), 720, 720 Landschaft, 662 See also landscape Laocoön and his sons (Athanadoros, Hagesandros, and Polydoros of Rhodes) (sculpture), 617, 628, 639, 698 Last Judgment in Burgundian/Flemish late medieval/ early Renaissance art, 20-8A, 20-11A in French/Spanish Romanesque art, 5, 11, 12,590 in Italian 14th century art, 400, 401, 14-7A in Italian Cinquecento Renaissance art, 598, 616, 22-18B, 22-54A Last Judgment (Cavallini), Santa Cecilia, Trastevere, 407b, 409, 14-7. Last Judgment, Arena Chapel, Padua (Giotto), 400, 401, 409 light Last Judgment, Saint-Lazare (Gislebertus), 5, 11, 12, 590 Last Judgment, Sistine Chapel (Michelangelo Buonarroti), 598, 616, 616, 22-18B, Last Judgment Altarpiece, Hôtel-Dieu (Rogier van der Weyden), 544, 544b, 20-8A Last Supper in Burgundian/Flemish late medieval/ early Renaissance art, 538, 546-547 in Italian Cinquecento Renaissance art, 602, 603, 628, 637 in Italian Mannerist art, 636-637 in Italian Quattrocento Renaissance art, 576, 577 See also Eucharist Last Supper (Tintoretto), 636-637, 636 Last Supper, Altarpiece of the Holy line, 7 linear perspective, 565, 566-568, 567, 720

Sacrament, Saint Peter's, Louvain (Bouts), 546-547, 547

Last Supper, Sant'Apollonia, Florence (Andrea del Castagno), 576, 577 Supper, Santa Maria delle Grazie (Leonardo da Vinci), 602, 603, 628, 637 late 20th century European and American art Op Art, 8 Post-Painterly Abstraction, 1, 2 Late Renaissance, 600 See also Italian Cinquecento Renaissance art lateral sections, 12 laudatio, 570 Laurentian Library, Florence (Michelangelo Buonarroti), 640-641, 641 Law and Gospel (Cranach), 653, 653 Le Brun, Charles east facade, Louvre, Paris, 714, 715, 724 Galerie des Glaces, palace of Versailles, 716, 716 palace of Versailles, 715, 716 Le Nain, Louis: Family of Country People, 721-722, 721 Le Nôtre, André: park, palace of Versailles, 715, 716 Le Vau, Louis: east facade, Louvre, Paris, 714, 715, 724 League of Cambrai, 622 Legend of the True Cross, San Francesco, Arezzo (Piero della Francesca), 578, 578b, 21-24A Legenda Maior (Saint Bonaventura), 14-5B Leo X (Pope), 607-608, 613 Leonardo da Vinci, 601-605 and Andrea del Sarto, 22-8A cartoon for Madonna and Child with Saint Anne and the Infant Saint John, 602-603, 602 and Correggio, 638 and Dürer, 649, 23-4A, 23-5A The Fetus and Lining of the Uterus, 604, 605 and Francis I, 605, 657 and human figure, 582 and humanism, 560 Last Supper, Santa Maria delle Grazie, 602, 603, 628, 637 life of, 601 Madonna of the Rocks, 567, 601-602, 601, 604 Mona Lisa, 567, 603-604, 603, 21-29A, 22-10A name of, 405 painting techniques, 539 on painting vs. sculpture, 609 project for a central-plan church, 605, 605b, 22 and Raphael, 605, 606 Treatise on Painting, 609 Vitruvian Man, 603b, 22-3A Lescot, Pierre: Louvre, Paris, 658, 658, 715, The Letter (Vermeer), 712, 712b, 25-20A Leyster, Judith: Self-Portrait, 705, 705 Library of San Marco, Venice (Sansovino), 623b, 22-30A Il Libro dell'Arte (The Handbook of Art) (Cennini), 414, 539, 573 Life of Jesus, Maestá altarpiece, Siena Cathedral (Duccio), 411, 412, 412, 14-8B Life of Phocion (Plutarch), 25-32A in Burgundian/Flemish late medieval/ early Renaissance art, 20-4A in Dutch Baroque art, 702, 706, 707, 708, 711, 712, 25-13A, 25-18B in French Baroque art, 721, 722 in Italian 14th century art, 409, 14-7A in Italian Baroque art, 682-683 in Italian Cinquecento Renaissance art, 602, 624 in Italian Mannerist art, 637 in Italian Quattrocento Renaissance art, 573, 574, 21-43A in Spanish Baroque art, 688, 689, 692 Limbourg brothers (Pol, Herman, Jean), Les Très Riches Heures du Duc de Berry, 550-551, 550, 551

See also perspective

Lion and Tiger Hunt (Rubens), 25-1A Lion Hunt (Rubens), 10, 10, 697, 25-1A Lippi, Filippino, 577 Lippi, Fra Filippo, 581 Madonna and Child with Angels, 577-578, 577, 604 Lisbon (Portugal): Santa Maria Divina Providencia (Guarini), 24-14A literature and humanism. 560 and Italian late medieval art, 406, 412 See also books liturgy, 550-551 See also Eucharist Lives of the Most Eminent Painters, Sculptors, and Architects (Vasari), 407 Lochner, Stefan: Madonna in the Rose Garden, 553, 553b, 20-18A loggias, 576, 582, 14-19A, 21-37A London (England) Banqueting House, Whitehall (Jones), 723-724, 723 Saint Paul's Cathedral (Wren), 724, 724 longitudinal sections, 12 Lorenzetti, Ambrogio, 14-19A Allegory of Good Government, Palazzo Pubblico, Siena, 416b, 14-16A Effects of Good Government in the City and in the Country, Palazzo Pubblico, Siena, 416, 416, 417 Lorenzetti, Pietro, 14-19A Birth of the Virgin, Siena Cathedral, 415, 415 Lorrain, Claude. See Claude Lorrain lost-wax process (cire perdue), 673, 22-52A Louis XIV (king of France), 714-715, 717, 718 Louis XIV (Rigaud), 714-715, 714 Louvain (Belgium) Saint Peter's, 546-547, 547 Stadhuis, 20-11A Louvre, Paris (Lescot), 658, 658, 23-14A east facade (Perrault, Le Vau, and Le Brun), 714, 715, 724 Love Emblems (Krul), 25-20A Loves of the Gods, Palazzo Farnese, Rome (Carracci), 680-681, 680 low-relief sculpture. See bas-relief sculpture Loyola, Ignatius. See Ignatius of Loyola, Saint Lucy, Saint, 624 Luke, Saint, 545, 23-15A lunettes, 551, 22-18B Luther, Martin, 616, 652, 654, 656 luxury arts. See illuminated manuscripts; metalwork M machicolated galleries, 416 Maderno, Carlo

east facade, Saint Peter's, Rome, 669, 671-672, 671, 676 Santa Susanna, Rome, 670-671, 670, 676 Madonna and Child. See Virgin and Child Madonna and Child Enthroned with Saints, Or San Michele, Florence (Daddi), 419, 419b, 14-19/ Madonna and Child with Angels (Lippi), 577-578, 577, 604 Madonna and Child with Saint Anne and the Infant Saint John, cartoon for (Leonardo da Vinci), 602-603, 602 Madonna and Child with Saints (San Zaccaria Altarpiece) (Bellini), 543, 624-625, 624 Madonna Enthroned (Giotto), Church of Ognissanti, Florence, 407-408, 407, 578, 14-19A Madonna Enthroned with Angels and Prophets, Santa Trinitá, Florence (Cimabue), 406, 406 Madonna in a Church (van Eyck), 540, 540b, 20-4A Madonna in the Meadow (Raphael), 606, 606 Madonna in the Rose Garden (Lochner), 553, 553b, 20-18A Madonna of the Harpies (Andrea del Sarto), 606, 606b, 22-8 Madonna of the Pesaro Family (Titian), 628, 628

Madonna of the Rocks (Leonardo da Vinci), 567, 601-602, 601, 604

Madonna with the Long Neck (Parmigianino), 633-634, 633

Madrid (Spain) El Escorial (Herrera and Baustista de Toledo), 664-665, 665 Palacio del Buen Retiro, 691 San Plácido, 24-28A Maestá altarpiece (Duccio), Siena Cathedral, 410, 411–412, *411*, *412b*, *412*, *578*, 14-8B, 14-10A Magellan, Ferdinand, 664 magus/magi. See Adoration of the Magi Maitani, Lorenzo: Orvieto Cathedral, 412-413, 413, 418 Malouel, Jean, 537, 538 Man in a Red Turban (van Eyck), 542-543, 543 Manetti, Antonio, 566 Manetti, Giannozzo, 570, 588 maniera, 632, 682 maniera greca, 404–405, 407, 14-7A, 14-8B Mannerism, 632, 657 Spanish High Renaissance/Mannerist art, 664-666, 667, 23-23 See also Italian Mannerism; Northern European High Renaissance/ Mannerist art Mantegna, Andrea, 624 Camera Picta (Painted Chamber), Palazzo Ducale, Mantua, 594-596, 594, 595, 615 Foreshortened Christ (Lamentation over the Dead Christ), 596, 596, 21-49A Saint James Led to Martyrdom, Chiesa degli Eremitani, Padua, 596b, 21-49A Mantua (Italy) Palazzo Ducale, 594-596, 594, 595 Sant'Andrea (Alberti), 593-594, 593, 593, 642 manuscripts, illuminated. See illuminated manuscripts Maori art. See New Zealand art maps Cinquecento Rome, 600 early 19th century Europe, 646 Europe (1648), 696 late medieval Italy, 405 Northern Europe (1477), 536 Renaissance Florence, 561 Vatican City, 673 Marcus Aurelius (Roman emperor), 571, Margaret de Mâle, 537, 20-2A Margaret of Austria, 662 Marriage of the Virgin (Raphael), 605, 605 Martin V (Pope), 404, 21-41A Martini, Simone: Annunciation altarpiece, Siena Cathedral, 413-415, 413 Martyrdom of Saint Philip (Ribera), 688, 688 martyrium, 619 Mary (duchess of Burgundy), 551, 556, 20-15A Mary (mother of Jesus). See Virgin Mary Mary Magdalene in Burgundian/Flemish late medieval/ early Renaissance art, 544 in Italian 14th century art, 409 in Italian Cinquecento Renaissance art, 632 in Italian Quattrocento Renaissance art, 21-12A Mary of Burgundy at Prayer (Master of Mary of Burgundy), 551, 551b, 20-15A Mary of Hungary, 662 Masaccio (Tommaso di ser Giovanni di Mone Cassai), 573 Expulsion of Adam and Eve from Eden, Santa Maria del Carmine, Florence, 574, 575, 22-18A Holy Trinity, Santa Maria Novella, Florence (fresco), 574-576, 575 and Leonardo da Vinci, 601 and Lippi, 577 and Melozzo da Forlì, 21-41A and Michelangelo Buonarroti, 610, 22-18A name of, 405 Tribute Money, Santa Maria del Carmine, Florence (fresco), 574, 574 Masolino da Panicale, 573 mass, 8 Mass. See Eucharist Massys, Quinten: Money-Changer and His Wife, 659-660, 660 Master of Flémalle: Mérode Altarpiece, 534, 535, 541, 549

Master of Mary of Burgundy: Hours of Mary of Burgundy, 551, 551b, 20-15A Materials and Techniques boxes framed paintings, 543 fresco painting, 408 graphic arts, 556 perspective, 567 Renaissance drawings, 604 tempera and oil painting, 539 matins, 550 matte, 538 Matthew, Saint, 681, 702, 24-17A maulstick, 661 mausoleum, 537 Mazo, Juan del, 692 medal showing Bramante's design for Saint Peter's (Caradosso), 619, 619 Medici, Cosimo I de', 559, 586, 634 Medici, Giovanni di Bicci de', 559, 21-31A Medici, Giulio de', 608 Medici, Lorenzo de' (the Magnificent), 559, 580, 588, 610 Medici, Lorenzo di Pierfrancesco de', 559, Medici, Marie de', 697, 698-699 Medici family and Botticelli, 559, 21-29A Bronzino portraits, 635 and Donatello, 568 expulsion of, 588 and female patrons, 630 importance of, 559 Palazzo Medici-Riccardi (Michelozzo di Bartolommeo), 585-586 and papacy, 608, 652, 21-31A and Pollaiulo, 569-570 and Uccello, 580-581 medieval art International Style, 413-414, 572, 573, 581 See also Gothic art; Italian late medieval art; Northern European late medieval/ early Renaissance art; Romanesque art medium/media. 7 Meeting of Bacchus and Ariadne (Titian), 628, 629 Meeting of Saints Anthony and Paul, Isenheim Altarpiece (Grünewald), 647, 658 mela medica, 580-581 Melencolia I (Dürer), 651, 651 Melozzo da Forlì: Pope Sixtus IV Confirming Platina as Librarian, Biblioteca Apostolica Vaticana, Rome, 589b, 21-41A Melun Diptych (Fouquet), 552, 552 memento mori, 695 Memling, Hans Diptych of Martin van Nieuwenhove, 549, 549 Saint John Altarpiece, Hospitaal Sint Jan, Bruges, 548-549, 548 Tommaso Portinari and Maria Baroncelli, 549, 549b, 20-14A Memmi, Lippo: Annunciation altarpiece, Siena Cathedral, 413-415, 413 mendicant orders, 404, 405, 420, 576, 14-6A Las Meninas (The Maids of Honor) (Velázquez), 690, 691-692, 691 mercantilism, 697, 702, 703 Mérida (Mexico): Casa de Montejo, 664b, Merisi, Michelangelo. See Caravaggio Mérode Altarpiece (Master of Flémalle), 534, 535, 541, 549 metalwork Italian Mannerist, 638-639 See also bronze casting Metamorphoses (Ovid), 23-22A, 24-6A Mezquita: Great Mosque, Córdoba, 24-14A Michael, Archangel, 20-8A, 22-42A Michelangelo Buonarroti, 609-610 and Andrea del Sarto, 22-8A and Anguissola, 635 Bound Slave (Rebellious Captive), 612, 613, 614 Campidoglio, Rome, 620-621, 621b, 22-26A Creation of Adam, Sistine Chapel ceiling, 598, 615, 615, 681 David, 611, 611, 674, 675 Fall of Man, Sistine Chapel ceiling, 598, 615, 615b, 22-18A

and Ghirlandaio, 610 and Laocoön and his sons (Athanadoros, Hagesandros, and Polydoros of Rhodes) (sculpture), 617, 628 Last Judgment, Sistine Chapel, 598, 616, 616, 22-18B, 22-54A Laurentian Library, Florence, 640-641, 641 Moses, tomb of Julius II, 612–613, 612 on painting vs. sculpture, 609 Palazzo Farnese, Rome, 620-621, 621 Pietá, 610, 610 Pietá (unfinished), 617-618, 617, 632 and Raphael, 607 on Rogier van der Weyden, 545 and Rubens, 697 Saint Peter's, Rome, 619-620, 620, 664, 671-672 and Sansovino, 22-30A Sistine Chapel ceiling, Vatican, Rome, 598, 599, 605, 614–615, 614, 615, 681, 698, 22-18A, 22-18B and Tintoretto, 636 tomb of Giuliano de' Medici, San Lorenzo, Florence, 613-614, 613, 22-52 tomb of Julius II, 611-613, 612, 614 tomb of Lorenzo, San Lorenzo, Florence, 613, 614 unfinished statue, 11, 11 Michelozzo di Bartolommeo: Palazzo Medici-Riccardi, Florence, 585-586, 586, 587, 621, 21-37A Milan (Italy) Leonardo da Vinci's residence in, 601 San Francesco Grande, 601 Santa Maria delle Grazie, 602, 603 Milton, John, 686 Mint, Piazza San Marco, Venice (Sansovino), 623b. 632. 22-30A Miraculous Draught of Fish, Altarpiece of Saint Peter, Cathedral of Saint Peter, Geneva (Witz), 553, 553 Miseries of War (Callot), 722, 722 modeling in Italian Baroque art, 685 in Italian Quattrocento Renaissance art, 574 in late medieval Italian art, 409, 412 in Northern European High Renaissance/ Mannerist art, 659 in Northern European late medieval/ early Renaissance art, 544 See also chiaroscuro Modernism. See American Modernism; European prewar Modernism; Surrealism modules, 10 in Italian Quattrocento Renaissance architecture, 582, 582-583, 584, 585 moldings in Italian late medieval art, 418 in Italian Quattrocento Renaissance art, 583, 586 in Northern European High Renaissance/ Mannerist architecture, 658 molds, 11 Mona Lisa (Leonardo da Vinci), 567, 603-604, 603, 21-29A, 22-10A monasteries: Northern European late medieval/early Renaissance, 537 monastic orders, 404 Dominican, 404, 420, 576, 14-6A Franciscan, 404, 405, 14-6A Money-Changer and His Wife (Massys), 659-660,660 monochrome: in Dutch Baroque art, 705 Montejo the Younger, Francisco, 23-23A Moorish art. See Islamic art More, Thomas, 647, 23-11/ mosaics: Greek Late Classical period, 654 Moses, 22-32A, 23-15 Moses, tomb of Julius II (Michelangelo Buonarroti), 612-613, 612 mosques: Great Mosque, Córdoba, 24-14A Mother of God. See Virgin Mary Mount Vesuvius area art. See Pompeian/ Vesuvius area art Mundy, Peter, 695 mural painting Italian 13th century, 407, 14-5A, 14-5B Italian 14th century, 400, 401, 408, 409,

416-417, 419-420, 14-8A, 14-8B

Murillo, Bartolomé Esteban: Immaculate Conception of the Escoria, 688, 688b, 24-25 Musicians (Caravaggio), 681, 681b, 24-17A Myron: Diskobolos (Discus Thrower), 617-618,674 mystery plays, 409, 538, 548 mystic marriage, 549 mythology. See religion and mythology N Nanni di Banco: Four Crowned Saints, Or San Michele, 563, 563 naos. See cella narrative art Baroque, 692 Burgundian/Flemish late medieval/early Renaissance, 20-11A Italian 14th century, 409, 412, 14-8A Italian Cinquecento Renaissance art, 614 - 615Italian late medieval, 405 Italian Quattrocento Renaissance, 565, 566-568, 21-24A Nativity, 403-404, 415, 548, 573 naturalism, 401 See also naturalism/realism naturalism/realism in Baroque art, 688, 720 in Burgundian/Flemish late medieval/ early Renaissance art, 538, 540-541, 543, 546, 548, 20-2A in French late medieval/early Renaissance art, 551 in Holy Roman Empire late medieval/ early Renaissance art, 20-18A and humanism, 560 in Italian 14th century art, 407, 408, 419, 14-7A, 14-8B, 14-10/ in Italian late medieval art, 401, 406 in Italian Quattrocento Renaissance art, 568, 569, 570, 573, 21-124 in Northern European High Renaissance/ Mannerist art, 651, 660, 23-4A, 23-5A nave arcades in Gothic architecture, 584 in Italian late medieval architecture, 413 naves, 20-4A in Italian 13th century architecture, 14-6A in Italian 14th century architecture, 413, 14-18/ in Italian Mannerist architecture, 642 in Italian Quattrocento Renaissance architecture, 21-31A Negretti, Jacopo. See Palma il Giovane Neolithic art: Egyptian Predynastic art, 10 Neo-Platonism, 559, 581, 613 Nephthys (Egyptian deity), 659 Neptune and Amphitrite (Gossaert), 659, 659 Nerezi (Macedonia): Saint Pantaleimon, 409 Netherlandish Proverbs (Bruegel the Elder), 662,663 New Sacristy, San Lorenzo, Florence, 613-614, 613 New Saint Peter's. See Saint Peter's, Rome New Zealand art, 13 Newton, Isaac, 717-718, 724 Niccolò da Tolentino, 580 Niccolò di Segna: Resurrection, San Sepolcro Cathedral, 578 Nicholas III (Pope), 14-7A Nicholas of Cusa, 23-4A Nicodemus, 544, 618 Night Watch (The Company of Captain Frans Banning Cocq) (Rembrandt), 706, 707 nimbus. See halos Ninety-five Theses (Luther), 652 nipote, 21-41A Noli me tangere, 412 Northern European art. See Burgundian/ Flemish late medieval/early Renaissance art; Dutch . . . art; Flemish Baroque art; French . . . art; German Expressionism; Holy Roman Empire . . . art; Northern European . . . art Northern European High Renaissance/ Mannerist art, 644-663, 646map, 667

Italian Quattrocento Renaissance

21-24A, 21-41A, 21-49A

574-576, 578-579, 589-590, 594-596,

Dutch, 658-663, 667 French, 656–658, 667, 23-14A societal contexts, 646-647, 652-653, 656-657, 658-659 timeline, 646 Northern European late medieval/early Renaissance art, 534-557, 536map Burgundian/Flemish. See Burgundian/ Flemish late medieval/early Renaissance art French, 550-552, 557, 20-15A Holy Roman Empire, 552-556, 557, 20-18A, 20-21 societal contexts, 536-537, 550, 555-556 timeline, 536 Notre Dame Cathedral, Chartres. See Chartres Cathedral nudity in Italian Baroque art, 680–681, 24-17A in Italian Cinquecento Renaissance art, 628, 631 in Italian Mannerist art, 639, 22-52A in Italian Quattrocento Renaissance art, 568, 579, 582 in Northern European High Renaissance/ Mannerist art, 645, 649, 654, 659, 23-3A Nuñez de Balboa, Vasco, 664 Nuremberg Chronicle (Koberger) (ill. by Wolgemut and shop), 554-555, 555, 556 Nymphs, Fountain of the Innocents, Paris (Goujon), 658, 658b, 23-14A 0 O'Keeffe, Georgia: Jack in the Pulpit No. 4, 4, 4 Oceanic art, 13 Octavian (Roman emperor). See Augustus oculus/oculi, 14-6A, 21-31A Ogata Korin. See Korin ogee arches, 420 ogival arches. See pointed arches oil painting Italian Cinquecento Renaissance, 601, 624, 631 Northern European late medieval/early Renaissance, 538 vs. tempera painting, 538, 539 See also painting Old Saint Peter's, Rome, 607 Old Testament themes in Baroque art, 683, 25-13A in Burgundian/Flemish late medieval/early Renaissance art, 537-538, 540, 547 in Italian 13th century art, 14-5B in Italian Cinquecento Renaissance art, 612-613, 614, 615, 22-18A in Italian Quattrocento Renaissance art, 561-562, 566 On Architecture (Vitruvius), 603, 622, 22-3A See also Vitruvius On Love (Ficino), 581 On Painting (Alberti), 566 On the Art of Building (Alberti), 568, 586, 588 On the Dignity and Excellence of Man (Manetti), 588 Op Art, 8 Or San Michele, Florence, 419, 419b, 562-565, 563, 564, 565, 14-19A, 21-36.

Orcagna, Andrea: tabernacle, Or San

Doric order; Ionic order

orthogonals, 547, 567, 574, 581

418, 590, 590, 14-12.

Ottoman Empire, 622

Ovetari, Imperatrice, 21-49A

Ovid, 560, 625, 23-22A, 24-6A

Order of Mercy, 688-689

Michele, Florence, 419, 419b, 14-19A

orders (of Greek temple architecture). See

Orvieto Cathedral (Maitani), 412-413, 413,

Hospital), Florence (Brunelleschi), 410,

orders, monastic. See monastic orders

Ospedale degli Innocenti (Foundling

582-583, 583, 585, 21-36A

Otto III (Holy Roman Emperor), 20-11A

Padua (Italy) Arena Chapel (Cappella Scrovegni) (Giotto), 400, 401, 408, 409, 412, 14-8A, 14-8B, 14-10A Chiesa degli Eremitani, 596b, 21-49A

Р

painting American Modernist, 4 Burgundian/Flemish late medieval/early Renaissance, 538, 539, 540-549, 20-4A, 20-8A, 20-9A, 20-11A, 20-14A Dutch Baroque. See Dutch Baroque art El Greco, 665-666 Flemish Baroque, 10, 697-701, 25-1A, 25-2A Florentine 14th century, 14-19A Florentine Quattrocento Renaissance. See Florentine Quattrocento Renaissance painting French Baroque, 8, 9, 714-715, 718-723, papacy 25-32A French late medieval/early Renaissance, 552 frescoes. See fresco painting Giotto di Bondone, 400, 401, 407–409, 14-8A, 14-8B Holy Roman Empire late medieval/early Renaissance, 552-553, 20-18A Italian 13th century, 404-406, 14-5A, 14-5B Italian Baroque. See Italian Baroque painting Italian Cinquecento Renaissance. See Italian Cinquecento Renaissance painting Italian Mannerist, 632-638, 22-42A, 22-46A, 22-54A Japanese Edo period, 8-9 landscapes. See landscape painting Leonardo and Michelangelo on, 609 murals. See mural painting Northern European High Renaissance/ Mannerist, 647–648, 652, 654–656, 657, 659-663, 23-3A, 23-4A, 23-11A oil. See oil painting Op Art, 8 Pisan 14th century, 419-420 Post-Painterly Abstraction, 1, 2 Quattrocento princely courts, 589-590, 591, 592-593, 595-596, 21-41A, 21-43A, 21-49A Sienese 14th century, 411-412, 413-415, **416, 417,** 14-7A, 14-10A, 14-16A Spanish Baroque, 687-692, 24-25A, 24-28A, 24-28B techniques. See painting techniques tempera. See tempera painting vases: Greek Archaic period, 570 See also icons; illuminated manuscripts painting techniques fresco, 408 Italian Cinquecento Renaissance, 601, 603, 624, 631 late medieval/early Renaissance Northern Europe, 539 oil vs. tempera, 539 Palacio del Buen Retiro, Madrid, 691 Palazzo Barberini, Rome, 685-686, 685 Palazzo Carignano, Turin (Guarini), 676, 676b, 24-9A Palazzo Comunale, Borgo San Sepolcro, 578-579, 578, 578 Palazzo Contarini (Ca d'Oro), Venice, 586, 586b, 21-37 Palazzo del Tè, Mantua (Giulio Romano), 640, 640, 22-54A Palazzo della Signoria (Palazzo Vecchio) (Arnolfo di Cambio), Florence, 417, 417b, 14-18B, 21-37A Palazzo di Parte Guelfa, Florence, 585 Palazzo Ducale, Mantua, 594-596, 594, 595 Palazzo Farnese, Rome (Sangallo and Michelangelo Buonarroti), 620-621, 621 Loves of the Gods (Carracci), 680-681, 680 Palazzo Medici-Riccardi, Florence (Michelozzo di Bartolommeo), 585-586, 586, 587, 621, 21-37A Palazzo Pubblico, Siena, 415-416, 415, 416, 417.14-16A.14-18B Palazzo Rucellai, Florence (Alberti and Rossellino), 587-588, 587 Palazzo Vecchio (Palazzo della Signoria) (Arnolfo di Cambio), Florence, 417, 417b, 14-18B, 21-37A Palladio, Andrea, 619, 622 and della Porta, 642 and Jones, 723, 724

San Giorgio Maggiore, Venice, 623-624, 623, 623, 636-637

and Sansovino, 22-30A Villa Rotonda, near Vicenza, 622, 623 and Wren, 724 Palma il Giovane Pietá, 631-632, 631 on Titian, 631 Pantheon, Rome and Italian Baroque art, 673 and Italian Cinquecento Renaissance architecture, 619, 623 and Italian Quattrocento Renaissance architecture, 584, 585 Great Schism, 404, 536, 21-41A and Italian Baroque art, 670, 671, 672 and Italian Cinquecento Renaissance art, 599,605 and Italian Quattrocento Renaissance art, 589-590 See also specific popes Papal States. See papacy; Rome parallel hatching, 555, 582 parapets, 416 parchment, 604 See also books Paris (France) Église du Dôme (Church of the Invalides) (Hardouin-Mansart), 718, 718 Fountain of the Innocents, 658, 658b, 23-14A See also Louvre Parma Cathedral, Parma, 638, 638 Parmigianino (Girolamo Francesco Maria Mazzola) and Correggio, 638 Madonna with the Long Neck, 633-634, 633 Self-Portrait in a Convex Mirror, 633, 633 Parthenon (Iktinos and Kallikrates), Athens and Italian Ouattrocento Renaissance architecture, 588 pediment statuary, 602-603 Passion of Christ in Burgundian/Flemish late medieval/ early Renaissance art, 538 in Italian 14th century art, 412 See also Betrayal of Jesus; Crucifixion; Deposition; Entry into Jerusalem; Flagellation of Jesus; Lamentation; Last Supper; Noli me tangere The Passion of Sacco and Vanzetti (Shahn), 4, 4, 6 Pastoral Symphony (Titian), 626, 627 Patinir, Joachim: Landscape with Saint Jerome, 662, 662 patronage, 6-7 Dutch Baroque art, 694, 695, 702, 703 Flemish Baroque art, 697, 698 French Baroque art, 714-715 and humanism, 560 Italian Baroque art, 669, 670, 681, 685, 24-6A, 24-14A, 24-17A Italian Cinquecento Renaissance art, 599, 601, 605, 606, 607-608, 630, 631 Italian late medieval art, 410, 418-419 Italian Quattrocento Renaissance art, 559, 569-570, 573, 589, 590, 591, 21-31A, 21-41A Northern European High Renaissance/ Mannerist art, 657, 662 Northern European late medieval/early Renaissance art, 535, 536, 537, 542, 544, 547, 548, 549, 550, 552 Spanish Baroque art, 689, 690, 24-28A See also artist's profession; donor portraits patrons, 6-7 See also patronage Paul III (Pope), 616, 617, 619, 620, 621, 641, Paul V (Pope), 670, 671, 22-40A Pazzi Chapel, Santa Croce, Florence (Brunelleschi), 584, 584, 585, 585, 585, 21-36A pediments in Italian Baroque architecture, 24-9A in Italian Cinquecento Renaissance architecture, 621 in Italian Cinquecento Renaissance art, 642 in Italian Quattrocento Renaissance architecture, 582 Pietá (Michelangelo Buonarroti)

in Northern European High Renaissance/ Mannerist architecture, 658

in Spanish High Renaissance/Mannerist architecture, 665 Peeters, Clara: Still Life with Flowers, Goblet, Dried Fruit, and Pretzels, 701, 701 pendentives, 585, 614, 24-14A Penitent Mary Magdalene (Donatello), 568, 568b, 21-12A, 21-24A Il Penseroso (Milton), 686 period style, 3 Perrault, Claude: east facade, Louvre, Paris, 714, 715, 724 personal style, 4-5 personification, 5-6 perspective, 8-10 atmospheric, 567, 574, 601, 604, 720, 20-11A in Baroque art, 8, 9, 672, 686, 711, 720, 24-4Å, 25-18B in Burgundian/Flemish late medieval/ early Renaissance art, 547, 20-11A and humanism, 560 in Italian 14th century art, 409, 14-7A, in Italian Cinquecento Renaissance art, 603, 605, 628 in Italian Quattrocento Renaissance art, 565, 566-568, 567, 574, 575-576, 581, 589, 590, 593, 596, 21-41A, 21-49A See also foreshortening; illusionism Perugino (Pietro Vannucci) Christ Delivering the Keys of the Kingdom to Saint Peter, 567 Christ Delivering the Keys of the Kingdom to Saint Peter, Sistine Chapel, 589-590, 589, 22-18B and Raphael, 605, 606 Pesaro, Jacopo, 628 Pesaro Madonna (Madonna of the Pesaro Family) (Titian), 628, 628 Pescia (Italy): San Francesco, 404-405, 404, 14-5B Peter, Saint in Holy Roman Empire late medieval/ early Renaissance art, 552-553 in Italian Cinquecento Renaissance art, 624, 628 in Italian Quattrocento Renaissance art, 574, 589 in Northern European High Renaissance/ Mannerist art, 652 Petrarch, Francesco, 406, 407, 412, 560 Petrus Christus: A Goldsmith in His Shop, 546, 546 Philip, Saint: Martyrdom of Saint Philip (Ribera), 688, 688 Philip II (king of Spain), 635, 658-659, 664, 665,697 Philip III (king of Spain), 687 Philip IV (king of Spain), 687, 690, 692, 697, 24-28A. Philip the Bold (duke of Burgundy), 537, 20-2A Philip the Good (duke of Burgundy), 538 Philosophy (School of Athens), Vatican Palace, Rome (Raphael), 606-607, 607, 624, 628, 651, 22-18B Philoxenos of Eretria: Battle of Issus (Alexander Mosaic), 654 physical evidence, 2 piano nobile, 21-37A piazzas, 632, 672, 22-30A Piero della Francesca Battista Sforza and Federico da Montefeltro, 590, 591, 592 Enthroned Madonna and Saints Adored by Federico da Montefeltro (Brera Altarpiece), 590, 590b, 21-43A Flagellation, 592-593, 592, 21-24A Legend of the True Cross, San Francesco, Arezzo (Piero della Francesca), 578, 578b, 21-24A and Melozzo da Forlì, 21-41A Resurrection, Palazzo Comunale, Borgo San Sepolcro, 578-579, 578 piers, 12 in Italian 14th century architecture, 14-12A, 14-18A in Italian Quattrocento Renaissance architecture, 587 Pietá (Michelangelo Buonarroti), 610, 610

(unfinished), 617-618, 617, 632

Pietá (Titian and Palma il Giovane), 631-632, 631 Pietás in Burgundian/Flemish late medieval/ early Renaissance art, 544 in Italian Cinquecento Renaissance art, 610, 617-618, 631, 632 pietra serena, 583, 585, 21-31A Pietro Cavallini. See Cavallini, Pietro Pietro da Cortona: Triumph of the Barberini, Palazzo Barberini, Rome, 685-686, 685 Pietro dei Cerroni. See Cavallini, Pietro pilasters, 575 in Italian Baroque architecture, 671, 678 in Italian Cinquecento Renaissance architecture, 620, 621 in Italian Mannerist architecture, 641, 642 in Italian Quattrocento Renaissance architecture, 587, 588, 594 in Northern European High Renaissance/ Mannerist architecture, 658 pilgrimage: and Italian 13th century architecture, 14-5A Pilgrimage to Cythera (Watteau), 25-1A pinnacles, 411, 413, 14-12A Pisa (Italy) baptistery, 402-403, 402, 403 Camposanto, 419-420, 419 Pisa Cathedral, 413, 417 Pisa Cathedral, 413, 417 Pisan late medieval art, 419-420 Pisano, Andrea, 14-19A doors, Baptistery of San Giovanni, Florence, 418-419, 418, 561 Pisano, Giovanni pulpit, Sant'Andrea, Pistoia, 403-404, 403 Siena Cathedral, 14-12A Pisano, Nicola, 405 baptistery pulpit, Pisa, 402-403, 402, 403, 415 pulpit, Siena Cathedral, 14-12A Pistoia (Italy): Sant'Andrea, 403-404, 403 La Pittura (Self-Portrait as the Allegory of Painting) (Gentileschi), 683-684, 684 Pius II (Pope), 593 Pizarro, Francisco, 664 plague (Black Death), 406, 416, 419, 14-19A planes, 7 plans (architectural), 12 See also central plans plans (urban). See urban planning Plateresque style, 664, 23-23A platero, 664 Platina, Bartolomeo, 21-41A Plato, 560, 600, 606-607, 609, 613 See also Neo-Platonism Plutarch, 25-32A poesia, 626 poetry. See literature pointed arches, 3 in Gothic architecture, 402 in Italian 13th century architecture, 14-6A in Italian 14th century architecture, 420 in Italian Quattrocento Renaissance architecture, 21-31A political vandalism, 14-16A Poliziano, Angelo, 581, 609 Pollaiuolo, Antonio del Battle of Ten Nudes, 581–582 Hercules and Antaeus, 569-570, 569, 639 Polydoros of Rhodes: Laocoön and his sons (sculpture), 617, 628, 639, 698 Polykleitos canon of, 588, 700 Doryphoros (Spear Bearer), 563 polyptychs, 538 polytheism, 673 Pompeian/Vesuvius area art: and Italian Quattrocento Renaissance art, 595 Pontius Pilate, 592 Pontormo, Jacopo da: Entombment of Christ, 632-633, 632, 22-42A Pope Leo X with Cardinals Giulio de' Medici and Luigi de' Rossi (Raphael), 608, 608 Pope Sixtus IV Confirming Platina as Librarian, Biblioteca Apostolica Vaticana, Rome (Melozzo da Forli), 589b, 21-41A Porta Maggiore, Rome, 22-30A portals. See jambs porticos, 576

Portinari, Tommaso, 547-548, 20-14A Portinari Altarpiece (Hugo van der Goes), 547-548, 547 portrait medals, 21-29A Portrait of a Lady (Rogier van der Weyden), 546b, 20-9. Portrait of a Noblewoman (Fontana), 630b, Portrait of a Young Man with a Book (Bronzino), 634b, 22-46A Portrait of Te Pehi Kupe (Sylvester), 13, 13 Portrait of the Artist's Sisters and Brother (Anguissola), 635, 635 portraiture in Burgundian/Flemish late medieval/ early Renaissance art, 538, 541-543, 548, 549, 20-2A, 20-9A, 20-14A in Dutch Baroque art, 704, 705, 706, 707, 708, 25-15A in El Greco's art, 665 in Flemish Baroque art, 701 in French Baroque art, 714-715 in French late medieval/early Renaissance art, 552 and humanism, 560 in Italian Cinquecento Renaissance art, 603-604, 614, 630, 631, 22-10A, 22-40A in Italian Mannerist art, 634-635, 22-46A in Italian Quattrocento Renaissance art, 563, 570, 571, 579-580, 590, 592 in Northern European High Renaissance/ Mannerist art, 656, 657, 661-662, 23-11A in Northern European late medieval/ early Renaissance art, 535 and patronage, 6 in Spanish Baroque art, 689, 690, 24-28B See also donor portraits Post-Painterly Abstraction, 1, 2 Poussin, Nicolas, 717 Burial of Phocion, 720, 720b, 25-32A Et in Arcadia Ego, 718, 719, 719 Landscape with Saint John on Patmos, 720, 720 notes for a treatise on painting, 718, 719 Pozzo, Fra Andrea: Glorification of Saint Ignatius, Sant'Ignazio, Rome, 686, 687 Praxiteles Aphrodite of Knidos, 581, 654 and Donatello, 568 predellas, 411 Predynastic period Egyptian art, 10 prefiguration, 547, 561 preliminary drawings (cartoons), 408, 602-603 Presentation in the Temple, 538, 539 primary colors, 7 Primaticcio, Francesco, 657 Primavera (Botticelli), 558, 559, 581 printing press, 554, 560 printmaking, 536, 556 Baroque, 703, 708-709, 722 and drawing, 604 Holy Roman Empire late medieval/early Renaissance, 554–556, 20-21A Italian Quattrocento Renaissance, 581-582 Northern European High Renaissance/ Mannerist, 649-651, 653, 23-5A See also woodcuts project for a central-plan church (Leonardo da Vinci), 605, 605b, 22-6A Prometheus Bound (Rubens), 25-13A propaganda. See art as a political tool proportion, 10-11 in Italian Cinquecento Renaissance architecture, 22-6A in Italian Quattrocento Renaissance architecture, 584, 586, 588, 594 See also hierarchy of scale; modules proscenium, 675 Protestant Reformation, 646, 656-657 and Books of Hours, 551 and Counter-Reformation, 616, 617, 637, 641, 646, 670, 672, 686 and Dürer, 652 and Italian Baroque art, 670 and Netherlands High Renaissance/ Mannerist art, 659 and visual imagery, 652-654 provenance, 3

psalters, 550 Pucelle, Jean Belleville Breviary, 550 Hours of Jeanne d'Evreux, 550 pulpit, Sant'Andrea, Pistoia (Giovanni Pisano), 403–404, 403 pulpits, 402 punchwork, 412, 414 Purgatory, 584 putti, 570, 595, 614–615, 627, 22-30A, 23-15A Pythagoras, 607 Q

quadrifrons, 23-14A quadro riportato, 680, 684–685 quatrefoil, 419 Quatrocento, 559 *See also* Italian Quattrocento Renaissance art

R

quoins, 621

.

Rabelais, François, 647 Raphael (Raffaello Santi) and Andrea del Sarto, 22-8A Baldassare Castiglione, 608, 608b, 22-10A and Carracci, 681 and Correggio, 638 Galatea, Villa Farnesina, Rome, 608-609, 608 and Giulio Romano, 640 life of, 605, 607-608 Madonna in the Meadow, 606, 606 Marriage of the Virgin, 605, 605 Pope Leo X with Cardinals Giulio de' Medici and Luigi de' Rossi, 608, 608 and Poussin, 718 and Reni, 684 School of Athens (Philosophy), Vatican Palace, Rome, 606-607, 607, 624, 628, 651, 22-18B Raverti, Matteo, 21-37A realism. See naturalism/realism Rebellious Captive (Bound Slave) (Michelangelo Buonarroti), 612, 613, 614 refectory, 576 regional style, 3 Regnaudin, Thomas: Apollo Attended by the Nymphs, palace of Versailles, 717, 717, Reims Cathedral (Jean d'Orbais, Jean de Loup, Gaucher de Reims, and Bernard de Soissons) and Or San Michele, 563 and Santa Maria del Fiore, 418 sculpture, 402 relics: Italian Baroque era, 24-14A relief printing, 556 relief sculpture, 12 African, xvi, 11, 12 Egyptian Predynastic, 10 French/Spanish Romanesque, 5, 11, 12, 590 Italian 13th century, 403-404 Italian 14th century, 418-419 Italian Mannerist, 22-52A Italian Quattrocento Renaissance, 560-562, 565, 566-568, 585, 21-36A Northern European High Renaissance/ Mannerist, 658, 23-14A religion and mythology. See Christianity; classical influences on later art; specific Greek/Roman deities **Religion and Mythology boxes** Great Schism, mendicant orders, and confraternities, 404 Protestant Reformation, 653 Rembrandt van Rijn Anatomy Lesson of Dr. Tulp, 706, 706 and attribution, 6 Blinding of Samson, 706-707, 707b, 25-13A and Callot, 722 Christ with the Sick around Him, Receiving the Children (Hundred-Guilder Print), 709, 709 The Company of Captain Frans Banning Cocq (Night Watch), 706, 707 Juno, 25-Return of the Prodigal Son, 706–707, 707

Self-Portrait, 1658, 708, 708b, 25-15A

Self-Portrait, ca. 1659-1660, 705, 708, 708 and Titian, 632 Renaissance, 401, 406-407 artist training, 414, 545, 573 and humanism, 406-407, 560 See also Italian Cinquecento Renaissance art; Italian late medieval art; Italian Quattrocento Renaissance art; Northern European High Renaissance/ Mannerist art; Northern European late medieval/early Renaissance art Renaud de Cormont: Amiens Cathedral, 418 Reni, Guido: Aurora, Casino Rospigliosi, Rome, 684-685, 685 renovatio, 402 restoration, 408, 603, 615, 14-5A, 22-18B Resurrection, Palazzo Comunale, Borgo San Sepolcro (Piero della Francesca), 578-579, 578 Resurrection, San Sepolcro Cathedral (Niccolò di Segna), 578 Resurrection of Christ, 578-579 retable, 538 Retable de Champmol (Broederlam), 538, 539 Return of the Prodigal Son (Rembrandt), 706-707, 707 revetment, 418 Riace (Italy), sea near: head of a warrior (sculpture), 11, 11 rib vaulting: in Italian 13th century architecture, 14-5A, 14-6. Ribera, José de: Martyrdom of Saint Philip, 688, 688 ribs (of vaults), 12, 21-31A See also rib vaulting Riemenschneider, Tilman: Creglingen Altarpiece, 554, 555 Rigaud, Hyacinthe: Louis XIV, 714-715, 714 Ripa, Cesare, 683 Robert de Luzarches: Amiens Cathedral, 418 Robusti, Jacopo. See Tintoretto Rogier van der Weyden, 544-546, 20-8A Deposition, 544-545, 544 Last Judgment Altarpiece, Hôtel-Dieu, 544, 544b, 20-8A Portrait of a Lady, 546b, 20-9A Saint Luke Drawing the Virgin, 545-546, 545.23-15A Rolin, Nicholas, 20-8A Roman art Early Empire, 7 Pompeian/Vesuvius area, 595 See also classical influences on later art Roman religion and mythology. See classical influences on later art; specific Greek/ Roman deities Roman sculpture: Early Empire, 7 Romanesque art, 413 French/Spanish Romanesque sculpture, 5, 11, 12, 590 and Italian 14th century architecture, 413 and Italian Quattrocento Renaissance art, 588 Rome (Italy), 600 Arch of Constantine, 589 Basilica Nova, 594, 619 Biblioteca Apostolica Vaticana, 589, 21-41A Casino Rospigliosi, 684-685, 685 Chapel of Saint Ivo (Borromini), 678, 678, 679 Colosseum, 587-588, 22-30A Fountain of the Four Rivers (Bernini), 668, 669, 670 Il Gesù (Church of Jesus), Rome (della Porta and Vignola), 641-642, 642, 671, 686, 686 Old Saint Peter's, 607 Palazzo Barberini, 685–686, 685 Palazzo Farnese (Sangallo and Michelangelo), 620-621, 621, 680-681, 680 Porta Maggiore, 22-30A sack of (1527), 22-30A San Carlo alle Quattro Fontane (Borromini), 676, 676, 677, 718, 24-9A San Paolo fuori le mura (Saint Paul's Outside the Walls), 14-7 San Pietro in Vincoli, 611-613, 612 Sant'Agnese in Agone (Borromini), 668

Sant'Ignazio, 686, 687

Santa Maria della Vittoria (Bernini), 674, 675, 675 Santa Susanna (Maderno), 670-671, 670. 676 Tempietto (Bramante), 618-619, 618, 623, 22-6A Villa Farnesina, 608-609, 608 See also Pantheon; Saint Peter's; Sistine Chapel, Vatican; Vatican Palace Roscioli, Gian Maria, 720 rose windows, 412, 14-12A Rossellino, Bernardo Palazzo Rucellai, Florence, 587-588, 587 tomb of Leonardo Bruni, 570-571, 570 Rossi, Luigi de', 608 Rossi, Porperzia de', 630 rotundas, 538 roundels. See tondo/tondi Royal Academy of Painting and Sculpture (France), 714 Royal Chapel, palace of Versailles (Hardouin-Mansart): Versailles, palace of, 717–718, 717 Rubens, Peter Paul Allegory of Sight, 697, 697b, 25-1A Arrival of Marie de' Medici at Marseilles, 698-699, 699 Consequences of War, 699-700, 700 Drunken Silenus, 25-1A Elevation of the Cross, 697-698, 698 Garden of Love, 698, 698b, 25-2A life of, 697 Lion and Tiger Hunt, 25-1A Lion Hunt, 10, 10, 697, 25-1A Prometheus Bound, 25-13A and Rembrandt, 706, 25-13A and Titian, 632 and Velázquez, 692 Ruisdael, Jacob van Jewish Cemetery, 710, 710b, 25-18A View of Haarlem from the Dunes at *Overveen*, **710**, **710**, 25-18A, 25-18B rusticated style, **586**, **621**, 22-30A Ruysch, Rachel, 701 Flower Still Life, 713, 713

Sacco and Vanzetti, 4, 6 sacra conversazione, 624 sacre rappresentazioni, 409 Sacrifice of Isaac (Brunelleschi), 561-562, 562 Sacrifice of Isaac (Ghiberti), 561, 562, 562 Saint Anthony Tormented by Demons (Schongauer), 555, 556 Saint Bavo Cathedral, Ghent, 540-541, 540, 541 Saint Francis Altarpiece, San Francesco, Pescia (Berlinghieri), 404-405, 404, 14-5B Saint Francis in the Desert (Bellini), 624, 624b, 22-32A Saint Francis Master: Saint Francis Preaching to the Birds, San Francesco, Assisi (fresco), 405, 405b, 14-5B Saint Francis Preaching to the Birds, San Francesco, Assisi (Saint Francis Master) (fresco), 405, 405b, 14-5B Saint George, Or San Michele (Donatello), 564-565, 564 Saint George and the Dragon, Or San Michele (Donatello), 565, 565 Saint James Led to Martyrdom, Chiesa degli Eremitani, Padua (Mantegna), 596b, 21-49A Saint John Altarpiece, Hospitaal Sint Jan, Bruges (Memling), 548-549, 548 Saint Luke Drawing the Virgin (Rogier van der Weyden), 545-546, 545, 23-15A Saint Luke Drawing the Virgin Mary (Gossaert), 659b, 23-1 Saint Mark, Or San Michele (Donatello), 563-564, 564 Saint Mary, Kraków, 554, 554 Saint Pantaleimon, Nerezi, 409 Saint Paul's Cathedral, London (Wren), 724, Saint Paul's Outside the Walls (San Paolo fuori le mura), Rome, 14-7A Saint Peter's, Louvain, 546-547, 547 Saint Peter's, Rome (Michelangelo Buonarroti), 619-620, 620 baldacchino (Bernini), 673, 673

Bramante's plan for, 607, 618, 619, 619, 671.22-0 east facade (Maderno), 669, 671-672, 671, 676 and El Escorial, 664 Julius II's rebuilding plans, 605 piazza (Bernini), 672, 672 Pietá (Michelangelo Buonarroti), 610, 610 and Raphael, 608 and tomb of Julius II, 612 and Wren, 724 See also Old Saint Peter's Saint Serapion (Zurbarán), 688-689, 689 Saint Theodore, south transept, Chartres Cathedral (relief sculpture), 564 Saint-Denis abbey church: and Chartreuse de Champmol, 537 Saint-Lazare, Autun Italian Quattrocento Renaissance art and, 590 Last Judgment (Gislebertus), 5, 12, 590 saints, 402 See also specific saints Sala della Pace, Palazzo Pubblico, Siena, 415-416, 415, 416b, 416, 417, 14-16A Saltcellar of Francis I (Cellini), 638, 639, 22-52A Salutati, Coluccio, 561 San Carlo alle Quattro Fontane, Rome (Borromini), 676, 676, 677, 718, 24-9A San Francesco, Arezzo, 21-24A San Francesco, Assisi, 405, 405b, 407, 14-5A, 14-5B, 14-7 San Francesco, Pescia, 404-405, 404, 14-5B San Francesco Grande, Milan, 601 San Giorgio Maggiore (Palladio), Venice, 623-624, 623, 623, 636-637 San Giovanni, baptistery of. See Baptistery of San Giovanni, Florence San Lorenzo, Florence (Brunelleschi), 583b, 594, 21-37 tomb of Giuliano de' Medici (Michelangelo Buonarroti), 613-614, 613, 22-52A San Marco, Florence, 576, 576 San Miniato al Monte, Florence, 588 San Niccolò del Carmine, Siena, 22-42A San Paolo fuori le mura (Saint Paul's Outside the Walls), Rome, 14-7 San Pietro in Vincoli, Rome, 611-613, 612 San Plácido, Madrid, 24-28 San Sepolcro Cathedral, 578 San Zaccaria Altarpiece (Madonna and Child with Saints) (Bellini), 543, 624-625, 624 Sánchez Cotán, Juan: Still Life with Game Fowl, 687-688, 687 Sangallo, Antonio da (the Younger), 657, 22-30A Palazzo Farnese, Rome, 620-621, 621 Sansovino, Andrea, 22-30A Sansovino, Jacopo, 623 Library of San Marco, Venice, 623b, 22-30A Mint, Piazza San Marco, Venice, 623b, 632, 22-30A Sant'Agnese in Agone, Rome (Borromini), 668 Sant'Andrea, Mantua (Alberti), 593-594, 593, 593, 642 Sant'Andrea, Pistoia, 403-404, 403 Sant'Apollonia, Florence, 576, 577 Sant'Egidio, Florence, 548 Sant'Ignazio, Rome, 686, 687 Santa Cecilia, Trastavere, 407b, 409, 14-6, 14-7A Santa Croce, Florence, 3-4, 3, 404, 14-5A, Pazzi Chapel, 584, 584, 585, 585, 585, 21-36A Santa Maria, Trastavere, 14-7A Santa Maria del Carmine, Florence, 574, 574, 575. 584 Santa Maria del Fiore. See Florence Cathedral Santa Maria della Vittoria, Rome (Bernini), 674, 675, 675 Santa Maria delle Grazie, Milan, 602, 603 Santa Maria Divina Providencia, Lisbon (Guarini), 24-14A Santa Maria Gloriosa dei Frari, Florence, 627, 627, 628, 628 Santa Maria Novella, Florence, 404, 406b, Birth of the Virgin (Ghirlandaio) (fresco), 579, 579 and della Porta, 642 Holy Trinity (Masaccio) (fresco), 574-576,

575

El Greco, 665

Italian Baroque, 683–684, 24-17A

West facade (Alberti), 588, 588, 642, 14-6A Santa Susanna, Rome (Maderno), 670-671, 670, 676 Santa Trinitá, Florence, 406, 406, 572, 573 Santi, Giovanni, 605 Santi, Raffaello, See Raphael Santo Spirito, Florence (Brunelleschi), \583-584, 583, 583, 586, 594, 21-31A Saqqara (Egypt): Hesire relief (relief sculpture), 10, 10, 12 sarcophagi and Italian 14th century art, 402, 415 and Italian Quattrocento Renaissance art, 570 saturation, 7 Savonarola, Girolamo, 588 Scala Regia, Vatican Palace, Rome (Bernini), 672, 672b, 24-4A Schongauer, Martin, 582 Saint Anthony Tormented by Demons, 555, 556 School of Athens (Philosophy) (Raphael), Vatican Palace, Rome, 606-607, 607, 624, 628, 651, 22-18B schools (of art), 6 science and Baroque art, 694, 717-718, 722, 724 and Italian Cinquecento Renaissance art, 605 607 and Italian late medieval art, 401 and Northern European High Renaissance/ Mannerist art, 650, 23-4A and perspective, 565-566 Scrovegni, Enrico, 400, 401, 410 Scrynmakers, Margarete, 534, 535 scudi, 684 sculpture African: Benin, xvi, 11, 12 Baroque, 673, 674-675, 717, 24-6A Burgundian/Flemish late medieval/early Renaissance, 537-538, 20-2A Egyptian: Predynastic, 10 Florentine Quattrocento Renaissance. See Florentine Quattrocento Renaissance sculpture French/Spanish Romanesque, 5, 11, 12, 590 Greek Early/High Classical, 11 Holy Roman Empire late medieval/early Renaissance, 553-554 Italian 13th century, 403-404 Italian 14th century, 418-419 Italian Cinquecento Renaissance, 11, 610-614, 617-618 Italian Mannerist, 638-639, 22-52A Leonardo and Michelangelo on, 609-610 Northern European High Renaissance/ Mannerist, 658, 23-14A relief. See relief sculpture Roman Early Empire, 7 Spanish High Renaissance/Mannerist, techniques. See sculpture techniques texture in, 8 sculpture in the round, 12 sculpture techniques, 11 lost-wax process, 673, 22-52A Sebastian, Saint, 647 Second Style, 595 secondary colors, 7 sections (architectural), 12 segmental pediments, 621 Self-Portrait (Dürer), 649-650, 650, 23-11A Self-Portrait (Leyster), 705, 705 Self-Portrait (Te Pehi Kupe), 13, 13 Self-Portrait (van Hemessen), 661, 661 Self-Portrait, 1658 (Rembrandt), 708, 708b, Self-Portrait, ca. 1659-1660 (Rembrandt), 705, 708, 708 Self-Portrait as the Allegory of Painting (La Pittura) (Gentileschi), 683-684, 684 Self-Portrait in a Convex Mirror (Parmigianino), 633, 633 self-portraits Burgundian/Flemish late medieval/early Renaissance, 543, 545cap, 546 and cultural differences, 13 Dutch Baroque, 695, 705, 708, 25-15A

Italian Cinquecento Renaissance, 607, 618, 633 Italian Mannerist, 633 Italian Quattrocento Renaissance, 578 Northern European High Renaissance/ Mannerist, 649-650 Serapion, Saint, 688-689 Servite order, 404 sexuality. See eroticism Sforza, Battista, 590, 591, 592 Sforza, Caterina, 630 Sforza, Francesco, 605 Sforza, Ludovico, 601 sfumato, 539, 604 Shahn, Ben: The Passion of Sacco and Vanzetti, 4, 4, 6 sibyls, 540 Siena (Italy) Campo, 415, 415 Palazzo Pubblico, 415-416, 415, 416, 417, 14-16A, 14-18B San Niccolò del Carmine, 22-42A See also Siena Cathedral; Sienese 14th century art Siena Cathedral, 14-12A Annunciation altarpiece (Martini and Memmi), 413-415, 413 Birth of the Virgin (Lorenzetti), 415, 415 Feast of Herod (Donatello), 565, 565 Maestá altarpiece (Duccio), 410, 411-412, 411, 412b, 412, 14-8B, 14-10A and Santa Maria del Fiore, 417 Sienese 14th century art, 411-416 architecture, 412-413, 415-416, 14-12A painting, 411-412, 413-415, 416, 417, 14-7A, 14-10A, 14-16A societal contexts, 409, 14-16A Sigismund (Holy Roman Emperor), 404 Signorelli, Luca: The Damned Cast into Hell, Orvieto Cathedral (Signorelli), 590, 590, 616 Signoria, 563 Silk Road, 412 silver. See metalwork silverpoint, 545, 604 sinopia, 408 Sistine Chapel, Vatican, Rome ceiling (Michelangelo Buonarroti), 598, 599, 605, 614-615, 614, 615, 681, 698, 22-18A, 22-18B Christ Delivering the Keys of the Kingdom to Saint Peter, Sistine Chapel (Perugino), 589-590, 589, 22-18B Last Judgment (Michelangelo Buonarroti), 598, 616, 616, 22-18B, 2 restoration, 408, 615, 22-18B Sixtus IV (Pope), 589, 21-41A Sixtus V (Pope), 670 slave trade, 697 Sluter, Claus Virgin and Child, saints, and donors, Chartreuse de Champmol (sculpture), 537, 537b, 20 Well of Moses, Chartreuse de Champmol, 537-538, 537 societal contexts of art Burgundian/Flemish late medieval/early Renaissance, 536-537 Dutch Baroque, 695, 696-697, 702, 709 English Baroque, 723 Flemish Baroque, 696-697, 699-700 French Baroque, 714, 722 importance of, 1-2 Italian 14th century art, 406-407, 409, 410, 14-164 Italian Cinquecento Renaissance art, 600, 622 Italian late medieval art, 404, 406-407 Italian Quattrocento Renaissance art, 560, 561, 563, 584, 588 Northern European High Renaissance/ Mannerist art, 646-647, 652-653, 656-657, 658-659 Northern European late medieval/early Renaissance art, 536-537, 550, 555-556 Spanish Baroque, 687, 691 Spanish High Renaissance/Mannerist, 664 See also religion and mythology Society of Jesus (Jesuit order), 641-642, 686 Socrates, 560

Sorel, Agnès, 552 space, 8 Spanish art in the Americas, 664, 23-23A Baroque, 687-692, 693, 24-25A, 24-28A, French/Spanish Romanesque sculpture, 5, 11, 12, 590 High Renaissance/Mannerist, 664-666, 667.23-234 spectrum, 7 Spínola, Ambrogio di, 691 Spiritual Exercises (Loyola), 675 Stadhuis, Louvain, 20-11. stained-glass windows, 12 in Gothic architecture, 20-4A in Italian 13th century architecture, 14-5A Stanza della Segnatura, Vatican Palace, Rome, 606-607, 607 stanza/stanze, 606 Stanzas for the Joust of Giuliano De' Medici (Poliziano), 609 Starry Night (van Gogh), 666 statues, 12 See also sculpture Steen, Jan: Feast of Saint Nicholas, 712-713, 712 Stephen, Saint, 552 stigmata, 405 Still, Clyfford: 1948-C, 1, 2 still life, 5 in Baroque art, 687, 687-688, 694, 695, 701, 713 Still Life with a Late Ming Ginger Jar (Kalf), 713, 713 Still Life with Flowers, Goblet, Dried Fruit, and Pretzels (Peeters), 701, 701 Still Life with Game Fowl (Sánchez Cotán), 687-688, 687 storytelling. See narrative art Stoss, Veit: altar of the Virgin Mary, church of Saint Mary, Kraków, 554, 554 stretcher bars, 543 stringcourses, 586 style, 3-5 stylistic evidence, 3 stylobate, 618 stylus, 545, 556, 604 subtractive light, 7 subtractive sculpture, 11 Supper Party (van Honthorst), 702, 703 Surrealism and Bosch, 645 and El Greco, 666 Surrender of Breda (Velázquez), 690, 691 Sylvester, John Henry: Portrait of Te Pehi Kupe, 13, 13 symbols, 5

See also attributes

tabernacle, Or San Michele, Florence (Orcagna), 419, 419b, 14-19A Tarvisium, Nuremberg Chronicle (Koberger) (ill. by Wolgemut and shop), 554-555, 555, 556 Tatti, Jacopo. See Sansovino, Jacopo tattoo (tatu/tatau), 13 Te Pehi Kupe: Self-Portrait, 13, 13 technique, 7 Teerlinc, Levina: Elizabeth I as a Princess (attr.), 661-662, 661 tempera painting

- in Italian 13th century art, 404-405 in Italian 14th century art, 407-408, 411-412, 413-415, 14-10A
- in Italian Cinquecento Renaissance art, 602, 22
- in Italian Quattrocento Renaissance art, 572, 573, 577-578, 579-580, 581, 591, 592, 21-29A
- vs. oil painting, 538, 539
- See also mural painting; painting The Tempest (Giorgione da Castelfranco),
- 626-627, 626, 666 Tempietto, Rome (Bramante), 618-619, 618,
- 623, 22-6A Temptation of Saint Anthony (Grünewald),

647, 648 tenebrism, 682-683, 683, 698 tenebroso. See tenebrism

ter Brugghen, Hendrick, 723 Calling of Saint Matthew, 702, 702 Teresa of Avila, Saint, 675, 688 terminus ante quem, 2 terminus post quem, 2 terracotta in Italian 14th century art, 414 in Italian Quattrocento Renaissance art, 583, 585, 21-36A terribilitá, 599 textiles: and Italian 14th century art, 412 texture, 8 Thirty Years' War (1618-1648), 687, 696, 700, 722 tholos/tholoi, 618 Thomas de Cormont: Amiens Cathedral, 418 Three goddesses (Hestia, Dione, and Aphrodite?), Parthenon east pediment, Athens (sculpture), 602-603 thrust, 21-31A timelines Italian Baroque art, 670 Italian Cinquecento Renaissance/ Mannerism art, 600 Italian late medieval art, 402 Italian Quattrocento Renaissance art, 560 Northern European Baroque art, 696 Northern European High Renaissance/ Mannerist art, 646 Northern European late medieval/early Renaissance art, 536 Tintoretto (Jacopo Robusti), 665, 666 *Last Supper*, 636–637, 636 Titian (Tiziano Vecelli) Assumption of the Virgin, 627, 627 and Carracci, 681 and El Greco, 665 Feast of the Gods, 625, 625, 626, 628 Isabella d'Este, 630, 630, 631, 22-40A Madonna of the Pesaro Family, 628, 628 Meeting of Bacchus and Ariadne, 628, 629 Palma il Giovane on, 631 Pastoral Symphony, 626, 627 Pietá, 631-632, 631 and Poussin, 718 and Rubens, 697 and Tintoretto, 636 Venus of Urbino, 628, 629, 631 Tokugawa shogunate. See Edo period Japanese painting Tomb of Edward II, Gloucester Cathedral, 570 tomb of Giuliano de' Medici, San Lorenzo, Florence (Michelangelo Buonarroti), 613-614, 613, 22-5 tomb of Julius II (Michelangelo Buonarroti), 611-613, 612, 614 tomb of Leonardo Bruni (Rossellino), 570-571, 570 tomb of Lorenzo, San Lorenzo, Florence (Michelangelo Buonarroti), 613, 614 Tommaso Portinari and Maria Baroncelli (Memling), 549, 549b, 20-14A tonality, 7 tondo/tondi, 583, 585 Tornabuoni, Giovanna, 580 Tornabuoni, Giovanni, 579 Tornabuoni, Lucrezia, 630 tracery, 414, 664 Traini, Francesco: Triumph of Death, 419-420, 419 tramezzo, 14-6A transepts in Italian 13th century architecture, 14-5A in Italian Quattrocento Renaissance architecture, 564 Transfiguration of Christ, 412 transubstantiation, 24-18A Trastavere (Italy) Santa Cecilia, 407b, 409, 14-7A Santa Maria, 14-7A Treatise on Painting (Leonardo da Vinci), 609 Treaty of Westphalia (1648), 670, 696-697 trefoil arches, 402, 14-18B Les Très Riches Heures du Duc de Berry (Limbourg brothers (Pol, Herman, Jean)), 550-551, 550, 551 Tribute Money, Santa Maria del Carmine, Florence (Masaccio) (fresco), 574, 574 triforium, 20-4A

Trinity in Italian Baroque architecture, 24-14A in Italian Quattrocento Renaissance art 574-576 triptychs, 415 Triumph of Death (Traini or Buffalmacco), 419-420, 419 Triumph of the Barberini, Palazzo Barberini, Rome (Pietro da Cortona), 685-686, 685 Triumph of the Name of Jesus, Il Gesù (Gaulli), 686, 686 Triumph of Venice (Veronese), 637, 637 triumphal arches, 575, 594 trompe l'oeil, 595, 24-14A trumeaus, 20-2A tunnel vaults. See barrel vaults Turin (Italy) Cappella della Santissima Sindone (Chapel of the Holy Shroud) (Guarini), 678, 678b, 24-14A Palazzo Carignano (Guarini), 676, 676b, 24-9A Tuscan columns, 587, 618, 640, 22-30A twentieth century art. See late 20th century European and American art tympanum/tympana, 538, 590, 14-12A U U.S. art. See American Modernism; late 20th century European and American art Uccello, Paolo: Battle of San Romano, 580-581, 580 unfinished statue (Michelangelo Buonarroti), 11, 11 Urban VI (Pope), 404 Urban VIII (Pope), 669, 670, 673, 685, 686 urban planning: Roman Empire, 14-18B Urbino (Italy), 590, 592-593 V Vallodolid (Spain): Colegio de San Gregorio, 664-665, 664 value, 7 Van Dyck, Anthony, 635 Charles I Dismounted, 701, 701 van Eyck, Hubert: Ghent Altarpiece, 538, 540-541, 540, 541, 543, 20-8A van Eyck, Jan, 23-4A Ghent Altarpiece, 538, 540-541, 540, 541, 543, 20-8A Giovanni Arnolfini and His Wife, 541-542, 542, 692, 20-14A and invention of oil painting, 538 Madonna in a Church, 540, 540b, 20-4A Man in a Red Turban, 542-543, 543 and Raphael, 608 van Gogh, Vincent: Starry Night, 666 van Hemessen, Caterina, 545 Self-Portrait, 661, 661 van Hemessen, Jan Sanders, 661 van Honthorst, Gerrit and La Tour, 723 Supper Party, 702, 703 van Nieuwenhove, Martin, 549 van Ruytenbach, Willem, 706 vanishing point, 547, 567, 574, 575-576, 590 vanitas, 695, 713, 23-3A, 25-18A Vanitas Still Life (Claesz), 694, 695, 713 Vannucci, Pietro. See Perugino Vasari, Giorgio on Andrea del Sarto, 22-8A on Beccafumi, 22-42A on Giotto, 407, 14-7A on Gossaert, 659, 23-15A on Masaccio, 574 on Michelangelo, 610 on Parmigianino, 633 on Rossi, 630 on van Eyck, 538 vase painting: Greek Archaic period, 570 Vatican. See papacy; Rome Vatican Palace Scala Regia (Bernini), 672, 672b, 24-4A School of Athens (Philosophy) (Raphael), 606–607, 607, 624, 628, 651, 22-18B Stanza della Segnatura, 606–607, 607 vault ribs. See rib vaulting vaults, 12 See also barrel vaults; groin vaults; rib

vaulting Vecelli, Tiziano. See Titian Velázquez, Diego, 708 Christ on the Cross, 689, 689b, 24-28A King Philip IV of Spain (Fraga Philip), 689. 689b. 24-28B Las Meninas (The Maids of Honor), 690, 691-692,691 Surrender of Breda, 690, 691 Water Carrier of Seville, 689, 689 vellum, 604 See also books Venetian 14th century art, 420 Venice (Italy), 420 Ca d'Oro (Palazzo Contarini), 586, 586b, 21-37A Cinquecento, 622, 624-629, 631-632, 638, 22-32A Doge's Palace, 420, 420, 637, 22-30A Library of San Marco (Sansovino), 623b, Mint, Piazza San Marco (Sansovino), 623b, 632, 22-30A San Giorgio Maggiore (Palladio), 623-624, 623, 623, 636-637 Venus. See Aphrodite Venus, Cupid, Folly, and Time (Bronzino), 634, 634 Venus of Urbino (Titian), 628, 629, 631 Vermeer, Jan Allegory of the Art of Painting, 712, 712 and art market, 703, 711 and camera obscura, 711 The Letter, 712, 712b, 25-20A View of Delft, 711, 711b, 25-18B Woman Holding a Balance, 711, 711 vernacular, 406 Veronese, Paolo (Paolo Caliari) Christ in the House of Levi, 636, 637 Triumph of Venice, 637, 637 Verrocchio, Andrea del Bartolommeo Colleoni, 571-572, 571, 23-5A David, 569, 569, 611, 674, 675 and Leonardo da Vinci, 601 Versailles, palace of, 715-716 aerial view, 715 Apollo Attended by the Nymphs (Girardon and Regnaudin), 717, 717, 24-6A Galerie des Glaces (Hardouin-Mansart and Le Brun), 716, 716 park (Le Nôtre), 715, 716 Royal Chapel (Hardouin-Mansart), 717-718, 717 Vesuvius area art. See Pompeian/Vesuvius area art Vicenza (Italy): Villa Rotonda (Palladio), 622, 623 View of Delft (Vermeer), 711, 711b, 25-18B View of Haarlem from the Dunes at Overveen (Ruisdael), 710, 710, 25-18A, 25-18B View of Toledo (El Greco), 666, 666 Vignola, Giacomo da: Il Gesù (Church of Jesus), Rome, 641-642, 642, 671, 686, 686 vilass, 622, 623 Villa Farnesina, Rome, 608-609, 608 Villa Rotonda, near Vicenza (Palladio), 622, 623 Villanueva, Jerónimo de, 24-28A Virgin and Child in Burgundian/Flemish late medieval/ early Renaissance art, 537, 549, 20-2A in French late medieval/early Renaissance art, 552, 20-15A in Italian 14th century art, 411-412, 578, 14-19A in Italian Cinquecento Renaissance art, 543, 601-603, 606, 624-625, 628, 22-8A in Italian Mannerist art, 633-634 in Italian Quattrocento Renaissance art, 571, 577-578, 604, 21-36A Virgin and Child (Virgin of Paris), Notre-Dame Cathedral, Paris (sculpture), 20-24 Virgin and Child, Melun Diptych (Fouquet), 552, 552 Virgin and Child, saints, and donors, Chartreuse de Champmol (Sluter) (sculpture), 537, 537b, 20-2. Virgin and Child Enthroned with Saints, Maestá altarpiece, Siena Cathedral (Duccio), 411-412, 411, 578 Virgin Mary

Annunciation to. See Annunciation to Mary

in Burgundian/Flemish late medieval/ early Renaissance art, 540, 544, 548-549, 20-4A, 20-8. in French late medieval/early Renaissance art, 20-18A in Holy Roman Empire late medieval/ early Renaissance art, 554 in Italian 13th century art, 403 in Italian 14th century art, 409 in Italian Cinquecento Renaissance art, 605, 627 in Italian Quattrocento Renaissance art, in Northern European High Renaissance/ Mannerist art, 23-15A in Spanish Baroque art, 24-25A See also Pietás; Virgin and Child Virgin of Paris, Notre-Dame Cathedral, Paris (sculpture), 20-2. Virgin of the Immaculate Conception: in Spanish Baroque art, 24-25 Virgin with Saints and Angels, Saint John Altarpiece (Memling), 548-549, 548 Visconti, Giangaleazzo (duke of Milan), 561 Visitation, 538, 539 Vita (Bellori), 682 Vitruvian Man (Leonardo da Vinci), 603b, 22-3A Vitruvius, 586, 588, 603, 622, 650-651, 22-6A volume, 8 voussoirs, 640 Vyd, Joducus, 540 W wall tombs: Italian Quattrocento Renaissance, 570 Water Carrier of Seville (Velázquez), 689, 689 Watteau, Antoine: Pilgrimage to Cythera, 25-1A Waves at Matsushima (Korin), 8-9, 9 weaving. See textiles welding, 11 Well of Moses, Chartreuse de Champmol (Sluter), 537-538, 537 Wilhelm IV (duke of Bavaria), 654 windows in Italian 13th century architecture, 14-5A lancets, 14-5/ in Northern European High Renaissance/ Mannerist art, 658 oculi, 14-6A, 21-31A See also clerestories; stained-glass windows witchcraft, 649 Witches' Sabbath (Baldung Grien), 649, 649 Witz, Konrad: *Altarpiece of Saint Peter*, Cathedral of Saint Peter, Geneva, 552-553, 553 Wolgemut, Michel, 649 illustrator of Nuremberg Chronicle (Koberger), 554–555, 555, 556 Woman Holding a Balance (Vermeer), 711, 711 Women Artists, 1550-1950 exhibit, 684 The Women Regents of the Old Men's Home at Haarlem (Hals), 705, 705 women's roles in society Baroque era, 684, 705 late medieval/early Renaissance Flanders, 545 Renaissance, 414, 630, 661, 662 See also specific women woodcuts, 6, 554-555, 556, 649-651, 653, 20-21A, 23-5A World War II, 21-49A Wren, Christopher: Saint Paul's Cathedral, London, 724, 724 Written Sources boxes artists' guilds, 410 Bellori, 682 Counter-Reformation Italy, 617 Wrongful Beheading of the Count (Bouts), 546b, 20-11A Y Young Man Holding a Medal of Cosimo de' Medici (Botticelli), 21-29A Z

zoomorphic forms. See animals Zuan di Franza, 21-37A Zuccari, Federico, 604 Zurbarán, Francisco de: Saint Serapion, 688-689, 689

Zwingli, Ulrich, 653-654